AMERICAN RADIANCE

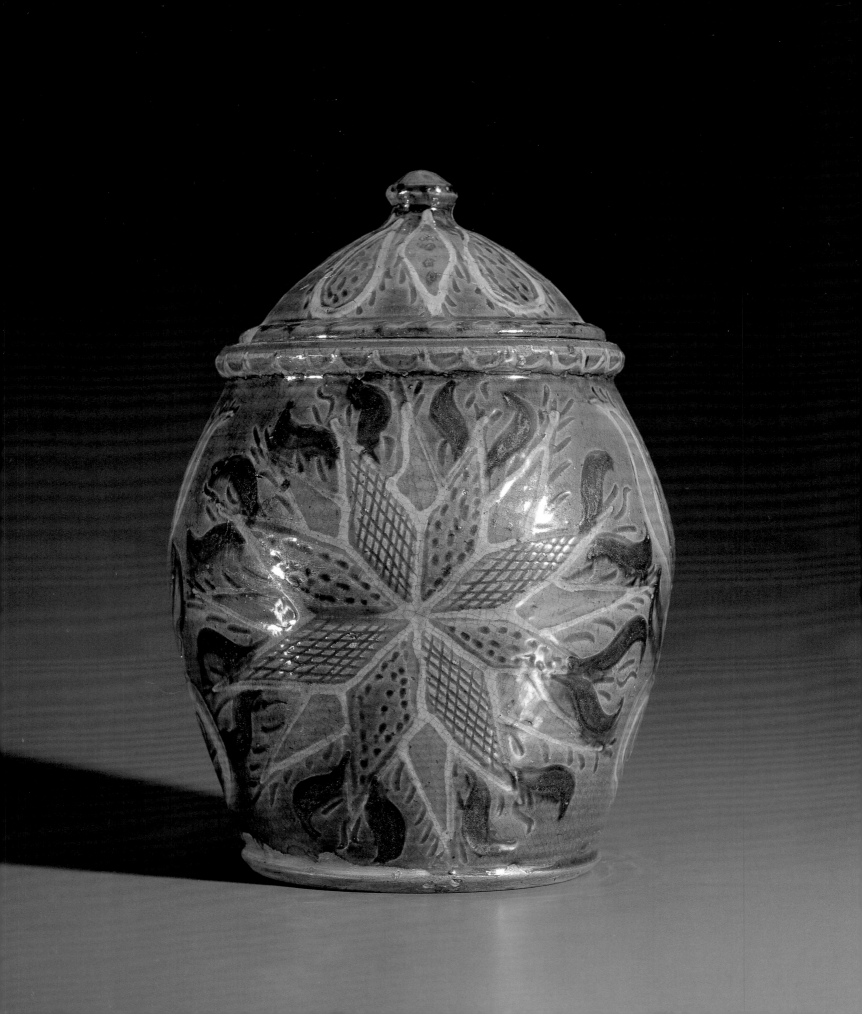

AMERICAN RADIANCE

THE RALPH ESMERIAN GIFT
to the
AMERICAN FOLK ART MUSEUM

Stacy C. Hollander

Foreword by
Gerard C. Wertkin

Essay by
Ralph Esmerian

Principal photography by
John Bigelow Taylor

Project coordinated by
Tanya Heinrich

With contributions by
Helen Kellogg and Steven Kellogg
Lee Kogan
Jack L. Lindsey
Kenneth R. Martin
Charlotte Emans Moore
Betty Ring
Ralph Sessions
Donald R. Walters
Carolyn J. Weekley
Frederick S. Weiser
Gerard C. Wertkin

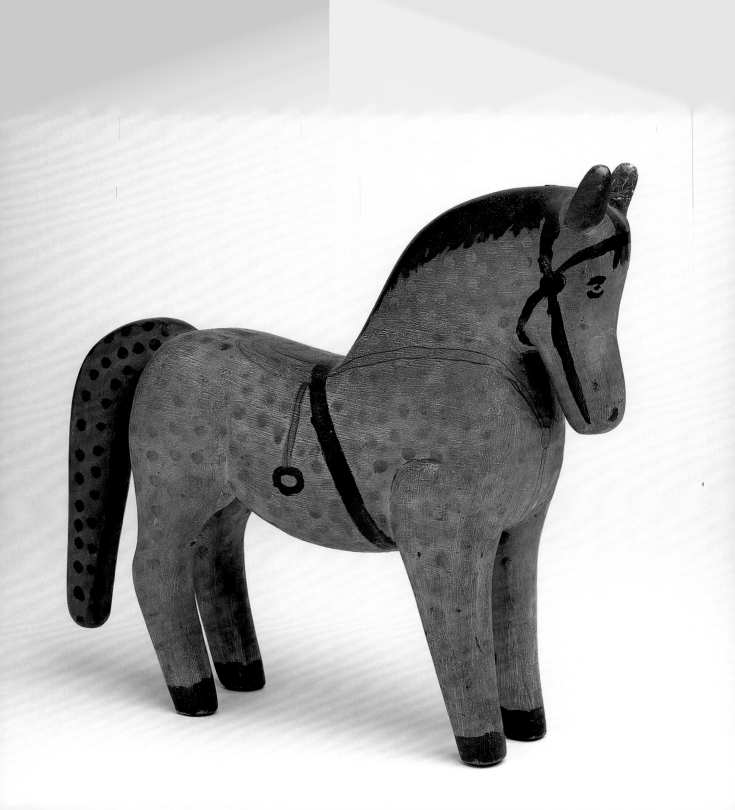

"American Anthem" signals a new era for the American Folk Art Museum as it establishes its new home on West 53rd Street. This series of inaugural exhibitions provides a rare opportunity to experience the complex world of American folk art, a genre that reflects the diversity of the American experience and expresses our commonly held heritage. Through the assembling of the historic, provocative, and engaging works from the Ralph Esmerian Collection and the Museum's permanent holdings, along with recently acquired materials by 20th-century visionary Henry Darger, viewers will be introduced to the vast and remarkable field of American folk art.

Philip Morris is proud to partner with the American Folk Art Museum at this critical point in its history. Since the mid-1970s, we have had a long-standing commitment to the field of folk art by supporting exhibitions featuring Amish and African American quilts, and folk art traditions from Switzerland, the American South, and the Dominican Republic. Through our sponsorships, we are pleased to help audiences broaden their understanding of this indigenous work and provide a showcase for the many artists who work outside of the mainstream but in their own way express the particular character of our country.

Our support of "American Anthem" continues Philip Morris' more than forty-year history of supporting the arts and our strong belief in giving back to the communities in which we do business.

Jennifer P. Goodale

Jennifer P. Goodale
Director, Corporate Contributions
Philip Morris Companies Inc.

Principal photography copyright © 2000 John Bigelow Taylor, New York.

Published in conjunction with the exhibition "American Radiance: The Ralph Esmerian Gift to the American Folk Art Museum," presented December 2001 through June 2002 as part of "American Anthem," the inaugural series of exhibitions at the American Folk Art Museum's new building at 45 West Fifty-third Street, New York, and sponsored by

PHILIP MORRIS
COMPANIES INC.

Library of Congress Cataloging-in-Publication Data
American Folk Art Museum.
 American radiance: the Ralph Esmerian gift to the American Folk Art
 Museum / Stacy C. Hollander; principal photography by John Bigelow Taylor;
 with contributions by Helen Kellogg . . . [et al.].
 p. cm.
 Includes bibliographical references and index.
 ISBN: 0-8109-6741-3 (cloth : alk. paper)
 1. Folk art–United States–Catalogs. 2. Art–New York (State)–New York–
Catalogs. 3. Esmerian, Ralph, 1940–Art collections–Catalogs. 4. American
Folk Art Museum –Catalogs. I. Hollander, Stacy C. II. Title.
NK805.M87 2001
745'.0973'0747471–dc21 2001022795

Distributed in 2001 by Harry N. Abrams, Incorporated, New York.

Frontispiece: Solomon Grimm, *Covered Jar with Star Decoration,* 1822 (cat. no. 87)
Page 4: Artist unidentified, *Horse Toy,* c. 1860–1890 (cat. no. 132)
Page 11: June Ewing, *Museum Opening,* c. 1980
Page 16: Artist unidentified, *Miniature Slipware Plate,* c. 1820–1850 (cat. no. 96a)
Page 18: Heinrich Engelhard, *Presentation Fraktur for Jacob Bordner,* 1830
(cat. no. 166)

Note: For each artwork, height precedes width precedes depth. Artists' spellings are retained in the titles.

Edited by Tanya Heinrich
Produced by Marquand Books, Inc., Seattle
 www.marquand.com
Designed by John Hubbard with assistance by Vivian Larkins
Typeset by Jennifer Sugden
Printed by C & C Offset Printing Co., Ltd., Hong Kong

10 9 8 7 6 5 4 3 2 1

Harry N. Abrams, Inc.
100 Fifth Avenue
New York, N.Y. 10011
www.abramsbooks.com

CONTENTS

ACKNOWLEDGMENTS

My first words of thanks must be directed to Ralph Esmerian, whose love of American folk art and of the American Folk Art Museum has been illuminating and inspiring. His open generosity and gentle guidance have offered rewards that expand the largesse of his gift, and I am personally indebted to him for his trust.

The wonder of the artworks that comprise this gift and the great responsibility they represent have engendered both joy and trepidation. A project of this scope needs a clear head and a firm hand at the top, and in my colleague Tanya Heinrich, general editor and project coordinator, I also have a partner and a friend. Without her precise mind and extraordinary language and organizational skills, this project simply would not have been possible. The preparation of this volume depended upon the teamwork of many staff members of the Museum. Rosemary Gabriel, director of publications, navigated the complexities of the publishing world with her usual aplomb to bring this volume to fruition. Riccardo Salmona, deputy director, and Cheryl Aldridge, director of development, were tireless in their fund-raising efforts to make its realization possible. Ann-Marie Reilly, registrar, has been unstinting of her time in organizing checklists and unfailing in her support, good sense, and smiling assistance in preparing artworks for photography and examination by the contributing writers. My thanks go to Judith Steinberg, assistant registrar, for her help in relieving the burdens of workaday responsibilities and her many hours spent supervising photography and other tasks. Janey Fire, director of photographic services, has showered us with words of cheer just when they were needed and was a sea of calm in a storm of photography and its aftermath. Eugene P. Sheehy and Rita Keckeissen, volunteer librarians, and Katya Ullmann, library assistant, were invaluable in providing research suggestions and access to materials in the Museum's library. For their editorial input, I am grateful to Benjamin J. Boyington, Jocelyn Meinhardt, and Natasha Waxman. Andrew E. Albertson, Alissa Bouler, Stephen Feeney, Sara Kay, David Lahoda, Sarah Munt, Kate Silverman, Laura Tilden, Joy Wayne, Sandra Wong, and Diana Zanganas deserve a note of thanks for their assistance on a variety of tasks.

My regard, affection, and gratitude to all the contributors who jumped eagerly into the fray and came through with fresh, thoughtful, informative, and eloquent reflections on the artworks in this volume: Helen Kellogg and Steven Kellogg, Lee Kogan, Jack L. Lindsey, Kenneth R. Martin, Charlotte Emans Moore, Betty Ring, Ralph Sessions, Donald R. Walters, Carolyn J. Weekley, Frederick S. Weiser, and Gerard C. Wertkin. The very special nature of this project inspired all participants to stretch just a little farther. In our photographer, John Bigelow Taylor, and his helpmate Dianne Dubler, we were blessed to find an artist who has made the collection sing from these pages. Ed Marquand, John Hubbard, Vivian Larkins, Jennifer Sugden, Amy Cilléy, Laura Hulscher, Gretchen Miller, Elsa Varela, Marta Vinnedge, Marie Weiler, and Carrie Wicks at Marquand Books, with the outside support of Suzanne Kotz, Laura Iwasaki, and Bonny McLaughlin, took our words and pictures and wrought the magic you now hold in your hands. And last, to my friend and mentor, Gerard C. Wertkin, director of the American Folk Art Museum, thank you always for your wisdom.

The authors owe a tremendous debt of gratitude to the following colleagues, scholars, collectors, family descendants, and so many others who have shared freely of their expertise and information. Any omissions are mine alone: Toby Appel, historical librarian, and Mona Panaitisor, library assistant, Harvey Cushing/John Hay Whitney Medical Library, Yale University, New Haven, Conn.; Georgia B. Barnhill, Andrew W. Melon Curator of Graphic Arts, American Antiquarian Society, Worcester, Mass.; Linda Baumgarten, curator of textiles and costumes, Colonial Williamsburg Foundation, Williamsburg, Va.; Helen Bender, interlibrary loan librarian, and Theresa A. Francisco, adult librarian (Charlestown branch), Boston Public Library; Pat Blackler, village historian, Skaneateles Historical Society, Skaneateles, N.Y.; Margaret Moore Booker, curator, Coffin School, Egan Institute of Maritime Studies, Nantucket, Mass.; William F. Brooks Jr., executive director, Vermont State Craft Centers, Burlington, Middlebury, and Manchester, Vt.; Rose M. Bryan; Dennis Buck, curator, Aurora Historical Society, Aurora, Ill.; Evelyn Conger Caprio; Margaret Togin Lawton Cassell; Charles M. Chestnutwood; Robyn Christensen, library assistant, The Bostonian Society, Boston; Alexandra B. Earle, executive director, Duxbury Rural and Historical Society, Duxbury, Mass.; Harry Folsom; Lila Fourhman-Shaull, assistant librarian, York County Historical Society, York, Pa.; Tobin Fraley; Tom Frusciano, Archibald S. Alexander Library, Rutgers University, New Brunswick, N.J.; Donald W. Gardner, director, Marblehead Historical Society, Marblehead, Mass.; Donna-Belle Garvin, curator, New Hampshire Historical Society, Concord; Margaret Gerberich, volunteer genealogist, Lebanon County Historical Society, Lebanon, Pa.; Nicholas Graham, reference librarian, Massachusetts Historical Society, Boston; Vernon S. Gunnion; David Hankins, president, Otisfield Historical Society, Otisfield, Maine; Betsy Hannula, executive director, Fitchburg Historical Society, Fitchburg, Mass., and curator, Westminster Historical Society, Westminster, Mass.; J. Edward Hood, research historian, architecture and material life, Frank G. White, curator of mechanical arts, and Nan Wolverton, curator of decorative arts, Old Sturbridge Village, Sturbridge, Mass.; Alice Hudson, chief curator, map division, New York Public Library; Dr. Tony Hyman, curator and director, National Cigar Museum, Shell Beach, Calif.; Ralph Katz; Arthur B. Kern; Kate and Joel Kopp, America Hurrah, New York; Matthew Lawton; Jasun Lego;

Barbara Luck, curator of paintings and drawings, Abby Aldrich Rockefeller Folk Art Museum, Colonial Williamsburg Foundation, Williamsburg, Va.; Judith N. Lund; James Martin, Orion Analytical, Williamstown, Mass.; Grace-Ellen McCrann, special collections librarian, New Jersey Historical Society, Newark; Barbara McMurray, associate registrar, and Barbara Rathburn, assistant registrar, Shelburne Museum, Shelburne, Vt.; Nancy E. McNicol; Susan Messimer, curator of community life, Landis Valley Museum, Lancaster, Pa.; Thomas Michie, curator of decorative arts, Museum of Art, Rhode Island School of Design, Providence; Richard Miller; Judith and James Milne, New York; Gerry Moore, research taxonomist, Brooklyn Botanic Garden, Brooklyn, N.Y.; William D. Moore, executive director, Enfield Shaker Museum, Enfield, N.H.; Joseph Peknik, principal technician, department of musical instruments, and Betsy Baldwin, associate archivist, The Metropolitan Museum of Art, New York; Sue Welsh Reed, curator of prints and drawings, Museum of Fine Arts, Boston; Gretchen Sachse, Tompkins County historian, DeWitt Historical Society, Ithaca, N.Y.; Robert C. Schoeberlein, curator of photographs, special collections, Maryland State Archives, Baltimore; E. Lee Shepard, assistant director for manuscripts and archives, Virginia Historical Society, Richmond; Marseea Sills, Wayne Historical Commission, Wayne, N.J.; Carolyn S. Stauffer, executive director, Hanover Area Historical Society, Hanover, Pa.; Sharon Steinberg, assistant research librarian, Connecticut Historical Society, Hartford; Elizabeth Stillinger; Randall Wade Thomas, executive director, Freeport Historical Society, Freeport, Maine; Sandra Shaffer Tinkham; Kevin J. Tulimieri, Nathan Liverant and Son Antiques, Colchester, Conn.; Paul Vardeman; Anne Verplanck, curator of prints and paintings, and Eleanor Neville McD. Thompson, National Endowment of the Humanities librarian, The Henry Francis du Pont Winterthur Museum, Winterthur, Del.; Elizabeth V. Warren, consulting curator, American Folk Art Museum, New York; Barbara K. Weeks, associate registrar, Sarah Cantor, assistant registrar, Mary E. Herbert, assistant curator of manuscripts, and Donna Williams, research and library reference assistant, Maryland Historical Society, Baltimore; Diane Wenger, chair of museum and library committee, and Andrew Wyatt, on behalf of the board of directors, Historic Schaefferstown, Inc., Schaefferstown, Pa.; Marianne C. Zephir, site manager, Gropius House, Society for the Preservation of New England Antiquities, Lincoln, Mass.; and the staffs of Family History Center, The Church of Jesus Christ of Latter-Day Saints, New York, and The Woodbridge Public Library, Woodbridge, N.J.

Stacy C. Hollander
Senior Curator and Director of Exhibitions
American Folk Art Museum

JOURNEY

Two school diplomas and a university degree were my reward for serving seventeen years in the trenches of formal education. Names, dates, facts, philosophies, had been retained dutifully in my mind, but at the age of twenty-two I remained out of focus about myself and a career. My solution was to step off the whirring carousel, walk away from the familiar, and gain new perspectives.

And for two years I lived and taught school in Athens. Coming from New York, city of energy and modernity, I needed the contrast of Greece with her ancient culture that had provided the foundations of Western art and governance. If America was the apex of current civilization, then Greece contained its primitive and uninhibited beginnings.

During my weekend travels away from the Byzantine cities and towns, pockets of the Grecian landscape seemed absolutely unchanged from ancient times. On two occasions, in the Peloponnesus and along the Mani coast, I remember walking alone—not a scrap of paper or rusty beer can, no jet stream painting the sky, not even the sputtering motor of a caïque. There wasn't one reminder of the twentieth century. I was walking on rocky terrain—broken only by the occasional olive tree— whose worn patina bore witness to life in antiquity. Across the water, silhouetted against a timeless twilight backdrop, the wavy coastline appeared trampled and beaten down by centuries of human activity. Soldiers, sailors, farmers, and shepherds, plying land and sea millenniums ago, passed before me on the stark stage. Isolated in this ancient landscape, I was indeed a New York Yankee in Homer's Hellas, but this was no sleep, this was no dream.

Call it an awakening, at once very spiritual and physical. A new set of muscles was born and stretched, totally independent of my academic intellect, which had labored for so long in classrooms to appreciate history. Being on location with sights and sounds gave a vital life force to what the mind had learned long ago. The image of the land, that earth so essential to the beginnings of Western civilization, had touched me and reached my core. During my stay in Athens I collected shards and pieces of ancient pottery as a way of marking those special moments in the Greek countryside. Baked earth, shaped and decorated by human hands, underlined the basic working relationship between nature and man.

NEW YORK, 1964

For fear of becoming an expatriate, I returned to America in the summer of 1964. As it always has, the visual impact of the city skyline stunned me as I crossed the Triborough Bridge on my way home to New York. The thrust of the gateway city's creativity and energy, so neatly packaged in buildings and the grid, underline the unique standing America has in human history. Where the worn and crusty earth of a Greek landscape had served me as a marker for the beginnings of our civilization, so the towering skyscrapers symbolized a country that has created opportunity and government for a vast population as no previous society has been able to do.

Having lived and worked overseas for two years, I had gained a different perspective on America. It was the center of the world, a cultural and material force to be envied and hated, to be loved and pursued as an earthly paradise for humanity. In such a short, historical time—two hundred and fifty years—this community had grown from immigrant seeds to become a national entity that reached out to the world and spread its culture.

History books had taught me the names of heroes and the principles of independence and representation. But the day-to-day work and settlement of this land had been in the hands of unknown soldiers and families, farmers and tradespeople. I had never been told their story. Tools, tableware, bedcovers, birth certificates—what survives today from those pioneers who laid the foundations for the society in which I live, for the civilization that is so special in human history?

One week back from Athens and I realized that my great friend June Ewing had an upcoming birthday for which I was totally unprepared. With four children and an open door of welcome to friends and animals, June lived with country furniture and pieces that created a warm atmosphere of comfort and simplicity. Having grown up in a very French eighteenth-century apartment environment and the accompanying discipline of scheduled meals and guests, I had been immediately seduced by June's naturalness and humanity. It had always seemed obvious to me that the Early American furnishings in her homes were an automatic by-product of her character and sensibilities.

My immediate need on that humid July day was to find a good present; an article in the newspaper directed me to a new folk art gallery on Fifty-seventh Street. I spotted a colorful coverlet and bought it. Awaiting my change and the gift-wrapped package, I looked around: there on a battered tavern table was a small slipware dish. "Pennsylvania German," said the dealer, noticing my fascination. I turned it over, and once again, there was the earth, the rough underside providing such a contrast to the smooth slip surface. No mistaking this piece for my antique shards. Time had barely touched the veneer of this plate compared to the millenniums Greek pottery had survived. Fired over a century ago, the neon glitter of the Pennsylvania slip seemed positively modern compared to its ancient counterpart. Yet, it too was an artifact, a survivor of a great culture. In the end, I walked out with two purchases: a bulky birthday gift to be carried and a piece of Pennsylvania earth slipped into my pocket. My American journey had begun.

Ralph Esmerian

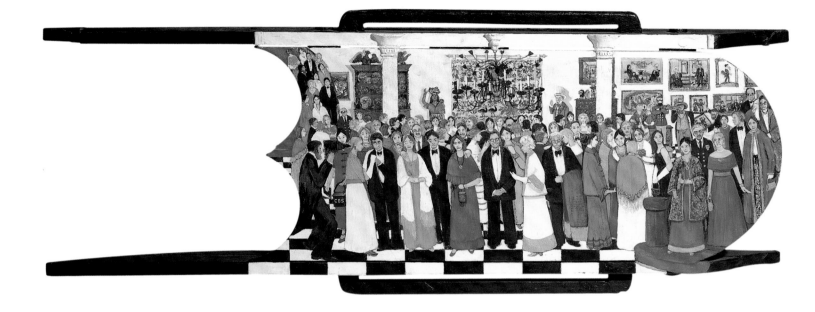

Opening Night, c. 1983
June Ewing, New York
Acrylic and plaster on wood,
16 × 40 × 4½ in.
P1.2001.373

Former Museum director Robert Bishop
and trustee Alice Kaplan, in white dress,
are depicted in the center. At left, Ralph
Esmerian is shown kissing a woman's hand.

June Ewing was an intercollegiate cham-
pion swimmer, concert pianist, wife, and
mother. During the 1970s and '80s, Ewing,
without instruction or formal training, took
up painting on sleds, cupboard doors, and
wheel hubs that could be turned into lamps.
She completed approximately fifteen pieces.
June Ewing died in 1992.

I was very fortunate to be able to entrust the following experts with
some of my folk art for care and restoration: Stephen Story, Tom Yost,
and Joel Zakow (paintings); Christa Gaehde, Paper Conservation Studio,
Susanne Schnitzer, and Marjorie Shelley (works on paper); The Society
for the Preservation of New England Antiquities (furniture); Gina
Bianco, Christine Giuntini, Hilda Janssens, and Helene Von Rosenstiel
(textiles); Robert M. Carroll and André Chervin (metal); Nello Nanni
(leather, bookbindings, mats); Jed Bark and Jacob Guttmann (frames
and mats). They each deserve a big thank-you, for they are the unsung
heroes in the preservation of art and culture.

R.E.

The publication of this magnificent volume celebrates two culminating events in the forty-year history of the American Folk Art Museum: the inauguration of the Museum's new building at 45 West Fifty-third Street in Manhattan and Ralph Esmerian's gift of his exceptionally important American folk art collection. The two events are inextricably bound together. Both are reflections of the mission adopted by the Museum's founders in 1961 and the fulfillment of the dreams of its supporters over the four decades since then. Neither could have been achieved without the passionate commitment of Ralph Esmerian.

Esmerian's name appears in the records of the American Folk Art Museum for the first time in 1973. The minutes of a meeting of the Museum's board of trustees on November 8 of that year refer to a proposal by Edith Barenholtz to invite Esmerian to serve as a trustee. Barenholtz, who with her husband, Bernard, was an avid and respected collector of American folk sculpture and antique toys, was devoted to the then-struggling museum and concerned about its future. The six members of the board who were present that day could not have known how significant her suggestion would prove to be, but they acted upon it quickly. Richard Taylor, a trustee who also functioned as the Museum's counsel, met with Esmerian and secured his agreement to serve. Then thirty-three years of age and relatively new to the field, Esmerian also agreed to assume the office of treasurer.

The Museum faced many challenges in 1973. Despite a proud record of public service since its founding in 1961—especially during the five-year directorship of Mary Black (1964–1969)—and some pioneering exhibitions of widespread parameters and influence under Black and the Museum's first curator, Herbert W. Hemphill Jr., the Museum had been unable to sustain its operations or secure its future. It was into this uncertain institutional environment that Ralph Esmerian entered as a newly elected trustee. That he chose to do so at all may have been surprising in view of the problems facing the Museum. That he did so with the strong and prescient conviction that the Museum not only would survive but, if properly nurtured, would build a national center in New York for the study and appreciation of American folk art must have seemed a small miracle. His decision brought a renewed spirit to the institution that has animated its direction ever since. He served as Museum treasurer until 1977, as president from 1977 to 1999, and as chairman from 1999 to the present.

It is widely acknowledged that Esmerian brooked no compromise in the formation of his collection. This, of course, has presented more than a slight challenge to him. At least two generations of collectors in the field of American folk art—more, perhaps, in the Pennsylvania German arena—preceded him. Major public collections were already in place. By the time he began to collect in earnest in the 1960s and 1970s, there was substantial competition in the marketplace which continued to grow. Collecting American folk art was no longer an inexpensive pursuit. Esmerian's 1984 purchase for the Museum of the great portrait *Girl in Red Dress with Cat and Dog* by Ammi Phillips, for example, was widely heralded in general and arts publications as much for its million-dollar price tag, a record for the time, as for the inherent importance of this wonderful painting.

Although Ralph Esmerian had given or promised individual works of art to the American Folk Art Museum through the years of his association with the institution, it was not until the Museum's new building was under construction that he announced his readiness to formally commit the collection as a whole to its stewardship. In anticipation of the completion of its striking Fifty-third Street facilities, which were designed by the acclaimed architectural team of Tod Williams Billie Tsien & Associates, the Museum had successfully reached out to many individuals to augment the impressive holdings of its permanent collection. Esmerian's gift crowned this effort.

The gift of the Esmerian Collection imposed a pressing burden, happily accepted, on the staff of the Museum. With less lead time than usual for a project of this magnitude, it was necessary to begin research almost immediately on each artwork in the collection in preparation for this book and the exhibition it documents. Photography had to be arranged and individual object entries written. Stacy C. Hollander, the Museum's gifted senior curator and director of exhibitions, assumed overall supervision of this effort. She not only coordinated the research of a group of experts in several specialized areas but also undertook considerable original research and writing herself. Hollander gave unstintingly of her many talents to make certain that this volume would match the excellence of the collection it represents. The result is a book of transcending beauty and true scholarship. I am pleased to recognize the success of her efforts with deep gratitude and respect.

Another staff member whose efforts were critically important to the success of the publication was Tanya Heinrich, who served as editor. Heinrich, on leave from her usual responsibilities as associate editor of *Folk Art,* the Museum's quarterly magazine, undertook the editorial function with painstaking attention to detail and an exacting demand for accuracy, consistency, and style. She had charge of communications with the design and production teams and brought precision and creativity to the solution of problems. I cannot begin to thank her adequately for her dedication to the goals of the project.

Despite the demands of a rigorous schedule, the preparation of this book was rendered less daunting by the participation of Ralph Esmerian himself. Fortunately for the project team, he kindly placed his files at the Museum's disposal and gave his own time and attention to the many questions and requests for information that arose. It was a special pleasure for me, as director of the Museum, to observe this work as it progressed,

to participate in it from time to time, and to be able to welcome Esmerian to the Museum's offices so regularly. His insistence on aesthetic excellence, his disdain for pedantry and pretension, and his grace and good humor all had an impact on this volume.

I am deeply indebted to the Philip Morris Companies for their belief in our project and their willingness to underwrite its cost. The Museum's relationship with Philip Morris extends back through more than twenty years of engaging presentations. On behalf of the Board of Trustees and staff of the Museum, I extend this expression of gratitude to Jeffrey Bible, chairman, Jennifer P. Goodale, director of corporate contributions, and other friends in the company. With the completion of its splendid new building and the presentation of a truly great collection, the American Folk Art Museum enters the fifth decade of its service to the public. Folk art now has a permanent home in New York. It is a time for gratitude—and for celebration.

Gerard C. Wertkin
Director
American Folk Art Museum

Ralph Esmerian is an unrepentant romantic. This becomes apparent as soon as he speaks of his love of American folk art, his habitual air of Old World reserve melting into an animated use of evocative words like "earth," "culture," "soul." Esmerian was in his mid-twenties when he discovered American folk art; his first purchase was a Pennsylvania German child's plate with simple slip decoration. From this modest beginning, and over a period of more than thirty years, he has assembled what may be the most impressive collection of American folk art still held in private hands. Esmerian has been president and chairman of the board of the American Folk Art Museum since 1977, and during those years, he has been an active advocate for expanded Museum quarters. This volume and the accompanying exhibition have been organized to celebrate the opening of the American Folk Art Museum's new building on West Fifty-third Street and to honor the extraordinarily generous and important gift of the Esmerian Collection that marks this long-awaited moment. The Esmerian gift follows in the tradition of those influential early-twentieth-century patrons whose collections now form the core holdings of other American museums: Abby Aldrich Rockefeller (Folk Art Museum, Williamsburg), Electra Havermeyer Webb (Shelburne Museum), Edward Duff Balken (Princeton), and Martha Codman Karolik and Maxim Karolik (Museum of Fine Arts, Boston), to name but a few. In transferring more than four hundred stellar works of art to the American Folk Art Museum, Esmerian has, in a single stroke, made the Museum's collection of traditional American folk art one of the finest in the world.

The romantic aspect of this largesse is certainly not lost on Esmerian, who comes naturally by his curious yet appealing combination of extreme reticence and large gesture. Esmerian admits readily to the mythology he has woven around his collection, especially those artworks that speak strongly to European roots and the migrations of ideas and traditions. It is a mythology that he has experienced first-hand. Ralph Esmerian was born in Paris in 1940, the youngest son of Raphael, his Armenian-French father, and Virginia, his American mother. He is a fourth-generation dealer in colored gemstones, a business started in Constantinople (now Istanbul) by his great-grandfather. Before Esmerian's father was born, the family was living in Paris, where they had fled from the violence being perpetrated against the Armenian people in Turkey. The family lapidary business survived the move, and by the time Esmerian's father was twelve, he was already being trained to cut colored gemstones. As immigrants, the Esmerians embraced their new culture, and although they maintained strong ties to the community of expatriate Armenians, the family became essentially French. Shortly after Ralph's birth, his parents moved the family to America to escape the growing Nazi presence. But French remained the ruling culture in the formal New York apartment that they appointed with

eighteenth-century French furniture, and French was the first language Ralph learned.

As a young man, Esmerian attended the Groton School in Massachusetts, partly because his elegantly mannered father was impressed by the deference of the young men who snapped to attention when he and his son first visited. So young Ralph was sent to New England to be educated, and along the way he discovered a love of theater and performance. His participation in drama clubs continued during his undergraduate years at Princeton University, where he had applied to escape the forbidding New England winters and to be closer to New York. At Princeton, Esmerian majored in French literature, but he also directed, produced, and acted in the Theatre Intime, which had nurtured the talents of Jimmy Stewart, Joshua Logan, and others. Although his parents supported a career in the theater, Esmerian found the atmosphere too self-absorbed; he preferred to "act in the real world."

Unsure what he wanted to do after graduation, Esmerian went to Athens College in Greece, where he taught English, French, and theater to students ages five, twelve, and nineteen under a teaching fellowship awarded by the Ford Foundation. Family duty had obliged his father to enter the jewelry business at a young age, though his natural proclivities might have led him to be a writer. So Raphael was sensitive to his son's desires to explore and did not pressure him to go into a business he himself considered medieval. Esmerian returned from Greece in 1964 and entered graduate school at New York University to become a city planner. When Raphael announced his intention to retire, however, his son apprenticed himself during the day to help wind down the business, and he continued his studies during the evening. To their mutual surprise and gratification, Raphael became reinvigorated by his son's presence and interest, and Esmerian left graduate school to become a full-time student of the business. Part of the incentive was a growing enjoyment of the connoisseurship associated with gemstones and the intricacies of that world, but the greater satisfaction was derived from working with his father and forging a new friendship as one adult to another.

Esmerian's father had always been a big influence on him, a loving but remote figure whose aristocratic presence drew his son but made intimacy difficult. The elder Esmerian was a very private man with a passion for rare books and bindings that was neither shared by nor foisted upon his wife and three children. Ralph grew up with a sense that collecting was a loner's game, but occasionally, when Ralph expressed a particular interest, his father would suddenly open up and pull out a book to explain what excited him. From these youthful encounters with his father's critical faculties, his adult apprenticeship under his father's demanding tutelage, and his own intrinsic taste, Ralph developed an aesthetic discernment that could be applied to any art form.

So Esmerian's romanticism may not be entirely unfathomable after all: the scion of a proud expatriate Armenian family, a fourth-generation dealer in colored gemstones, the son of a world-class collector of rare bindings as well as French prints and drawings and American impressionist paintings. What is unexpected, perhaps, is the locus that Esmerian chose as the touchstone for his own passion, which he has pursued for more than three decades. An intensely private man with a highly refined sensibility steeped in French cultural traditions, he is nevertheless irresistibly drawn to that most accessible, raw, and democratic of American arts: American folk art.

To enter Esmerian's world is to abandon one's usual mundane considerations. All that matters is quality, beauty, rarity, and the creative song of the individual's hand at work. This is true not only of his collection of folk art but in his other collecting interests as well: art nouveau bronzes and pre-Raphaelite drawings that display languishing women forever frozen in attitudes of sensual indifference; nineteenth- and twentieth-century children's book illustrations by artists such as Arthur Rackham, Edmund Dulac, Ernest H. Shepard, Beatrix Potter, Jean and Laurent de Brunhoff, and Antoine de Saint-Exupéry. Disney animation cells—Pinocchio, Mickey, and the whole gang—share wall space with Little Lulu, and early photographs of rolling dunes, art deco skyscrapers, and silent movie stars create a mystique all their own. Serious or whimsical, the collections are rich, tactile, decorative, and surprising, and they convey a contagious enjoyment of pattern, texture, form, and color. More important, they speak to a refreshing optimism and joy in life and an outright rejection of adult irony and cynicism. And it is this optimism that, after all, may be at the heart of Esmerian's wonder and delight with American folk art.

Esmerian was not a collector as a child; like a boy in a Norman Rockwell painting, he preferred to play baseball. As an adult, his collection did not grow as a calculated plan to amass one thing or another. Rather, the collection grew almost by happenstance and in response to Esmerian's appetite for rare and beautiful things. Today the collection is not united by a single theme, although Pennsylvania German material predominates, but by its remarkable internal aesthetic consistency. For Esmerian, each object must "sing," and the chorus of voices he has joined together celebrates the strength of tradition, competence, and resolute individualism that has characterized American art and culture since the early years of the republic. It is this human dimension that has called so compellingly to Esmerian and to other collectors of American folk art, for while the act of collecting shows a reverence for objects, the process is also a journey of self-discovery and self-definition. In

the United States, in particular, the quest for identity has played an important role in the formation of major early folk art collections, such as those assembled by immigrants Elie Nadelman and Maxim Karolik. And it influences the direction of collecting today, as Americans continue to seek the answer to the riddle of their own Americanness. Esmerian remembers himself as a boy who was "American in marvelous ways," a removal that suggests his European home environment may have placed him slightly outside the mainstream. Playing baseball as a youth performed the same function in his life as collecting does today: it locates him in the culture he has experienced as both an insider and an outsider.

Esmerian became acutely aware of the quest for cultural identity during the years he lived in Greece. From 1962 through 1964, he traveled the countryside immersed in the ancient history that was ever present in the small villages he visited. He began to think about America and its beginnings, the cultural seeds that had grown into the complex and multilayered society he called his own. These musings were reinforced everywhere he visited, America looming in the minds of ordinary Greek citizens as a distant dream, still a golden land.

One of the most important cultural signifiers he discovered was pottery, a form that is redolent of the earth and, with a single object, can evoke an entire historical epoch. He instinctively felt that each piece acted as a catalyst for mentally traveling back in time, and he began to habitually associate relics with the past. After he returned to the United States, he happened upon a small piece of pottery, a miniature plate, that infused him with the same sense of the past, of an artifact that belonged to a larger societal construct. He became increasingly fascinated by Pennsylvania German arts and was attracted by the boldness and consistency of color and design. He recognized that an embracing tradition informed each example, even as the maker added his own creative signature. Pottery was a springboard for a deeper visual investigation of Pennsylvania German arts that ultimately also encompassed fraktur, portraits, landscapes, carvings, furniture, and textiles.

During this early period, Esmerian primarily purchased folk art directly from dealers, notably the Kindigs and the Bohnes, in Pennsylvania. It was not until 1966 that he bought his first fraktur—hand-decorated documents handwritten in German, many of which served as birth and baptismal certificates. Romance once again nurtured his fascination, as he had read Monroe Fabian's recitations of finding such documents in the National Archives, where they had survived with petitions for pensions from Revolutionary War veterans or their widows. Esmerian

responded to the practical purpose, their use as legal documents, their intimacy and lack of pretension. Over time, this became a leitmotif in his collecting patterns, and one that he may have unconsciously sought as a counterpart to the rarefied world of his profession. Although working daily with precious symbols of wealth and international taste, his private moments are spent with objects such as fraktur, which speak tellingly of birth and death, ritual and tradition, survival and need.

Esmerian's sensitivity to works on paper may derive from his early exposure to his father's collections of bindings, books, prints, and drawings. Over many years, he has gathered a rich collection of watercolor portraits and landscapes, fraktur, Shaker gift drawings, mourning pieces, and genre scenes. Among his first purchases were portraits by Jacob Maentel which provided a context for the pottery and other Pennsylvania German decorative arts; today, his gift to the Museum includes one of the largest and most important holdings of watercolors by this artist. His serious interest in New England material began in 1979, stimulated by the sale of Stewart Gregory's collection at Sotheby's. Joseph H. Davis offered the same magical window into nineteenth-century New England that Maentel had opened in Pennsylvania. Because he collected numbers of works by both artists, a compelling picture emerges of past lives and aspirations, with an immediacy that elucidates these very different cultural communities.

In 1972 Esmerian purchased his first pair of oil portraits, by colonial artist John Durand. His encounter with the fresh, beautiful faces of the young man and woman, probably newly married, evoked a sense of communion and human interaction. This engagement with the individual painted visage sparked a small and very personal collection of portraits, "people" with whom Esmerian has felt some special kinship. The most well known is the painting *Girl in Red Dress with Cat and Dog*, by Ammi Phillips, which Esmerian purchased in 1984 and immediately turned over to the custodianship of the Museum. But he has chosen to live with an eclectic group of friends: sober-faced couples, fragile young girls, eccentric families, sturdy little boys.

In 1974 the Whitney Museum of American Art in New York presented "The Flowering of American Folk Art, 1776–1876." The exhibitions of the 1930s had codified the field of American folk art, but "Flowering" proved undeniably that it merited the serious attention of the artworld. The visually and contextually exciting material, gathered from myriad sources, established a new paradigm for collectors, museums, scholars, and all those with an interest in early American art and life. Esmerian's collection, which contains many important works that were included in "Flowering," can be perceived as having a similar impact, an astonishing feat for an individual, especially as this maverick collector refuses to be guided by what he should buy and purchases simply what he loves.

It is almost not possible to quantify the seminal works of art that Esmerian has gathered over the past thirty-some-odd years. They are the icons that emerged and endured during the century that effectively formed the field. They are *Dapper Dan* and *Situation of America, Ruthy Rogers* and *Girl in Red Dress with Cat and Dog*. They are weathervanes and samplers, gift drawings and scrimshaw. They were made by Rufus Hathaway and Reuben Moulthrop, Johannes Spitler and Johann Adam Eyer. They are the work of sailors and schoolgirls, professionals and amateurs. In every arena that Esmerian has entered, he has demonstrated a sense of heightened expectation. And with patience, time, and discernment, those expectations have been met and surpassed.

Raphael Esmerian thought that his son's collection was "junk," with one exception. In 1975 Ralph came across a sublime *Peaceable Kingdom* by Edward Hicks, at the Kennedy Galleries in New York. As a young man, he could not afford the extravagant price then being asked for the painting. Yet he recognized that it was worth the stretch. He asked his father to take a look at it, knowing it was almost antithetical to Raphael's collecting interests. The painting transcended the elder Esmerian's stringent standards, however, and he bought it for his own collection. When Raphael became sick, Ralph moved in with his father and cared for him until he died, in 1976. Just prior to his death, Raphael gave the Hicks painting to his son, an acknowledgment that it was Ralph's recognition of its artistic value that had truly prompted the purchase.

Among the many important lessons Ralph Esmerian learned from his father were both the pleasures and the responsibilities of ownership. In his professional life, Esmerian has worked hard to preserve the history of great jewelry and jewelry makers. He has supported research and publications, and he has created an archive of antique jewelry and original design sources. As a collector, he has made the folk art in his home routinely available to students and scholars, and he has generously loaned to many museum exhibitions.

Nina Fletcher Little, the great collector of early New England material culture, made two revealing observations that bear repeating. The first is that "every serious collector develops a personal philosophy (even if unconsciously) that guides the choice and scope of his or her acquisitions." The second is that "most collectors do not find it sufficient just to collect." Trained in the art of giving, as well as looking and appreciating, with this gift, Ralph Esmerian has made the most romantic gesture of all.

Stacy C. Hollander

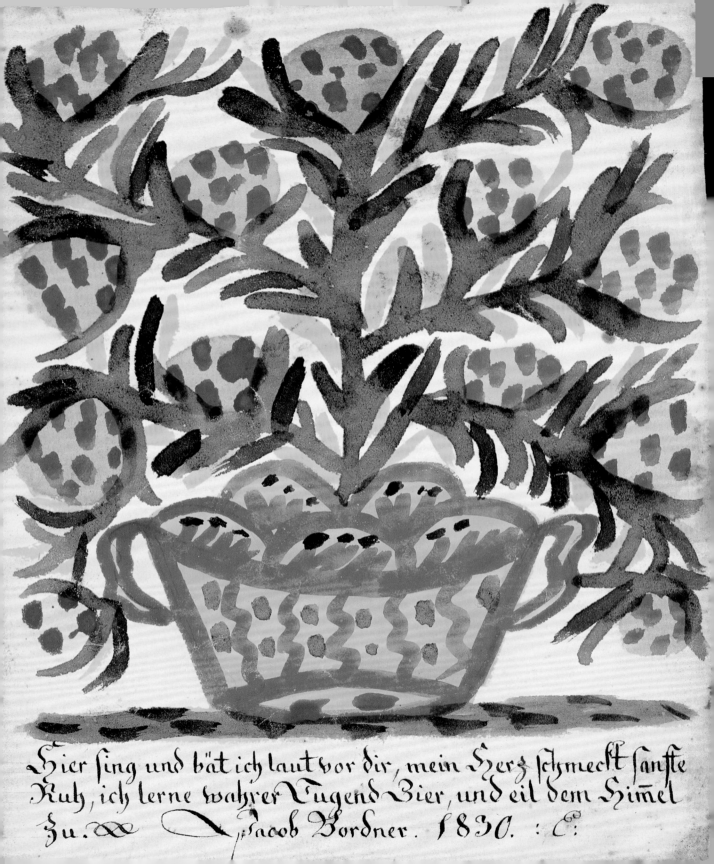

Hier fing und bät ich laut vor dir, mein Herz schmeckt sanffte
Ruh, ich lerne wahrer Tugend Bier, und eil dem Himel
Zu. ∞ Jacob Bordner. 1830. :C:

COLOR PLATES

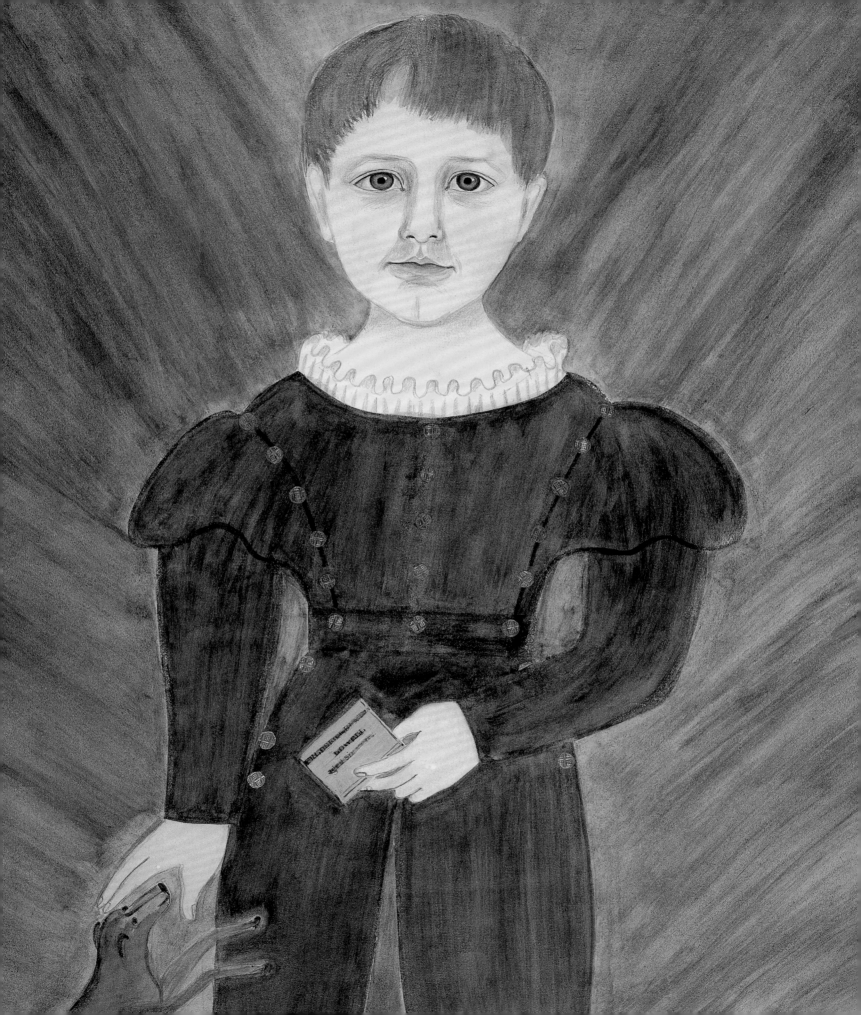

CHAPTER 1

SINGULAR FACES

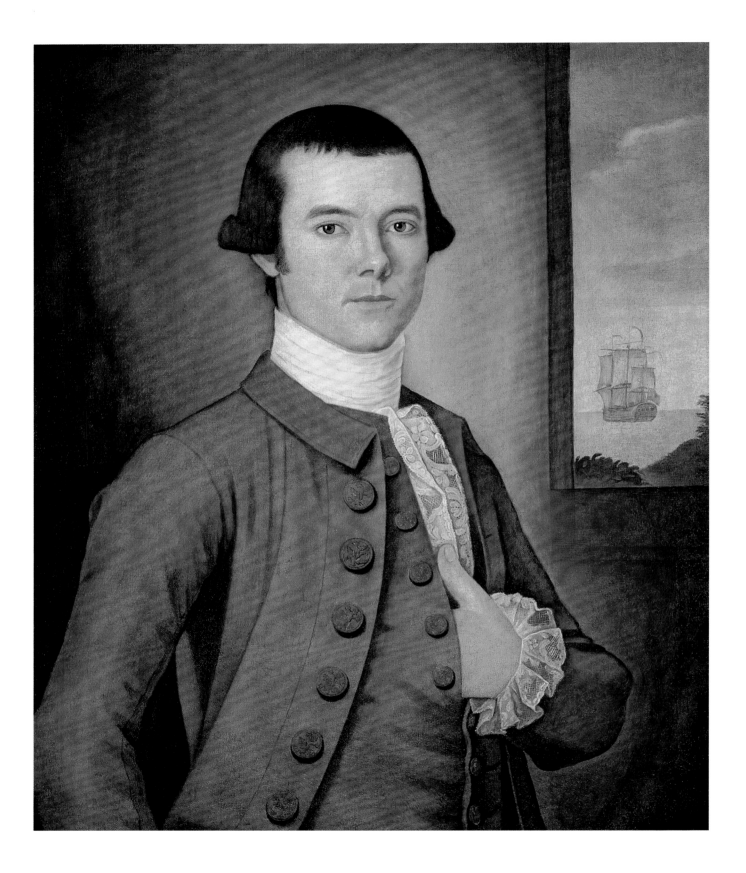

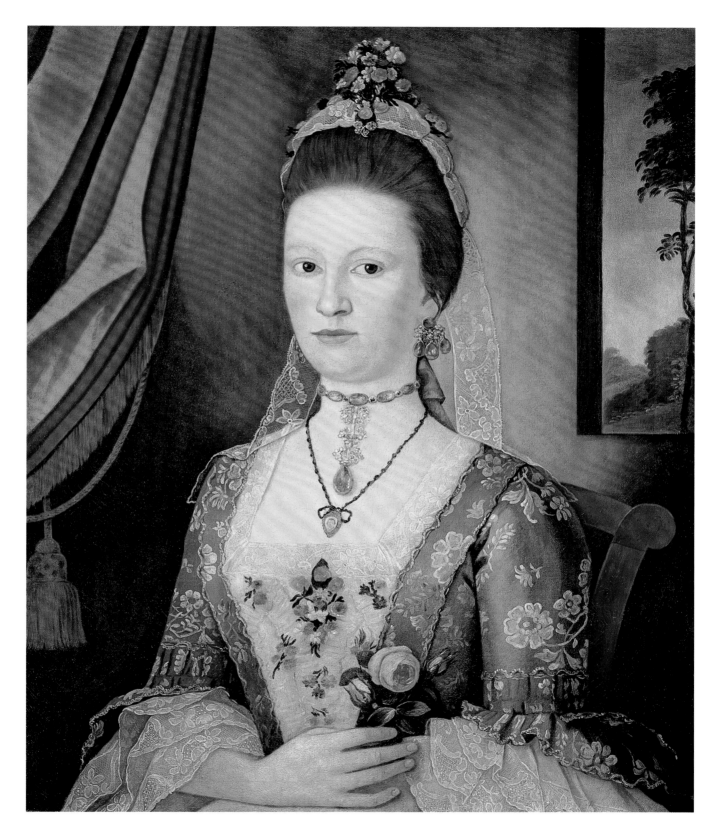

1a–b. PORTRAIT OF A MAN (POSSIBLY CAPTAIN FITZHUGH GREENE) and
PORTRAIT OF A WOMAN (POSSIBLY MRS. FITZHUGH GREENE), c. 1768–1770
Attributed to John Durand (act. 1765–1782), New York, Connecticut, or Virginia
Oil on canvas, 29⁵⁄₁₆ × 24⁵⁄₁₆ in. each, P1.2001.1, 2

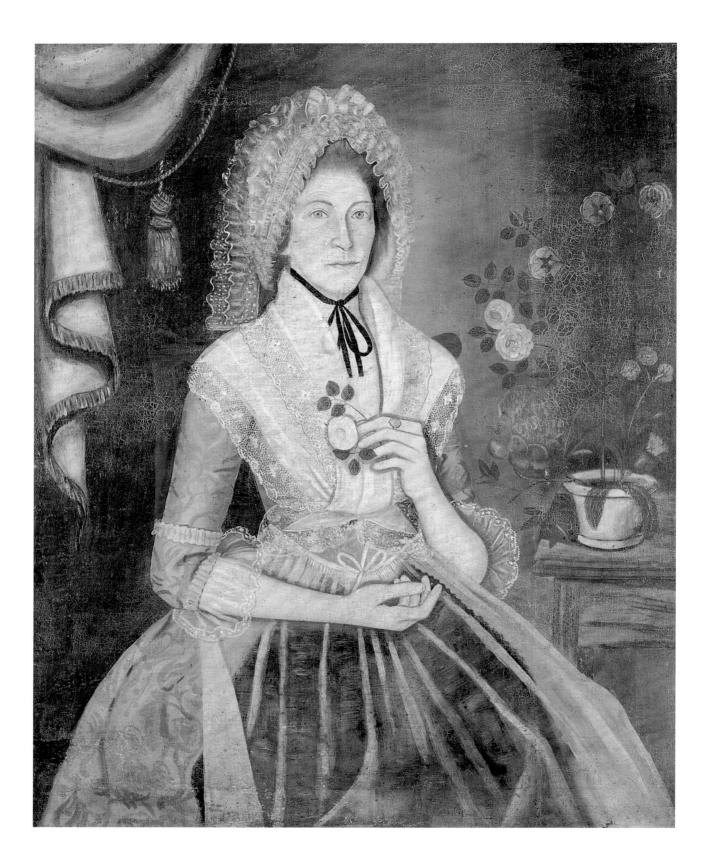

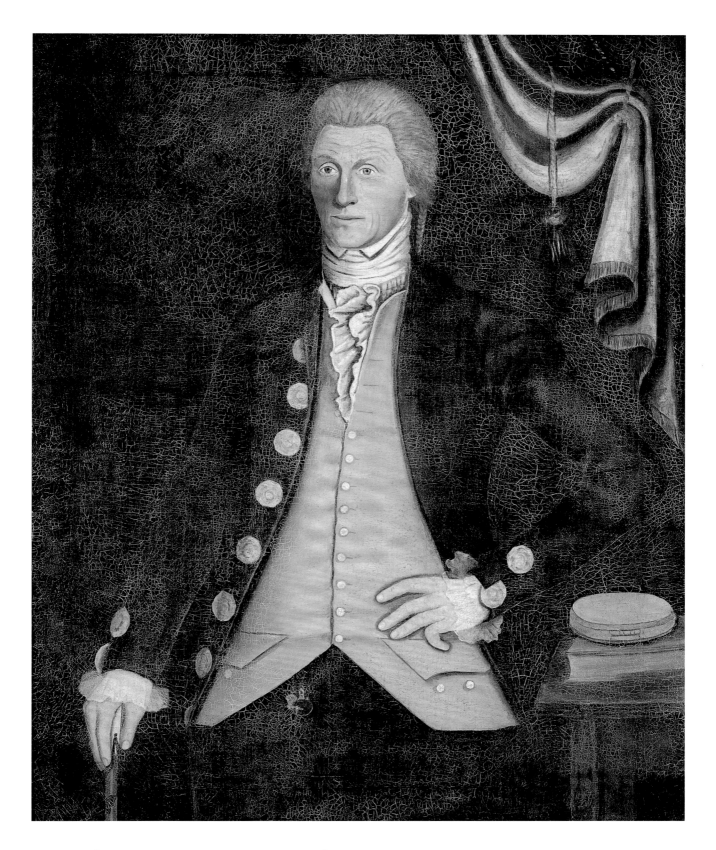

2a–b. Mary Kimberly Thomas Reynolds and James Blakeslee Reynolds, c. 1788
Attributed to Reuben Moulthrop (1763–1814), West Haven, New Haven County, Connecticut
Oil on canvas, 45¼ × 36 in. each, P3.1995.1, 2

3. **JONATHAN KNIGHT,** c. 1797
Artist unidentified, Connecticut
Oil on paperboard, mounted on Masonite, 34 × 24 in., P1.2001.3

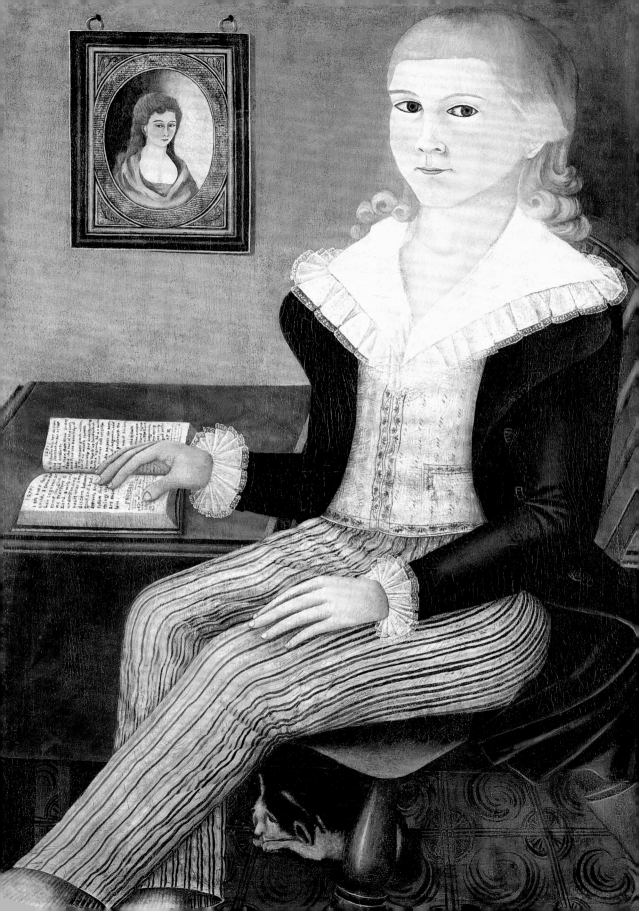

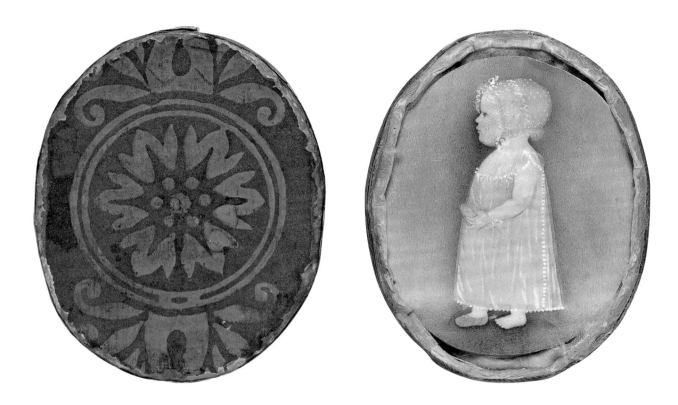

4. MARY H. HUNTINGTON, c. 1814
 Artist unidentified, Brockton, Plymouth County, Massachusetts
 Watercolor and gouache on paper, in embossed wallpaper–covered
 pasteboard box with silk lining and cotton padding, 3 × 2½ × 2¾ in. oval,
 P1.2001.4

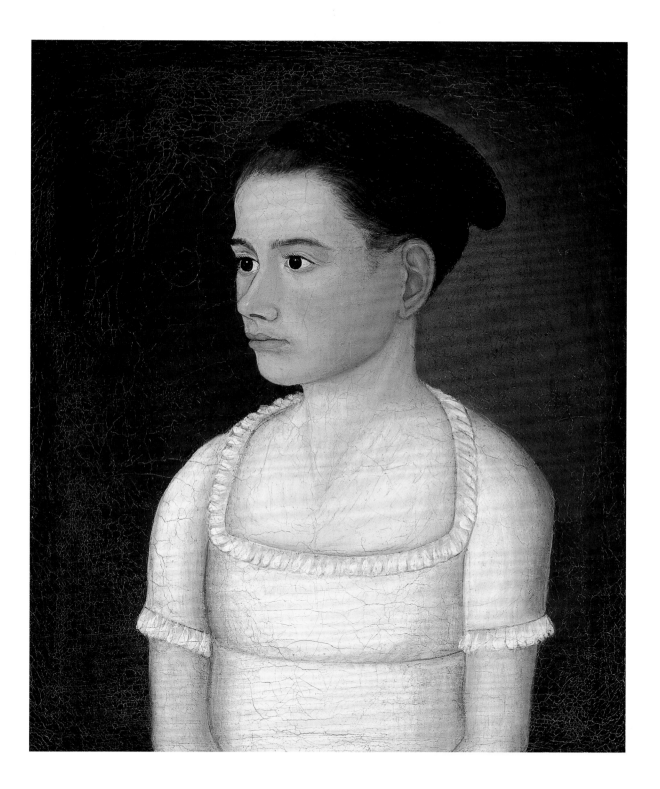

5. Young Woman of the Folsom Family
(probably Anna Gilman Folsom), c. 1812–1821
Henry Folsom (1792–1814 or c. 1805–1825),
Exeter, Rockingham County, New Hampshire, or Boston
Oil on canvas, 21½ × 17⅝ in., P1.2001.5

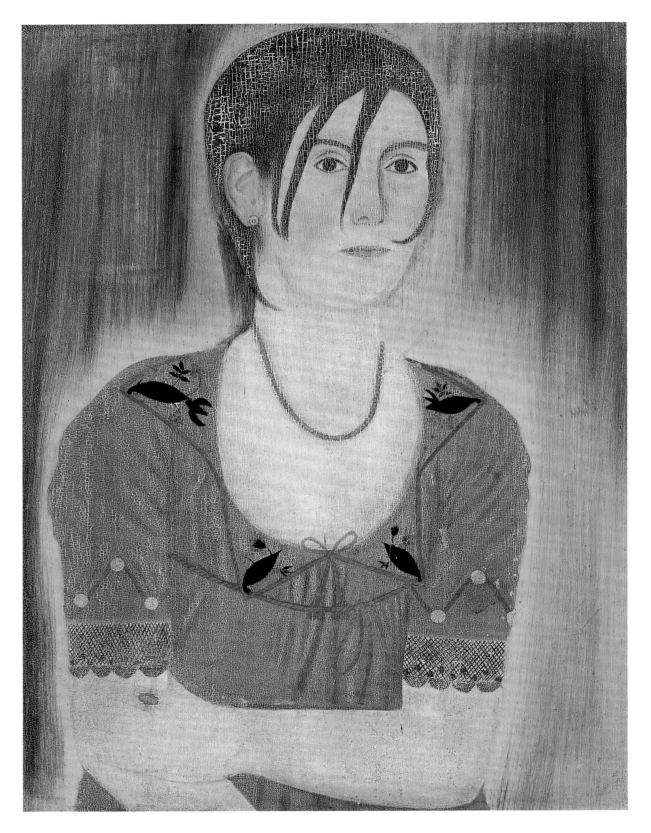

6. WOMAN IN ROSE DRESS, c. 1805–1815
Artist unidentified, Vermont
Oil on pine panel, 26⅝ × 24⅝ × ½ in., P1.2001.6

7. WOMAN IN VEIL, c. 1825
Attributed to Emily Eastman (1804–c. 1841), Loudon,
Merrimack County, New Hampshire
Watercolor and ink on paper, 14 9/16 × 10⅝ in., P1.2001.7

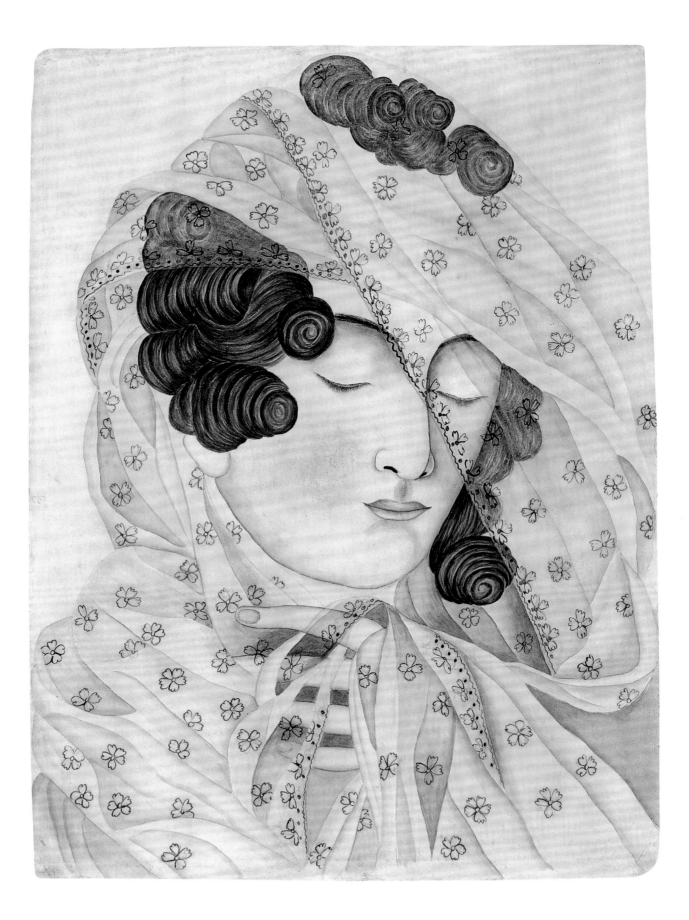

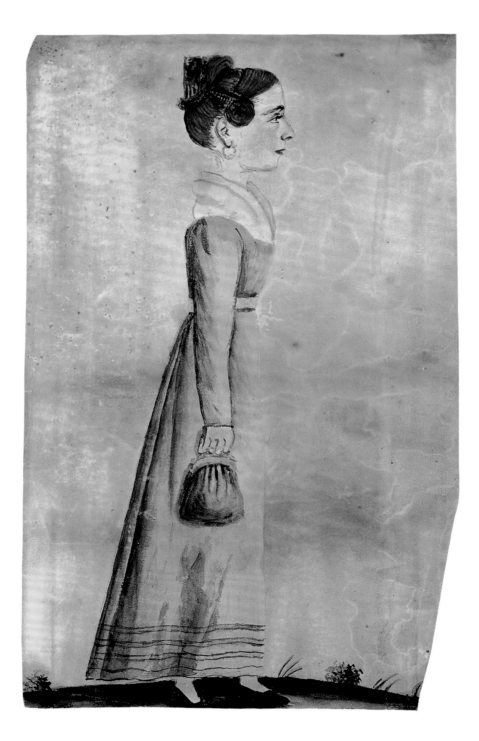

8. YOUNG WOMAN IN BLUE DRESS
(GRANDMOTHER HARTMAN), 1827
Jacob Maentel (1778–?), Schaefferstown, Lebanon County,
Pennsylvania
Watercolor, gouache, ink, and pencil on paper, 9½ × 6 in.,
P1.2001.8

9. AMELIA AND ELIZA DANNER, c. 1815
Jacob Maentel (1778–?), Hanover, York County, Pennsylvania
Watercolor, gouache, ink, and pencil on paper, 10½ × 8⅜ in. (sight),
P1.2001.9

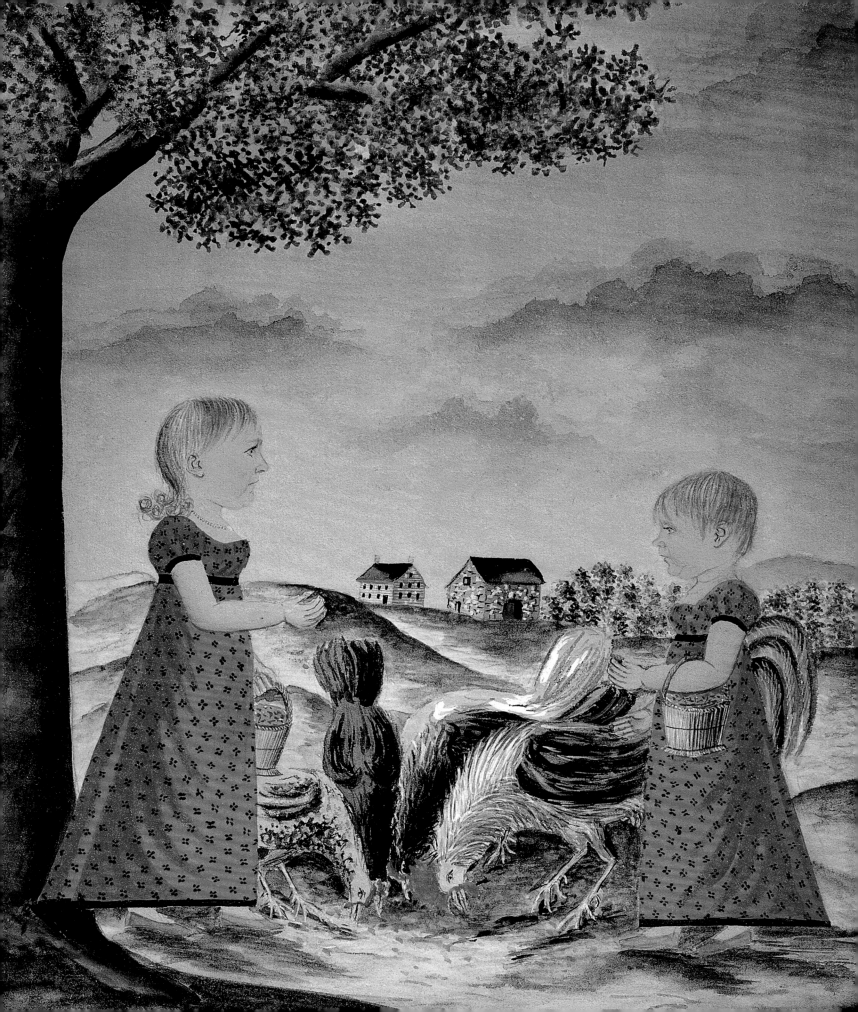

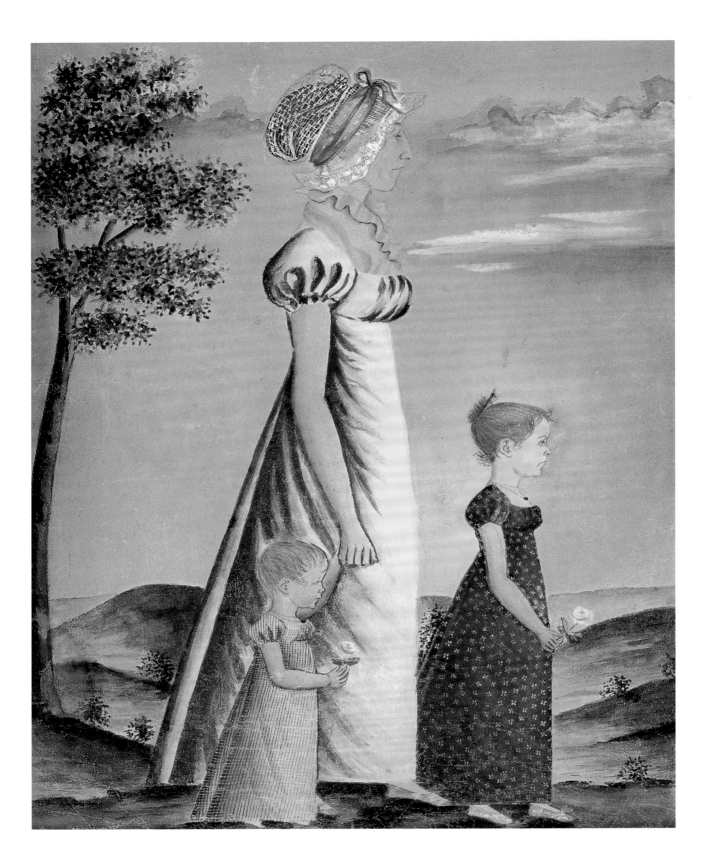

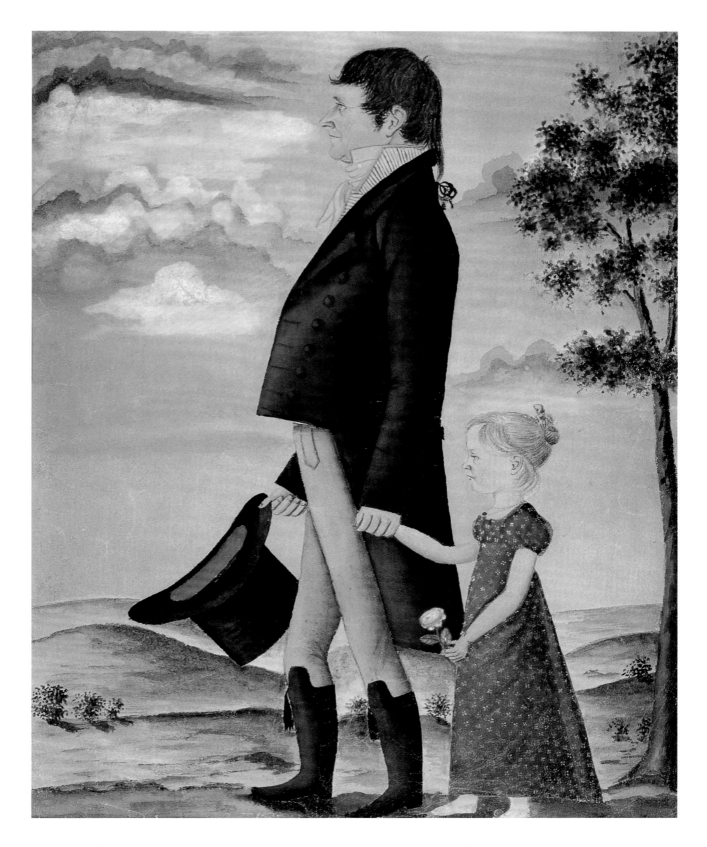

10a–b. MOTHER AND DAUGHTERS OF ELIZABETHTOWN, PENNSYLVANIA, and
FATHER AND DAUGHTER OF ELIZABETHTOWN, PENNSYLVANIA, c. 1815–1820
Jacob Maentel (1778–?), Elizabethtown, Lancaster County, Pennsylvania
Watercolor, gouache, ink, and pencil on paper, 10¾ × 8½ in. each (sight), P1.2001.10a, b

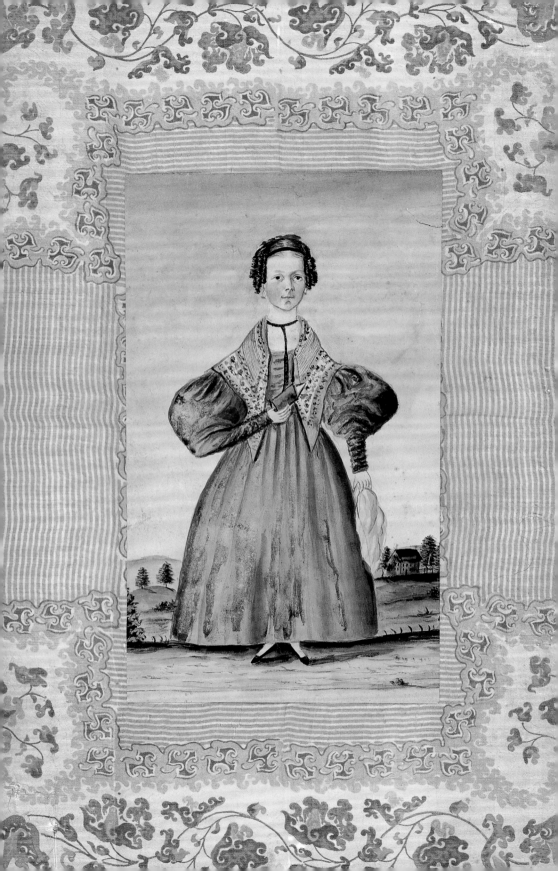

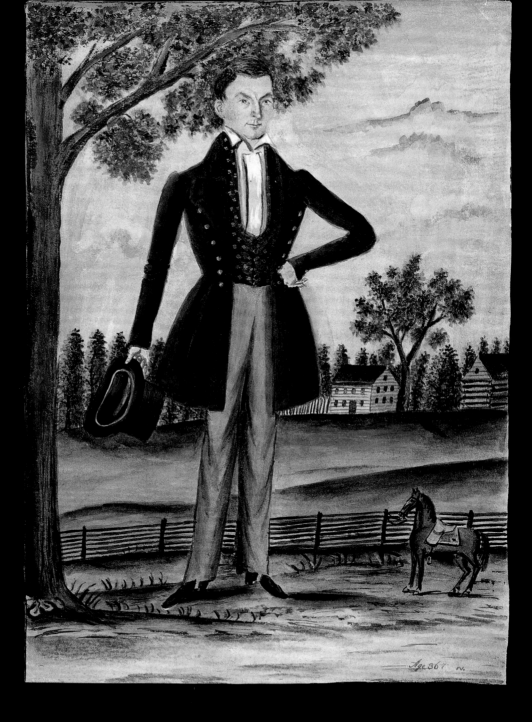

CATHERINE WILT, c. 1830–1832
Jacob Maentel (1778–?), York, York County, Pennsylvania
Watercolor, gouache, ink, and pencil on paper, mounted on
printed cotton, 14 × 8 in. (23⁹⁄₁₆ × 14½ in. with cotton ground),
P1.2001.11

12. YOUNG MR. FAUL, c. 1835–1838
Jacob Maentel (1778–?), Lancaster, Lancaster County,
Pennsylvania
Watercolor, gouache, ink, and pencil on paper, 15⅞ × 10⅞ in.
P1.2001.12

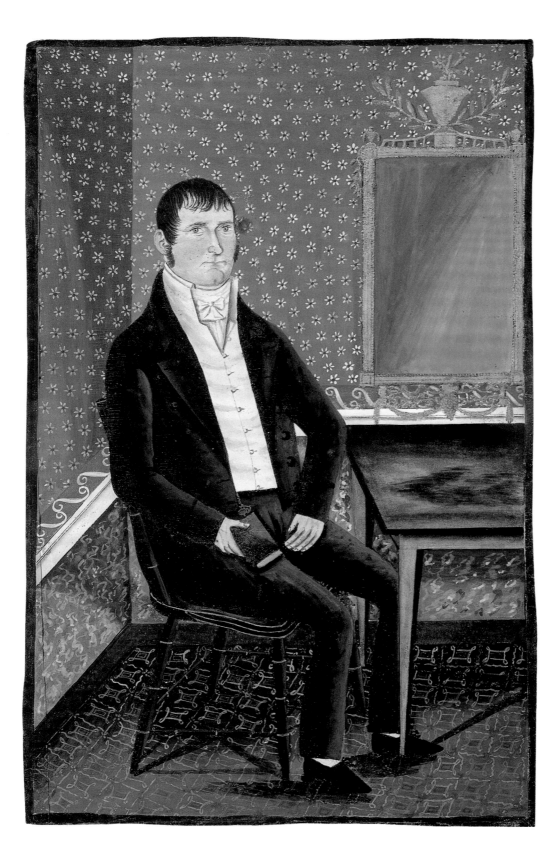

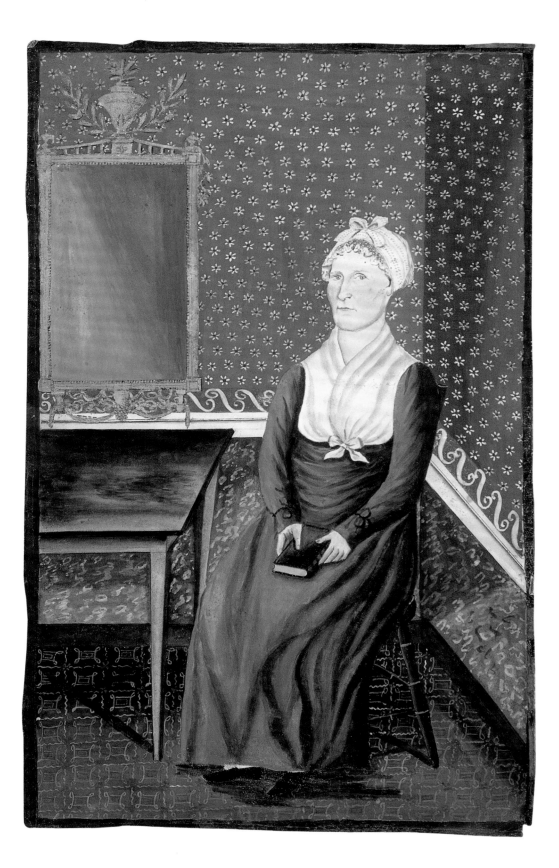

13a–b. **JOHN BICKEL** and **CATERINA BICKEL**, c. 1815–1825
Jacob Maentel (1778–?), Jonestown, Lebanon County, Pennsylvania
Watercolor, gouache, ink, and pencil on paper, 19 × 12 in. each, P1.2001.13a, b

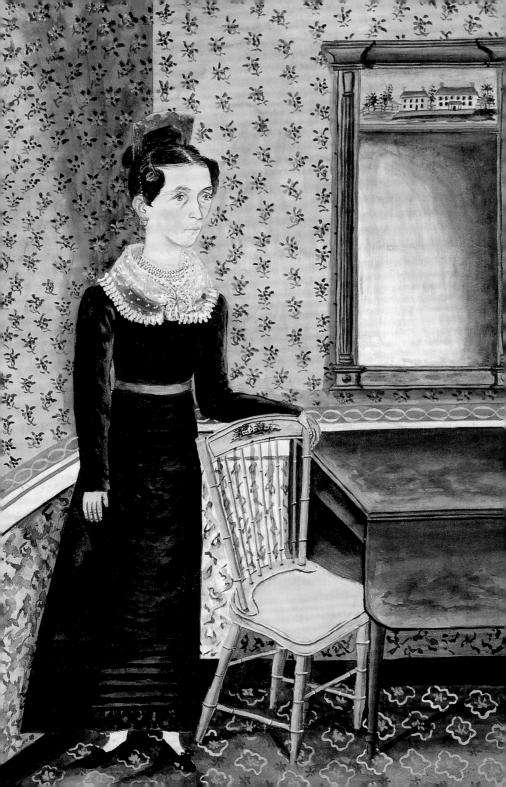

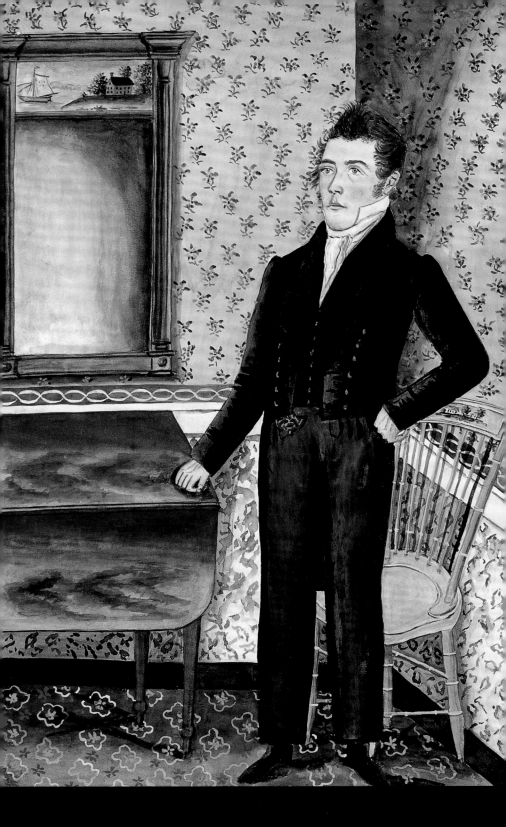

14a–b. MARIA REX ZIMMERMAN and PETER ZIMMERMAN, c. 1828
Jacob Maentel (1778–?), Schaefferstown, Lebanon County, Pennsylvania
Watercolor, gouache, ink, and pencil on paper, 17 × 10½ in. each, P1.2001.143.b

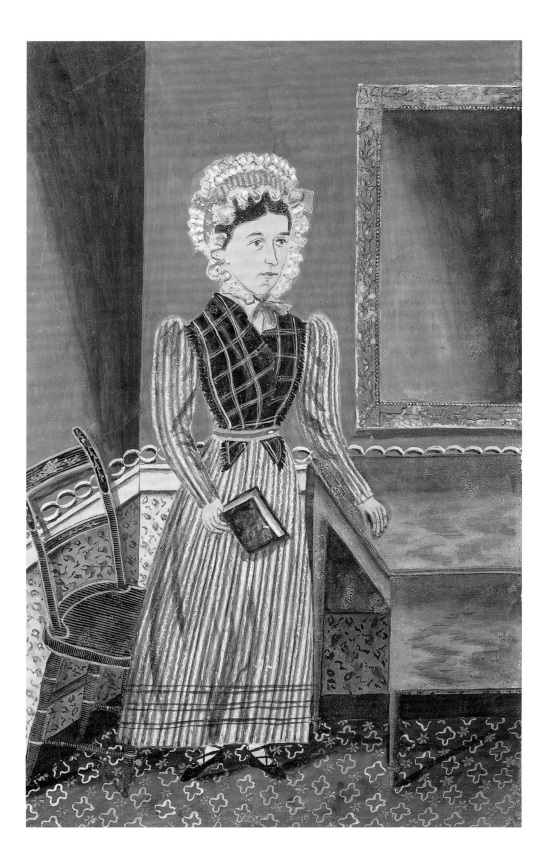

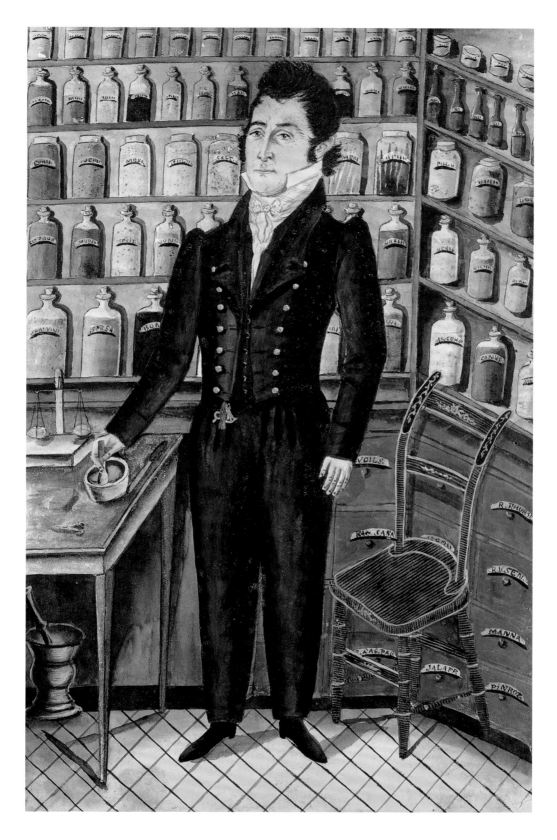

15a–b. MARY VALENTINE BUCHER and DR. CHRISTIAN BUCHER, c. 1825–1830
Jacob Maentel (1778–?), Schaefferstown, Lebanon County, Pennsylvania
Watercolor, gouache, ink, and pencil on paper, 16½ × 10⅛ in. (sight) and
16½ × 10½ in. (sight), P1.2001.15a, b

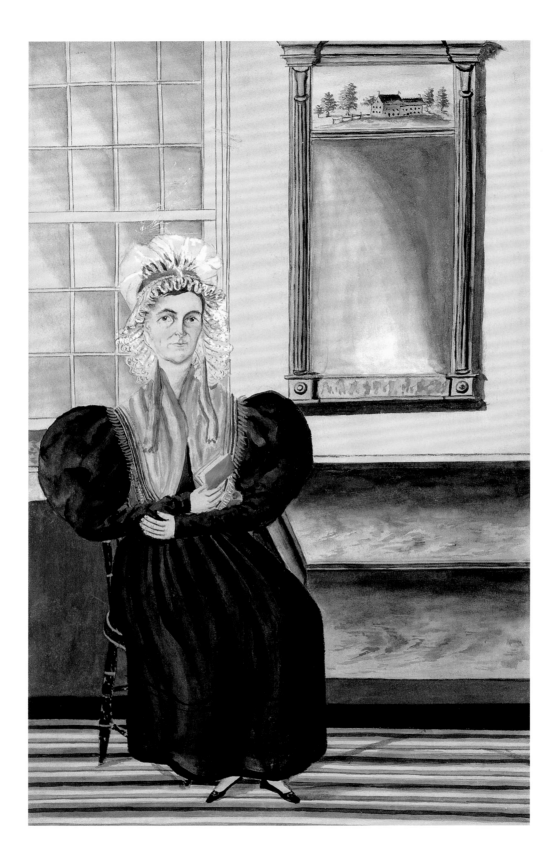

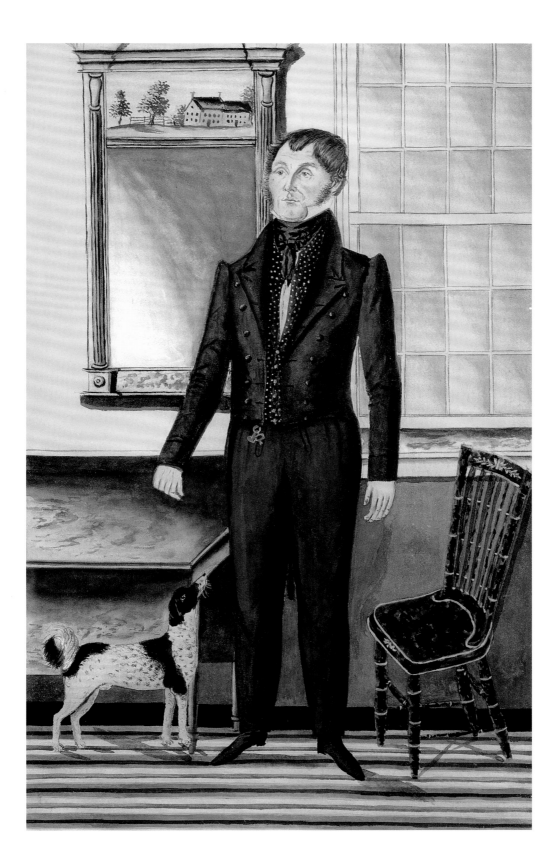

16a–b. ELIZABETH HAAK and MICHAEL HAAK, c. 1830–1835
Jacob Maentel (1778–?), Lebanon, Lebanon County, Pennsylvania
Watercolor, gouache, ink, and pencil on paper, 17 × 10¾ in. each, P1.2001.16a, b

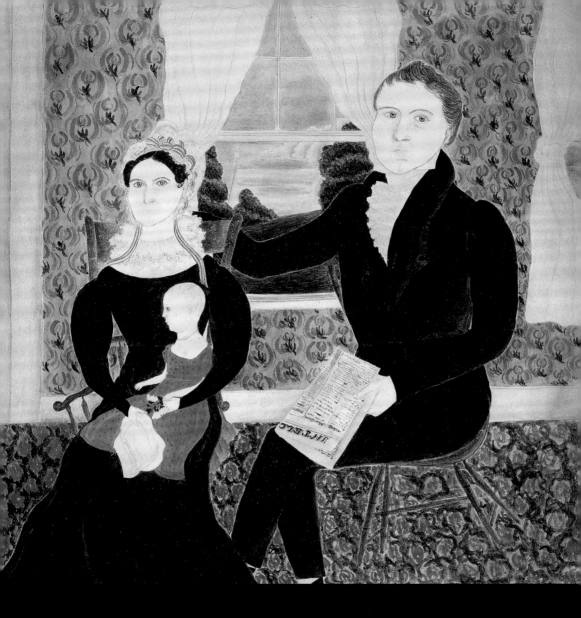

17. MR. AND MRS. LYMAN DAY AND DAUGHTER CORNELIA, c. 1823–1824
Deborah Goldsmith (1808–1836), Sangerfield, Oneida County, New York
Watercolor and pencil on paper, 9 × 8¾ in. P1.2001.17

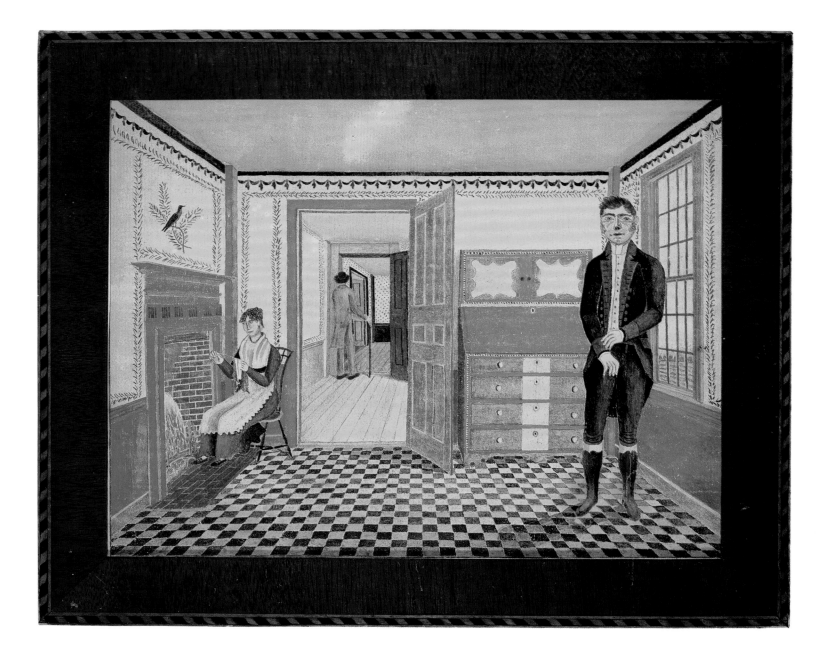

18. Interior of John Leavitt's Tavern, c. 1825
Joseph Warren Leavitt (1804–1833), Chichester, Merrimack County, New Hampshire
Watercolor, ink, and pencil on paper, in original maple frame, 6½ × 8⅝ in. (sight)
(8⁹⁄₁₆ × 10½ × ½ in. framed), P1.2001.18

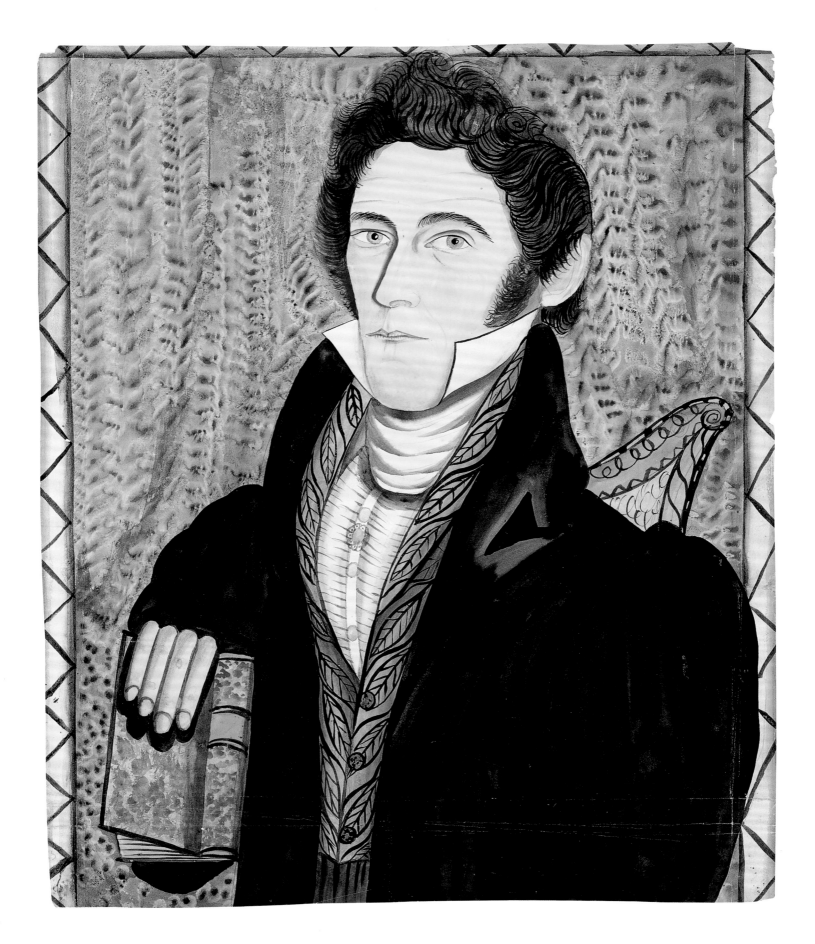

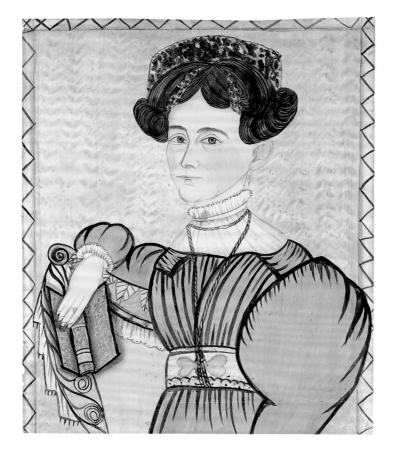

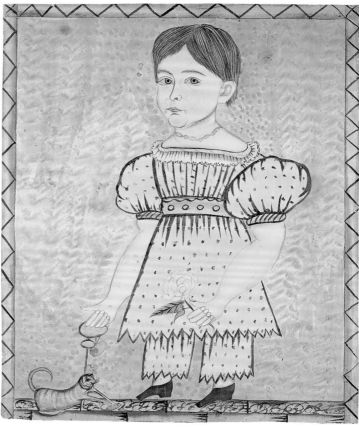

19a–c. Barnabas Bartol Carver, Mary Coffin Carver,
and Frances Ann Carver, c. 1835
The Carver Limner, Freeport, Cumberland County, Maine
Watercolor and pencil on paper, 22 × 18 in. each, P1.2001.19, 20, 21

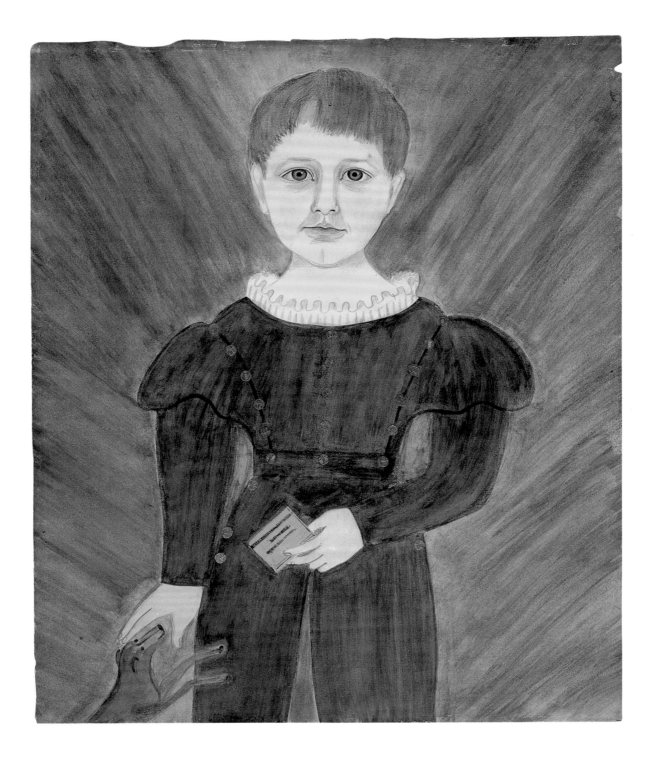

20. FREDERICK BUXTON, c. 1831
Samuel Addison Shute (1803–1836) and
Ruth Whittier Shute (1803–1882), Lowell,
Middlesex County, Massachusetts
Watercolor, gouache, pencil, and ink on paper with
applied gold foil, 18¼ × 15¼ in., P1.2001.22

21. JEREMIAH H. EMERSON, c. 1832
Samuel Addison Shute (1803–1836) and
Ruth Whittier Shute (1803–1882), Nashua,
Hillsborough County, New Hampshire
Watercolor, gouache, pencil, and ink on paper with applied
gold foil, 29¼ × 19 in. (sight), P1.2001.23

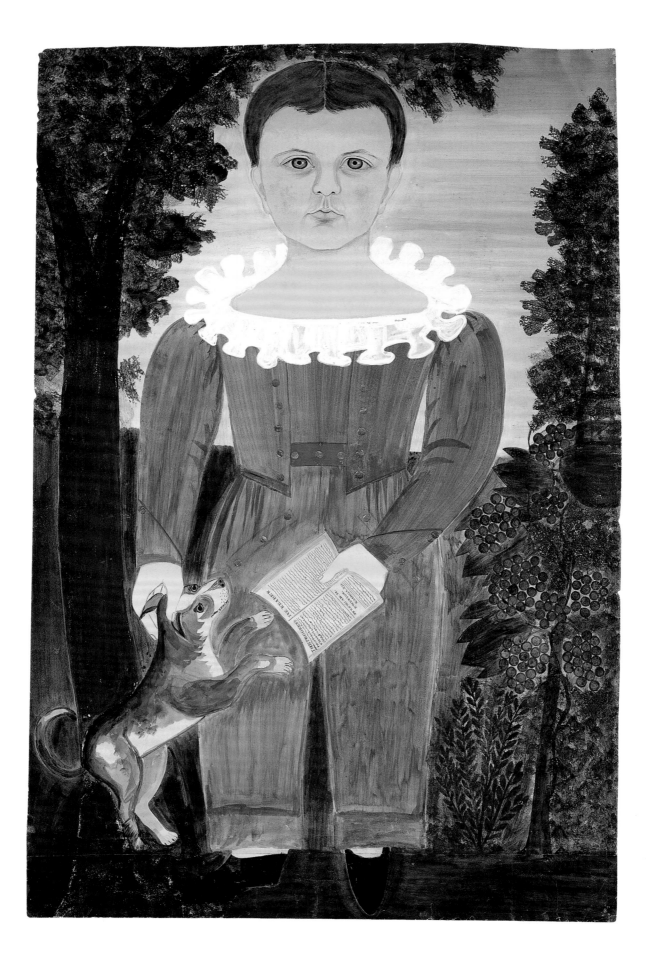

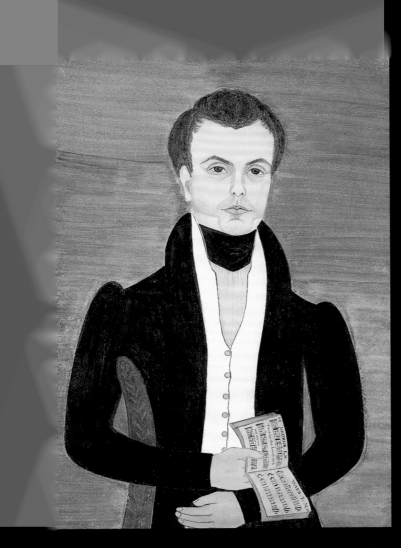

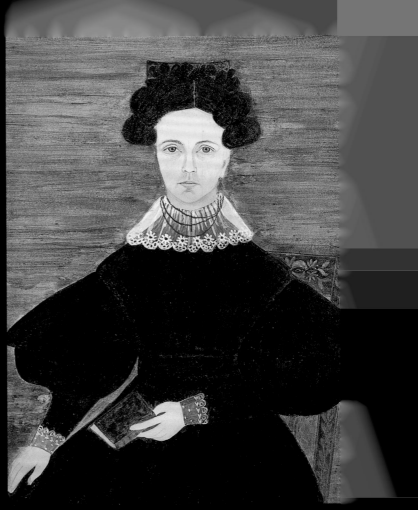

22a–b. Josiah C. Burnham and Abigail S. Burnham, c. 1831–1832
Samuel Addison Shute (1803–1836) and Ruth Whittier Shute (1803–1882), probably Lowell, Middlesex County, Massachusetts
Watercolor, gouache, pencil, and ink on paper with applied gold foil, 13½ × 9½ in. each, P1.2001.24a, b

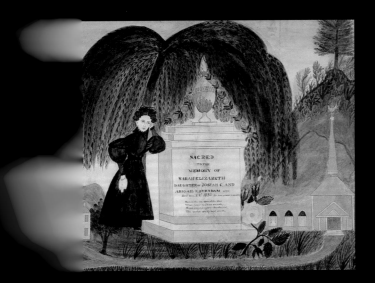

rning Piece for Sarah Elizabeth Burnham,
–1832
el Addison Shute (1803–1836) and Ruth Whittier Shute
–1882), probably Lowell, Middlesex County, Massachusetts

24. Master Burnham, c. 1831–1832
Samuel Addison Shute (1803–1836) and Ruth Whittier Shute (1803–1882), probably Lowell, Middlesex County, Massachusetts
Watercolor, gouache, pencil, and ink on paper, 27½ × 19 in.,

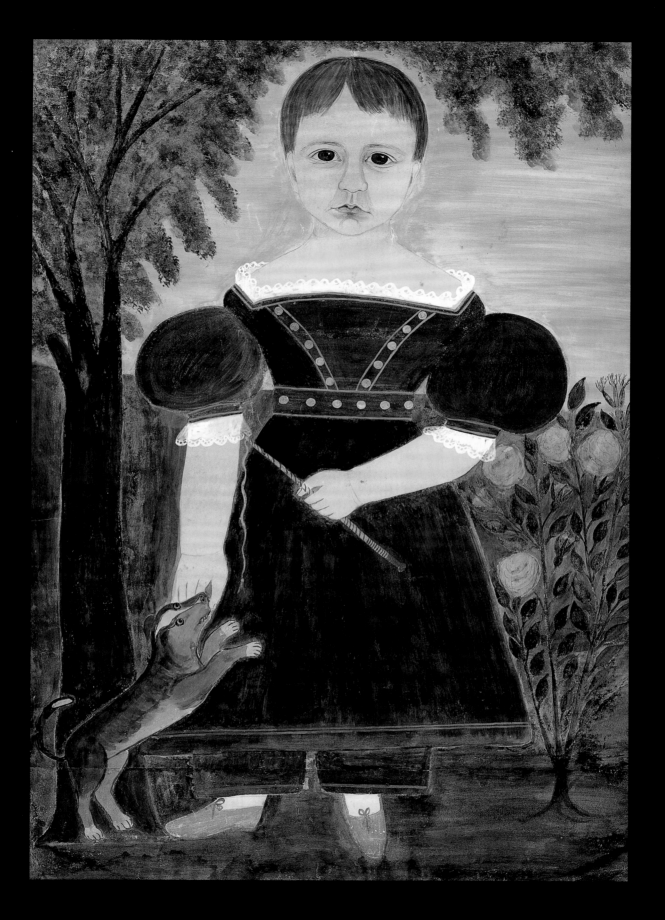

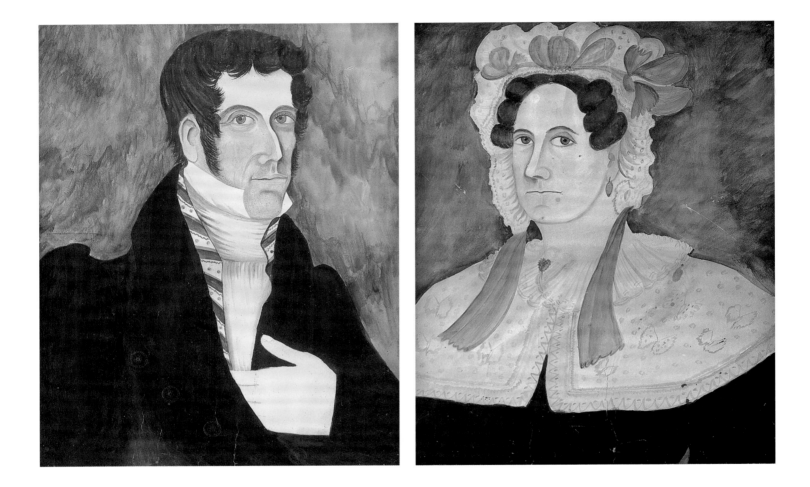

25a–b. Gentleman Wearing a Striped Waistcoat and Woman Wearing a Bonnet with Pink Ribbons, c. 1828–1830
Samuel Addison Shute (1803–1836) and Ruth Whittier Shute (1803–1882), possibly Brattleboro, Windham County, Vermont
Watercolor, gouache, pencil, and ink on paper, 21⅞ × 17⅜ in. each (sight), P1.2001.27, 28

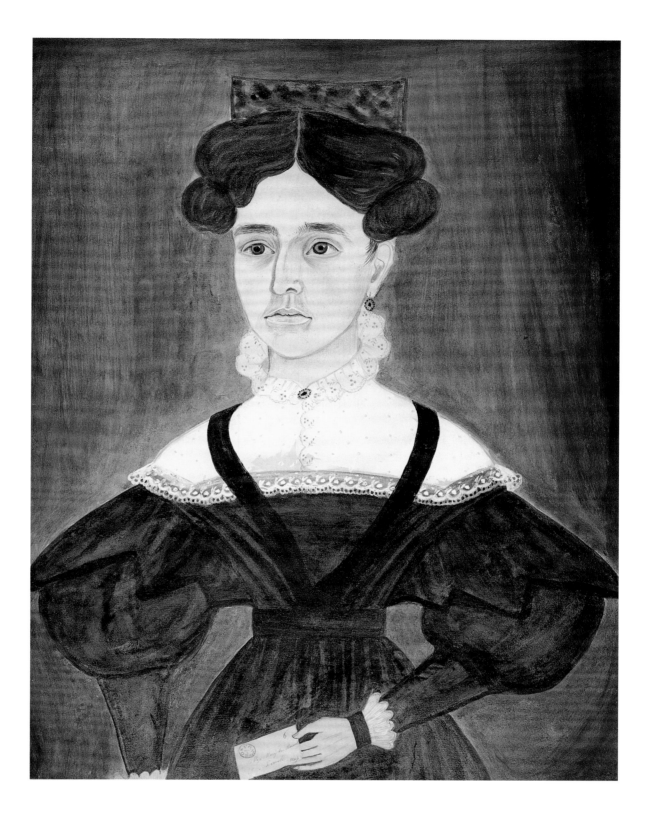

26. MARY ANN RUSSELL, 1828
 Samuel Addison Shute (1803–1836) and Ruth Whittier Shute (1803–1882),
 Lowell, Middlesex County, Massachusetts
 Watercolor, gouache, pencil, ink, and gum arabic on paper, in original pine frame with
 mahogany veneer, 18 × 13½ in. (25⁵⁄₁₆ × 20⅞ × 1¼ in. framed), P1.2001.29

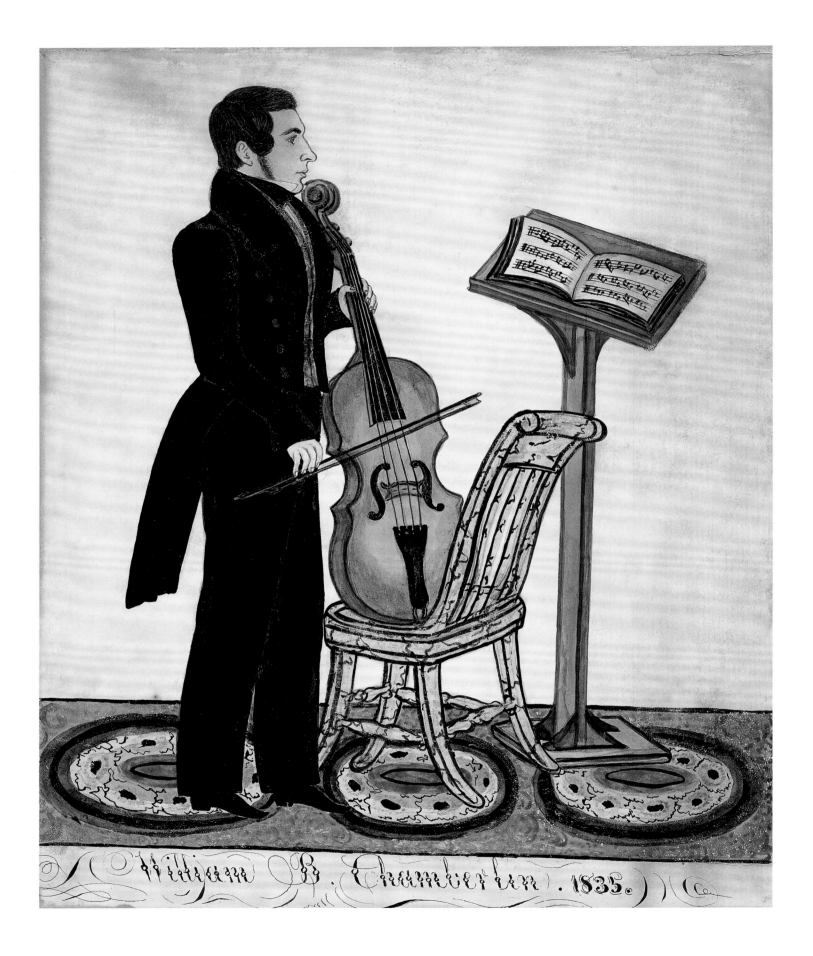

William R. Chamberlin. 1835.

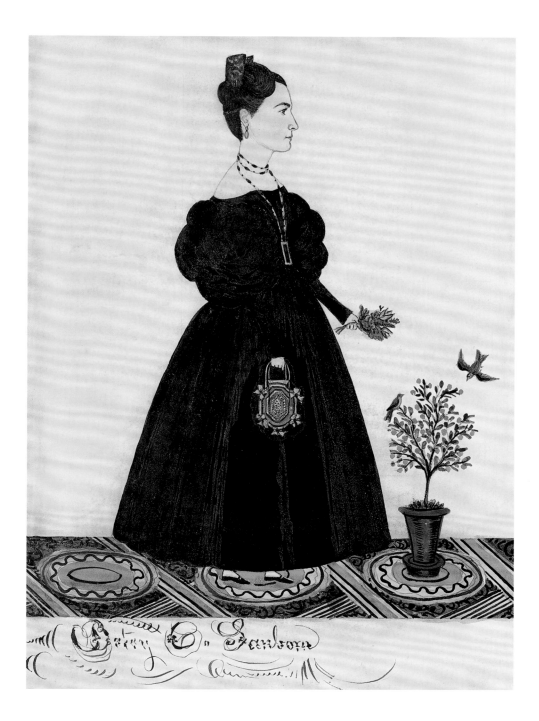

27. WILLIAM B. CHAMBERLIN WITH VIOLONCELLO AND MUSIC, 1835
Joseph H. Davis (act. 1832–1837), probably Brookfield, Carroll County,
New Hampshire
Watercolor, pencil, and ink on paper, 10¾ × 8¹³⁄₁₆ in. (sight), P1.2001.31

28. BETSY C. SANBORN, 1835
Joseph H. Davis (act. 1832–1837), probably Brookfield, Carroll County,
New Hampshire
Watercolor, pencil, and ink on paper, 10⅝ × 7¾ in. (sight), P1.2001.32

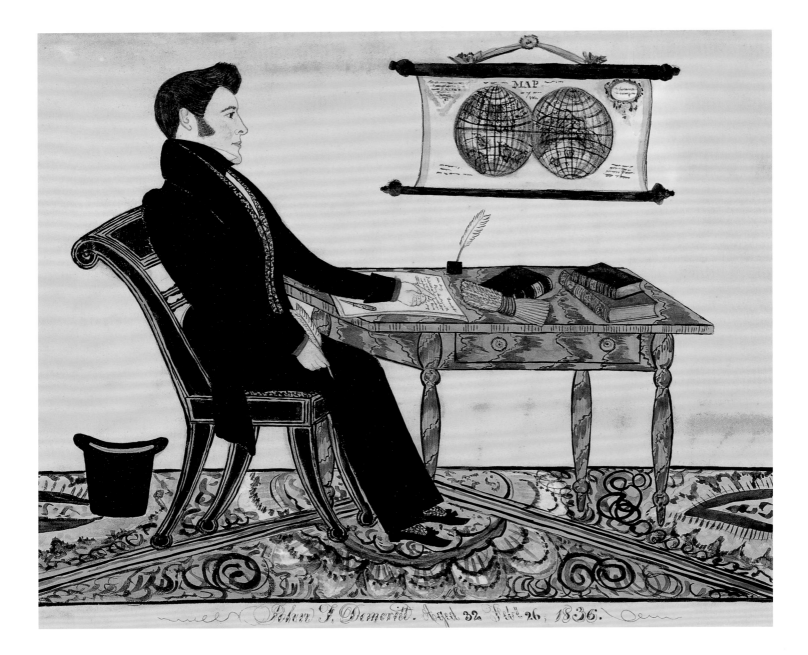

29. JOHN F. DEMERITT, 1836
Joseph H. Davis (act. 1832–1837), probably Barrington, Strafford County,
New Hampshire
Watercolor, pencil, and ink on paper, 9¹¹⁄₁₆ × 11 in. (sight), P1.2001.33

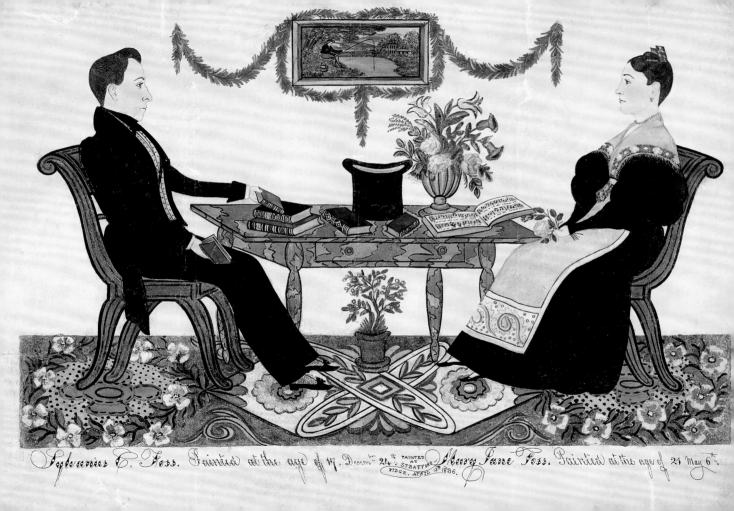

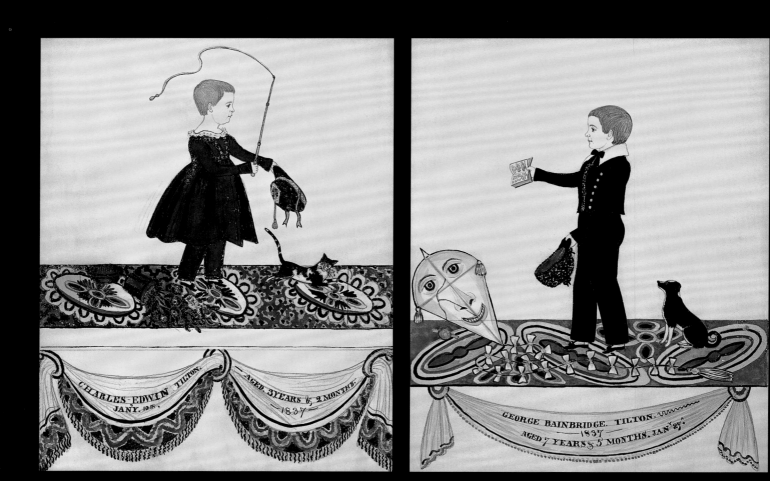

CHARLES EDWIN TILTON.
JANY. 10th.

AGED 3YEARS & 2 MONTHS.
1837

GEORGE BAINBRIDGE. TILTON.
1837
AGED 7 YEARS & 5 MONTHS. JANY 27th.

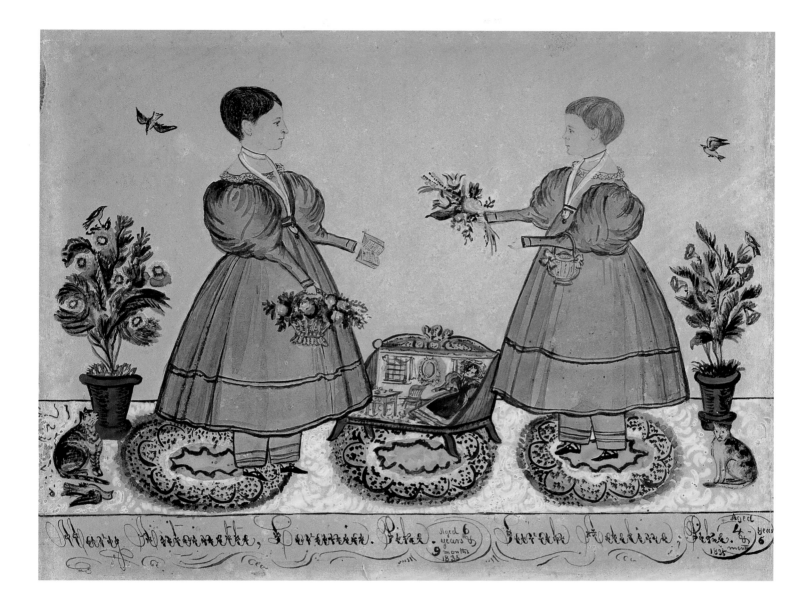

32. MARY ANTOINETTE LORANIA PIKE AND SARAH ADELINE PIKE, 1835
Joseph H. Davis (act. 1832–1837), probably Maine or New Hampshire
Watercolor, pencil, and ink on paper, 8½ × 11 in. (sight), P1.2001.36

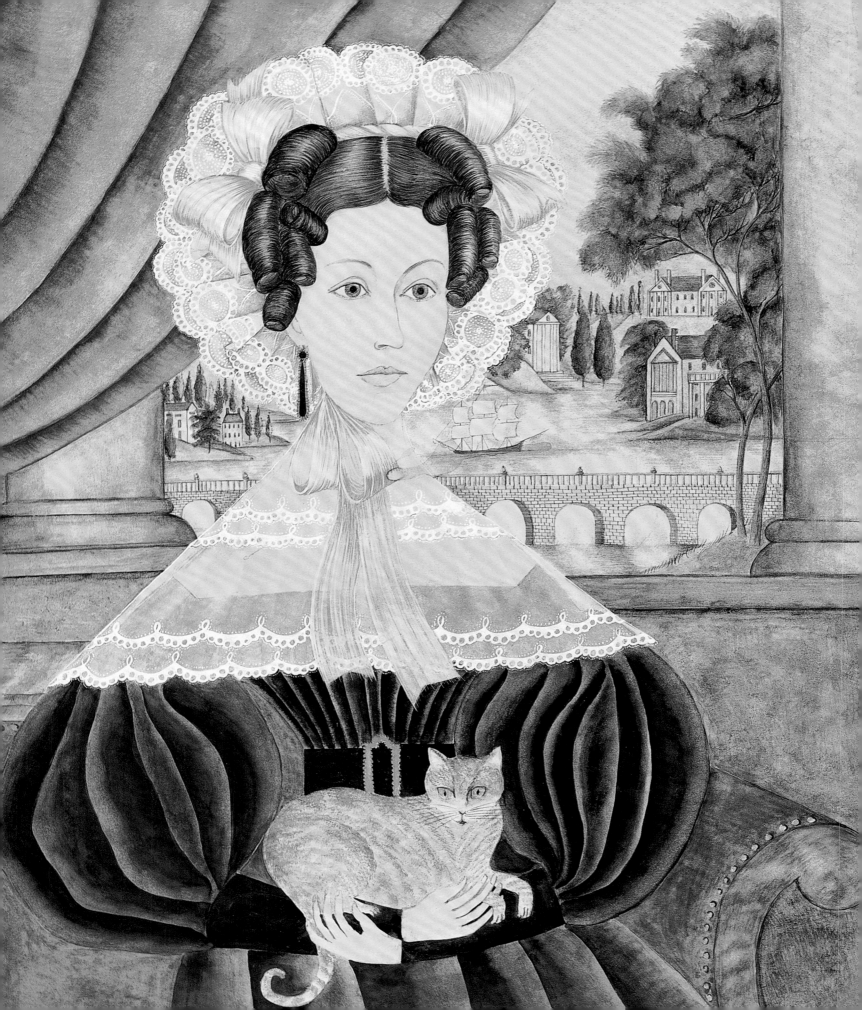

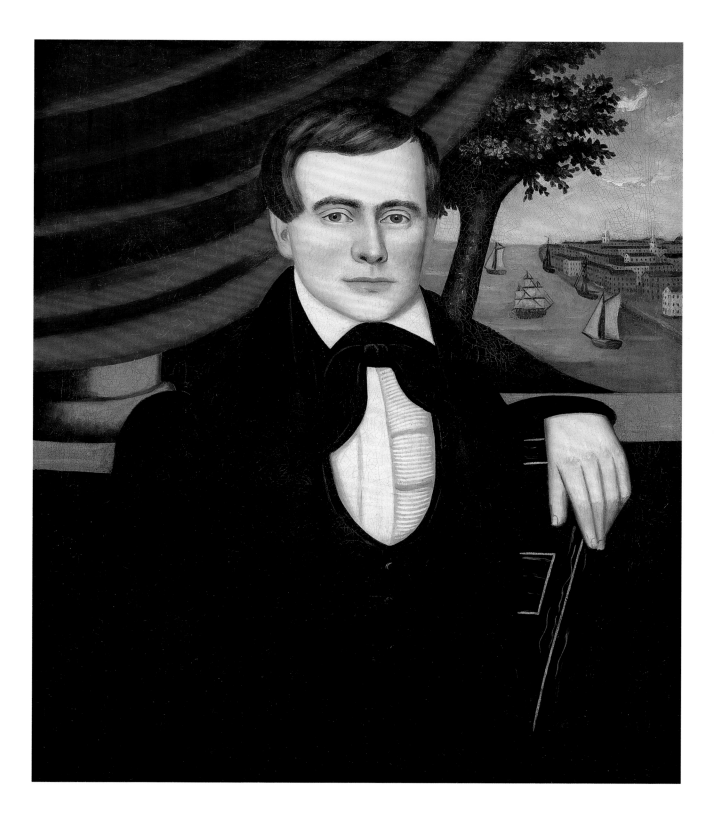

33. Mrs. Keyser, c. 1834
Artist unidentified, Baltimore
Watercolor, gouache, ink, and pencil on paper, in original frame
covered with embossed paper with traces of gilt, 22¾ × 18¼ in.
(sight) (34⁷⁄₁₆ × 28³⁄₈ × 1¹³⁄₁₆ in. framed), P1.2001.37

34. Portrait of a Young Man (probably
William Lauriston Cook), c. 1838–1839
Erastus Salisbury Field (1805–1900),
Petersham, Worcester County, Massachusetts
Oil on canvas, 29½ × 25¼ in. (sight), P1.2001.38

35. Girl in Red Dress with Cat and Dog, c. 1830–1835
Ammi Phillips (1788–1865), vicinity of Amenia, Dutchess County, New York
Oil on canvas, 30 × 25 in., P2.1984.1

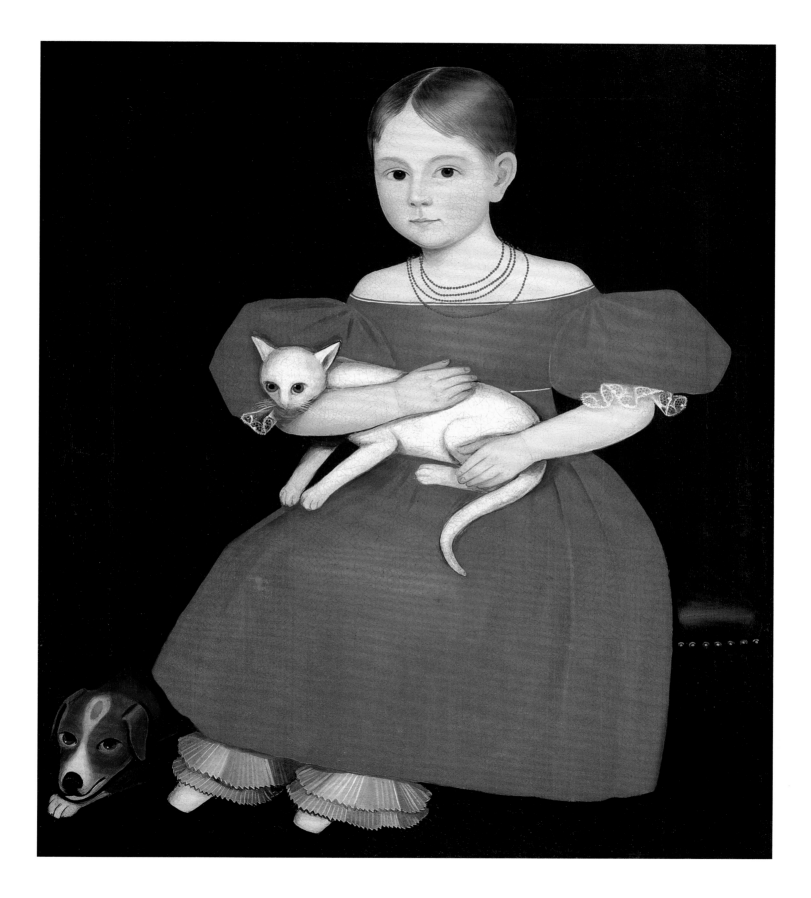

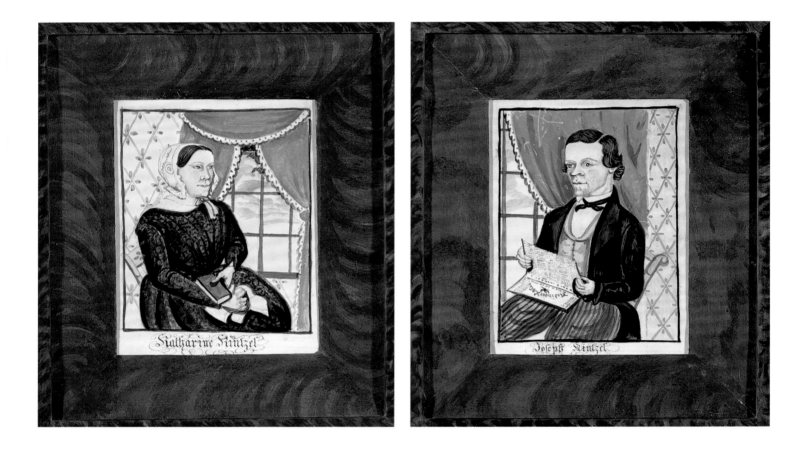

36a–c. **KATHARINE KINTZEL, JOSEPH KINTZEL,** and **MARY ANN KINTZEL,** c. 1857
The Reading Artist, Berks County, Pennsylvania
Watercolor, pencil, and ink on paper, in original grain-painted pasteboard frame with modern wood outer
frame and glazing, 14¹⁄₁₆ × 11⁷⁄₈ in. (*Mrs. Kintzel* and *Mr. Kintzel*) and 14¼ × 11¹⁵⁄₁₆ in. (*Mary Ann*) (framed),
P1.2001.39, 40, 41

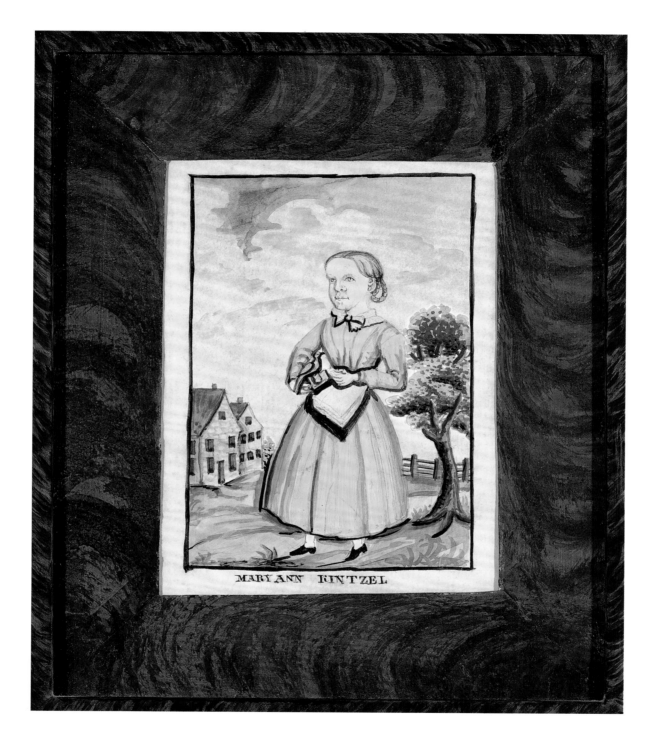

MARY ANN KINTZEL

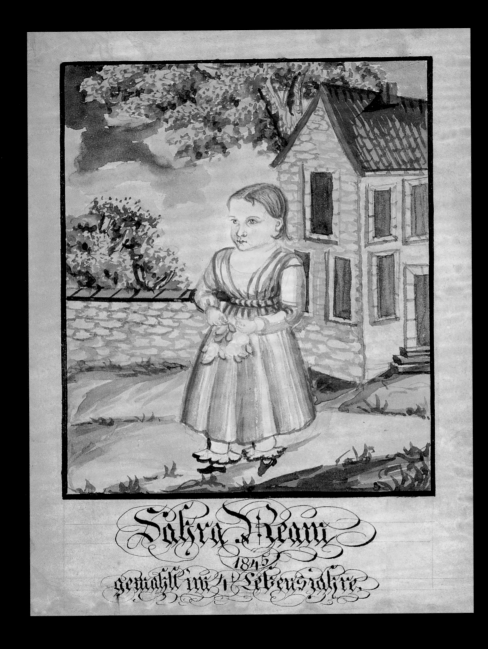

37. **SAHRA REAM,** 1845
 The Reading Artist, Berks County, Pennsylvania
 Watercolor, pencil, and ink on paper, 9⅛ × 6⅝ in., P1.2001.42

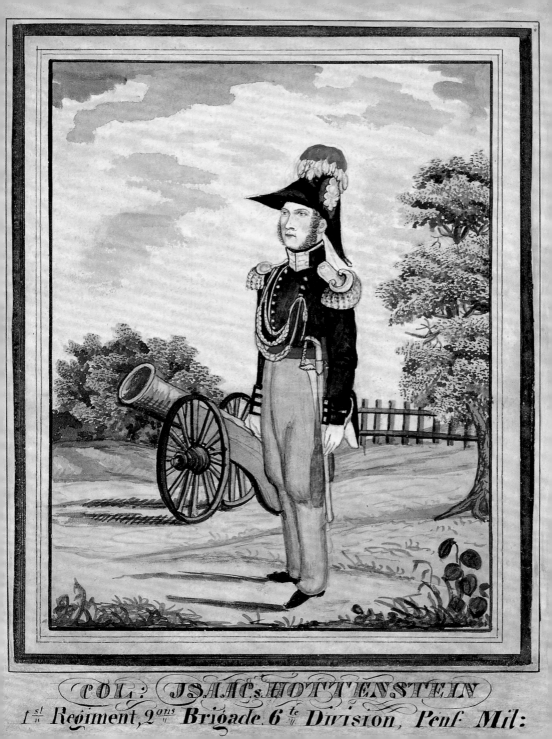

COL: ISAAC HOTTENSTEIN
1st Regiment, 2ons Brigade. 6te Division, Penf: Mil:

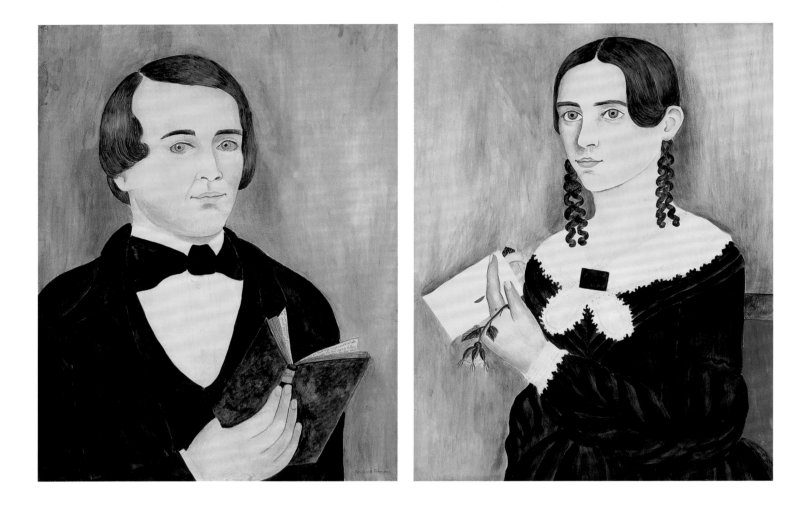

39a–b. YOUNG MAN HOLDING A BIBLE and
YOUNG WOMAN HOLDING A LETTER AND ROSE, 1844
Mary B. Tucker (dates unknown), probably Massachusetts
Watercolor, ink, and pencil on paper, 21¾ × 16⅝ in. and 22 × 16¾ in., P1.2001.44a, b

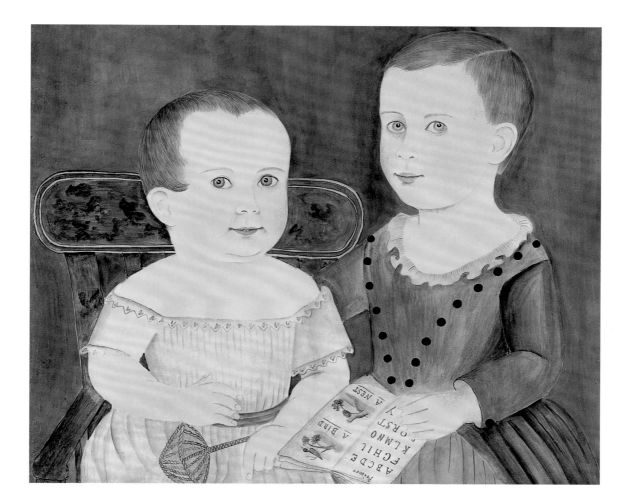

40. LEARNING THE ABCs, c. 1840–1844
Attributed to Mary B. Tucker (dates unknown), probably Massachusetts
Watercolor and pencil on paper, 19¼ × 23 in., P1.2001.45

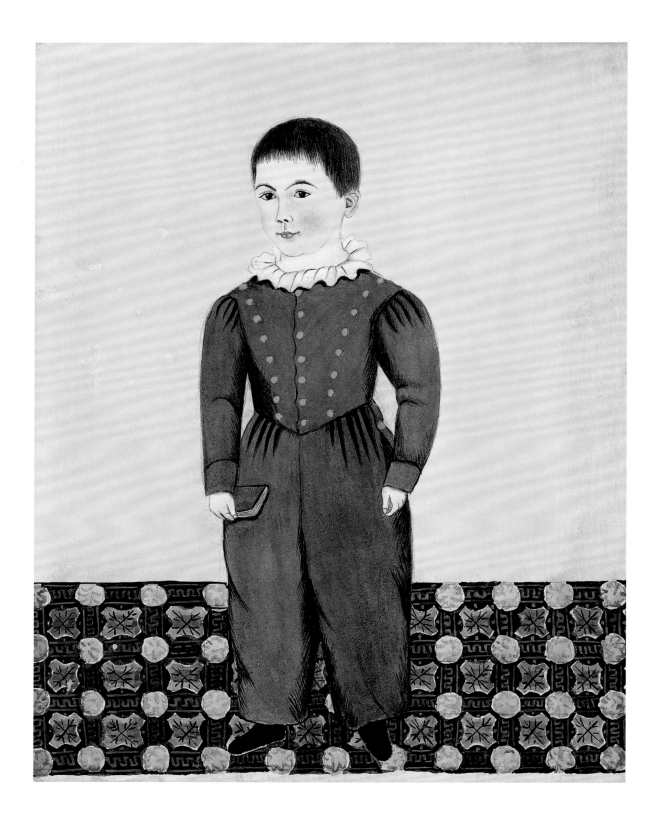

41. JAMES M. MITCHELL, c. 1835
Artist unidentified, Amesbury, Essex County, Massachusetts
Watercolor, gouache, paint, ink, and pencil on paper,
mounted on wood backing, 8⅞ × 6¹⁵⁄₁₆ in., P1.2001.46

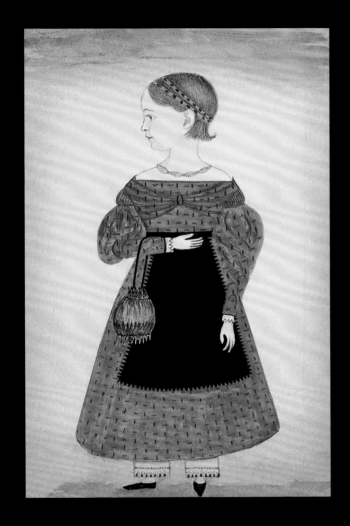

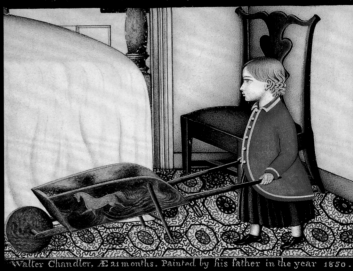

43. **WALTER CHANDLER, Æ 21 MONTHS**, 1850
Walter Chandler (1826–?), Elizabethtown,
Union County, New Jersey
Watercolor and gouache on paper, 2¾ × 3¼ in., P1.2001.48

Walter Chandler, Æ 21 months. Painted by his father in the year 1850.

42. **YOUNG GIRL IN RED**, c. 1835–1840
Justus Dalee (act. 1826–c. 1848), New York State
Watercolor and pencil on paper, 4¾ × 3 in., P1.2001.47

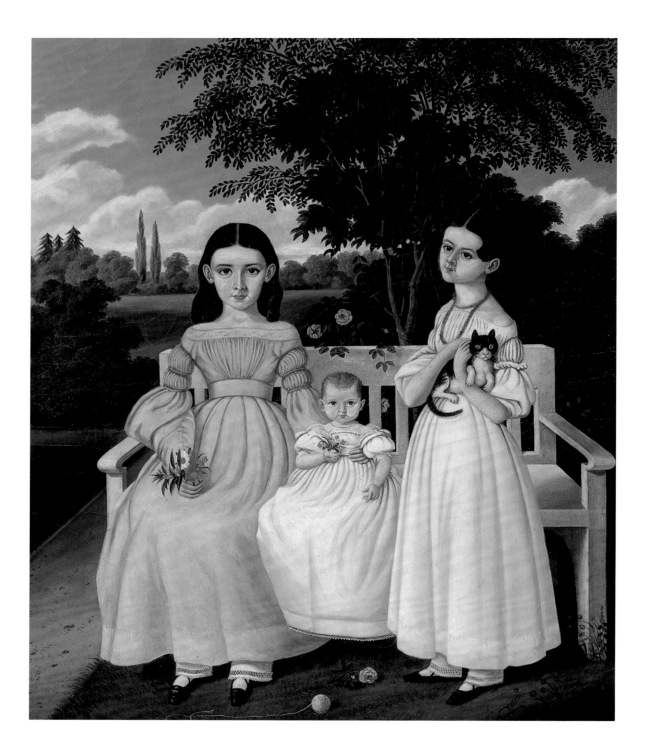

44. THREE CHILDREN IN A LANDSCAPE, c. 1838
Henry Walton (1804–1865), Finger Lakes region, New York
Oil on canvas, 19¼ × 16 in. (sight), P1.2001.49

45. THE FARWELL CHILDREN, c. 1841
Attributed to Deacon Robert Peckham (1785–1877),
Fitchburg, Worcester County, Massachusetts
Oil on canvas, 52½ × 39½ in., P1.2001.50

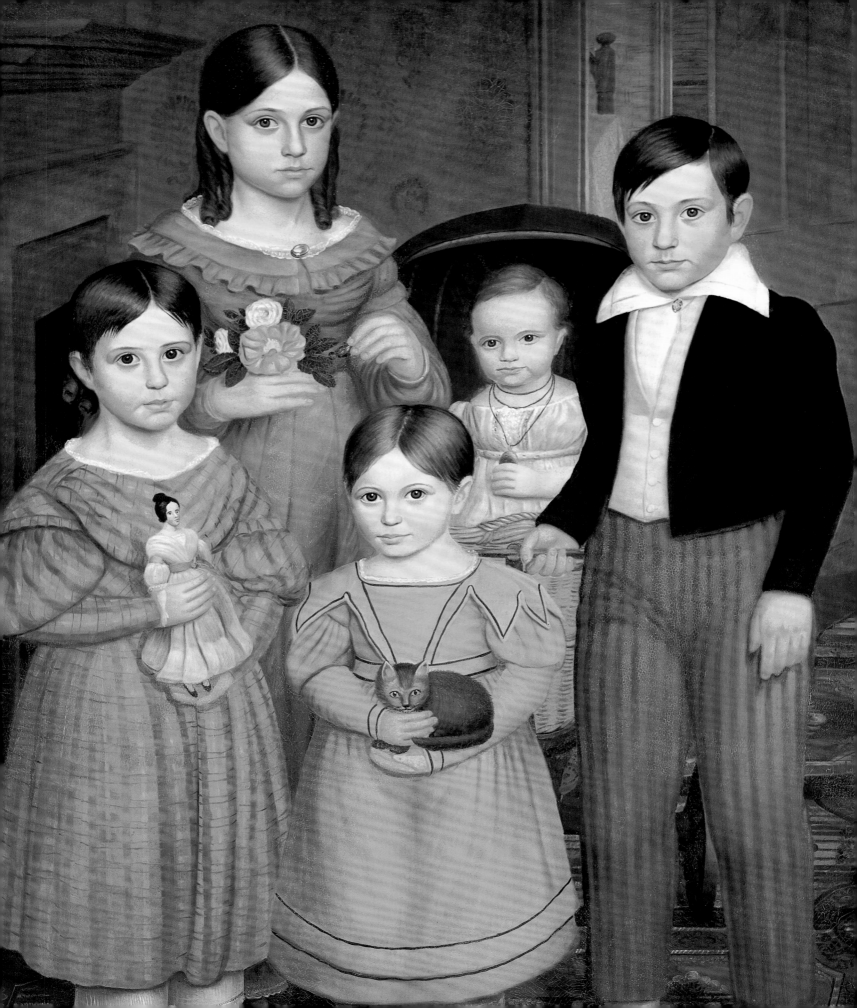

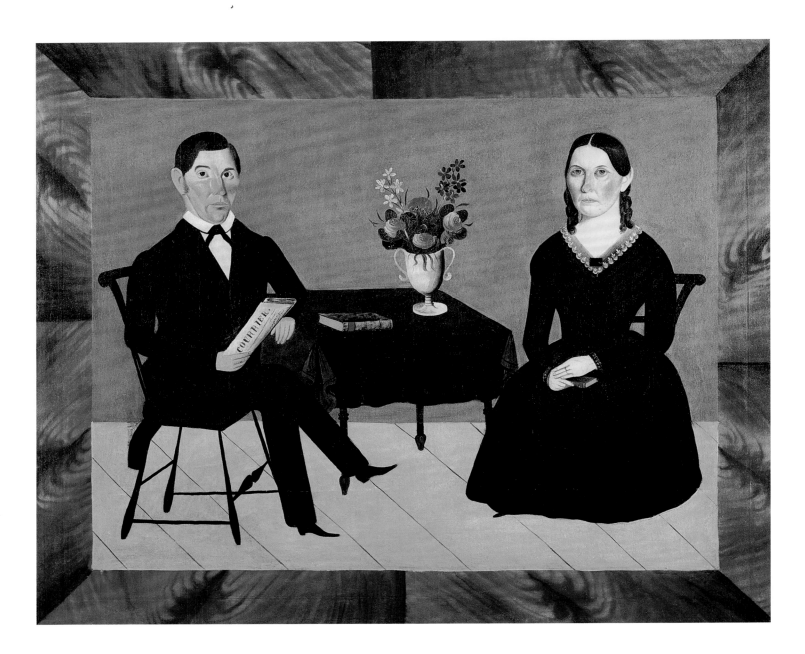

46. **David and Catherine Stolp Crane**, c. 1845
Sheldon Peck (1797–1868), Aurora, Kane County, Illinois
Oil on canvas, 35¹¹⁄₁₆ × 43⅝ in., P1.2001.51

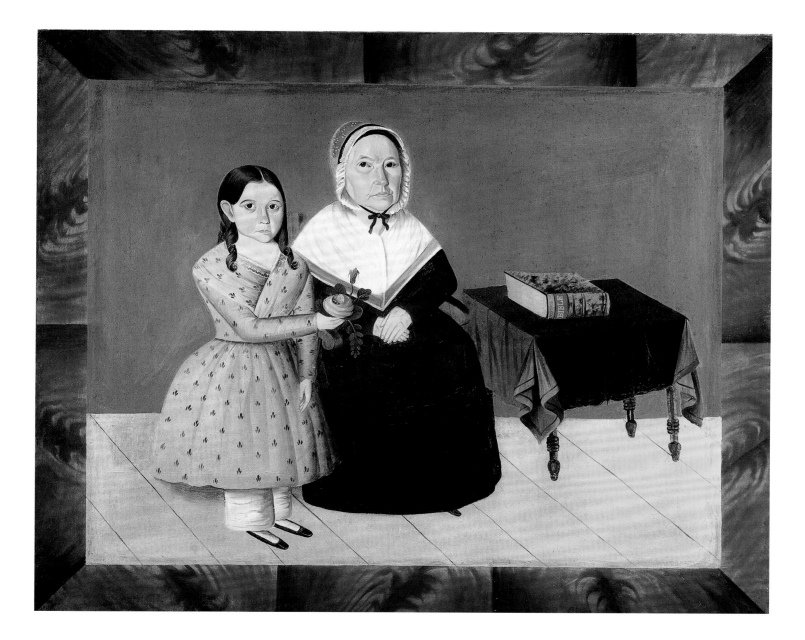

47. ANNA GOULD CRANE AND GRANDDAUGHTER JANETTE, c. 1845
Sheldon Peck (1797–1868), Aurora, Kane County, Illinois
Oil on canvas, 35½ × 45½ in., P1.2001.52

CHAPTER 2

THE WORLD OUTSIDE

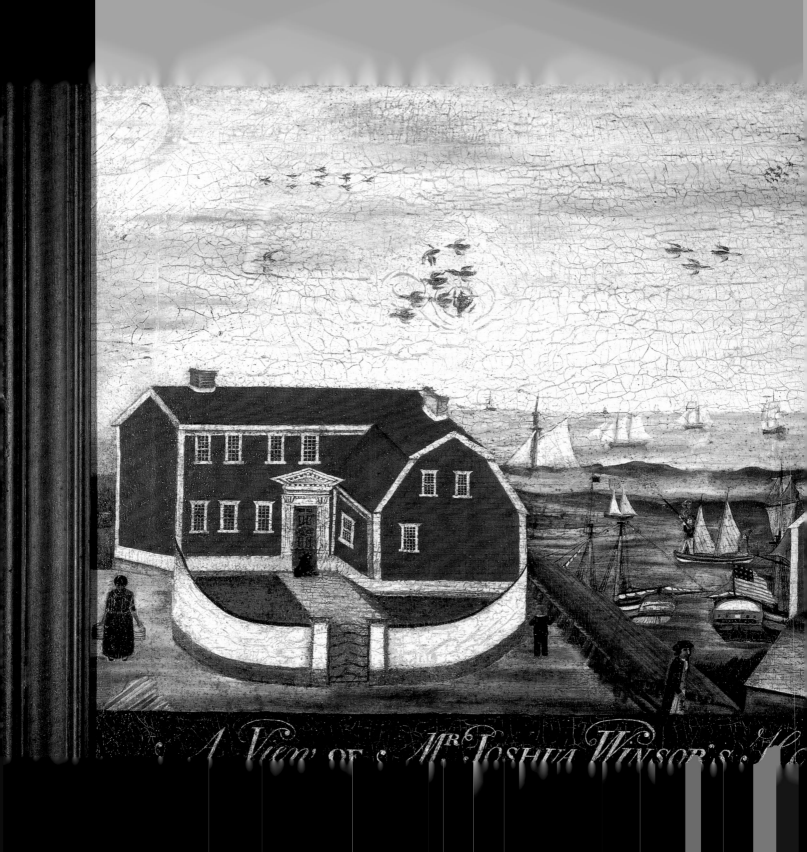

A View of Mr Joshua Winsor's H[...]

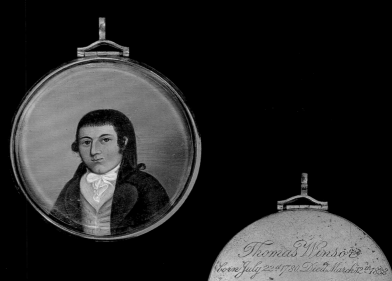

49a–b. **THOMAS WINSOR MINIATURE**, 1797
Rufus Hathaway (1770–1822), Duxbury,
Plymouth County, Massachusetts
Oil on ivory, in gold locket, 2⅜ in. diam., P1.2001.54

48.
A VIEW OF MR. JOSHUA WINSOR'S HOUSE & C., 1793–1795
Rufus Hathaway (1770–1822), Duxbury, Plymouth County,
Massachusetts
Oil on canvas, in original painted wood frame, 23¼ × 27½ in.

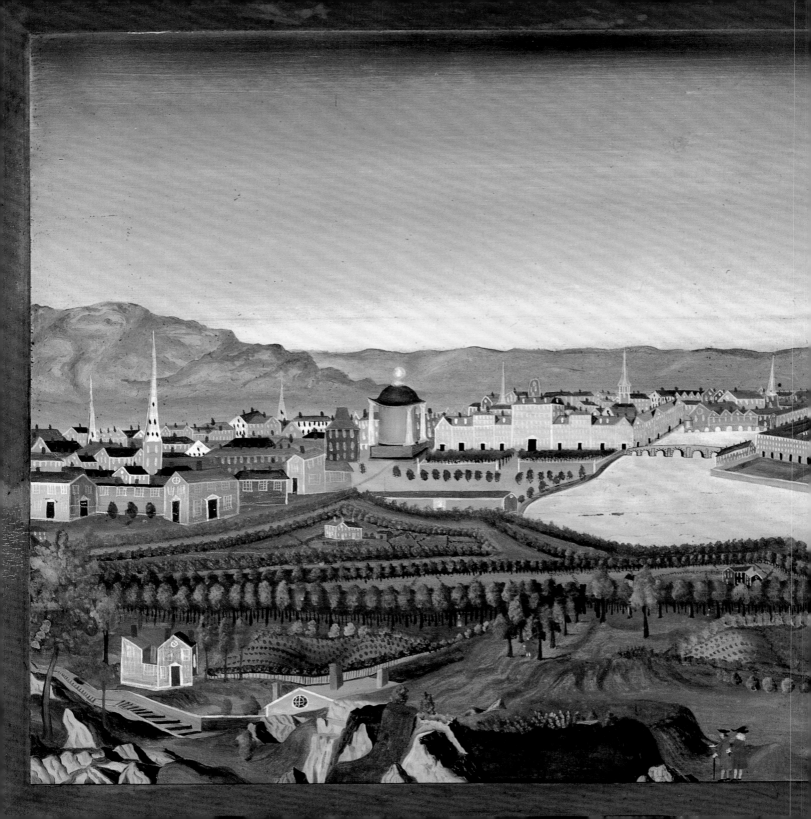

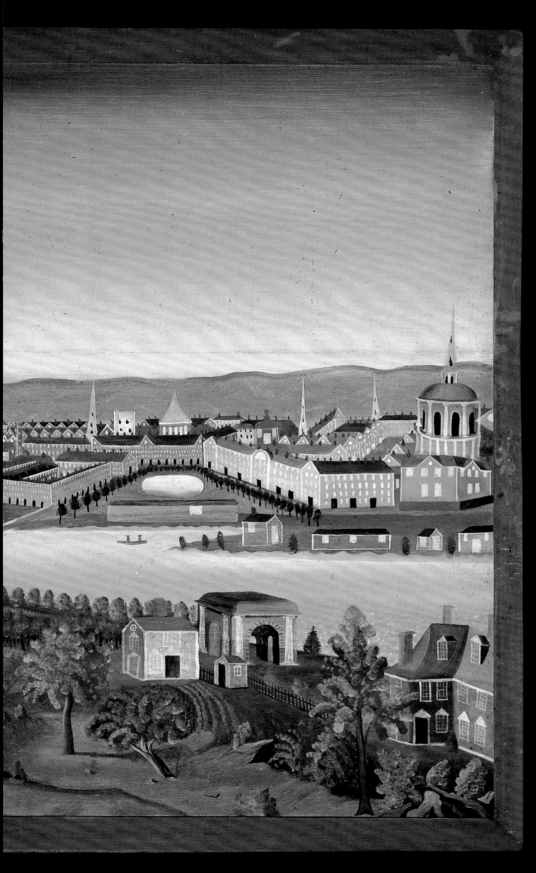

50.
SCENIC OVERMANTEL, c. 1780
Winthrop Chandler (1747–1790), Petersham, Worcester County,
Massachusetts
Oil on pine panel with beveled edges, 29¼ × 47¼ × 1½ in., P1.2001.55

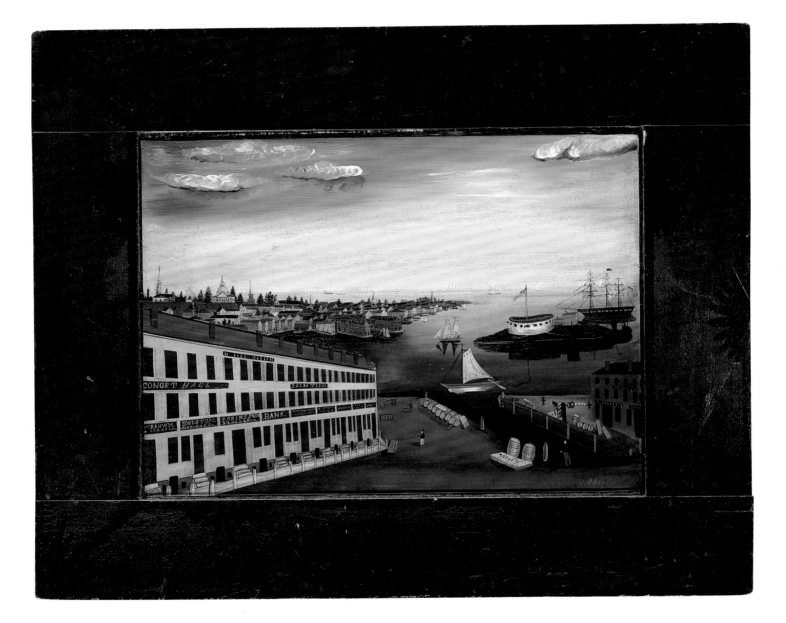

51. **Fireboard with View of Boston Harbor**, c. 1825–1835
Artist unidentified, Massachusetts
Oil on pine panel, in original painted wood frame, 27¼ × 32¾ × 1 in. (framed), P1.2001.56

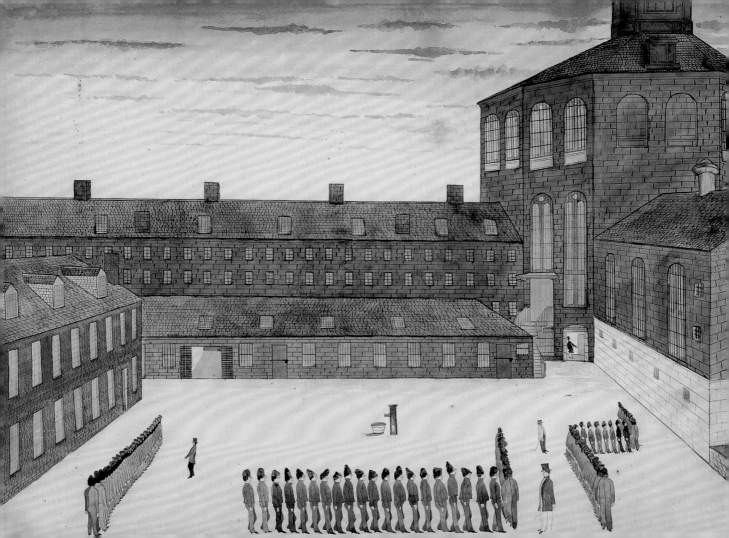

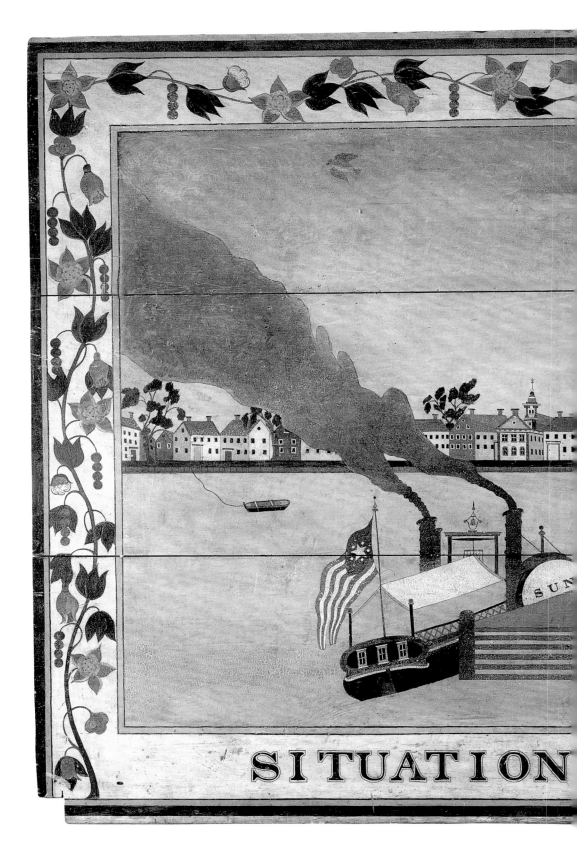

53. SITUATION OF AMERICA, 1848., 1848
Artist unidentified, New York
Oil on wood panel, 34 × 57 × 1⅜ in., P1.2001.58

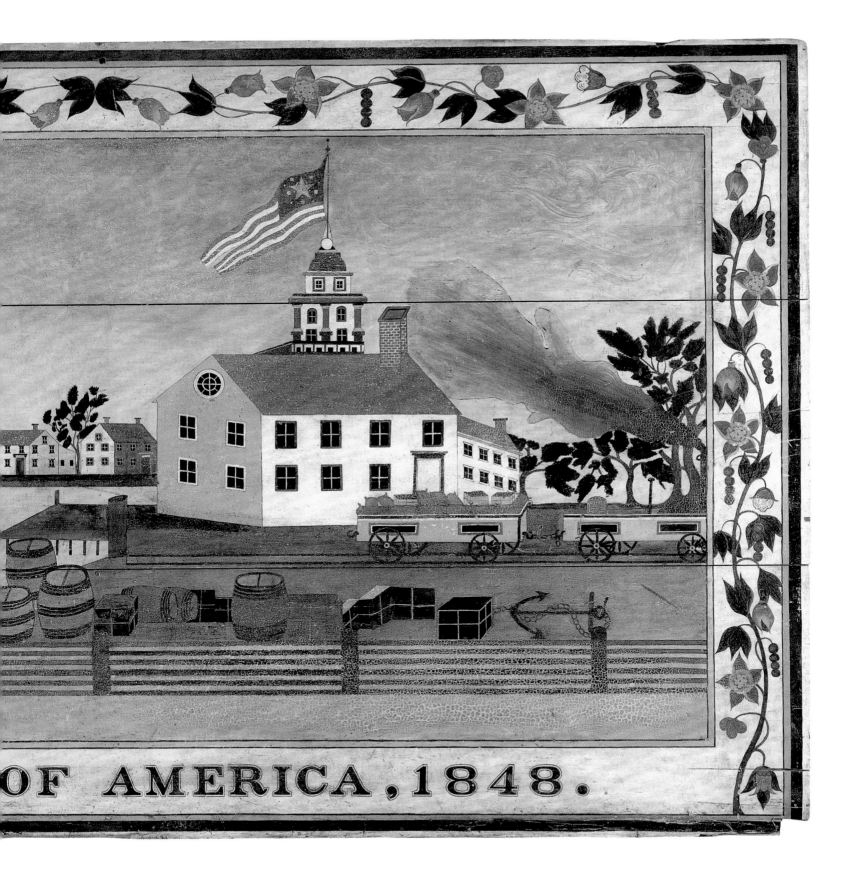

OF AMERICA, 1848.

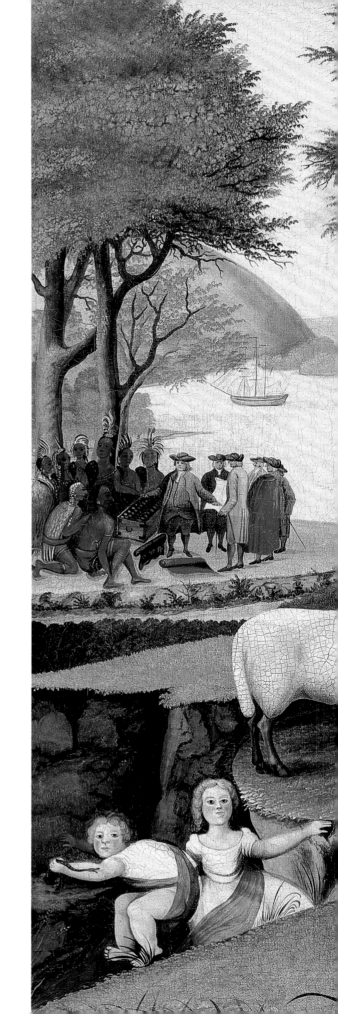

54. THE PEACEABLE KINGDOM, 1846–1848
Edward Hicks (1780–1849), Newtown, Bucks County, Pennsylvania
Oil on canvas, 26 × 29⅜ in., P1.2001.59

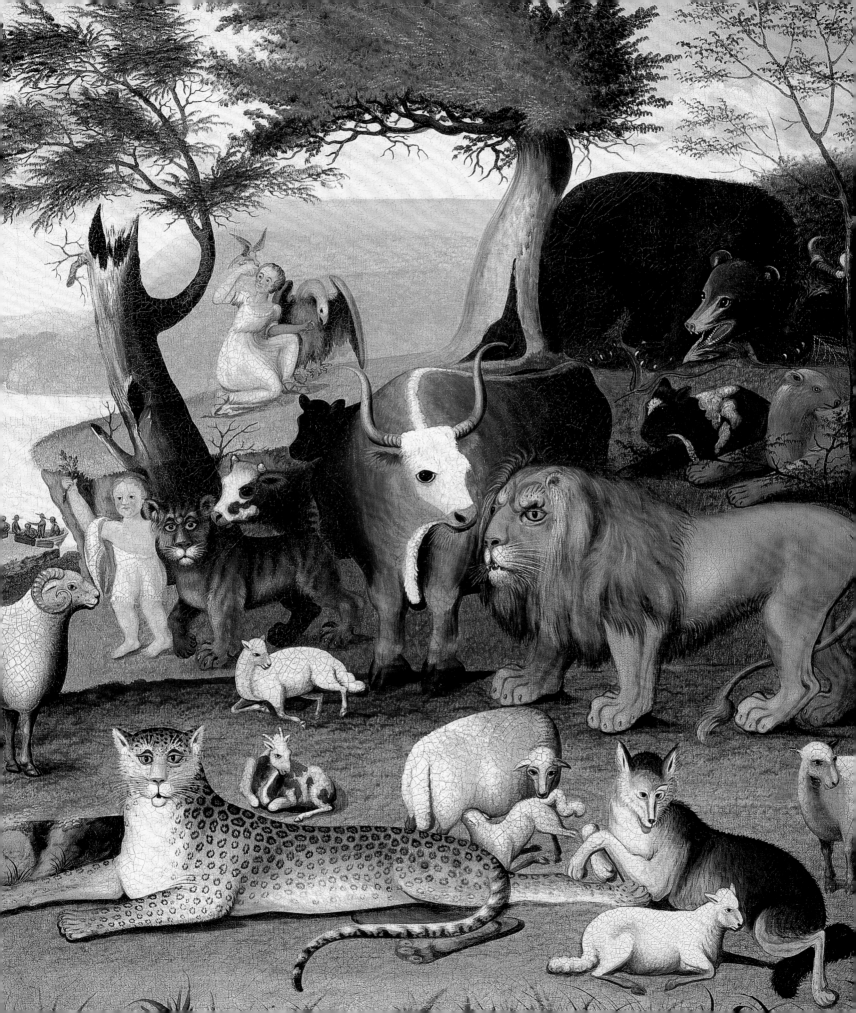

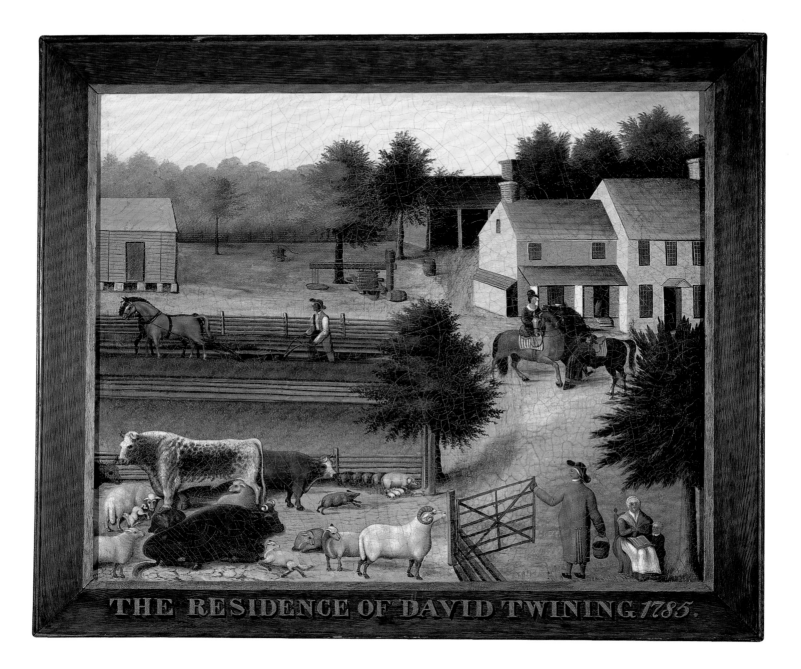

55. THE RESIDENCE OF DAVID TWINING 1785., 1846
Edward Hicks (1780–1849), Newtown, Bucks County, Pennsylvania
Oil on canvas, in original wood frame with paint and gold leaf, 26⅛ × 29¾ in.
(30½ × 35⅞ × 1⅜ in. framed), P1.2001.60

56.
FARMSTEAD OF JACOB S. HUNSECKER, c. 1860–1875
Charles H. Wolf (dates unknown), southeastern Pennsylvania
Watercolor and ink on paper, 23⅞ × 31¾ in., P1.2001.61

57.
THE PROPERTY OF DANIEL AND SARAH LEIBELSPERGER, 1882
Ferdinand A. Brader (1833–after 1895), Fleetwood, Berks County, Pennsylvania
Pencil on paper, 30⅝ × 51³⁄₁₆ in. (sight), P1.2001.62

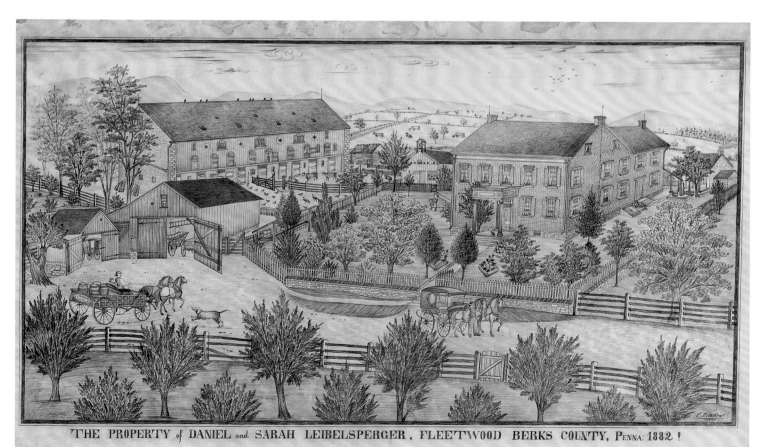

THE PROPERTY of DANIEL and SARAH LEIBELSPERGER, FLEETWOOD BERKS COUNTY, PENNA: 1882!

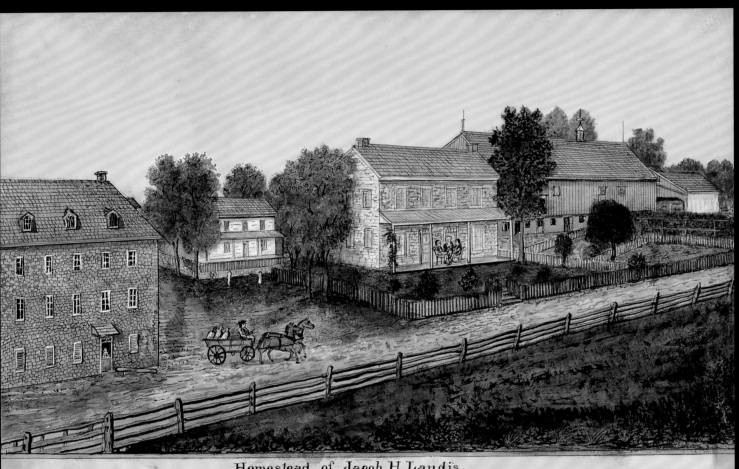

Homestead of Jacob H. Landis,
From a sketch taken by Jacob Stauffer, July 17, 1879, during a visit, in company with Dr. S.S. Rathvon, and enjoyed the kind hospitality of their host and his family. Presented in commemoration of that day by the humble delin or, not as a matter of skill or beauty – but as a token of fond memories.

July 22ᵈ 1879. aged in his 71 Year of age, Lancaster, Pa.

58. HOMESTEAD OF JACOB H. LANDIS, 1879
Jacob Stauffer (1808–1880), Lancaster County, Pennsylvania
Watercolor and ink on paper, 9⅝ × 13⅜ in., P1.2001.63

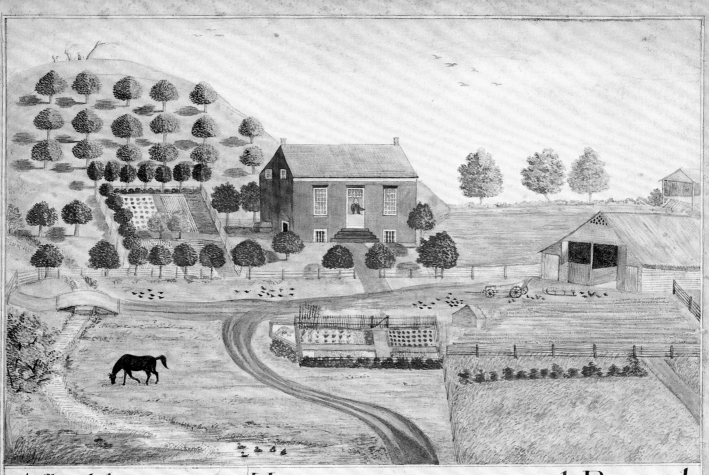

Afbeelding van een Huis in Oost Jersey, aan de Pesayack
Rivier, twintig mylen N.W. van Nieuw York, en Sestien mylen N.O. van Morris Town.

Geteikend door Peter Oudenaarde 1786

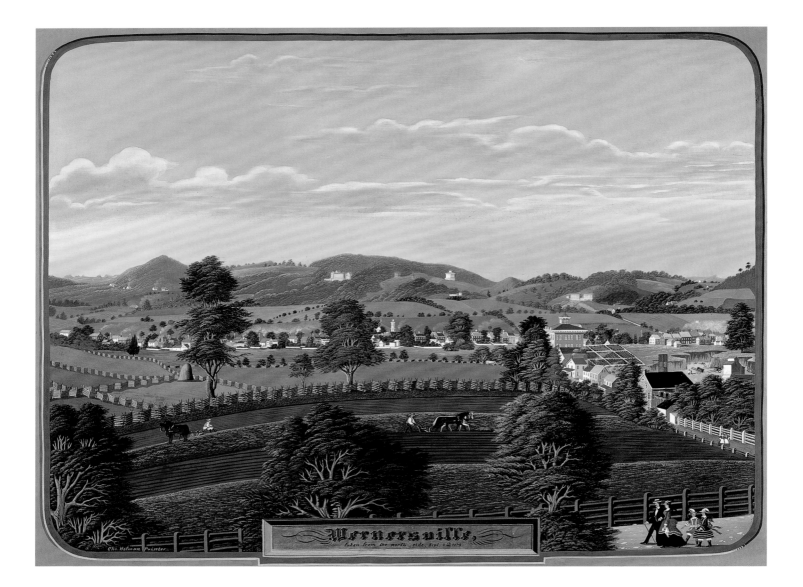

60. WERNERSVILLE, TAKEN FROM THE NORTH-SIDE, 1879
Charles C. Hofmann (1821–1882), Berks County, Pennsylvania
Oil on zinc-plated tin, 25½ × 33½ in. (sight), P1.2001.65

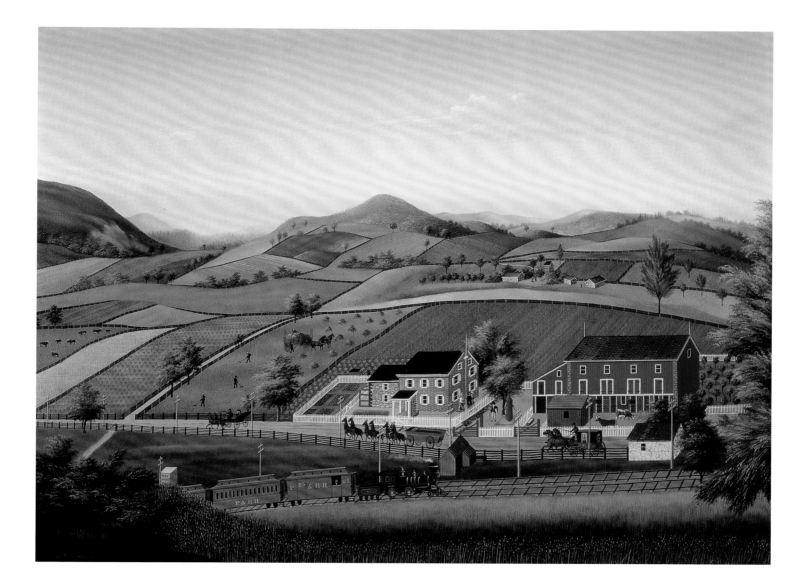

61. BERKS COUNTY FARMSCAPE, c. 1879–1886
John Rasmussen (1828–1895), Berks County, Pennsylvania
Oil on zinc-plated tin, 26⅜ × 35⅜ in., P1.2001.66

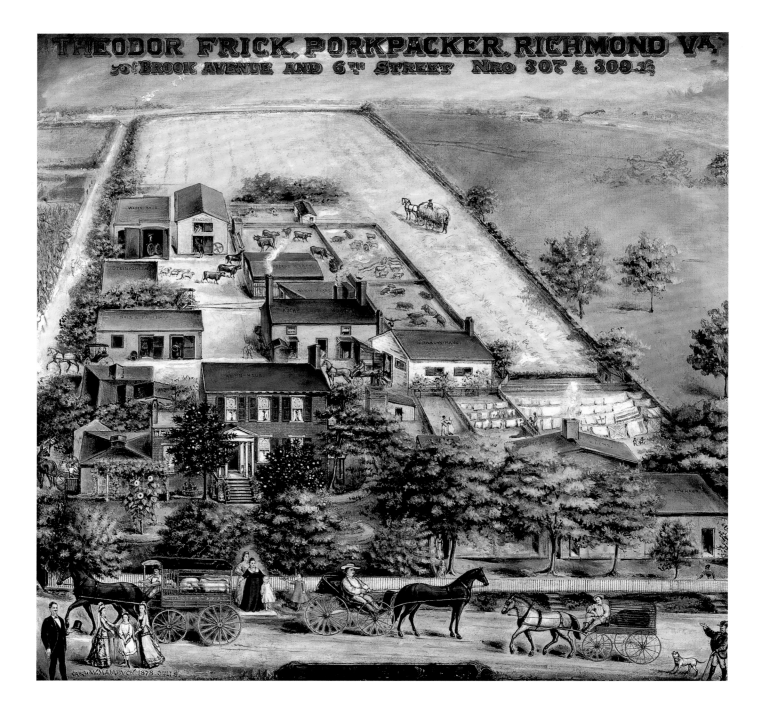

62. THEODOR FRICK, PORKPACKER, RICHMOND, VA., 1878
Carl W. Hambuch (?–1879), Richmond
Oil on canvas, 41 × 42⅛ in., P1.2001.67

63. HORSE JACK OF WOODBRIDGE, NJ, 1871
James Bard (1815–1897), New York
Oil and ink on paperboard, 8⁷⁄₁₆ × 11¹³⁄₁₆ in.,
P1.2001.68

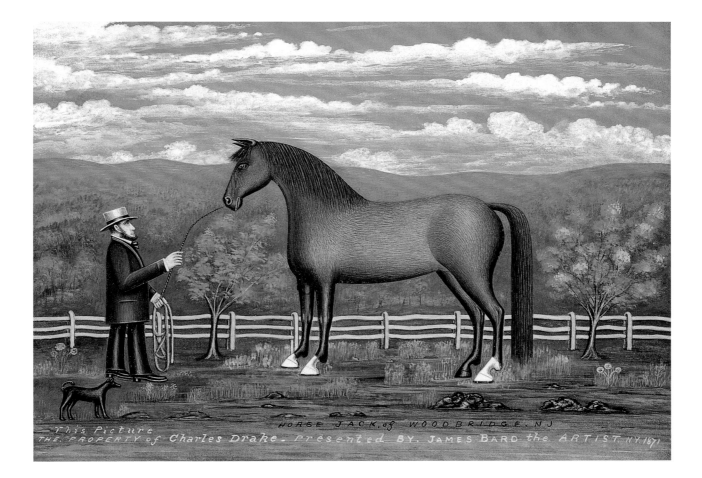

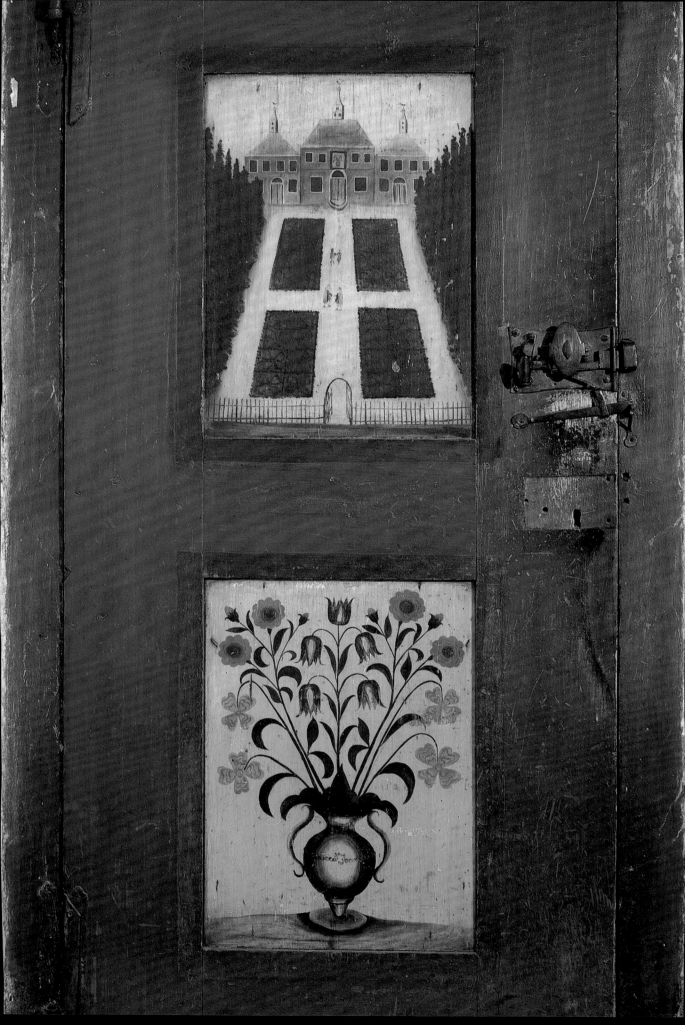

CHAPTER 3

INTERIOR GLIMPSES

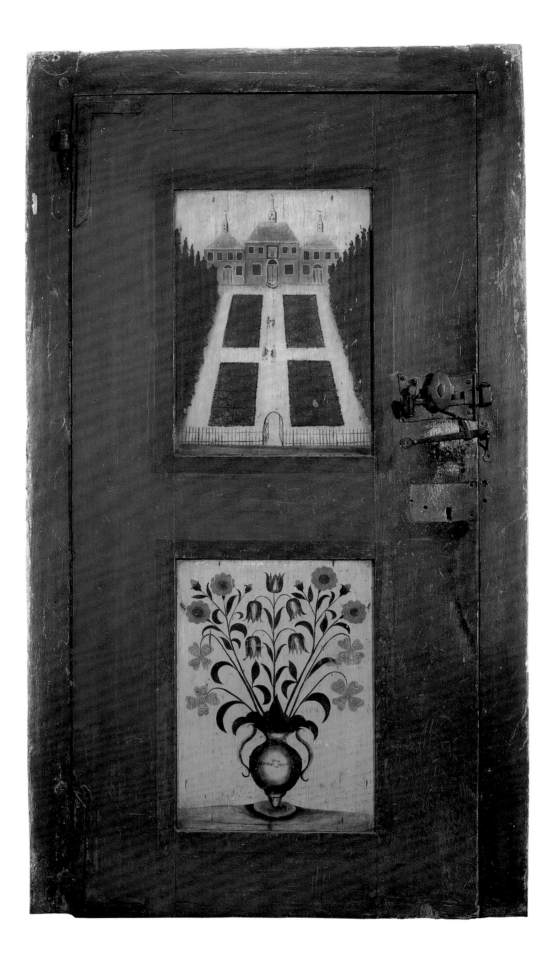

64. **Door from Cornelius Couwenhoven House,**
mid-eighteenth century
Daniel Hendrickson (1723–1788), Pleasant Valley,
Holmdel Township, Monmouth County, New Jersey
Paint on yellow pine and white oak, with wrought-iron
hinges, lock, and hardware, 78⅝ × 44¼ × 4 in. (with door
frame), P1.2001.69

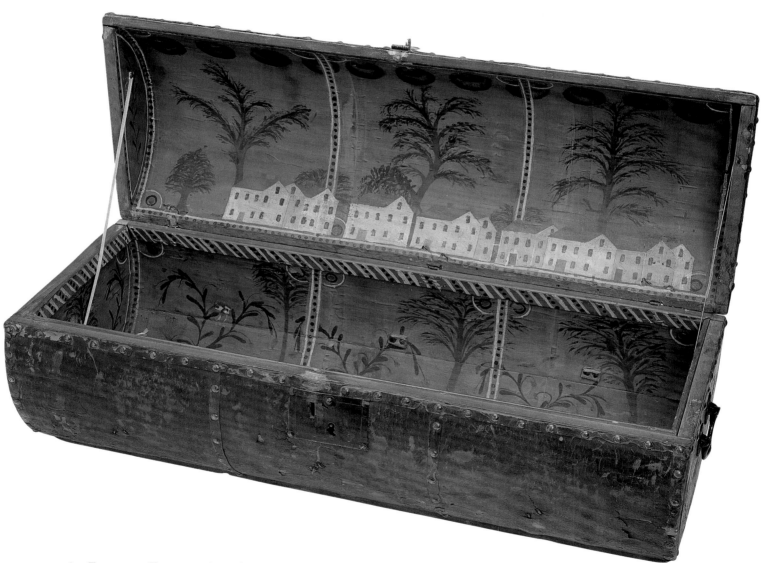

65. **Traveling Trunk,** c. 1800–1820
Artist unidentified, possibly New York
Hide-bound wood and paint on paper lining, with iron
hardware and brass tacks, 12½ × 31 × 12 in. (closed),
P1.2001.70

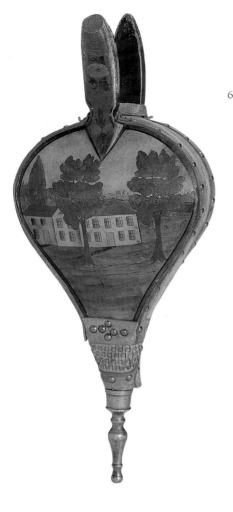

66. **Bellows with Architectural Scene**, c. 1830
Artist unidentified, New England
Paint and ink on wood, with brass tacks and leather,
17⅞ × 7¼ × 3 in., P1.2001.71

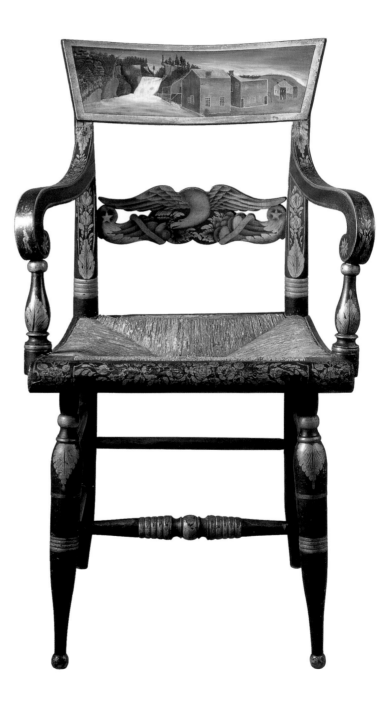

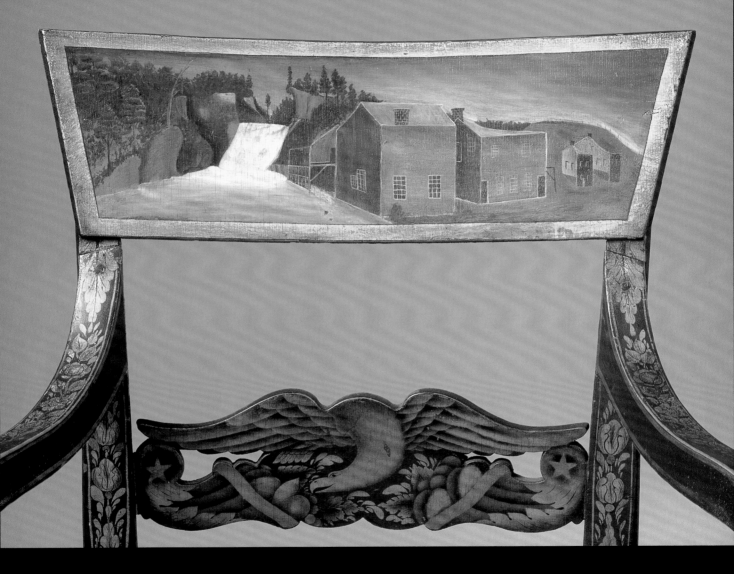

67. **Armchair with View of Ithaca Falls,** c. 1817–1825
Chairmaker unidentified, decoration probably by R.H. Ranney (dates unknown), Ithaca, Tompkins County, New York
Paint, bronze powder stenciling, and gold leaf on wood, with rush seat, 37¾ × 21 × 16½ in., P1.2001.72

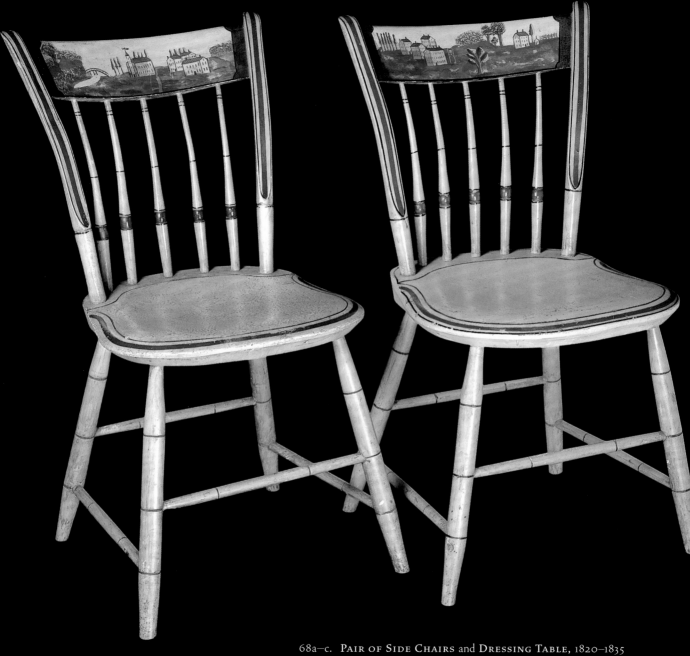

68a–c. PAIR OF SIDE CHAIRS and DRESSING TABLE, 1820–1835
Artist unidentified, Worcester, Worcester County, Massachusetts
Paint on maple and pine; *chairs:* 33¼ × 15¾ × 18 in. and 33½ × 17 × 18 in.,
table: 37⅜ × 33 × 20 in. P1.2001.733.b.74.

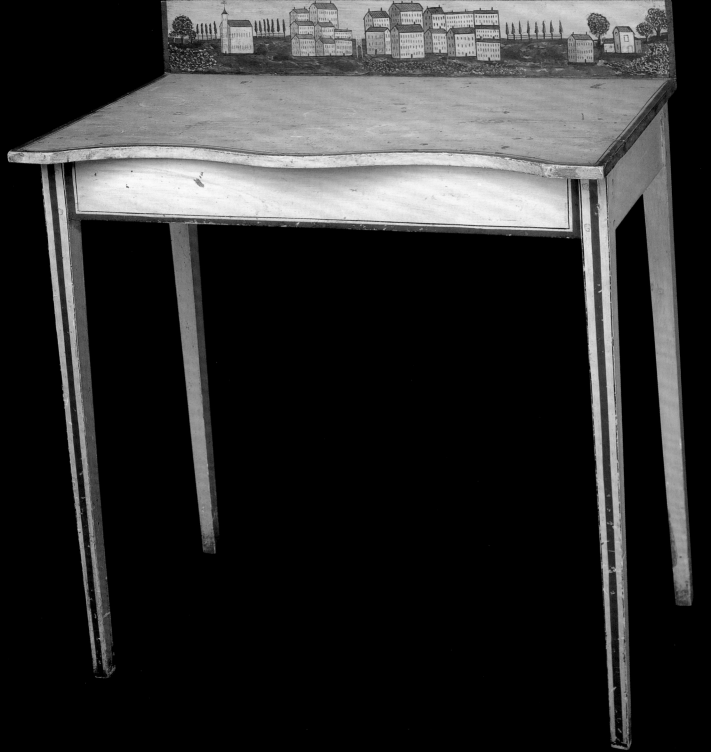

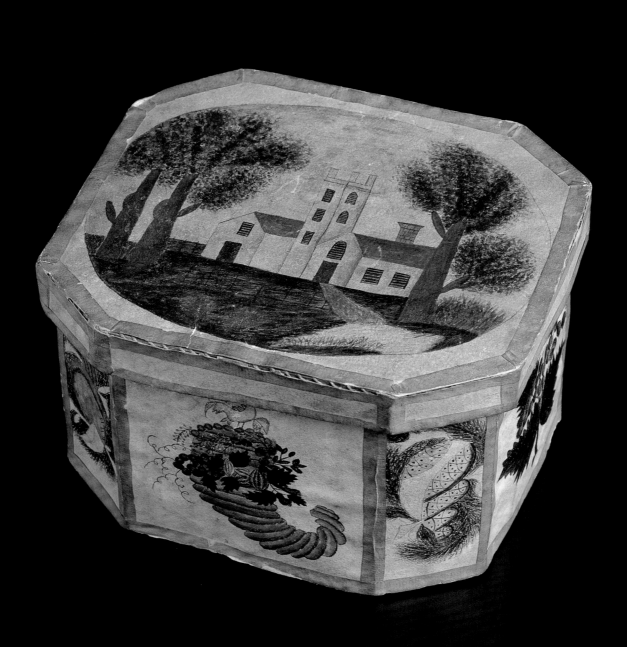

69. **TRINKET BOX,** c. 1820–1830
Artist unidentified, New England
Watercolor on paper on pasteboard,
3½ × 5⁷⁄₁₆ × 4¾ in., P1.2001.75

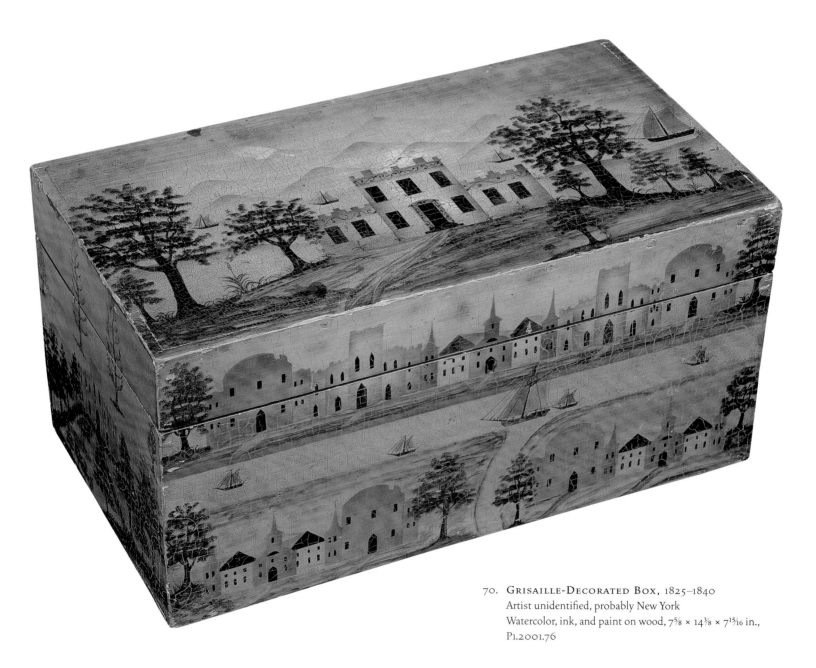

70. **GRISAILLE-DECORATED BOX,** 1825–1840
Artist unidentified, probably New York
Watercolor, ink, and paint on wood, 7⁵⁄₈ × 14³⁄₈ × 7¹⁵⁄₁₆ in.,
P1.2001.76

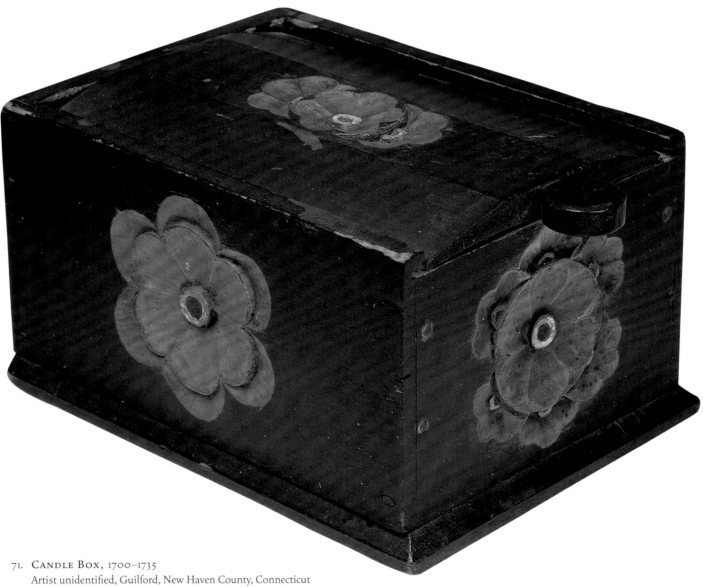

71. **Candle Box,** 1700–1735
Artist unidentified, Guilford, New Haven County, Connecticut
Paint on poplar, 5⅞₁₆ × 10½ × 7³⁄₁₆ in., P1.2001.77

72. **WALL BOX WITH EAGLE AND FLORAL DECORATION,**
c. 1790–1820
Artist unidentified, probably vicinity of Wethersfield,
Hartford County, Connecticut
Paint on white pine, 22 × 13 × 6 in., P1.2001.78

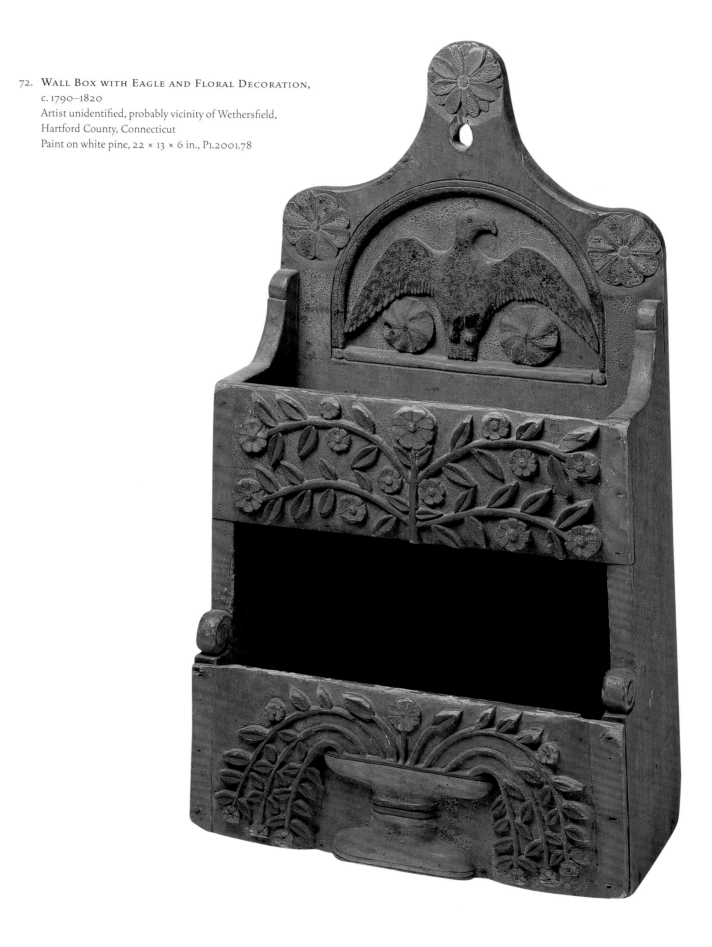

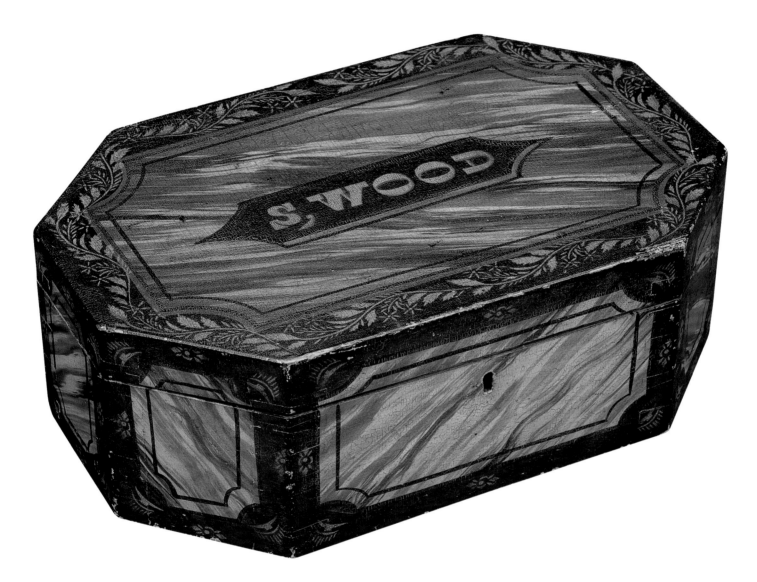

73. OCTAGONAL BOX, c. 1830
Artist unidentified, probably Vermont
Paint and bronze powder stenciling on pine,
4¾ × 12¾ × 8¼ in., P1.2001.79

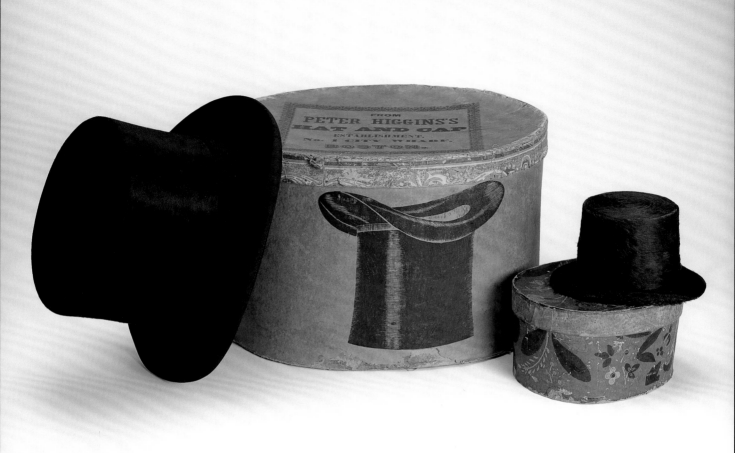

74a. **Bandbox and Beaver Top Hat**, c. 1835
Silas Goodrich (bandbox) and Collins & Fairbanks (top hat),
Boston
Printed wallpaper on pasteboard, with silk-lined beaver
skin hat; *bandbox:* 9¼ × 14 × 12⁵⁄₁₆ in. oval,
top hat: 5⅝ × 12 × 10 in. oval, P1.2001.80a, b

74b. **Miniature Bandbox and Beaver Top Hat**, c. 1830
Artist unidentified (band box) and George Vail (top hat), Newark,
Essex County, New Jersey
Printed wallpaper on pasteboard, with silk-lined beaver skin hat;
bandbox: 3⅞ × 6⅞ in. oval, *top hat:* 3½ × 6 × 4⅞ in. oval, P1.2001.81a, b

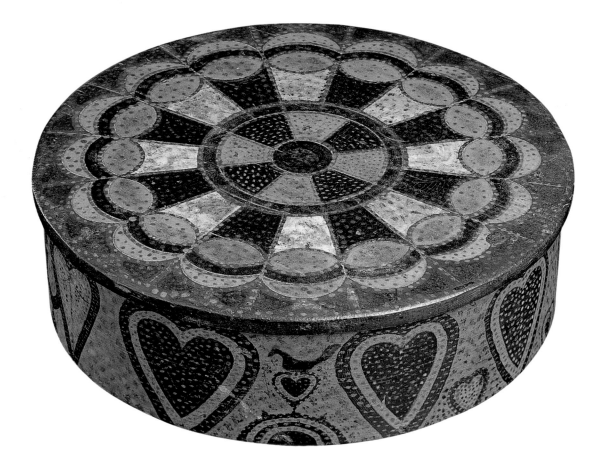

75. ROUND BOX WITH HEART DECORATIONS, c. 1840–1850
George Robert Lawton (1813–1885), Scituate, Providence County,
Rhode Island
Paint on pine and maple, 2¼ × 7½ in. diam., P1.2001.82

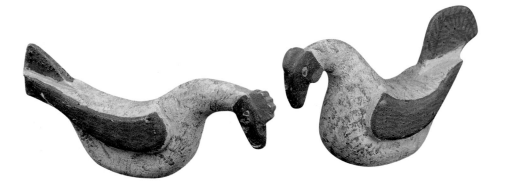

76a–b. TWO ROOSTERS, c. 1840–1850
George Robert Lawton (1813–1885), Scituate, Providence County, Rhode Island
Paint on pine, 2¾ × 3⅛ × 1 in. and 2⅝ × 3¾ × ¾ in., P1.2001.83a, b

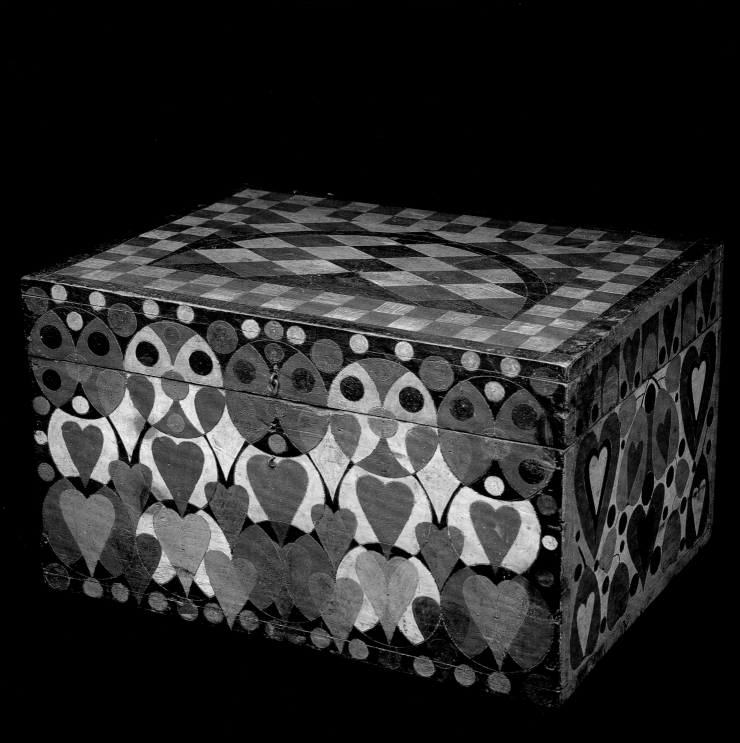

77. **Box with Heart Decorations**, c. 1842
George Robert Lawton (1813–1885), Scituate, Providence
County, Rhode Island
Paint on pine, with leather hinges, lined with wallpaper and
newspaper remnants, printed engraving, and ink drawing,
10½ × 17½ × 12¾ in., P1.2001.84

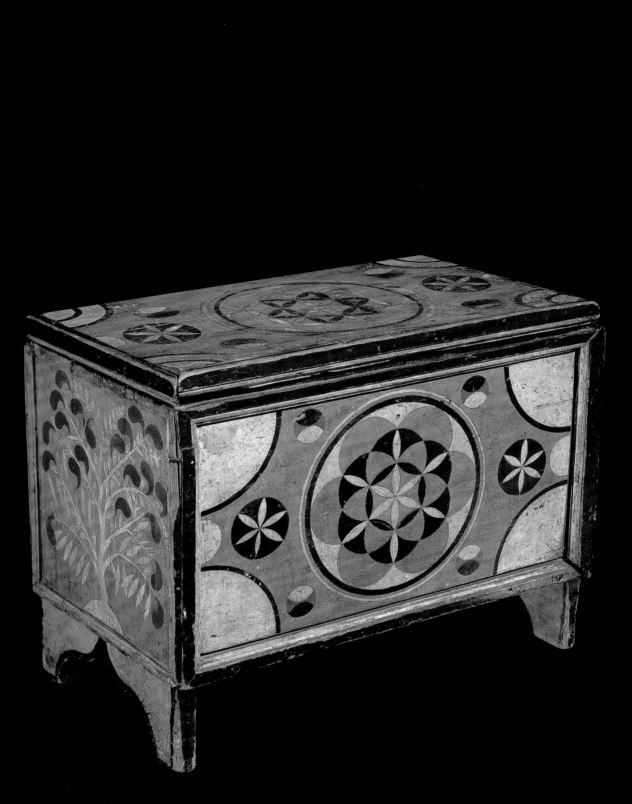

78. CHILD'S BLANKET CHEST, c. 1830
Artist unidentified, possibly Rhode Island or New York
Paint on pine with iron hardware, 16¼ × 20¾ × 11¼ in., P1.2001.85

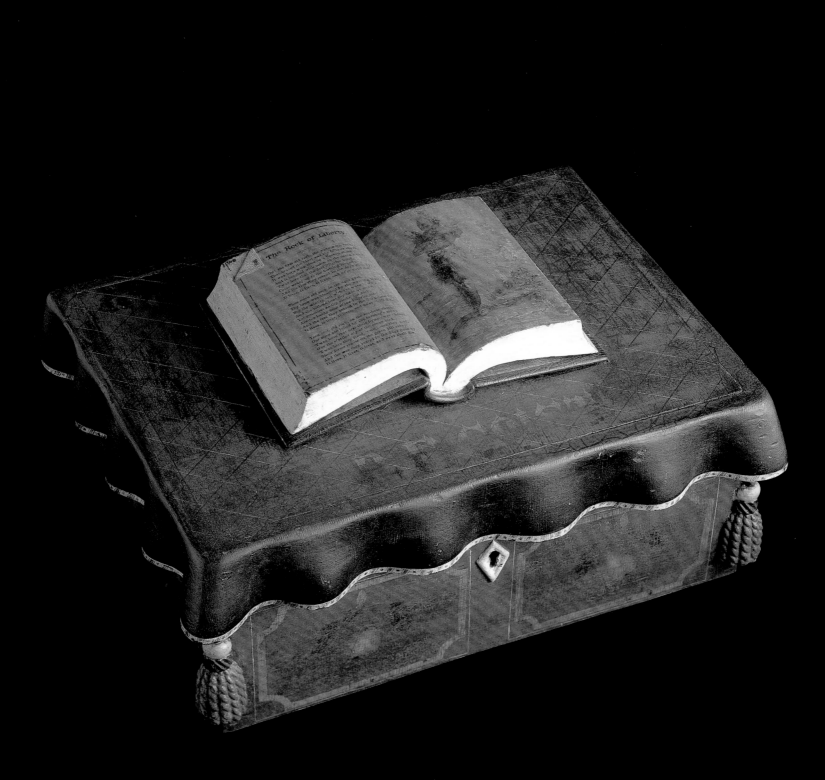

79. **LECTERN BOX,** second half nineteenth century
Artist unidentified, New England
Paint on wood with applied printed pages,
7½ × 14¼ × 10½ in., P1.2001.86

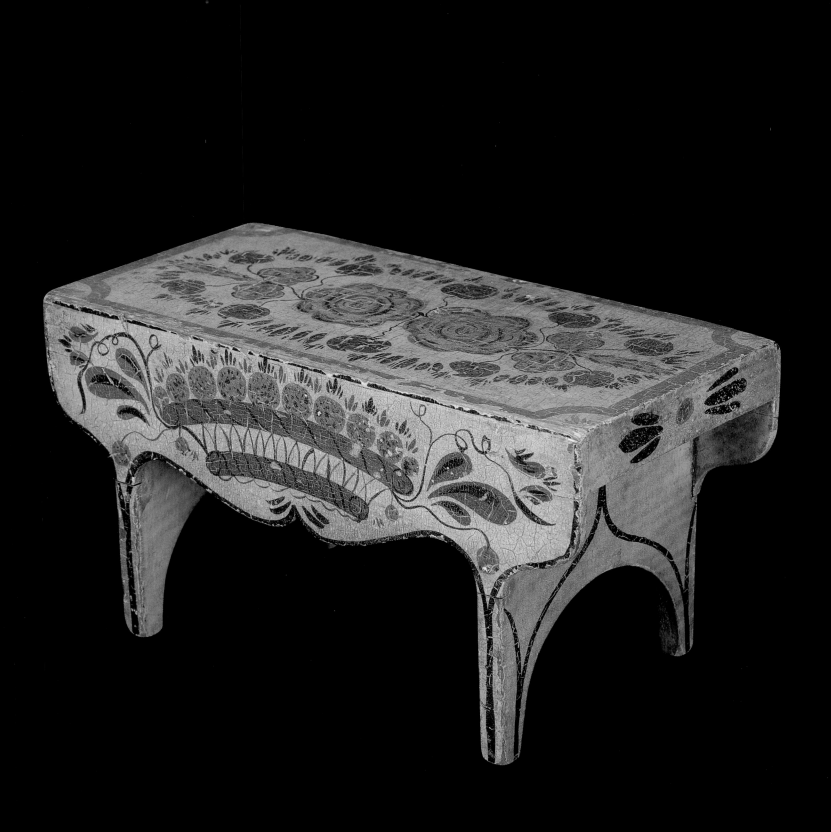

80. MINIATURE FOOTSTOOL, c. 1830–1840
Artist unidentified, probably New England or Pennsylvania
Paint on wood, 4⅞ × 8¹³⁄₁₆ × 4⅜ in., P1.2001.87

81. **Miniature Dressing Bureau,** 1872–1878
 Attributed to Hanson B. Y[o]ungs (c. 1858–1878),
 Conesville, Schoharie County, New York
 Paint on cigar-box wood, cigar-box cardboard,
 and mirror, 15⅛ × 7¾ × 4½ in., P1.2001.88

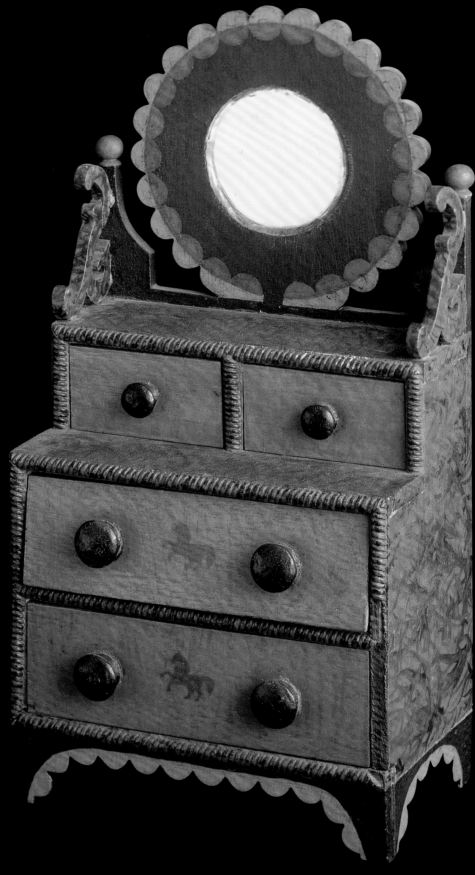

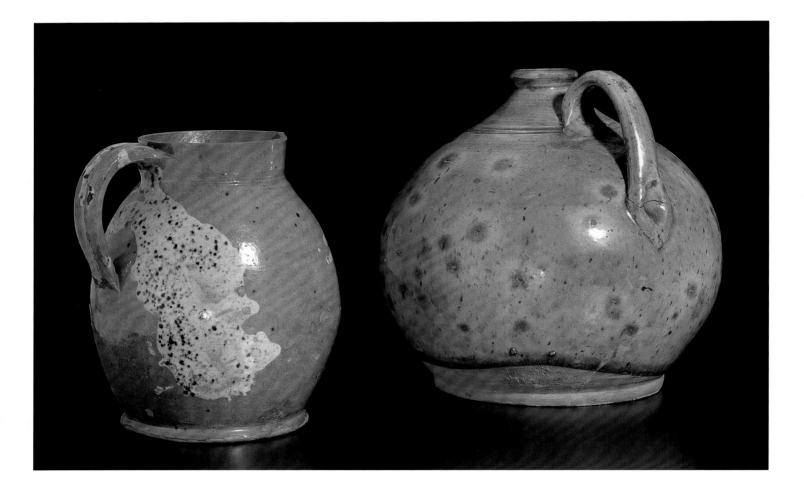

82a. BROWN PITCHER WITH YELLOW AND
GREEN SPLASHES, c. 1800–1825
Attributed to Nathaniel Seymour (1763–1849),
West Hartford, Hartford County, Connecticut
Glazed red earthenware, 6⅜ × 5½ × 4½ in., P1.2001.89

82b. OLIVE-GREEN HANDLED JUG WITH
RUST AND YELLOW SPOTS, c. 1830–1860
Artist unidentified, probably vicinity of Gonic, Strafford County,
or Plymouth, Grafton County, New Hampshire
Glazed red earthenware, 7⅝ × 7½ in. diam., P1.2001.90

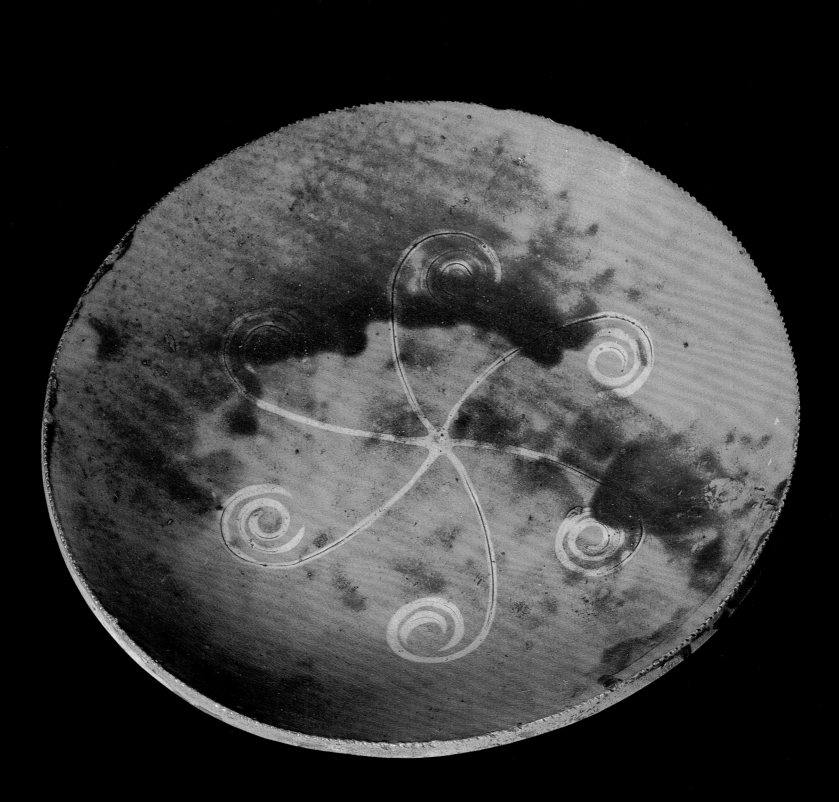

83. **BURNT ORANGE SLIPWARE PLATE WITH SPIRAL DECORATION,**
c. 1820–1850
Artist unidentified, vicinity of Goshen, Litchfield County, or Norwalk,
Fairfield County, Connecticut
Glazed red earthenware, 2¼ × 12¾ in. diam., P1.2001.91

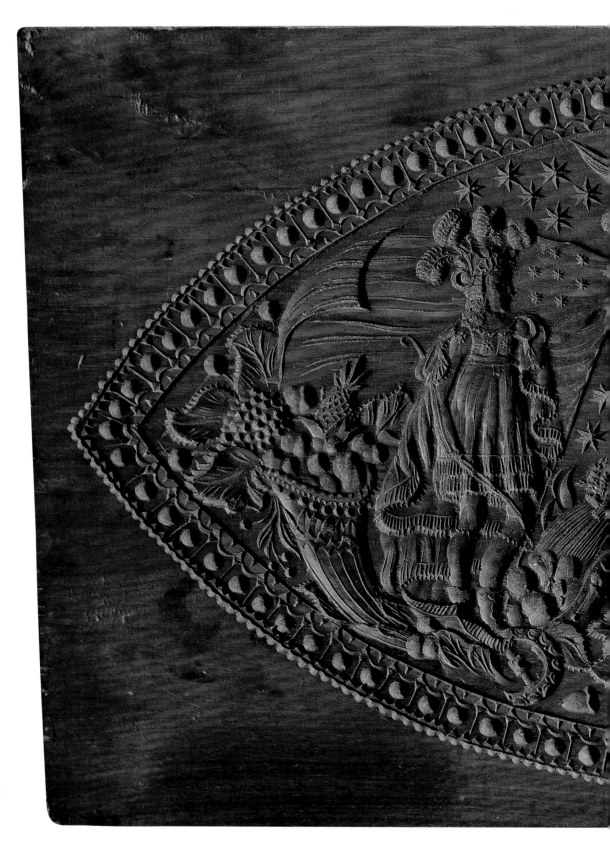

84.
Cake Board, c. 1827–1845
Attributed to John Conger (c. 1803/4–1869),
New York
Mahogany, 15⅝ × 27 × 1⅜ in., P1.2001.92

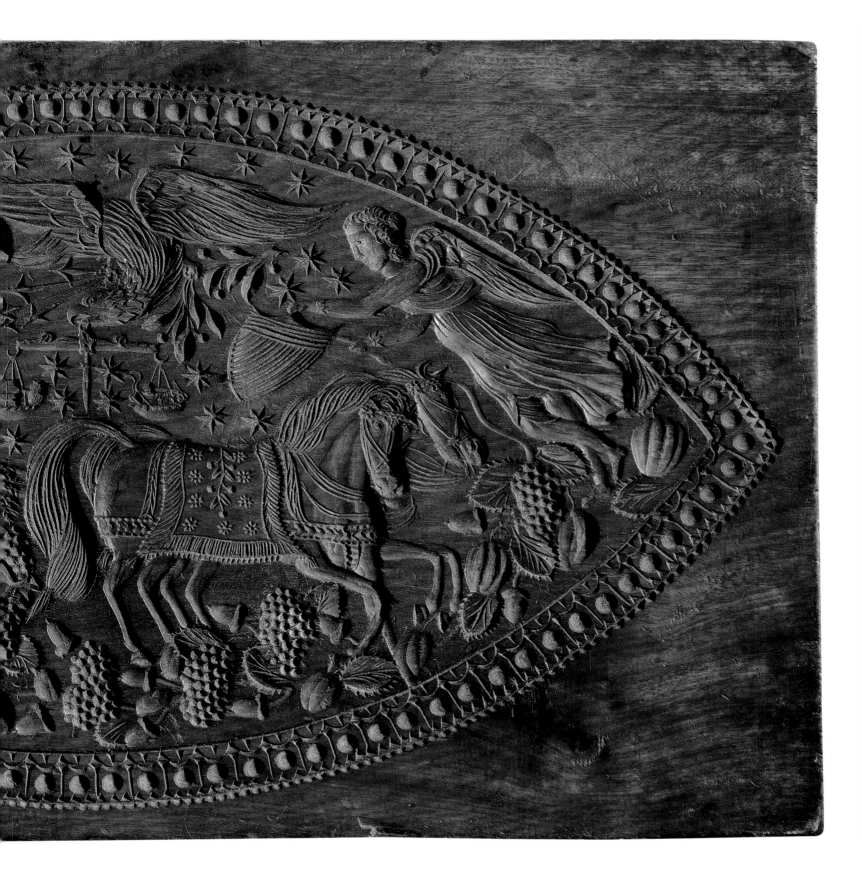

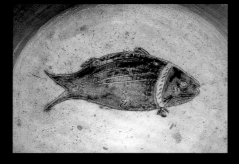

85.
PUNCH BOWL, 1811
Attributed to John Crolius Jr. (1755–c. 1835), New York
Salt-glazed gray stoneware, 7¾ × 15½ in. diam., P1.2001.93

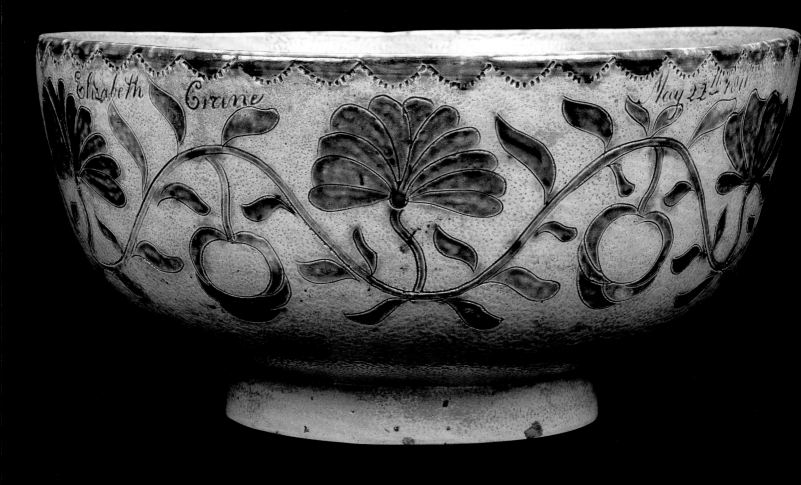

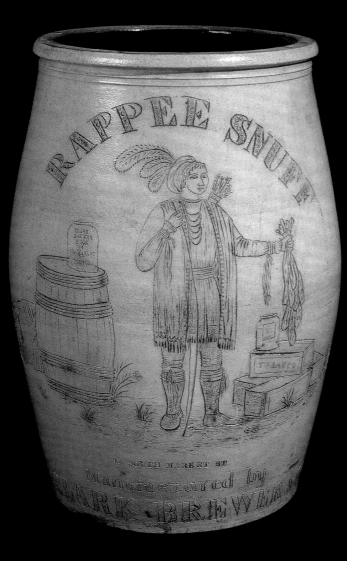

86. **STORAGE JAR OR CROCK**, c. 1850–1870
Artist unidentified, New England, probably Boston
Glazed gray stoneware, 26⅝ × 15¼ in. diam. (at top), P1.2001.94

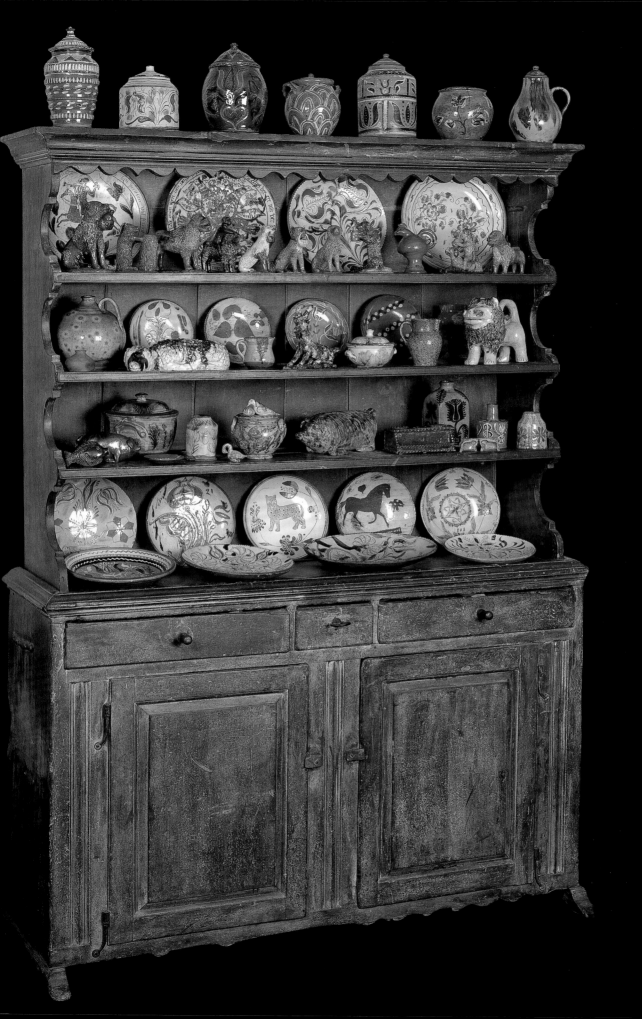

CHAPTER 4

❧

PENNSYLVANIA AND BEYOND
POTTERY

87. **Covered Jar with Star Decoration**, 1822
Solomon Grimm (1787–?), Rockland Township, Berks County, Pennsylvania
Glazed red earthenware, 10 × 5¾ in. diam., P1.2001.95

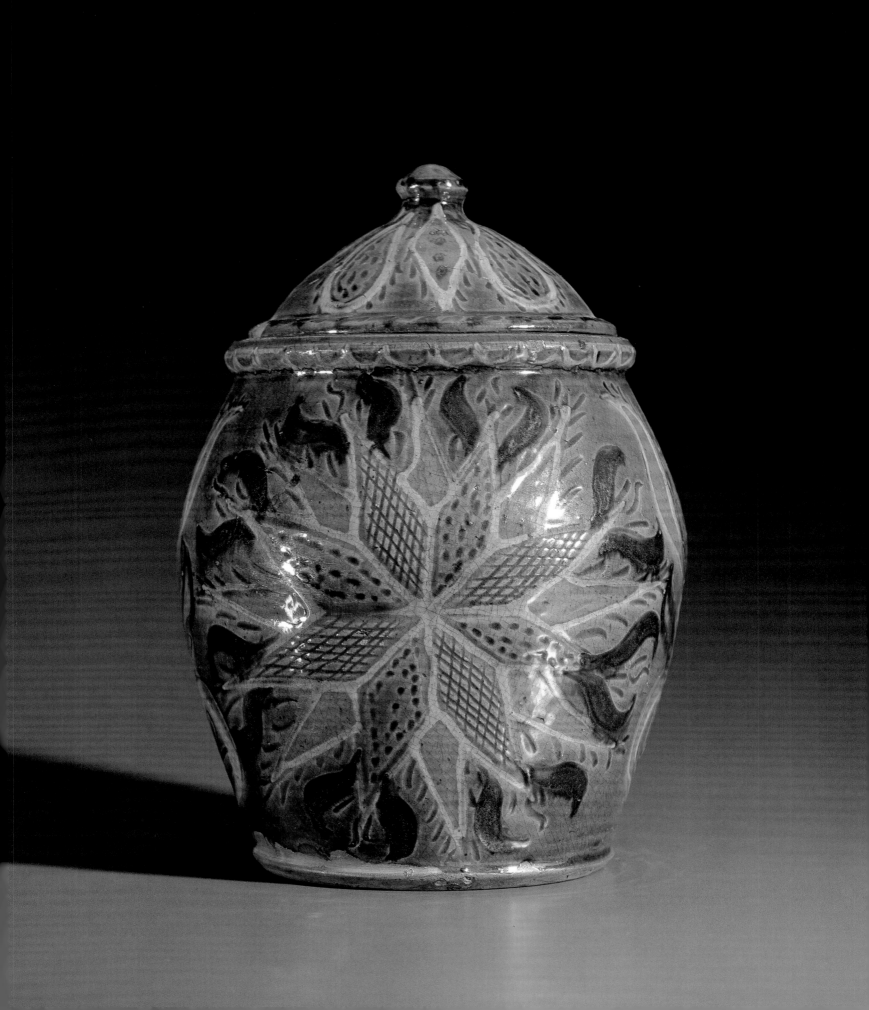

89. COVERED JAR WITH BANDS OF TULIPS, c. 1780–1840
Artist unidentified, probably Montgomery County, Pennsylvania
Glazed red earthenware, 9¾ × 6¼ in. diam., P1.2001.97

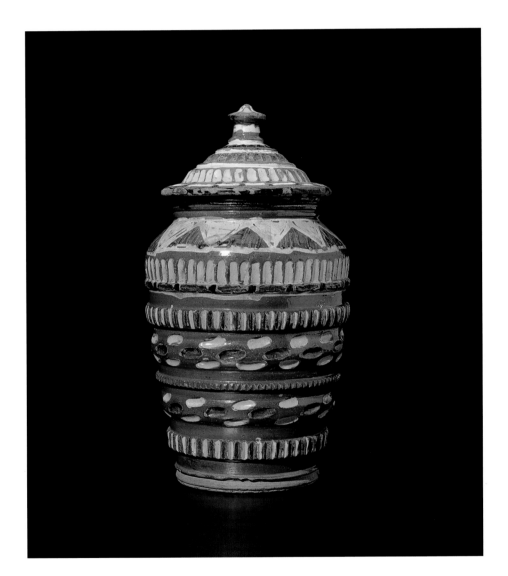

88. COVERED JAR WITH INCISED VERTICAL
AND HORIZONTAL BANDS, c. 1820–1850
Artist unidentified, southeastern Pennsylvania
Glazed red earthenware, 10½ × 5¼ in. diam., P1.2001.96

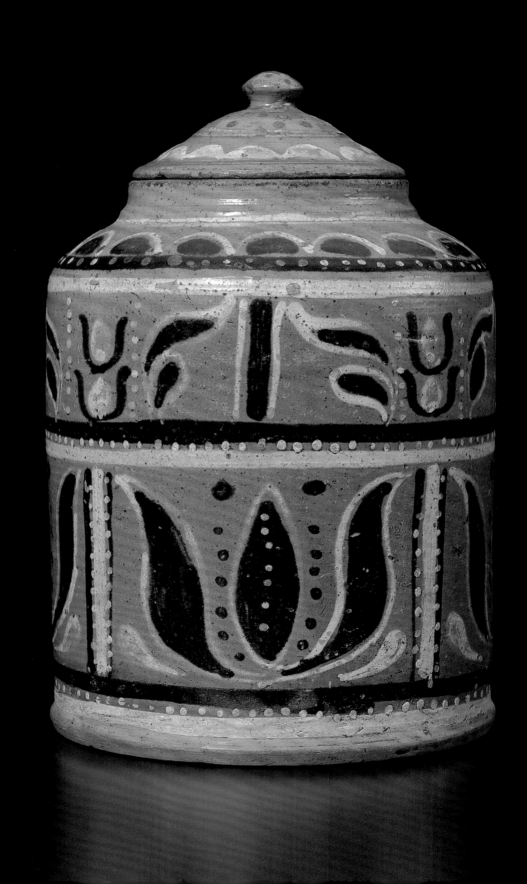

91. COVERED JAR WITH HANDLES AND SLIP DECORATION, 1790
Artist unidentified, probably Bucks County, Pennsylvania
Glazed red earthenware, 7⅛ × 6¼ × 5⅛ in., P1.2001.99

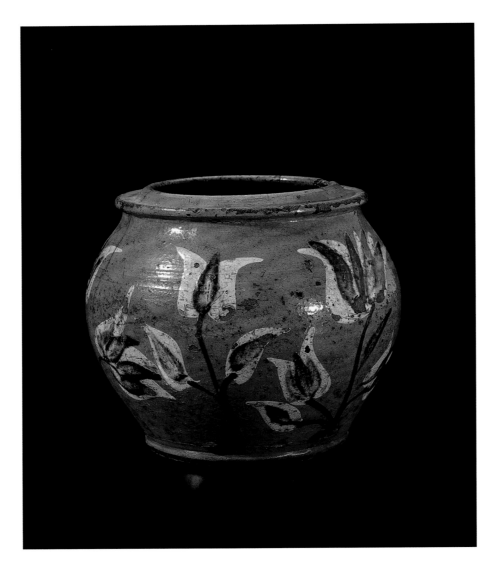

90. JAR WITH TULIP DECORATION, c. 1780–1795
Attributed to Christian Klinker (act. 1773–1798),
Nockamixon Township, Bucks County, Pennsylvania
Glazed red earthenware (lid missing), 6½ × 6¼ in. diam.,
P1.2001.98

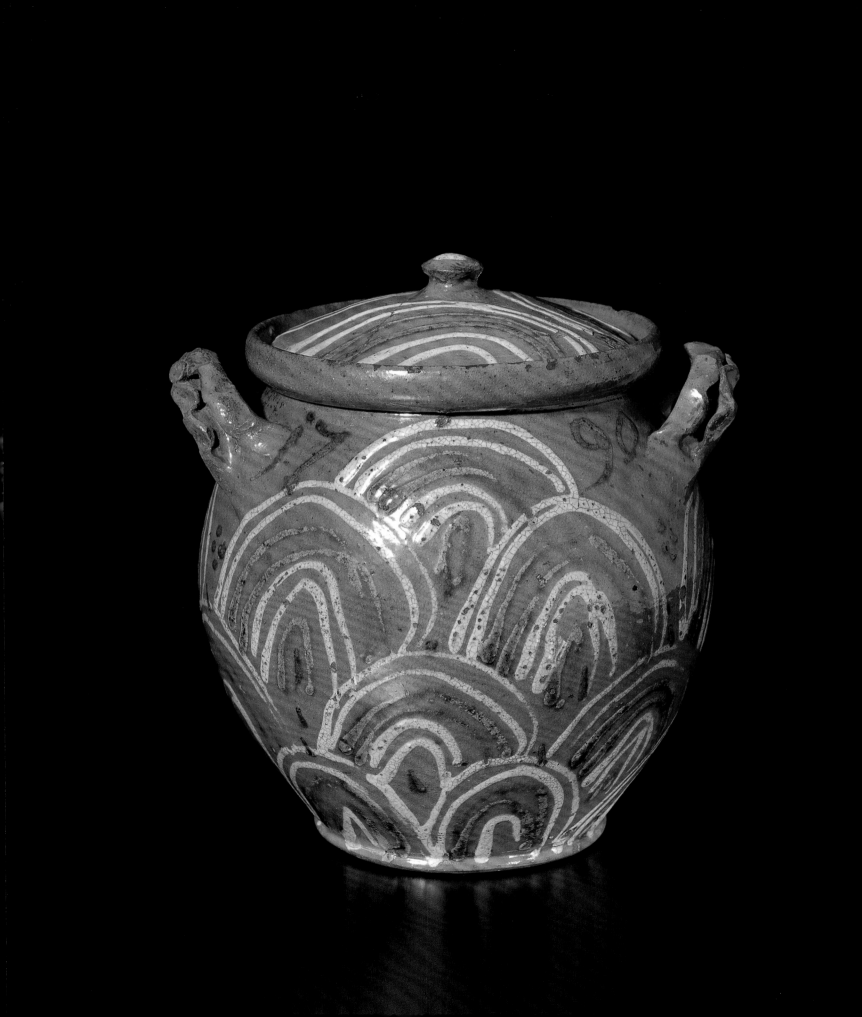

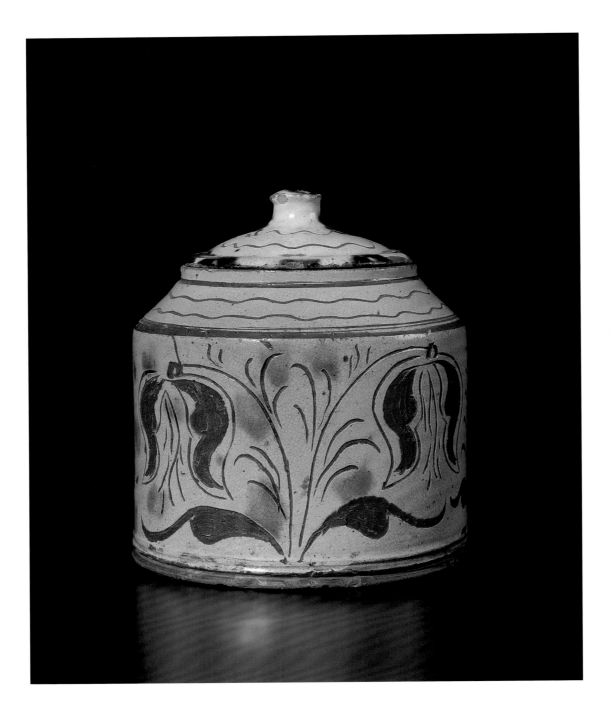

92. **Covered Jar with Sgraffito Tulip Decoration,** c. 1830–1840
Possibly Conrad Mumbouer (1761–1845) or John Monday (1809–1862),
Haycock Township, Bucks County, Pennsylvania
Glazed red earthenware, 7¼ × 6 in. diam., P1.2001.100

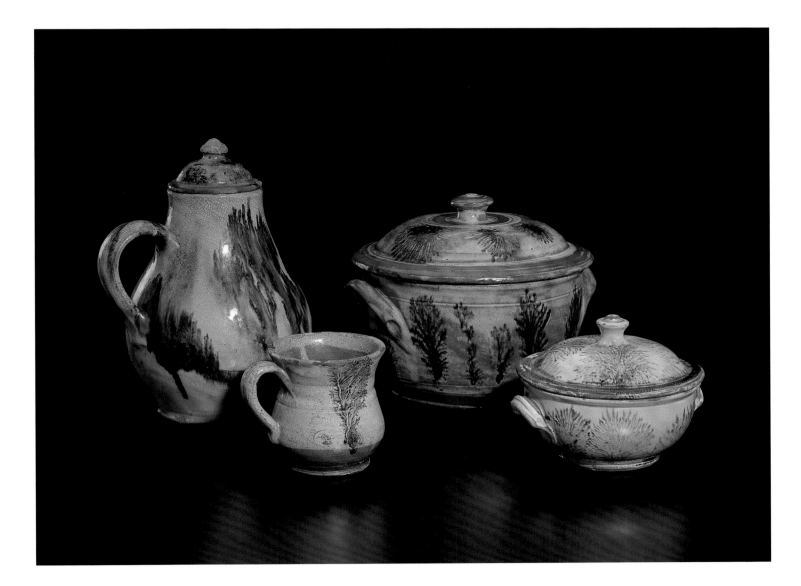

93a. COFFEE OR CHOCOLATE POT, c. 1800–1840
Artist unidentified, southeastern Pennsylvania
Glazed red earthenware, 9 × 5½ in., P1.2001.101

93b. PITCHER, c. 1830–1860
Artist unidentified, southeastern Pennsylvania
Glazed red earthenware, 3⅝ × 4 × 3¼ in., P1.2001.102

93c. LARGE COVERED BOWL WITH HANDLES WITH
SPONGEWORK AND SEAWEED DECORATION, c. 1820–1850
Artist unidentified, southeastern Pennsylvania
Glazed red earthenware, 6½ × 8¼ × 7¾ in., P1.2001.103

93d. SMALL COVERED BOWL WITH HANDLES WITH
SPONGEWORK AND SEAWEED DECORATION, c. 1820–1850
Artist unidentified, southeastern Pennsylvania
Glazed red earthenware, 4 × 5⅞ × 5⅜ in., P1.2001.104

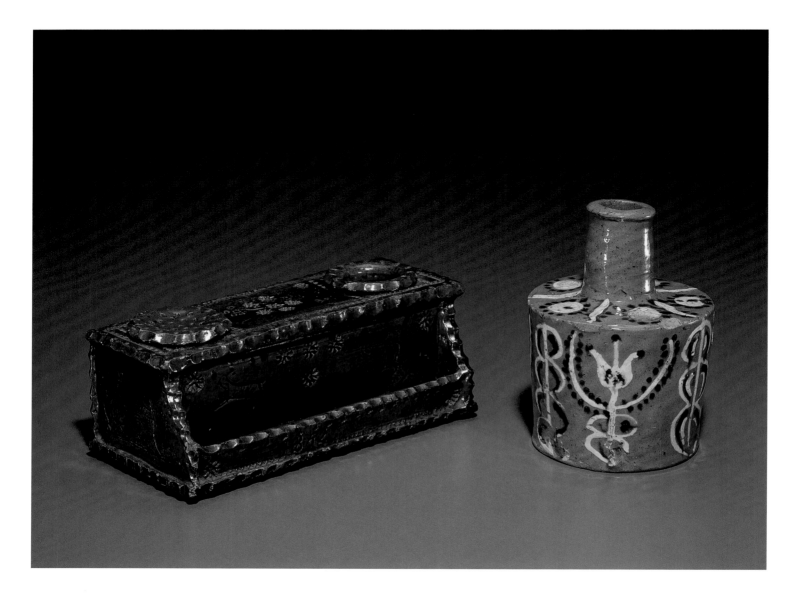

94a. INKSTAND, 1852
Attributed to David Haring (1801–1871),
Nockamixon Township, Bucks County, Pennsylvania
Glazed red earthenware, 2¾ × 7¼ × 3¼ in.,
P1.2001.105

94b. INK BOTTLE, c. 1835–1860
Artist unidentified, southeastern Pennsylvania
Glazed red earthenware, 5 × 3¼ in. diam.,
P1.2001.106

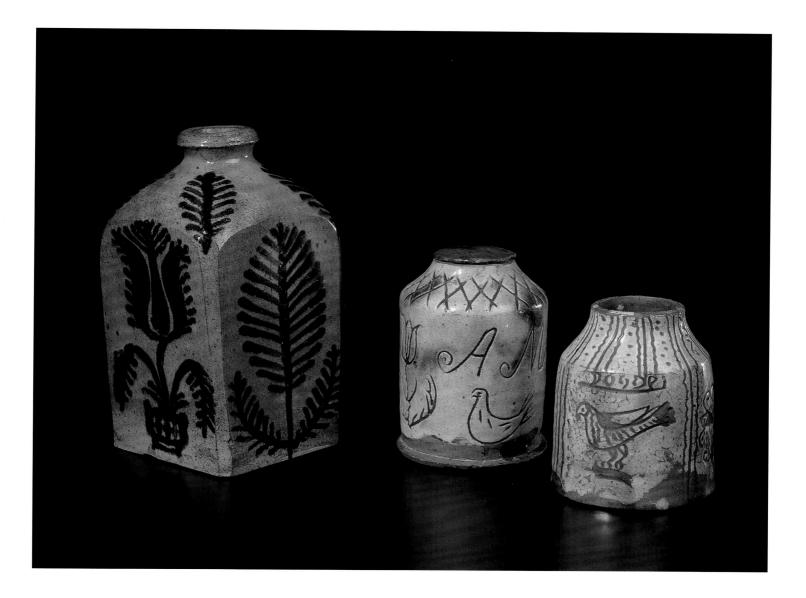

95a. FOUR-SIDED TEA CANISTER, 1846
Artist unidentified, southeastern Pennsylvania
Glazed yellow earthenware, 7½ × 3¾ × 3⅝ in.,
P1.2001.107

95b. TEA CANISTER WITH INITIALS, 1793
Artist unidentified, southeastern Pennsylvania
Glazed red earthenware, 5 × 3⁵⁄₁₆ in. diam.,
P1.2001.108

95c. "DODOE" TEA CANISTER, c. 1790–1820
Artist unidentified, southeastern Pennsylvania
Glazed red earthenware, 4¼ × 3⁵⁄₁₆ in. diam.,
P1.2001.109

97. **Slipware Charger with Combed Decoration**
c. 1800–1840
Artist unidentified, southeastern Pennsylvania
Glazed red earthenware, 2⅞ × 15½ in. diam., P1.2001.112

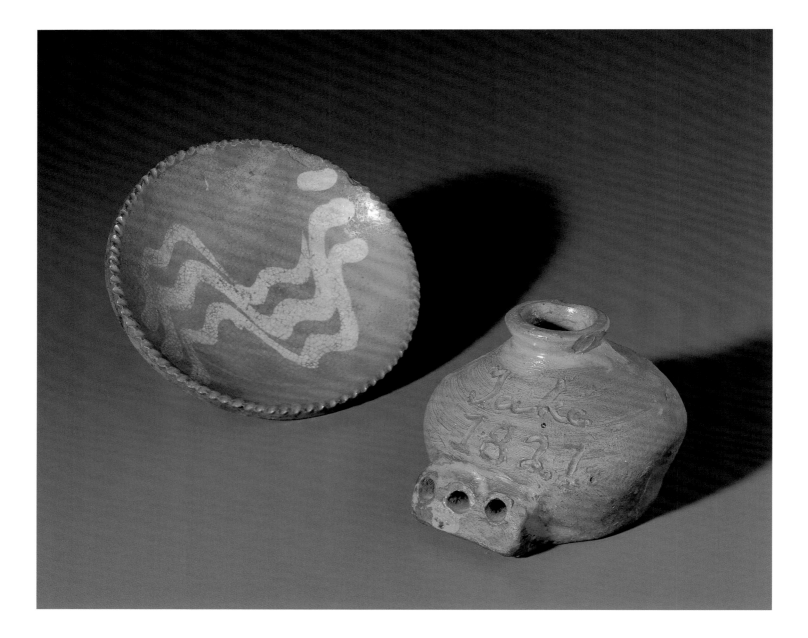

96a. **Miniature Slipware Plate**, c. 1820–1850
Artist unidentified, southeastern Pennsylvania
Glazed red earthenware, ⅝ × 4¹⁵⁄₁₆ in. diam., P1.2001.110

96b. **Slip Trailing Cup**, 1827
Artist unidentified, southeastern Pennsylvania
Glazed red earthenware, 2¾ × 2⅜ × 3⅛ in., P1.2001.111

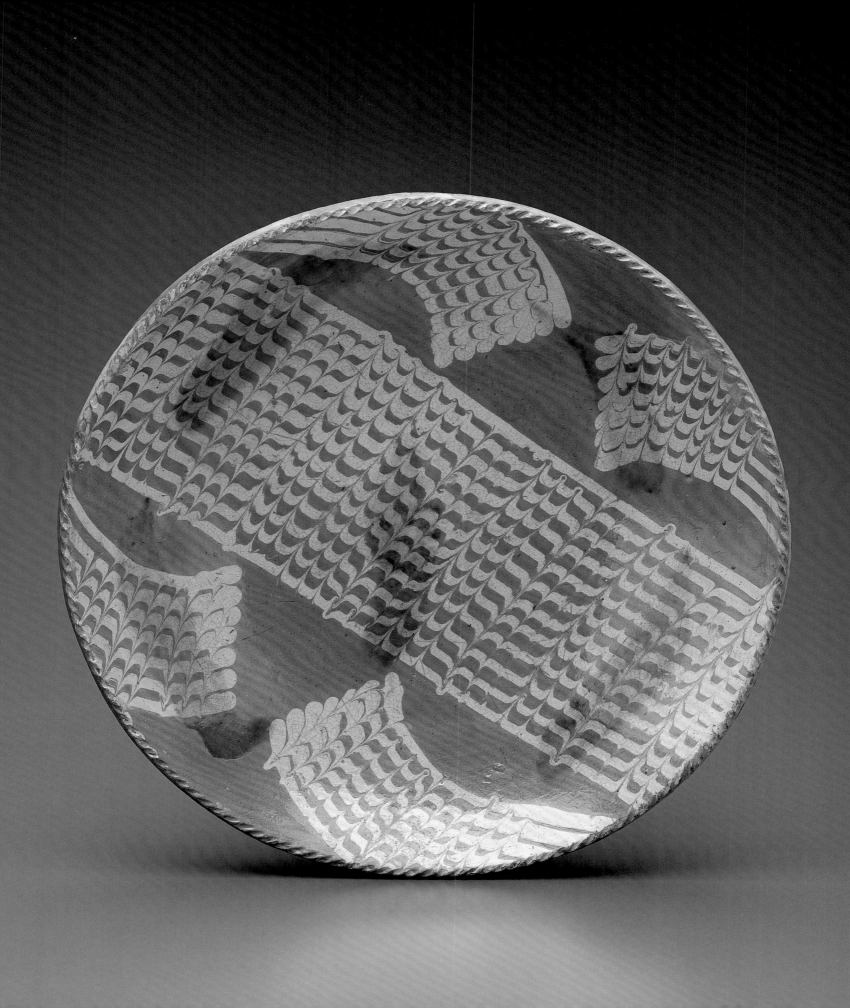

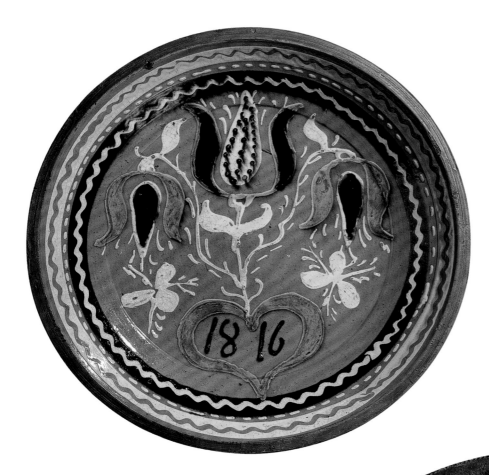

98.
Slipware Plate with Black Tulips, 1816
Artist unidentified, southeastern Pennsylvania
Glazed red earthenware, 2 × 11⁹⁄₁₆ in. diam., P1.2001.113

99. **Slipware Plate with Bird
on Branch**, c. 1800–1840
Artist unidentified, southeastern Pennsylvania
Glazed red earthenware, 2⁵⁄₁₆ × 13¼ in. diam.,
P1.2001.114

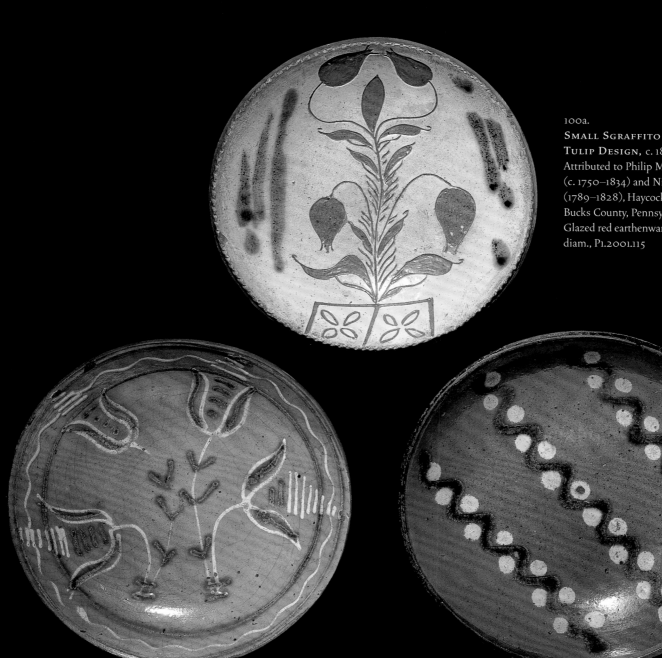

100a.
SMALL SGRAFFITO PLATE WITH TULIP DESIGN, c. 1810–1825
Attributed to Philip Mumbouer
(c. 1750–1834) and Nicholas Mumbouer
(1789–1828), Haycock Township,
Bucks County, Pennsylvania
Glazed red earthenware, 1½ × 7 in.
diam., P1.2001.115

100b. **SMALL SLIPWARE PLATE OR DEEP DISH WITH FOUR TULIPS**, c. 1785–1800
Artist unidentified, southeastern Pennsylvania
Glazed red earthenware, 1½ × 7¼ in. diam.,
P1.2001.116

100c. **SMALL SLIPWARE PLATE WITH THREE WAVY STRIPES**, c. 1865–1880
Willoughby Smith (1839–1905), Wolmersdorf,
Berks County, Pennsylvania
Glazed red earthenware, 1⅝ × 7¾ in. diam., P1.2001.117

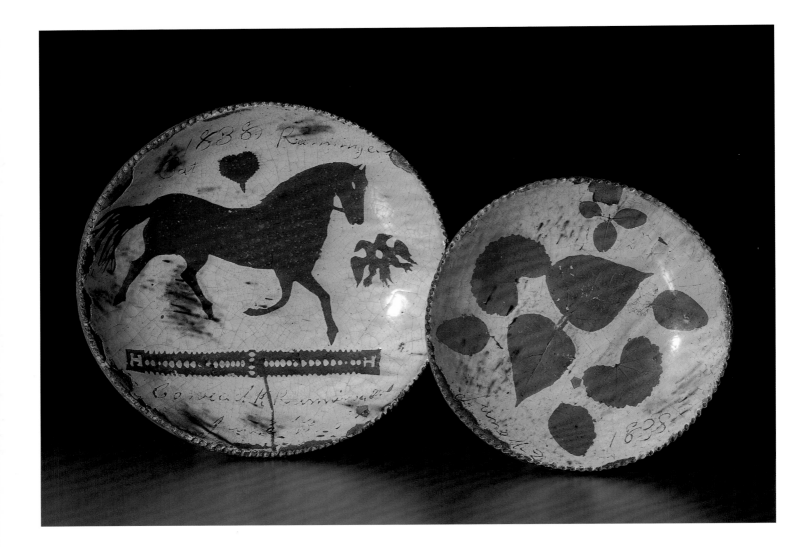

101a. **RUNNING HORSE SILHOUETTE RESIST PLATE**, 1838
Conrad Kolb Ranninger (1809–1869),
Montgomery County, Pennsylvania
Glazed red earthenware, 1¾ × 7⅝ in. diam., P1.2001.118

101b. **LEAF SILHOUETTE RESIST PLATE**, 1838
Conrad Kolb Ranninger (1809–1869), Montgomery County,
Pennsylvania
Glazed red earthenware, 1⅜ × 7½ in. diam., P1.2001.119

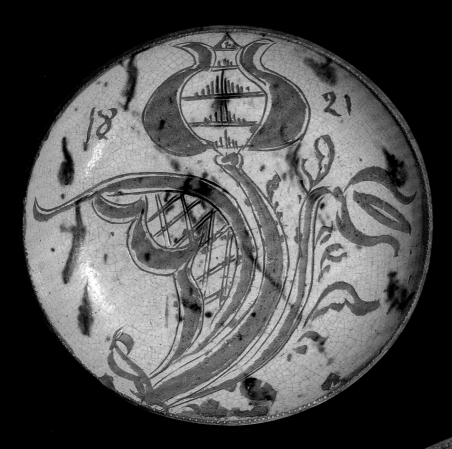

102.
Sgraffito Plate with Sweeping Tulip, 1821
Attributed to William Mills (c. 1772–1870),
Haycock Township, Bucks County, Pennsylvania
Glazed red earthenware, 1⅝ × 10⅛ in. diam.,
P1.2001.120

103. **Sgraffito Plate for Johan Ketterer**, 1829
Attributed to Conrad Mumbouer (1761–1845),
Haycock Township, Bucks County, Pennsylvania
Glazed red earthenware, 2¼ × 11⅞ in. diam., P1.2001.121

Hirist Abgebilt
Ein Döbelder
Adler

niemant begehrt, 1792 Aus der ett mit der thon mach der
Zefner aller kant; Wer etwas kan der brükt man ken den unge hikten

105.
Sgraffito Plate or Deep Dish with Three Tulips, c. 1785–1800
Artist unidentified, southeastern Pennsylvania
Glazed red earthenware, 2¼ × 13 in. diam., P1.2001.123

106.
Sgraffito Plate or Deep Dish with Floral Sprays, c. 1785–1805
Attributed to David Spinner (1758–1811), Milford Township, Bucks County, Pennsylvania
Glazed red earthenware, 1⅞ × 12⅞ in. diam., P1.2001.124

104.
Sgraffito Plate or Deep Dish with Double-Headed Eagle, 1792
Attributed to George Hubener (1757–1828), Limerick Township, Montgomery County, Pennsylvania
Glazed red earthenware, 2¼ × 12⅝ in. diam., P1.2001.122

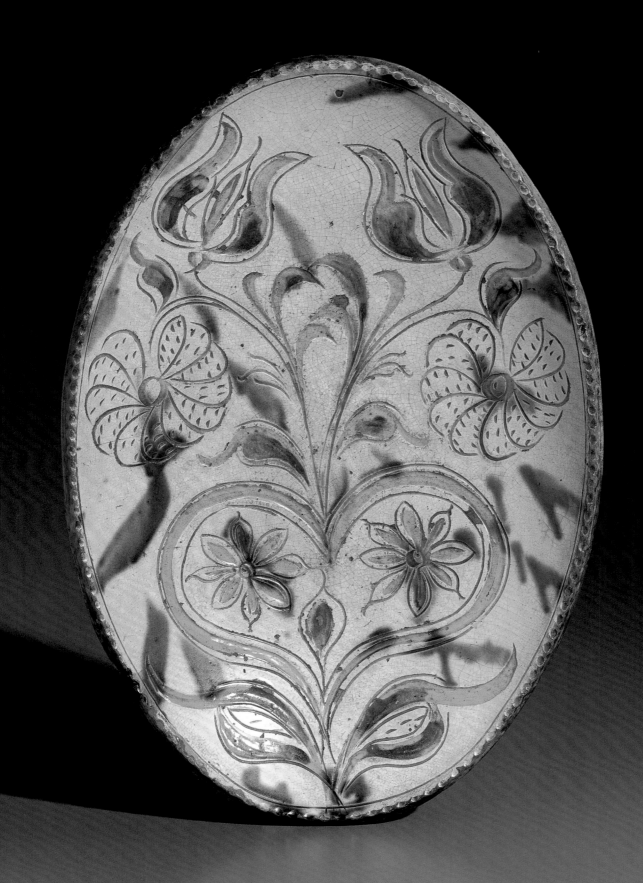

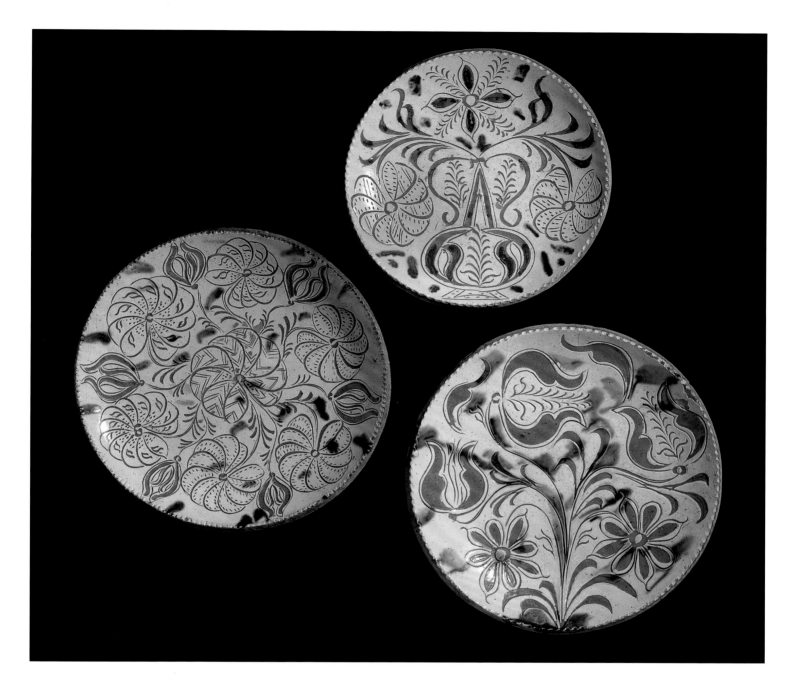

108a.
**SGRAFFITO PLATE WITH PINWHEEL FLOWERS
AND TULIPS**, c. 1835–1845
Attributed to Conrad Mumbouer (1761–1845) or John Monday
(1809–1862), Haycock Township, Bucks County, Pennsylvania
Glazed red earthenware, 1¾ × 11³⁄₁₆ in. diam., P1.2001.126

107.
OVAL SGRAFFITO DISH WITH FLOWERS AND HEART,
c. 1835–1845
Attributed to Conrad Mumbouer (1761–1845) or John Monday
(1809–1862), Haycock Township, Bucks County, Pennsylvania
Glazed red earthenware, 1½ × 14⅞ in. oval, P1.2001.125

108b.
SGRAFFITO PLATE WITH VASE OF FLOWERS, c. 1835–1845
Attributed to Conrad Mumbouer (1761–1845) or John Monday
(1809–1862), Haycock Township, Bucks County, Pennsylvania
Glazed red earthenware, 1¼ × 10⅛ in. diam., P1.2001.127

108c.
SGRAFFITO PLATE WITH OPEN TULIPS, c. 1830–1840
Attributed to Conrad Mumbouer (1761–1845),
Haycock Township, Bucks County, Pennsylvania
Glazed red earthenware, 1⅞ × 11⅞ in. diam., P1.2001.128

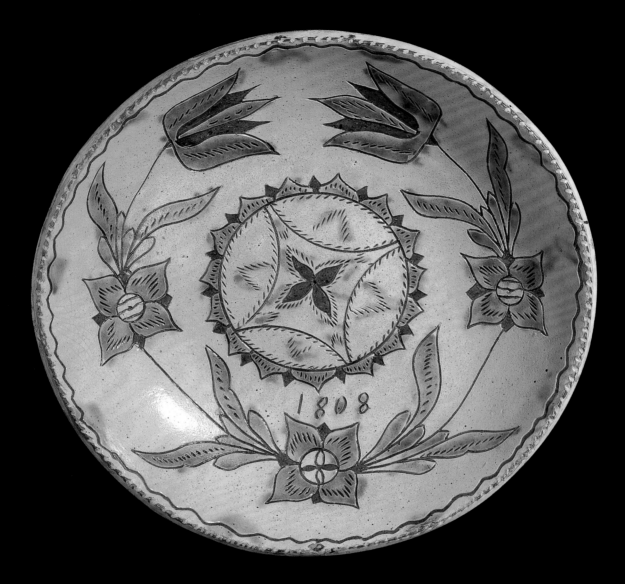

109. **Sgraffito Plate with Tulips and Center Medallion**, 1808
Attributed to Andrew Headman (c. 1756–1830), Rockhill Township, Bucks County, Pennsylvania
Glazed red earthenware, 2⅜ × 9¾ in. diam., P1.2001.129

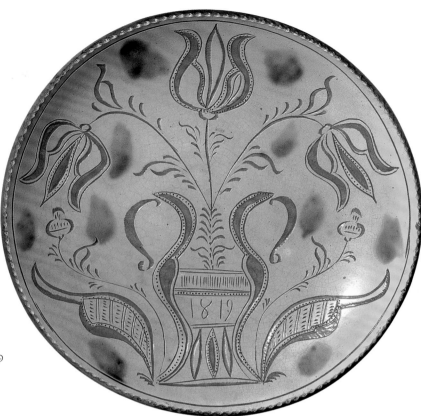

110.

Sgraffito Plate with Three Tulips in Vase, 1819
Attributed to John Dry (1785–1870), Dryville,
Rockland Township, Berks County, Pennsylvania
Glazed red earthenware, 1½ × 11⅞ in. diam., P1.2001.130

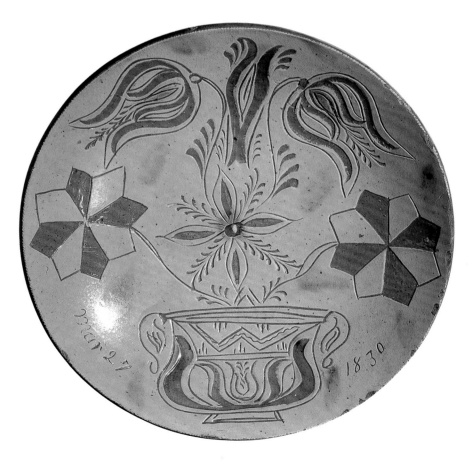

111.

**Sgraffito Plate with Tulips and Flowers
in Vase, 1830**
Attributed to John Monday (1809–1862),
Haycock Township, Bucks County, Pennsylvania
Glazed red earthenware, 2 × 10¾ in. diam., P1.2001.131

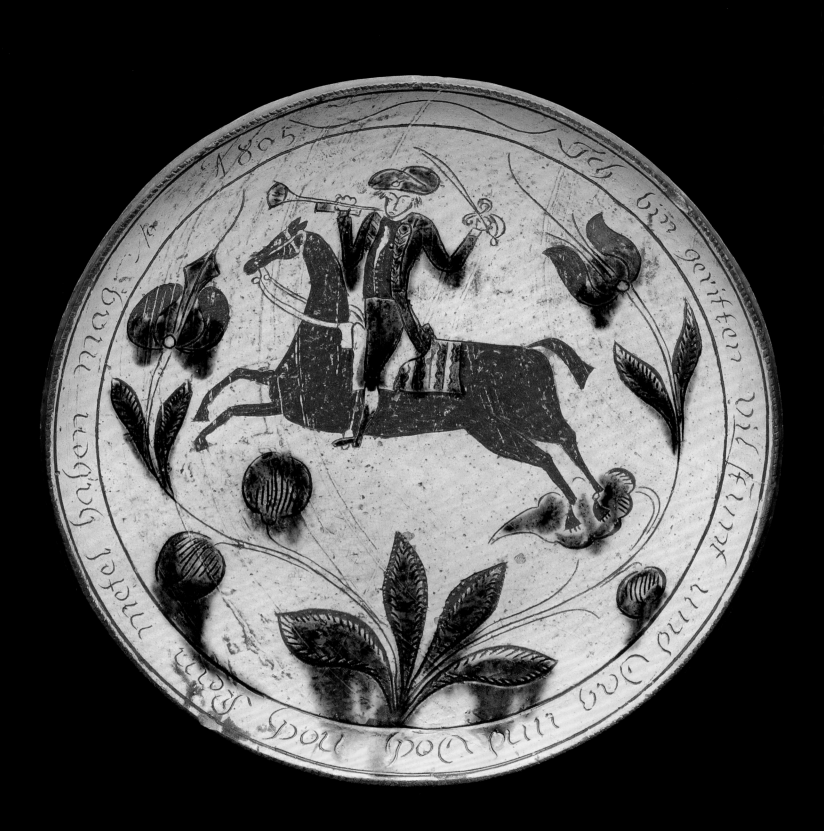

112.
Sgraffito Plate with Horse and Rider, 1805
John Neis (1785–1867), Upper Salford Township,
Montgomery County, Pennsylvania
Glazed red earthenware, 1¾ × 12⅜ in. diam., P1.2001.132

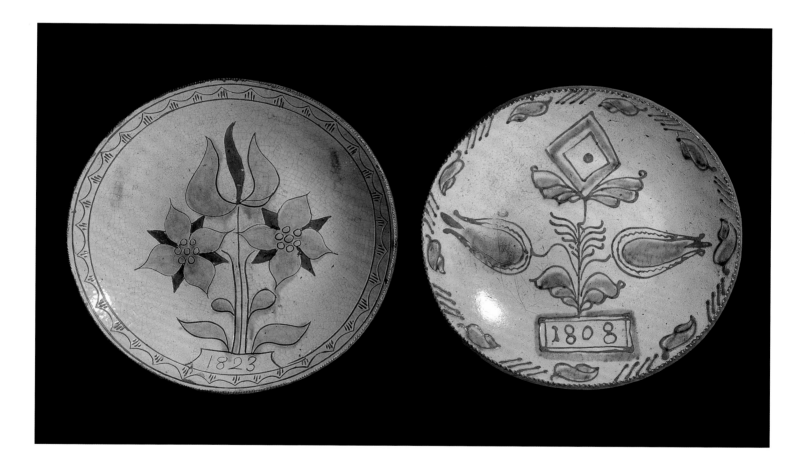

113a. **Sgraffito Plate with Tulip and Two Flowers**, 1823
Attributed to John Neis (1785–1867), Upper Salford Township,
Montgomery County, Pennsylvania
Glazed red earthenware, 1¹¹⁄₁₆ × 11³⁄₁₆ in. diam., P1.2001.133

113b. **Slipware Plate with Two Tulips and
Diamond-shaped Flower**, 1808
Attributed to John Leidy II (1780–1838), Franconia Township,
Montgomery County, Pennsylvania
Glazed red earthenware, 1⅝ × 11 in. diam., P1.2001.134

114. **PIG BOTTLE OR FLASK,** c. 1830–1860
Attributed to Daniel Henne or Joseph Henne (act. 1830–1876),
Shartlesville, Bern Township, Berks County, Pennsylvania
Glazed red earthenware, 4⅝ × 11 × 4⅛ in., P1.2001.135

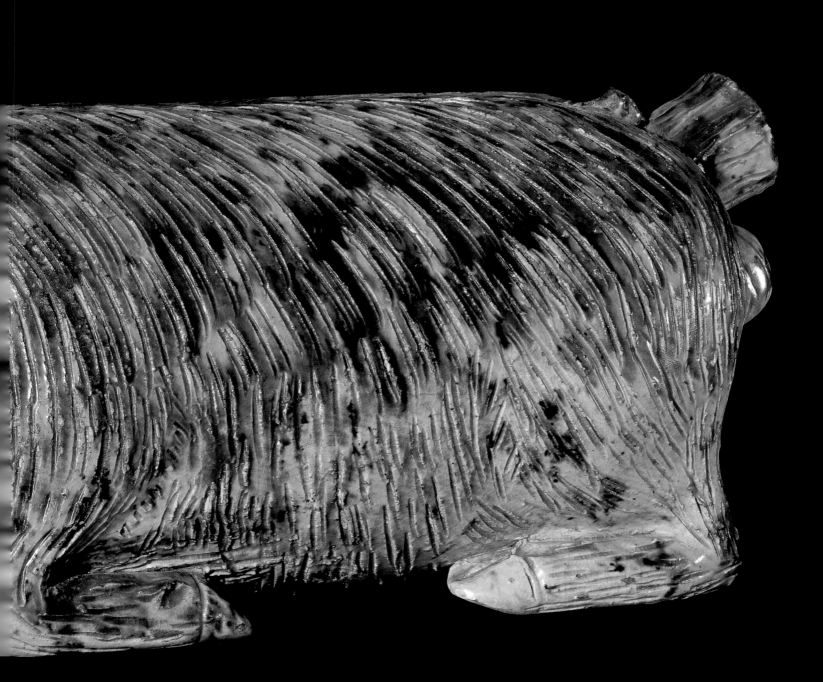

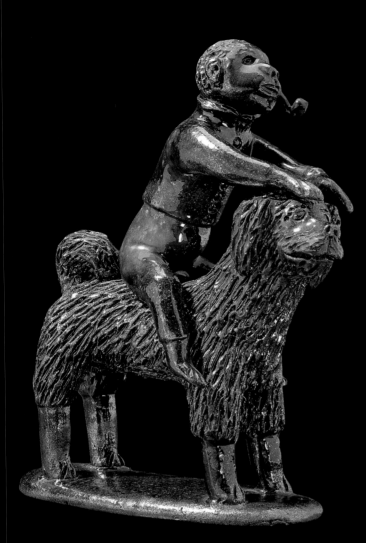

117. **Pipe-Smoking Monkey
Riding a Dog**, c. 1850–1870
Attributed to Solomon Bell (1817–1882), Strasburg,
Shenandoah County, Virginia
Glazed red earthenware, 8⅝ × 6¼ × 2⅛ in., P1.2001.143

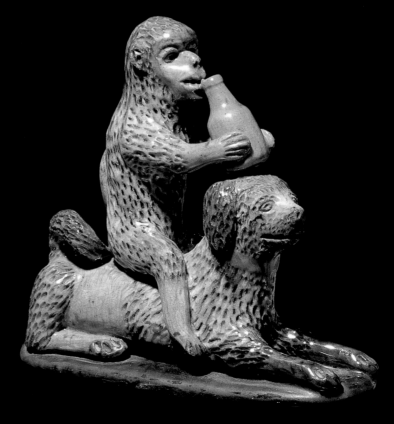

118. **Monkey Astride a Reclining Dog**, c. 1850–1870
Artist unidentified, southeastern Pennsylvania
Glazed red earthenware, 5¼ × 5½ × 2⅛ in., P1.2001.144

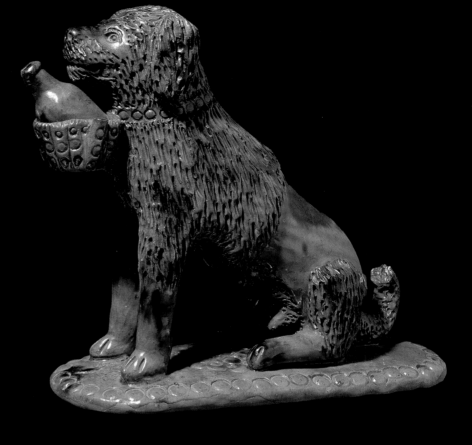

120. **SEATED DOG WITH BOTTLE IN BASKET,**
c. 1840–1870
Attributed to John Bell (1800–1880), Waynesboro,
Franklin County, Pennsylvania
Glazed red earthenware, 7½ × 7¾ × 3½ in., P1.2001.146

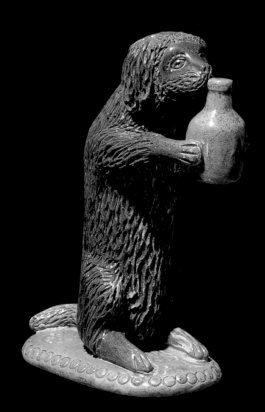

119. **UPRIGHT DOG HOLDING A JUG,** c. 1850–1880
Attributed to Samuel Bell or Solomon Bell (act. 1834–1882),
Strasburg, Shenandoah County, Virginia
Glazed red earthenware, 6⅛ × 4½ × 2¼ in., P1.2001.145

121. SOUVENIR BOTTLE, c. 1880–1885
Attributed to Wallace Kirkpatrick (1828–1896), Anna,
Union County, Illinois
Salt-glazed gray stoneware, 3¼ × 6¾ × 3 in., P1.2001.147

123. ROOSTER WHISTLE, c. 1810–1840
Artist unidentified, southeastern Pennsylvania
Glazed red earthenware, 6 × 4 × 3¼ in.,
P1.2001.149

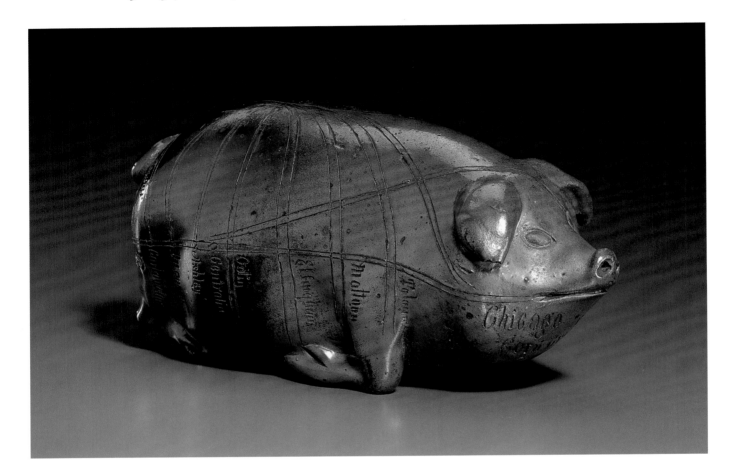

122.
RECLINING LAMB SUGAR MOLD,
c. 1820–1860
Artist unidentified, southeastern
Pennsylvania
Glazed red earthenware, 1½ × 2⅛ × 1⅜ in.
(closed), P1.2001.148

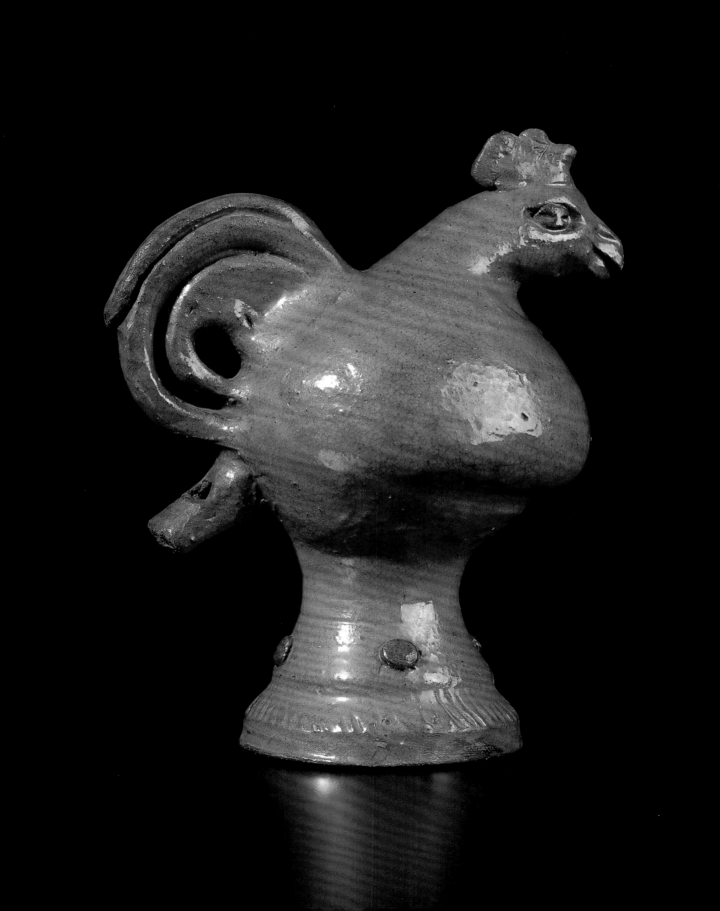

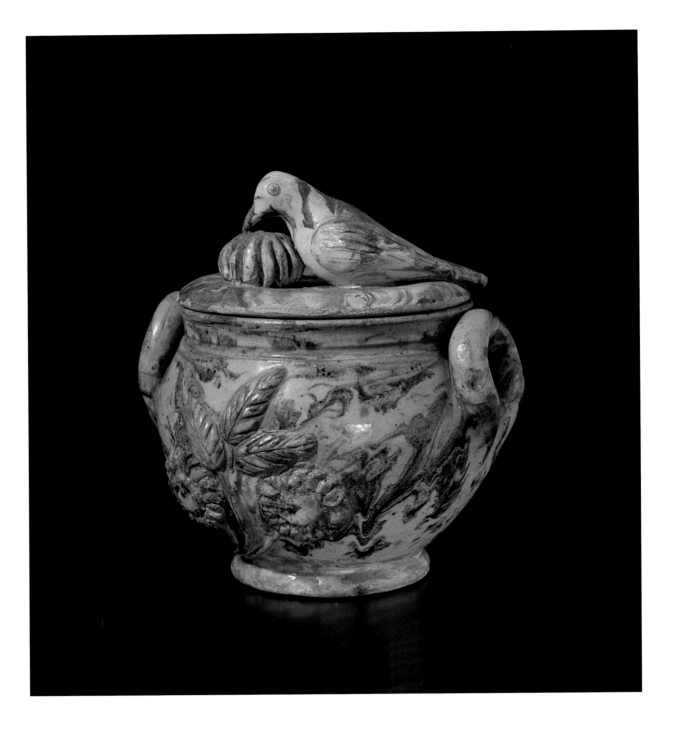

124.
COVERED SUGAR BOWL WITH APPLIED BIRDS AND FLOWERS,
c. 1881–1883
Attributed to Anthony Wise Baecher (1824–1889), The Big Hunting
Creek Pottery (act. 1881–1883), owned by Joseph E. Simons
(1838–1893), Mechanicstown, Frederick County, Maryland
Glazed red earthenware, 6¾ × 6 × 5¼ in., P1.2001.150

125.
SEATED GOAT, c. 1870–1889
Anthony Wise Baecher (1824–1889), Winchester,
Frederick County, Virginia
Glazed red earthenware, 6⅞ × 7⅝ × 2³⁄₁₆ in., P1.2001.151

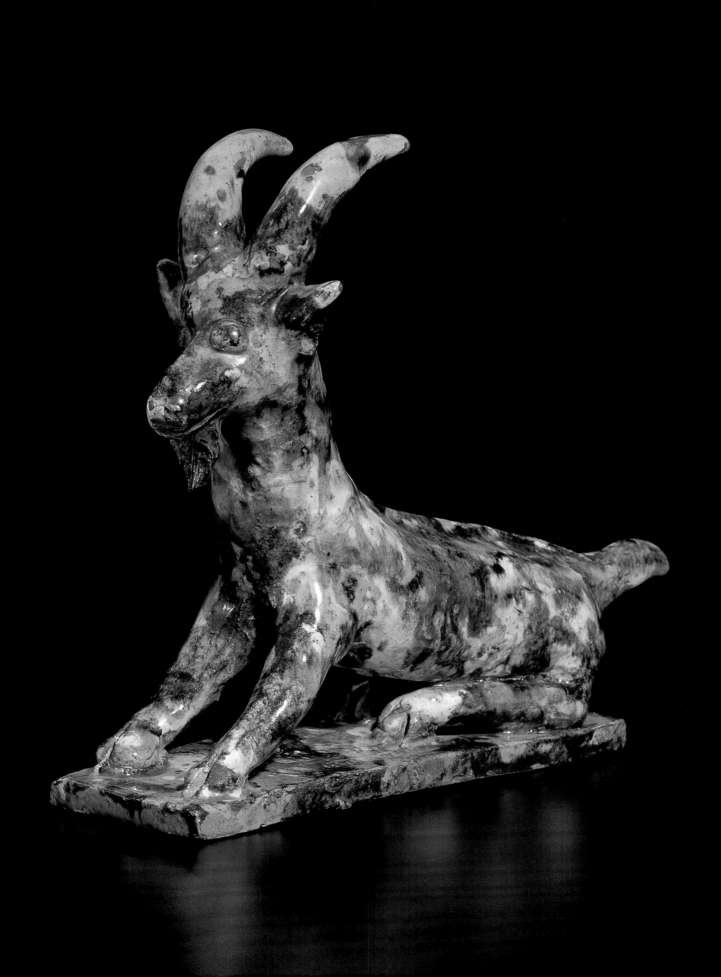

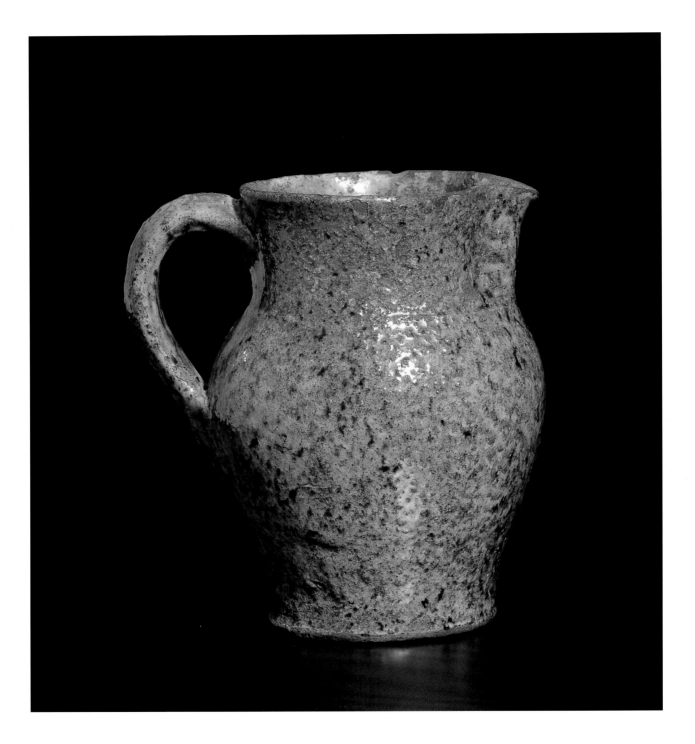

126. PITCHER WITH MOTTLED GREEN GLAZE, c. 1870–1889
Anthony Wise Baecher (1824–1889), Winchester,
Frederick County, Virginia
Glazed red earthenware, 5¼ × 4½ in. (with handle), P1.2001.152

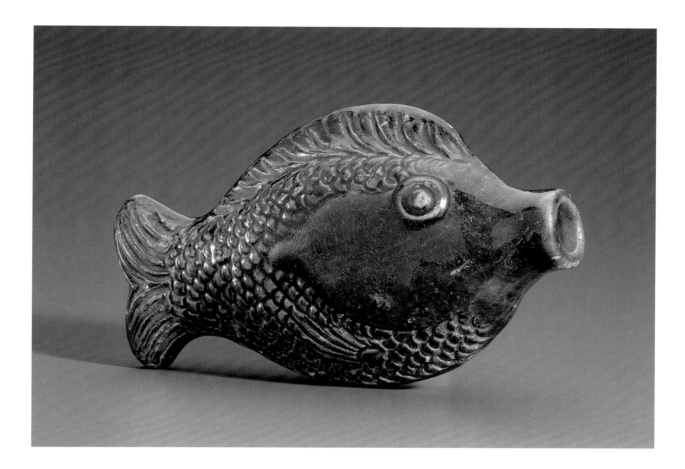

127. FISH FLASK OR BOTTLE, c. 1800–1822
Attributed to Rudolph Christ (act. c. 1800–1822),
Salem, Forsythe County, North Carolina
Glazed red earthenware, 2⅝ × 4½ × 1⅜ in., P1.2001.153

129. **Lion**, c. 1850–1860
Attributed to John Bell (1800–1880),
Waynesboro, Franklin County, Pennsylvania
Glazed red earthenware, 8 × 8½ × 4¼ in.,
P1.2001.155

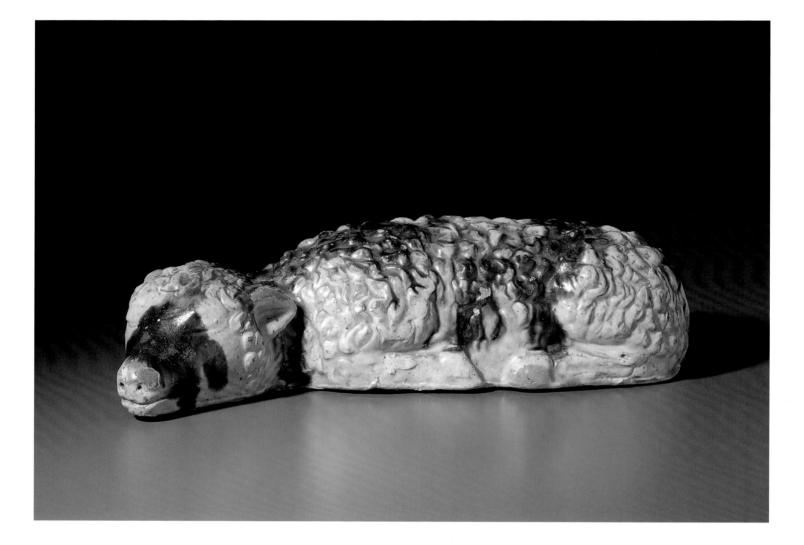

128. **Sleeping Lamb**, c. 1882–1904
S. Bell and Sons (Samuel Bell, Charles Bell, and Richard Franklin Bell),
(act. 1882–1909)
Strasburg, Shenandoah County, Virginia
Glazed red earthenware, 3⅝ × 12 × 5¼ in., P1.2001.154

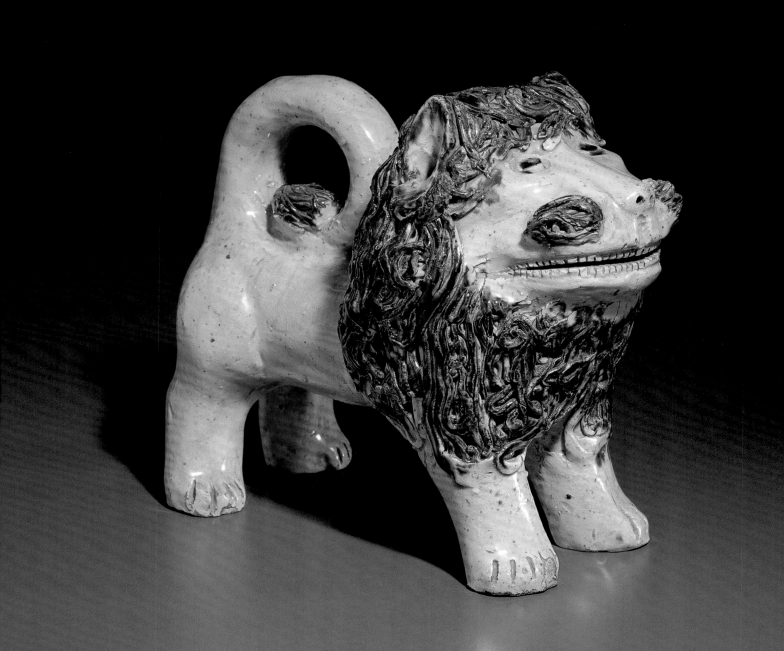

CHAPTER 5

PENNSYLVANIA AND BEYOND

DECORATIVE ARTS AND FURNITURE

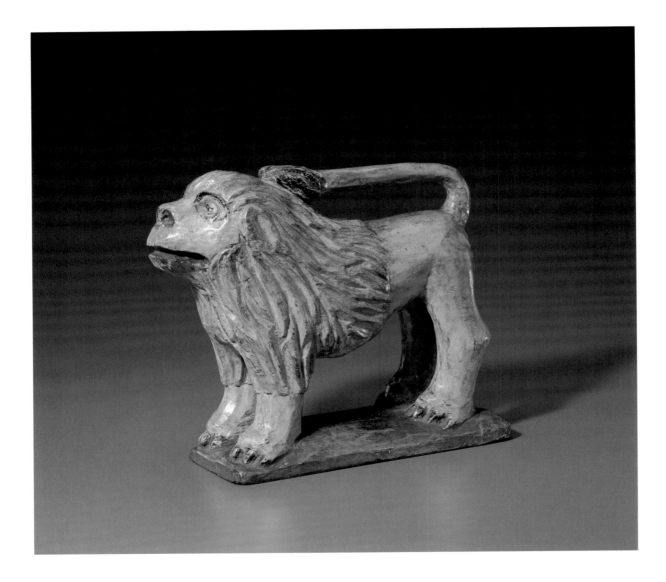

130. **LION**, c. 1860–1890
Wilhelm Schimmel (1817–1890), Cumberland County, Pennsylvania
Paint on pine, 7⅜ × 7½ × 3 in., P1.2001.156

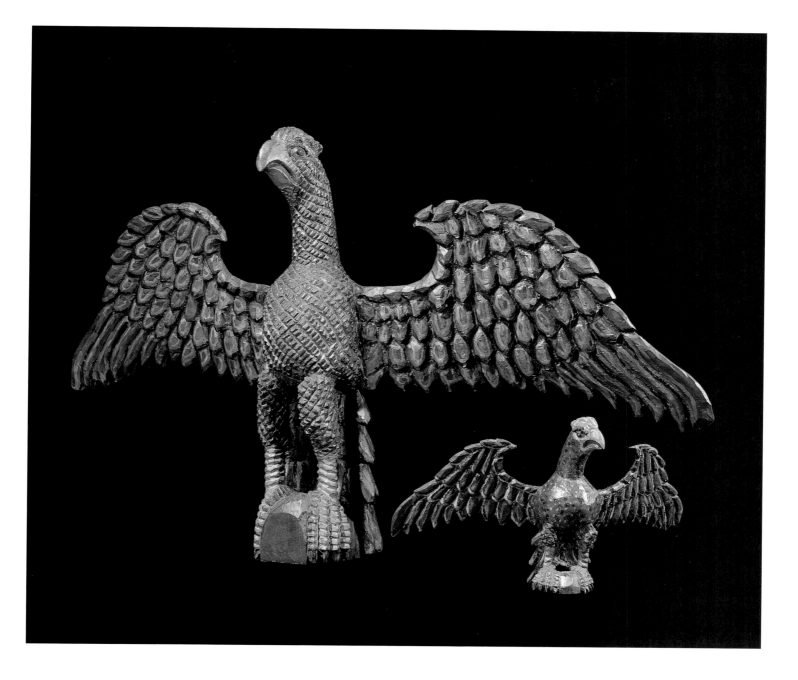

131a. **LARGE EAGLE**, c. 1860–1890
Wilhelm Schimmel (1817–1890),
Cumberland County, Pennsylvania
Paint on pine, 21⅜ × 37¾ × 10 in., P1.2001.157

131b. **SMALL EAGLE**, c. 1860–1890
Wilhelm Schimmel (1817–1890),
Cumberland County, Pennsylvania
Paint on pine, 8 × 14 × 6 in., P1.2001.158

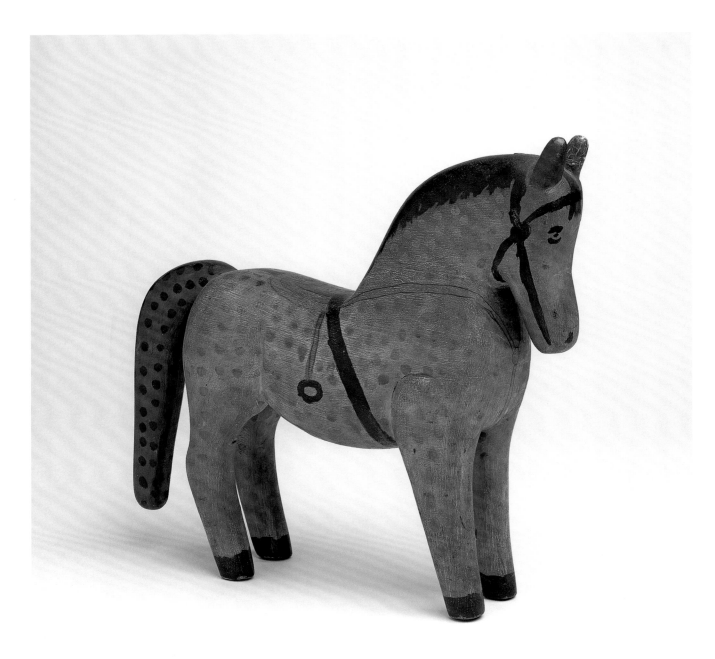

132. HORSE TOY, c. 1860–1890
Artist unidentified, probably Cumberland County, Pennsylvania
Paint on poplar, 11¾ × 12⅜ × 3½ in., P1.2001.159

133. **Kangaroo,** mid-nineteenth century
Artist unidentified, probably Pennsylvania
Paint on wood, 28 × 49½ × 5 in., P1.2001.160

134a. **Cast Bracket or Tool Holder**, c. 1780–1830
Artist unidentified, southeastern Pennsylvania
Iron, 2⅞ × 8 × 3 in., P1.2001.161

134b. **Forged Bracket or Tool Holder**, c. 1780–1820
Artist unidentified, southeastern Pennsylvania
Iron, 3¹⁄₁₆ × 8⅜ × 3⁵⁄₁₆ in., P1.2001.162

135. PIE CRIMPER, c. 1790–1820
Artist unidentified, probably southeastern Pennsylvania
Iron, 2⅜ × 8 × ¼ in., P1.2001.163

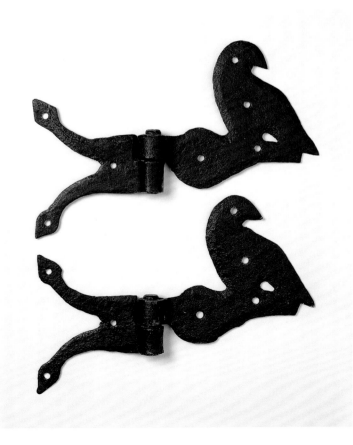

136. PAIR OF DOOR HINGES, c. 1750–1780
Attributed to Hopewell Forge (act. 1744–1780),
Union Township, Berks County, Pennsylvania
Iron, 7 × 10¼ × 1 in. each, P1.2001.164a, b

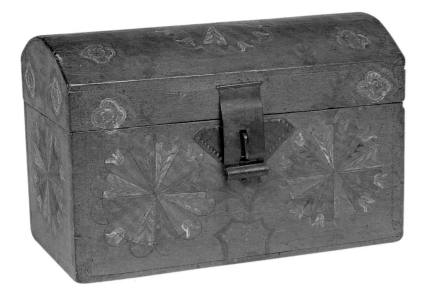

137.
BLUE-GREEN DOME-TOP STORAGE BOX, c. 1800
Artist unidentified, Lancaster or Lancaster County, Pennsylvania
Paint on pine and poplar, with sheet-tin hasp and hardware, 7⅜ × 11 × 5⅝ in., P1.2001.165

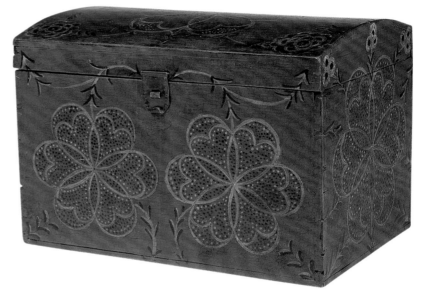

138.
RED DOME-TOP STORAGE BOX, c. 1800–1840
Artist unidentified, Lancaster or Lancaster County, Pennsylvania
Paint on pine, with sheet-tin hasp and hardware, 8¾ × 12⅜ × 8¾ in., P1.2001.166

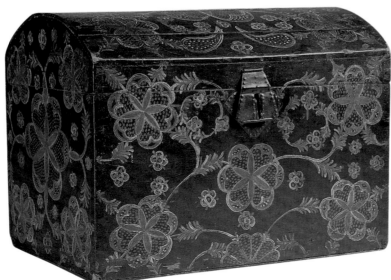

139.
BLACK DOME-TOP STORAGE BOX, c. 1800–1840
Artist unidentified, Lancaster or Lancaster County, Pennsylvania
Paint on poplar, with sheet-tin hasp and hardware, 11⅛ × 14⁹⁄₁₆ × 10 in., P1.2001.167

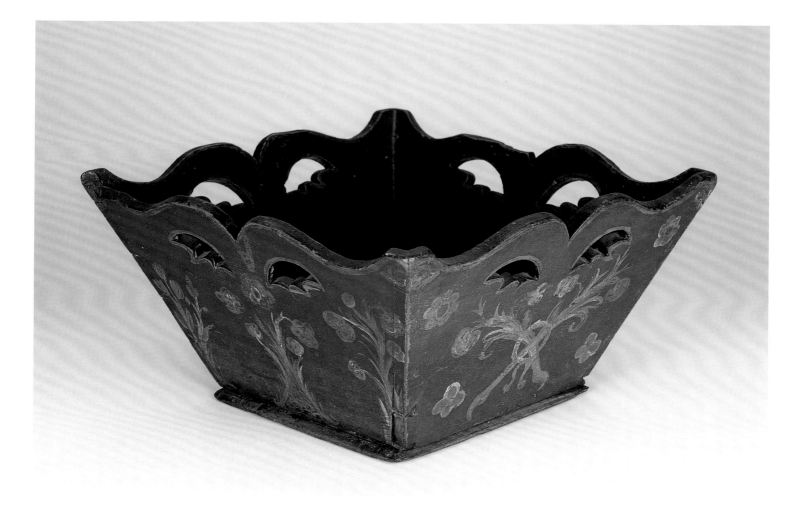

140. OPEN BOX OR TRAY, c. 1820–1850
Artist unidentified, southeastern Pennsylvania
Paint on pine and poplar, 5½ × 10 × 9¾ in., P1.2001.168

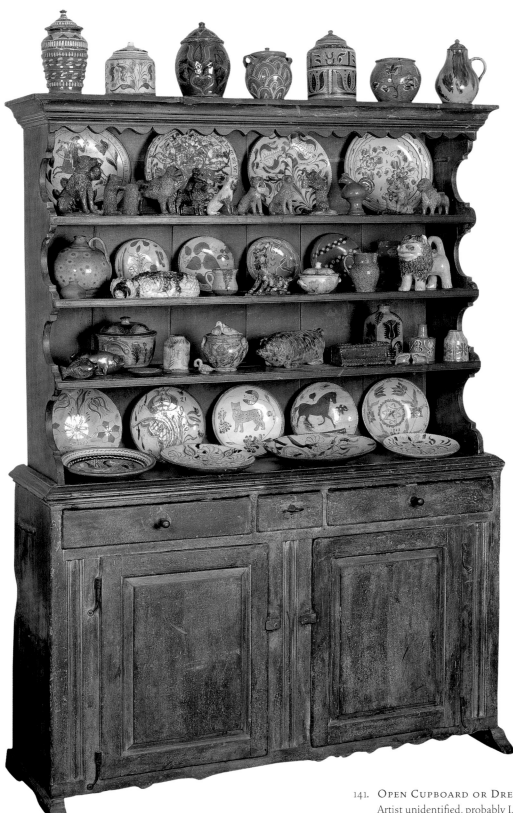

141. **Open Cupboard or Dresser**, c. 1750–1780
Artist unidentified, probably Lancaster, Lancaster County, Pennsylvania
Paint on pine and poplar, with iron hardware, 85 × 60⅞ × 20¼ in.,
P1.2001.169

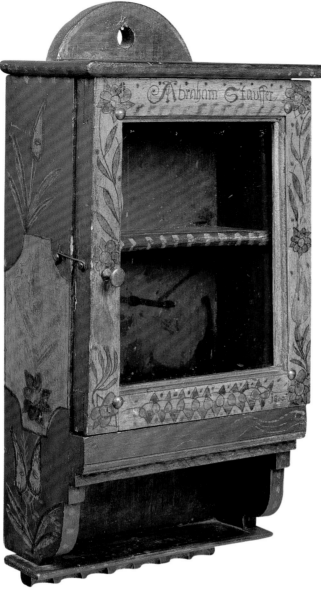

142.
HANGING CUPBOARD WITH SPOON SHELF, 1800
Attributed to John Drissel (act. 1790–c. 1835),
Milford Township, Bucks County, Pennsylvania
Paint on pine, with glass and iron hardware,
19 × 10 × 5⅜ in., P1.2001.170

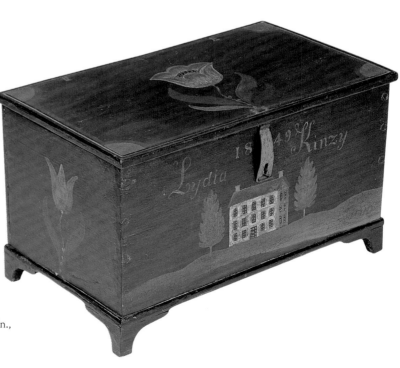

143. **MINIATURE CHEST OR BOX,** 1849
Attributed to Jacob Weber (1802–?),
Brecknock Township, Lancaster County, Pennsylvania
Paint on pine, with tin hasp and hinges, 6⅛ × 10 × 5¹⁵⁄₁₆ in.,
P1.2001.171

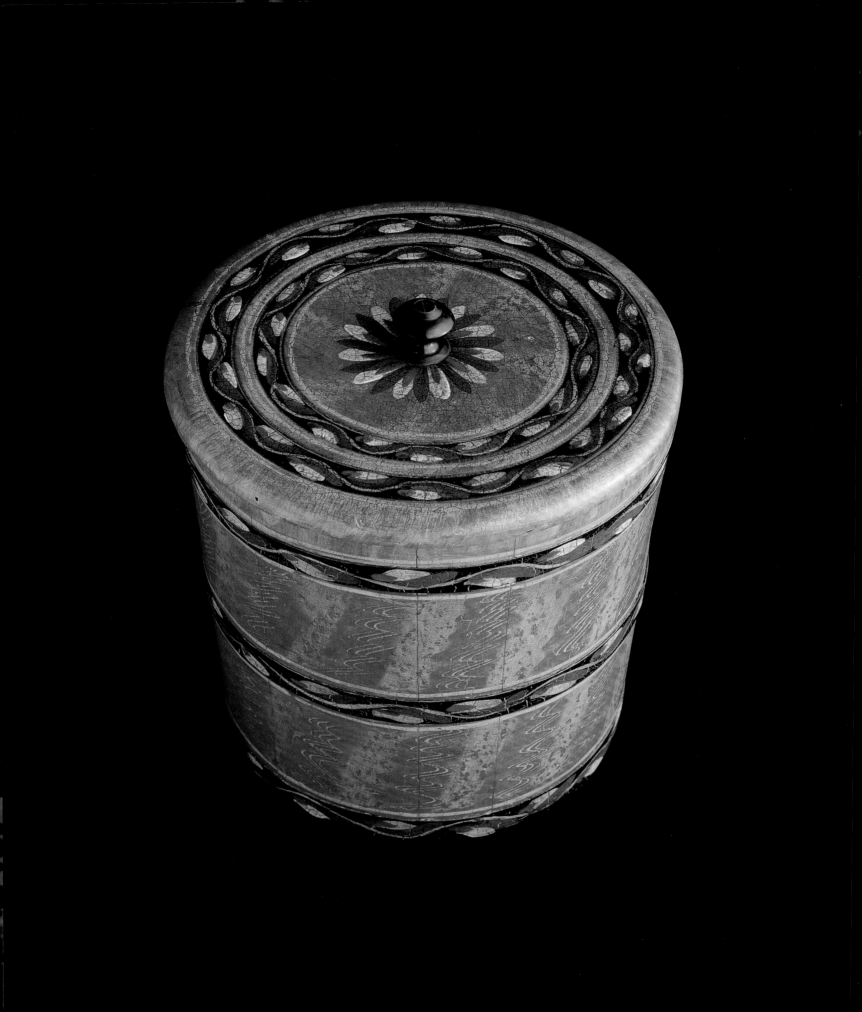

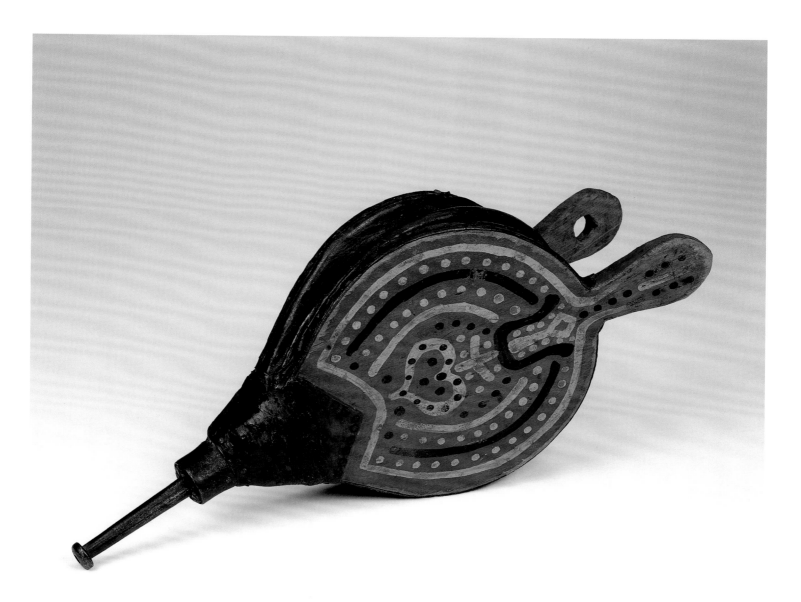

144.
Sugar Bucket, 1888
Joseph Long Lehn (1798–1892), Elizabeth Township,
Lancaster County, Pennsylvania
Paint on poplar, oak, and iron, 8½ × 8¼ in. diam., P1.2001.172

145.
Bellows, 1847
Artist unidentified, probably Schuylkill or
Northumberland County, Pennsylvania
Paint on pine, with leather and iron, 18⅛ × 7⅞ × 4¼ in., P1.2001.173

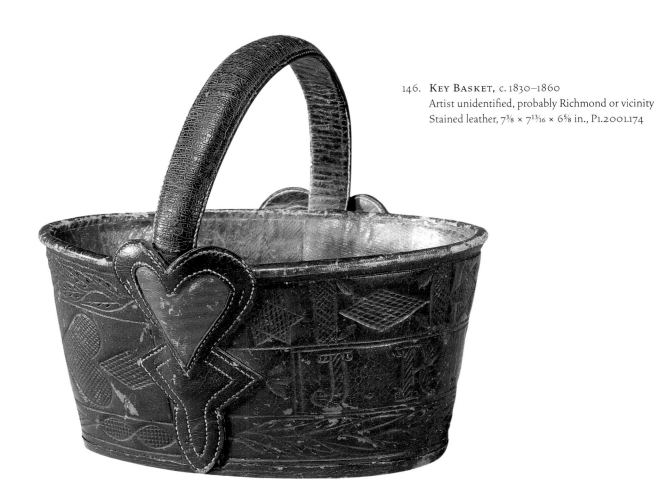

146. KEY BASKET, c. 1830–1860
Artist unidentified, probably Richmond or vicinity
Stained leather, 7⅜ × 7¹³⁄₁₆ × 6⅝ in., P1.2001.174

147. DRUM, 1812
Benjamin Brown (1748–1834), Bloomfield,
Hartford County, Connecticut
Paint on pine and maple, with deerskin, cowhide,
brass, and rope, 11½ × 13 in. diam., P1.2001.175

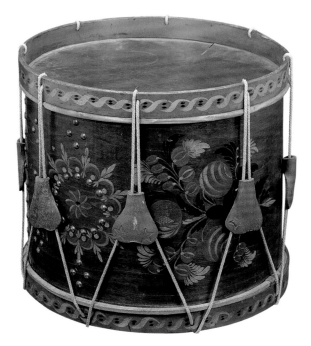

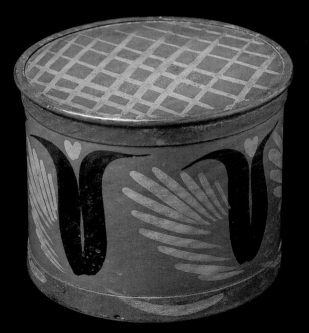

148. STORAGE BOX, 1853
Artist unidentified, Pennsylvania
Paint on maple, ash, and tin,
2¹¹⁄₁₆ × 3¹⁵⁄₁₆ in. diam., P1.2001.176

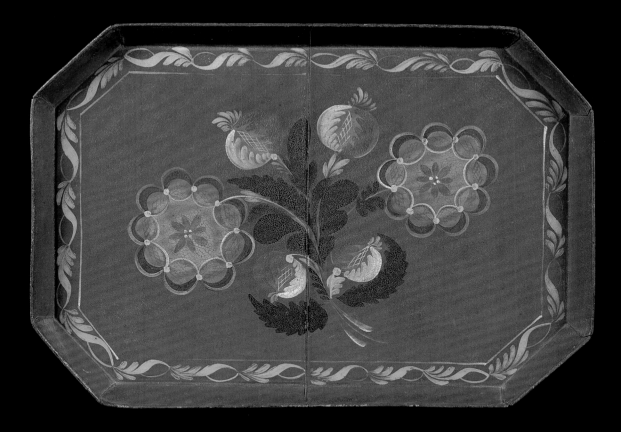

149. TWO-SHEET WAITER, c. 1820–1825
Artist unidentified, southeastern Pennsylvania
Paint on tinplate, 12 × 17¼ × 1 in., P1.2001.177

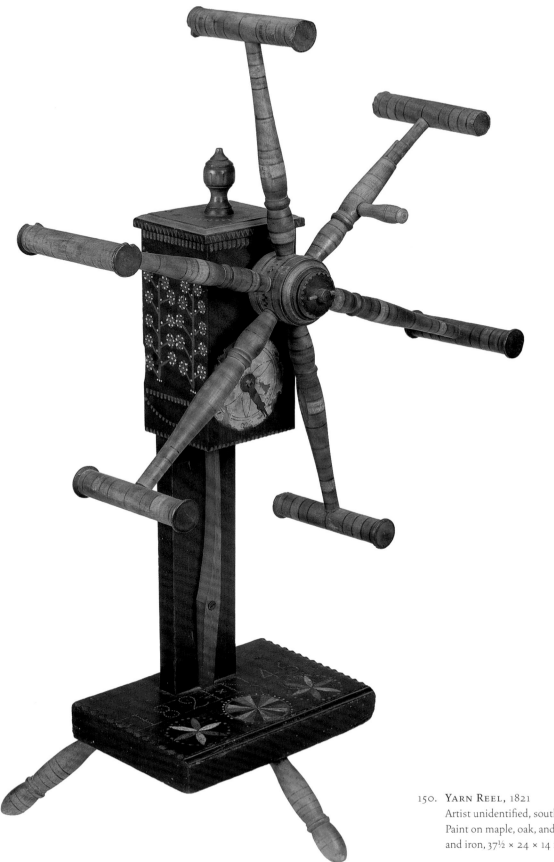

150. YARN REEL, 1821
Artist unidentified, southeastern Pennsylvania
Paint on maple, oak, and poplar, with ink on paper,
and iron, 37½ × 24 × 14 in., P1.2001.178

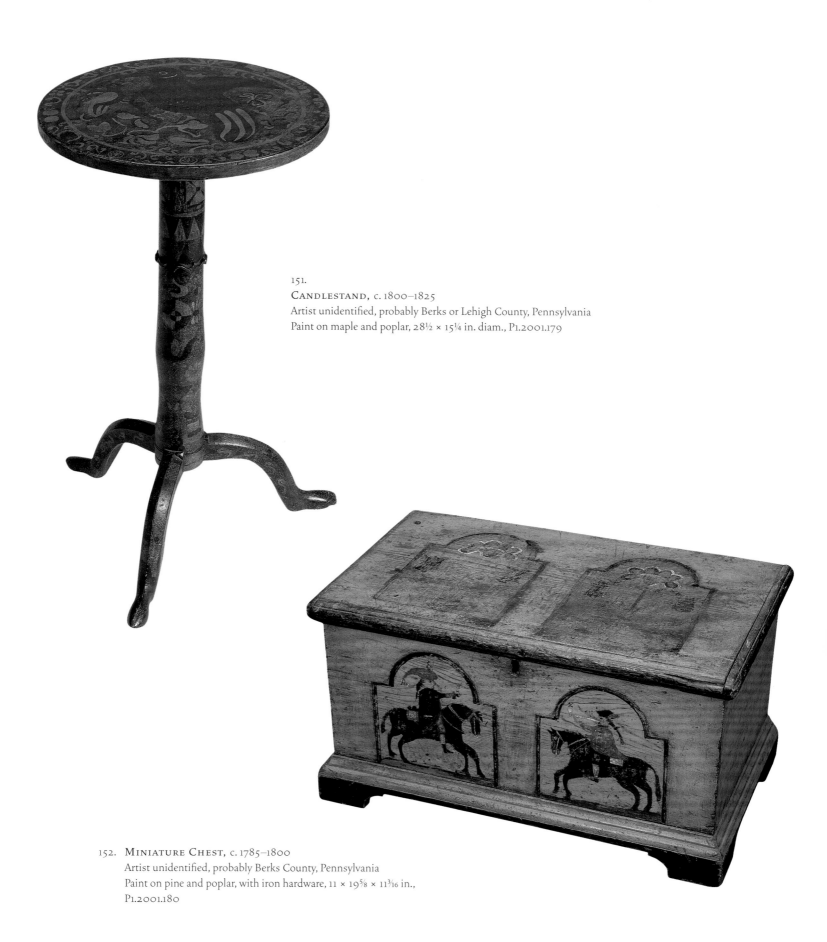

151.
CANDLESTAND, c. 1800–1825
Artist unidentified, probably Berks or Lehigh County, Pennsylvania
Paint on maple and poplar, 28½ × 15¼ in. diam., P1.2001.179

152. MINIATURE CHEST, c. 1785–1800
Artist unidentified, probably Berks County, Pennsylvania
Paint on pine and poplar, with iron hardware, 11 × 19⅝ × 11³⁄₁₆ in.,
P1.2001.180

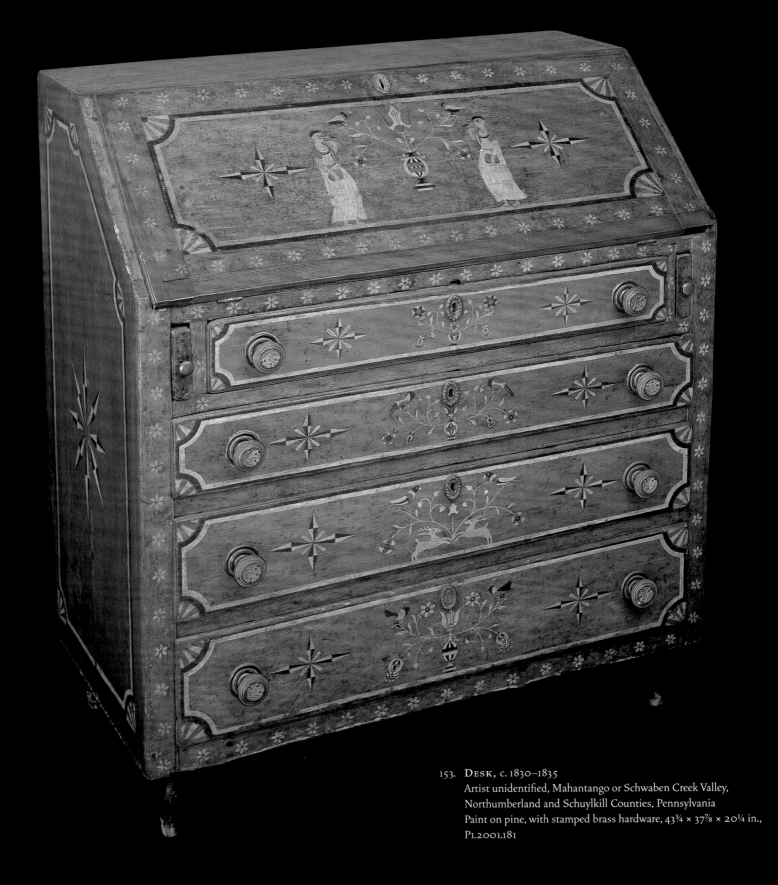

153. DESK, c. 1830–1835
Artist unidentified, Mahantango or Schwaben Creek Valley,
Northumberland and Schuylkill Counties, Pennsylvania
Paint on pine, with stamped brass hardware, 43¾ × 37⅞ × 20¼ in.,
P1.2001.181

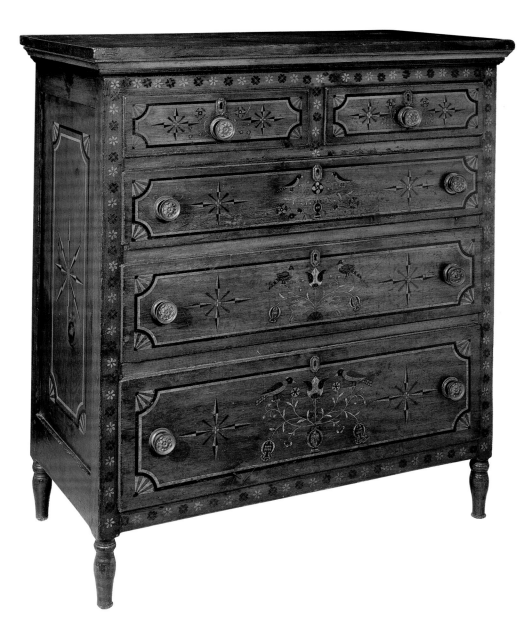

154.
CHEST OF DRAWERS, c. 1830–1840
Artist unidentified, Mahantango or
Schwaben Creek Valley, Northumberland
and Schuylkill Counties, Pennsylvania
Paint on pine, with stamped brass hardware,
47¾ × 42⁹⁄₁₆ × 21¹⁵⁄₁₆ in., P1.2001.182

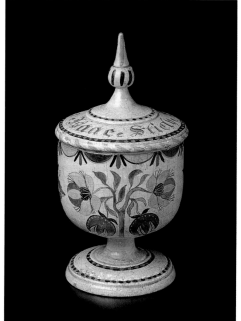

155. **SPICE CUP,** 1861
Attributed to Jared Stiehly (1833–1911) and
Elizabeth Mayer Stiehly (1826–1878), Mahantango
or Schwaben Creek Valley, Northumberland and
Schuylkill Counties, Pennsylvania
Paint on poplar, 7¾ × 4 in. diam., P1.2001.183

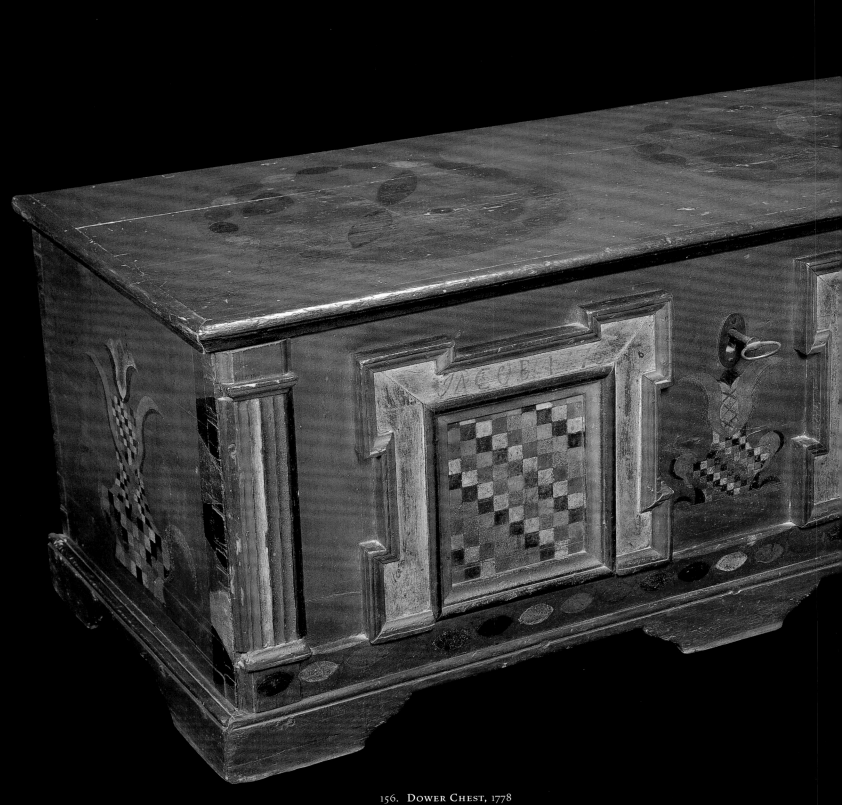

156. **Dower Chest,** 1778
Johannes Kniskern (1746–?), Schoharie County, New York
Paint on pine with iron hasp, key, and hardware, 19¾ × 47 × 21 in., P1.2001.184

157. **MINIATURE CHECKERBOARD
 CHEST,** c. 1790–1810
 Artist unidentified, probably
 Schoharie County, New York
 Paint on pine, 8½ × 19⅛ × 10 in.,
 P1.2001.185

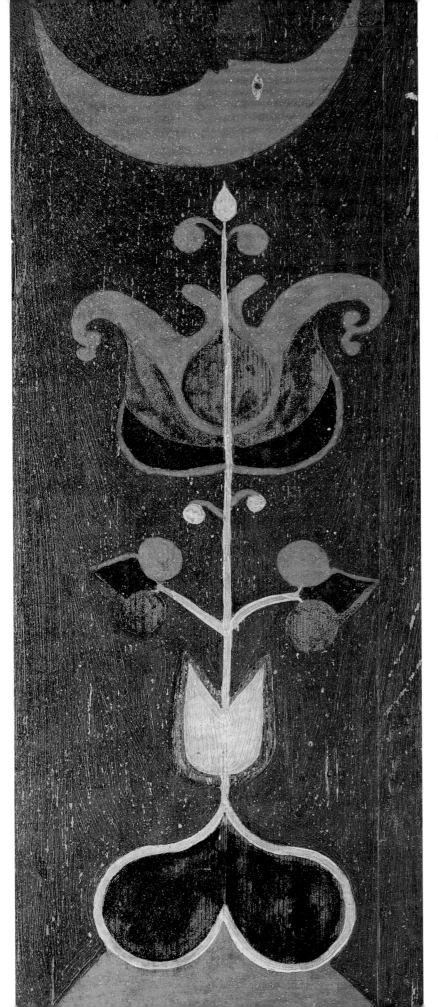

detail, no. 158

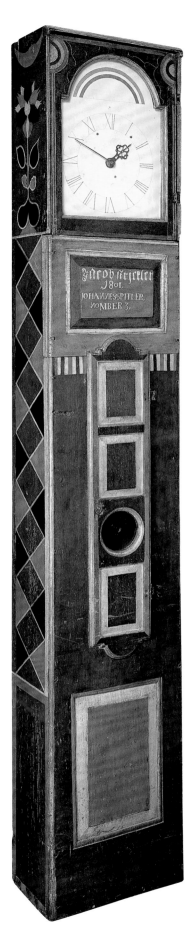

158.
TALL CASE CLOCK, 1801
Johannes Spitler (1774–1837), Shenandoah County, Virginia
Paint on yellow pine, brass and steel works, modern watercolor
and ink on period-paper face, and original sheet-iron dial,
85½ × 14¾ × 8¼ in., P1.2001.186

159. **FRAKTUR WITH INVERTED HEART,** 1803
Jacob Strickler (1770–1842), Shenandoah County, Virginia
Watercolor and ink on paper, 6³⁄₁₆ × 8¼ in. (sight),
P1.2001.187

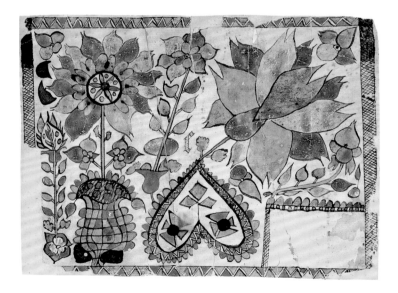

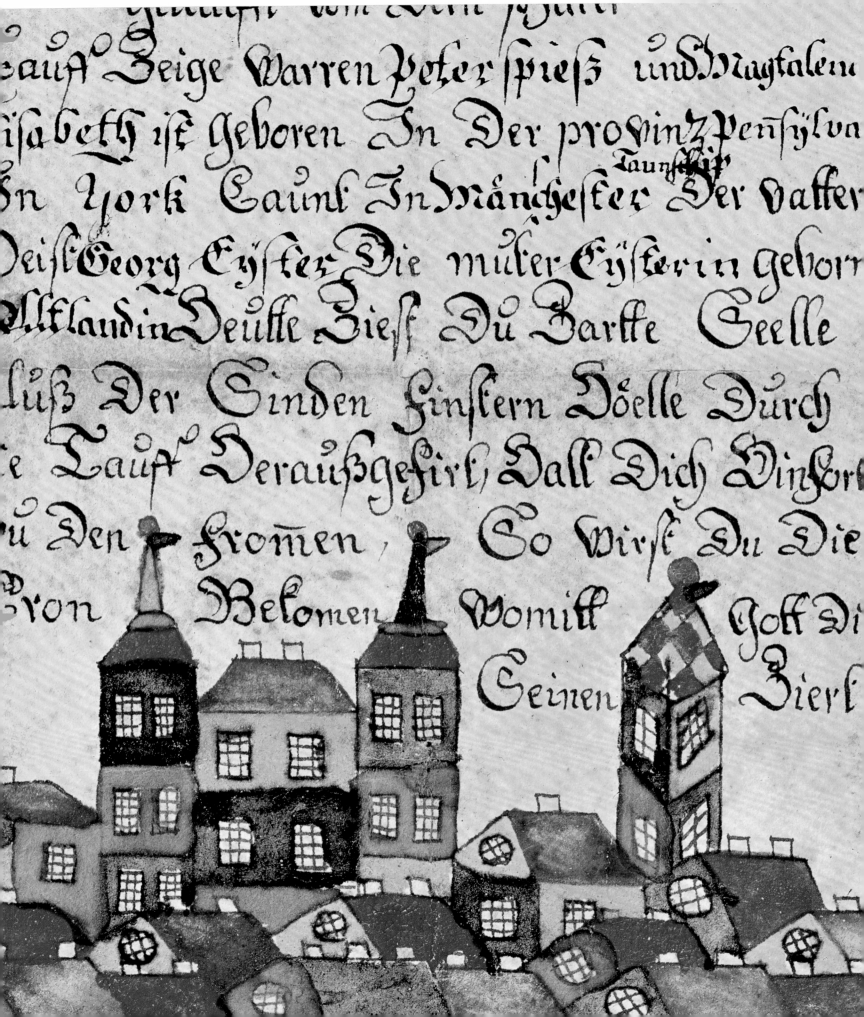

... auß Zeige Waren Peter Spieß und Magdalen
...isabeth ist geboren In der provinz Pensilva
In York Caunt In Manchester Taunschip Der Vatter
Heist Georg Eyster Die muter Eysterin gebor
...Klaudin Deulle Zieß du Zartte Seele
...luß Der Sinden Finstern Höelle Durch
...Tauf Deraußgefirt Dall Dich Dinfor...
...u den Fromen, So Virst Du Die
...von Belomen Womitt Gott Di...
Seinen Zierl...

CHAPTER 6

PENNSYLVANIA AND BEYOND

FRAKTUR

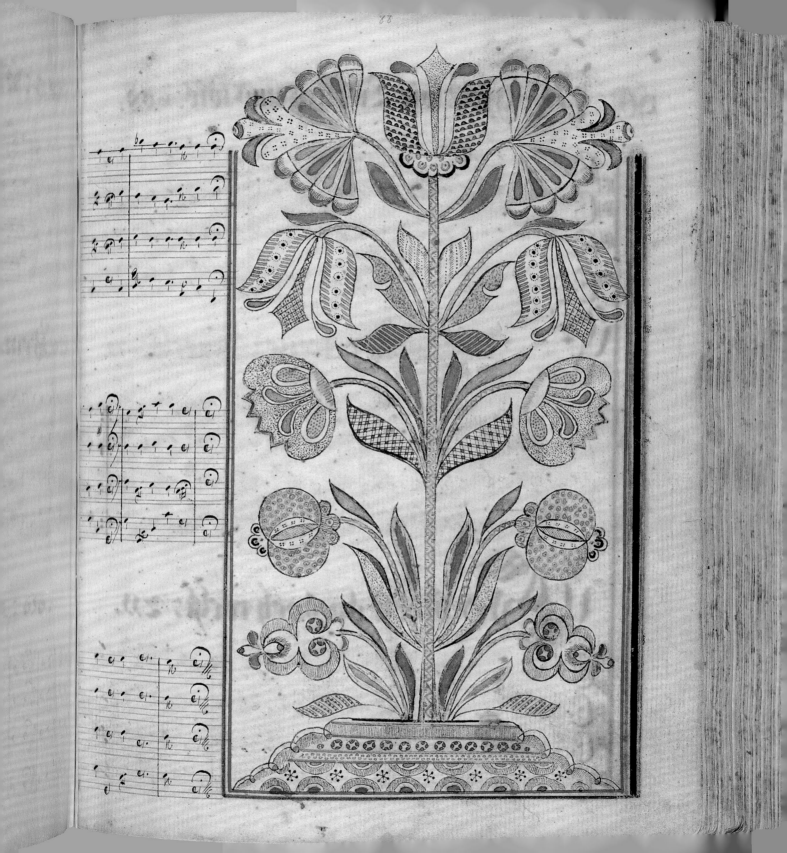

162a–b. **Ephrata Cloister Tunebook**, c. 1745
Artists unidentified, Ephrata Cloister, Ephrata, Lancaster County, Pennsylvania
Watercolor and ink on paper, with cloth and leather binding, 8⅜ × 7⅝ × 1⅞ in. (closed),
P1.2001.190

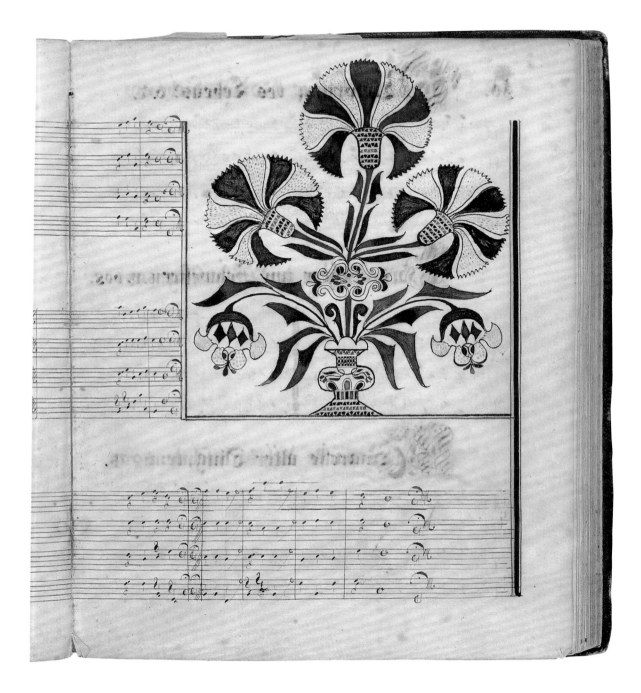

163a–b. **Ephrata Cloister Tunebook**, c. 1745
Artists unidentified, Ephrata Cloister, Ephrata, Lancaster County, Pennsylvania
Watercolor and ink on paper, with cloth and leather binding, 8¼ × 6¾ × 1³⁄₁₆ in. (closed),
P1.2001.191

164a–b. **Snow Hill Cloister Tunebook**, 1852
Artist unidentified, possibly Jacob Ritter,
Snow Hill Cloister, Snow Hill, Franklin County, Pennsylvania
Watercolor and ink on paper, with leather binding, 6¾ × 8¼ × 1¾ in. (closed), P1.2001.192

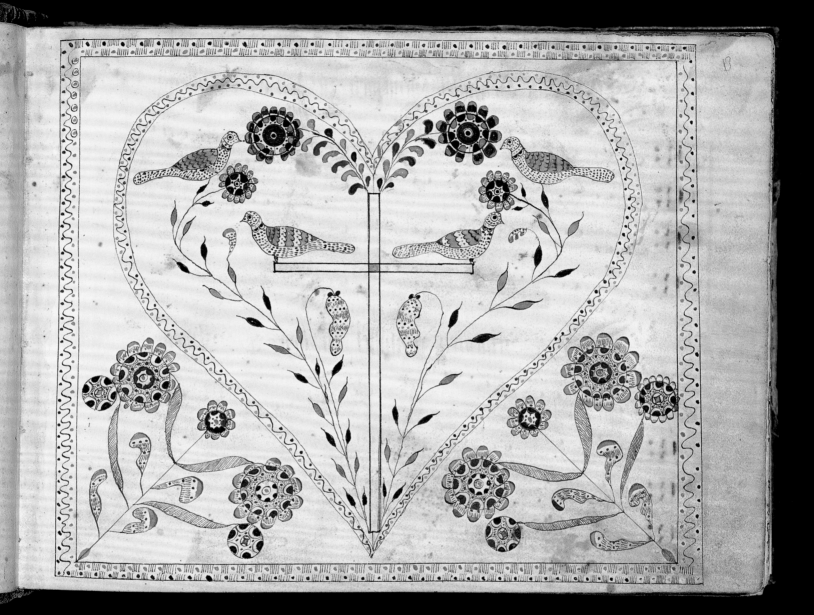

165. **BOOKPLATE FOR ROSINA HERING, 1827**
Heinrich Engelhard (dates unknown),
probably western Berks County, Pennsylvania
Watercolor and ink on paper, 5¾ × 3⁷⁄₁₆ in.,
P1.2001.193

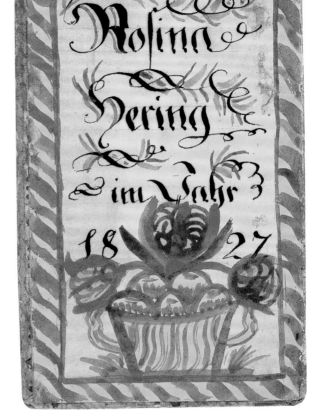

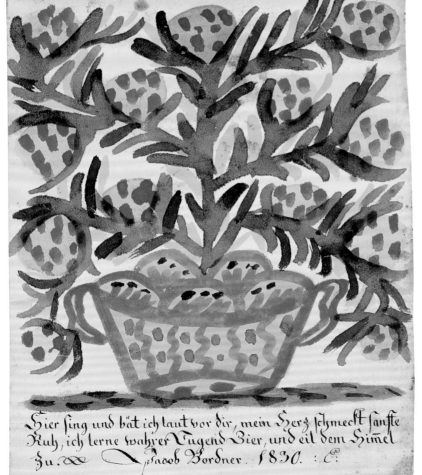

166.
PRESENTATION FRAKTUR FOR JACOB BORDNER, 1830
Heinrich Engelhard (dates unknown),
probably western Berks County, Pennsylvania
Watercolor and ink on paper, 7½ × 6 in., P1.2001.194

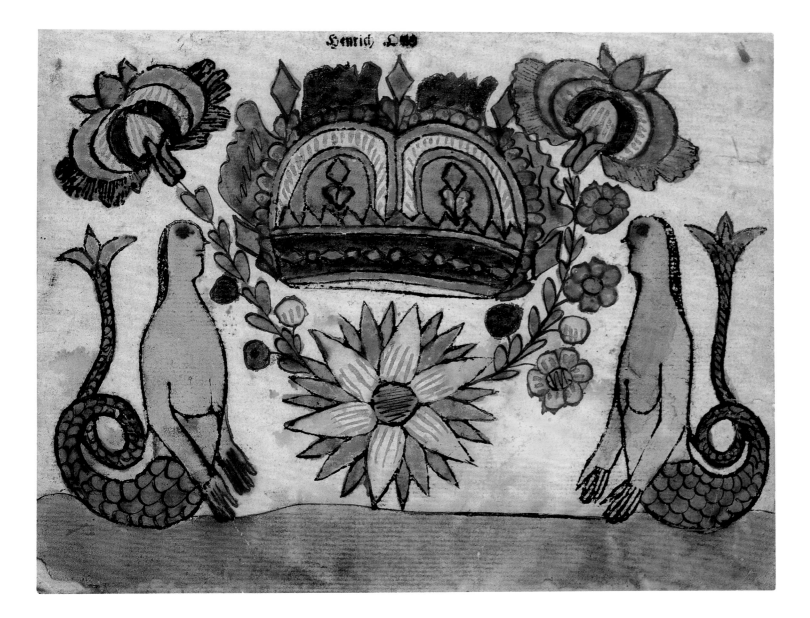

167. PRESENTATION FRAKTUR OF MERFOLK, FLOWERS, AND CROWN, c. 1785
Johann Henrich Otto (1733–c. 1800), probably Lancaster or Lebanon County, Pennsylvania
Watercolor and ink on block-printed paper, 6⅜ × 8¹⁄₁₆ in., P1.2001.195

168. BIRTH AND BAPTISMAL RECORD FOR MARTIN ANDRES, C. 1788
Johannes Ernst Spangenberg (?–1814), probably Easton, Northampton County, Pennsylvania
Watercolor and ink on paper, 12¾ × 15⅝ in., P1.2001.196

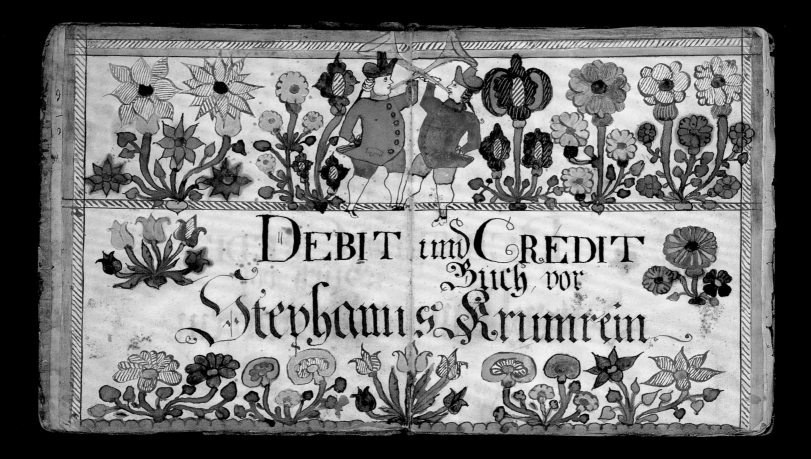

169. **Account Book for Stephanus Krumrein**, c. 1790
Johannes Ernst Spangenberg (?–1814), probably Easton, Northhampton County, Pennsylvania
Watercolor and ink on paper, with leather binding with watercolor decoration, 8 × 6⅞ × 1 in. (closed),
P1.2001.197

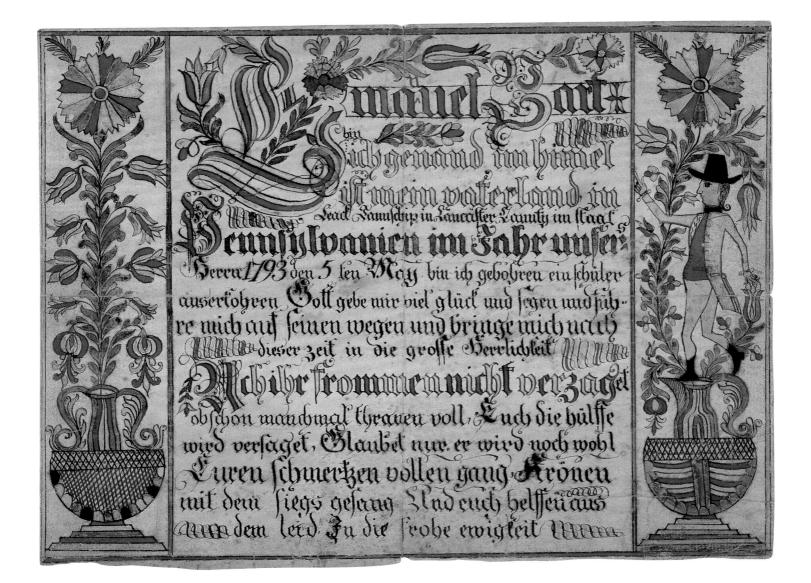

170. **Birth Record for Emanuel Bart**, c. 1800
Leacock Township Artist, probably Leacock Township, Lancaster County, Pennsylvania
Watercolor and ink on paper, 7⅝ × 10 in., P1.2001.198

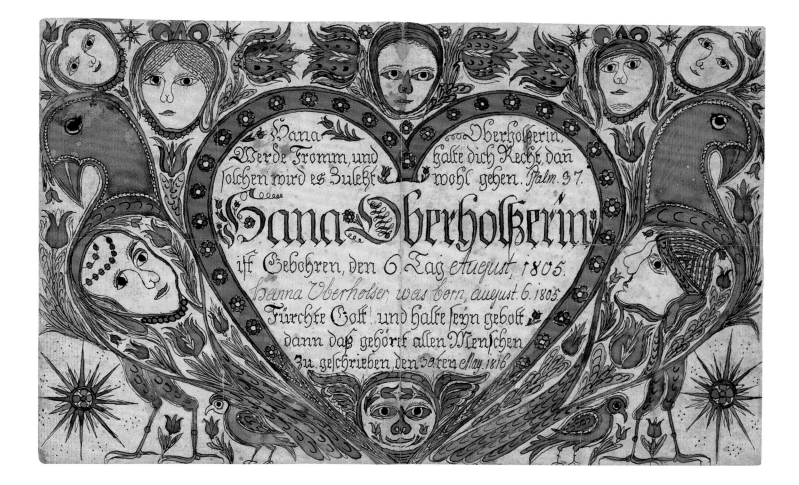

171. BIRTH RECORD FOR HANA OBERHOLTZER, 1816
David Cordier (dates unknown), probably Lancaster County, Pennsylvania
Watercolor and ink on paper, 7¾ × 12¼ in., P1.2001.199

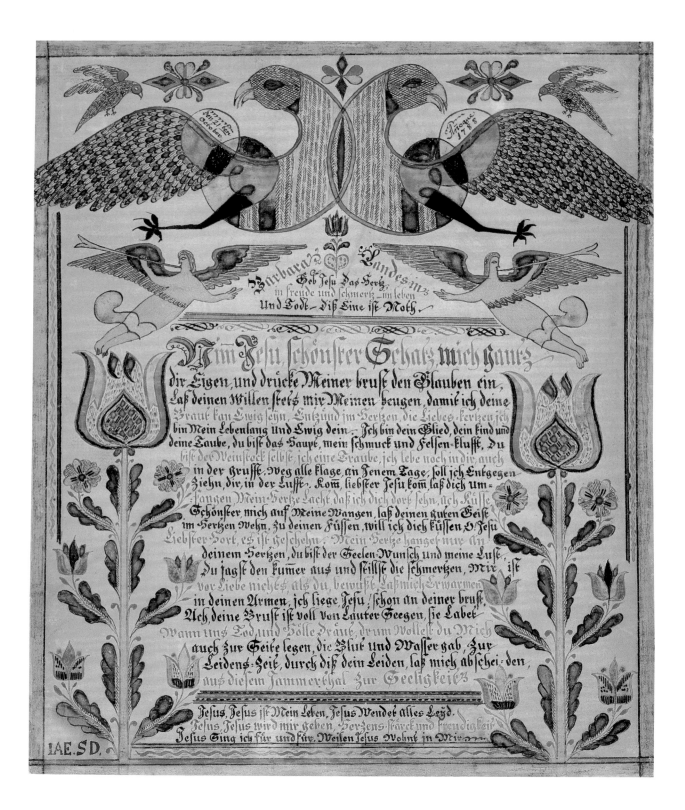

172. Religious Text with Double Eagle
for Barbara Landes, 1788
Johann Adam Eyer (1755–1837), probably Bedminster Township,
Bucks County, Pennsylvania
Watercolor and ink on paper, 9⅞ × 8 in., P1.2001.200

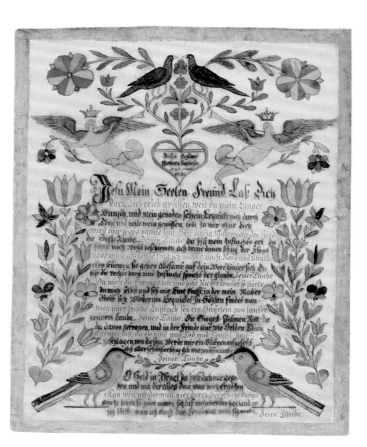

173. RELIGIOUS TEXT WITH TWO BLUE DOVES
FOR BARBARA LANDES, 1792
Johann Adam Eyer (1755–1837), probably Bedminster Township,
Bucks County, Pennsylvania
Watercolor and ink on paper, 9⅞ × 8 in., P1.2001.201

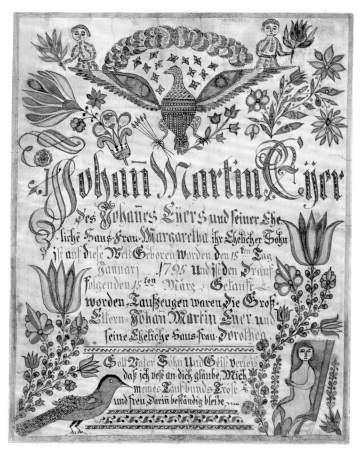

174. *TAUFSCHEIN* FOR JOHANN MARTIN EYER, c. 1795
Johann Adam Eyer (1755–1837), probably Upper Mount Bethel
Township, Northampton County, Pennsylvania
Watercolor and ink on paper, 9⅞ × 7⅝ in., P1.2001.202

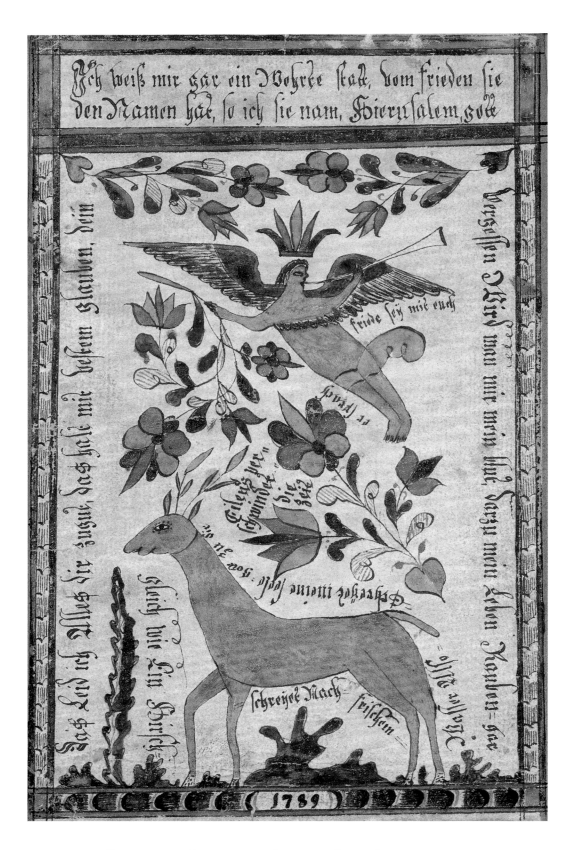

175. **PRESENTATION FRAKTUR WITH ANGEL AND DOE**, 1789
Johann Adam Eyer (1755–1837), probably Bedminster Township,
Bucks County, Pennsylvania
Watercolor and ink on paper, 7⁷⁄₁₆ × 4¾ in., P1.2001.203

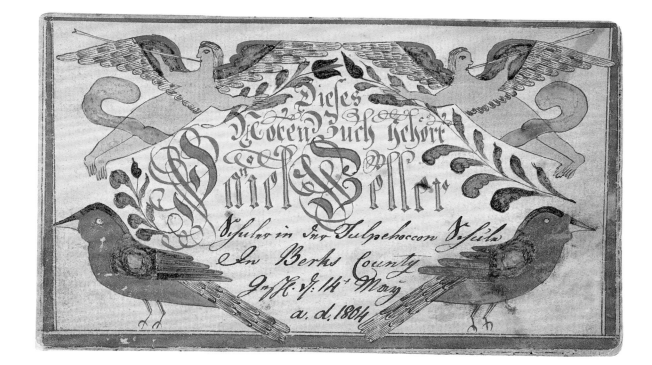

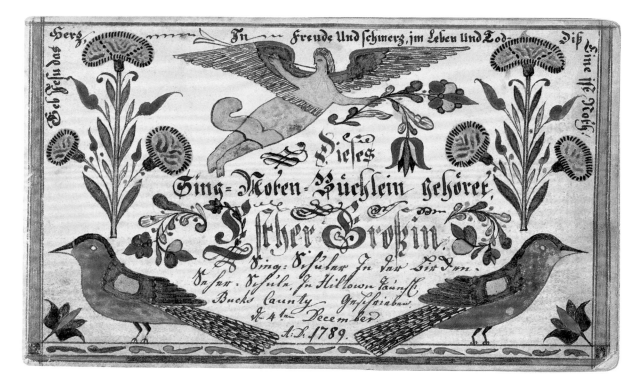

176. **TUNEBOOK FOR DANIEL ZELLER**, 1804
Johann Friedrich Eyer (1770–1827), Tulpehocken,
Berks County, Pennsylvania
Watercolor and ink on paper, with paper binding,
3⅞ × 6½ × 3/16 in. (closed), P1.2001.204

177. **TUNEBOOK FOR ESTHER GROSS**, 1789
Johann Adam Eyer (1755–1837), Hilltown Township,
Bucks County, Pennsylvania
Watercolor and ink on paper, with paper binding,
4 × 6½ × ⅛ in. (closed), P1.2001.205

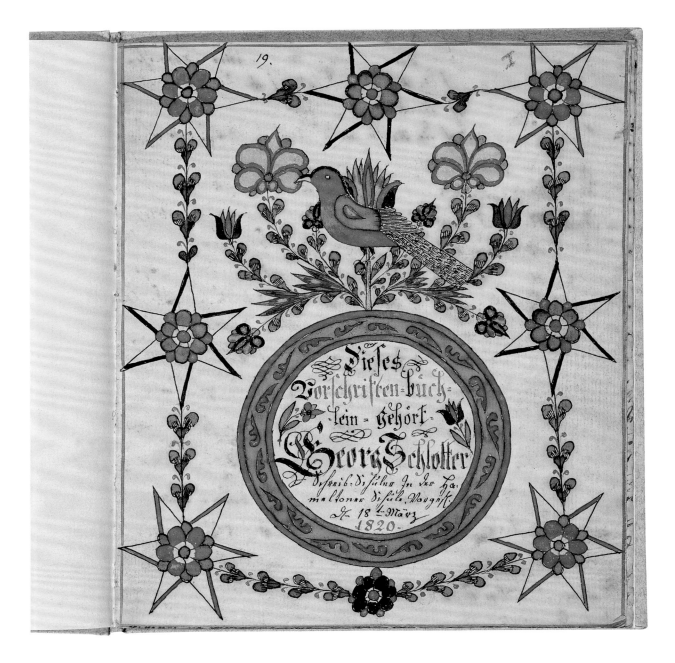

178. **Penmanship Example Booklet for Georg Schlotter**, 1820
Johann Adam Eyer (1755–1837), Hamilton Township, Monroe County, Pennsylvania
Watercolor and ink on paper, with paper binding, 8 × 6³⁄₁₆ × ³⁄₈ in. (closed), P1.2001.206

179. **Spiral Religious Text**, c. 1780–1785
Johann Adam Eyer (1755–1837), probably Bedminster Township,
Bucks County, Pennsylvania
Watercolor and ink on paper, 8⁵⁄₈ × 6⁷⁄₈ in., P1.2001.207

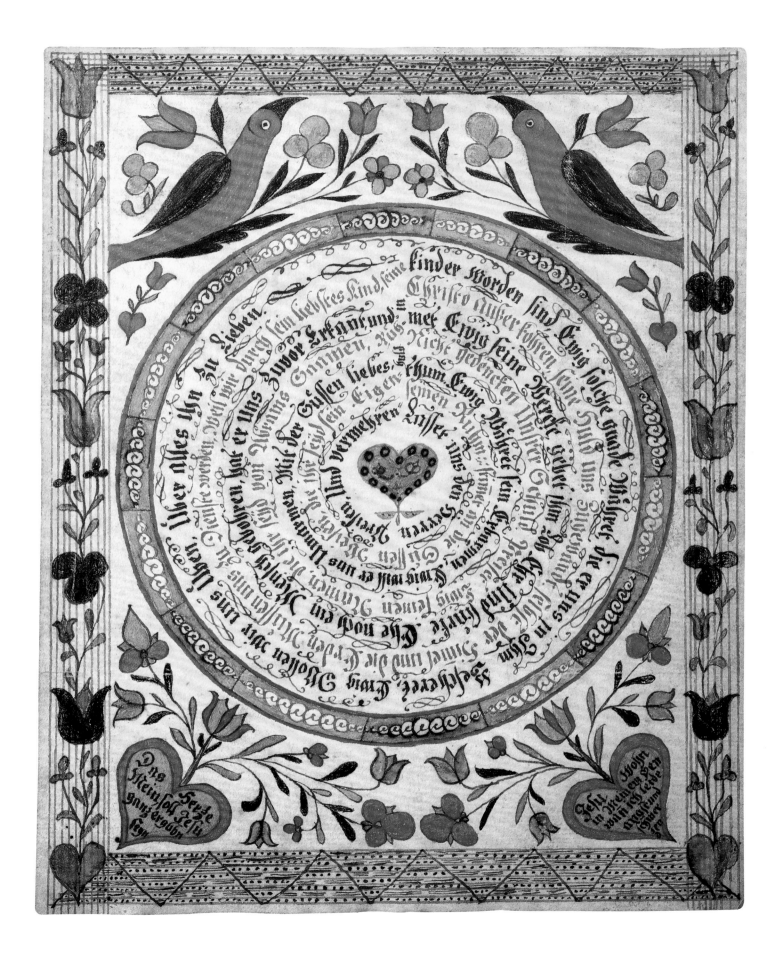

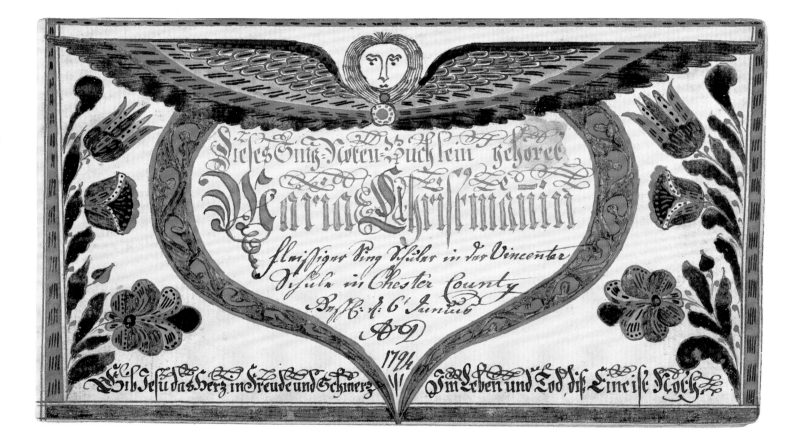

180. TUNEBOOK FOR MARIA CHRISTMANN, 1794
Christian Strenge (1757–1828), Vincent Township, Chester County, Pennsylvania
Watercolor and ink on paper, with paper binding, 3¹¹⁄₁₆ × 6⅜ × ⅛ in. (closed), P1.2001.208

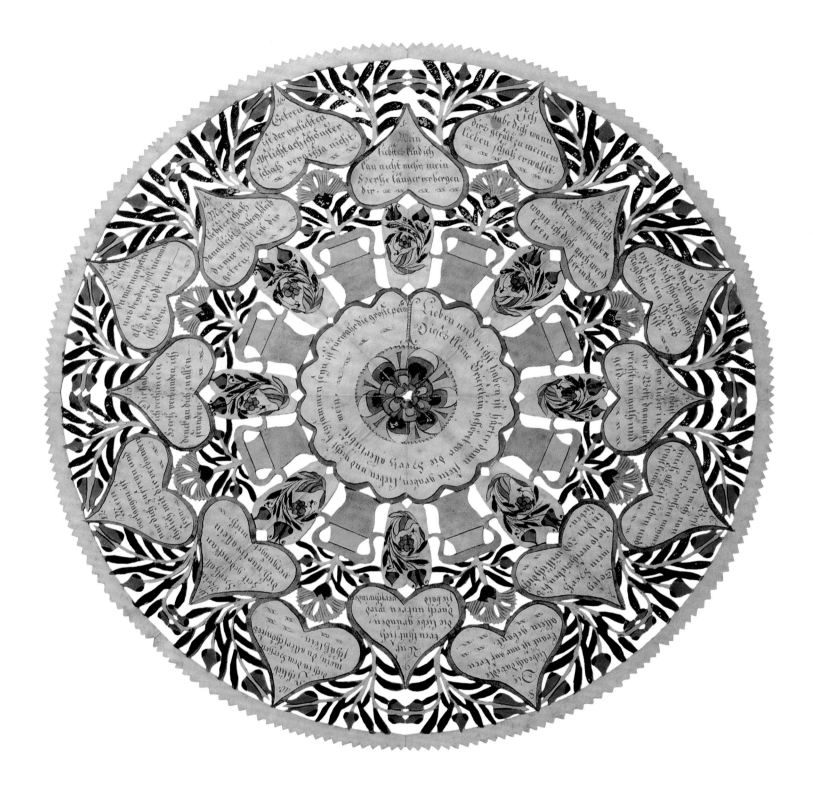

181. *LIEBESBRIEF*, c. 1790
Christian Strenge (1757–1828), East Petersburg, Lancaster County, Pennsylvania
Watercolor and ink on cut paper, 13¼ in. diam., P1.2001.209

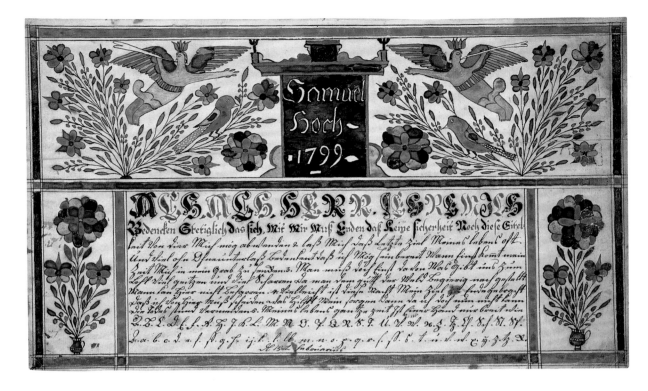

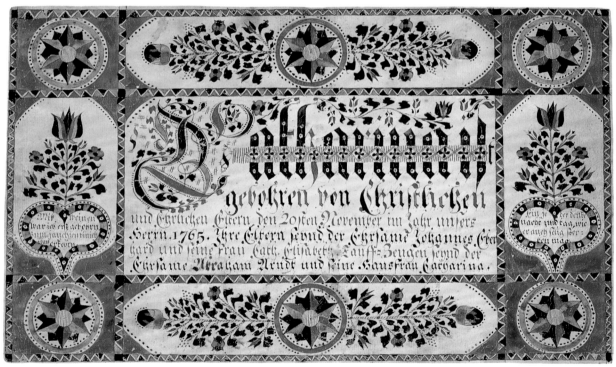

182. *Vorschrift* for Samuel Hoch, 1799
Oley Mermaid Artist, probably Oley Valley,
Berks County, Pennsylvania
Watercolor and ink on paper, 7¾ × 12⅝ in., P1.2001.210

183. *Taufschein* for Catharina Eberhard, c. 1780
Artist unidentified, southeastern Pennsylvania
Watercolor and ink on paper, 7⅞ × 12¾ in., P1.2001.211

184. *TAUFSCHEIN* FOR JOHANNES DOTTERE, c. 1831
Northhampton County (or Bird-in-the-Hand) Artist,
probably Chestnut Hill Township, Northhampton County, Pennsylvania
Watercolor and ink on paper, 15¹⁄₁₆ × 12 in., P1.2001.212

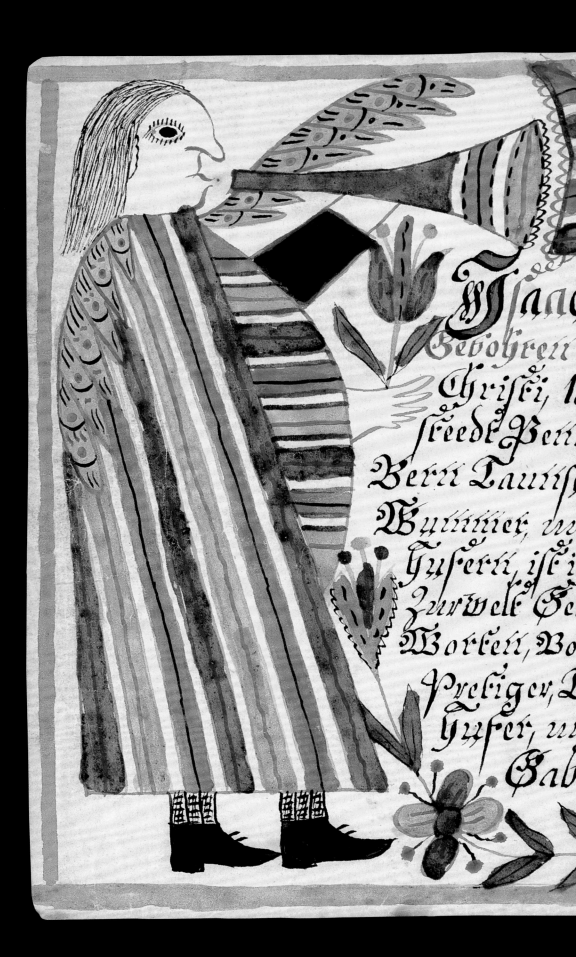

185.
TAUFSCHEIN FOR ISAAC WUMMER, c. 1810
School of John Conrad Gilbert, probably
Berks County, Pennsylvania
Watercolor and ink on paper, 7⅞ × 12³⁄₁₆ in.,
P1.2001.213

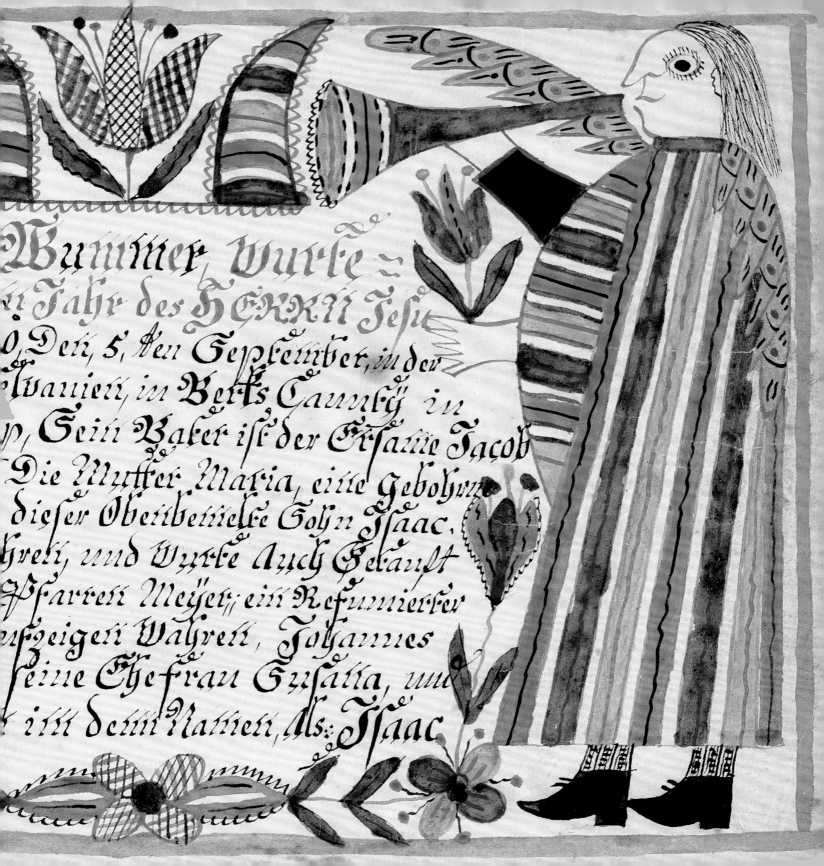

Wummer Vurtze=
en Fahr des HErrn Jesu
O Den, 5, ten September, in der
lvanien, in Berks Caunty in
p, Sein Vater ist der Ersame Jacob
Die Mutter Maria, eine Gebohrne
dieser Oberbettiche Sohn Isaac.
hren, und Vurtze Auch Getauft
Pfarren Meyer, ein Reformierter
wzeigen Wahren, Johannes
eine Ehefrau Susalia, und
ik ihm denn Namen, als: Isaac

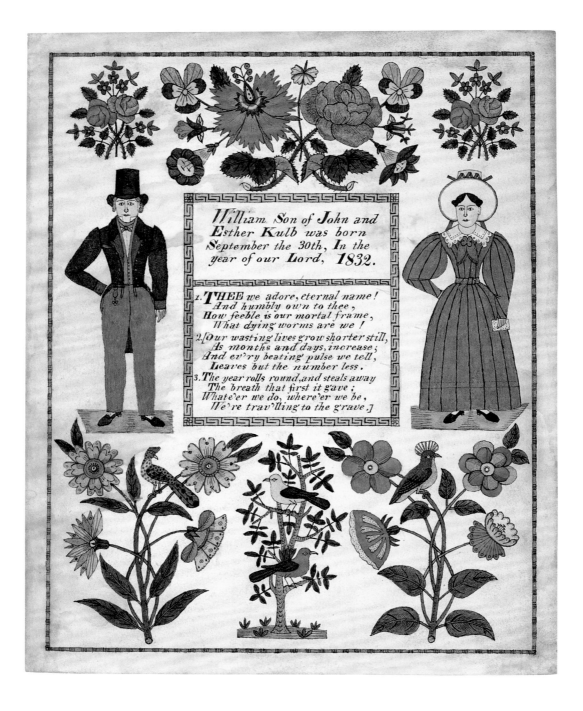

186. BIRTH RECORD FOR WILLIAM KULB, c. 1832
John Zinck (dates unknown), probably Lancaster County, Pennsylvania
Watercolor and ink on paper, 9⅞ × 7⅞ in., P1.2001.214

187. CERTIFICATE OF BIRTH AND BAPTISM
FOR JOHN WESLEY DASHAM, c. 1852
Henry Young (1792–1861), probably Aaronsburg,
Centre County, Pennsylvania
Watercolor and ink on paper, 11 × 7½ in., P1.2001.215

"Certificate of Birth and Baptism."

Mr. John Wesley Dasham, a Son, of Mr. Jacob Dasham, and his wife Lydia, born a Royer, was born December the 16th 1852. This Child was born in Potter Township, Centre County, State of Pennsylvania, and baptised by the Revd. Rothrauf. His Sponsors were, the Parents.

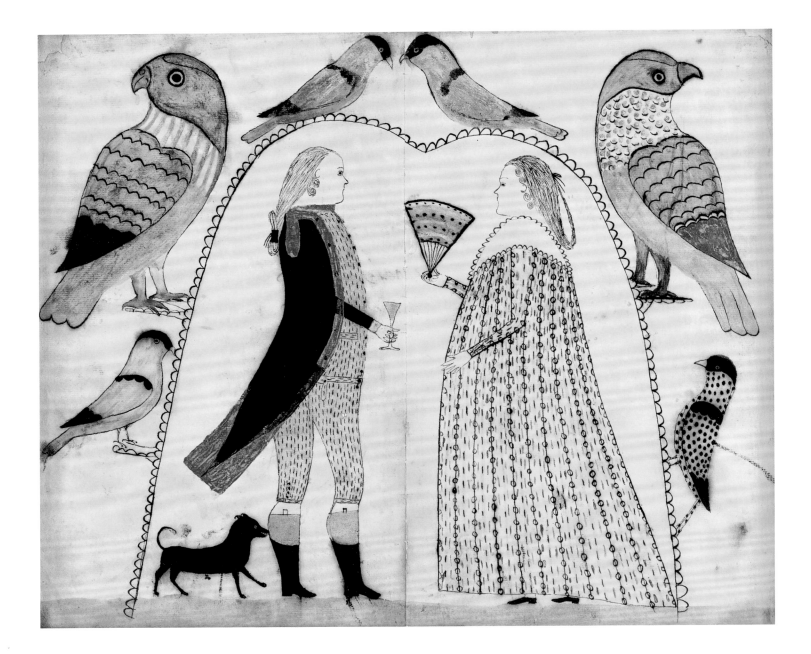

188. COUPLE UNDER AN ARBOR, c. 1800
Artist unidentified, probably Pennsylvania
Watercolor and ink on paper, 11¾ × 14 in., P1.2001.216

189. RELIGIOUS TEXT, 1820–1835
John Van Minian (act. 1791–1835), Berks or Montgomery County,
Pennsylvania, or Baltimore County, Maryland
Watercolor and ink on paper, 8⅛ × 4½ in., P1.2001.217

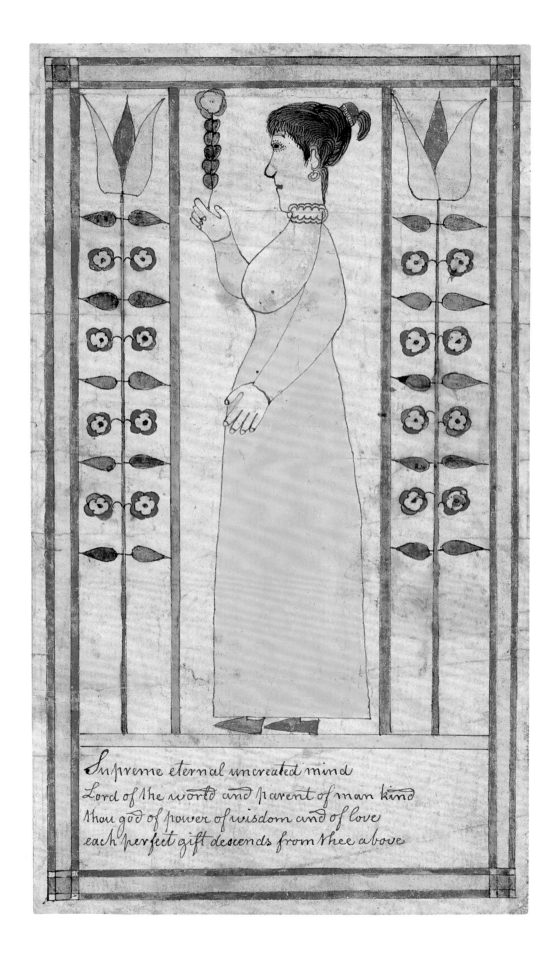

Supreme eternal uncreated mind
Lord of the world and parent of man kind
thou god of power of wisdom and of love
each perfect gift descends from thee above

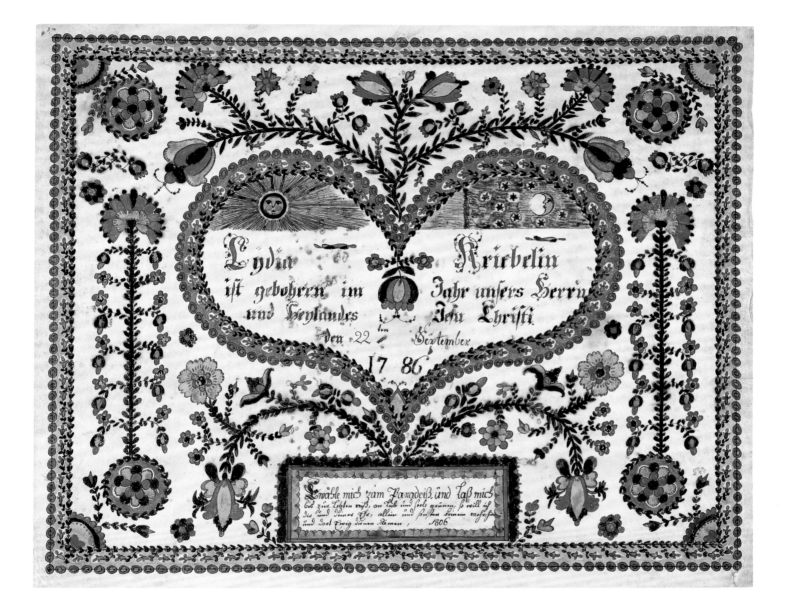

190. Birth Record for Lydia Kriebel, 1806
 "Gott allein die Ehre" Artist, Montgomery County, Pennsylvania
 Watercolor and ink on paper, 13⅛ × 15¾ in., P1.2001.218

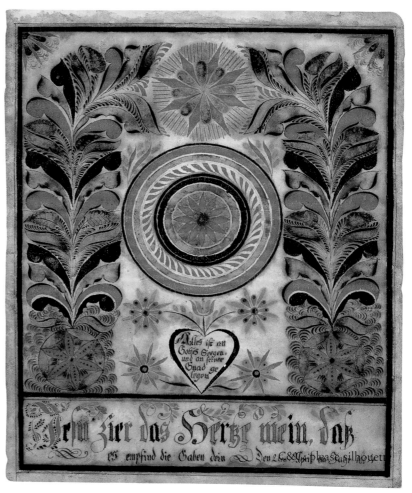

191. RELIGIOUS TEXT WITH CENTER MEDALLION, 1804
David Kriebel (1787–1848), probably Gwynned Township,
Montgomery County, Pennsylvania
Watercolor and ink on paper, 9⅜ × 7¹⁵/₁₆ in., P1.2001.219

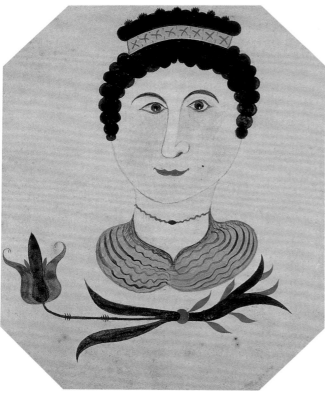

192.
WOMAN WITH CROWN, c. 1842–1850
Sarah Kriebel Drescher (1828–1908),
Worcester Township, Montgomery County,
Pennsylvania
Watercolor and ink on paper, 7⅛ × 5⅞ in.,
P1.2001.220

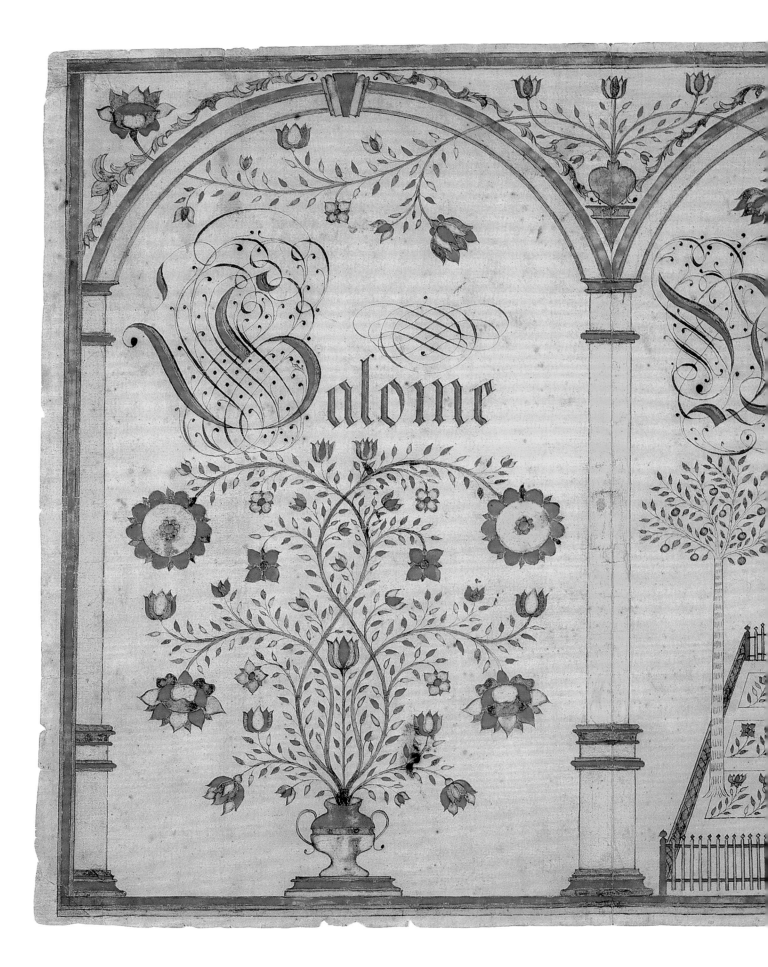

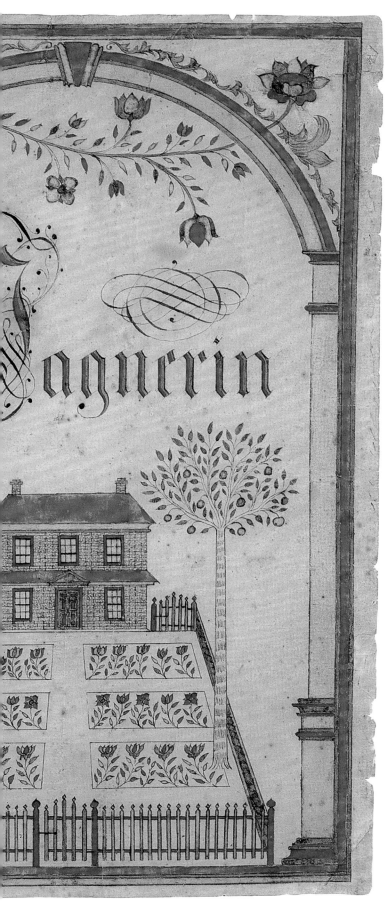

agnerin

193.
DRAWING FOR SALOME WAGNER, c. 1810
Artist unidentified, probably Montgomery County, Pennsylvania
Watercolor and ink on paper, 12¹⁵⁄₁₆ × 16¼ in., P1.2001.221

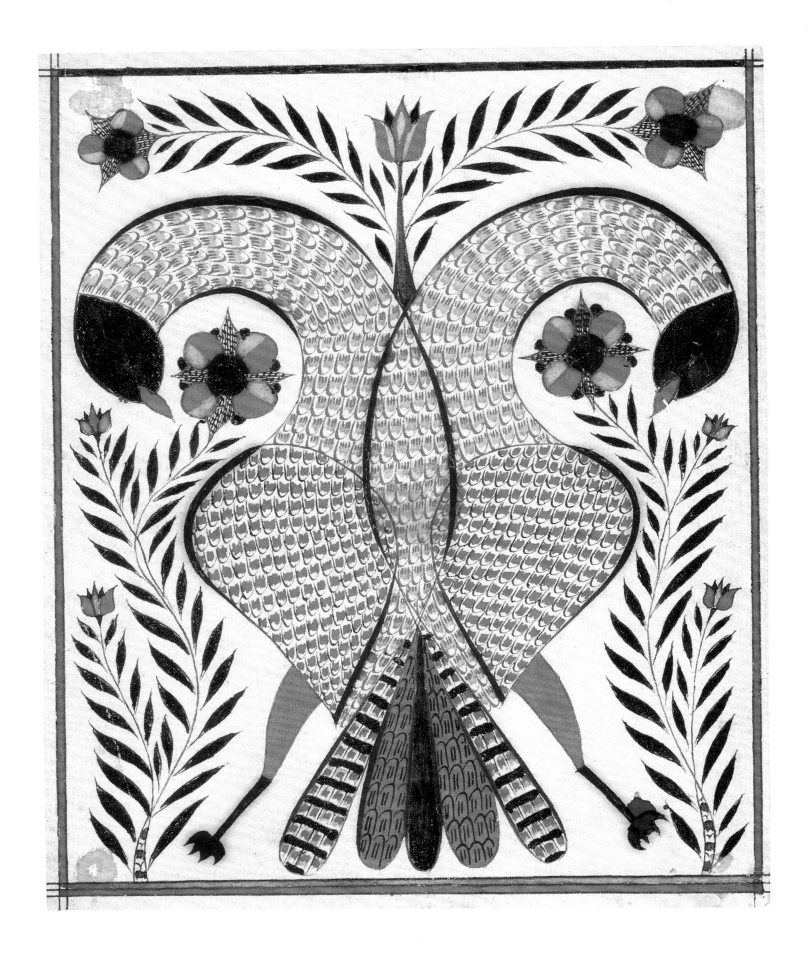

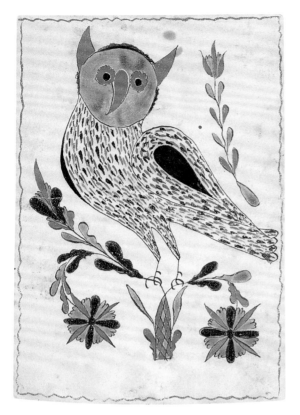

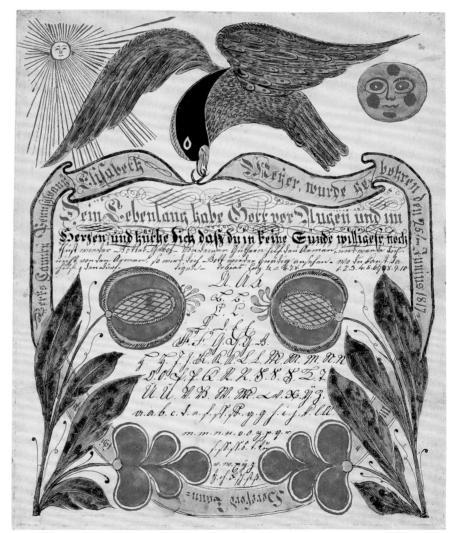

195.
Presentation Fraktur of an Owl, c. 1810
Artist unidentified, probably Lehigh County, Pennsylvania
Watercolor and ink on paper, 5¼ × 3½ in., P1.2001.223

194. **Presentation Fraktur of a Double Eagle**, c. 1815
David Kulp (1777–1834), Bucks County, Pennsylvania
Watercolor and ink on paper, 7⅝ × 6¼ in., P1.2001.222

196. *Vorschrift* and **Birth Record**
for Elisabeth Meyer, c. 1817
Hereford Township Artist, Hereford Township,
Berks County, Pennsylvania
Watercolor and ink on paper, 9¾ × 7⅞ in.,
P1.2001.224

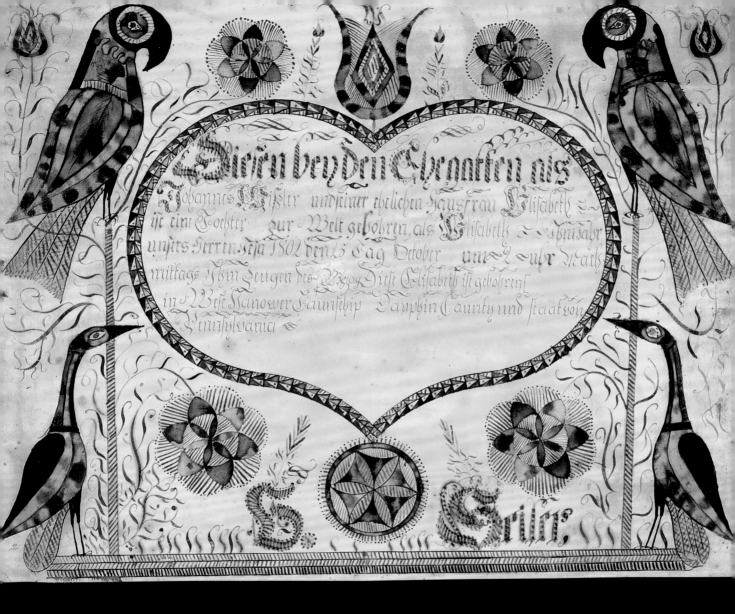

197. *TAUFSCHEIN* FOR ELISABETH WISSLER, C. 1810
Heinrich Seiler (dates unknown), probably Dauphin County,
Pennsylvania
Watercolor and ink on paper, 12⅛ × 12 in. P1.2001.335

198. LABYRINTH, C. 1820
Heinrich Seiler (dates unknown), probably Lebanon
or Dauphin County, Pennsylvania
Watercolor and ink on paper, 14¾ × 12⅛ in. 1299.272

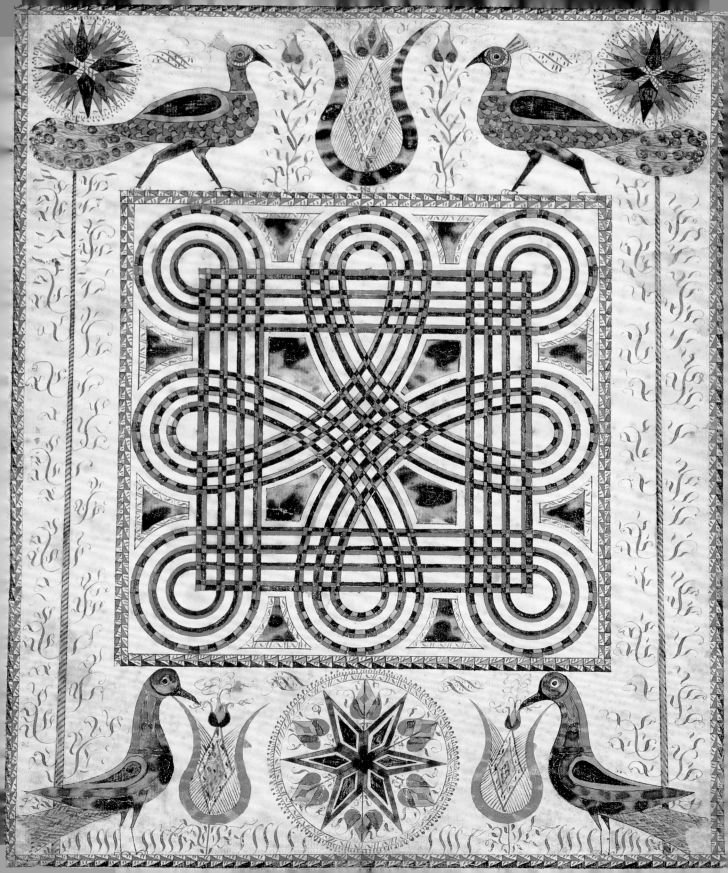

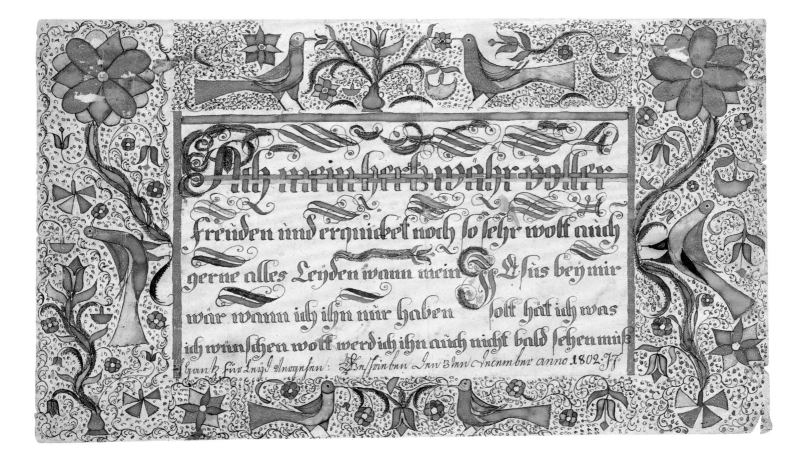

199. Religious Text with Birds and Flowers, 1802
Jacob Fleischer (1761–1845), probably Lancaster County, Pennsylvania
Watercolor and ink on paper, 8 × 13⁷⁄₁₆ in., P1.2001.226

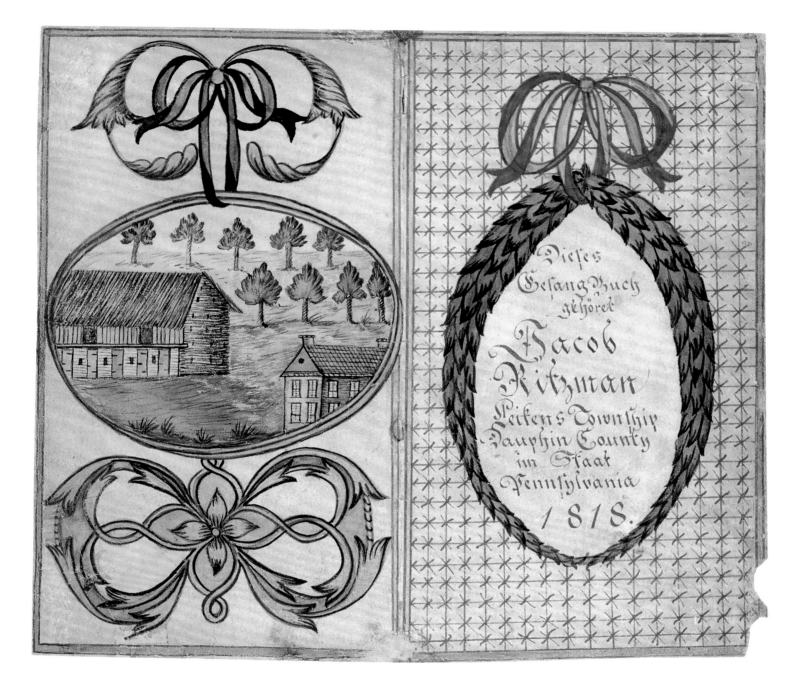

200. BOOKPLATE FOR JACOB RITZMAN, 1818
Karl Münch (1769–1833), Lykens Township, Dauphin County, Pennsylvania
Watercolor and ink on paper (removed from original book), 7 × 6¼ in., P1.2001.227

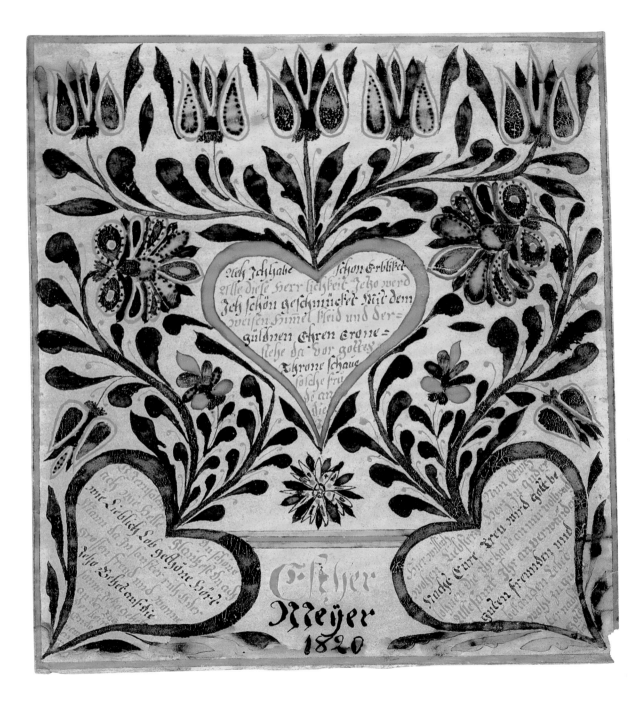

201. RELIGIOUS TEXT FOR ESTHER MEYER, 1820
Artist unidentified, southeastern Pennsylvania
Watercolor and ink on paper, 7⁵⁄₁₆ × 6⁷⁄₁₆ in.,
P1.2001.228

202. RELIGIOUS TEXT WITH BIRDS AND HEARTS, 1824
Artist unidentified, Weaverland, Earl Township,
Lancaster County, Pennsylvania
Watercolor and ink on paper, 12 × 9⅞ in., P1.2001.229

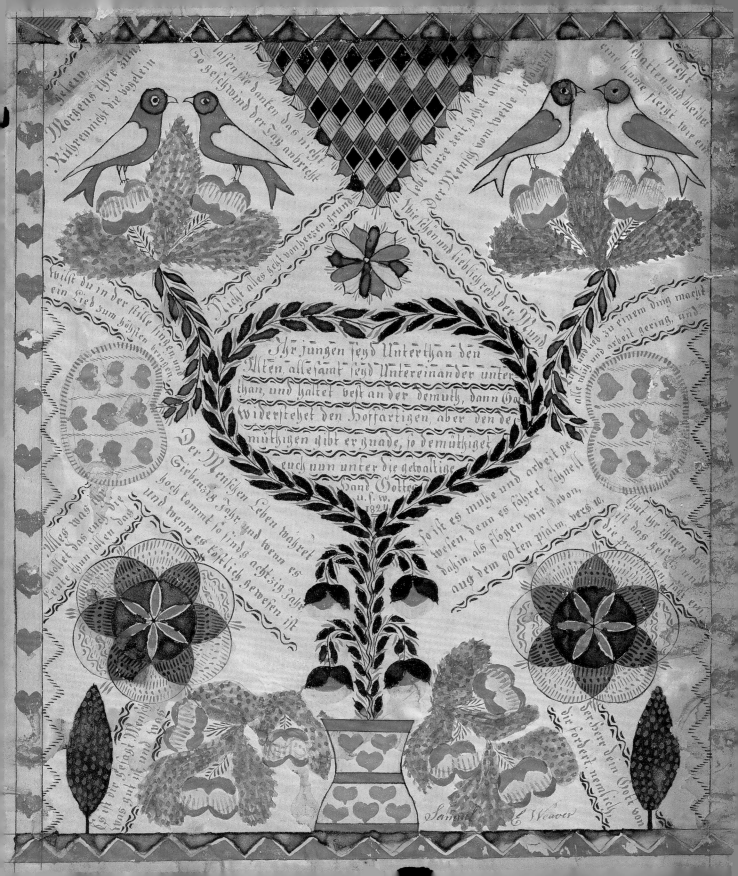

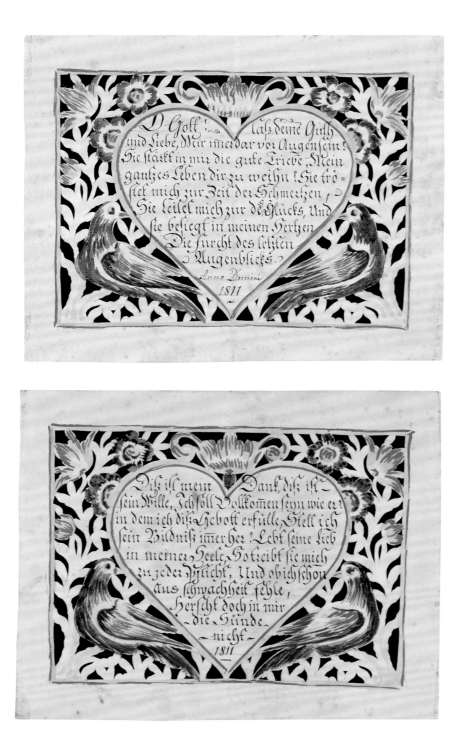

203a–b. RELIGIOUS TEXT PAPERCUTS, 1811
William A. Faber (dates unknown), probably
Lancaster or Berks County, Pennsylvania
Watercolor and ink on cut paper, 6⅛ × 7¾ in. each,
P1.2001.230a, b

204. BOOKPLATE FOR SARA HOCH, 1808
David Kulp (1777–1834), Bucks County, Pennsylvania
Watercolor and ink on paper, 6¹³⁄₁₆ × 4½ in., P1.2001.231

232

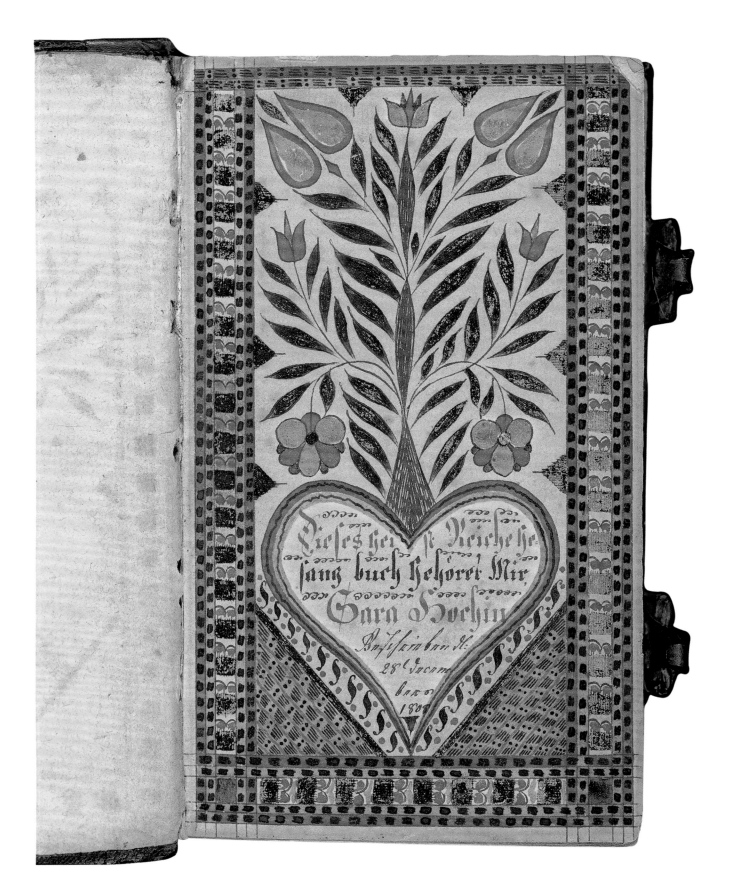

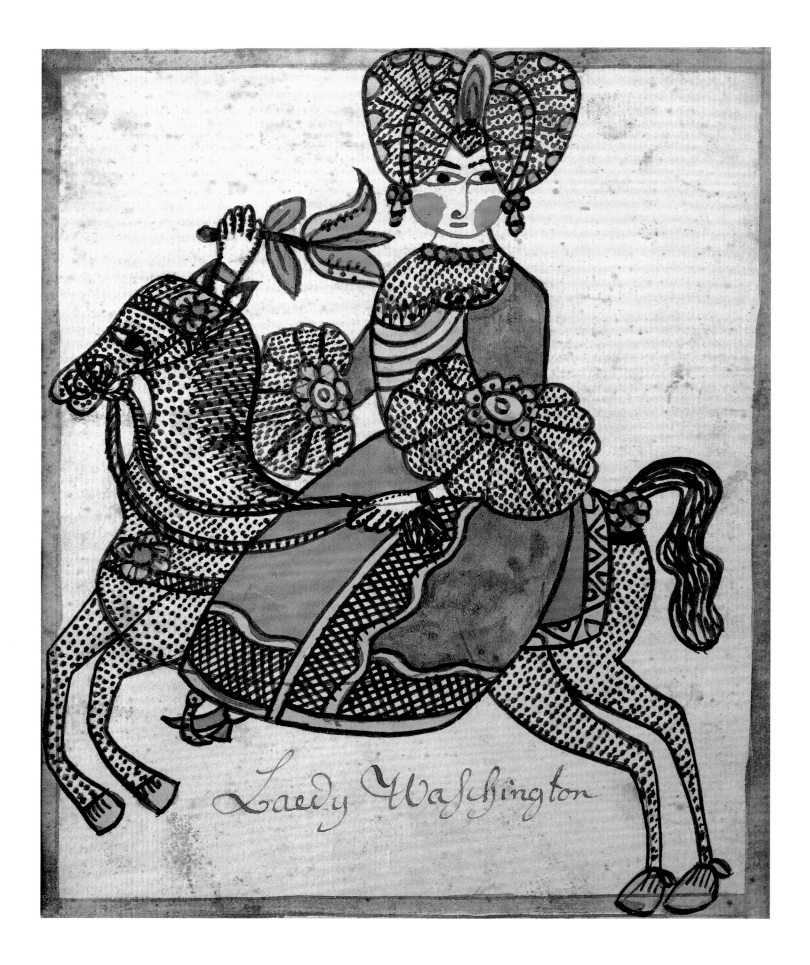

Laedy Washington

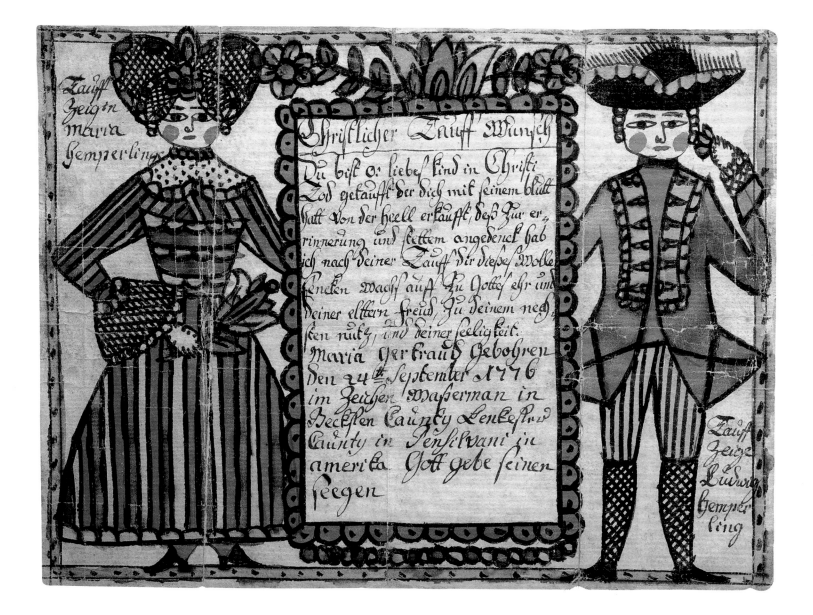

206. *Taufwunsch for Maria Gertraud*, c. 1776
The Sussel-Washington Artist, probably Berks County, Pennsylvania
Watercolor and ink on paper, 6⁷⁄₁₆ × 8¹⁄₁₆ in., P1.2001.233

205. Laedy Waschington, c. 1780
The Sussel-Washington Artist, possibly Berks County, Pennsylvania
Watercolor and ink on paper, 7¾ × 6¼ in., P1.2001.232

207. *TAUFSCHEIN* FOR ELISABETH EYSTER, c. 1780
Artist unidentified, probably York County, Pennsylvania
Watercolor and ink on paper, 8¾ × 6¾ in., P1.2001.234

208. GENNERAL WASCHINGTON, c. 1810
Artist unidentified, southeastern Pennsylvania
Watercolor, gouache, ink, and metallic paint on paper, 9⅝ × 8 in., P1.2001.235

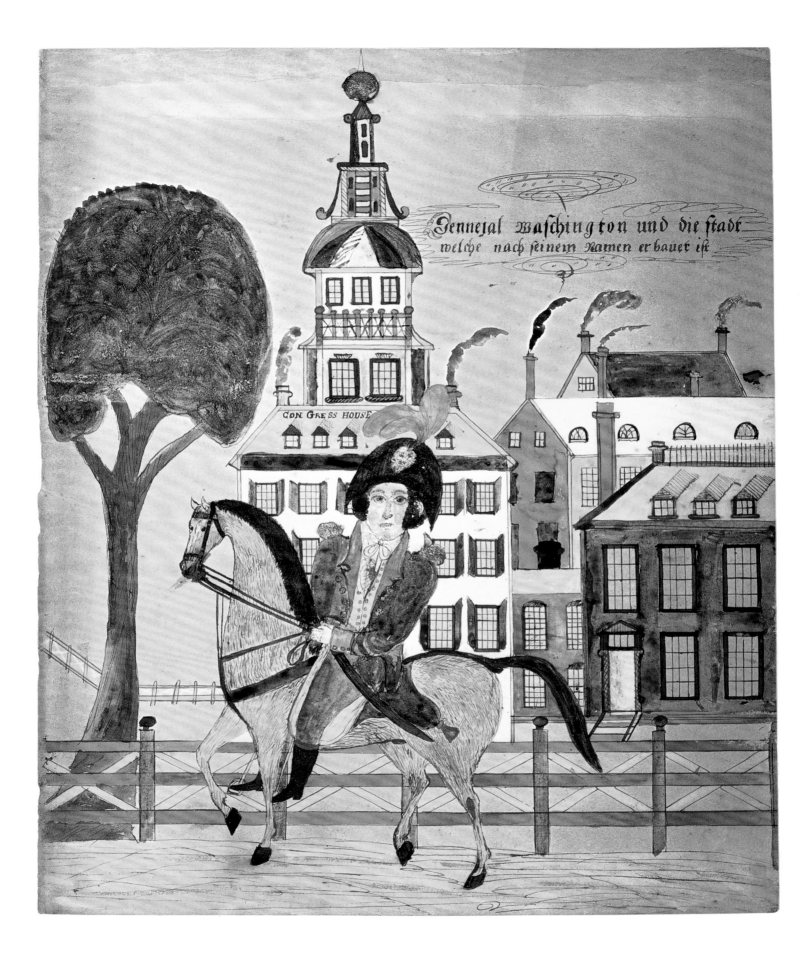

Gennejal Waſchington und die ſtadt
welche nach ſeinem Namen erbauet iſt

CON GRESS HOUSE

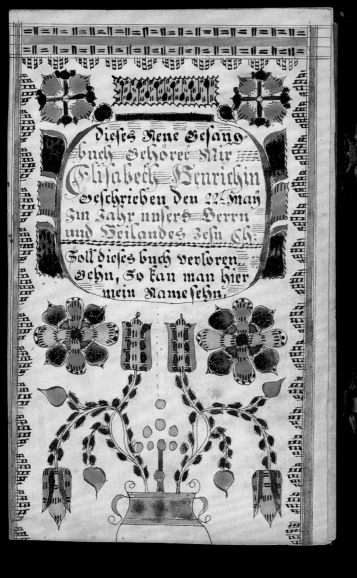

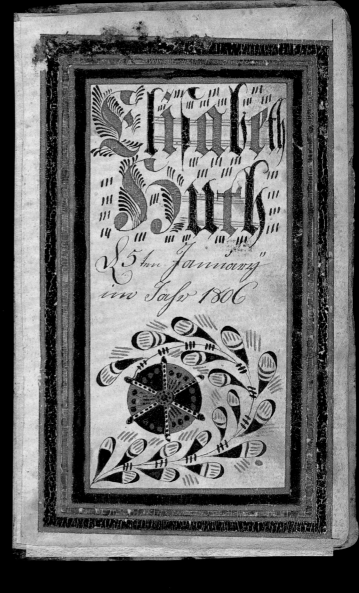

209. **Bookplate for Elisabeth Henrich**, c. 1815
Attributed to Samuel Musselman (dates unknown),
probably Bucks County, Pennsylvania
Watercolor and ink on paper, 6¾ × 4⅜ in., P1.2001.236

210. **Bookplate for Elisabeth Huth**, 1806
Possibly David Kriebel (1787–1848), probably
Montgomery County, Pennsylvania
Watercolor and ink on paper, 5½ × 3⅜ in., P1.2001.237

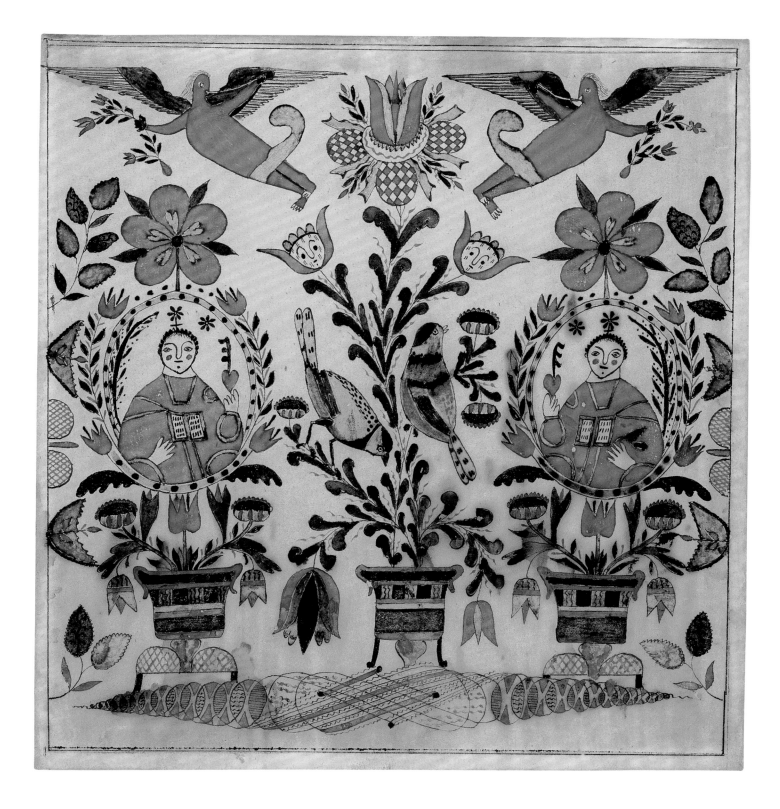

211. TWO PRIESTS, c. 1810
Artist unidentified, possibly Berks or Montgomery County, Pennsylvania
Watercolor and ink on paper, 8⅞ × 7¼ in., P1.2001.238

Jacob Schmidt's Gesang-Buch

in Washington Taunschip, Franklin County, Pennsylvania. den 5ten May

1833.

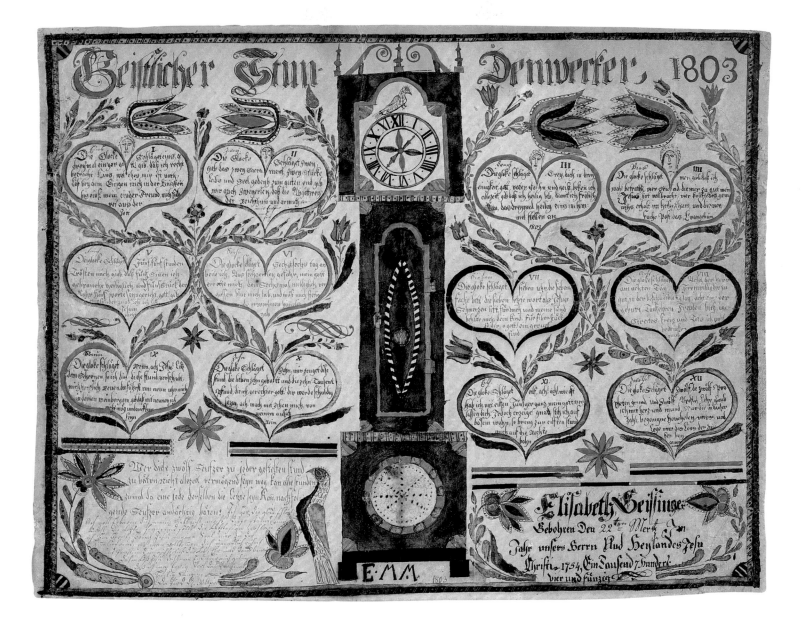

213. RELIGIOUS TEXT WITH SPIRITUAL CHIMES FOR ELISABETH GEISSINGER, 1803
Artist unidentified, probably Bucks County, Pennsylvania
Watercolor and ink on paper, 12⅞ × 15⅞ in., P1.2001.240

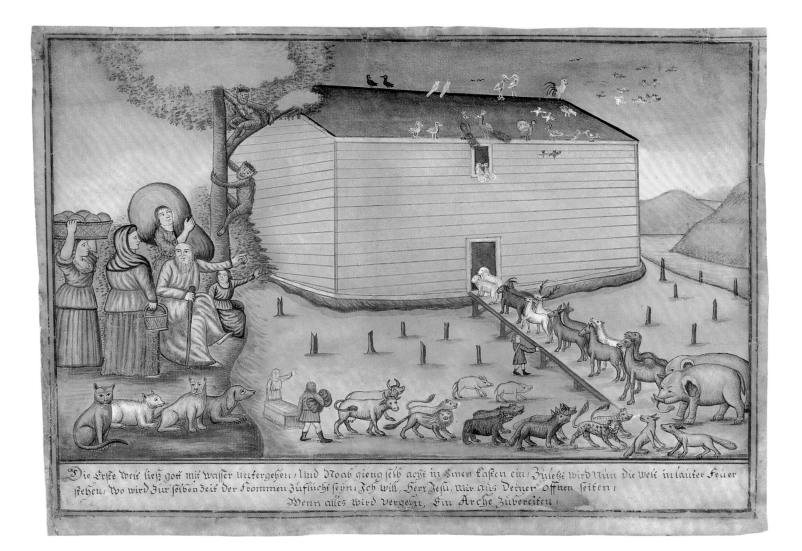

Die Erste Welt ließ gott mit wasser untergehen, Und Noah gieng selb acht in einen kasten ein, Zuletzt wird Nun die welt in lauter Feuer stehen, Wo wird Zur selben Zeit der frommen Zuflucht seyn, Ich will, Herr Jesu, mir aus Deiner offnen seiten, Wenn alles wird vergehn, Ein Arche Zubereiten,

214. NOAH'S ARK, c. 1830
John Landis (1805–?), possibly Lancaster County, Pennsylvania
Watercolor and ink on paper, 10 × 13⅝ in., P1.2001.241

215. THE BIRTH OF CHRIST, 1835
John F.W. Stahr (dates unknown), probably
southeastern Pennsylvania
Watercolor and ink on paper, 15¾ × 12⅝ in., P1.2001.242

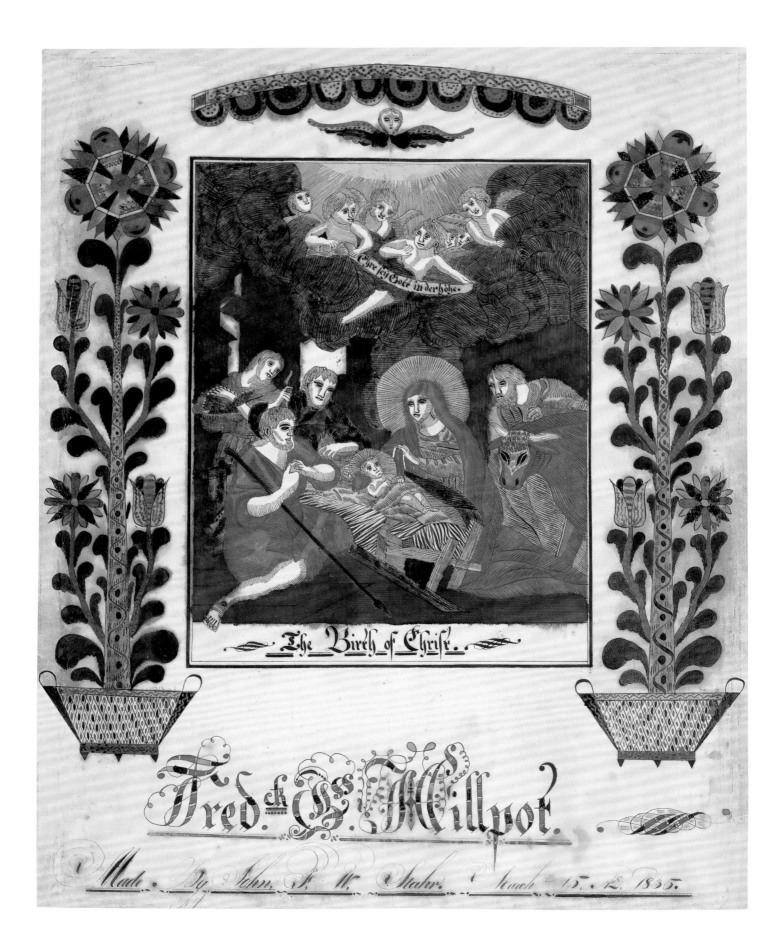

The Birth of Christ.

Fred.ck G. S. M. Cillpot.

Made. By John, F. W. Staler. March. 15. 12. 1835.

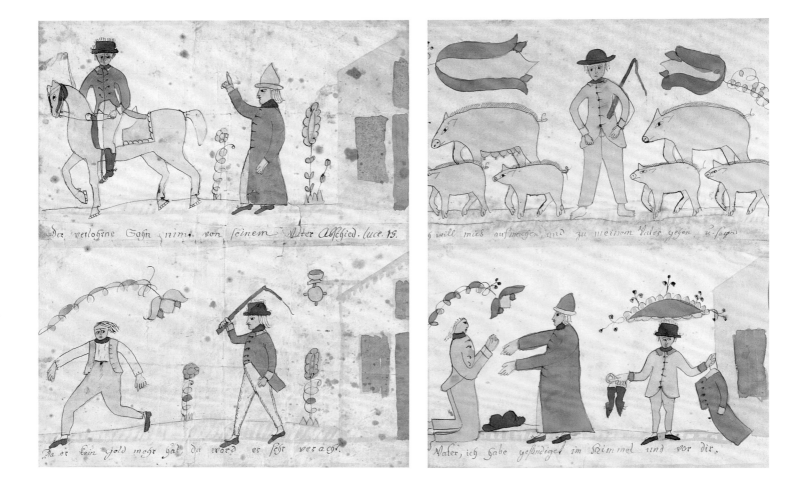

216a–b. THE PRODIGAL SON, c. 1805
Friedrich Krebs (1749–1815), probably Dauphin County, Pennsylvania
Watercolor and ink on paper, 15 × 12¼ in. and 15¼ × 12 in., P1.2001.243a, b

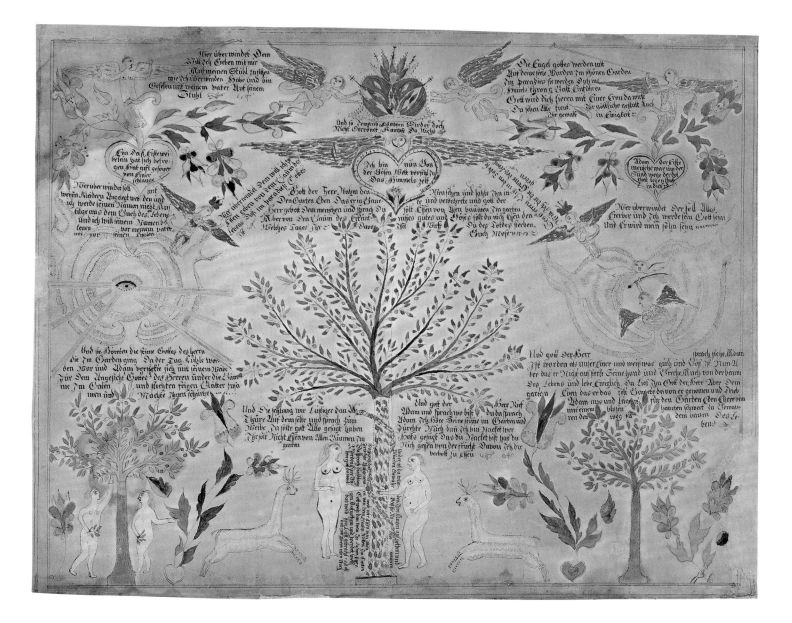

217. RELIGIOUS TEXT WITH ADAM AND EVE, early nineteenth century
Artist unidentified, southeastern Pennsylvania
Watercolor and ink on paper, 13 × 15⅞ in., P1.2001.244

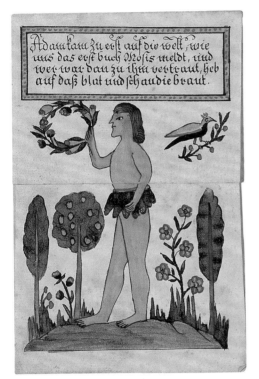

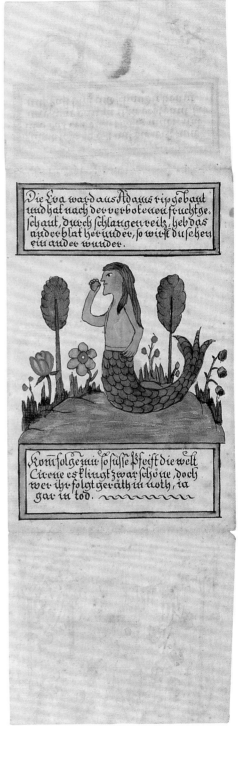

218a–l. METAMORPHOSIS, c. 1810
Durs Rudy Sr. (1766–1843) or Durs Rudy Jr. (1789–1850),
probably Lehigh County, Pennsylvania
Watercolor and ink on paper, 6¹⁄₁₆ × 3¹¹⁄₁₆ in., 6⅛ × 3¾ in.,
6³⁄₁₆ × 3¾ in., and 6³⁄₁₆ × 3¹¹⁄₁₆ in. (folded), P1.2001.245a–d

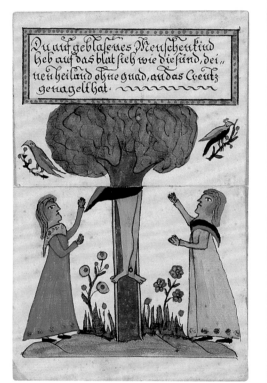

Du auf geblasenes Menschenkind
heb auf das blat sieh wie die sünd, dei-
nen heiland ohne gnad, an das Creutz
genagelt hat. ～～～

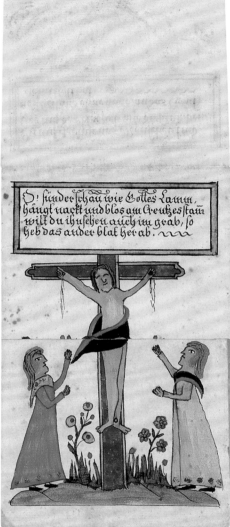

O sünder schau wie Gottes Lamm,
hängt nackt und blos am Creutzes stam
wilt du ihn sehen auch im grab, so
heb das ander blat herab. ～

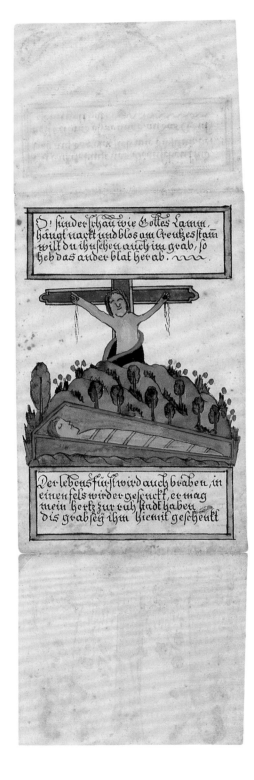

O sünder schau wie Gottes Lamm,
hängt nackt und blos am Creutzes stam
wilt du ihn sehen auch im grab, so
heb das ander blat herab. ～

Der lebens fürst wird auch begraben, in
einen fels wird er gesenkt, er mag
mein hertz zur ruh statt haben
dis grab sey ihm hiemit geschenkt

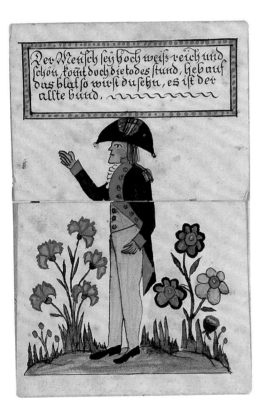

Der Mensch sey hoch, weiß, reich und
schön, kompt doch die todes stund, heb auf
das blat so wirst du sehn, es ist der
allte bund.

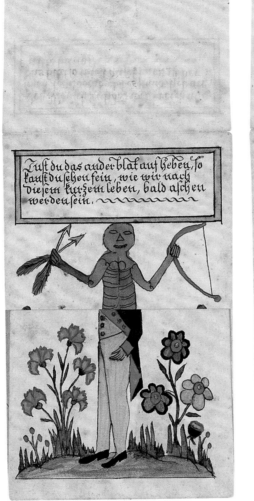

Just du das ander blat auf heben, so
kanst du sehen fein, wie wir nach
diesem kurzem leben, bald aschen
werden sein.

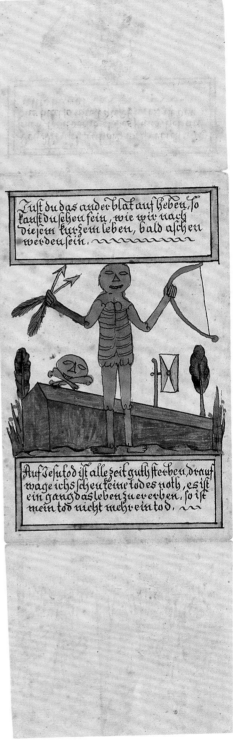

Just du das ander blat auf heben, so
kanst du sehen fein, wie wir nach
diesem kurzem leben, bald aschen
werden sein.

Auf Jesu tod ist alle zeit guth sterben, drauf
wag ichs scheu keine todes noth, es ist
ein ganß das leben zu verberben, so ist
mein tod nicht mehr ein tod.

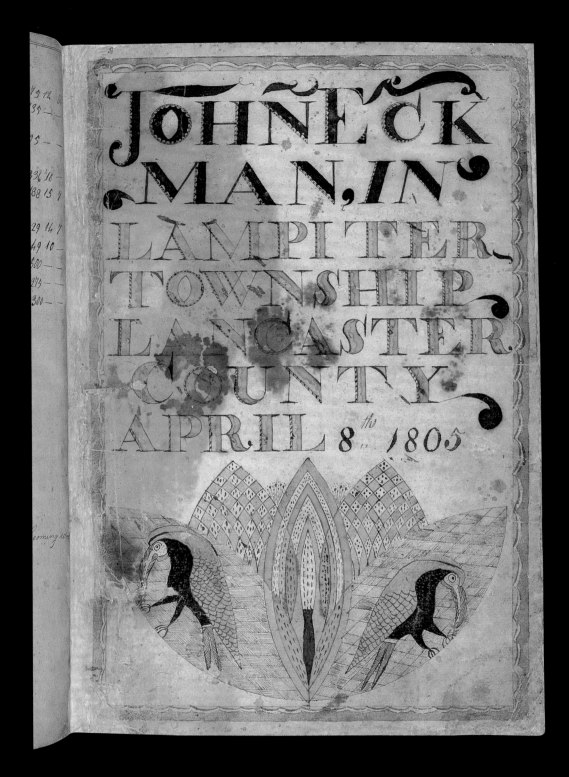

219a–d. **Book of Sample Accounts of John Eckman**, 1805
Artist unidentified, possibly John Eckman (dates unknown),
Lampeter Township, Lancaster County, Pennsylvania
Watercolor and ink on paper, with paper binding,
12¼ × 8⅜ × ⅜ in. (closed), P1.2001.246

£	S	D		£	S	D
263	4	—	Contra			
300	—	—	By Lewis's Stock My Account Due to him			
290	10	—	287 £3 Ns English A 3½ per Cent is	811	2	2½
400	—	—	By Abel my Account due to him 250 Livres			
60	—	—	Tournois 12d per	12	10	—
275	—	—	By wares from Leghorn for Sales 20 Chests wine			
47	10	—	and 13 oil	101	9	
38	16	—	By Stock for My Neat Capital	3116	7	4
72	18	4		3611	4	6½
207	18	4				
231	—	—				
101	4	—				
600	—	—				
205	—	—				
173	0	10½				
105	—	—				
225	—	—				
3571	4	6½				

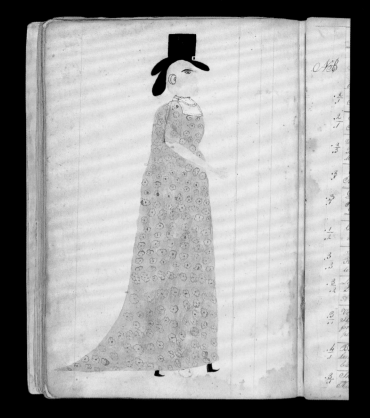

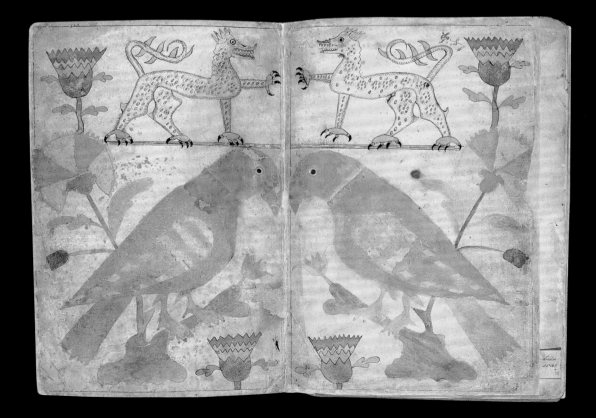

Compound Subtraction

Dry Measure

Cl	Bu	Pe	Qr		Cl	Bu	Pe
19	2	1			40	1	2
10	1	3			16	3	1
7	0	2 Ans			23	3	2 1

Qr	B	Pe		Qr	B	Pe
19	1	1		26	1	3
12	7	2		19	1	2
6	2	3 Ans		7	0	1

Time

D	H	M	S		D	H	M	Sec
41	15	28	13		71	10	20	10
22	16	33	31		10	19	44	20
18	20	48	41		5	4	15	23 14

Y	D	H	M	Sec
17	1	10	13	10
10	2	14	6	15
6	5	20	5	55 Ans

Motion

o	'	''		o	'	''
49	10	12		41	2	10
12	11	16		12	19	46
28	58	56	24	42	24 o 1	

o	'	''
62	13	9
49	18	33
12	54	36

Answer John White

Questions to exercise Subt:

1) A Man was born in the year 1702 & Demand his age in the year 1767 — 1767 1702 — 65

2) Their are 2 Numbers the greater Number is 61 & the lesser is 44 Demand the Difference Answer — 61 44 — 17 Ans

3) Their were 4 Bags of Money Containing as follows Viz the first 34 £ the 2d 50 £ the 3d 100 £ the 4th 150 £ which were to be Paid several Taxes but 1 of the bagebing left there were but 234 £ paid Demand which bag was left

4) The Brewer and the Baker drew Bills Each upon the other the brewer stands indebted 45 £ 19 s the baker 26 £ 2 s Viz who is the person indebted & how much Answer

5) King Charles the Martyr was beheaded in the year 1648 how many years till since

6) A Man borrows 33 £ paid in part 12 £ 10 s Demand how much remains

7) What Sum is that which taken from 100 £ Leaves 48 £ 7 s 6d

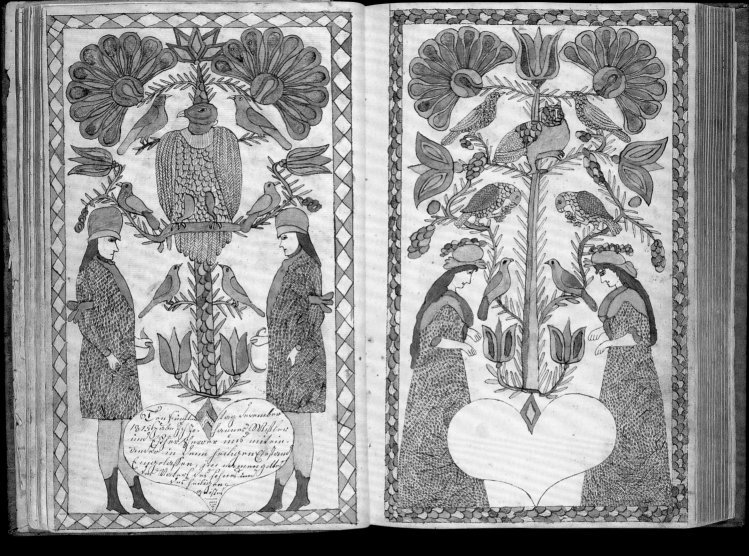

220a–c. BOOK OF ARITHMETIC PROBLEMS OF JOHANNES WHISLER, 1814–1815
Artist unidentified, probably Johannes Whisler (?–1874), Mifflin Township,
Cumberland County, Pennsylvania
Watercolor and ink on paper, with leather binding, 13 × 8⅛ × 1¹⁵⁄₁₆ in. (closed),
P1.2001.247

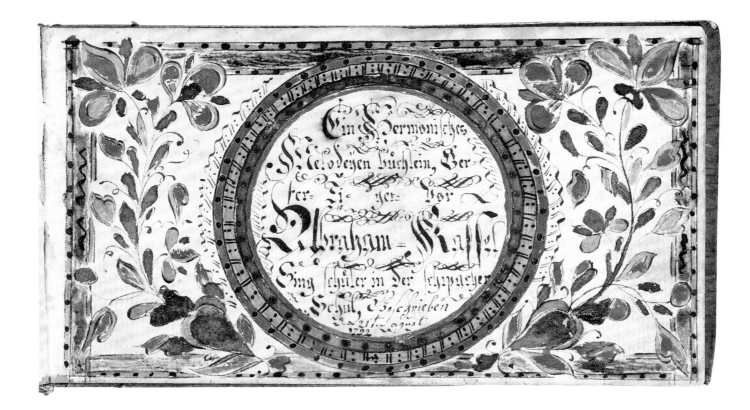

221. **Tunebook for Abraham Kassel**, 1792
Jacob Gottschall (1769–1845), Skippack, Montgomery County, Pennsylvania
Watercolor and ink on paper, with leather binding, 3¾ × 6⅝ × ½ in. (closed),
P1.2001.248

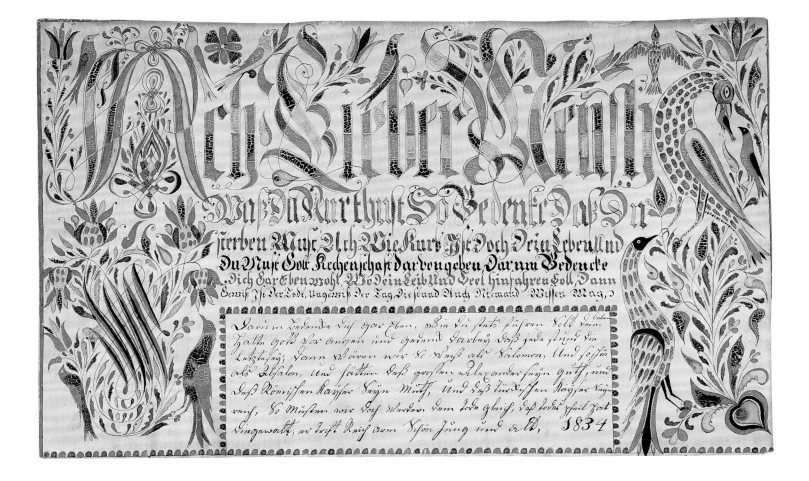

222. *VORSCHRIFT* WITH BIRDS, 1834
Gottschall family member, probably Franconia Township, Montgomery County, Pennsylvania
Ink, watercolor, and gouache on paper, 8 × 12¾ in., P1.2001.249

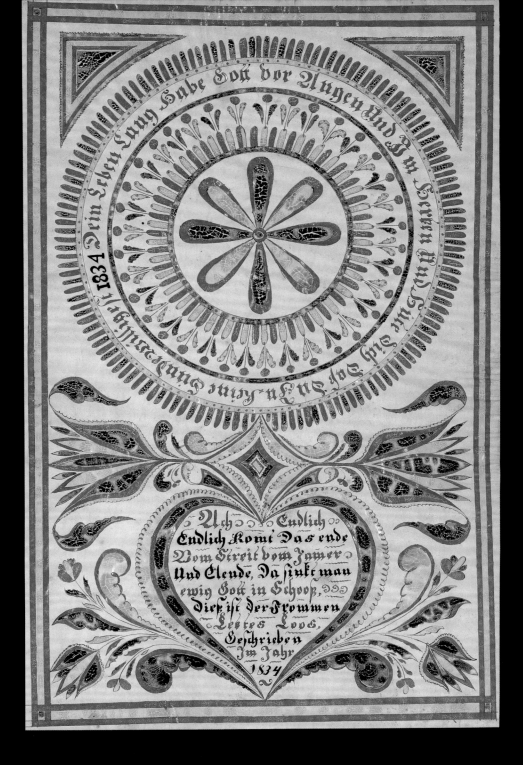

223. **RELIGIOUS TEXT WITH MEDALLION ABOVE HEART**, 1834
Samuel Gottschall (1808–1898), Salford Township,
Montgomery County, Pennsylvania
Ink, watercolor, and gouache on paper, 12⅛ × 7⅝ in., P1.2001.250

224. **RELIGIOUS TEXT WITH TWO WOMEN IN STRIPED DRESSES**, c. 1834
Samuel Gottschall (1808–1898), Salford Township, Montgomery County,
Pennsylvania
Ink, watercolor, and gouache on paper, 12¼ × 8 in., P1.2001.251

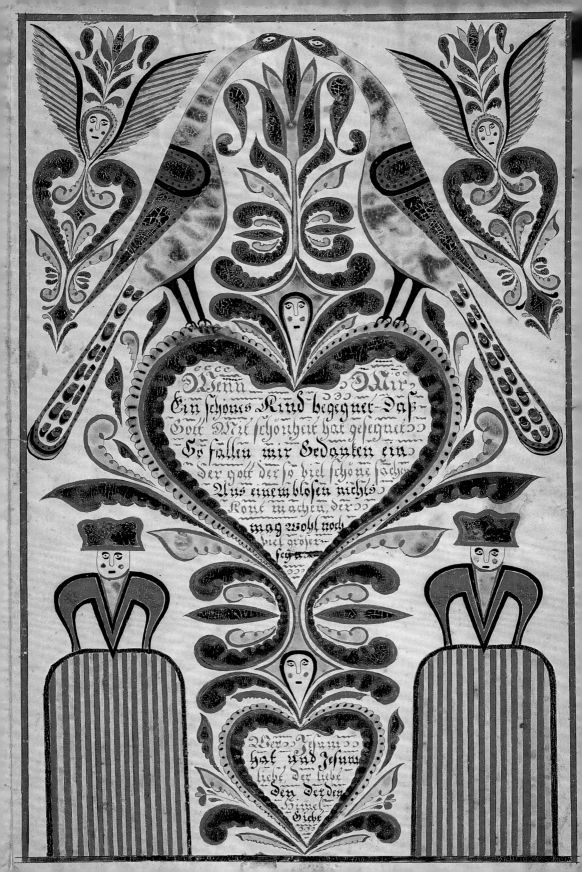

225. MAN FEEDING A BEAR AN EAR OF CORN, c. 1840
Artist unidentified, probably Pennsylvania
Watercolor, ink, and pencil on paper, 5⅝ × 7½ in.,
P1.2001.252

A day of feasting & ordain, Let joy and mirth
abound My son was dead yet lives again
Was lost and now is found.

And now my young companion
A warning take by me
Leave off your rambling
And shun bad company

CHAPTER 7

NARRATIVE WATERCOLORS

Now I have Gold and Silver store Poor
Bribes from the Rich pawnd of the —
No worldly cares can trouble me
Turn Down the Leaf & you Shall See

226a–o.

METAMORPHOSIS, 1794
Artist unidentified, probably New England
Watercolor and ink on paper, *Adam:* 6⅛ × 3¹⁄₁₆ in.
Cain: 6⅛ × 3³⁄₁₆ in., *Lion:* 6¹⁄₁₆ × 3³⁄₁₆ in., *Child:*
6⅛ × 3⅛ in., *Gold and Silver:* 6⅛ × 2¹⁵⁄₁₆ in. (folded
P1.2001.253a–e

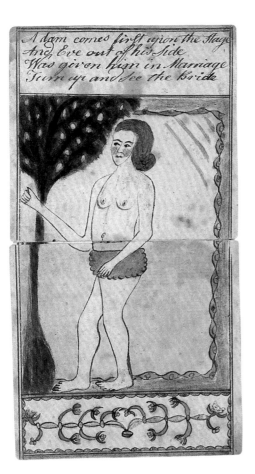

A dam comes first upon the stage
And Eve out of his Side
Was given him in Marriage
Turn up and see the Bride

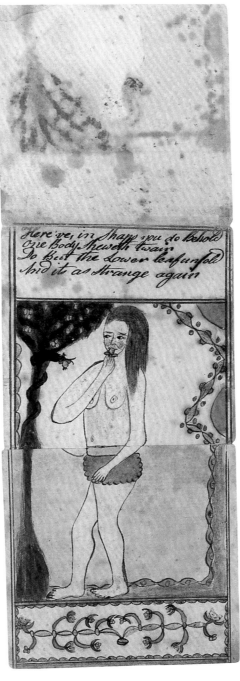

Here've, in Shape you do behold
One Body sheweth twain
Do but the Lower leaf unfold
And it as strange again

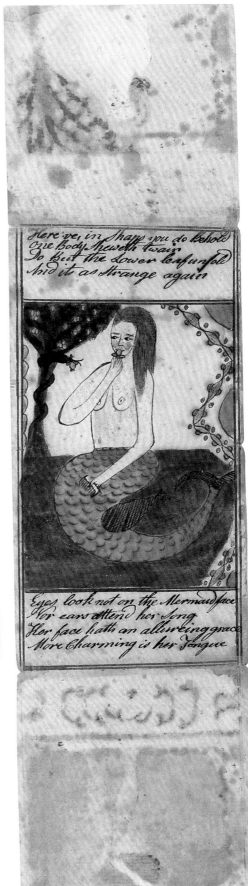

Here've, in Shape you do behold
One Body sheweth twain
Do but the Lower leaf unfold
And it as strange again

Eyes look not on the Mermaid face
Nor ears attend her Song
Her face hath an alluring grace
More Charming is her Tongue

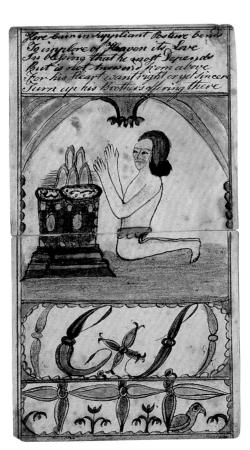

Here Cain in suppliant Posture bends
To implore of Heaven its Love
In helping that he must Depends
But is not answerd from above
For his Heart want right or yet sincere
Turn up his Brothers offering there

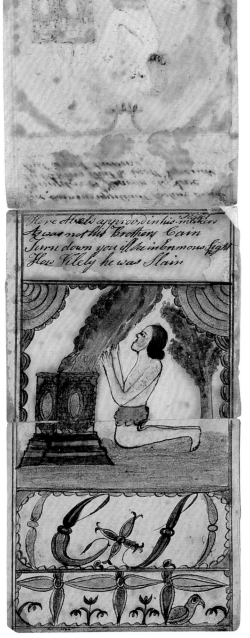

Here Abels approvd in his Maker
He was not his Brothers Cain
Turn down you'll be in enmous sight
How Vilely he was Slain

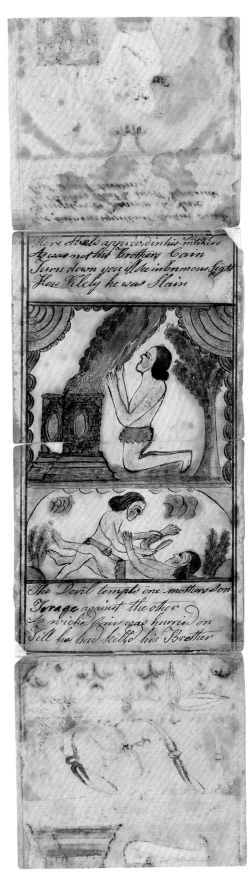

Here Abels approvd in his Maker
He was not his Brothers Cain
Turn down you'll be in enmous sight
How Vilely he was Slain

The Devil tempts one mothers Son
To rage against the other
So wicked Cain was hurried on
Till he had killd his Brother

A Lion rousd from his Den
on purpose for to range
he is Turnd into another Beast
Turn up and see how strange

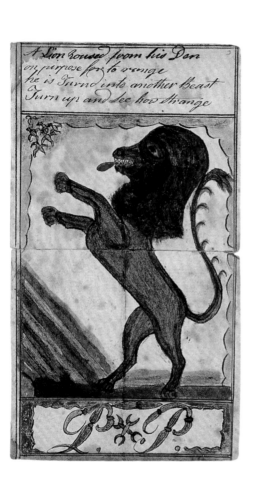

ℒ B ℒ P

A Griffen shape you do Behold
Half fowl half Beast to be
Do but the Lower Leaf unfold
and a Stranger sight you see

ℒ B ℒ P

A Griffen shape you do Behold
Half fowl half Beast to be
Do but the Lower Leaf unfold
and a Stranger sight you see

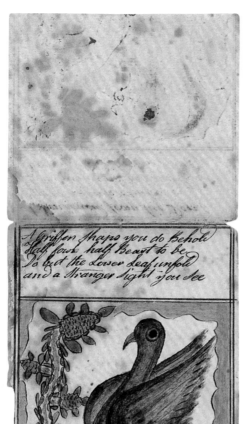

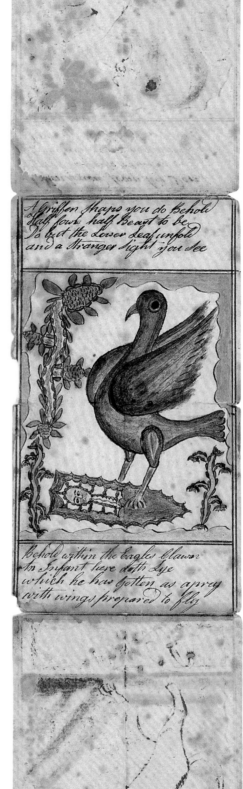

Behold within the Eagles Clawes
An Infant here doth Lye
which he has Gotten as a prey
with wings prepared to fly

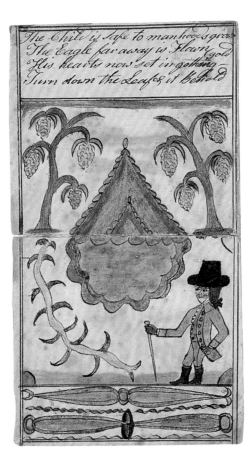

The Child is safe to man hoods grown
The Eagle far away is Flown
His hearts now set in gothing gold
Turn down the Leaf & it Behold

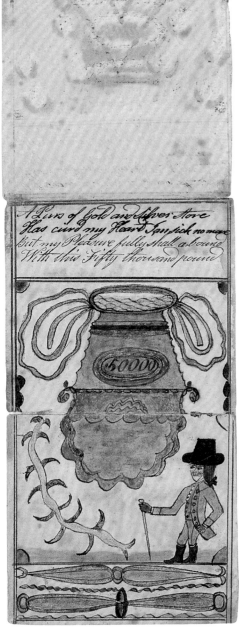

A Purs of Gold and Silver Store
Has cur'd my Heart I'm sick no more
But my Pleasure fully shall abound
With this Fifty thousand pound

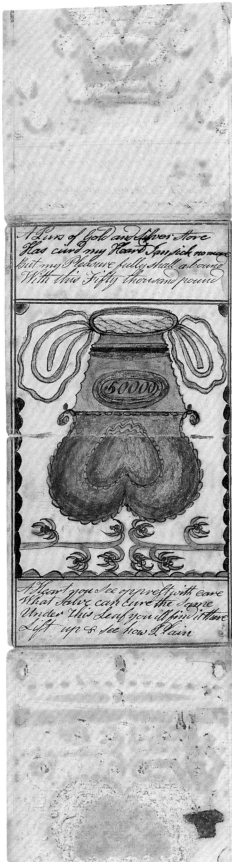

A Purs of Gold and Silver Store
Has cur'd my Heart I'm sick no more
But my Pleasure fully shall abound
With this Fifty thousand pound

A Heart you see oppres't with care
What Salve can cure the same
Under this Leaf you'll find it have
Lift up & see how Plain

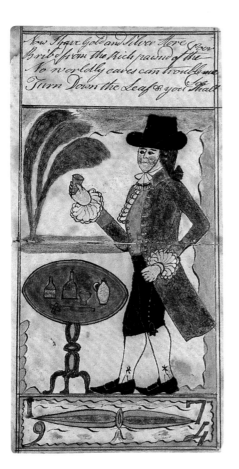

Now I have Gold and Silver Here Ever
Bribes from the rich paund of the
No worldly cares can trouble me
Turn Down the Leafe & you Shall

1 7
9 4

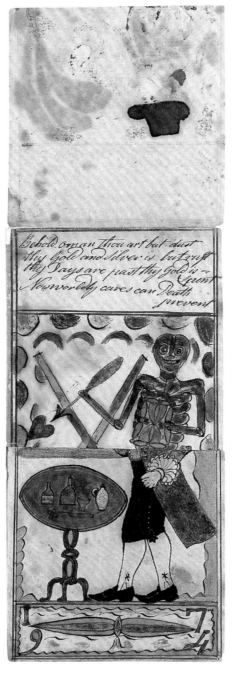

Behold O man thou art but dust
thy Gold and Silver is but rust
thy Days are past thy Gold is
Spent
No worldly cares can Death
prevent

1 7
9 4

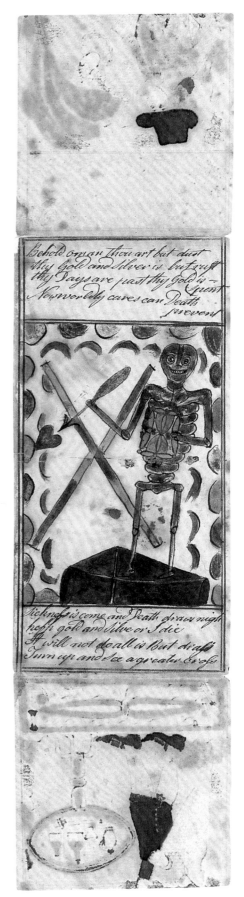

Behold O man thou art but dust
thy Gold and Silver is but rust
thy Days are past thy Gold is
Spent
No worldly cares can Death
prevent

Sickness is come and Death draws nigh
helpe gold and Silver or I die
If will not doall is But drass
Turn up and See a greater Crofs

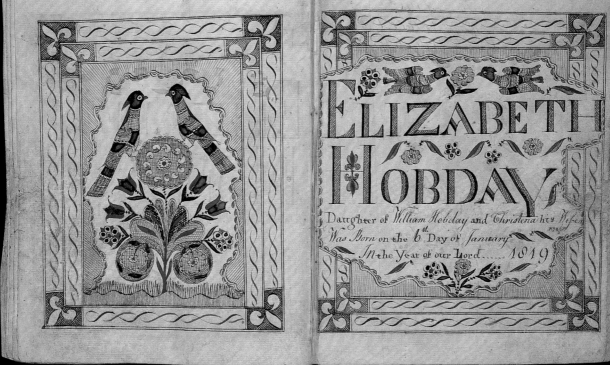

227a–b. HOBDAY FAMILY RECORD BOOK, c. 1820–1825
Artist unidentified, Frederick County, Virginia
Ink on paper with paperboard binding,
10¼ × 8 × 3/16 in. (closed), P1.2001.254

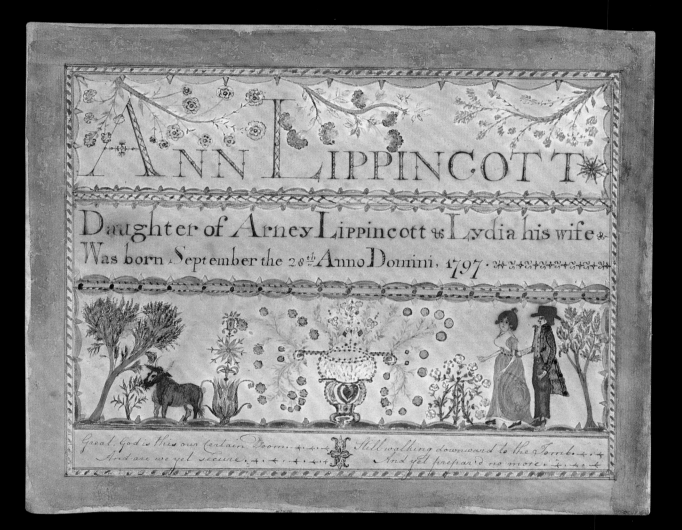

228. BIRTH CERTIFICATE FOR ANN LIPPINCOTT, 1797
The New Jersey Artist, Burlington County, New Jersey
Watercolor and ink on paper, 8 × 9⅞ in., P1.2001.255

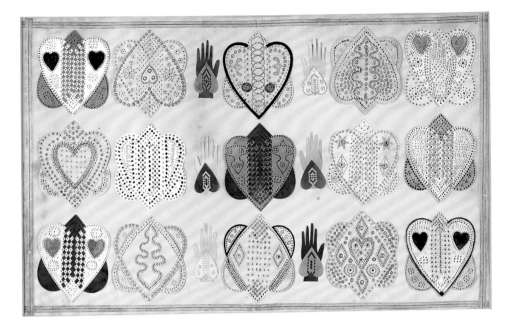

229.
HEART AND HAND LOVE TOKENS, c. 1820
Artist unidentified, probably New England
Watercolor and ink with gilt paper on cut
and pinpricked paper, mounted on paper,
9¼ × 14⅛ in., P1.2001.256

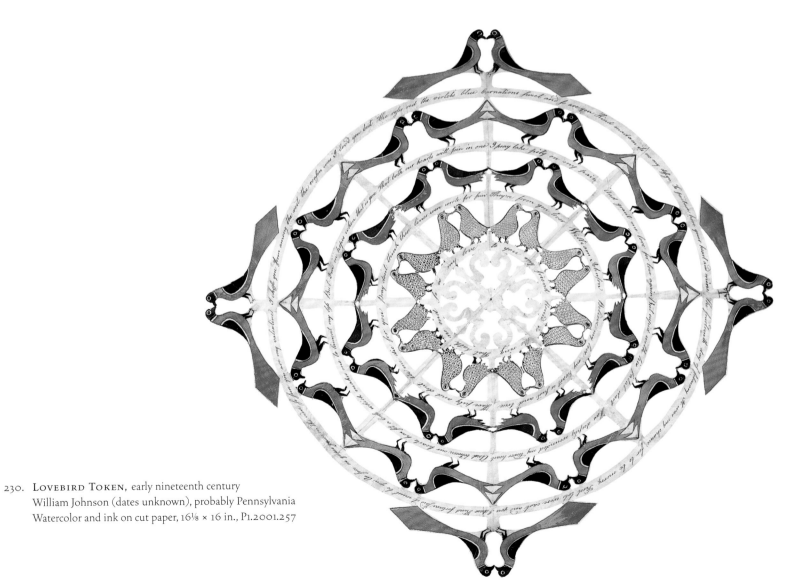

230. LOVEBIRD TOKEN, early nineteenth century
William Johnson (dates unknown), probably Pennsylvania
Watercolor and ink on cut paper, 16⅛ × 16 in., P1.2001.257

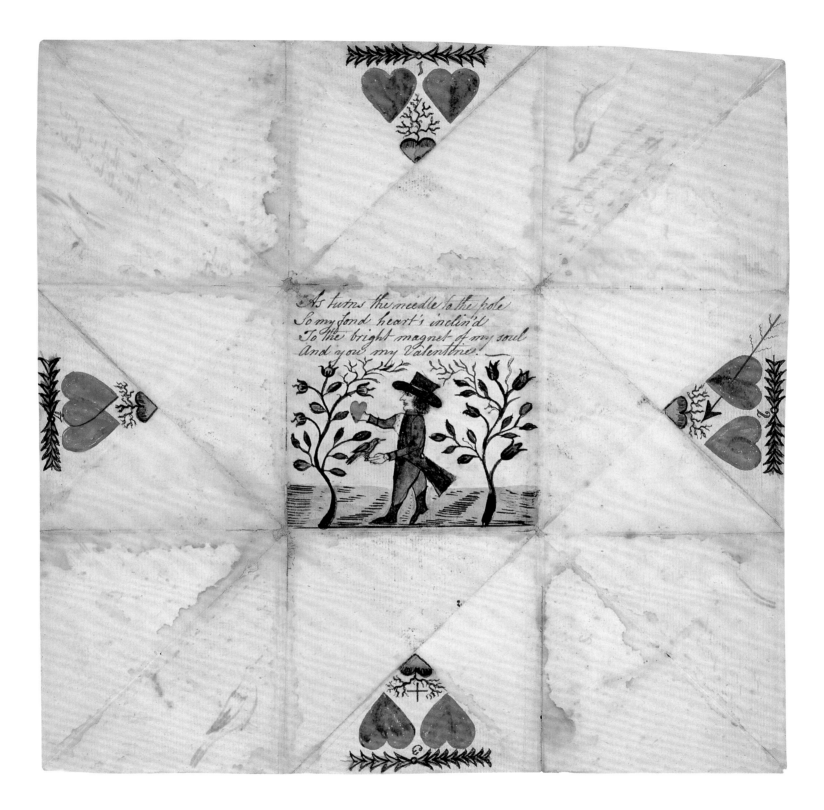

As turns the needle to the pole
So my fond heart's inclin'd
To the bright magnet of my soul
And you my Valentine.

231. **PUZZLE PURSE LOVE TOKEN,** c. 1790–1810
Artist unidentified, Pennsylvania or New England
Watercolor and ink on paper, 12½ × 12⁵⁄₁₆ in.,
P1.2001.258

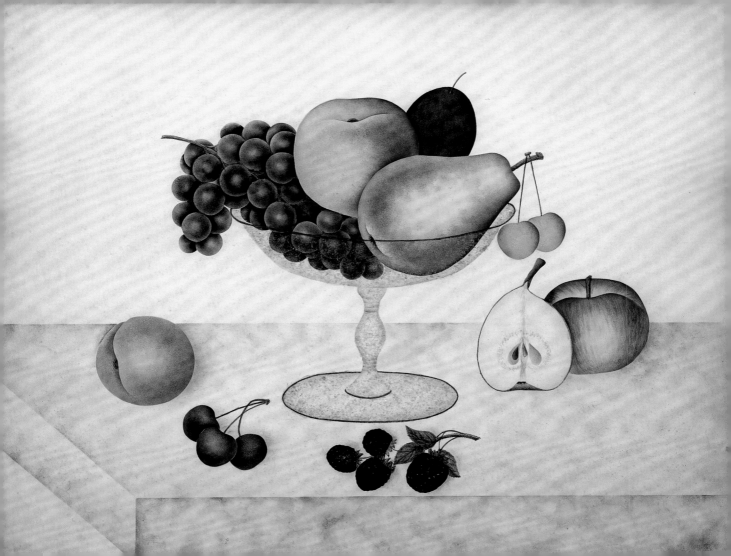

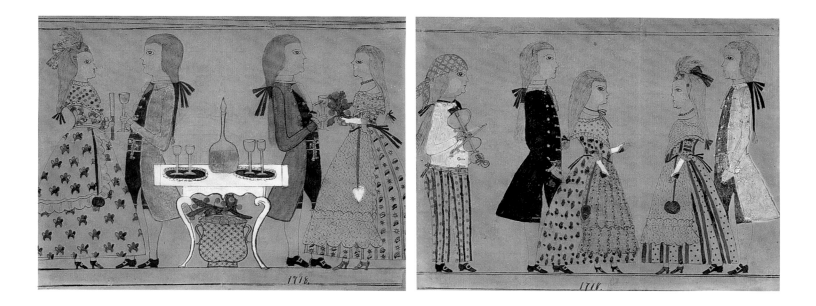

234a–b. THE PRODIGAL SON REVELING WITH HARLOTS, 1778
Artist unidentified, probably Connecticut
Watercolor and ink on paper, 7 × 9 in. each, P1.2001.261a,b

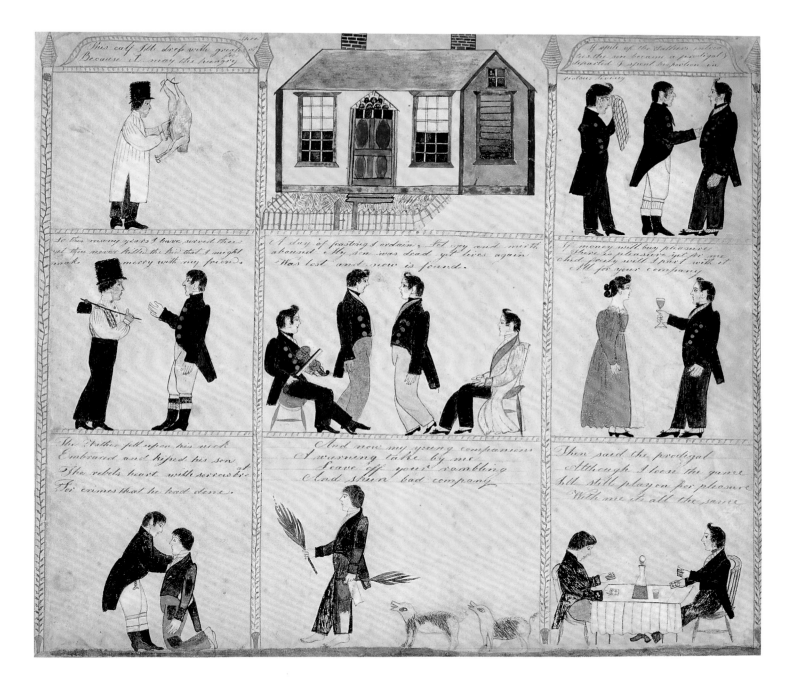

235. THE PRODIGAL SON, c. 1830–1835
Attributed to Ruby Devol Finch (1804–1866), probably Westport,
Bristol County, Massachusetts
Watercolor, gouache, ink, and pencil on paper, 12⅜ × 14 in., P1.2001.262

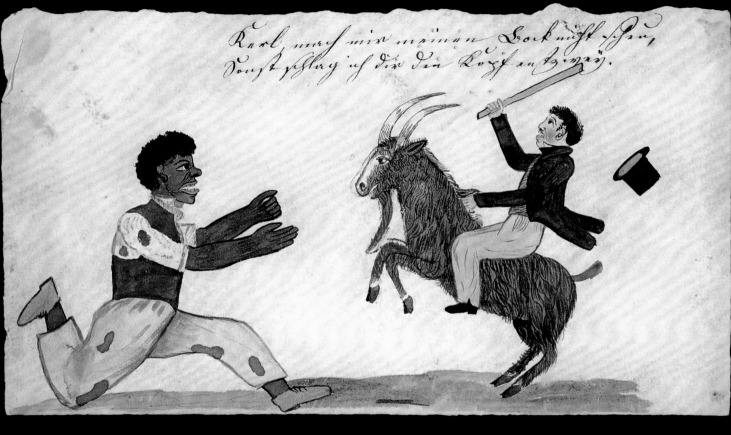

236. **Two Men and a Goat**, c. 1825
Artist unidentified, probably Pennsylvania
Watercolor and ink on paper, 4¹³⁄₁₆ × 8¼ in.,
P1.2001.263

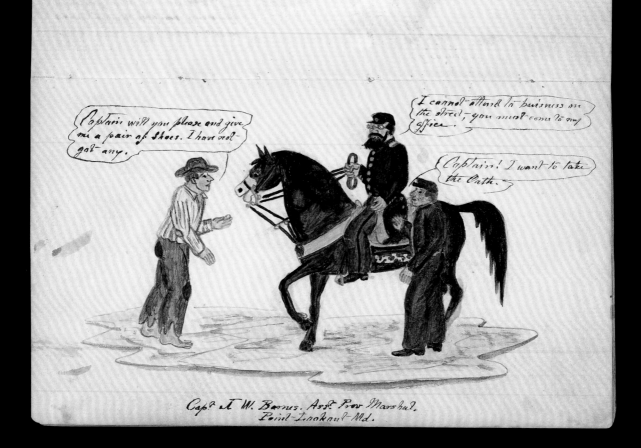

Capt. A. W. Barnes. Ass't Prov Marshal.
Point-Lookout-Md.

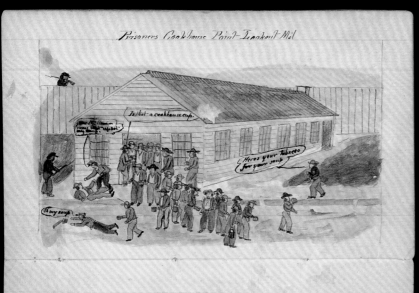

Prisoners Cookhouse Point-Lookout-Md

Point-Lookout-Md

238.
MAN WITH A WALKING STICK, c. 1939–1947
Bill Traylor (1852/56–1949), Montgomery, Alabama
Crayon on paperboard with ink inspection stamp,
10½ × 9¾ in., P1.2001.265

239. ROSS THE UNDERTAKER, c. 1940
Bill Traylor (1852/56–1949), Montgomery, Alabama
Poster paint and pencil on paperboard, 13⅞ × 14⅞ in.,
P1.2001.266

240. MAN WITH A PLOW, c. 1939–1942
Bill Traylor (1852/56–1949), Montgomery, Alabama
Poster paint and pencil on paperboard, 15 × 25¾ in., P1.2001.267

CHAPTER 8

GIRLS AT SCHOOL, WOMEN AT HOME

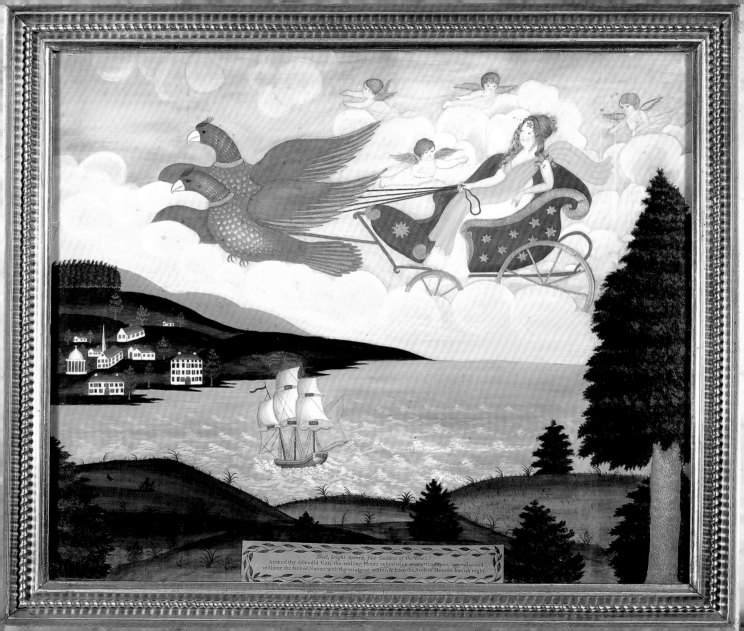

Hail, bright Aurora, fair Goddess of the Morn!
Around thy splendid Car, the smiling Hours submissive wait attendance, ascend—and
reillume the face of Nature with thy refulgent beams, & from the Arch of Heaven banish night.

242. **Map of the Animal Kingdom,** 1835
Artist unidentified, probably New England
Watercolor, ink, and pencil on paper, 26 × 34¾ in., P1.2001.269

243. OGDEN FAMILY MOURNING PIECE, 1813
Ellen Ogden (1795–1870), probably Litchfield, Litchfield County, Connecticut
Watercolor and ink on silk, with original reverse-painted eglomisé mat in
original gilded wood frame, 22⅞ × 29 in. (sight) (29 × 36⅛ × 2 in. framed),
P1.2001.270

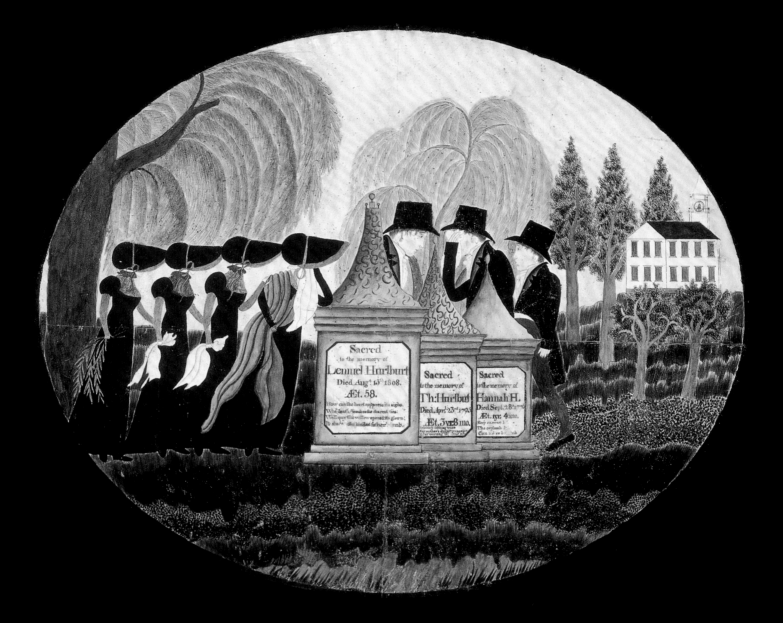

244. HURLBURT FAMILY MOURNING PIECE, c. 1808
Probably Sarah Hurlburt (1787–1866), Connecticut
Watercolor and ink on paper, 17 × 20 in. oval (sight), P1.2001.271

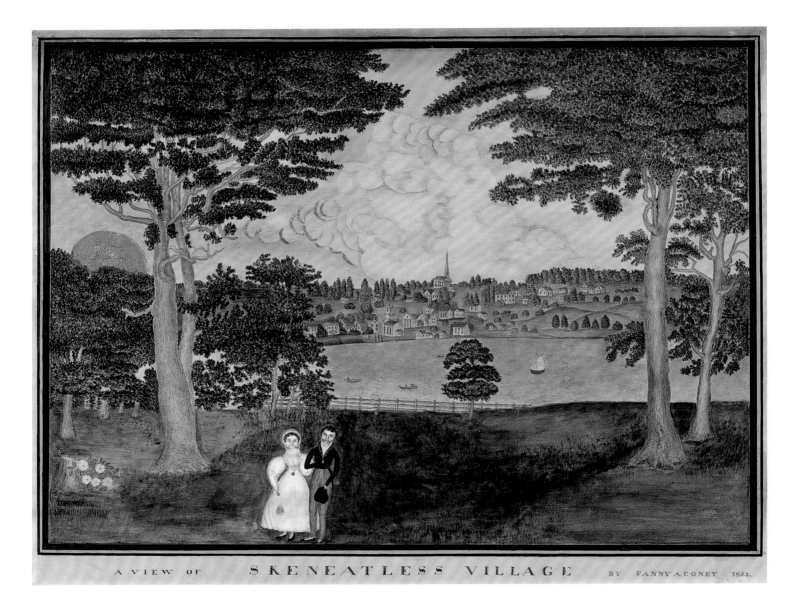

A VIEW OF SKENEATLESS VILLAGE BY FANNY A. CONEY 1832.

245. A VIEW OF SKENEATLESS VILLAGE, 1832
Fanny A. Coney (1814–1838), Portland, Chautauqua County,
or Skaneateles, Onondaga County, New York
Watercolor on paper, 14⅛ × 17¾ in. (sight), P1.2001.272

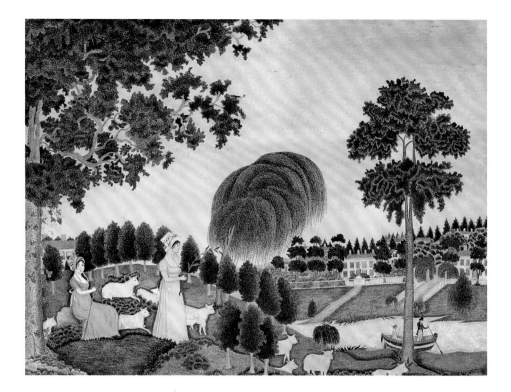

246.
RIVER TOWNSCAPE WITH FIGURES, C. 1810
Prudence Perkins (dates unknown),
possibly Rhode Island
Watercolor on paper, 18¼ × 22¼ in., P1.2001.273

247.
CHARLES STEPHEN MORGAN AND
ALCINDA GIBSON MORGAN, 1830
Martha M. Graham (dates unknown), Virginia
Watercolor on velvet, 16 × 22½ in., P1.2001.274

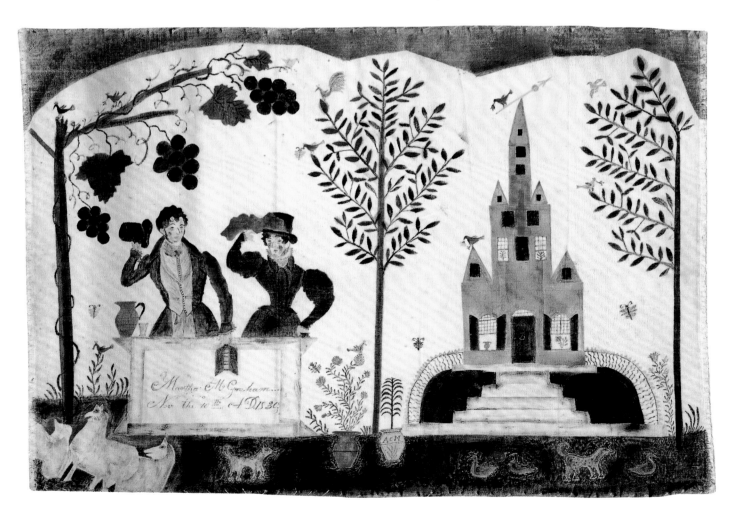

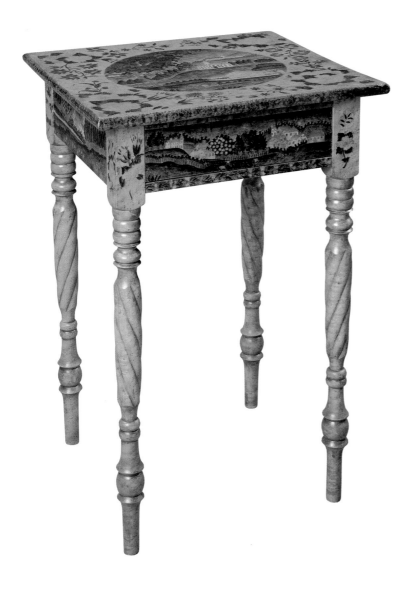

248. WORKTABLE, c. 1819
Artist unidentified, New Hampshire, possibly West Nottingham,
Rockingham County
Watercolor, pencil, and ink on bird's-eye maple, 28⅝ × 18⅝ × 18 in.,
P1.2001.275

249. VIOLIN, c. 1830
Artist unidentified, probably New England
Watercolor, pencil, and ink on wood, 23½ × 8⅛ × 2¾ in.,
P1.2001.276

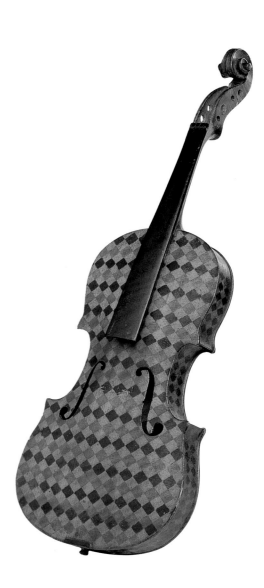

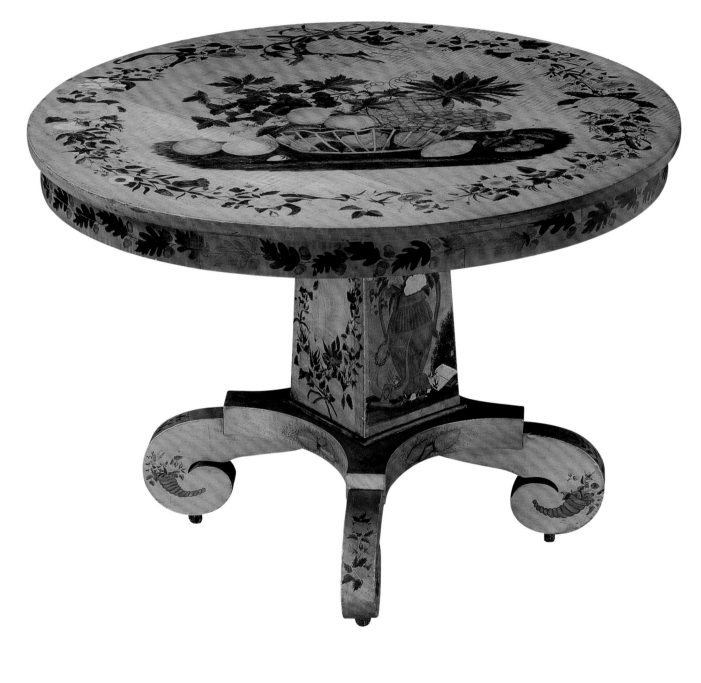

250. SARAH D. KELLOGG CENTER TABLE, c. 1841
Sarah D. Kellogg (1822–1854), Amherst, Hampshire County,
Massachusetts
Watercolor, ink, and pencil on maple, 27½ × 35¼ in. diam.,
P1.2001.277

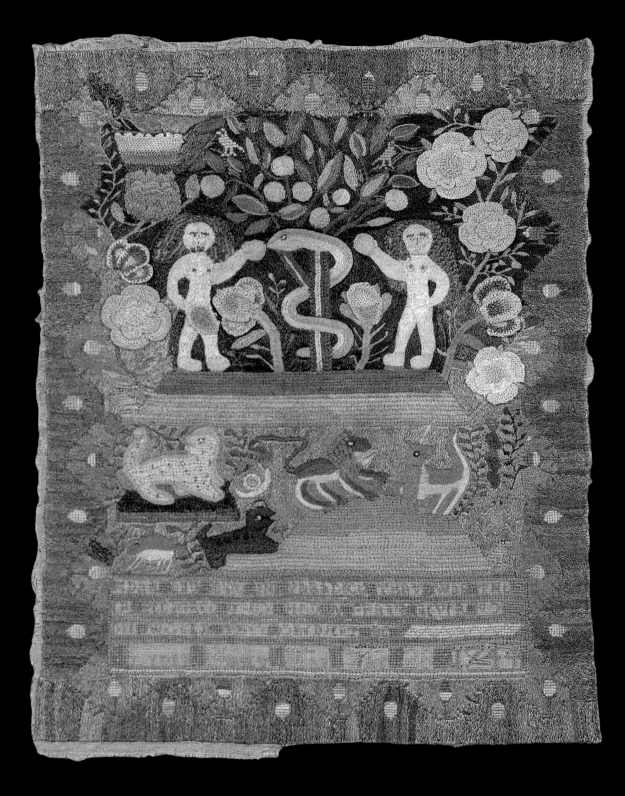

251. **ADAM AND EVE IN PARADICE**, 1744
Lydia Hart (dates unknown), Boston
Silk on fine linen, 11½ × 9 in., P1.2001.278

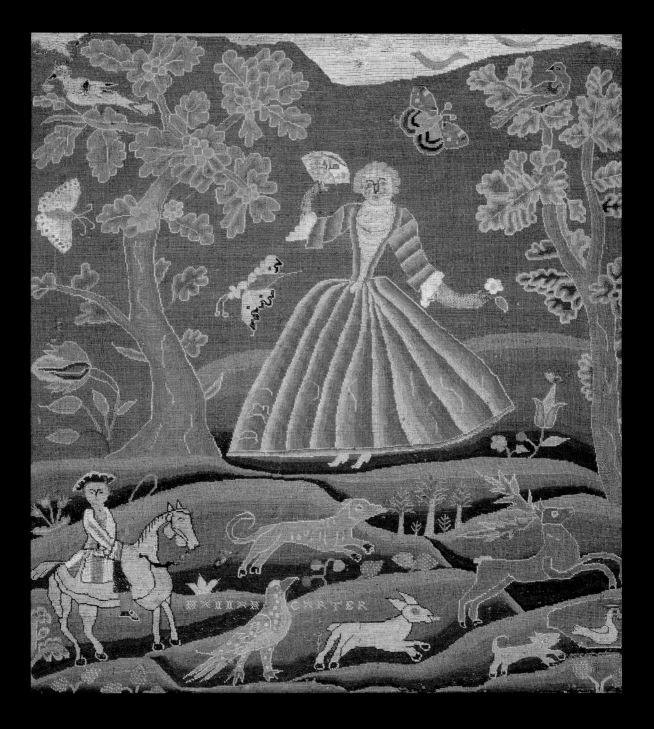

252. **Hannah Carter Canvaswork Picture**, c. 1748
Hannah Carter (dates unknown), Boston
Silk and wool on fine linen, 21$^{1}/_{16}$ × 18$^{7}/_{8}$ in., P1.2001.279

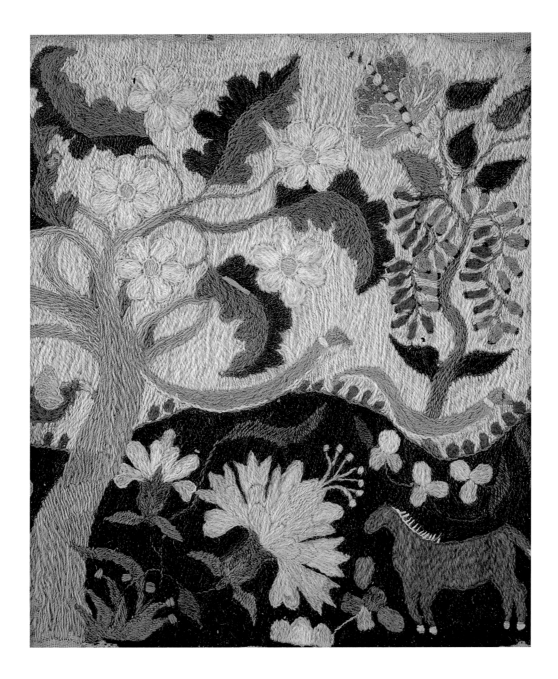

253. CREWELWORK PICTURE, c. 1750–1760
 Artist unidentified, New England, probably Massachusetts
 Wool on linen, 9 × 7⅜ in., P1.2001.280

254. RUTHY ROGERS SAMPLER, c. 1789
 Ruthy Rogers (1778–1812), Marblehead, Essex County, Massachusetts
 Silk on linen, 10½ × 9 in., P1.2001.281

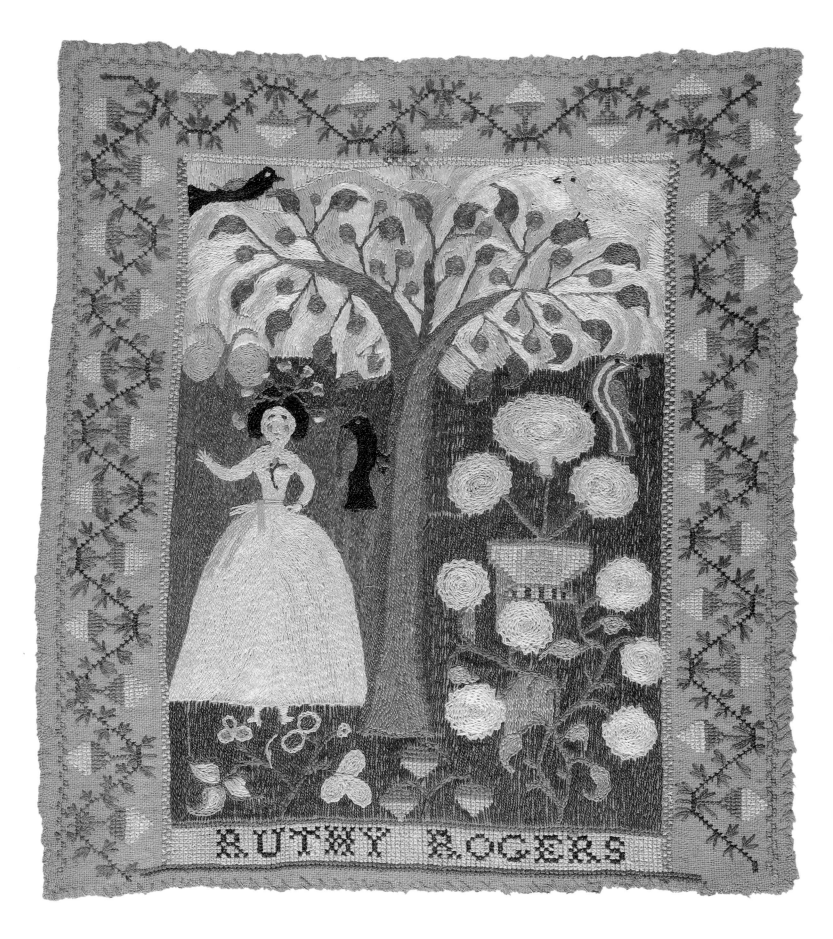

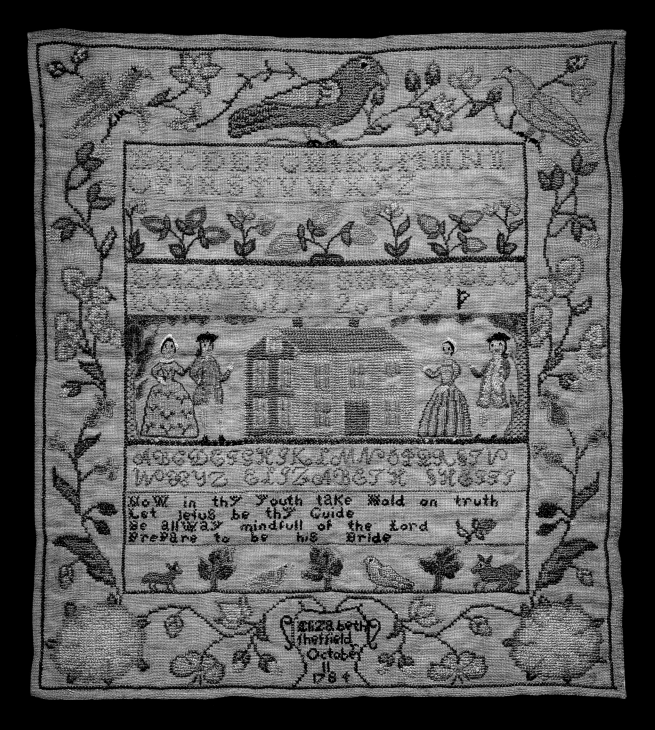

255. ELIZABETH SHEFFIELD SAMPLER, 1784
Elizabeth Sheffield (1771–?), Newport, Rhode Island
Silk on linen, 13 × 11 in., P1.2001.282

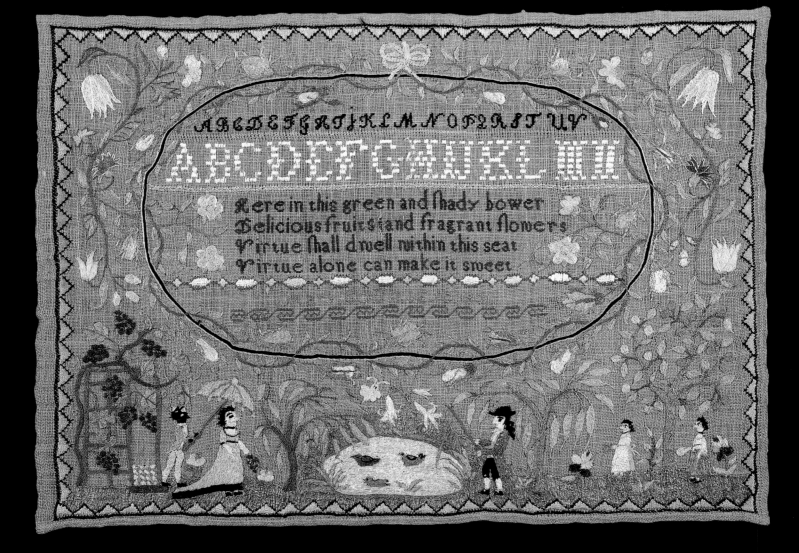

256. Mary Coffin Sampler, 1801
Mary Coffin (1790–1864), Newburyport,
Essex County, Massachusetts
Silk on linen, 15 × 20½ in., P1.2001.283

257. SALLIE HATHAWAY NEEDLEWORK PICTURE, c. 1794
Sallie Hathaway (1782–1851), probably Massachusetts or New York
Silk on silk, 17 × 20¼ in., P1.2001.284

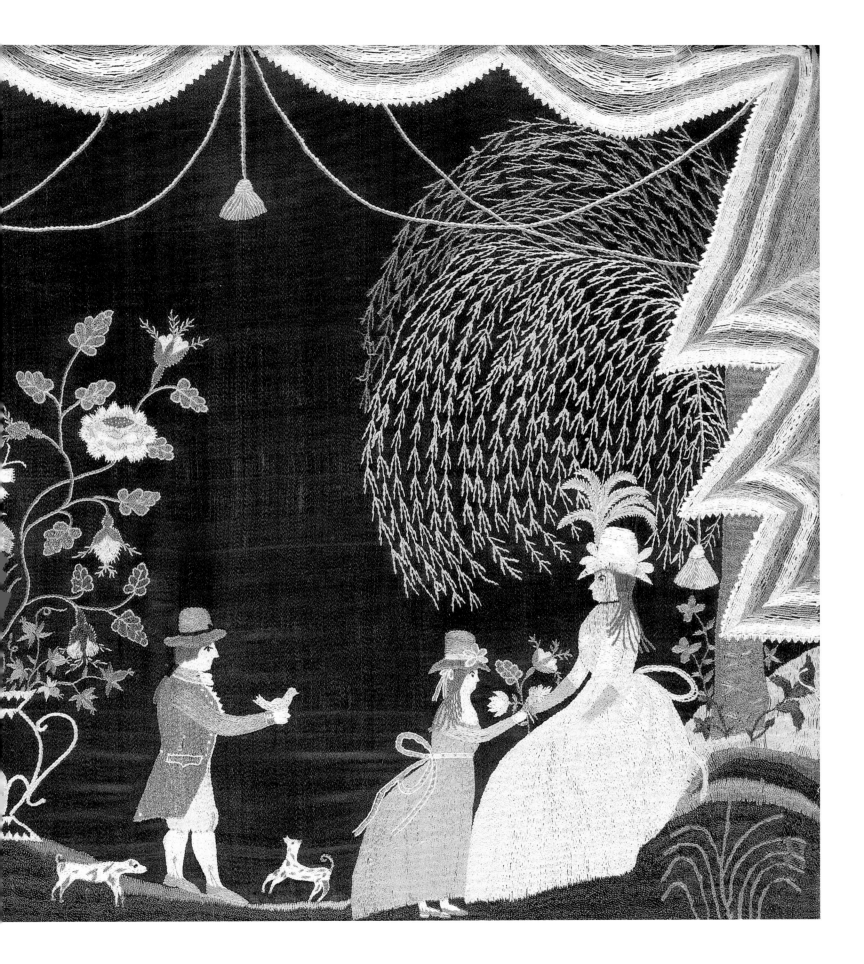

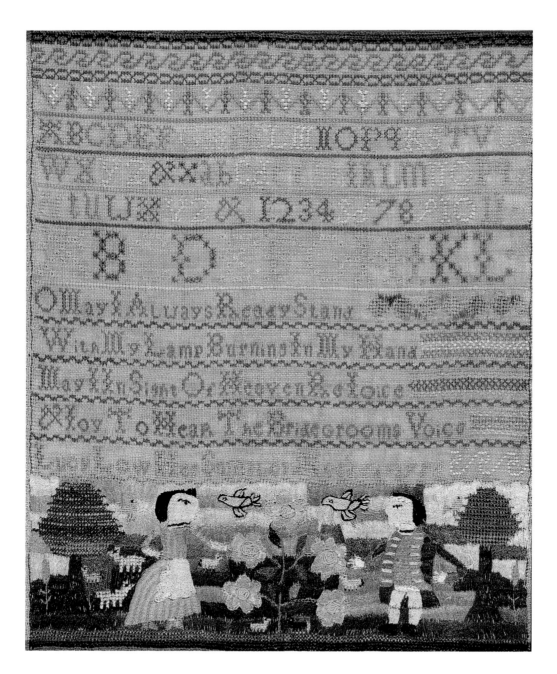

258. LUCY LOW SAMPLER, 1776
Lucy Low (1764–1842), Danvers, Essex County, Massachusetts
Silk on linen, 14½ × 11⅜ in., P1.2001.285

DE N OP ST

1 2 3 4 5 6 7 8 9 10 11 12 13

GK

RS YZ crown

Honor and renown. shall the ingenious

State House

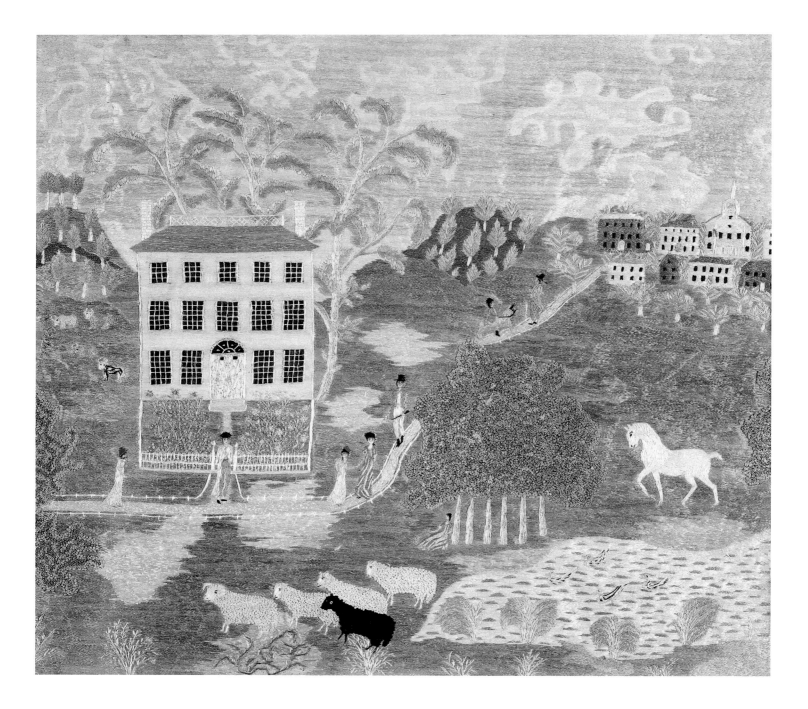

260. Newburyport Needlework Picture, c. 1805–1810
Artist unidentified, Newburyport, Essex County, Massachusetts
Silk on linen, 16¼ × 17½ in., P1.2001.287

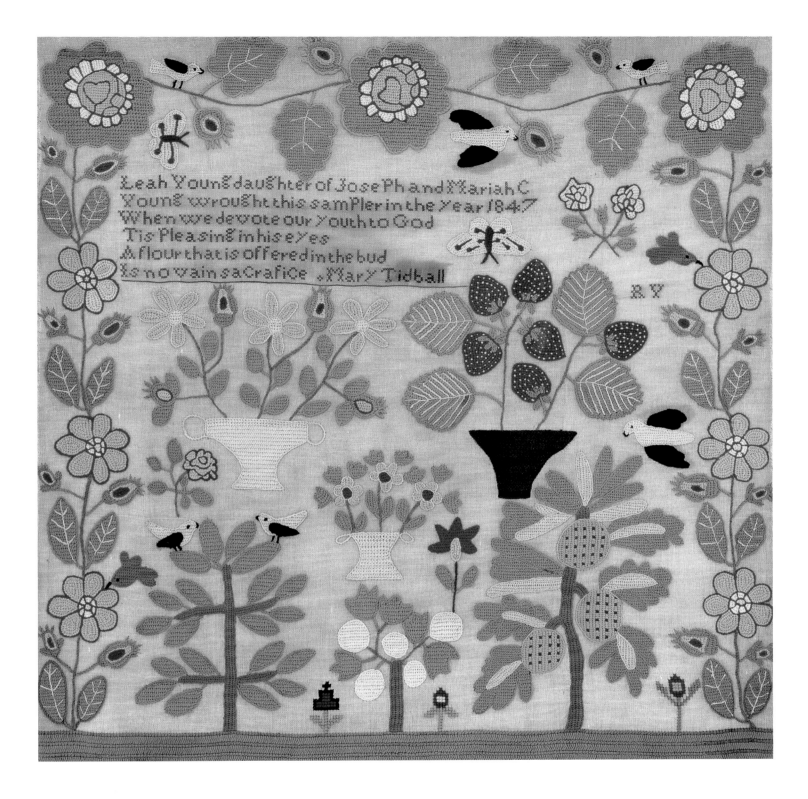

261. **LEAH YOUNG SAMPLER**, 1847
Leah Young (c. 1831–?), Peters Township, Washington County, Pennsylvania
Wool and linen on linen, 25½ × 24½ in., P1.2001.288

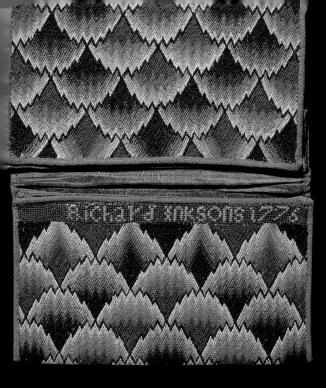

262.
RICHARD INKSONS DOUBLE POCKETBOOK, 1776
Artist unidentified, possibly Pennsylvania
Wool on linen with silk lining and wool twill tape
binding, 10½ × 8¼ in. (open), P1.2001.289

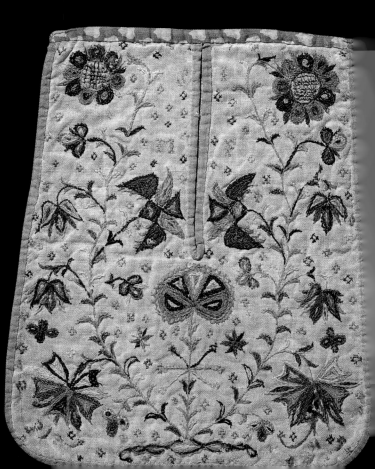

263.
POCKET, c. 1740–1770
Artist unidentified, Pennsylvania
Crewel on linen with cotton and linen
binding, 10¼ × 8¼ in., P1.2001.290

264.
Reticule with Still Life, c. 1825
Possibly Ruth Brown (dates unknown), Brattleboro,
Windham County, Vermont
Watercolor and ink on velvet with silk lining and woven
ribbon tie, 9 × 8½ in., P1.2001.291

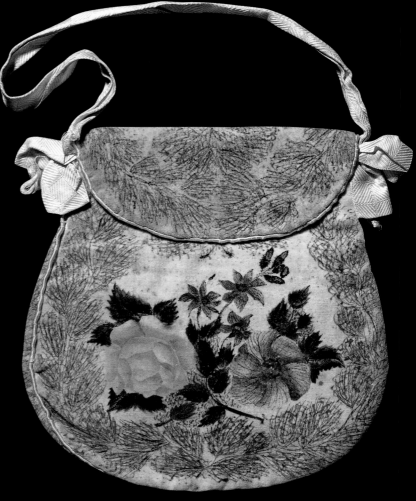

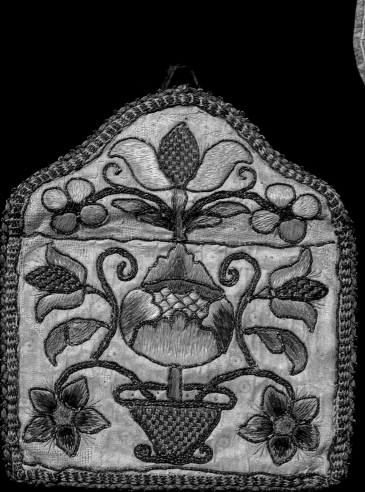

265.
Pocketbook with Basket of Flowers,
c. 1720–1750
Artist unidentified, Pennsylvania, possibly Chester County
Silk and metallic thread on silk over linen with spangles,
4½ × 5½ in. (closed), P1.2001.292

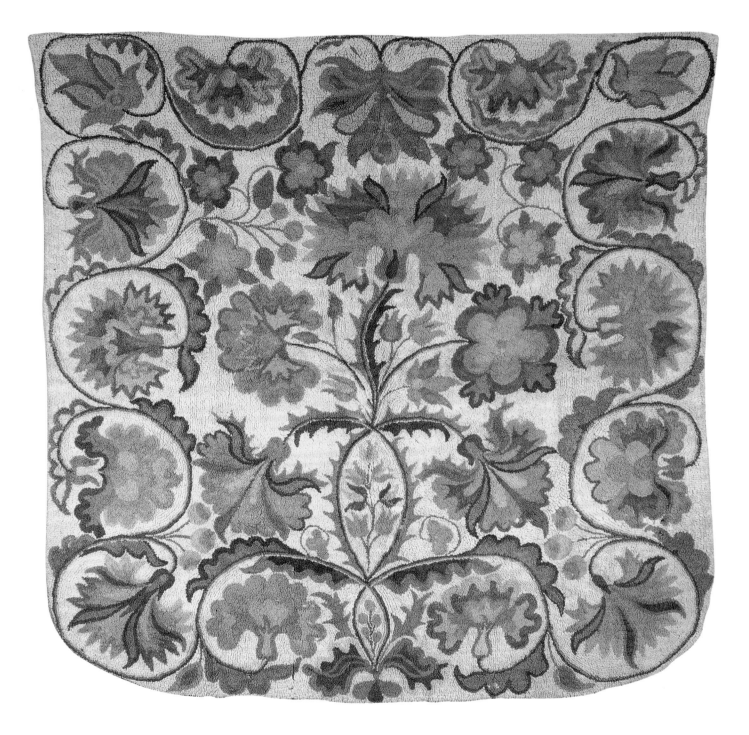

266. BED RUG, c. 1790–1810
Artist unidentified, Connecticut River Valley
Wool on woven wool, 100 × 96 in., 1995.32.2

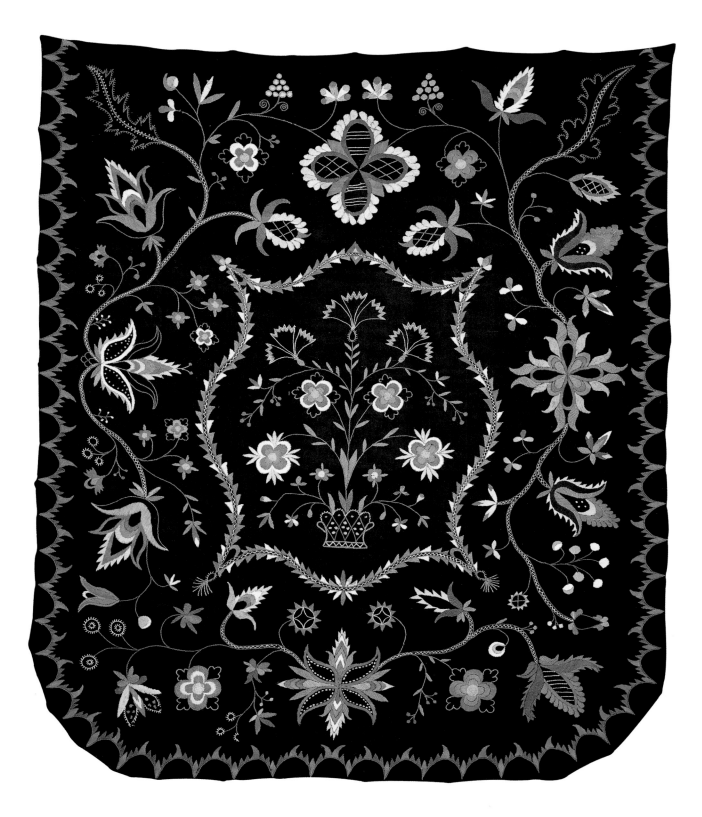

267. CREWEL BEDCOVER, 1815–1825
Artist unidentified, New England or New York
Wool with wool embroidery, 100 × 84 in., 1995.32.1

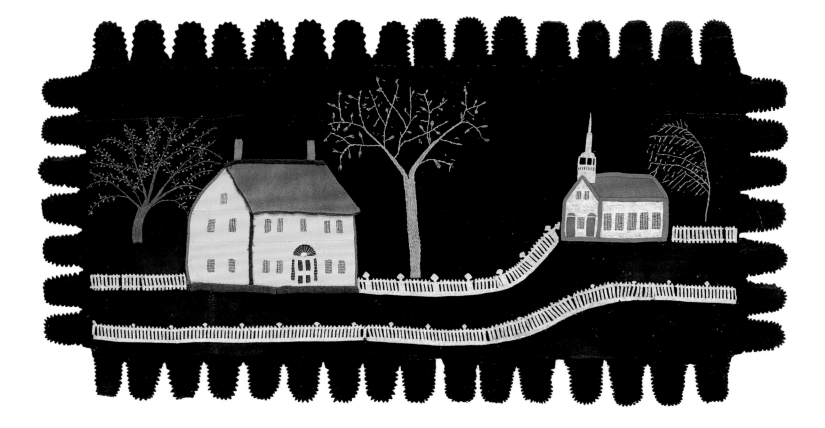

268. PICTORIAL TABLE RUG, c. 1840
Artist unidentified, possibly Otisfield, Oxford County, Maine
Wool appliqué, gauze, and embroidery on wool, 29 × 53 in., P1.2001.293

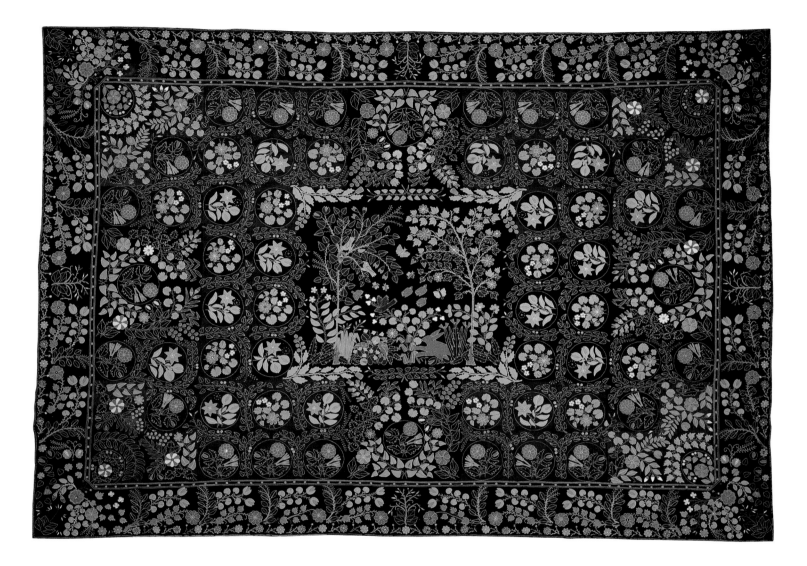

269. APPLIQUÉD CARPET, c. 1860
 Artist unidentified, northeastern United States, possibly Maine
 Wool appliqué and embroidery on wool, 112 × 158 in., P1.2001.294

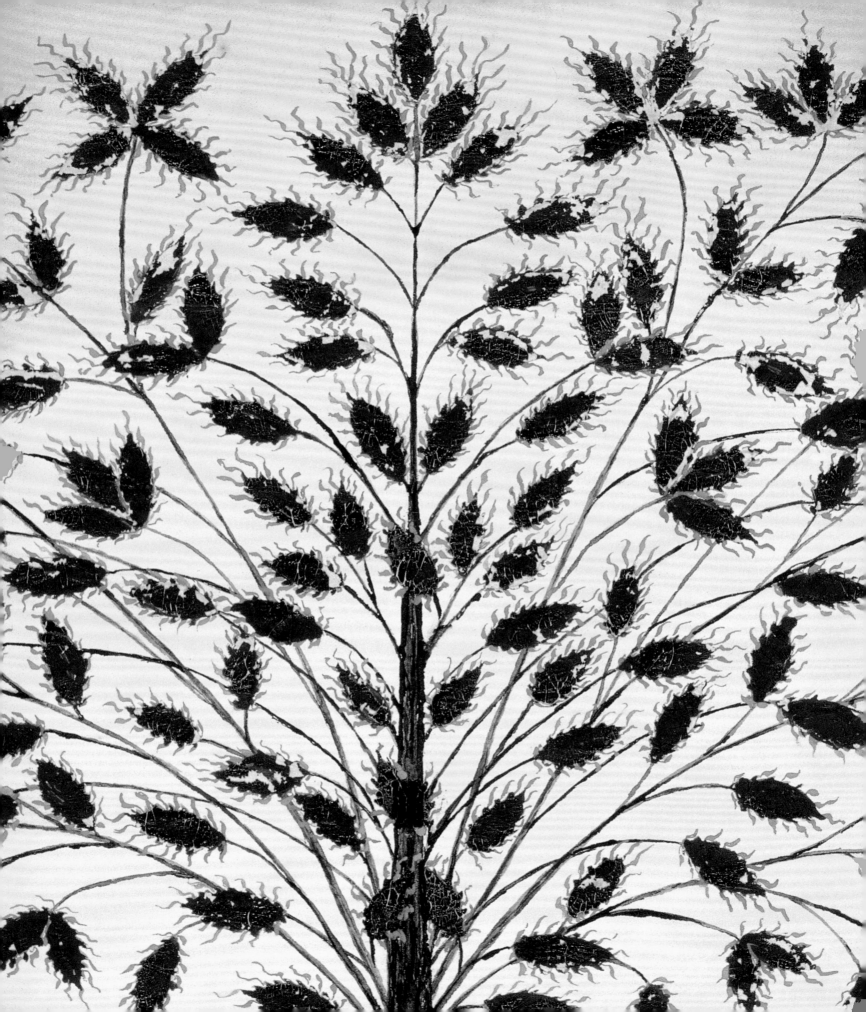

CHAPTER 9

SIMPLE GIFTS
THE SHAKERS

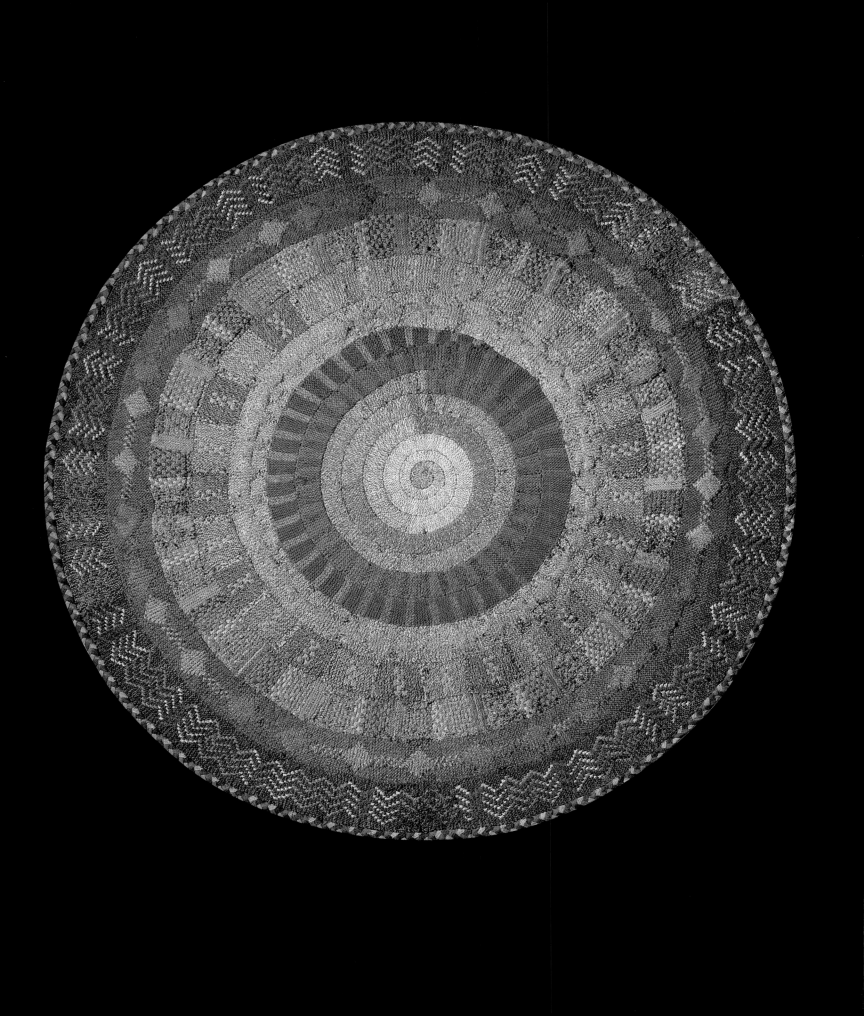

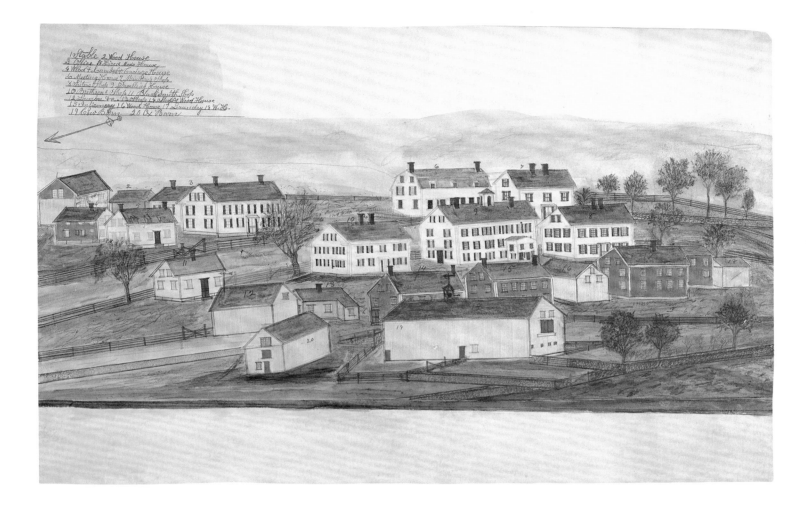

271. **VIEW OF THE CHURCH FAMILY, ALFRED, MAINE**, c. 1880
Joshua Bussell (1816–1900), Alfred, York County, Maine
Pencil, ink, and watercolor on paper, 17½ × 27¾ in., P1.2001.296

270. **KNITTED RUG**, c. 1890–1895
Attributed to Elvira Curtis Hulett (c. 1805–1895),
probably Hancock, Berkshire County, Massachusetts
Wool, 50 in. diam., P1.2001.295

272. **SHAKER RED OVAL BOX,**
early-to-mid-nineteenth century
Artist unidentified, New York or
New England
Paint on maple and pine with nails,
1⅝ × 4¾ × 3⅛ in., P1.2001.297

273. **SHAKER RED ROUND BOX,** c. 1851
Attributed to Joseph Johnson (1781–1852),
Canterbury, Merrimack County, or Enfield,
Grafton County, New Hampshire
Paint on maple and pine with copper nails,
1¾ × 3 in. diam., P1.2001.298

274. **SHAKER OVAL BOX WITH
PINCUSHION,** c. 1846
Artist unidentified, Enfield, Grafton County,
New Hampshire
Paint on maple and pine with copper tacks
and worsted top, 2³⁄₁₆ × 3¹¹⁄₁₆ × 2½ in. oval
(including cushion), P1.2001.299

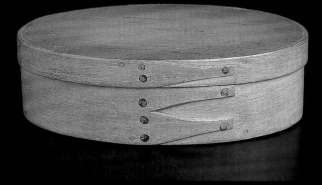

275. **SHAKER YELLOW OVAL BOX**, 1836
Artist unidentified, Enfield, Grafton County,
New Hampshire
Paint on maple and pine with copper nails,
1 × 2^{15}⁄₁₆ × 1^{7}⁄₈ in., P1.2001.300

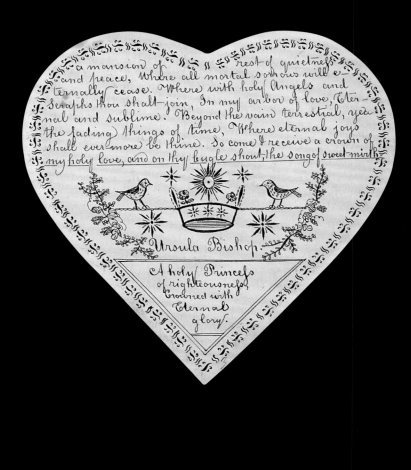

a mansion of rest of quietness and peace, Where all mortal sorrows will eternally cease. Where with holy Angels and Seraphs thou shalt join, In my arbor of love, Eternal and sublime. Beyond the vain terrestrial, yea the fading things of time, Where eternal joys shall evermore be thine. So come I receive a crown of my holy love, and on thy bugle shout, the song of sweet mirth

Ursula Bishop.

A holy Princess of righteousness Crowned with Eternal glory.

276. **GIFT DRAWING FOR URSULA BISHOP** (verso), probably 1844
Polly Ann (Jane) Reed (1818–1881), New Lebanon,
Columbia County, New York
Ink on cut paper, 4 × 4 in., P1.2001.301a

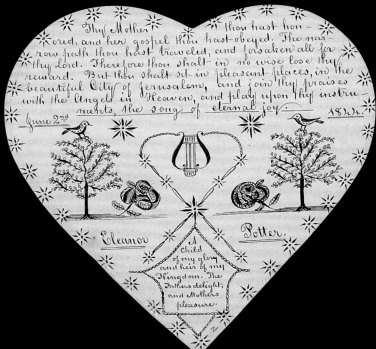

Thy Mother thou hast hon-
ored, and her gospel thou hast obeyed. The nar-
row path thou hast traveled, and forsaken all for
Thy Lord. Therefore thou shalt in no wise lose thy
reward. But thou shalt sit in pleasant places, in the
beautiful City of Jerusalem, and join thy praises
with the Angels in Heaven, and play upon thy instru-
ments, the song of eternal joy.

June 2nd 1844.

Eleanor Potter.

A
child
of my glory
and heir of my
Kingdom. The
Fathers delight,
and Mothers
pleasure.

277.
Gift Drawing for Eleanor Potter (verso), 1844
Polly Ann (Jane) Reed (1818–1881), New Lebanon,
Columbia County, New York
Ink on cut paper, 4 × 4 in., P1.2001.301b

unto my Throne; For thou hast
walked the path of virtue, and drank the cup
of sorrow, yet never hast thou murmured against
thy God, nor raised thy hand against the straitness
of the road. And now thou shalt in my kingdom shine,
with a garment unspotted, and a robe that is pure,
for thou hast stood steadfast, unshaken and sure. So
come and receive a bright seal of my love, by which
thou shalt be known by my Angels above, To be a pure
child of my eternal glory bright, who has walked
the path of the _____ just and upright.

—Jane Smith.

A Holy Saint
of the Most-High,
Crowned with his
everlasting love,
and enrobed with
his richest
blessing.

278. **Gift Drawing for Jane Smith** (verso), probably 1844
Polly Ann (Jane) Reed (1818–1881), New Lebanon,
Columbia County, New York
Ink on cut paper, 4 × 4 in., P1.2001.301c

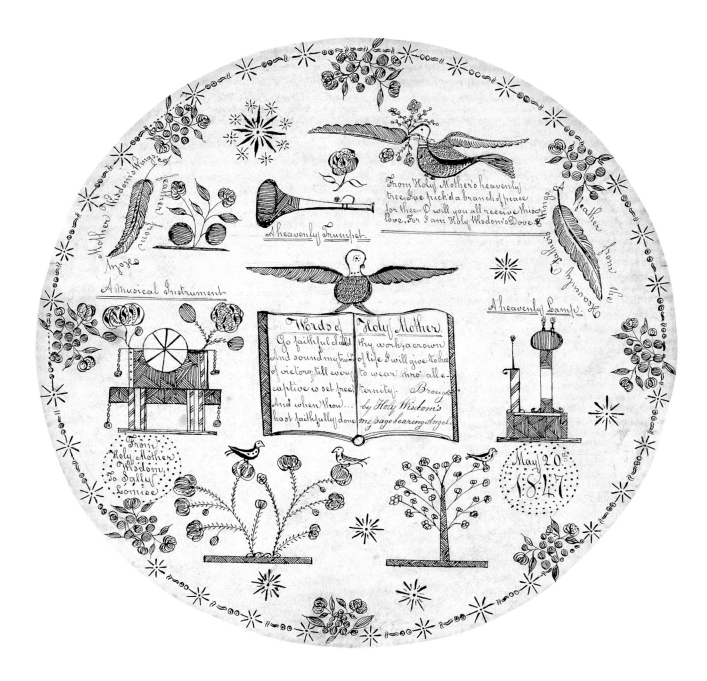

279. **Gift Drawing from Holy Mother Wisdom to Sally Lomise**, 1847
Attributed to Sarah Bates (1792–1881), New Lebanon, Columbia County, New York
Ink on cut paper, 6¾ in. diam., P1.2001.301d

280. **Gift Drawing: A Reward of True Faithfulness
From Mother Lucy To Eleanor Potter**, 1848
Polly Ann (Jane) Reed (1818–1881), New Lebanon, Columbia County, New York
Watercolor and ink on paper, 11⅜ × 10½ in. (sight), P1.2001.302

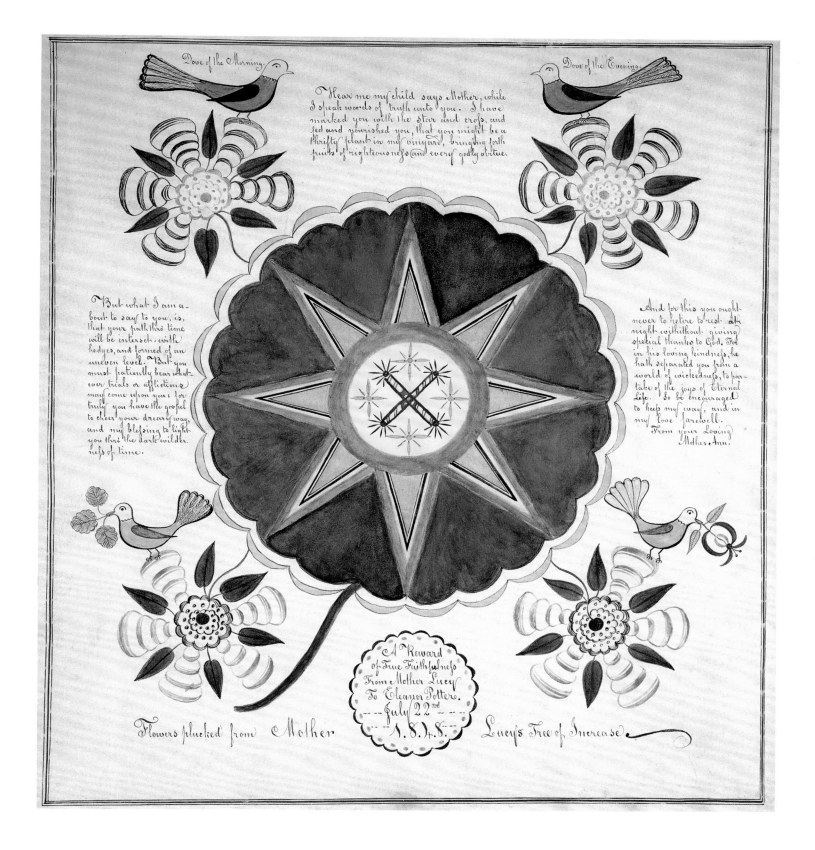

Dove of the Morning.

Dove of the Evening.

Hear me my child says Mother, while I speak words of truth unto you. I have marked you with the star and cross, and fed and nourished you, that you might be a thrifty plant in my vinyard, bringing forth fruits of righteousness and every godly virtue.

But what I am about to say to you, is, that your path thro' time will be intersected with hedges, and formed of an uneven level. But you must patiently bear whatever trials or afflictions may come upon you: for truly you have the gospel to cheer your dreary way, and my blessing to light you thro' the dark wilderness of time.

And for this you ought never to retire to rest at night withithout giving special thanks to God. For in his loving kindness, he hath separated you from a world of wickedness, to partake of the joys of Eternal Life. So be encouraged to keep my way, and in my love farewell.
From your Loving
Mother Ann.

A Reward of True Faithfulness From Mother Lucy To Eleanor Potter.
July 22nd
1.8.)4.8.

Flowers plucked from Mother
Lucy's Tree of Increase

1st My children dear, how I do love,
And nourish with my care;
I do feed you from above,
And hear your fervent prayer.

2nd Tis I once more your Mother dear
Who does you now address;
And daily guide you with that fear
Which you should ever possess.

3rd To those who ask I give my love,
Kind Elders now believe;
That when you look to heaven above
You will certainly receive.

4th For those like you who faithful are
Shall ever blest by me
I know full well you have much care
And troubles oft you see.

5th When upon Earth my care was great,
Afflictions oft I felt.

The world scoff'd you did berate
And hastily in me did dwelt.

6th But to my God I then did look
His mercy to implore
When many times my frame was shook
By an Almighty power.

7th This gave me strength for to perform
My duty while below
Though Dragon like in man made form
Some raged two and fro.

8th But now dear children you can sing
In peace within your door;
Rise unto your Heavenly King
And dance upon your floor.

9th For this unto the Lord give thanks
That you have liberty
To dance and sing in Zions ranks
And praise your Maker free.

This drawing was given by Mother Ann as an emblem of her love; for the Elder Sisters at the Church, City of Union; Brought by Sarah Dunn to an inspired Sister at the City of Peace and drafted by the same June, 1854.

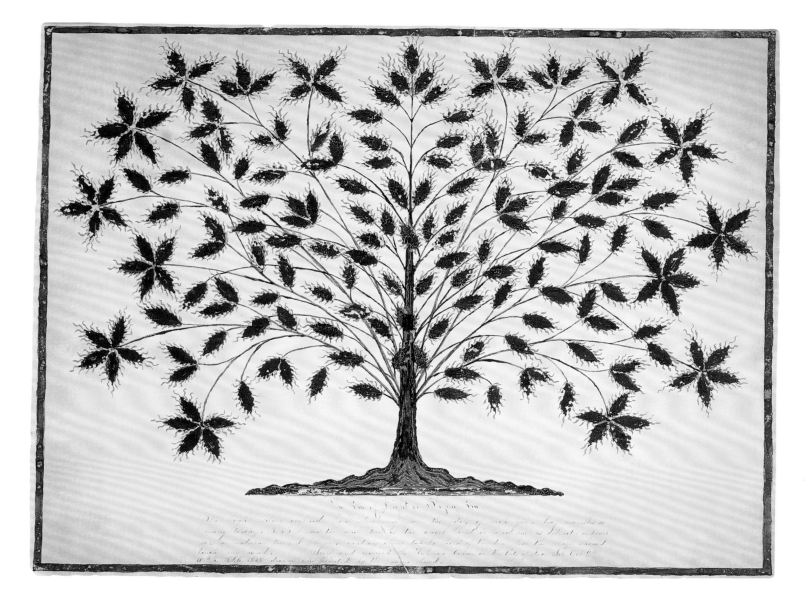

282. GIFT DRAWING: THE TREE OF LIGHT OR BLAZING TREE, 1845
Hannah Cohoon (1788–1864), Hancock, Berkshire County, Massachusetts
Ink, pencil, and gouache on paper, 16 × 20⅞ in., P2.1997.1

281. GIFT DRAWING: 1ST MY CHILDREN DEAR, WHOM I DO LOVE, 1854
Polly Collins (1801–1884), Hancock, Berkshire County, Massachusetts
Ink, pencil, and watercolor on paper, 19 × 12 in., P2.1997.2

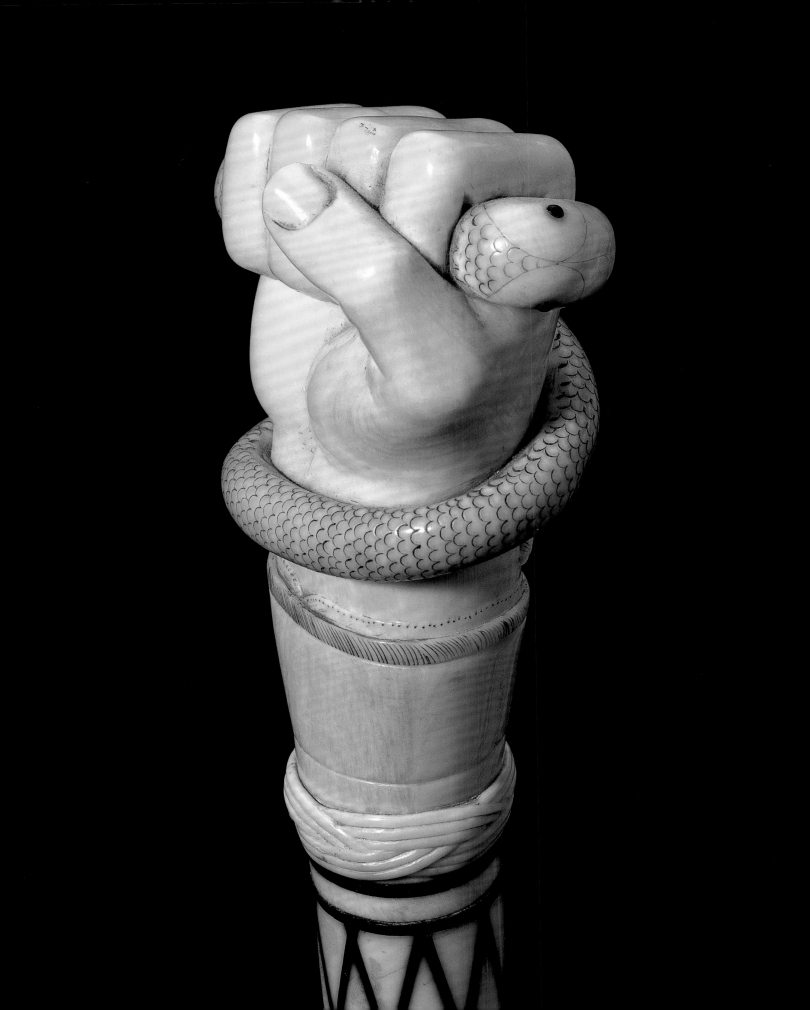

CHAPTER 10

SCRIMSHAW

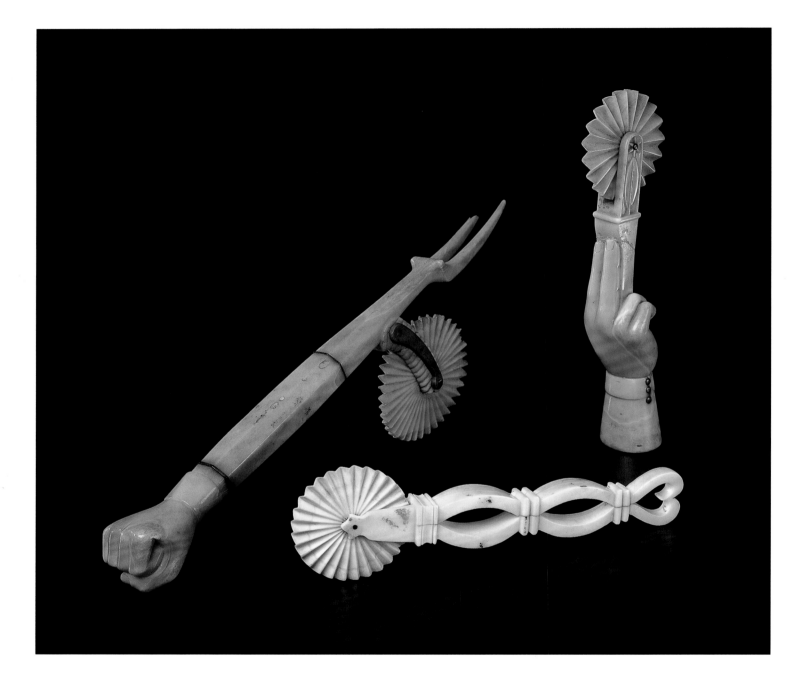

283a.
CLENCHED FIST JAGGING WHEEL
AND PIE TESTER, c. 1850
Artist unidentified, New England
Walrus ivory with metal, 3½ × 9⅛ × 1⅛ in.,
P1.2001.303

283b.
OPEN HEART JAGGING WHEEL, c. 1850
Artist unidentified, probably eastern United States
Whale ivory with metal, 1¹¹⁄₁₆ × 5⅞ × ½ in.,
P1.2001.304

283c.
HAND AND CUFF JAGGING WHEEL, c. 1850
Artist unidentified, probably eastern United States
Probably walrus ivory with nails, 1¾ × 6 × 1¼ in.,
P1.2001.305

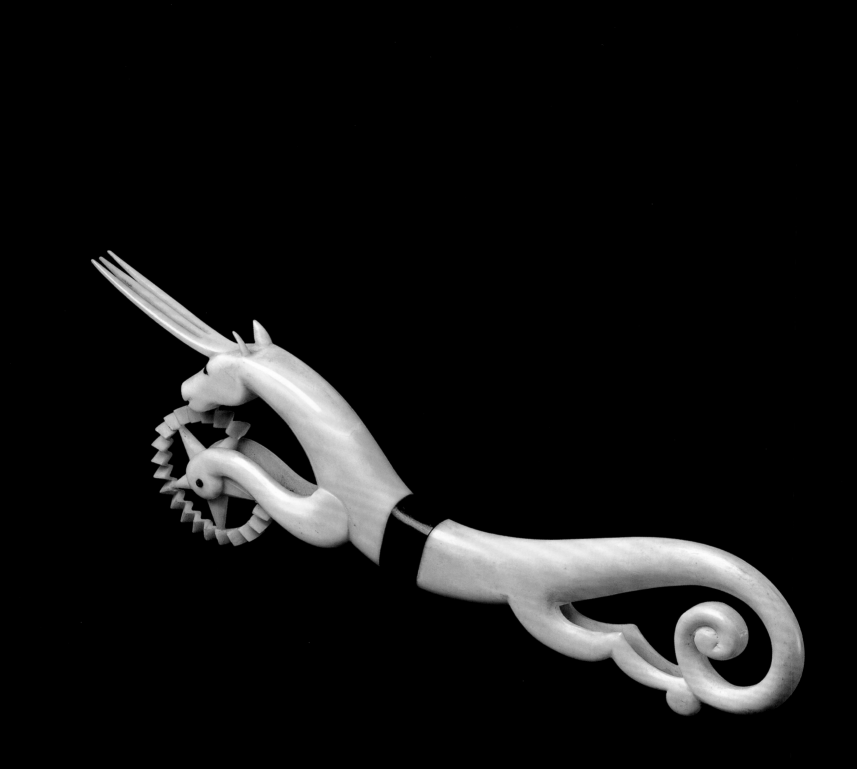

284. SEA HORSE JAGGING WHEEL, c. 1870
 Artist unidentified, New England
 Whale ivory and ebony with silver pins, 2¾ × 6 × 1½ in., P1.2001.306

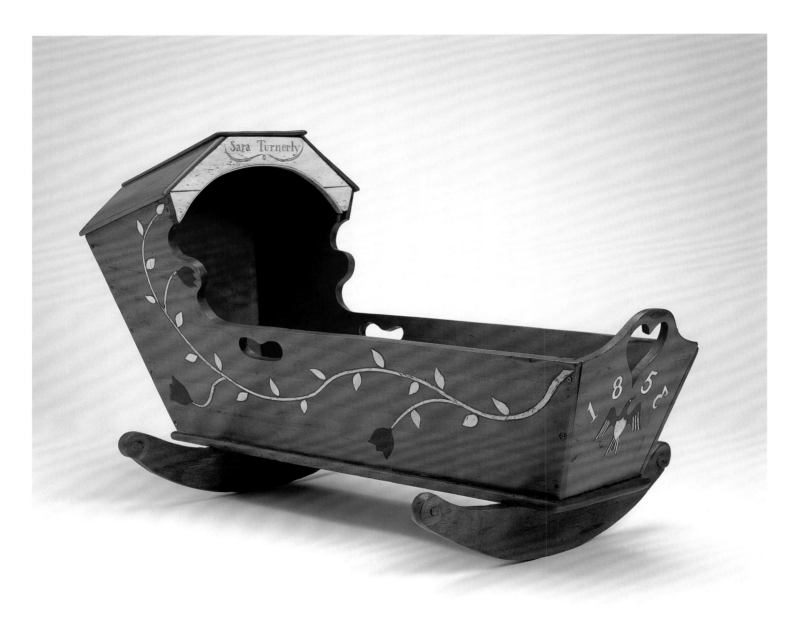

285. DOLL CRADLE FOR SARAH TURNERLY, 1853
Jacob Turnerly (dates unknown), possibly vicinity of Clinton,
Middlesex County, Connecticut
Cherry, ebony, and whale skeletal bone with paint and ink,
13⁷⁄₈ × 22⁵⁄₈ × 12³⁄₄ in., P1.2001.307

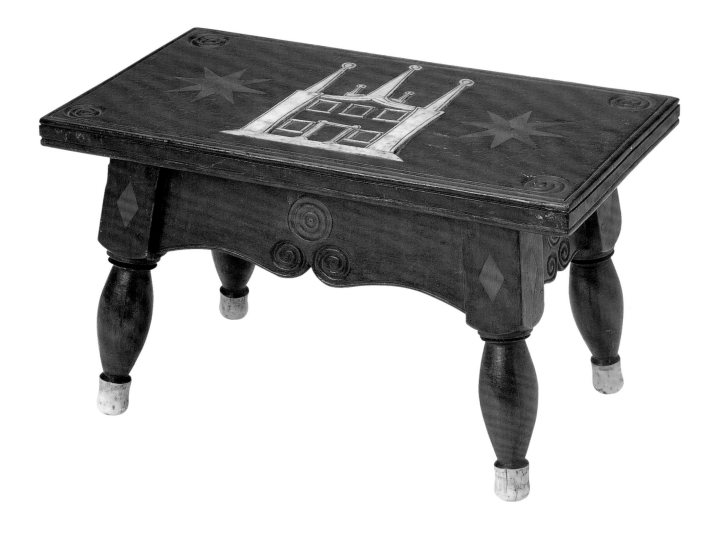

286. FOOTSTOOL WITH SCRIMSHAW DECORATION, c. 1850
Artist unidentified, probably eastern United States
Mahogany, exotic wood, whale ivory, and whale skeletal bone,
7⅝ × 12½ × 7⅛ in., P1.2001.308

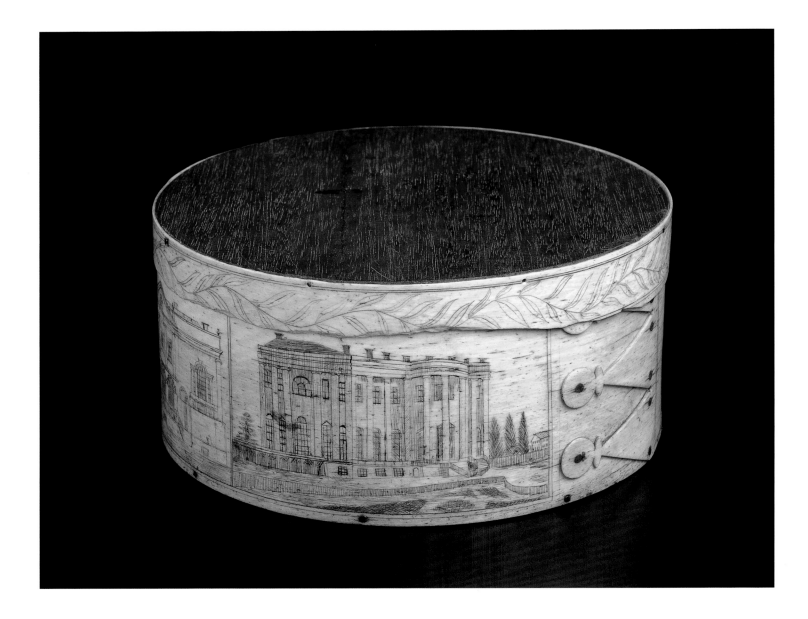

287. DITTY BOX, c. 1845
Artist unidentified, probably New England
Whale skeletal bone, mahogany, and rosewood with nails,
3⅓ × 6¼ in. diam., P1.2001.309

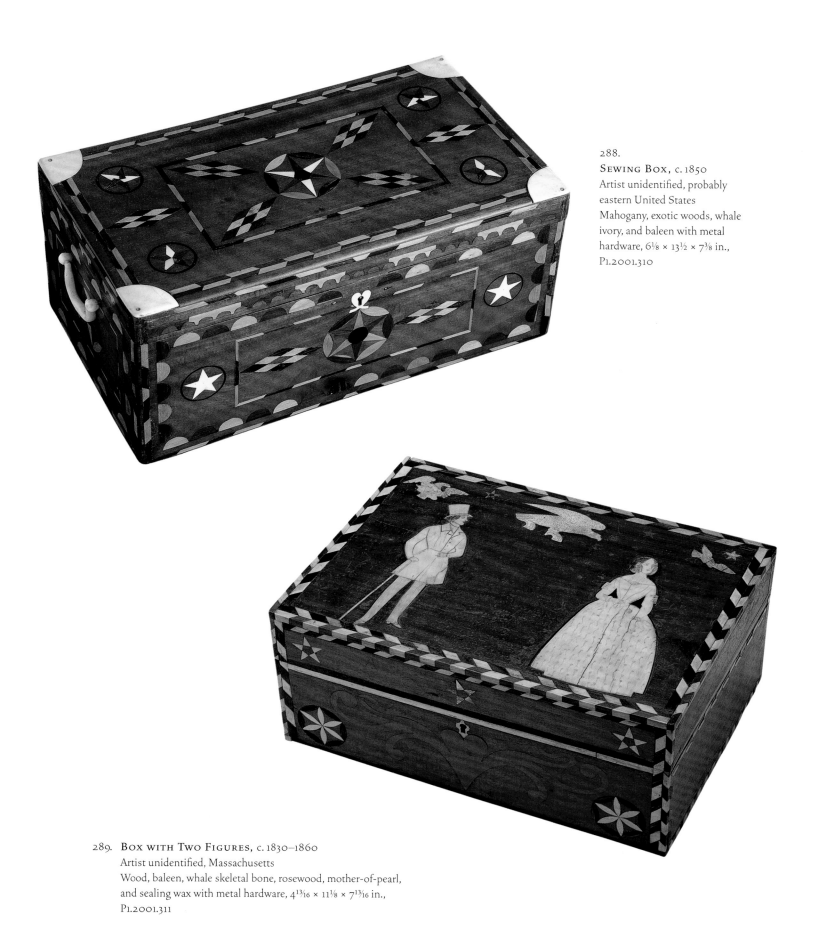

288.
Sewing Box, c. 1850
Artist unidentified, probably
eastern United States
Mahogany, exotic woods, whale
ivory, and baleen with metal
hardware, 6⅛ × 13½ × 7⅜ in.,
P1.2001.310

289. **Box with Two Figures**, c. 1830–1860
Artist unidentified, Massachusetts
Wood, baleen, whale skeletal bone, rosewood, mother-of-pearl,
and sealing wax with metal hardware, 4¹³⁄₁₆ × 11⅛ × 7¹³⁄₁₆ in.,
P1.2001.311

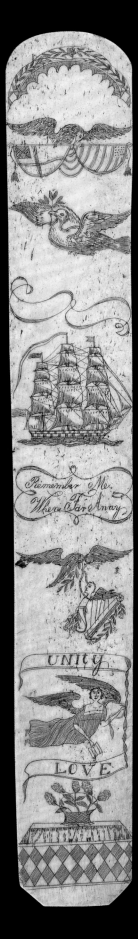

290.
Busk with Ship and Angel, c. 1840
Attributed to A.V. Booth (dates unknown), probably eastern United States
Ink on whale skeletal bone, 12⅝ × 1¹¹⁄₁₆ × ¹⁄₁₆ in., P1.2001.312

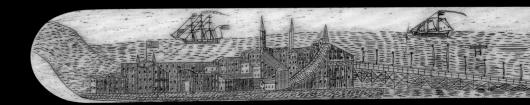

291. **Busk with Harbor View,** c. 1845
Artist unidentified, possibly New Bedford Harbor,
Bristol County, Massachusetts
Ink on whale skeletal bone, 13¹⁄₁₆ × 1¼ × ¹⁄₁₆ in.,
P1.2001.313

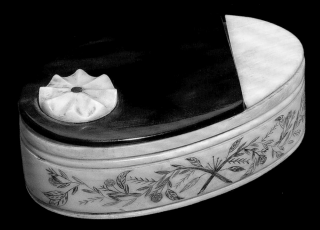

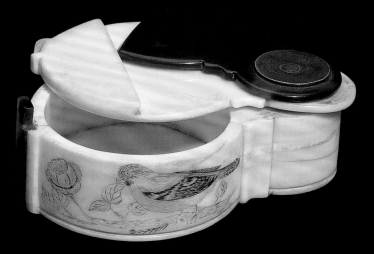

292. **PUZZLE BOX**, c. 1870
Attributed to Captain Edward Penniman (1831–1913),
probably Cape Cod, Massachusetts
Ink on whale ivory with tortoiseshell and metal,
1 × 2¾ × 1¹¹⁄₁₆ in., P1.2001.314

293. **PUZZLE BOX FOR BESSIE PENNIMAN**, c. 1885
Attributed to Captain Edward Penniman (1831–1913),
Cape Cod, Massachusetts
Ink on whale ivory with tortoiseshell, copper, and silver,
1⅛ × 3 × 1⅞ in., P1.2001.315

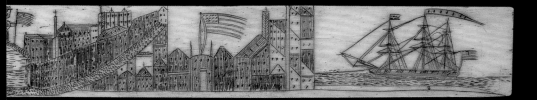

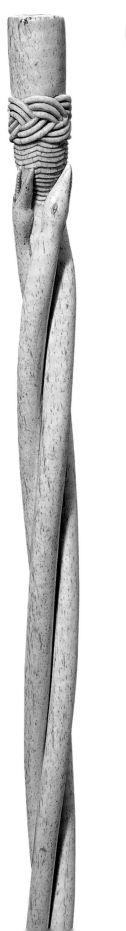

294.
CANE WITH THREE TWISTED SNAKES, c. 1860
Artist unidentified, probably eastern United States
Whale skeletal bone, 34⅛ × 1¼ in. diam., P1.2001.316

295.
CANE WITH ELEPHANTS, LIONS, WHALES, AND SHIPS, c. 1845
Artist unidentified, Nantucket, Massachusetts
Whale ivory with ebony, tortoiseshell, abalone shell, mother-of-pearl,
amber, and silver, 32¼ × 1¾ in. diam., P1.2001.317

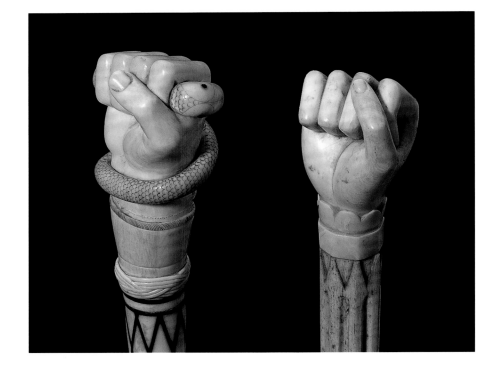

296a.
CANE WITH FIST HOLDING SNAKE
HANDLE, c. 1840
Artist unidentified, Nantucket, Massachusetts
Whale ivory and whale skeletal bone with
ebony, tortoiseshell, abalone shell, mother-of-
pearl, and silver, 35⅛ × 2 in. diam., P1.2001.318

296b.
CANE WITH FIST HANDLE, c. 1850
Artist unidentified, probably New England
Whale ivory and whale skeletal bone with
ebony, tortoiseshell, abalone shell, brads,
and brass, 34⅞ × 1½ in. diam., P1.2001.319

297a.
CANE WITH FEMALE LEG HANDLE, c. 1860
Artist unidentified, probably eastern United States
Whale ivory and whale skeletal bone with horn,
ink, and nail, 29¾ × 3½ in., P1.2001.320

297b.
CANE WITH FEMALE LEG AND
DARK BOOT HANDLE, c. 1860
Artist unidentified, probably eastern United States
Whale skeletal bone, mahogany, and ivory with
paint, 34 × 3¾ in., P1.2001.321

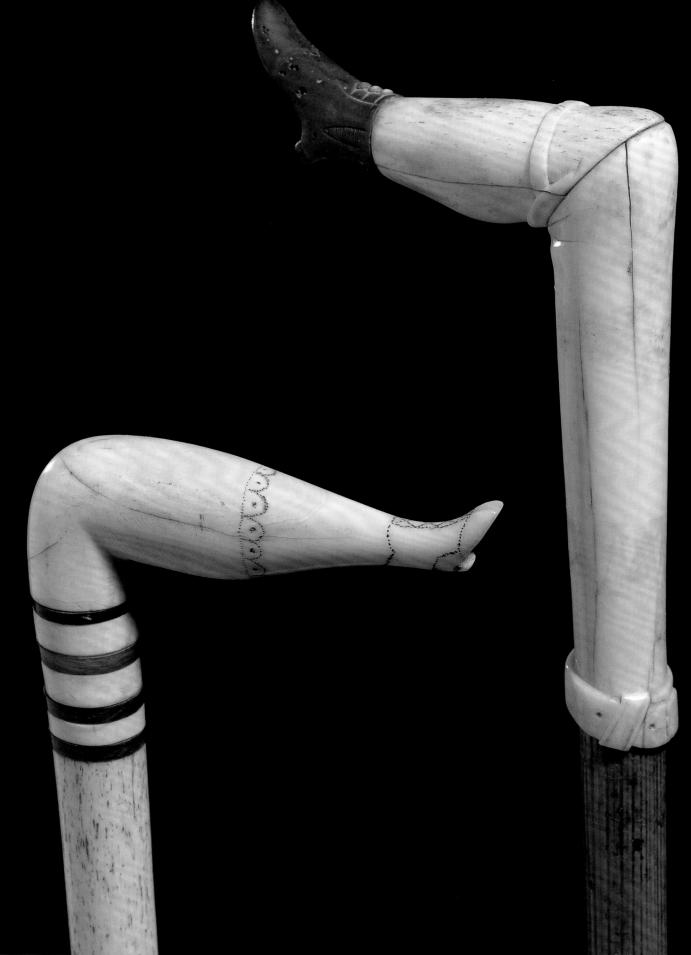

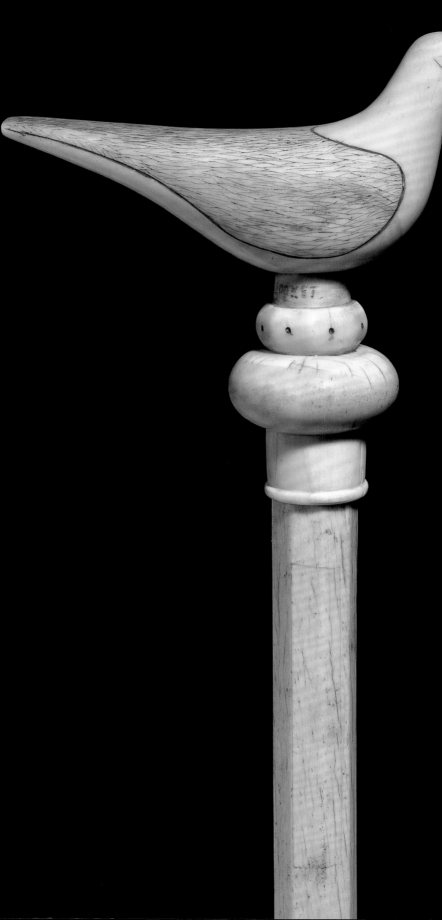

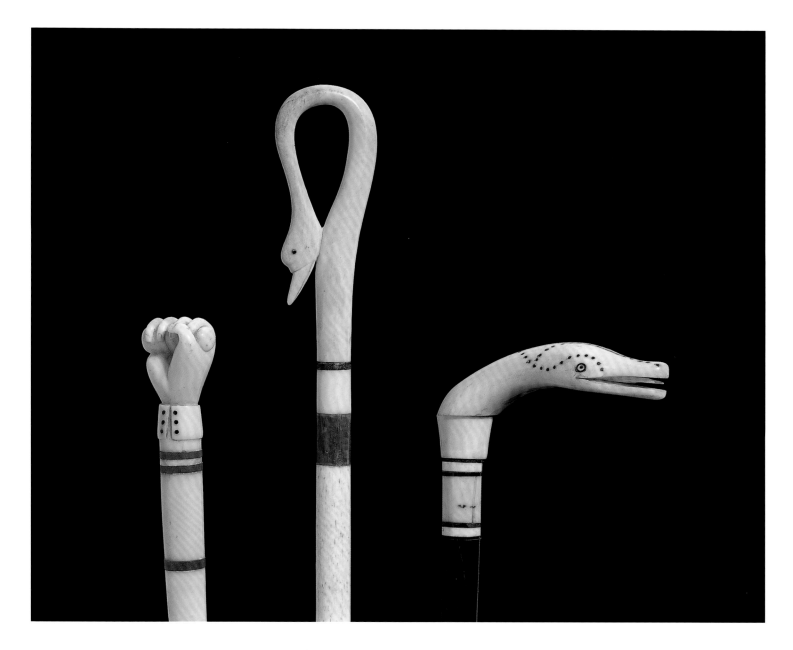

299a.

LADY'S WALKING STICK WITH FIST
HANDLE, c. 1850
Artist unidentified, probably eastern United States
Whale ivory, whale skeletal bone, and baleen with
ink and metal, 28 × ⅞ in. diam., P1.2001.323

299b.

POINTER WITH SWAN HANDLE,
nineteenth century
Artist unidentified, probably eastern United States
Whale skeletal bone, whale ivory, and wood,
34½ × 1³⁄₁₆ in., P1.2001.324

299c.

RIDING CROP WITH SERPENT HEAD
HANDLE, c. 1870
Artist unidentified, probably eastern United States
Ironwood and ivory with nails, 26¾ × 2¾ in.,
P1.2001.325

298.

CANE WITH BIRD HANDLE, c. 1860
Artist unidentified, probably eastern United States
Whale ivory and whale skeletal bone with ink, 39¾ × 4¾ in.,
P1.2001.322

CHAPTER 11

SCULPTURE

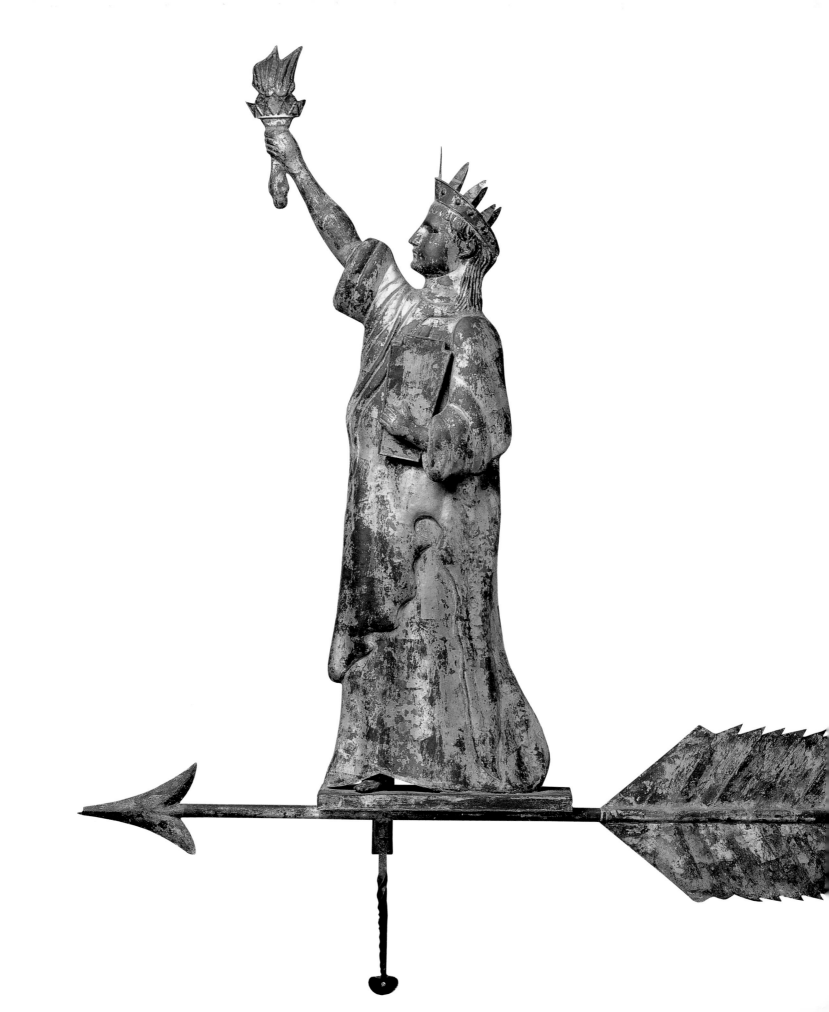

300. **STATUE OF LIBERTY WEATHERVANE**, after 1886
Probably J.L. Mott Iron Works, New York
Copper, zinc, and iron with gold leaf, 53¼ × 55¼ × 5 in.,
P1.2001.326

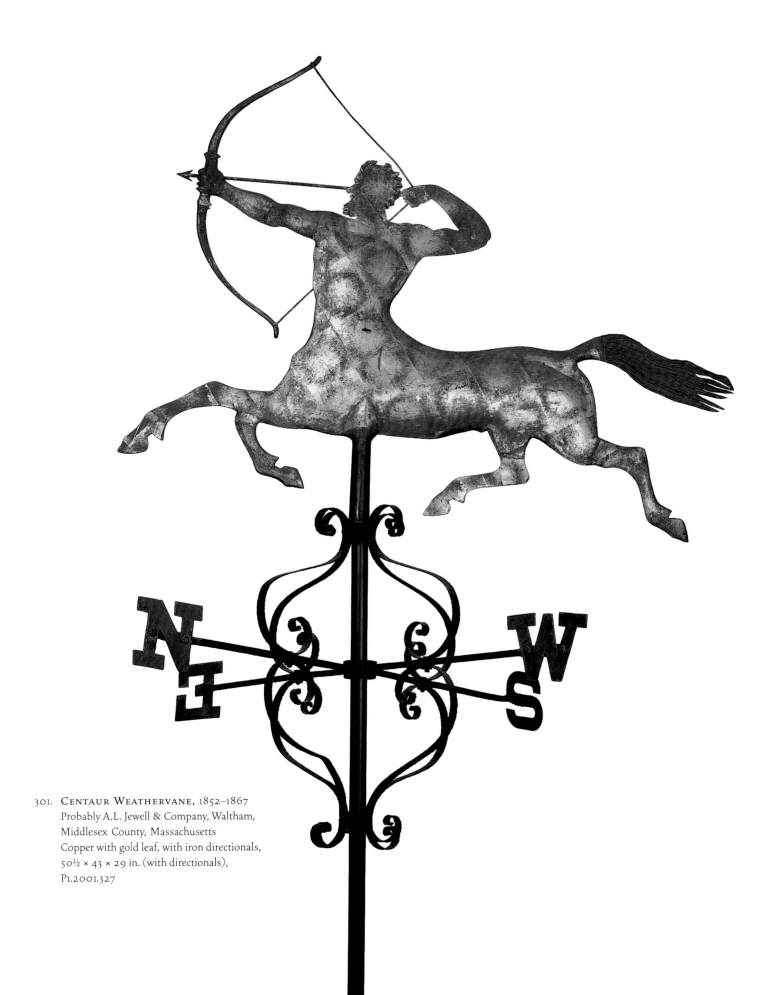

301. CENTAUR WEATHERVANE, 1852–1867
Probably A.L. Jewell & Company, Waltham,
Middlesex County, Massachusetts
Copper with gold leaf, with iron directionals,
50½ × 43 × 29 in. (with directionals),
P1.2001.327

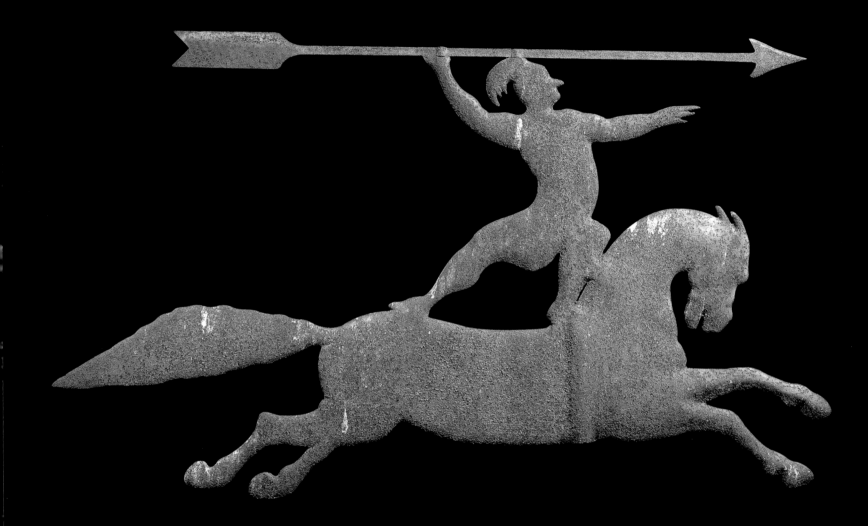

302. **Horse and Rider Weathervane**, c. 1870
Artist unidentified, New England
Cast iron with traces of paint, 22⅛ × 42½ × 1 in.,
P1.2001.328

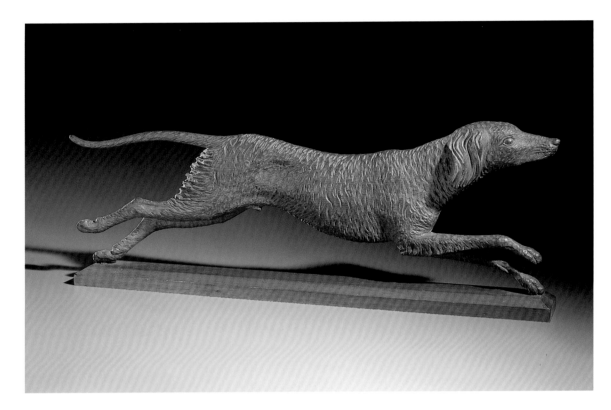

303.
FOXHOUND
WEATHERVANE PATTERN,
1869–1870
Attributed to Henry Leach
(1809–1885), Boston
Pine, 10½ × 26⅝ × 2¾ in.,
P1.2001.329

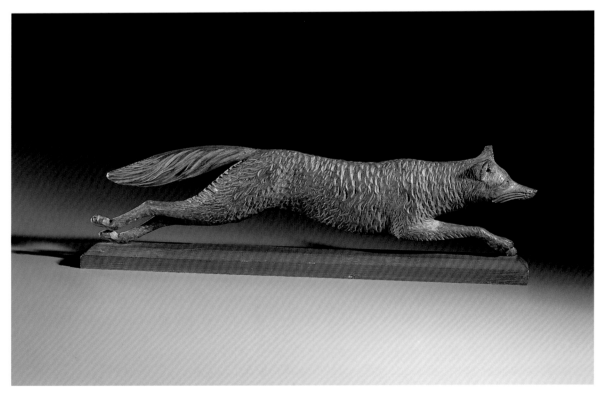

304.
FOX WEATHERVANE
PATTERN, 1869–1870
Attributed to Henry Leach
(1809–1885), Boston
Pine, 6¾ × 22½ × 2⅝ in.,
P1.2001.330

305.
SQUIRREL EATING NUT
WEATHERVANE PATTERN, 1869–1870
Attributed to Henry Leach (1809–1885), Boston
Pine, 16¼ × 16¾ × 17½ in., P1.2001.331

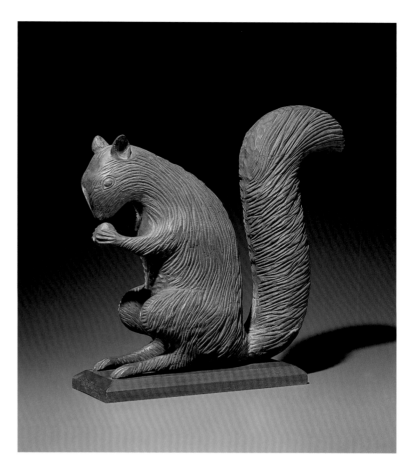

306.
ENGLISH SETTER WEATHERVANE PATTERN,
c. 1871
Attributed to Henry Leach (1809–1885), Boston
Paint on wood, 17 × 35½ × 4 in., P1.2001.332

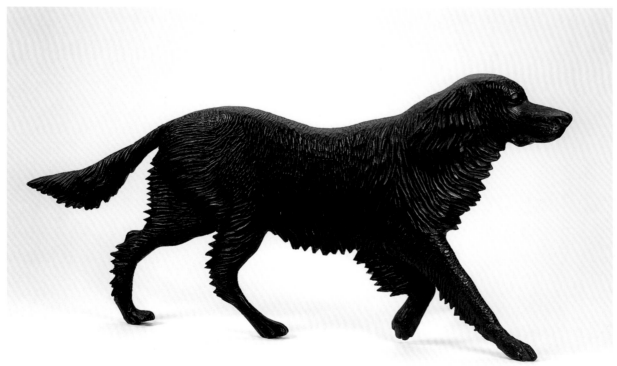

307. **Pheasant Hen Weathervane**, c. 1875
Artist unidentified, probably Connecticut
Pine with traces of paint, 22 × 31 × 10 in.,
P1.2001.333

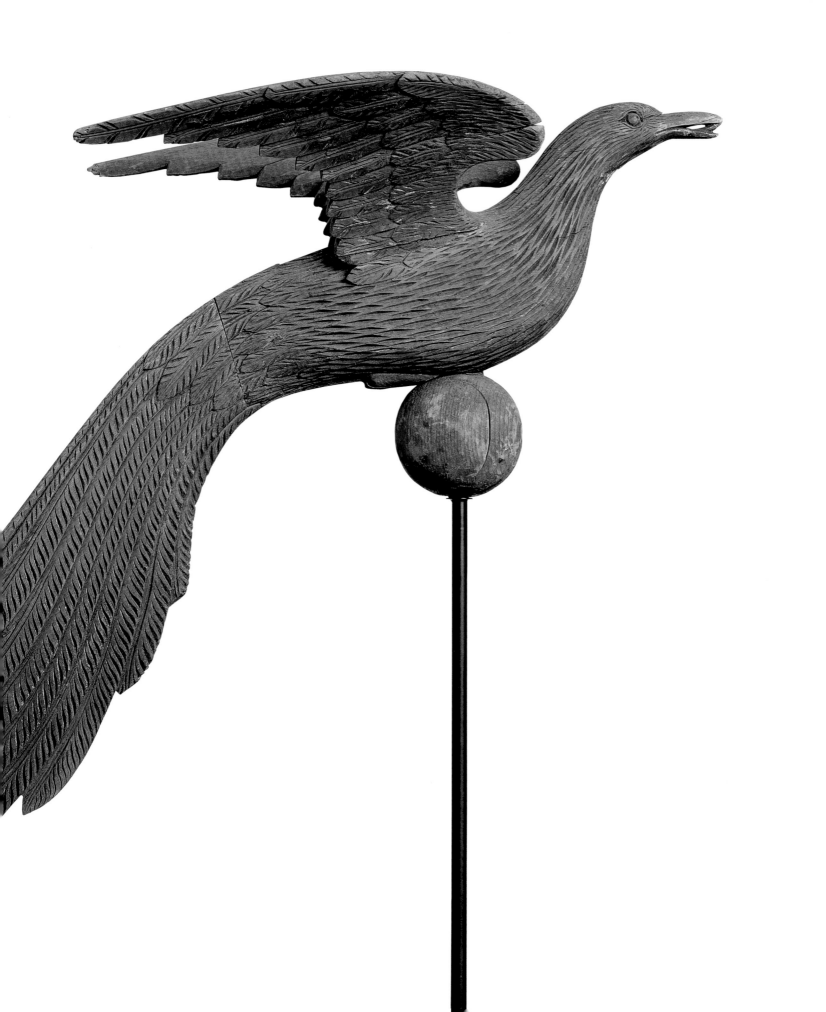

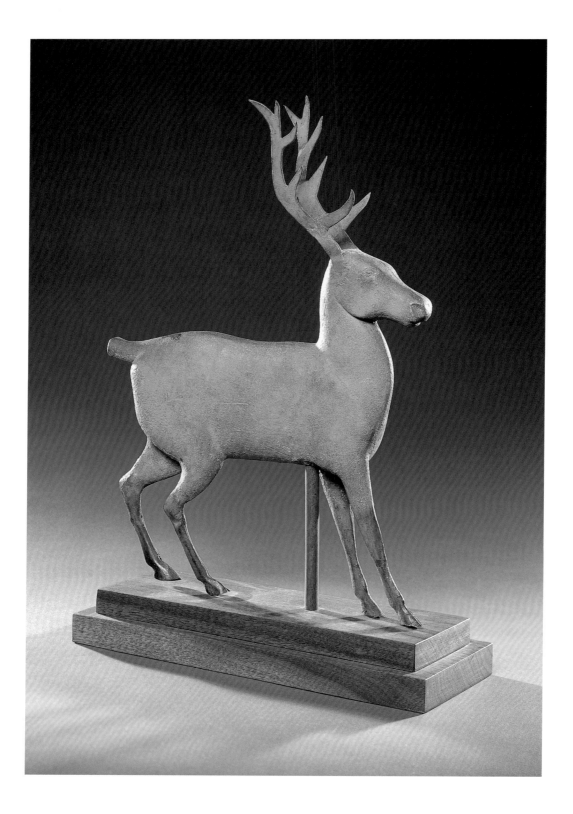

308. MINIATURE DEER WEATHERVANE, c. 1852–1867
Attributed to J. Howard & Company,
West Bridgewater, Plymouth County, Massachusetts
Paint on zinc and copper, 12¾ × 9 × 5 in., P1.2001.334

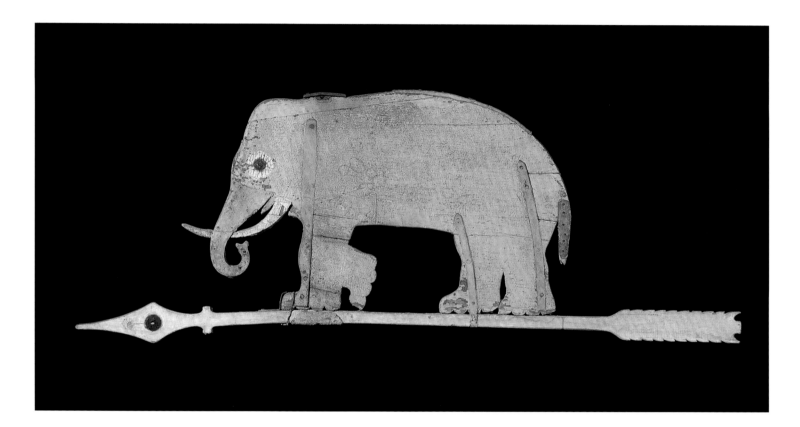

309. ELEPHANT WEATHERVANE, late nineteenth century
Artist unidentified, probably Bridgeport,
Fairfield County, Connecticut
Paint on pine with iron, 19½ × 48¼ × 1 in., P1.2001.335

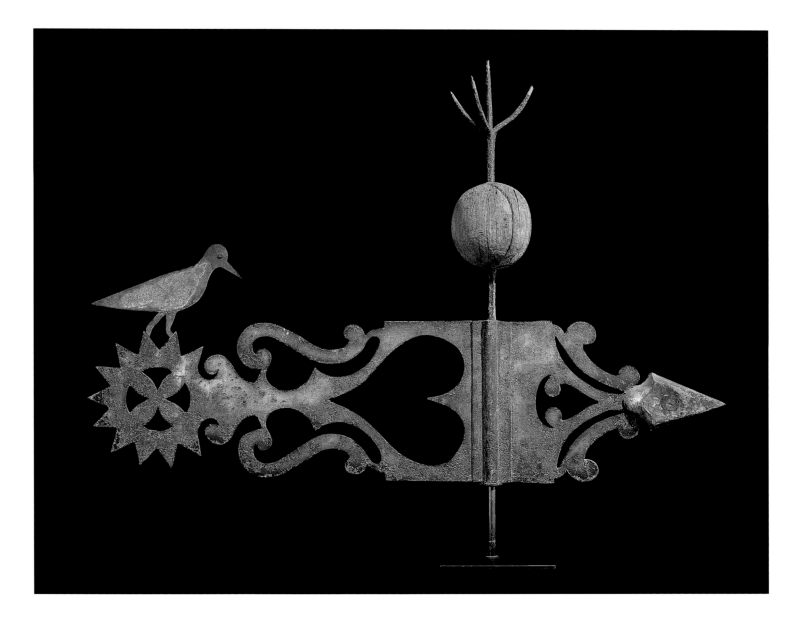

310. BANNERET AND BIRD WEATHERVANE, c. 1880
Artist unidentified, possibly New England
Iron and zinc with gold leaf and wood, 34 × 48 × 6½ in.,
P1.2001.336

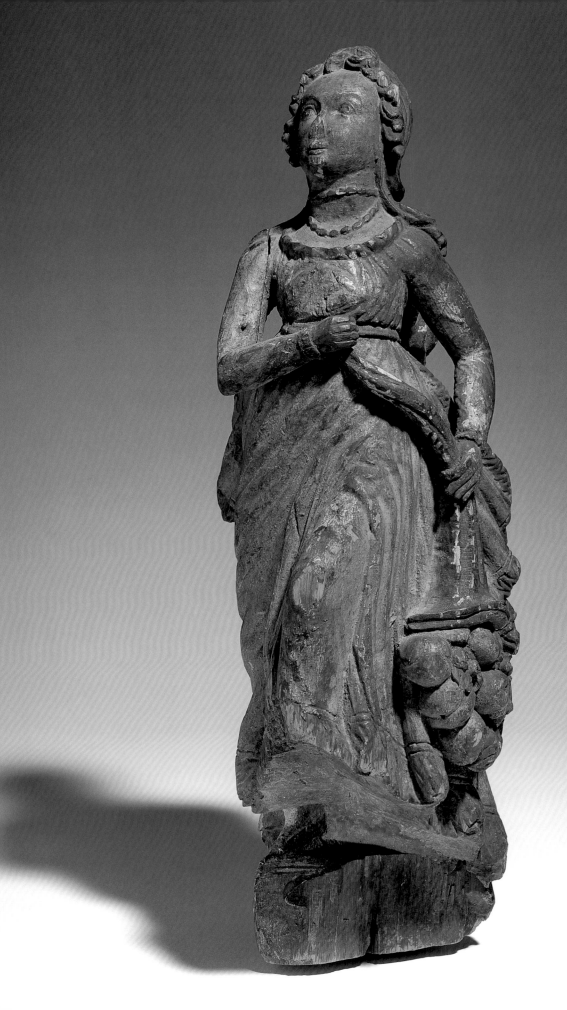

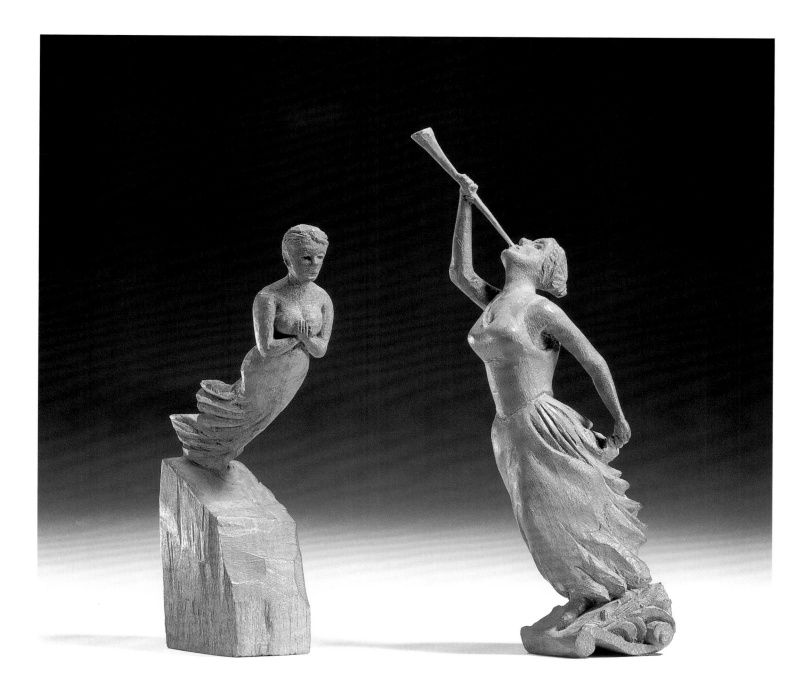

311. FIGUREHEAD MODEL, c. 1810
Artist unidentified, probably New England
Wood with traces of paint, 18 × 5¾ × 6 in., P1.2001.337

312a–b. MINIATURE FIGUREHEADS: MERMAID and
WOMAN WITH TRUMPET, second half nineteenth century
Artist unidentified, probably Salem, Essex County, Massachusetts
Cherry, 4⅛ × 1³⁄₁₆ × 1⅞ in. and 5½ × 1¼ × 1⅝ in., P1.2001.338, 339

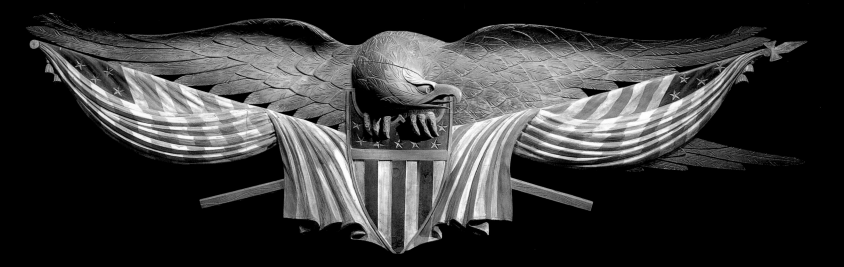

313. **EAGLE,** c. 1890
John Haley Bellamy (1836–1914), Kittery Point,
York County, Maine
Paint on pine with traces of gold leaf, 30 × 99 × 10 in.,
P1.2001.340

314. **GEORGE WASHINGTON,** mid-nineteenth century
Artist unidentified, probably Pennsylvania
Walnut, 24½ × 8 × 3⅛ in., P1.2001.341

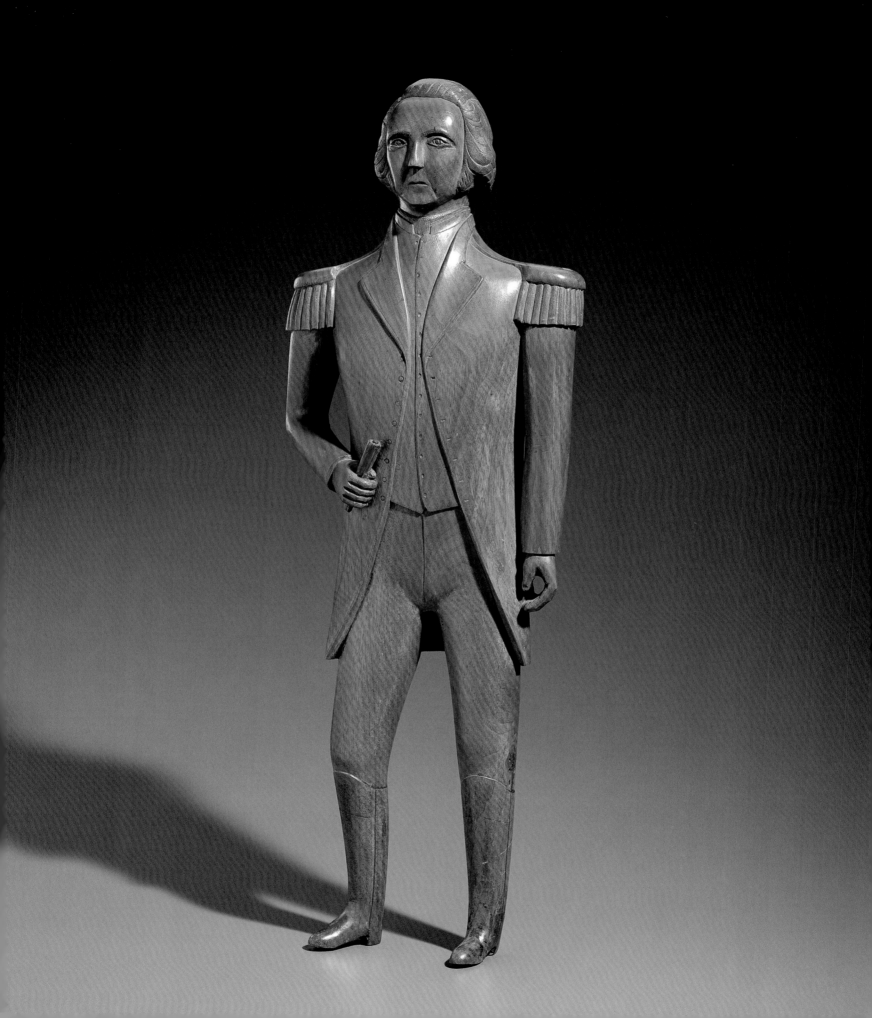

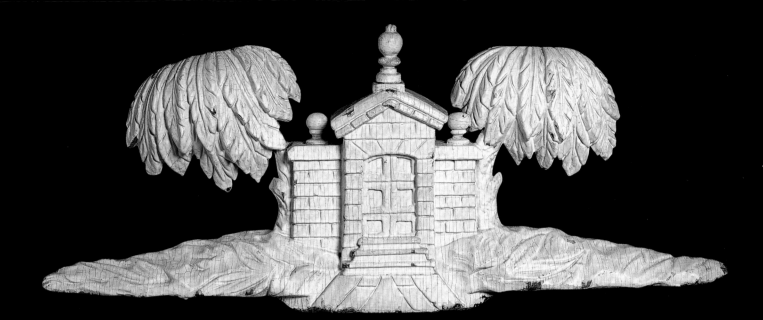

315. **MEMORIAL: GATE OF HEAVEN**, mid-nineteenth century
Artist unidentified, possibly Maine
Paint on wood, 12⅝ × 29½ × 3⅜ in., P1.2001.342

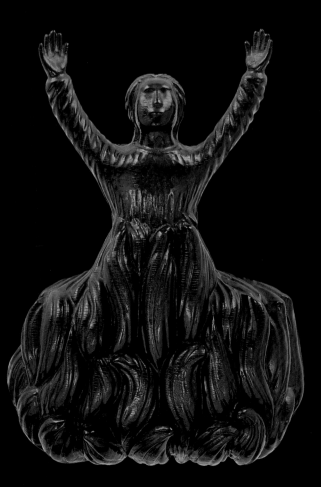

316. **FLAMES OF JUDGMENT**, mid-nineteenth century
Artist unidentified, northeastern United States
Paint on wood, 11⅛ × 7¼ × 2¼ in., P1.2001.343

317. **LADY WITH MUFF**, c. 1940
William Edmondson (1874–1951), Nashville
Limestone, 15½ × 6½ × 6¾ in., P1.2001.344

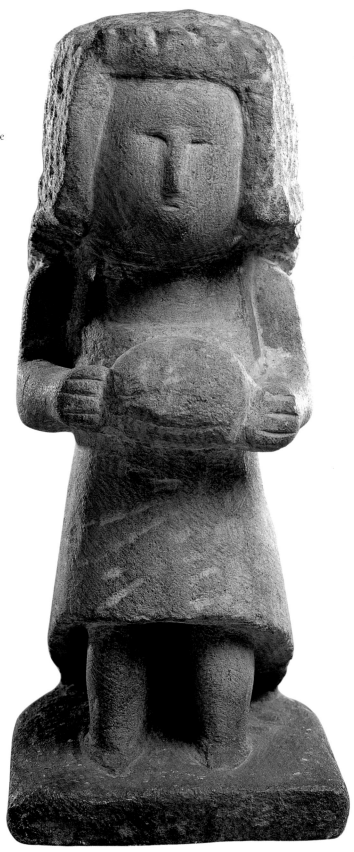

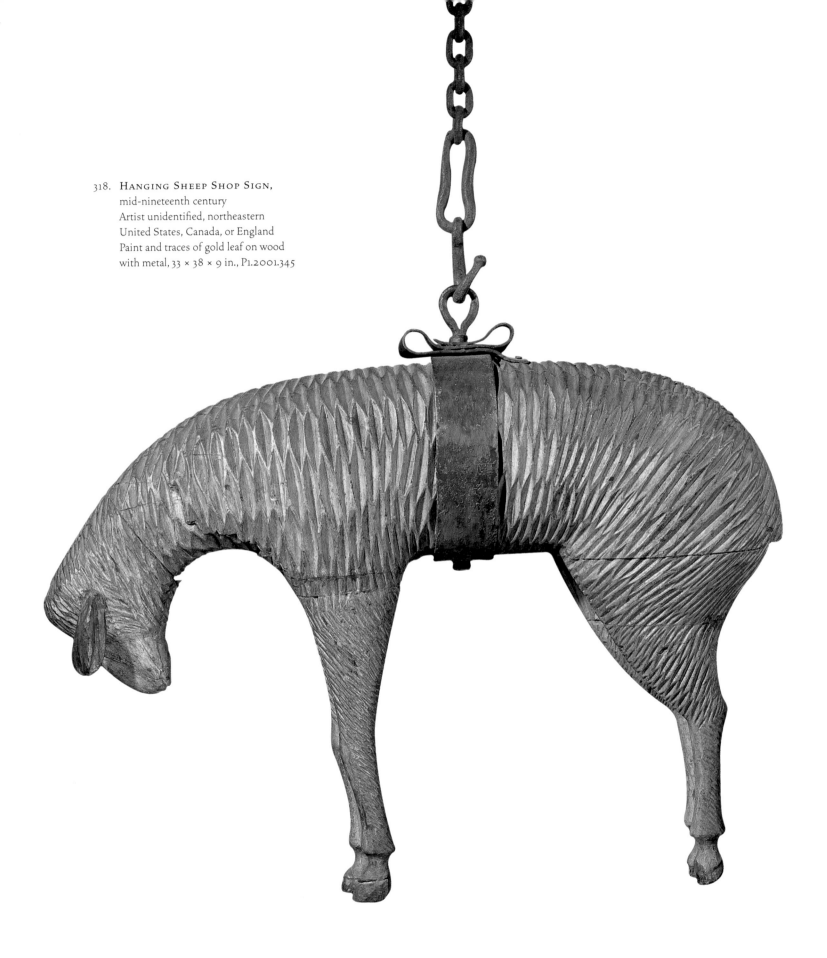

318. HANGING SHEEP SHOP SIGN,
mid-nineteenth century
Artist unidentified, northeastern
United States, Canada, or England
Paint and traces of gold leaf on wood
with metal, 33 × 38 × 9 in., P1.2001.345

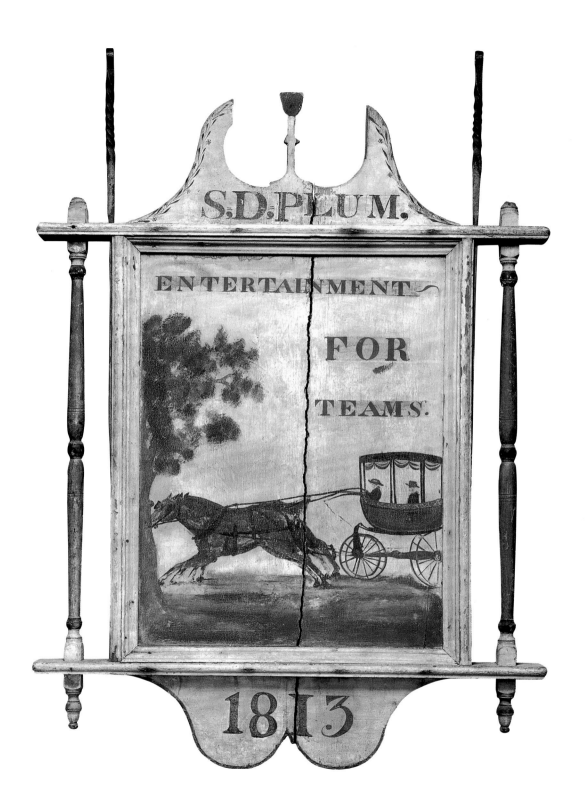

319. S.D. Plum Tavern Sign (recto), 1813
Artist unidentified, probably Meriden, New Haven County, Connecticut
Paint on pine with iron, 51 × 34 × 3 in., P1.2001.346

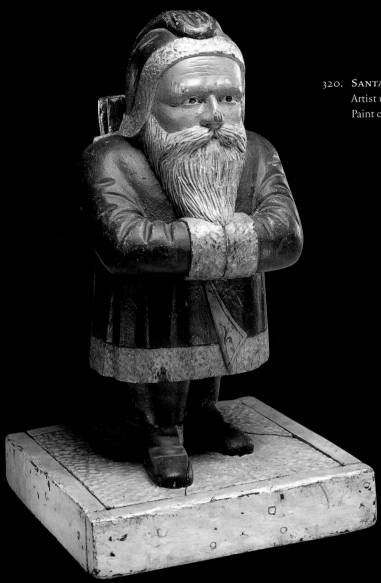

320. **SANTA CLAUS**, late nineteenth century
Artist unidentified, northeastern United States
Paint on wood, 22½ × 11⅞ × 11¾ in., P1.2001.347

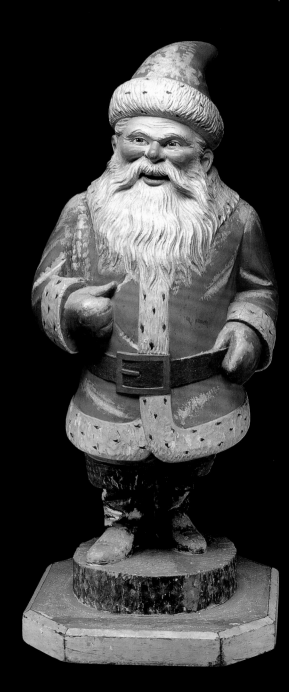

321. **SANTA CLAUS**, 1923
Samuel Anderson Robb (1851–1928), New York
Paint on wood with mica flakes, 38¾ × 16 × 15⅞ in.,
P1.2001.348

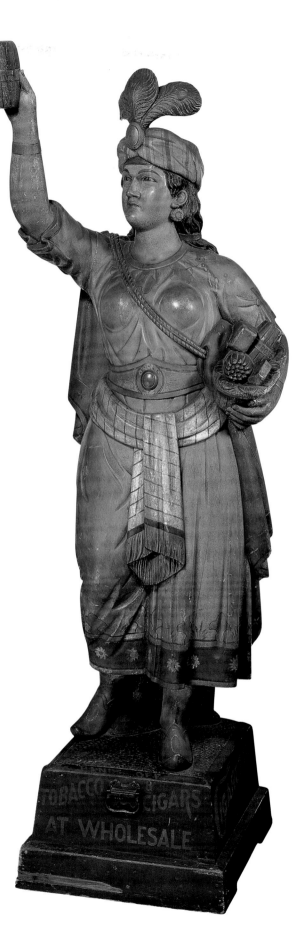

322. **Sultana**, c. 1880
Attributed to the workshop of Samuel Anderson Robb
(act. 1876–1903), New York
Paint on wood with iron, 86 × 26½ × 28 in., P1.2001.349

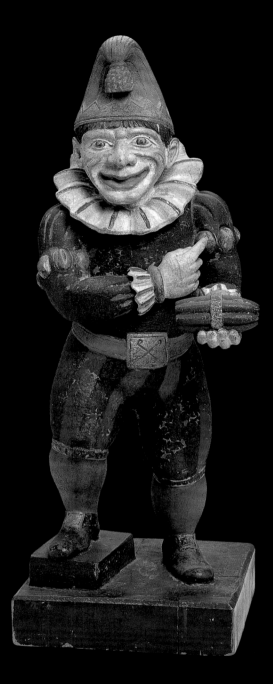

324. **Punch**, 1870
Charles Henkel (1842–1915),
Brattleboro, Windham County,
Vermont
Paint on wood, 25⅜ × 9⅛ × 9⅛ in.,
P1.2001.351

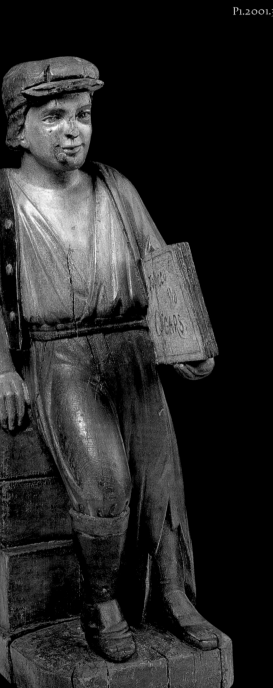

323. **Newsboy**, c. 1880
Artist unidentified, eastern or
midwestern United States
Paint on pine, 35½ × 11½ × 13¼ in.,
P1.2001.350

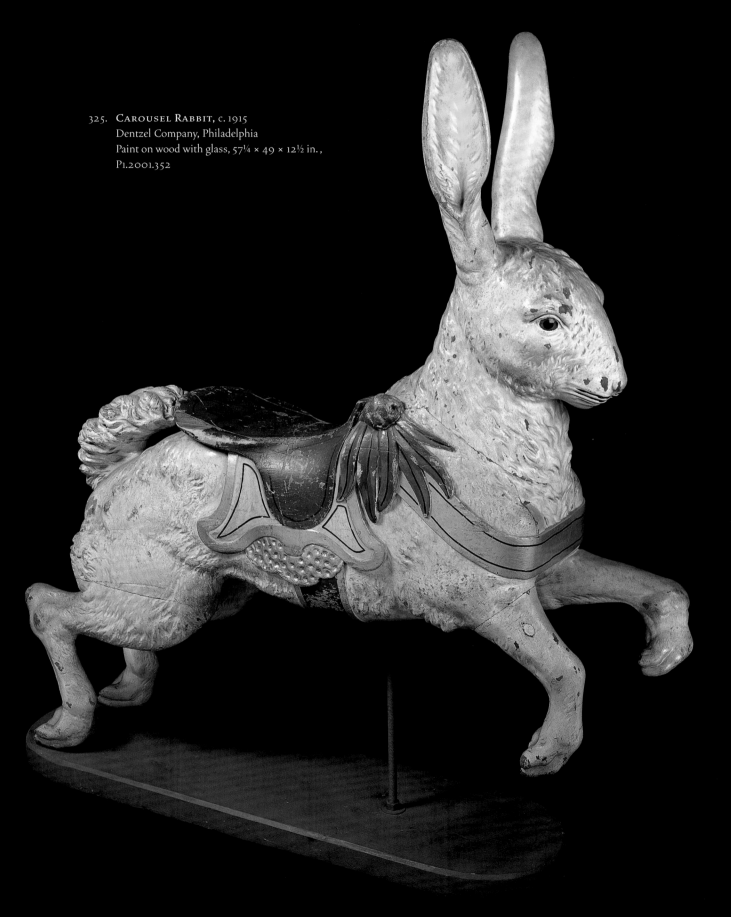

325. **CAROUSEL RABBIT**, c. 1915
Dentzel Company, Philadelphia
Paint on wood with glass, 57¼ × 49 × 12½ in.,
P1.2001.352

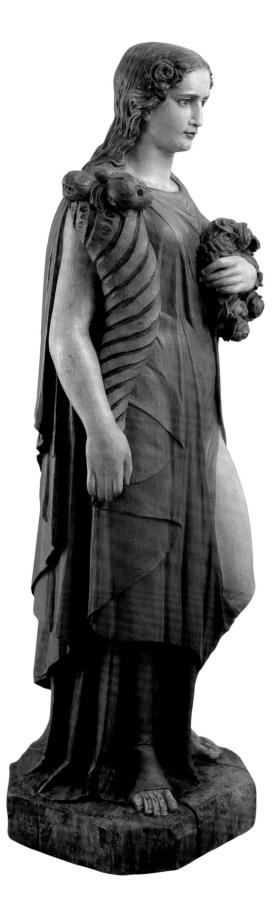

326. ALLEGORICAL FIGURE: FLORA,
1840–1880
Artist unidentified, probably New York
Paint on wood, 53½ × 14¾ × 17½ in.,
P1.2001.353

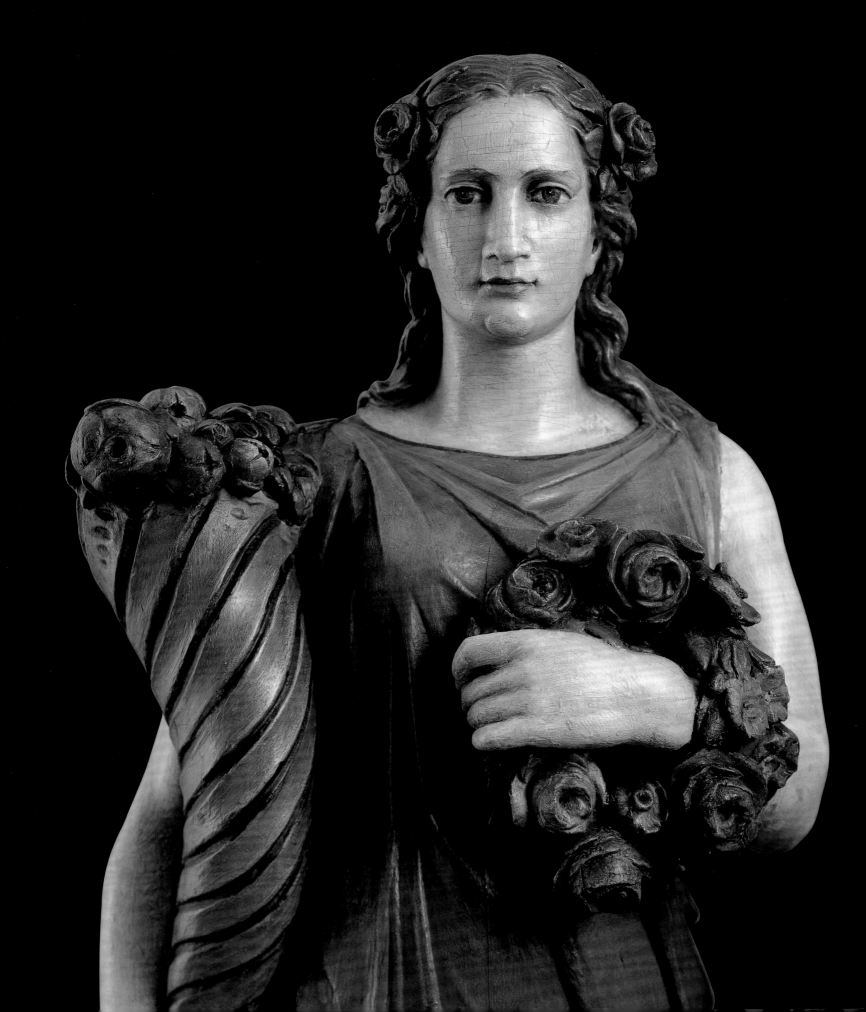

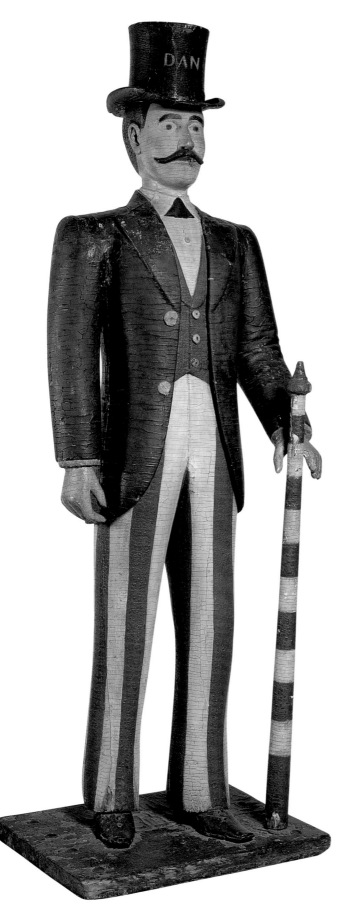

327. **DAPPER DAN**, c. 1880
Artist unidentified, probably Washington, D.C., or Philadelphia
Paint on wood with metal, 68¼ × 22⅛ × 17¾ in., P1.2001.354

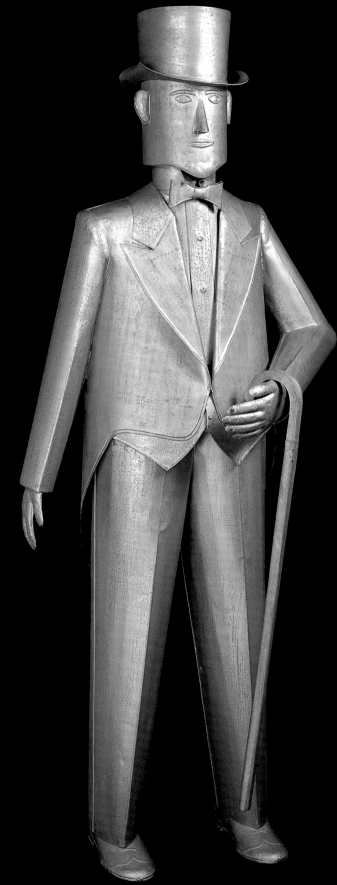

328. TIN MAN, c. 1930
David Goldsmith (1901–1980), Long Island City, Queens, New York
Paint on galvanized sheet metal, 72 × 25 × 11 in., P1.2001.355

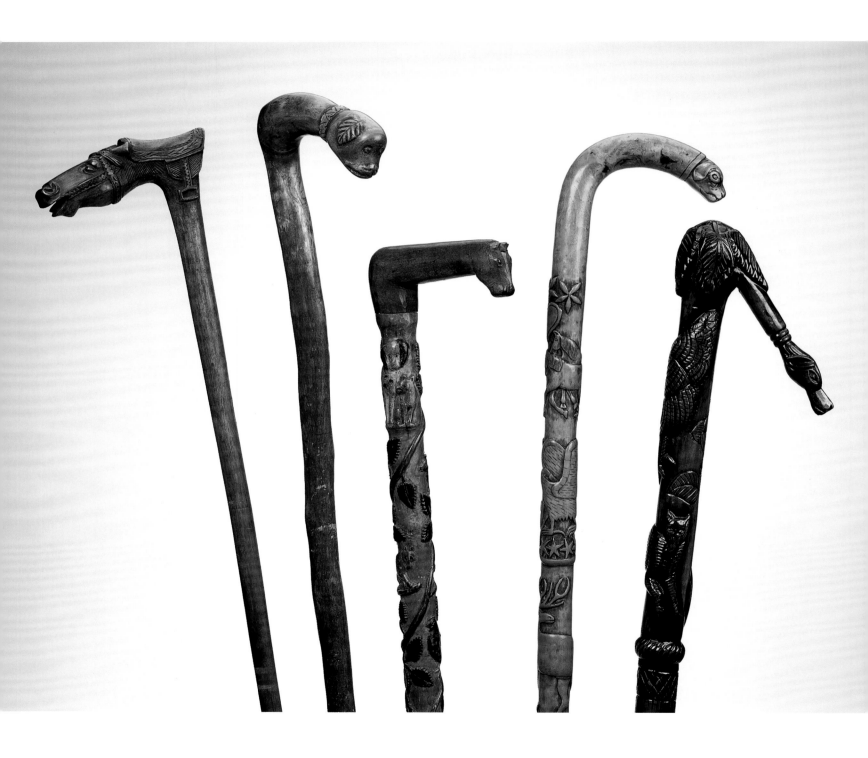

329a. CANE WITH HORSE HEAD
AND BRIDLE HANDLE, late
nineteenth/early twentieth century
Artist unidentified,
possibly Pennsylvania
Dogwood with brass ferrule,
36¼ × 5³⁄₁₆ in., P1.2001.356

329b. CANE WITH DOG HEAD
HANDLE, c. 1900
Attributed to "Schtockschnitzler"
Simmons (act. 1885–1910),
Berks County, Pennsylvania
Dogwood root with paint with
brass ferrule, 37⅜ × 4⅝ in.,
P1.2001.357

329c. ANIMALS AND VINE CANE
WITH HORSE HEAD HANDLE,
late nineteenth/
early twentieth century
Artist unidentified,
eastern United States
Paint on wood, 30 × 4½ in.,
P1.2001.358

329d. ANIMALS CANE WITH DOG
HEAD HANDLE, c. 1900
Probably the Bally Carver,
Berks County, Pennsylvania
Wood with metal ferrule and
rubber tip, 32¾ × 4¾ in.,
P1.2001.359

329e. DOG AND ROOSTER CANE,
c. 1896
Artist unidentified,
eastern United States
Wood with ink and varnish,
34¼ × 5 in., P1.2001.360

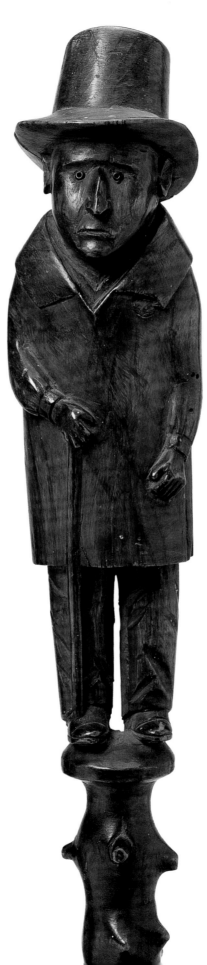

330. SHIP CAPTAIN CANE,
mid-nineteenth century
Artist unidentified, probably
New England
Hickory with brass ferrule,
33 × 2¼ in. diam., P1.2001.361

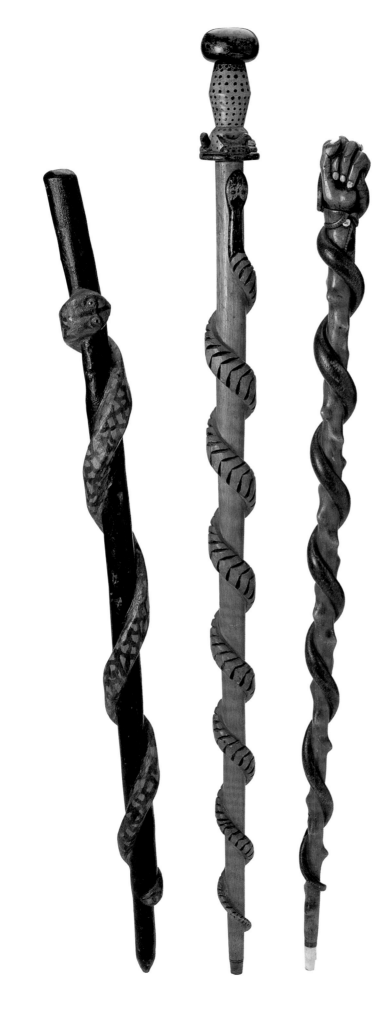

331. **SNAKE CANE,** late nineteenth/
 early twentieth century
 Artist unidentified,
 eastern United States
 Paint on poplar and wisteria with
 glass and cat's teeth, 33½ × 2 in. diam.,
 P1.2001.362

332. **SNAKE CANE WITH NESTING
 BIRDS HANDLE,** late nineteenth/
 early twentieth century
 Artist unidentified, probably
 Duanesburg, Schenectady County,
 New York
 Paint on wood with brads and metal
 thimble ferrule, 38¼ × 2¼ in. diam.,
 P1.2001.363

333. **SNAKE CANE WITH FIST
 HANDLE,** late nineteenth century
 Artist unidentified,
 eastern United States
 Paint on olive wood with ivory, brads,
 and brass, 34½ × 2 in. diam.,
 P1.2001.364

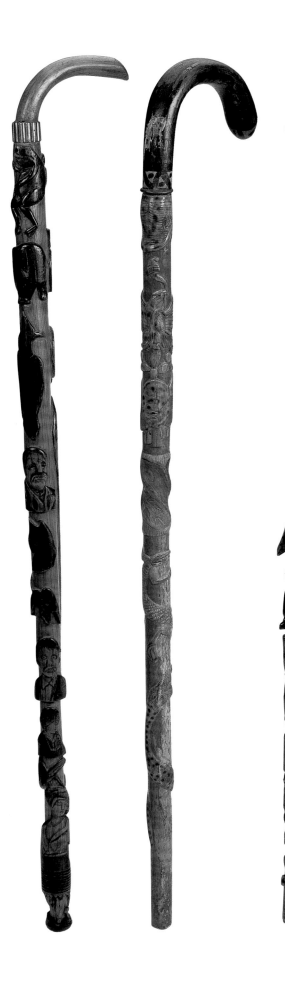

334. **Portraits and Animals Cane,** late nineteenth century
Artist unidentified,
possibly Pennsylvania
Paint on wood with copper and
rubber ferrule, 37 × 5¼ in.,
P1.2001.365

335. **Eagles, Snakes, and Lizard Cane,** late nineteenth/
early twentieth century
Artist unidentified,
eastern United States
Paint on wood, 37 × 6⅛ in.,
P1.2001.366

336. **Animals Cane,** late nineteenth/
early twentieth century
Artist unidentified,
eastern United States
Paint on wood with brass handle
and ferrule, 34⅞ × 4⅝ in.,
P1.2001.367

337. **The Times Cane,**
late nineteenth century
Artist unidentified,
northeastern United States
Wood, 39 × 1 in. diam.,
P1.2001.368

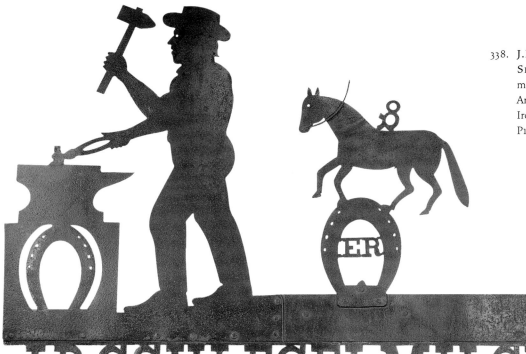

338. J.B. SCHLEGELMILCH BLACKSMITH
SHOP SIGN AND WEATHERVANE,
mid-nineteenth century
Artist unidentified, southeastern Pennsylvania
Iron with traces of paint, 28⅜ × 42 × ¼ in.,
P1.2001.369

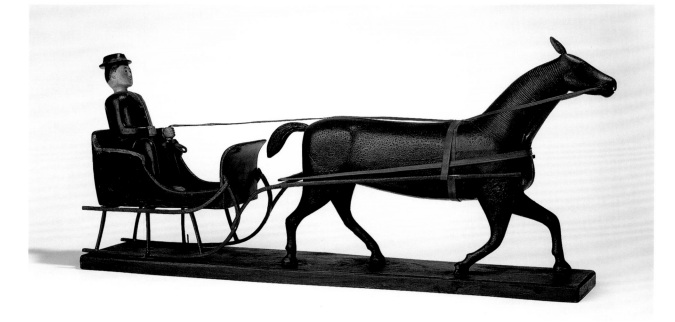

339. HORSE-DRAWN SLEIGH AND DRIVER,
late nineteenth century
Artist unidentified, probably New England
Paint and varnish on wood with leather,
12⅝ × 26 × 5 in., P1.2001.370

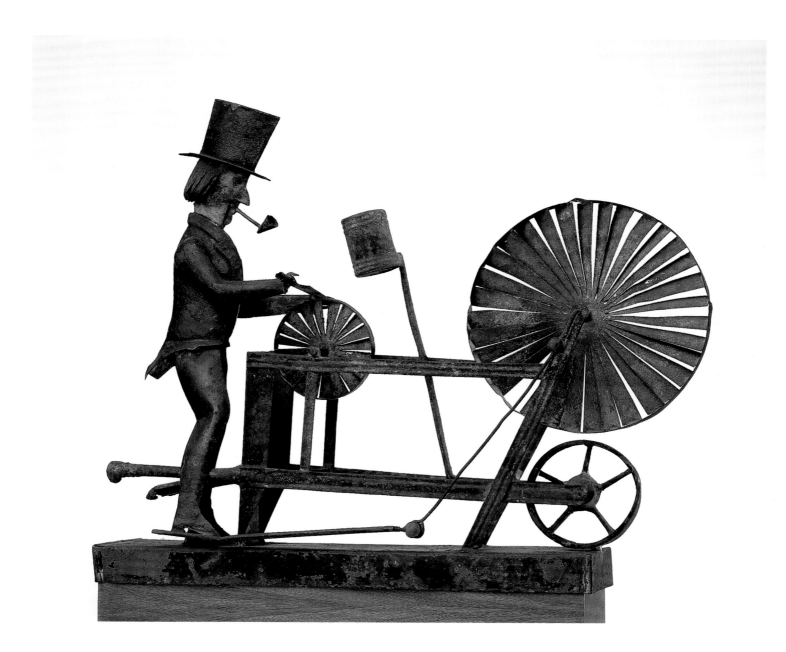

340. KNIFE GRINDER, c. 1875
Artist unidentified, probably New England
Paint on tin, 13½ × 16¼ × 3½ in., P1.2001.371

341. FAME WEATHERVANE, c. 1890
Attributed to E.G. Washburne & Company, New York
Copper and zinc with gold leaf, 39 × 35¾ × 23½ in., P1.2001.372

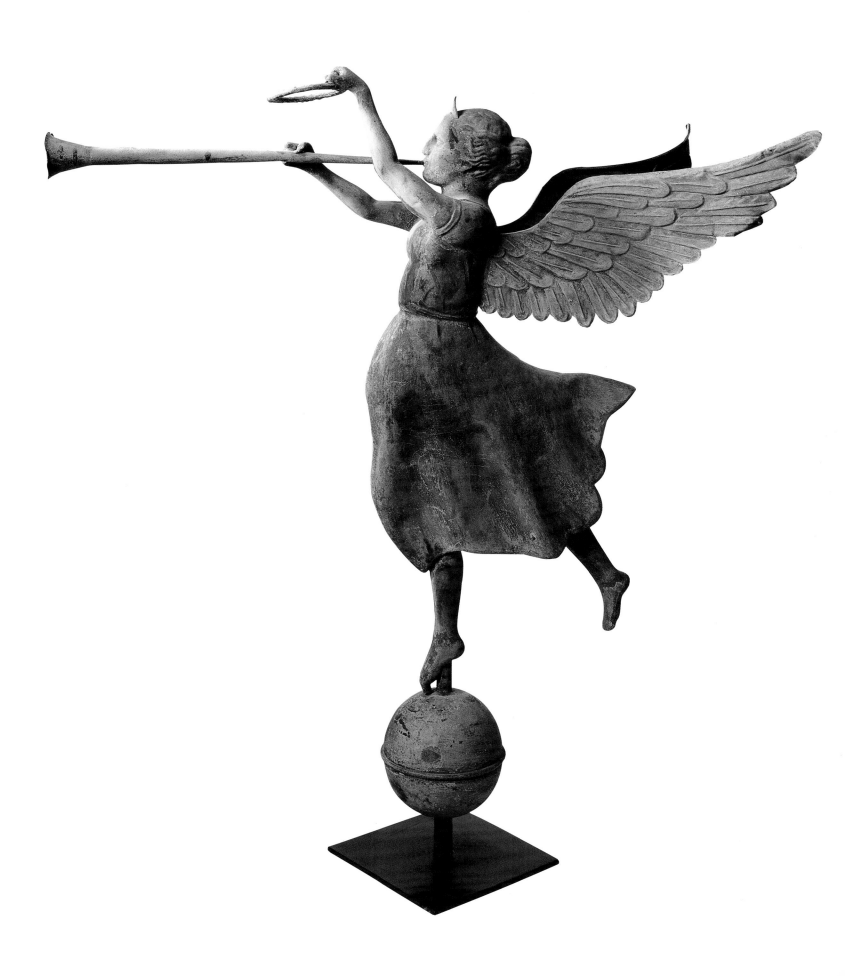

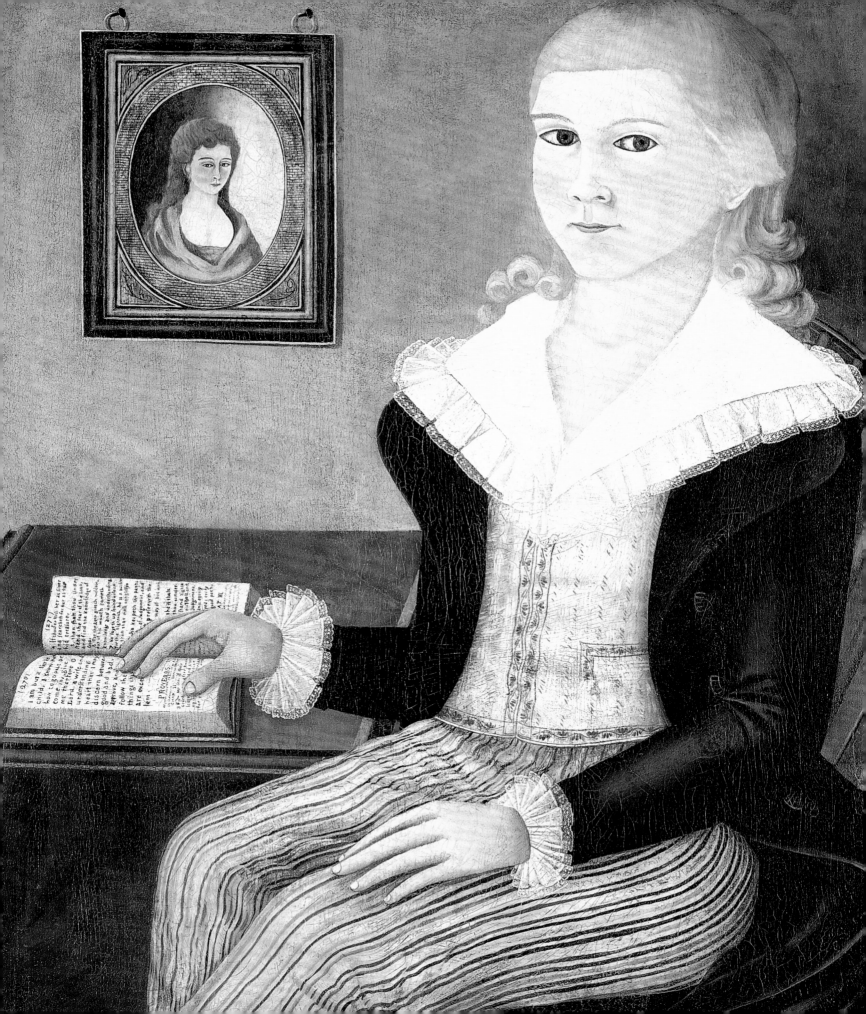

CATALOG

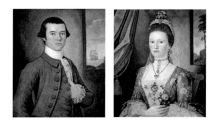

1a–b. PORTRAIT OF A MAN (POSSIBLY CAPTAIN FITZHUGH GREENE)
and **PORTRAIT OF A WOMAN (POSSIBLY MRS. FITZHUGH GREENE)**
Attributed to John Durand (act. 1765–1782)
New York, Connecticut, or Virginia
c. 1768–1770
Oil on canvas
29⁵⁄₁₆ × 24⁵⁄₁₆ in. each
P1.2001.1, 2

PROVENANCE:
J. Crooks, Esq., The Hospital for Sick Children, London; Sotheby's, London, sale 3/70, lot 22; Pawsey & Payne, London; Florene Maine, Ridgefield, Conn., 1972.

PUBLISHED:
Fales, Martha Gandy. *Jewelry in America, 1600–1900*. Woodbridge, England: Antique Collectors' Club, 1995, p. 45, back cover (*Woman* only).

John Durand remains a mysterious character in the annals of American art history, though he was a preeminent painter of wealthy New York families during the second half of the eighteenth century. Durand's career can be traced from Virginia to New York, Connecticut, and even Bermuda, but the trail ends in 1782, when his name appeared on a tax list for Dinwiddie County in Virginia.[1] Durand is first documented in Virginia, in 1765, but was painting in New York City the following year, when he portrayed James Beekman's six children. His name appears in Beekman's account book as "Monsieur Duran," a notation that has led to conjecture that the artist was of French heritage. In 1768 he portrayed merchant Garret Rapalje and his family. The painting of the four Rapalje children is the artist's only known group portrait and endures as one of his most successful works.[2] In April of the same year, Durand advertised in the *New-York Gazette, or, The Weekly Post-Boy* that he had "from infancy endeavored to qualify himself in the Art of historical Painting."[3] Like other artists of the period, including those with some European training, Durand aspired to this genre, which, regardless of the importance given to it by artists, had difficulty finding patronage in colonial America. As no paintings of historical subjects by Durand are known, he appears to have been unsuccessful in this ambition.

Durand's style was changeable throughout his career. The portraits relied on a sensitive color sense and linear treatment for facial modeling and decorative appeal. The palette ranged from earth tones to rococo

pinks and blues. The Virginia portraits, in particular, appear "dry and hard," as his nephew Robert Sully characterized them, when compared to the more naturalistic and decorative New York portraits.[4] Despite the changes in palette, there are certain consistent conventions in Durand's portraits. These include a flower upheld in one hand of female sitters, often near the bosom; flowers turned on their stems to reveal star-shaped leaves; and a particular display of fingers, often with one or two lifted and separated from the rest.

These portraits are purported to depict Captain and Mrs. Fitzhugh Greene of Newport, Rhode Island.[5] Mrs. Greene's aristocratic bearing, rich jewels, and beautiful, flowered blue silk dress support the ownership of the merchant vessel implied in her husband's portrait.[6] In each portrait, the subject is set against a plain wall, and window cutouts appear at the far right. His offers a seascape with his ship in the background, while hers affords a glimpse of a verdant landscape. They share a quiet self-containment and a freshness of face. But unlike Captain Greene's minimal composition painted in earth tones, Mrs. Greene's portrait is adorned with a draped curtain in a rose color with gold cording, fringe, and tassel. The lusciousness of her jewels is matched by the profusion of flowers on her bodice and headdress and the blush blooming in her cheeks; in one hand she holds a rose in full flower. When juxtaposed to the drab coloring of her husband's portrait, Mrs. Greene can clearly be perceived as his adornment, a fertile beauty in the flush of womanhood.

—S.C.H.

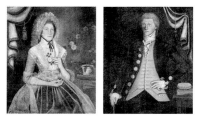

2a–b. MARY KIMBERLY THOMAS REYNOLDS
and **JAMES BLAKESLEE REYNOLDS**
Attributed to Reuben Moulthrop (1763–1814)
West Haven, New Haven County, Connecticut
c. 1788
Oil on canvas
45¼ × 36 in. each
P3.1995.1, 2

PROVENANCE:
Descended in family to Alice Reynolds, New Haven, Conn.; Richard L. Mills, Exeter, N.H.; Bertram K. and Nina Fletcher Little, Brookline, Mass.; Sotheby's sale 6526, "Little Collection, Part I," 1/94, lot 75.

EXHIBITED:
"Reuben Moulthrop, 1763–1814," The Connecticut Historical Society, Hartford, 1956.
"Paintings by New England Provincial Artists, 1775–1800," MFA, 1976.

1 Biographical information based on Franklin W. Kelly, "The Portraits of John Durand," *The Magazine Antiques* 122, no. 5 (November 1982): 1080–87.
2 Collection N-YHS; see ibid., p. 1081.
3 Rita S. Gottesman, comp., *The Arts and Crafts in New York, 1726–1776: Advertisements and News Items from New York City Newspapers* (New York: N-YHS, 1938), pp. 1–2.
4 Kelly, "Portraits of John Durand," p. 1084.

5 Former owner Florene Maine provided this identification but without documentation. The paintings were sold by Sotheby's in London (3/70) as an anonymous pair of American portraits. No other works by Durand are known to have been painted in Rhode Island.
6 In New Haven about 1770, Durand painted another pair of portraits that feature a ship in the background—an unusual element in his work. The portraits of Colonel William Douglas and his wife, Hannah Mansfield Douglas, are illustrated in "Queries," *The Magazine Antiques* 102, no. 6 (December 1972): 1024.

PUBLISHED:

Bishop, Robert, and Jacqueline Marx Atkins. *Folk Art in American Life.* New York: Viking Studio
 Books in association with MAFA, 1995, p. 7 (*Mrs. Reynolds* only).
Black, Mary, and Jean Lipman. *American Folk Painting.* New York: Clarkson N. Potter, 1966,
 pp. 28–29.
Hollander, Stacy C. "Reuben Moulthrop: Artist in Painting and Waxworks." *Folk Art* 19, no. 3
 (fall 1994): cover, pp. 36–37.
Kogan, Lee, and Barbara Cate. *Treasures of Folk Art: Museum of American Folk Art.* New York:
 Abbeville Press in association with MAFA, 1994, pp. 8, 9.
Little, Nina Fletcher. *Country Arts in Early American Homes.* New York: E.P. Dutton, 1975, p. 113
 (*Mrs. Reynolds* only).
———. *Little by Little: Six Decades of Collecting American Decorative Arts.* New York: E.P. Dutton,
 1984, pp. 135, 139.
———. *Neat and Tidy: Boxes and Their Contents Used in Early American Households.* New York:
 E.P. Dutton, 1980, pl. 16 (*Mr. Reynolds* only).
———. *Paintings by New England Provincial Artists, 1775–1800.* Boston: Leether Press in associa-
 tion with MFA, 1976, pp. 39, 41.
Sawitzky, Susan. "New Light on the Early Work of Reuben Moulthrop." *Art in America* 44,
 no. 3 (fall 1956): 55.
Thomas, Ralph W. "Reuben Moulthrop, 1763–1814." *Connecticut Historical Society Bulletin* 21,
 no. 4 (October 1956): 100.

Marriage was a primary occasion for commissioning portraits through the middle of the nineteenth century.[7] James Reynolds (1754–1834) and Mary Kimberly Thomas (1754–1833) were wed about 1788 and were probably painted then; their first child was born the following year, in 1789.[8] Each is shown in the separate sphere determined by gender: Mr. Reynolds's masculine presence is emphasized by his standing posture in the conventional hand-on-hip attitude, while Mrs. Reynolds is seated on a fiddleback chair, her receptive pose belied by her direct and determined gaze. Mr. Reynolds's open jacket reveals a buttoned vest, forming a triangle that points directly to his face. He wears a powdered tie-wig with the hair combed back into a fixed braid; one hand grasps an ivory-handled cane, and a watch key and fob hang at his waist. His tricorne hat is on the wall behind him, and a snuffbox sits on the table. Mrs. Reynolds wears a beautiful, figured open robe over a dark petticoat, a lace shawl crosses over and is tucked into her waistband, and an elaborate lace cap with lappets tops her hair. She holds a rose to her bosom in one upturned hand, and a pot of flowers in bloom sits on a table beside her, drawing upon emblematic traditions associated with love and fruitfulness. Even so, both Mr. and Mrs. Reynolds are painted without sentimentality. Lines creasing their foreheads and the sides of their mouths hint at a sense of humor and make their otherwise severe and masklike faces unusually expressive.

These portraits may have been painted by Reuben Moulthrop, an East Haven, Connecticut, artist who achieved renown for his waxworks of full-size figures arranged in tableaux, which were displayed throughout Connecticut, in New York City, and as far away as the West Indies.[9] The portraits of the Reynoldses predate Moulthrop's earliest documented work, portraits of Sarah and Job Perit, painted in 1790, and show the influence of John Durand, who was active in East Haven, New York, and Virginia.[10] Some of the conventions associated with Durand's portraits are evident in the portrayal of Mrs. Reynolds: the hand raised to her breast and holding a rose, the other arm crossing at the waist, and the careful disposition of fingers, with their delicate fluttering. The portrait of Mr. Reynolds also refers to Durand's work in the hand-on-hip pose and the curled little finger, an affectation borrowed directly from Durand's *The Rapalje Children*.[11] In both Reynolds portraits, heavy outlining describes hands and clothes and suggests the overlapping of three-dimensional forms. An attempt to create a spatial context is seen in passages such as the black ribbon around Mrs. Reynolds's neck, which recedes behind the sheer gauze of her shawl.

The only major exhibition of Moulthrop's work—at the Connecticut Historical Society in Hartford in 1956—demonstrated the great disparities in the portraits thought to be by Moulthrop, making firm attributions problematic.[12] Discrepancies between the Reynolds and Perit portraits at first make it seem unlikely that Moulthrop painted both pairs. Similarities of treatment do exist, though, in the artist's fascination with skin texture; the waxy, sculptural folds of the curtains in the Reynolds portraits recall the ruffles of Job Perit's shirt; and the star-shaped motif on each of Mr. Perit's buttons is similar to flowers shown from the stem side in the portrait of Mrs. Reynolds. Heavy outlining is also used in the portraits of the Perits, though with greater discretion than in the Reynolds paintings. Another link between the two pairs is provided by *Captain Amos Morris,* which is clearly painted by the artist of the Reynolds portraits and related to the signed portrait of Job Perit in the unusual scalloped coat hem that appears in both works.[13]

7 In his statistical analysis of early-nineteenth-century American folk portraiture, Jack Larkin discovered that portrait pairs of married couples accounted for up to one-half of the paintings he studied; see Larkin, "The Faces of Change: Images of Self and Society in New England, 1790–1850," in Caroline F. Sloat, ed., *Meet Your Neighbors: New England Portraits, Painters, & Society, 1790–1850* (Sturbridge, Mass.: Old Sturbridge, 1992), p. 17.

8 This was a second marriage for Mary Kimberly, who was married to Seth Thomas until his death in 1782. They had four children, at least three of whom died before reaching adulthood. Her second marriage produced two children. A portrait in a private collection similar in style, size, and composition to the portraits of the Reynoldses depicts a young girl. Her relation, if any, to the Reynoldses has not been determined, however. See Nina Fletcher Little, *Paintings by New England Provincial Artists, 1775–1800* (Boston: Leether Press in association with MFA, 1976), pp. 38–41, for additional biographical information on the Reynoldses.

9 "Reuben Moulthrop, 1763–1814," *Connecticut Historical Society Bulletin* 20, no. 2 (April 1955): 45. In the (*New Haven*) *Connecticut Journal,* Sept. 4, 1793, Moulthrop advertised that an "Artist in PAINTING and WAX-WORK" would be in residence at the "Sign of the GODDESS IRIS in State Street," exhibiting sensational representations in wax such as "the KING OF FRANCE in the Act of losing his Head, under the GUILLOTINE, preserving every Circumstance which can give to the Eye of the Spectator a realizing View of that momentous and interesting Event. Also A SPEAKING FIGURE, which, even in its unfinished State, has afforded the highest Satisfaction to the Curious." In the same advertisement, Moulthrop offered miniature and portrait painting, as well as likenesses taken in wax. To further the realism of his wax vignettes, Moulthrop hired two dressmakers from England to live in his home and sew costumes for the figures, which were constructed from a wooden framework, stuffed, and dressed. The heads, hands, and feet were cast in beeswax and painted in oil colors, and natural hair and glass eyes were used to complete the semblance of life.

10 Collection MMA. Each Perit portrait is inscribed on the back with the sitter's name and age, the year, and the artist's signature: "Ruben [*sic*] Moulthrop, Pinxit." See Stacy C. Hollander, "Reuben Moulthrop: Artist in Painting and Waxworks," *Folk Art* 19, no. 3 (fall 1994): 40, 41.

11 The use of the hand-on-hip convention in America, frequently employed by Durand, is derived from European mezzotints.

12 The small number of documented examples, changeable styles, and deterioration of surface over time have contributed to the difficulties in making firm attributions. The exhibition sparked reactions regarding the attributions, and these were discussed in the pages of the *Connecticut Historical Society Bulletin* 21, no. 4 (October 1956), and 22, no. 2 (April 1957). Later, several of the portraits were discovered to be by other Connecticut artists.

13 The portrait of Morris is in the collection of the New Haven Colony Historical Society; see Hollander, "Reuben Moulthrop," p. 39. It was painted about the same time as the Reynolds portraits and before the documented Perit portraits. The handling of the faces is similar. Moulthrop was the likely artist of the Morris portrait as the two men were related through marriage, of Morris's granddaughters to Moulthrop's brothers-in-law.

A round of letters between Thomas Robbins and his family with Moulthrop reveals a great deal about the client-artist relationship.[14] Robbins had been trying for five years to have Moulthrop paint his parents, a commission interrupted first by Moulthrop's thriving waxworks business and then by a bout of "tipus fever" that left the artist weak and unable to work for some time, and which may have been the extenuating cause of his death two years later, in 1814. The correspondence indicates that Moulthrop was able to paint seven portraits in seven weeks, including two of the elder Reverend Robbins, who complained to his son, "I had no idea it would take so long." The letters also show that Moulthrop would exchange portraiture for services, in this instance for the care and feeding of his horse. Perhaps of greatest interest, though, is the fact that the results of the sessions provided an opportunity for other artists and potential clients to see the work in progress. Reverend Robbins wrote to his son, "Our pple came in plenty day after day as into a Museum—all agree that the likenesses are admirably drawn...."

—S.C.H.

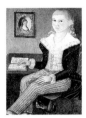

3. JONATHAN KNIGHT
Artist unidentified
Connecticut
c. 1797
Oil on paperboard, mounted on Masonite
34 × 24 in.
P1.2001.3

INSCRIPTION:
Recto, facing pages of book, paint: (270) / I am but a little / child, I know not / how to go out or / come in, give / me therfore O / Lord, a wife and / understanding / heart that I may / discern between / good and bad, / approve, and / follow the / things that / are excel / lent. / PROVERBS. / [illegible] / CHAP. II / 3 My son if thou / criest after know / ledge and [liftest] / up thy voice / for un[derstan]ding; (271) / 4 If thou seekest her as silver / and searchest for her as for / hid treasure, / 5 then shalt thou under / stand the fear of the Lord, / and find the knowledge of God. / 6 For the Lord giveth wisdom, / out of his mouth cometh / knowledge and understanding / 7 he layeth up found wisdom / for the rightous he is a buckler / [to] them that walk uprightly. / [8] he keepeth the paths / of judgement, and / preserveth the / way of his faith / [9] then shalt / thou under / stand righte / ousness, and / judgement, / and equity / yea every / good path / [CH]AP III / [illegible]

PROVENANCE:
Descended in family; Harriet Skinner Staples; Harriet Staples Wheeler Phillips; Sotheby Parke-Bernet sale 4784M, 1/82, lot 25.

EXHIBITED:
"Young America: A Folk Art History," MAFA at IBM Gallery of Science and Art, New York, 1986.
"Life in the New World: Selections from the Permanent Collection of the Museum of American Folk Art," Sotheby's, New York, 1987.

PUBLISHED:
Lipman, Jean, Elizabeth V. Warren, and Robert Bishop. *Young America: A Folk Art History.* New York: Hudson Hills Press in association with MAFA, 1986, p. 32.
Warren, Elizabeth V. "Young America: A Folk Art History." *The Magazine Antiques* 130, no. 3 (September 1986): 463.

When portrait painting in America was revitalized after the Revolutionary War, its center of activity moved from Boston to Connecticut, and its emphasis changed from capturing sumptuous trappings to focusing on the sitter in an unadorned style more befitting a new nation trying to forge an identity apart from European traditions. Although the artist who painted this gentle likeness of Jonathan Knight (1789–1864) is not yet identified, the portrait itself fits comfortably within the convention established by Ralph Earl (1751–1801), who favored direct contact with the subject in a spare and unromanticized interior. Knight sits by a simple table in a blue-painted Windsor chair with bold turned legs, a cat curled at his feet. He is reading a Bible open to 1 Kings 3:7: "I am but a little child," followed by Proverbs 2:3–9. An early portrait, perhaps of his mother, hangs on the wall behind him. His environment is filled with pattern and visual rhythms, from the painted floor to the ruffles and stripes of his clothing to the vigorous spring of his blond curls.

The sweetness of the visage in this portrait is a true indication of the nature of the subject. For more than fifty years, Knight trained doctors at Yale and was esteemed as an inspiring teacher and excellent surgeon. His father had been an army surgeon during the Revolutionary War, and his mother was the daughter of a physician. By the time he was fifteen, Knight was accepted into Yale College, and he graduated in 1808. After teaching in Norwich and in New London, he returned to Yale as a tutor. He had also pursued medical studies and, in 1811, was granted a license to practice by the Connecticut Medical Society. At the suggestion of Benjamin Silliman, professor of chemistry at Yale, Knight left the school and entered the University of Pennsylvania to study anatomy and physiology. When he completed his degree, he returned to New Haven and by 1813 was appointed a full professor of anatomy and physiology. He also was married that year to Elizabeth Lockwood. In 1826 Knight was invited to be one of the founders of the General Hospital Society of Connecticut, and in 1838 he was appointed to the Chair of Surgery at Yale Medical School. In time he became the president of the National Medical Convention and was instrumental in the formation of the American Medical Association, serving as its first president. When New Haven Hospital was taken over by the federal government during the Civil War, the institution was renamed Knight United States General Hospital by order of the surgeon general.

Jonathan Knight died in 1864 of peritonitis. As one biographer wrote, "He was a clear-headed, logical lecturer; he was a careful, competent surgeon; he was an able organizer and administrator. These are the outward trappings of success, but his worth may be expressed in other terms. One can not look at his picture [possibly an 1828 portrait by Nathaniel Jocelyn] or review the limited number of letters written to him and by him without being impressed by the genial, kindly, warm-hearted personality. The 'beloved physician' was the well earned title given him by all who knew him."[15]

—S.C.H.

14 The letters were published in the *Connecticut Historical Society Bulletin* 20, no. 2 (April 1955). The portrait of Thomas Robbins is in the collection of the Connecticut Historical Society, Hartford; see ibid., p. 38.

15 Biographical information based on the following sources provided by Toby Appel and Mona Panaitisor, Harvey Cushing / John Hay Whitney Medical Library, Yale University, New Haven, Conn.: Franklin Bowditch Dexter, *Biographical Sketches of the Graduates of Yale College with Annals of the College History* 6, September 1805–1815 (New Haven, Conn.: Yale Univ. Press, 1912), Harold S. Burr, "Jonathan Knight and the Founding of the Yale School of Medicine," *Yale Journal of Biology and Medicine* 1 (1928–1929), and Dumas Malone, ed., *Dictionary of American Biography* 10 (New York: Charles Scribner's Sons, 1933).

4. MARY H. HUNTINGTON

Artist unidentified
Brockton, Plymouth County, Massachusetts
c. 1814
Watercolor and gouache on paper, in embossed wallpaper–covered
pasteboard box with silk lining and cotton padding
3 × 2½ × 2¾ in. oval
P1.2001.4

INSCRIPTION:
Underside of box, ink (barely legible): *Mary H. Huntington / oldest daughter of / Rev. Daniel
Huntington / Born on June 20th 1813 / Died Feb. 20, 1820 H.S. Chappell.*

PROVENANCE:
Descended in family to Isabel Chappell Lufler; Bertram K. and Nina Fletcher Little, Brookline,
Mass.; Sotheby's sale 6526, "Little Collection, Part I," 1/94, lot 442.

EXHIBITED:
"Neat and Tidy," Philadelphia Antiques Show, 1985.

PUBLISHED:
Little, Nina Fletcher. *Neat and Tidy: Boxes and Their Contents Used in Early American Households.*
New York: E.P. Dutton, 1980, p. 186.

By the time this miniature was painted, portraits "in lyttle" had a well-established foothold in America. Drawing upon European limning traditions that had evolved from illuminated manuscripts, portrait miniatures were most frequently painted in a water-based medium on vellum, card, or ivory and housed in a small box or locket.[16] Sometimes, miniature portraits were painted from full-scale ones and, conversely, served as prototypes for large portraits. The private act of viewing a miniature, nestled in the palm of a hand or in a locket worn around the neck, was in direct opposition to the public sense of full-size portraiture.

This enchanting miniature depicts Mary Hallam Huntington (1813–1820) at the age of about one year. The tiny handmade pasteboard box, covered with a single motif from an embossed wallpaper, protects the precious miniature from harm and provides an element of surprise when it is opened to reveal the delicate child. Little Mary stands in profile, one foot forward, wearing a cream-colored gown with a sheer overdress and bonnet of fine white netting. A smudge of green provides a horizontal floor plane, and a shadow delineates her pale dress and profile against the light-colored background. She wears a blue slipper on one foot and

holds the other slipper in her hand—a pose that has been used as an effective compositional device in depictions of young children by artists including John Brewster.[17] It has been conjectured that in some cases, the "one shoe off" motif indicates a postmortem portrait.[18] Mary Huntington, however, died in 1820, before her seventh birthday but well after the date this portrait was painted.

—S.C.H.

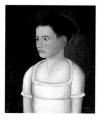

5. YOUNG WOMAN OF THE FOLSOM FAMILY (PROBABLY ANNA GILMAN FOLSOM)

Henry Folsom (1792–1814 or c. 1805–1825)
Exeter, Rockingham County, New Hampshire, or Boston
c. 1812–1821
Oil on canvas
21½ × 17⅝ in.
P1.2001.5

INSCRIPTIONS:
Verso, paint: *Henry Folsom;* typewritten paper label: *Henry Folsom c. 1805–1825 / Son of James and
Sarah (Gilman) / Folsom. Born Exeter, N.H., went to / Boston to study art and died when about / 20 years
of age. Portraits of his father, grandfather, and grandmother / mentioned in* Genealogy of the Folsom
Family */ This may be a portrait of his sister / Anna Gilman Folsom (Nancy) born 1797, / painted about
1821 when he was 16.*

PROVENANCE:
Found in Haverhill, Mass.; Roger Bacon, Exeter, N.H.; Bertram K. and Nina Fletcher Little,
Brookline, Mass.; Sotheby's sale 6526, "Little Collection, Part I," 1/94, lot 393.

Little is known of Henry Folsom, save that he went to Boston to study art and died at a young age. That he was a gifted student is established by this sensitive portrait of his sister and supported by a family genealogy, which records three additional portraits of family members, each said to show "great talent."[19] Members of the intermarried Folsom and Gilman families emigrated from Hingham, England, to Massachusetts in 1638, on the ship *Diligent,* of Ipswich. The first documentation of the Folsom family in Exeter occurs in 1655, although there was a Gilman presence after 1647. James Folsom (1765–1835), Henry's father, was a saddler. His marriage to Sarah Gilman (1766–1805) continued the long history of interrelationships between the two families, and they had eight children, four of them girls.

Nina Fletcher Little speculated that the lovely and intuitive portrait of this pensive young woman, with its sense of vulnerability and introspection, depicts Henry's sister Anna Gilman Folsom (1797–1868), who married John Calvin Gerrish on December 4, 1826. Gerrish was a printer and publisher of the *Exeter News Letter.* The girl's hair is pulled away from her face with a tortoiseshell comb in the front and swept up in the back. She wears a simple white dress with a high waist, tight sleeves, and

16 Carol Aiken, "The Emergence of the Portrait Miniature in New England," in Peter Benes, ed., *Painting and Portrait Making in the American Northeast: Annual Proceedings of the Dublin Seminar for New England Folklife,* vol. 19 (Boston: Boston Univ., 1995), pp. 30–45.

17 Paul S. D'Ambrosio and Charlotte M. Emans, *Folk Art's Many Faces: Portraits in the New York State Historical Association* (Cooperstown, N.Y.: NYSHA, 1987), p. 49.

18 Barbara Rothermel, "Mourning the Children: An Interpretation of the Symbols in Two Post-humous Portraits," *Folk Art* 22, no. 4 (winter 1997/98): 62.

19 These portraits were of James Folsom, the artist's father; his grandfather, possibly James Folsom (1737–1820); and his grandmother, possibly Elizabeth Webster (1740–1824); see Elizabeth Knowles Folsom, *Genealogy of the Folsom Family, a Revised and Extended Edition Including English Records, 1638–1938,* vol. 1 (Baltimore: Gate Press, 1975), pp. 387–89.

squared neckline, low in the front and high in the back, which suggest an earlier date than is ascribed in the note attached to the verso of the painting.[20] Although there is minimal attention to the girl's dress and body, her delicately poised head, in three-quarter view, is handled with naturalness and confidence, the pouting lips and sharp nose slightly overlapping the rim of her cheek.

—S.C.H.

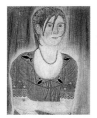

6. WOMAN IN ROSE DRESS
Artist unidentified
Vermont
c. 1805–1815
Oil on pine panel
26⅝ × 24⅝ × ½ in.
P1.2001.6

PROVENANCE:
Marvin and Jill Baten, White Plains, N.Y., 1995.

In March 1810, *Le Beau Monde and Monthly Register* described the trends in French evening fashion: "Among the fashionable dresses which are selected by persons who are distinguished in the highest circles for their superior taste, the most prevailing is the Persian Robe, made of pink satin, ornamented with black lace and drops of pearls." The young woman in this idiosyncratic portrait wears a dress in a beautiful rose color that is embellished not with black lace but with brooding blackbirds embroidered in the points of the Vandyke collar. The triangular points of the collar are repeated on the sleeves, which seem to be adorned with pearly buttons, as described in *Le Beau Monde,* and a deep cuff of hand-netted lace. At one time, the painting also included a fichu tucked into the neckline.[21]

The portrait is distinguished by the eccentric bangs separated into long strands that hang across the young woman's face. Although the hairstyle and blackbirds may be somewhat disturbing to modern eyes, the dress is probably a rural adaptation of Parisian fashion, and a modified version of the hairstyle is documented in portraits of the 1800–1805 period.[22] The portrait itself shows little modeling in the treatment of the face and body and is leanly painted over a gray undercoat. At least two additional portraits can be attributed to this unidentified artist.[23]

—S.C.H.

7. WOMAN IN VEIL
Attributed to Emily Eastman (1804–c. 1841)
Loudon, Merrimack County, New Hampshire
c. 1825
Watercolor and ink on paper
14⁹⁄₁₆ × 10⅝ in.
P1.2001.7

PROVENANCE:
John Gordon, New York; Christie's sale 9052, "Gordon Collection," 1/99, lot 257.

EXHIBITED:
"Masterpieces of American Folk Art," Monmouth Museum, Lincroft, N.J., 1975.

PUBLISHED:
Monmouth Museum. *Masterpieces of American Folk Art.* Lincroft, N.J.: Monmouth Museum in association with Monmouth County Historical Association, 1975, n.p.

Emily Eastman is known through a group of related watercolors that depict young women in fashionable styles of the early nineteenth century. Highly decorative, each features a woman with her head tilted slightly to the side, her elaborate ringlets framing a classical face. The strong features are sharply delineated, with precise lines forming the curved brows and shape of the nose. The watercolors most likely were based upon print sources, but none has been specifically identified to date. The watercolors are reminiscent, however, of fashion plates that were published in Europe, such as Ackerman's *Repository of Arts, Literature, Commerce, Manufactures, Fashions and Politics,* which first appeared in London in 1809 and continued through 1829. Illustrations such as these, which were distributed in periodicals and as separate plates, were influential in determining American taste in clothes. The types of dresses pictured in Eastman's watercolors were parodied in the pages of contemporary magazines such as *The Lady's Magazine,* which aptly described the costume pictured in *Woman in Veil:* "Manners of the Parisian Ladies.... Our fair females are covered with transparent shawls, which float and flutter over their shoulders and upon their bosoms, which are seen through them. With gauze veils, which conceal half of the face to pique our curiosity."

Eastman apparently worked through the 1820s, based upon the dress and hairstyles depicted in her watercolors. Beyond the fact that she was born in Loudon, New Hampshire, and married Dr. Daniel Baker in 1824, little more is known about her. She may be the Emily Eastman who was born to Ruth Carter and David Eastman and died in 1841.[24]

—S.C.H.

20 Based on the notes, if the painting depicts Anna Gilman Folsom, she would be twenty-four years of age, yet she appears to be considerably younger. According to the catalog entry for Sotheby's sale 6526 (1/94, lot 393), Nina Fletcher Little cited Henry Folsom's life dates as 1792 to 1814 and dated the portrait c. 1812, making his sister Anna about fifteen, a more likely age. Until her brother's dates are firmly established, however, it is difficult to state with authority which of his two younger sisters the artist portrayed.

21 It is not clear if this was a deliberate alteration or an effect of paint changes over time.

22 See Beatrix T. Rumford, ed., *American Folk Portraits: Paintings and Drawings from the Abby Aldrich Rockefeller Folk Art Center* (Boston: Little, Brown, in association with Colonial Williamsburg Foundation, 1981), p. 122, for the portrait of Maria Weston painted by Rufus Hathaway, c. 1800–1804, and probably in Duxbury, Mass.

23 These are portraits of an unidentified man and woman, c. 1810, illustrated in George E. Schoellkopf, *American Eighteenth- and Nineteenth-Century Folk Painting, Sculpture, and Pottery* (New York: George E. Schoellkopf, 1973), n.p.

24 Eastman's *Lady's Coiffure with Flowers and Jewels* is inscribed: "This picture painted by / Mrs Dr Daniel Baker soon after / she (married April 4th 1824)"; see Museum of Fine Arts, *M. & M. Karolik Collection of American Water Colors & Drawings, 1800–1875,* vol. 2 (Boston: MFA, 1962), p. 237. According to the catalog entry, Eastman was born in 1804 and was the daughter of David Eastman of Loudon, N.H. The Church of Jesus Christ of Latter-Day Saints Family Search Internet Genealogy Service <www.familysearch.com> (accessed April 2000) records an Emily Eastman (?–1841), the youngest of eight children born to Ruth Carter (1765–1841) and David Eastman (1763–1824).

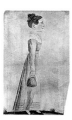

**8. YOUNG WOMAN IN BLUE DRESS
(GRANDMOTHER HARTMAN)** (with detail of verso)
Jacob Maentel (1778–?)
Schaefferstown, Lebanon County, Pennsylvania
1827
Watercolor, gouache, ink, and pencil on paper
9½ × 6 in.
P1.2001.8

INSCRIPTION (TRANSLATION OF GERMAN):
Verso, ink: *Made the 31st August 1827 by Jacob Mäntel*

PROVENANCE:
Dr. and Mrs. Henry P. Deyerle, Harrisonburg, Va.; Sotheby's sale 6716, "Deyerle Collection," 5/95, lot 633.

PUBLISHED:
Redler, Valerie. "Jacob Maentel: Portraits of a Proud Past." *The Clarion* (fall 1983): 51.

JACOB MAENTEL (1778–?)

German immigrant Jacob Maentel painted more than two hundred portraits of friends and neighbors in southeastern Pennsylvania and Indiana. Adding a unique and personal dimension to the rich legacy of Germanic culture in America, his watercolors provide a window into the homes of his community and the lives of its people. Maentel's own life has been more challenging to untangle and has attracted the work of generations of folk art scholars.[25]

Johann Adam Bernhard Jacob Maentel was born in Kassel, Westphalia, Germany, on October 15, 1778, and was baptized on October 25. He was the son of Frederich Ludwig Maentel, "beadle of the illustrious principal post office," and Elizabeth Krügerin.[26] Tradition maintains that he served under Napoleon, whose victory over Austria and establishment

of the kingdom of Westphalia under French rule coincide with Maentel's reaching draft age. He may have immigrated to Baltimore sometime between his father's death in 1805 and the appearance of a Jacob Maentel, "Portrait painter," in the Baltimore directory of 1807.[27] Maentel married Catherine Weaver of Baltimore about 1821, but he may already have been living or traveling in Pennsylvania by about 1807, based upon portraits of subjects in Dauphin, Lebanon, and York Counties. From September 1, 1814, to March 1, 1815, "Jacob Mantell" of Lancaster served in the Second Regiment of the Second Brigade of the Pennsylvania Militia under the command of Lieutenant Colonel John Lutz at York. He was paid $6.00 for this service and was naturalized in 1815 a short time later, in York County.

In 1816 Maentel was sketched by Lewis Miller in his visual chronicles of York County; however, a second, older Jacob Maentel, identified as a confectioner, also was sketched at the same time.[28] Adding to the confusion is the presence of the older Maentel in Indiana, after the artist was settled there, as well as references to the artist's wife as a confectioner.[29] In 1820 Maentel is listed in the census for Dauphin County, where he painted many subjects standing in grassy landscapes. By 1830 he was living in Schaefferstown, Lebanon County, where two of his children were born and where his name appears with many of his subjects— Zimmerman, Bucher, Haak—in the parish register of the Saint Luke's Evangelical Lutheran Church. His name also appears until 1833 in the Zimmerman ledger books for purchases of paint and confectioners' supplies.[30] But by 1838, Maentel is listed in the Indiana tax rolls for New Harmony Township, where he continued to portray members of the tight-knit German community, some of whom he had known in Pennsylvania. Maentel is buried in Maple Hill Cemetery in New Harmony; his undated headstone bears only the initials "J.M."

The encompassing dates of Maentel's identified watercolors are 1807 to 1846, with only four signed examples, including the portrait in the Esmerian Collection of a young woman in a blue dress, dated August 31, 1827, and signed "von Jacob Mäntel."[31] In addition to the important visual record they provide, Maentel's portraits are notable for their detailing of faces, dress, and backgrounds. Fine and distinct ink strokes delineate brows and lashes, while heavier washes indicate drapery and landscape elements. The watercolors fall into several stylistic categories of pose and setting. The portraits, from about 1810 through 1820, are full-length figures set in landscapes and standing in profile silhouetted against plain backgrounds or dramatic skies. Usually there are tufts of grass in the foreground, and Maentel later began to include architectural structures, fences, and other narrative elements. Overlapping this period are pairs of frontal figures set into colorful interiors; the portraits of the Bickels (cat. no. 13a–b), painted c. 1815–1825, are early examples of this

25 The information contained in this entry is based upon the work of these previous scholars, notably the following sources: Mary C. Black, "A Folk Art Whodunit," *Art in America* 53, no. 3 (June 1965): 96–105, Black, *Simplicity, a Grace: Jacob Maentel in Indiana* (Evansville, Ind.: EMAS, 1989), Mary Lou Robson Fleming, "Folk Artist Jacob Maentel of Pennsylvania and Indiana," *Pennsylvania Folklife* 37, no. 3 (spring 1988): 98–111, and Valerie Redler, "Jacob Maentel: Portraits of a Proud Past," *The Clarion* (fall 1983): 48–55.

26 Fleming, "Folk Artist Jacob Maentel," p. 102.

27 Redler, "Jacob Maentel," p. 50. Redler questions whether this is indeed the Jacob Maentel under consideration, as no portraits have been discovered that can be linked to Baltimore.

28 Black, *Simplicity, a Grace*, p. 14. These drawings are in the collection of the Historical Society of York County, Pa.

29 Kenneth Schwalm Jones to Josephine Elliott, Dec. 13, 1979 (AFAM files). Mr. Jones writes, "As I told you a Mrs. Jacob Mantel was listed as owning a cake shop in Schaefferstown in the early nineteenth century."

30 Diane Wenger, Historic Schaefferstown, letter to the author, Aug. 2, 2000 (AFAM files).

31 The other signed portraits are *Seated Man with a Book* (1828), *Johannes Zartmann* (1828), and the only signed Indiana portrait, *Jonathan Jaquess* (1841); see Redler, "Jacob Maentel," pp. 48, 53, and 55, respectively. A profile portrait of Mary Koss, cited by Redler, is dated 1807 and is the earliest work attributed to the artist.

format, which was, however, already fully developed based upon the confidence of their portrayals. By the mid-1820s, these symmetrical companion portraits had become Maentel's typical presentation, and he continued to reuse these established conventions in Indiana. —S.C.H.

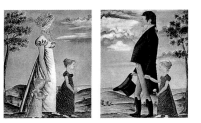

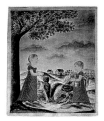

9. AMELIA AND ELIZA DANNER
Jacob Maentel (1778–?)
Hanover, York County, Pennsylvania
c. 1815
Watercolor, gouache, ink, and pencil on paper
10½ × 8⅜ in. (sight)
P1.2001.9

PROVENANCE:
Descended in family to Mr. and Mrs. D.E. Winebrenner, Hanover, Pa.; York Town Auction, 9/98, lot 564; Olde Hope Antiques, New Hope, Pa., 1999.

EXHIBITED:
"Folk Art of the Hanover Area," Hanover Area Historical Society, Hanover, Pa., 1983.

PUBLISHED:
Hanover Area Historical Society. *Folk Art of the Hanover Area, 1783–1883*. Hanover, Pa.: Hanover Area Historical Society, 1983, cover.

The double portrait of Amelia (1811–1877) and Eliza Danner (c. 1809–1886) is an especially appealing scene that convincingly demonstrates Jacob Maentel's ability to use familiar visual devices to fresh effect.[32] The watercolor shares characteristics with many outdoor compositions that Maentel executed in this early period of his career, such as the placement of a tall, shady tree on one side, with houses in the distance, and foreground figures standing in profile. The artist repeated this early formula in his later portraits of Indiana subjects. Part of the charm of this watercolor lies in the robust roosters pecking at feed that the girls toss from their straw baskets.[33] The vibrant red of their patterned dresses echoes the roosters' combs and focuses attention along the horizontal plane of the portrait. In fact, the entire scene is set unusually close to the picture plane when compared to other works by Maentel. This effectively creates an intimate interaction between the viewer and the sisters and offsets their static staging on either side of the watercolor. The rolling motion of the landscape and the active, low cloud formations further heighten this sense.

Amelia and Eliza were descended from Michael Danner, a prominent figure in the early history of Hanover, Pennsylvania. Amelia married Jacob Wirt (1801–1869) about 1827, and the portrait descended through their family. Eliza never married.[34] Both sisters are buried in Mount Olivet Cemetery in Hanover. —S.C.H.

10a–b. MOTHER AND DAUGHTERS OF ELIZABETHTOWN, PENNSYLVANIA, and FATHER AND DAUGHTER OF ELIZABETHTOWN, PENNSYLVANIA
Jacob Maentel (1778–?)
Elizabethtown, Lancaster County, Pennsylvania
c. 1815–1820
Watercolor, gouache, ink, and pencil on paper
10¾ × 8½ in. each (sight)
P1.2001.10a, b

PROVENANCE:
Art and Mary Feeman, Jonestown, Pa., 1977.

EXHIBITED:
"Small Folk: A Celebration of Childhood in America," MAFA and N-YHS, 1980/81.
"Simplicity, a Grace: Jacob Maentel in Indiana," EMAS, 1989/90.

PUBLISHED:
Black, Mary C. *Simplicity, a Grace: Jacob Maentel in Indiana*. Evansville, Ind.: EMAS, 1989, frontispiece.
Brant, Sandra, and Elissa Cullman. *Small Folk: A Celebration of Childhood in America*. New York: E.P. Dutton in association with MAFA, 1980, pp. 20–21.

During the 1920s, portraits of John and Catherine Hinkle were deposited with the Historical Society of York County, Pennsylvania, initiating public interest in the artist of German extraction who painted the comfortable farmers and professionals and their families residing in the Pennsylvania German communities of Hanover, Lancaster, Lebanon, and other counties.[35] The portraits established a conventional format that the artist, now identified as Jacob Maentel, explored for many years, in portraits such as these, of a family from Elizabethtown. Around 1815 Maentel portrayed the Gardner family, each parent on a facing sheet with one child.[36] The figures loom front and center with a blue-tinged landscape receding far into the distance. Few houses dot the spare landscape, and despite their obvious material well-being, the family members appear to be pioneers in an unpopulated land.

When Maentel painted this unidentified Elizabethtown family, he repeated much of the formula used in the Gardner portraits. They are divided into two groups on facing sheets: the father with one daughter on the right, and the mother with two daughters on the left. They stand in a barren, blue-tinged landscape devoid of houses, yet the sense of dislocation experienced in the portraits of the Gardners is absent, perhaps because the landscape is closer to the picture plane. Viewed together, the

32 These life dates were written on a piece of kraft paper and provided at the time of sale. They correspond to tombstone records; see Lila Fourhman-Shaull, York County Historical Society, York, Pa., letter to the author, Jan. 15, 2001 (AFAM files).
33 Maentel used roosters with dramatic results in at least one other portrait from this early period; see *Boy with Rooster* in Jean Lipman and Tom Armstrong, eds., *American Folk Painters of Three Centuries* (New York: Hudson Hills Press in association with WMAA, 1980), p. 123.

34 Biographical information provided by Charles M. Chesnutwood (descendant of Wirt); see letter to the author, Feb. 10, 2000 (AFAM files). He cites "Barnitz Report," in Henry James Young, comp., *Genealogical Reports for the Historical Society of York County, Pennsylvania*, vol. 12 (1936), and John Gibson, ed., *History of York County, Pennsylvania* (Chicago: F.A. Battey, 1886).
35 See Black, "Folk Art Whodunit," pp. 96–105.
36 Rumford, *American Folk Portraits*, p. 139.

family forms an arrangement that is reminiscent of the Danner sisters. The older girls are dressed in identical blue patterned dresses, their hair is swept up in a grown-up fashion, and one daughter appears to emulate her mother's stance. Like Mr. Gardner, this father holds his hat in his hand, its brilliant red lining drawing attention to the lower half of the composition and visually balancing the three figures in the mother's facing portrait.

—S.C.H.

11. CATHERINE WILT
Jacob Maentel (1778–?)
York, York County, Pennsylvania
c. 1830–1832
Watercolor, gouache, ink, and pencil on paper, mounted on printed cotton
14 × 8 in. (23⁹⁄₁₆ × 14½ in. with cotton ground)
P1.2001.11

PROVENANCE:
Descended in family to Frederick W. Shaffer; Sotheby Parke-Bernet sale 4785Y, 1/82, lot 883.

The portrait of Catherine Wilt (1817–1906) is one of four that descended in her family. It bears many of the hallmarks associated with Jacob Maentel's outdoor scenes: dry earth under the feet of the subject, rolling green hills studded with trees behind, and a house in the background. Details of costume and hair point to a date of about 1830–1832, supporting family tradition that the portrait was painted on the occasion of Wilt's confirmation, which occurred during that period. The paisley-bordered cotton upon which the watercolor is mounted is a remnant from the actual shawl depicted in the portrait.

Wilt married William Adams (1825–1858) in 1846. Her father, Peter, owned and operated a public inn in York on the south side of Market Street, east of Queen. The establishment was well known for the entertainments offered by traveling circuses and theater companies in its yards and a large interior room.[37] A series of drawings by Lewis Miller details the tavern and some of its entertainments, as well as an accident that occurred while the building was being erected.[38] Identified by Miller as "Peter Wilt's House," this may be the same home, at 45 South Queen Street, that was deeded to Catherine Wilt in 1850.

—S.C.H.

12. YOUNG MR. FAUL
Jacob Maentel (1778–?)
Lancaster, Lancaster County, Pennsylvania
c. 1835–1838
Watercolor, gouache, ink, and pencil on paper
15⅞ × 10⅞ in.
P1.2001.12

PROVENANCE:
Descended in family to Dorothy D. Faul, Robinson, Ill.; Edgar William and Bernice Chrysler Garbisch, Cambridge, Md.; Sotheby Parke-Bernet sale 3981, "Garbisch Collection, Part II," 4/77, lot 408.

EXHIBITED:
"A Portfolio of Primitive Watercolors," AARFAC, 1964.
"Jacob Maentel: A Folk Art Whodunit," MAFA, 1965.
On loan to N-YHS from the Garbisch Collection, 1971–1977.
"American Folk Painters of Three Centuries," WMAA, 1980.
"Simplicity, a Grace: Jacob Maentel in Indiana," EMAS, 1989/90.

PUBLISHED:
Black, Mary C. "Jacob Maentel: A Farmer Fond of Painting." *Antiques and the Arts Weekly* (Sept. 12, 1971): C-6.
———. *Simplicity, a Grace: Jacob Maentel in Indiana.* Evansville, Ind.: EMAS, 1989, p. 19.
Lipman, Jean, and Tom Armstrong, eds. *American Folk Painters of Three Centuries.* New York: Hudson Hills Press in association with WMAA, 1980, p. 116.

Four unsigned, undated portraits of the Faul family were instrumental in providing a crucial link between a group of watercolor portraits of New Harmony, Indiana, sitters and watercolors by Jacob Maentel executed in the Lancaster area of Pennsylvania.[39] Establishing that the artist had worked in both regions, Mary C. Black ultimately demonstrated without question that the portraits formerly attributed to one "Stettinius" were in fact by Maentel.[40]

Maentel codified an approach to portraits set in landscapes early in his artistic career. Watercolors from a later date, such as this portrait of Mr. Faul, rely on these earlier conventions: a tall shady tree on one side, houses in the distance, rolling hills in the middle ground. In the later works, however, the figures appear in frontal view as opposed to profile. In his portrait, Mr. Faul stands almost as tall as the tree on the left side of the composition. His commanding presence overpowers the landscape, which shows a dense row of trees in the distance and a neat white house and log cabin. Behind him is a split-rail fence to which a toy-size horse is tethered. Hand on hip, Mr. Faul stands larger than life and dominates his world.

—S.C.H.

37 The genealogical and historical information about the Wilt family descended with the portraits and was provided at the time of the Sotheby Parke-Bernet sale. The research appears to have been done by Frederick W. Shaffer, a descendant, in 1981; the information about Peter Wilt's tavern is excerpted from George Prowell, *History of York, Pennsylvania*, vol. 1 (Chicago: J.H. Beers, 1907), pp. 737, 797.

38 Collection AARFAM.

39 For the portraits of John Cooper Jr. and William Ferguson Cooper, see Black, *Simplicity, a Grace*, pp. 22, 23.

40 The extensive research done on the artist by Black and other scholars is well documented; see note 25 for key essays and articles.

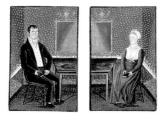

13a–b. JOHN BICKEL and CATERINA BICKEL
Jacob Maentel (1778–?)
Jonestown, Lebanon County, Pennsylvania
c. 1815–1825
Watercolor, gouache, ink, and pencil on paper
19 × 12 in. each
P1.2001.13a, b

PROVENANCE:
Found in Jonestown, Pa.; Ed and Mildred Bohne, Newmanstown, Pa., 1975.

EXHIBITED:
"American Folk Painters of Three Centuries," WMAA, 1980.
"Young America: A Folk Art History," MAFA at IBM Gallery of Science and Art, New York, 1986.
"Simplicity, a Grace: Jacob Maentel in Indiana," EMAS, 1989/90.
"Five-Star Folk Art: One Hundred American Masterpieces," MAFA, 1990.

PUBLISHED:
Lipman, Jean, and Tom Armstrong, eds. *American Folk Painters of Three Centuries.* New York:
 Hudson Hills Press in association with WMAA, 1980, p. 122.
Lipman, Jean, Elizabeth V. Warren, and Robert Bishop. *Young America: A Folk Art History.*
 New York: Hudson Hills Press in association with MAFA, 1986, p. 153.
Lipman, Jean, Robert Bishop, Elizabeth V. Warren, and Sharon L. Eisenstat. *Five-Star Folk Art:
 One Hundred American Masterpieces.* New York: Harry N. Abrams in association with MAFA,
 1990, p. 39.

The dazzling interior on display in these companion portraits belies the notion that Pennsylvania German culture was singularly insular. As has been convincingly demonstrated, the material stability of the community was not only dependent upon commerce with the broader population, but "worldly goods" were much sought and highly valued.[41] This interior is far from parochial in its taste; from the brilliant blue walls with repeated patterns and stenciled border above the dado to the elaborate gilded Boston-style mirror, an awareness of high-style fashions is much in evidence. Based upon their dress and the home furnishings, the portraits of John and Caterina Bickel may have been executed as early as 1816.[42] Jacob Maentel's watercolors at this time typically were profile views of figures standing in a landscape. About the Bickels themselves, little is known. John was probably the son of John Bickel, a Revolutionary War soldier who applied for his pension in March 1833, when living in Jonestown.[43] —S.C.H.

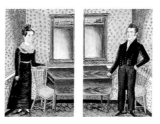

14a–b. MARIA REX ZIMMERMAN and PETER ZIMMERMAN
Jacob Maentel (1778–?)
Schaefferstown, Lebanon County, Pennsylvania
c. 1828
Watercolor, gouache, ink, and pencil on paper
17 × 10½ in. each
P1.2001.14a, b

PROVENANCE:
Descended in family to Ann Illig, Millbach, Pa.; Ed and Mildred Bohne, Newmanstown, Pa., 1984.

EXHIBITED:
"Pennsylvania Folk Art," AAM, 1974.
"Expressions of a New Spirit," MAFA, 1989.
"Simplicity, a Grace: Jacob Maentel in Indiana," EMAS, 1989/90.
"The Art of Embellishment: Painted and Stenciled Masterworks from the Museum of American
 Folk Art," Philadelphia Antiques Show and MAFA, 1992.

PUBLISHED:
Allentown Art Museum. *Pennsylvania Folk Art.* Allentown, Pa.: AAM, 1974, p. 51.
Black, Mary C. *Simplicity, a Grace: Jacob Maentel in Indiana.* Evansville, Ind.: EMAS, 1989, p. 29.
Hollander, Stacy C. "The Past Recorded: Decorative Details in American Folk Painting." *Philadelphia
 Antiques Show Catalog.* Philadelphia: Philadelphia Antiques Show, 1992, p. 45.
Nolan, J. Bennett. "Pennsylvania Sunday Best." *American Heritage* 8, no. 3 (April 1957): 50.
Redler, Valerie. "Jacob Maentel: Portraits of a Proud Past." *The Clarion* (fall 1983): 52 (*Mrs. Zimmerman* only).
Warren, Elizabeth V., and Stacy C. Hollander. *Expressions of a New Spirit: Highlights from the Permanent
 Collection of the Museum of American Folk Art.* New York: MAFA, 1989, pp. 30–31.

When Jacob Maentel started painting frontal portraits, he introduced a formula of colorful and elaborately appointed interiors that included furnishings such as these painted slat-back Windsor side chairs with bamboo turnings, expensive high-style looking glasses, and embellished wall and floor coverings. He frequently portrayed married couples on separate sheets of paper that formed a continuous and almost symmetrical scene when placed side by side.

Peter Zimmerman (1802–1887) was born in Millcreek Township, Pennsylvania, the youngest of ten children. As an adult, he was a well-respected farmer and cattle drover and made many trips west to procure livestock for markets in Schaefferstown.[44] He was a staunch Democrat, although he never sought public office, and a member of the Lutheran Church, for which he served as deacon, elder, and trustee. Maria Rex

41 Jack L. Lindsey, *Worldly Goods: The Arts of Early Pennsylvania, 1680–1758* (Philadelphia: PMA, 1999).

42 A comparison with dated portraits by artists such as Ammi Phillips, who was noted for his close and accurate attention to details of costume, indicates the 1816 date. See in particular the dated portraits of Joseph and Alsa Slade in Deborah Chotner, *American Naive Paintings* (Washington D.C.: NGA, 1992), pp. 274–75.

43 Virgil D. White, *Genealogical Abstracts of Revolutionary War Pension Files* I: A–E (Waynesboro, Tenn.: National Historical Publishing, 1990). Pastor Frederick S. Weiser verifies that the Bickels lived in Jonestown and that the portraits were recovered there; see letter to Lee Kogan, MAFA, Aug. 28, 1988 (AFAM files).

44 A.S. Brendle, *A Brief History of Schaefferstown* (Schaefferstown, Pa.: Historic Schaefferstown, 1979), p. 90.

(1804–1887) was descended on her mother's side from Alexander Schaeffer, the founder of Schaefferstown.[45] Her father, Abraham, and his brother Samuel were Schaefferstown storekeepers. Extant record books show Maentel was a patron of the store between at least 1825 and 1830; he had further transactions with Samuel Rex in 1832 and 1833.[46] Thus Maentel was probably personally familiar with Maria and her family when he painted these portraits.

The couple's house was built in 1758 and operated as a tavern until 1806, at which time Samuel Rex took up residence.[47] After he died, the house was passed to Abraham, who in turn gave it to Maria. She and Peter lived the remainder of their lives in the "Rex House," as it is presently known, and which is owned by Historic Schaefferstown, Inc. Interestingly, based upon contemporary examinations of sections of walls in the house, the patterns depicted in Maentel's rendering are most probably painted decorations, and not wallpaper.[48]

It is not known when the Zimmermans married, but their first child was baptized in 1827, just about the time these portraits were painted.[49] An interesting link exists between the Zimmermans and another prominent Schaefferstown family portrayed by Maentel, establishing that on occasion his clients were well known to one another. The couple's daughter Susan Amanda married Alfred Bucher, son of Dr. Christian and Mary Bucher (cat. no. 15a–b). Like his father, Alfred was a physician, continuing a long-established family tradition of pursuing the medical profession.[50] —S.C.H.

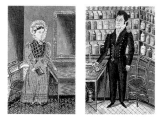

15a–b. MARY VALENTINE BUCHER and DR. CHRISTIAN BUCHER
Jacob Maentel (1778–?)
Schaefferstown, Lebanon County, Pennsylvania
c. 1825–1830
Watercolor, gouache, ink, and pencil on paper
16½ × 10⅛ in. (sight) and 16½ × 10½ in. (sight)
P1.2001.15a, b

PROVENANCE:
Descended in family to Dr. Hiester Bucher; Art and Mary Feeman, Jonestown, Pa., 1977.

EXHIBITED:
"American Folk Painters of Three Centuries," WMAA, 1980.
"The Pennsylvania Germans: A Celebration of Their Arts, 1683–1850," PMA, 1982/83.
"Young America: A Folk Art History," MAFA at IBM Gallery of Science and Art, New York, 1986.
"Simplicity, a Grace: Jacob Maentel in Indiana," EMAS, 1989/90.

PUBLISHED:
Bishop, Robert. Folk Painters of America. New York: E.P. Dutton, 1979, pl. 37 (Dr. Bucher only).
Black, Mary C. Simplicity, a Grace: Jacob Maentel in Indiana. Evansville, Ind.: EMAS, 1989, p. 20.
Garvan, Beatrice B., and Charles F. Hummel. The Pennsylvania Germans: A Celebration of Their Arts, 1683–1850. Philadelphia: PMA in association with Winterthur, 1982, pl. 73.
Kogan, Lee, and Barbara Cate. Treasures of Folk Art: Museum of American Folk Art. New York: Abbeville Press in association with MAFA, 1994, p. 27.
Lipman, Jean, and Tom Armstrong, eds. American Folk Painters of Three Centuries. New York: Hudson Hills Press in association with WMAA, 1980, p. 120.
Lipman, Jean, Elizabeth V. Warren, and Robert Bishop. Young America: A Folk Art History. New York: Hudson Hills Press in association with MAFA, 1986, p. 153 (Dr. Bucher only).
Media Projects. Images of Healing: A Portfolio of Images of American Medical and Pharmaceutical Practice. New York: Media Projects, 1980, cover (Dr. Bucher only).
Nolan, J. Bennett. "Pennsylvania Sunday Best." American Heritage 8, no. 3 (April 1957): 50.
Tobler, Jay, ed. The American Art Book. London: Phaidon Press, 1999, p. 282 (Dr. Bucher only).
Warren, Elizabeth V. "Young America: A Folk Art History." The Magazine Antiques 130, no. 3 (September 1986): 470 (Dr. Bucher only).

The portraits of Dr. Christian Bucher (1796–1860) and Mary Valentine Bucher (1803–1889) are among Jacob Maentel's best-known works. In an unusual departure from his watercolors of couples posed in symmetrical interior settings, the Buchers are shown each in his and her own environment: Mary Bucher in her comfortable domestic constellation holding a book—probably a Bible—and Dr. Bucher in the fully detailed professional sphere that proclaims his medical calling. Interestingly, an identical decorated chair visually links the two portraits, a reminder that a village doctor's office was usually in his home.

Dr. Bucher's interior appointments include a floor-to-ceiling medical cabinet with drawers and shelves filled with labeled bottles of various shapes and sizes that hold medicinal herbs and chemicals. The large table is laden with medical equipment: mortar and pestle, hand scales, a tooth extractor, and a knife; a larger bronze contusion mortar and pestle reside beneath the table. A set of keys hangs at Dr. Bucher's waist, and he is shown in the active pursuit of his profession, grinding a prescription.[51]

Mrs. Bucher takes a more passive posture. Her portrait is a melange of pattern and color: plaids mix with stripes against an interior with a decorated dado with stenciling above and vibrantly patterned floor cover below. Only the upper walls are without visual activity, their beautiful blue-green complementing the gilded mirror frame with applied decoration that hangs over the table. The table in each portrait is bisected, as though the two halves were to be joined. This treatment is consistent with Maentel's more typical portrait pairs.

45 Some discrepancy exists in Maria Rex's birth date. It is listed as 1802 in Biographical Annals of Lebanon County (Chicago: J.H. Beers, 1904), but her birth and baptismal record lists both events as occurring in Cocalico Township, Lancaster County, in 1804; her cemetery records also list the date of her birth as 1804. A second, probably earlier, portrait of Maria by Maentel is illustrated in Redler, "Jacob Maentel," p. 52. The portrait is identified as Maria Rex and is in Maentel's familiar earlier profile format, the standing figure in a landscape setting of low hills and sparse trees. She is wearing a dress similar to the one she wears in the interior portrait.
46 Wenger, letter to the author.
47 Andrew Wyatt, Historic Schaefferstown, letter to the author, July 24, 2000 (AFAM files).

48 Wyatt, telephone conversation with the author, July 31, 2000.
49 This contradicts information in Biographical Annals of Lebanon County that states Peter Zimmerman did not come to Schaefferstown until 1834. The entry on Zimmerman in the Annals includes a photograph of him as an older man.
50 Rose M. Bryan (descendant of the Buchers), letter to the author, Feb. 15, 2000 (AFAM files).
51 Although Bucher practiced in Pennsylvania, his portrait exactly matches a description of Dr. Samuel Shaw's medicine room in Plainfield, Mass., in 1833; see Barnes Riznik, Medicine in New England, 1790–1840 (Sturbridge, Mass.: Old Sturbridge, 1965), pp. 16–17.

The Buchers were married in 1825 and were residing on East Main Street in Schaefferstown by 1827, when their first child was born.[52] For many years, Dr. Bucher's portrait was identified as *The Apothecary*, based upon the pharmaceutical paraphernalia surrounding him. Family descendants have since established that he was a third-generation physician practicing in Schaefferstown for most of his professional life. The twentieth-century confusion lies in the nonspecialized nature of medicine during the early nineteenth century, when a physician also performed duties now associated with those of a pharmacist. Dr. Bucher's three sons were also physicians; one, Alfred, married Susan Amanda Zimmerman, whose parents were also portrayed by Maentel (cat. no. 14a–b). Dr. Bucher probably stopped practicing medicine by 1857, as his son I. Reily took over the practice that year. At his death, Dr. Bucher was remembered in *The Lebanon Courier* (April 23, 1889) as one of the "well known and highly respected citizens of this county . . . [whose] death will be extensively mourned."[53]

—S.C.H.

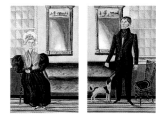

16a–b. ELIZABETH HAAK
and MICHAEL HAAK
Jacob Maentel (1778–?)
Lebanon, Lebanon County, Pennsylvania
c. 1830–1835
Watercolor, gouache, ink, and pencil
on paper
17 × 10¾ in. each
P1.2001.16a, b

PROVENANCE:
Edgar William and Bernice Chrysler Garbisch, Cambridge, Md.; Sotheby Parke-Bernet sale 3981, "Garbisch Collection, Part II," 4/77, lots 411, 412.

EXHIBITED:
On loan to N-YHS from the Garbisch Collection, 1971–1977.
"The Flowering of American Folk Art, 1776–1876," WMAA, 1974.
"The All-American Dog: Man's Best Friend in Folk Art," MAFA, 1977/78.

PUBLISHED:
Bishop, Robert. *The All-American Dog: Man's Best Friend in Folk Art.* New York: Avon Books in association with MAFA, 1978, pp. 34, 35.
Kogan, Lee, and Barbara Cate. *Treasures of Folk Art: Museum of American Folk Art.* New York: Abbeville Press in association with MAFA, 1994, p. 26.
Lipman, Jean, and Alice Winchester. *The Flowering of American Folk Art, 1776–1876.* New York: Viking Press in association with WMAA, 1974, p. 39.

The portraits of Michael and Elizabeth Haak follow the format established by Jacob Maentel in the 1820s for treating subjects in interior settings. Each is portrayed on a separate sheet, and the interiors are virtually mirror images. The dominant features are the multimullioned windows and the large, fancy looking glasses with scenic views. The landscape with houses and trees that appears on the reverse-painted glass panel on each mirror is considerably closer to the picture plane in Mr. Haak's portrait, perhaps suggesting his proprietary interest in the homestead.

The figures are shown in different poses, Mrs. Haak sitting in a slat-back Windsor side chair while Mr. Haak stands with one hand resting on the table, his pet dog looking up at him, and the identical chair off to the right side.

In general, the interior of the Haak home is more restrained in color and pattern than those seen in the portraits of the Bickels, Zimmermans, and Buchers (cat. nos. 13a–b, 14a–b, 15a–b). The walls are painted two colors but without any stenciled border or overall patterning. The floor is covered with a simple striped "Venetian" carpeting, and the stenciling on the chairs is less ornate than in the other pictures. When compared to the portraits of the Zimmermans, who seem confined within their surroundings, the Haaks appear more comfortably situated. The contrast of strong vertical and horizontal elements contributes to the feeling of greater space. The lower half of each composition is a series of horizontal thrusts: the dark tables blend into the dark walls behind and are emphasized by the bold striping on the rugs. At the same time, the tall windows and columned mirrors elevate the viewer's eyes to the top edge of the paper, creating a sense of greater height.

—S.C.H.

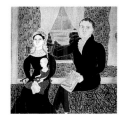

17. MR. AND MRS. LYMAN DAY
AND DAUGHTER CORNELIA
Deborah Goldsmith (1808–1836)
Sangerfield, Oneida County, New York
c. 1823–1824
Watercolor and pencil on paper
9 × 8¾ in.
P1.2001.17

INSCRIPTION:
Recto, on newspaper, paint: *INTELL*

PROVENANCE:
Avis and Rockwell Gardiner, Stamford, Conn.; Stewart E. Gregory, Wilton, Conn.; Sotheby Parke-Bernet sale 4209, "Gregory Collection," 1/79, lot 10.

EXHIBITED:
"Rediscovered Painters of Upstate New York, 1700–1875," NYSHA, 1958.
"An Eye on America: Folk Art from the Stewart E. Gregory Collection," MAFA, 1972.
"Women in Folk Art," AARFAC, 1973.
"The Paper of the State," MAFA, 1976.
"The Woman Folk Artist in America," MAFA, 1979.
"Small Folk: A Celebration of Childhood in America," MAFA and N-YHS, 1980/81.

PUBLISHED:
Brant, Sandra, and Elissa Cullman. *Small Folk: A Celebration of Childhood in America.* New York: E.P. Dutton in association with MAFA, 1980, p. 21.
Dewhurst, C. Kurt, Betty MacDowell, and Marsha MacDowell. *Artists in Aprons: Folk Art by American Women.* New York: E.P. Dutton in association with MAFA, 1979, p. 88.
———. "The Woman Folk Artist in America." *The Clarion* (winter 1979): 24.
Jones, Agnes Halsey. *Rediscovered Painters of Upstate New York, 1700–1875.* Utica, N.Y.: Munson-Williams-Proctor Institute, 1958, p. 45.
Karlins, N.F. *The Paper of the State.* New York: MAFA, 1976, p. 3.
Museum of American Folk Art. *An Eye on America: Folk Art from the Stewart E. Gregory Collection.* New York: MAFA, 1972, p. 24.

52 Mary Valentine was the granddaughter of Anthony Stiegel, brother of Henry W. Stiegel. The latter was the Baron Stiegel of glassmaking fame.
53 Bryan, letter to Jean Lipman and Tom Armstrong, March 2, 1980, and letters to the author, Feb. 22 and March 6, 2000 (AFAM files).

Deborah Goldsmith is one of a few early-nineteenth-century women documented as painting professionally, and her watercolors offer an affectionate glimpse into the lives of the farmers and artisans of rural upstate New York. It is thought that Goldsmith knew the people she portrayed, and this is supported by her delicate watercolor portraits that provide an intimate look at the faces of the region. This family portrait was probably painted within a year or so of the birth of daughter Cornelia to Lyman and Maria Preston Day.[54] It indicates that Goldsmith was attempting complex compositions at the young age of fifteen or sixteen and was already traveling from her home in Brookfield, New York, to paint portrait commissions. It also demonstrates her early interest in interior details and here provides a glimpse of the highly patterned but sparsely furnished Day home in the farming community of Sangerfield. Her only other known interior scene, *The Talcott Family*, was painted almost ten years later and shows greater maturity in technique and composition.[55] Yet the observant eye that carefully captured the decorative and emotional trappings of the Talcott home is already evident in this self-contained family scene and its details, such as the titled columns in the newspaper Mr. Day holds.

Goldsmith's family migrated from Guilford, Connecticut, to Brookfield between 1805 and 1808. She spent much of her adolescence in the more cultured environment of Hamilton, at the home of her sister and brother-in-law Sanford Boon, a silversmith. She was a devout Baptist, and her correspondence with her fiance, a Universalist, illuminates their struggle in resolving their different religious beliefs. Goldsmith married George Throop in 1832 and died just a few years later, in 1836, after having a premonition of her death. In addition to portraits of family, friends, and neighbors, she left behind two friendship albums started in 1826 and 1829 which were preserved by her descendants along with her box of paints. These are filled with a collection of poems and sentiments contributed by friends and culled from literary compendiums such as *The Reader* and *The Token*.[56] —S.C.H.

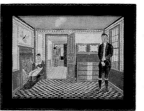

18. INTERIOR OF JOHN LEAVITT'S TAVERN
Joseph Warren Leavitt (1804–1833)
Chichester, Merrimack County,
New Hampshire
c. 1825
Watercolor, ink, and pencil on paper, in original maple frame
6½ × 8⅝ in. (sight) (8⁹⁄₁₆ × 10½ × ½ in. framed)
P1.2001.18

PROVENANCE:
Descended in Moses Morse family to Emma Punchon Radley, Winchester, Mass.; Mrs. Grace Stammers, Watertown, Mass.; Bertram K. and Nina Fletcher Little, Brookline, Mass.; Sotheby's sale 6526, "Little Collection, Part I," 1/94, lot 93.

EXHIBITED:
"The Decorative Arts of New Hampshire, 1725–1825," Currier Gallery of Art, Manchester, N.H., 1964.
"The Flowering of American Folk Art, 1776–1876," WMAA, 1974.
"By Good Hands," Currier Gallery of Art, Manchester, N.H., 1989.

PUBLISHED:
Black, Irma Simonton. "America in Art—Homes in the Wilderness." *Art in America* 49, no. 3 (1961): 52.
Black, Mary, and Jean Lipman. *American Folk Painting*. New York: Clarkson N. Potter, 1966, p. 127.
Currier Gallery of Art. *The Decorative Arts of New Hamphire, 1725–1825*. Manchester, N.H.: Currier Gallery of Art, 1964, p. 68.
Davidson, Marshall B., and Nina Fletcher Little. "American Decorative Wall Painting, 1700–1850." *American Heritage* 4, no. 2 (winter 1953): 36.
Doty, Robert M. *By Good Hands: New Hampshire Folk Art*. Manchester, N.H.: Currier Gallery of Art and Univ. of New Hamphire, 1989, p. 40.
Garrett, Elisabeth Donaghy. "Furnishing the Early American Home." *The Magazine Antiques* 138, no. 3 (September 1990): 552.
Garvin, Donna-Belle, and James L. Garvin. *On the Road North of Boston: New Hampshire Taverns and Turnpikes, 1700–1900*. Concord, N.H.: New Hampshire Historical Society, 1988, p. 120.
Greenlaw, Barry A. *New England Furniture at Williamsburg*. Williamsburg, Va.: Colonial Williamsburg Foundation, 1974, p. 123.
Idzerda, Stanley J. *Lafayette, Hero of Two Worlds: The Art and Pageantry of His Farewell Tour of America, 1824–1825*. Flushing, N.Y.: Queens Museum, 1989, fig. 65.
Lipman, Jean, and Alice Winchester. *The Flowering of American Folk Art, 1776–1876*. New York: Viking Press in association with WMAA, 1974, p. 64.
Lipman, Jean, Elizabeth V. Warren, and Robert Bishop. *Young America: A Folk Art History*. New York: Hudson Hills Press in association with MAFA, 1986, p. 36.
Little, Nina Fletcher. *American Decorative Wall Painting, 1700–1850*. New York: Studio Publications in association with Old Sturbridge Village, 1952, fig. 116.
———. "Decoration under Foot: Painted Floors in Early New England." *Country Life* 160, no. 3993 (January 1974): 33.
———. *Little by Little: Six Decades of Collecting American Decorative Arts*. New York: E.P. Dutton, 1984, p. 150.
———. "An Unusual Painting." *The Magazine Antiques* 43, no. 5 (May 1943): cover, p. 222.
Mayhew, Edgar De N., and Minor Myers Jr. *A Documentary History of American Interiors from the Colonial Era to 1915*. New York: Charles Scribner's Sons, 1980, pl. 11.
Peterson, Harold L. *American Interiors from Colonial Times to the Late Victorians*. New York: Charles Scribner's Sons, 1971, pl. 33.

54 Although their daughter's name has also been cited as Cordelia, her name is listed as Cornelia H., born May 23, 1822, in Cleveland Abbe and Josephine Genung Nichols, *Abbe–Abbey Genealogy* (New Haven, Conn.: Tuttle, Morehouse and Taylor, 1916), p. 202.
55 It has been published extensively, in part because of the wealth of visual information it provides about nineteenth-century interiors. Elements already evident in the earlier Day watercolor, such

as multiple patterning, are further enriched in *The Talcott Family*. The two paintings are compared in Rumford, *American Folk Portraits*, p. 110.
56 Biographical information based primarily on Sandra C. Shaffer, *Deborah Goldsmith, 1808–1836: A Naive Artist in Upstate New York* (East St. Louis, Ill.: Dan Addison Throop, 1975). See also D'Ambrosio and Emans, *Folk Art's Many Faces*, pp. 86–90.

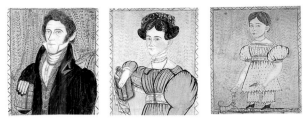

Painted to commemorate the 1824–1825 American tour of the Marquis de Lafayette (1757–1834), this watercolor endures today as a remarkable document of a stencil-decorated New England interior. For many years it was believed to depict the interior of Moses Morse's house in Loudon, New Hampshire.[57] The confusion can perhaps be laid to the fact that the watercolor descended in the Morse family and includes a portrait of Morse's wife, Sally, sewing by the fireplace. Morse was a local joiner and made the painting's frame, with diagonal stringing that echoes the stringing along the edges of the desk portrayed in the watercolor. Recent research strongly suggests that this is not the Morse home, however, but a view of the tavern belonging to the artist's father, John Leavitt. Mrs. Morse was the artist's cousin, perhaps explaining her presence in the watercolor.[58]

In this vivid scene, the viewer is able to look through three connecting rooms, each with a distinctive character created by the use of stencil and freehand painting. The placement of three figures—Lafayette looming large in the right foreground, Mrs. Morse seated by the fire, and an unidentified figure in the middle room—provides scale and perspective.[59] The most elaborate space is the highly patterned front main room. Every surface has received some type of painted decoration, from the checkerboard floor to the wall divided into bordered panels. According to Nina Fletcher Little, the delicate, foliate border design and swag-and-tassel frieze above are related to the work of an unidentified itinerant stenciler who traveled through the coastal towns of New England; the bird-and-leafy-branch motif over the fireplace has not been found elsewhere.[60]

—S.C.H.

19a–c. BARNABAS BARTOL CARVER, MARY COFFIN CARVER, and FRANCES ANN CARVER
The Carver Limner
Freeport, Cumberland County, Maine
c. 1835
Watercolor and pencil on paper
22 × 18 in. each
P1.2001.19, 20, 21

INSCRIPTIONS:
Mr. Carver: verso, ink on paper note: *Barnabus Bartol Carver / Born in Freeport Maine / 5/26-1799-D—[?]*
Mrs. Carver: verso, ink on paper note: *Mary Coffin Carver / B 1801-D. Freeport d. 1873 / Married Barnabus Carver / B. 1799-Freeport D. 1873 / Parents of Frances Ann Carver*
Frances Ann: verso, ink on paper note: *Daughter of / Barnabus B. and Mary C…. Carver / Frances Ann— B 1832—D. 1920*

WATERMARKS:
Mr. Carver: J. WHATMAN / TURKEY MILL (Maidstone, Kent, England); *Mrs. Carver* and *Frances Ann: J. WHATMAN / 1827* (Maidstone, Kent, England)

PROVENANCE:
Descended in family to Minerva K. Warner, Freeport, Maine; Richard L. Mills, Exeter, N.H.; Kennedy Galleries, New York; Marvin and Jill Baten, White Plains, N.Y., 1995.

The name of the artist who portrayed three members of the Carver family of Freeport, Maine, remains unknown, although a small body of work is now attributed to his hand. Identified simply as the Carver Limner, the artist is responsible for at least two additional portraits.[61] Barnabas Bartol Carver (1799–?) married Mary Coffin (1800/1–1873) in 1826. Both were descended from prominent Freeport families. Like his father and grandfather before him, Barnabas was a farmer but is also remembered in family history as a lawyer.[62] His family may also have been involved as merchants in coastal shipping and possibly local shipbuilding as well. The Carvers had several children, but Frances Ann (1832–1920) seems to have been the only child to survive into adulthood. In 1859 she married William Pote Kendall. The portraits remained in the family through the 1970s.[63]

57 This watercolor has been extensively published as *Interior of the Moses Morse House, Loudon, New Hampshire;* see Nina Fletcher Little, *American Decorative Wall Painting, 1700–1850* (New York: Studio Publications in association with Old Sturbridge Village, 1952, fig. 116; reprint, New York: E.P. Dutton, 1989, pl. 5). In the later edition, Little corrects the title and information.

58 The research conducted by Donna-Belle Garvin, New Hampshire Historical Society, Concord, in 1988, is appended to the back of the watercolor in Mrs. Little's hand. It is also published in Donna-Belle Garvin and James L. Garvin, *On the Road North of Boston: New Hampshire Taverns and Turnpikes, 1700–1900* (Concord, N.H.: New Hampshire Historical Society, 1988), p. 120, and summarized in the catalog of Sotheby's sale 6526 (1/94, lot 93).

59 In 1824 French artist Ary Sheffer presented a full-length portrait of Lafayette to the American Congress. In this oil, which is exactly contemporary with the Leavitt watercolor, Lafayette appears to have a much fuller figure and leans prominently on his walking stick. Even fictionalized accounts of his American tour comment upon his reliance on a cane. In Louisa May Alcott's *An Old-Fashioned Girl* (1869), "Grandma" describes Lafayette during his visit to Boston in 1825: "a little old man in nankeen trousers and vest, a long blue coat and ruffled shirt, leaning on his cane, for he was lame…." However, the strong similarities between the

two faces lend credence to the identification. The dark lines on Lafayette's face in the watercolor may be indicative of his age, as he would have been nearing seventy at this time.

60 The stencil decoration in the Leavitt tavern is discussed in Little, *American Decorative Wall Painting,* p. 101.

61 Dorothy Drinkwater Rees, letter to Freeport Historical Society, April 17, 1989 (AFAM files). Rees, a direct descendant of the Carver family, refers to a portrait of Dorcas Coffin Stubbs—sister of Mary Coffin Carver—that she inherited and which was on view at MFA in 1989. My gratitude to Sue Welsh Reed, MFA, for providing a photocopy of this painting. A portrait by the same artist of an unidentified man, possibly a Mr. Thissele, is illustrated in David A. Schorsch, *Masterpieces from Two Distinguished Private Collections* (New York: David A. Schorsch, 1995), pp. 8–9. In the catalog entry, Schorsch suggests there are as many as nine portraits that can be attributed to the Carver Limner but does not enumerate them.

62 Rees, letter to Freeport Historical Society.

63 I am grateful to Randall Wade Thomas, Freeport Historical Society, for providing biographical information about the Carver family and their descendants.

The Carver family portraits share several eccentricities that suggest the artist may have been trained as a furniture maker and/or decorative painter.[64] The unusual background is strongly reminiscent of surface treatments typically applied to boxes and case furniture to simulate woodgrain patterns and other decorative effects.[65] A sculpted quality informs all three portraits; this is especially evident in the deeply modeled pleats of Mr. Carver's stock and the treatment of fingers, like stacked dowels. The faces themselves seem almost gouged from wood and show a reliance on heavy outlining and a hard-edged, architectural approach. Repeated motifs, such as the leaflike designs on Mr. Carver's vest and the scarf draped over the back of the Windsor chair in Mrs. Carver's portrait, evoke associations with colonial furniture forms such as Hadley chests, whose low-relief carved decoration was made with the aid of templates.

All three portraits are bordered on three sides with bold black strokes in a pattern of alternating triangles. The full-length portrait of Frances Ann also has the additional feature of a bottom border that simulates bamboo, as is seen in decorated chairs of this period. Mr. and Mrs. Carver are both seated and depicted waist-length; their portraits do not face each other in the more usual convention. Neither exhibits the exaggerated proportions—long arms, tiny pet—that accentuate the activity of the cat and mouse in Frances Ann's portrait.[66] —S.C.H.

SAMUEL ADDISON SHUTE (1803–1836) and RUTH WHITTIER SHUTE (1803–1882)

Samuel Addison and Ruth Whittier Shute were an unusually talented, prolific, and enterprising pair of artists. They were married in Sommersworth, New Hampshire, on October 16, 1827. Ruth was a double first cousin of the celebrated abolitionist poet John Greenleaf Whittier, their fathers being brothers and their mothers being first cousins. She was born in Dover, New Hampshire, the eighth of nine children, on October 3, 1803. Samuel was born on September 24 of the same year. He attended the Governor Dummer Academy in Byfield, Massachusetts, and went on to Dartmouth College. He was a physician and a Freemason and was cited in a history of Weare, New Hampshire, as giving the oration at a Fourth of July celebration in 1827.[67]

After his marriage, Dr. Shute's focus shifted away from medicine, and he joined his wife in an artistic partnership that took the couple through the hamlets and small cities of northern New England and New York State, selling their services as itinerant portrait painters. Their efforts met with considerable success until Samuel's untimely death in Champlain, New York, in 1836, at the age of thirty-two.

An advertisement placed by the young artists in the (*Newport*) *New Hampshire Argus and Spectator* (April 15, 1833) shows one of their methods of attracting clients: "PORTRAIT / PAINTING! / MR. AND MRS. SHUTE / Would inform the Ladies and Gentlemen of Newport, N.H. that they / have taken a room at Nettleton's Hotel, where they will remain for a short / time. / All who may employ them may rest assured that a correct likeness of / the original will be obtained. If not the work may remain on our hands. / Prices will be regulated, according to the size of the portrait. / CALL AND EXAMINE THE PAINTINGS / Price from 5 to 10 dollars. / April 15, 1833."

The Shutes employed a highly unusual method of painting in that they simultaneously directed their creative energies to the same portrait. Although the great majority of their pictures are unsigned, a number of watercolors and oils are inscribed on the reverse: "Painted by R.W. Shute and S.A. Shute." In a few watercolors, their contributions are more specifically documented: "Drawn by R.W. Shute / and / Painted by S.A. Shute."

This apparently felicitous collaboration combined an attraction to multiple styles with an interest in experimenting with a diverse and unorthodox mixture of materials. The resulting body of work exhibits an astonishing vitality and complexity. When a portrait was painted in oil, the artists frequently interspersed applications of pigment with layers of varnish and glazes. When working on paper, their primary medium was watercolor, but that was freely supplemented with pastel, gouache, pencil, collage, gum arabic, and reserved blank areas in order to obtain different effects. The work is fresh and spontaneous, but great care seems

64 Rees, letter to Freeport Historical Society; family tradition has it that the portraits were painted by a New York artist who spent a summer on one of the islands off the coast of Maine.

65 The watercolor wash in the backgrounds was actually manipulated while wet with a material such as putty to create the grained patterning in exactly the same manner that furniture would have been decorated.

66 The last family owner, Minerva K. Warner, was a doll maker, and she fashioned a doll—which remains with a descendant—after the one held in Frances Ann's hand.

67 *The History of Weare, New Hampshire, 1835–1888* (Weare, N.H.: 1888), pp. 419, 603, 631.

to have been taken to obtain the individuality of the sitter, resulting in insightful renderings and likenesses that reflect a compelling degree of personal engagement.

Among the most numerous of the Shutes' clients were young women who had recently left their family farms to work in the mills that were bringing prosperity to the river towns of Massachusetts and New Hampshire. The portraits celebrate the confidence of the subjects and affirm a gentle pride in their newly independent status. The Shutes were particularly effective in their sympathetic portraits of children, and the new additions to the American Folk Art Museum's collection that are presented in this volume are outstanding examples of the artists' ability to capture the dignity, vulnerability, and poignance of their young sitters. Ruth and Samuel had themselves become parents in 1829. Their daughter Adelaide was born an invalid, and she remained with her mother throughout her life. A second daughter, Maria Antoinette, followed in 1831, but she survived only nine days. Her grave is located beside that of her father in the Millville Cemetery adjacent to the grounds of Saint Paul's School in Concord, New Hampshire. It is highly probable that the experience of coping with this loss explains the heightened sensitivity and quality of caring that distinguishes the young artists' portraits of children.

Although vital and intensely productive, the Shutes' joint career was tragically brief. The probability that Samuel's early death was preceded by a lingering illness is evidenced by the fact that by September 1833 the paintings were signed by Ruth alone. In addition, the next known newspaper solicitation for portrait commissions that appears after that date, in the May 24, 1834, edition of the *Plattsburgh (N.Y.) Republican,* mentions her name only.

For four years following Samuel's death, Ruth continued to travel in the region and to paint. Then, in 1840, she married Alpha Tarbell in Concord. She and Adelaide went with him to Lexington, Kentucky, where Ruth had two more daughters and where she is remembered as a pianist as well as a painter. Her last known painting, a portrait of a granddaughter, is dated 1874.[68] —H.K. & S.K.

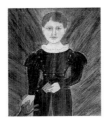

20. FREDERICK BUXTON
Samuel Addison Shute (1803–1836)
and Ruth Whittier Shute (1803–1882)
Lowell, Middlesex County, Massachusetts
c. 1831
Watercolor, gouache, pencil, and ink on paper
with applied gold foil
18¼ × 15¼ in.
P1.2001.22

INSCRIPTIONS:
Recto, on book, ink: *FREDERICK BUXTON / LOWELL / Aged Six years;* verso, pencil: *Buxton / Merrimac Corp / 39 Mid Row[?] / $1.50*

PROVENANCE:
Auctioned in Lowell, Mass., 1924; Dwight Hawkes; Sotheby Parke-Bernet sale 4268, 6/79, lot 874.

This portrait of Frederick Buxton first came to light in 1924, at an auction in Lowell, Massachusetts, as part of a group of four paintings that included his mother, Phebe, young Jeremiah Emerson, and that boy's mother, Sara Chandler Emerson.[69] The likenesses of the boys and their mothers are further linked by identical information found on the backs of the portraits of Phebe and Sara. A paper label—affixed to a new paper backing that transcribes the inscriptions from the original backing—states: "This picture is one of a pair bought in Lowell Massachusetts. It was taken from a board with the name Buxton."

Phebe Buxton's first husband and Frederick's father, Benjamin Buxton, died on August 23, 1827, at the age of forty-seven years and four months. In the Lowell City Directory of 1832, Phebe is listed as keeper of the boardinghouse at 39 Worthen Street, which was owned by the Merrimac Corporation and housed employees who worked at the company mill. In all likelihood she had assumed this position from the time of her widowhood until January 3, 1834, when the Lowell vital records reveal that she and Timothy Baker of Londonderry, New Hampshire, filed their marriage intentions.

Evidence linking the Shutes to 39 Worthen Street was discovered serendipitously when a copy of the Lowell Directory turned up in the Lowell town office with Dr. Shute's name and that address scrawled repeatedly on the inside cover. The specifics of this notation and exactly why the Shutes would be residing there remain a mystery, since, as far as is known, these boardinghouses were exclusively for mill workers.

In this portrait, the Shutes have given us a memorable image of a thoroughly beguiling, expressive, and winsome young boy for whom, regrettably, there is no information to continue his biography after he was painted in his sixth year. This is the only Shute likeness of a child composed with the radiating striped background that is found in many of their well-known paintings of mill girls like Emeline Parker and Eliza Gordon.[70] Frederick reaches for the small dog at his side with the same tender gesture that is seen in the juxtaposition of Masters Emerson and Burnham and their canine companions (cat. nos. 21, 24), but his dog is truncated below the forelegs. Frederick himself is painted in a three-quarter-length pose, which is true of a number of other Shute portraits of children; virtually all the adults are confined to formalized compositions that cut off the sitter at or near the waist. —H.K. & S.K.

68 Private collection. The following people were instrumental to our research on the Shutes: Mary Allis, Robert Bishop, Mary Black, Virginia Burdick, Bill Copely, Paul D'Ambrosio, Nancy Druckman, Ralph Esmerian, Nancy Evans, Catherine and John Goodwin, Michael and Colleen Cowles Heslip, Vera and Pepi Jelinek, Rachel Johnson, Lou and Aggie Jones, May W.S. Jones, Sybil and Arthur Kern, Lee Kogan, Judy Lenett, Bertram and Nina Fletcher Little, Barbara Luck, Nancy Muller, Jacqueline Oaks, John Rexford, Tom Rizzo, Bert and Gail Savage, David Schorsch, Esther Schwartz, Stephen Score, Peter and Leslie Warwick, Alice Winchester, and Ruth Wolfe.
69 The portrait of Sara Chandler Emerson is illustrated in Stacy C. Hollander, *American Anthem: Masterworks from the American Folk Art Museum* (New York: Harry N. Abrams in association with AFAM, 2001), cat. no. 60.
70 Collection MMA and AFAM, respectively. See National Gallery of Art, *101 American Primitive Water Colors and Pastels from the Collection of Edgar William and Bernice Chrysler Garbisch* (Washington, D.C.: NGA, 1966), p. 101, and ibid., cat. no. 61.

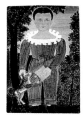

21. JEREMIAH H. EMERSON
Samuel Addison Shute (1803–1836)
and Ruth Whittier Shute (1803–1882)
Nashua, Hillsborough County, New Hampshire
c. 1832
Watercolor, gouache, pencil, and ink on paper with
applied gold foil
29¼ × 19 in. (sight)
P1.2001.23

INSCRIPTION:
Recto, on book, ink: *THE PROGRESSIVE READER / JEREMIAH H. / EMERSON / NASHUA, NH.*

PROVENANCE:
Auctioned in Lowell, Mass., 1924; Dwight Hawkes; Sotheby Parke-Bernet sale 4268, 6/79, lot 876.

Although inconclusive, fragments of information in two genealogical sources suggest a candidate for the adult Jeremiah H. Emerson who was depicted as a child in this arresting portrait. He appears in the 1845 Lowell, Massachusetts, vital records announcing his intention to marry Eliza Hall on March 13 of that year. In the Emerson genealogy, he is identified as Jeremiah Hurd Emerson and the son of Richard Emerson, who was born in South Reading, Massachusetts, in 1798. Richard was a journeyman shoemaker in Wakefield, Massachusetts, where he died at the age of thirty-two, widowing Sara Chandler, of Andover, whom he had married thirteen years earlier, and with whom he had been raising two other children. Jeremiah's sister Sara Eliza lived in Lowell, where she married Stephen T. Stanley in 1840. Although the genealogy lists Jeremiah's ultimate adult residence as Australia, it seems plausible that Sara Eliza may have been the custodian of his childhood portrait and the likeness of their widowed mother, and that may explain why the pictures descended together. As yet no convincing explanation accounts for how the Emerson and Frederick Buxton (cat. no. 20) portraits came to be auctioned as a foursome in 1924, or why they are further linked by the inscription of "Buxton" on the backing boards of the mothers' pictures.

Comparing the likenesses of the two boys shows how successfully the Shutes defined the children's distinct personalities with an economy of means. Jeremiah is considerably more stolid and reserved than the engaging Frederick, and, although his background is enlivened by elaborate foliage, the monochromatic palette reinforces his more withdrawn aspect. This is underscored when the painting is compared with the likeness of young Cynthia Jane Atkinson in the collection of the Lowell Historical Society, which is similarly composed but enlivened by more complex and intricate color relationships. The Shutes often injected graphic vitality into a composition by choosing to exaggerate a detail of the subject's costume, and nowhere is that more evident than in their treatment of Jeremiah's billowing, cloudlike white collar.

—H.K. & S.K.

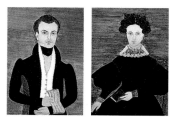

22a–b. JOSIAH C. BURNHAM and ABIGAIL S. BURNHAM
Samuel Addison Shute (1803–1836) and Ruth Whittier Shute (1803–1882)
Probably Lowell, Middlesex County, Massachusetts
c. 1831–1832
Watercolor, gouache, pencil, and ink on paper with applied gold foil
13½ × 9½ in. each
P1.2001.24a, b

INSCRIPTION:
Mr. Burnham: recto, on music book, ink: *54 HEBRON. L.M. / Thus far the Lord hath / led me on / WARD. L.M. 55*

PROVENANCE:
Descended to family member in Grafton, Mass.; Mrs. Frank L. Searles, Whitensville, Mass.; Edgar William and Bernice Chrysler Garbisch, Cambridge, Md.; Sotheby Parke-Bernet sale 4116, "Garbisch Collection, Part III," 4/78, lots 516, 517.

EXHIBITED:
"Nineteenth-Century American Women Artists," WMAA Downtown Branch, 1976.
"American Folk Painters of Three Centuries," WMAA, 1980.

PUBLISHED:
Kellogg, Helen. "Found: Two Lost American Painters." *Antiques World* 1, no. 2 (December 1978): 43.
Lipman, Jean, and Tom Armstrong, eds. *American Folk Painters of Three Centuries.* New York: Hudson Hills Press in association with WMAA, 1980, p. 168.
Savage, Bert, and Gail Savage. "Mrs. R.W. and S.A. Shute." *Maine Antique Digest* 6, no. 7 (August 1978): 3-B.

Josiah and Abigail Burnham were married on July 1, 1827, in Dover, New Hampshire, the hometown of Ruth Whittier. Less than three months later, on September 24, Whittier married Samuel Addison Shute in the adjacent hamlet of Sommersworth. Josiah worked at the Cocheco Mill in Dover, which stood on a plot of land owned by Ruth's father, Obadiah. The mill had been built by Isaac and Jacob Wendell, two of the most prominent mill owners in New England, and Isaac was married to Ruth's older sister, Anna. Josiah's employment at the mill is documented in the Dover town directory, where he is listed as a spinner in 1838 and a manufacturer in 1843. That the acquaintance of the Shutes and the Burnhams might have gone beyond that of portraitists and subjects is suggested by the music book in Josiah's hand, since it is known that Ruth was a musician as well as an artist.

Very few Shute watercolor portrait pairs are known, and none were painted in the small size of the Burnham likenesses. Only one other portrait of this size has surfaced to date. That picture, now in a private collection, has the same olive drab background applied with horizontal brushstrokes that is seen in the Burnham portraits. —H.K. & S.K.

23. MOURNING PIECE FOR
SARAH ELIZABETH BURNHAM
Samuel Addison Shute (1803–1836)
and Ruth Whittier Shute (1803–1882)
Probably Lowell, Middlesex County,
Massachusetts
c. 1831–1832
Watercolor, gouache, pencil, and ink on
paper with applied gold foil
15⅝ × 19 in.
P1.2001.25

INSCRIPTION:
Recto, on plinth, ink: *SACRED / TO THE / MEMORY OF / SARAH ELIZABETH / DAUGHTER OF JOSIAH C. AND / ABIGAIL S. BURNHAM WHO / died Dec. 24.h 1830. Æt. two years & 7 months, / Sure to the mansions of the blest / When infant innocence ascends, / Some angel, brighter than the rest, / The spotless spirits light attends.*

PROVENANCE:
Descended to family member in Grafton, Mass.; Mrs. Frank L. Searles, Whitensville, Mass.; Edgar William and Bernice Chrysler Garbisch, Cambridge, Md.; Sotheby Parke-Bernet sale 3692, "Garbisch Collection, Part III," 11/74, lot 2; Don and Faye Walters, Goshen, Ind.; George E. Schoellkopf, New York; Eileen and Richard Dubrow, Bayside, N.Y., 1983.

The discussion of the likenesses of Josiah and Abigail Burnham notes a number of circumstances that link their lives with the young artists who painted their portraits. In addition, the Shutes and the Burnhams shared the devastating deaths of baby daughters. This mourning picture marks the passing of Sarah Elizabeth Burnham on December 24, 1830, at two years and seven months of age. The Shutes were to endure the loss of nine-day-old Maria Antoinette only four weeks later. The moving inscription chosen for the tombstone in the center of the composition attests to the depth of the grief experienced by both the artists and their patrons, and further supports the supposition that there may have been a friendship between them. —H.K. & S.K.

24. MASTER BURNHAM
Samuel Addison Shute (1803–1836)
and Ruth Whittier Shute (1803–1882)
Probably Lowell, Middlesex County, Massachusetts
c. 1831–1832
Watercolor, gouache, pencil, and ink on paper
27½ × 19 in.
P1.2001.26

PROVENANCE:
Descended to family member in Grafton, Mass.; Mrs. Frank L. Searles, Whitensville, Mass.; Edgar William and Bernice Chrysler Garbisch, Cambridge, Md.; Sotheby Parke-Bernet sale 4116, "Garbisch Collection, Part III," 4/78, lot 425.

PUBLISHED:
Bishop, Robert. *Folk Painters of America.* New York: E.P. Dutton, 1979, p. 37.

This striking portrait of Master Burnham was acquired, along with the likenesses of his parents and the mourning piece memorializing his younger sister (cat. nos. 22a–b, 23), by Edgar William and Bernice Chrysler Garbisch from Mrs. Frank L. Searles, an antiques dealer. She had purchased them in Grafton, Massachusetts, from Burnham family descendants in 1950. It is an exceptional group of paintings, but perhaps the outstanding member of the quartet is this portrait. It is generally regarded as an example of the Shutes at the height of their creative powers and is one of the standouts in the entire spectrum of American folk portraiture.

It is difficult to remain unmoved by the attitude of preoccupied sadness that characterizes the young boy in this portrait. His large, expressive dark eyes invite the viewer's sympathy, and the melancholy atmosphere they establish is sustained by the rich variety of blue tonalities that dominate the picture. Perhaps the somber demeanor and the restrained palette that pervade his likeness can be explained by the simultaneous execution of the mourning piece for his sister.

—H.K. & S.K.

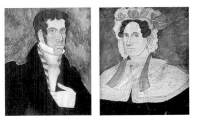

25a–b. GENTLEMAN WEARING A STRIPED WAISTCOAT and
WOMAN WEARING A BONNET WITH PINK RIBBONS
Samuel Addison Shute (1803–1836) and Ruth Whittier Shute (1803–1882)
Possibly Brattleboro, Windham County, Vermont
c. 1828–1830
Watercolor, gouache, pencil, and ink on paper
21⅞ × 17⅜ in. each (sight)
P1.2001.27, 28

WATERMARKS:
Gentleman: J. WHATMAN / TURKEY MILL / 1825 (Maidstone, Kent, England)
Woman: J. WHATMAN / TURKEY MILL / 1828 (Maidstone, Kent, England)

PROVENANCE:
Childs Gallery, Boston; Bertram K. and Nina Fletcher Little, Brookline, Mass.; Sotheby's sale 6612, "Little Collection, Part II," 10/94, lot 727.

PUBLISHED:
Kellogg, Helen. "Found: Two Lost American Painters." *Antiques World* 1, no. 2 (December 1978): 45 (*Gentleman* only).

Bertram K. and Nina Fletcher Little purchased these pictures from the Childs Gallery in Boston in 1966. They were originally found in Brattleboro, Vermont, but no information about the sitters accompanied them. The J. Whatman paper on which the gentleman and woman were painted bear watermarks dating 1825 and 1828, respectively. The pictures are part of an early, atypical group that long challenged attribution to the Shutes because of the stylistic disparities. However, they are linked to the work of the Shutes by a number of striking similarities.

Chronological and written clues that unite this group with work considered typical of the Shutes begin with the letter held by Mary Ann Russell (cat. no. 26) in her portrait which contains a handwritten postmark dated November 4, 1828. The first dated and signed paintings do not appear until 1832, with a pair of portraits of sisters Eliza Parker Townsend and Emeline Parker.[71] Each is signed "Drawn by R.W. Shute and painted by S.A. Shute Lowell, Massachusetts," and they are dated February 17 and 18, respectively. This inscription allowed a number of large watercolor portraits displaying the diagonally striped backgrounds and other unique characteristics of the Parker paintings to be attributed to the two artists named Shute. In 1978 research finally established the identity of the artists. Additional examples of their jointly signed work continued to surface, as well as unsigned paintings that expanded the earlier stylistic parameters, including portraits that were closely related to this superb pair.

The distinctive qualities of the group to which this pair of portraits belongs led to the hypothesis that they might represent the work of Samuel Shute alone, a point of view that was put forth in early Shute research. Since then, many more pictures have emerged, including several key examples that blur the stylistic boundaries and suggest transitions between artistic approaches that had previously seemed almost unconnected. These revelations brought into question the conclusion that portraits such as this pair were painted solely by Samuel. Ongoing research has extended the timeline of Ruth's artistic activity thirty-eight years after the death of her first husband. Emerging clues remain to be deciphered, but at this point it seems probable that Ruth was involved in the entire body of work and that she was the dominant creative force in all their collaborative efforts.　　　　　　　　　　—H.K. & S.K.

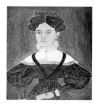

26. 　MARY ANN RUSSELL
Samuel Addison Shute (1803–1836)
and Ruth Whittier Shute (1803–1882)
Lowell, Middlesex County, Massachusetts
1828
Watercolor, gouache, pencil, ink, and gum arabic on paper, in original pine frame with mahogany veneer
18 × 13½ in. (25⁵⁄₁₆ × 20⅞ × 1¼ in. framed)
P1.2001.29

INSCRIPTION:
Recto, on letter, ink: *Mifs Mary Ann Russel / Lowell / Mafs; 6* [postage] */ Boston 1828 Nov 4* [postmark]

PROVENANCE:
Professor North, Clinton, N.Y.; Don H. and Barbara Ladd, Hampton, Conn.; Esther Schwartz, Patterson, N.J.; the Ladds, 1983.

PUBLISHED:
Kellogg, Helen. "Found: Two Lost American Painters." *Antiques World* 1, no. 2 (December 1978): 41.

26a. 　MARY ANN RUSSELL SAMPLER
Mary Ann Russell (dates unknown)
Lowell, Middlesex County, Massachusetts
Early nineteenth century
Silk thread on linen
7³⁄₁₆ × 6⅜ in. (sight)
P1.2001.30

INSCRIPTION:
Recto, silk thread: *Els. Lawrance / Mary Ann Russell aged 11.*

PROVENANCE:
Professor North, Clinton, N.Y.; Don H. and Barbara Ladd, Hampton, Conn.; Esther Schwartz, Patterson, N.J.; the Ladds, 1983.

Mary Ann Russell was a young mill worker who later, according to Lowell bank records, became a mantua maker, or garment maker. A sampler she made as a child has descended along with this portrait, which is the earliest dated work by Samuel Addison and Ruth Whittier Shute to have yet been discovered. The picture introduces some of the stylistic elements that would later become distinctive trademarks of their mature work, and it is the first of a number of watercolors of women in which the sitter holds a card identifying herself.

The subjects of two pictures with compositional elements that place them earlier, Sarah Ann Drew and Sarah Fuller, are identified on cartouches that appear in an upper corner and stand out against a dark background.[72] This pair can be grouped with other very early watercolors with opaque backgrounds painted in a range of grays and gray-browns. Although Russell is painted in the small-size format that characterizes this group, her background is the first known example showing a translucent watercolor treatment. The artists would develop the vertical brushstrokes seen in her portrait into a distinctive diagonal-striped effect in which the color is keyed to the tones used in rendering the figure, from whom the background appears to radiate. It is this background that appears regularly in the larger portraits that form the body of work from the early 1830s for which the Shutes are best known.

Russell's likeness also introduces more dramatic design elements within the figure that appear regularly in the later work. White gouache is boldly applied to her bodice, and it creates arresting contrasts to the rich sienna background, the elaborately contoured black dress, and the exposed paper on which the facial features are densely but sensitively penciled. The Shutes' ability to capture subtle nuances of personality in their portraits is nowhere more evident than in the poignance, modesty, and moving integrity that is uncannily projected in the likeness of this very impressive young woman.　　　　　　　　　　—H.K. & S.K.

71 Private collection and collection MMA, respectively. See Helen Kellogg, "Found: Two Lost American Painters," *Antiques World* 1, no. 2 (December 1978): 36, and National Gallery of Art, *101 American Primitive Water Colors*, p. 101.

72 The portrait of Sarah Ann Drew is illustrated in Museum of Fine Arts, *M. & M. Karolik Collection*, vol. 2, p. 105. The portrait of Sarah Fuller is in a private collection.

JOSEPH H. DAVIS (ACT. 1832–1837)

During the mid-1830s, Joseph H. Davis, the artist of more than 150 known compositions, executed watercolor likenesses of residents of southwestern Maine and southeastern New Hampshire. As early as 1832, he specialized in recording subjects in interior settings typical of nineteenth-century middle-class parlors. Individuals are seated on ornately grain-painted chairs positioned beside elaborately decorated tables where they read, write, attend to their children and pets, or pursue other commonplace activities. Davis's tables bear flower arrangements, bowls of fruit, books both tiny and massive, quill pens and inkwells, and gentlemen's beaver-skin hats. Behind the subjects, parlor walls are decorated with banjo clocks, maps, and pictures, wrapped in swags of greenery, that depict family homesteads or other picturesque scenery. Extraordinary carpets appearing as horizontal bands of geometrically designed pattern across the bottom of the compositions characterize this artist's work.

In other watercolors, Davis portrayed clients in exterior views appointed with garden flowers, potted plants, and flying birds. These individuals frequently are depicted participating in outdoor leisure activities, such as picking flowers and hunting birds. Among the most distinguishing features of Davis's work are elaborate calligraphic inscriptions found at the bottom of the watercolors and pertaining to the sitters, including their names, ages at the time their likenesses were made, and the towns where they resided. In at least one instance, the artist signed his name to a composition, annotating it with a personal description of himself as a "LEFT HAND / PAINTER."[73]

Like many of his contemporaries, Davis relied upon established networks of introduction to negotiate portrait commissions, allowing him to travel across state lines to unfamiliar regions. Davis's affiliation with the Freewill Baptist Church is among the most compelling associations to come to light.[74] Many of his sitters participated in this denomination, including Ira Libby, a deacon in the church in North Berwick, Maine, William B. Chamberlin (cat. no. 27), Sylvanus C. Foss and his sister Mary Jane (cat. no. 30), Bartholomew Van Dame, Azariah Caverly, and Thomas York, among others.[75] The northern branch of the Freewill Baptists, which practiced full immersion baptism of adults, was founded in 1790 by Benjamin Randall in New Durham, New Hampshire. Many of the towns in which Davis was most active, including Strafford, Farmington, Brookfield, Barrington, and Deerfield, are located within the same cultural region as New Durham and were influenced by Randall's Arminianist preaching.[76] In several of his compositions, Davis discreetly, but cleverly, alludes to this religious affiliation by portraying these individuals holding the newspaper *The Morning Star,* an organ of the Freewill Baptist Church.

Since Davis's rediscovery in the twentieth century, several individuals have proposed theories concerning his identity.[77] The complex historiography addressing this artist and his work has been intensified by the fact that his name is relatively common. Although a significant body of portrait work in watercolor has been attributed to him, he appears to have drawn these likenesses for a short period, from 1832 to 1837, thus contributing to his mysterious persona. Most recently, researchers Sybil and Arthur Kern have delved into primary sources across the Northeast to formulate a compelling biography for this man whose identity has been defined principally from the works of art he left behind.[78] They propose that the artist probably was born on August 10, 1811, in Limington, Maine, the son of land trader Joseph Davis and his wife, Phebe. In addition to farming and land speculating like his father, over the years this individual also worked as a manufacturer and an inventor. He lived in several towns in the Northeast, including Saco, Vassalboro, and Newfield, Maine; Morristown, New Jersey; and Wilmington, Massachusetts. He died on May 25, 1865, at the age of fifty-three, in Woburn, Massachusetts.

—C.E.M.

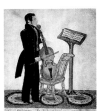

27. WILLIAM B. CHAMBERLIN WITH VIOLONCELLO AND MUSIC
Joseph H. Davis (act. 1832–1837)
Probably Brookfield, Carroll County, New Hampshire
1835
Watercolor, pencil, and ink on paper
10¾ × 8¹³⁄₁₆ in. (sight)
P1.2001.31

INSCRIPTION:
Recto, ink: *William B. Chamberlin. 1835.*

PROVENANCE:
Sotheby's sale 5429, 1/86, lot 425.

PUBLISHED:
Garvin, Donna-Belle, and James L. Garvin. *On the Road North of Boston: New Hampshire Taverns and Turnpikes, 1700–1900.* Concord, N.H.: New Hampshire Historical Society, 1988, p. 13.

73 See the portrait of Bartholomew Van Dame (collection Currier Gallery of Art, Manchester, N.H.) in Robert M. Doty, *By Good Hands: New Hampshire Folk Art* (Hanover, N.H.: Univ. Press of New England, 1989), cover.

74 Sybil Kern and Arthur Kern, "Joseph H. Davis: Identity Established," *The Clarion* 14, no. 3 (summer 1989): 48–50.

75 The double portrait of Fanny and Ira Libby is in a private collection. The Azariah Caverly family portrait is illustrated in D'Ambrosio and Emans, *Folk Art's Many Faces,* p. 64, and the Thomas York family portrait is illustrated in Rumford, *American Folk Portraits,* p. 85.

76 D. Hamilton Hurd, comp., *History of Rockingham and Strafford Counties, New Hampshire, with Biographical Sketches of Many of Its Pioneers and Prominent Men* (Philadelphia: J.W. Lewis, 1882), pp. 705–7.

77 Nina Fletcher Little, "New Light on Joseph H. Davis, 'Left-Hand Painter,'" *Antiques* 98, no. 5 (November 1970): 754–57, Gail Savage, Norbert H. Savage, and Esther Sparks, *Three New England Watercolor Painters* (Chicago: Art Institute of Chicago, 1974), Frank O. Spinney, "Joseph H. Davis, New Hampshire Artist of the 1830s," *The Magazine Antiques* 44, no. 4 (October 1943): 177–80, and Spinney, "The Method of Joseph H. Davis," *The Magazine Antiques* 46, no. 2 (August 1944): 73.

78 Kern and Kern, "Joseph H. Davis," pp. 45–53.

Captured as if in the midst of a recital, or perhaps just practicing for an impending concert, William B. Chamberlin plays the violoncello. The bass instrument of the violin family, the violoncello, or "cello," has deeper ribs and a shorter neck than the violin. Originating in the sixteenth century, the cello supplied the bass line to concerted works. The introduction of the endpin, or spike, in the late eighteenth century brought increased security and resonance to this instrument. This modification was not universally adopted until the late nineteenth century, and until then, performers sat and played the cello between their knees.[79]

Joseph H. Davis has given almost equal status to the instrument his client plays, as if both were posing for portraits. He articulates the subject's fingers to solicit the viewer's attention. In this composition, the focus is on the musician's hands, the medium through which his musical aspirations are communicated to his instrument. The fingers of his left hand are positioned around the cello's neck, while the fingers of his right hand clasp the bow at an angle, as if bowing the strings to create music. The score on the stand at the right—lacking a fifth line in the staff, measure bars, a clef, or a key signature—is an imaginary graphic confection invented by the artist.[80]

Efforts to link the subject of this portrait with individuals in the historic record have proved problematic partly because of the prevalence of the name in New Hampshire where this likeness is believed to have originated. Variation in the spelling of his last name, which either includes or omits a second letter *a*, in the third syllable, raises speculation about who this individual could be. The subject probably is the William B. Chamberlain who in 1836 married Betsy Chamberlain Sanborn, another of the artist's clients (cat. no. 28).[81] Identified as a captain in sources of the period, he resided in Brookfield, New Hampshire, where he was born about 1813.[82] A member of the Freewill Baptist Church, Chamberlain died prematurely, at the age of twenty-nine, on March 26, 1842. All records found for this individual, however, include the second letter *a*.[83] Since Davis meticulously inscribed the sitter's name directly below the portrait, a characteristic of his work, it seems surprising that he would have misspelled his client's last name, especially if he had hoped to execute a pleasing likeness and secure additional work. —C.E.M.

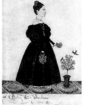

28. BETSY C. SANBORN
Joseph H. Davis (act. 1832–1837)
Probably Brookfield, Carroll County, New Hampshire
1835
Watercolor, pencil, and ink on paper
10⅝ × 7¾ in. (sight)
P1.2001.32

INSCRIPTIONS:
Recto, ink: *Betsy C. Sanborn;* verso of backing board, ink: *Jany 3rd 1835 Aged 21— / when Painted.*

PROVENANCE:
Descended in family to Mildred Seymour MacCoy (sitter's great-grandchild), Norwell, Mass.; Sotheby's sale 5429, 1/86, lot 426.

In drawing Betsy C. Sanborn's portrait, Joseph H. Davis utilized a format he often enlisted to execute likenesses of women. Sanborn stands on a decorative orange and yellow carpet, her body turned in three-quarter view, her face in profile; her hands and feet are diminutive. She holds a small bouquet of flowers in one hand, possibly tulips and roses, while clasping an orange-, blue-, green-, and gold-decorated purse in the other, props commonly seen in this artist's work. Reminiscent of Davis's other portraits, this likeness includes a potted plant with orange berries and two birds, one flying above and the other perched on a twig, animating an otherwise static composition.

Drawn in black with glazed highlights, Betsy's dress, with its balloon sleeves and Empire waist accentuated with a large brass buckle, is stylistically consistent with women's clothing from the mid-1830s. In addition to her beautiful tortoiseshell hair comb and gold drop earrings, Betsy wears a necklace, wrapped three times around her neck, that holds a timepiece, or possibly a locket, that is tucked into her waistband.[84] Among the most intriguing and yet inconsistent features of this portrait is what appears to be a partial inscription in the lower margin. Placed off-center, it includes only the sitter's name, with complementary flourishes below, but lacks other information that Davis loved to include in his watercolor likenesses, such as Sanborn's date of birth or when the artist recorded her appearance.[85]

According to a published history of the Sanborn family in America, Betsy Chamberlain Sanborn was born on January 3, 1814, the daughter of Ezekiel (1774–1830), a farmer, and Abigail Chamberlain Sanborn (1776–1854) of Brookfield, New Hampshire.[86] In 1836 she married William B. Chamberlain (c. 1813–1842) (cat. no. 27).[87] The 1840 federal census for

79 Sibyl Marcuse, *Musical Instruments: A Comprehensive Dictionary* (New York: W.W. Norton, 1975), p. 578, and Stanley Sadie, ed., *The Grove Concise Dictionary of Music* (London: Macmillan Press, 1988), p. 808.

80 My thanks to George and Donna Butler, Enfield Shaker Museum, Enfield, N.H., for their comments.

81 V.C. Sanborn, *Genealogy of the Family of Samborne or Sanborn in England and America, 1194–1898* (LaGrange, Ill.: privately printed, 1899), p. 338, entry 764. My thanks to Arthur B. Kern for this citation; see letter to the author, July 2, 2000 (AFAM files).

82 David C. Young and Robert L. Taylor, *Death Notices from Freewill Baptist Publications, 1811–1851* (Bowie, Md.: Heritage Books, 1985), p. 61. Young and Taylor differentiated entries, based upon the spelling of the last name as either Chamberlain or Chamberlin. This individual's notice was contained in the Chamberlain section. Of note, according to Donna-Belle Garvin and James L. Garvin, the subject was "the son of Brookfield, NH tavernkeeper Trueworthy

Chamberlin. This portrait shows the son playing a violoncello, or 'church bass,' most likely in the father's tavern hall"; see Garvin and Garvin, *On the Road North of Boston,* p. 13.

83 See also 1840 federal census for Brookfield, N.H.

84 Lynne Zacek Bassett, "Woven Bead Chains of the 1830s," *The Magazine Antiques* 148, no. 6 (December 1995): 797–807.

85 This information was written on a separate piece of paper and attached to the backing board of this painting. It is almost as if the artist were unable to transfer this data to the bottom of the composition, for an undetermined reason.

86 Sanborn, *Genealogy of the Family,* p. 338, entry 764. My thanks to Arthur B. Kern for this citation; see letter to the author, July 2, 2000 (AFAM files).

87 Two different portraits of a William B. Chamberlin were sold at auction in 1986 with this portrait of Sanborn. One clearly descended with her likeness; perhaps the second did as well.

the town of Brookfield lists Chamberlain as the head of his household, with one woman between the ages of twenty and thirty living at home, probably Betsy, and one daughter under the age of five. The portrait subject succeeded her husband in death by two years; she died on August 24, 1844, at the age of only thirty. —C.E.M.

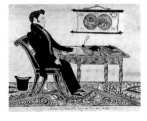

29. JOHN F. DEMERITT
Joseph H. Davis (act. 1832–1837)
Probably Barrington, Strafford County,
New Hampshire
1836
Watercolor, pencil, and ink on paper
9¹¹⁄₁₆ × 11 in. (sight)
P1.2001.33

INSCRIPTIONS:
Recto, bottom margin, ink: *John F. Demeritt. Aged 32 Feby 26, 1836.;* on map: *MAP;* on letter: *December* [?] [illegible]; verso of backing board, typewritten paper label: *From Durgin family, Barrington, N.H. descendants of / J.F. Demeritt, who was a / schoolmaster. Orig. frame & / glass. He married Eliza / Davis in 1845.*

PROVENANCE:
Descended in family to the Misses Durgin (sitter's great-grandnieces), Barrington, N.H.; R.G. Clifton, Franklin, N.H.; Bertram K. and Nina Fletcher Little, Brookline, Mass.; Sotheby's sale 6612, "Little Collection, Part II," 10/94, lot 883.

EXHIBITED:
"The Decorative Arts of New Hampshire, 1725–1825," Currier Gallery of Art, Manchester, N.H., 1964.
"Three New England Watercolor Painters," Art Institute of Chicago, 1974.
"American Folk Painters of Three Centuries," WMAA, 1980.

PUBLISHED:
Lipman, Jean, and Tom Armstrong, eds. *American Folk Painters of Three Centuries.* New York: Hudson Hills Press in association with WMAA, 1980, p. 68.
Little, Nina Fletcher. "Indigenous Painting in New Hampshire." *Antiques* 84, no. 1 (July 1964): 65.
———. "New Light on Joseph H. Davis, 'Left-Hand Painter.'" *Antiques* 98, no. 5 (November 1970): 754.
———. "New Light on Joseph H. Davis, Left-Hand Painter." In Jack T. Ericson, ed. *Folk Art in America: Painting and Sculpture.* New York: Mayflower Books, 1978, p. 1.
Savage, Gail, Norbert H. Savage, and Esther Sparks. *Three New England Watercolor Painters.* Chicago: Art Institute of Chicago, 1974, pp. 28–29.
Spinney, Frank O. "Joseph H. Davis, New Hampshire Artist of the 1830s." *The Magazine Antiques* 44, no. 4 (October 1943): 179.

John F. Demeritt must have been proud of his writing ability, choosing to have Joseph H. Davis portray him in the dramatic act of composing a letter, with one hand holding a quill pen, the other pointing to the text. Paper, an inkwell, another pen, some books, and a bundle of quills with a knife to sharpen them are all included as props that contribute to Demeritt's portrayal as educated and accomplished. The global map hanging on the wall, showing both the western and eastern hemispheres, further suggests that his ambitions transcended the provincial.

According to family tradition, Demeritt worked as a schoolmaster in Barrington, New Hampshire, although contemporary records state that he also farmed.[88] One source indicates that even as late as 1874, the average school year in this town lasted only sixteen weeks.[89] Thus, the sitter could have taught calligraphy, penmanship, or even geography to augment his seasonal agricultural income, a common practice among residents in rural communities. Born on February 26, 1804, John was the son of Andrew and Susan Hill Demeritt of Barrington.[90] During his courtship with his future wife, Eliza Davis (1807–1889), of Durham, New Hampshire, John wrote her a love letter in which he addressed their pending nuptials, stating that he hoped "my person and home be agreeable to you."[91] He and Eliza were married almost a year later on February 20, 1845.[92] The couple lived into their eighties; John F. Demeritt died on May 28, 1887, two years before his wife.[93] —C.E.M.

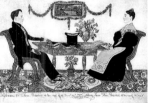

30. SYLVANUS C. FOSS AND
MARY JANE FOSS
Joseph H. Davis (act. 1832–1837)
Probably Strafford, Strafford County,
New Hampshire
1836
Watercolor, pencil, and ink on paper
10¾ × 15 in. (sight)
P1.2001.34

INSCRIPTION:
Recto, ink: *Sylvanus C. Foss. Painted at the age of 17. Decembr 24th; PAINTED / AT / STRAFFORD- / RIDGE. APRIL 13th 1836. Mary Jane Foss. Painted at the age of 21 May 6th.*

PROVENANCE:
Descended in family to James R. Bakker, Littleton, Mass.; Barry Cohen, New York, 1984.

88 See death record for John F. Demeritt, May 28, 1887, in which his occupation is listed as farmer, Bureau of Vital Records, Concord, N.H., and 1850 federal census for Barrington, Strafford County, in which the sitter is identified as a farmer with real estate valued at $1,000. For information pertaining to Barrington, see Hurd, *Rockingham and Strafford Counties*, pp. 607–14.
89 Alonzo J. Fogg, *The Statistics and Gazetteer of New-Hampshire* (Concord, N.H.: D.L. Guernsey, 1874), p. 61. John's brother Samuel M. worked as a teacher in Barrington. For contemporary references to his employment, see Mary C. Emhardt and Louise F. Williams, eds., *Barrington, New Hampshire, 1722–1972* (Barrington, N.H.: Town of Barrington, 1972), p. 45, and Barrington Town Records I & II, microfilm, New Hampshire State Library, Concord. In 1836 Davis also executed a likeness of Samuel (private collection), illustrated in Little, "New Light on Joseph H. Davis," p. 755. Samuel's great-grandchildren, the Misses Durgin, inherited his portrait, that of his brother John, and a rare still-life composition by Davis (former collection Bertram K. and Nina Fletcher Little), illustrated in the catalog for Sotheby's sale 6612 (10/94, lot 885).

90 Demeritt death record, op. cit., and Robert S. Canney, *Early Marriages of Strafford County, New Hampshire, 1630–1850* (Bowie, Md.: Heritage Books, 1991), p. 122.
91 The present location of the letter, dated July 11, 1844, is unknown; see catalog for Sotheby's sale 6612 (10/94), lot 883.
92 Marriage record for John F. Demeritt and Eliza Davis, Feb. 20, 1845, Bureau of Vital Records, Concord, N.H., and Barrington Town Records, I: 822, microfilm, New Hampshire State Library, Concord.
93 Death record for Eliza Demeritt, Sept. 30, 1889, Bureau of Vital Records, Concord, N.H., and Barrington, N.H., Historical Society, *Graveyards of Barrington, New Hampshire* (Barrington, N.H.: Barrington, N.H., Historical Society, 1976), pp. 52, 6A-5.

Joseph H. Davis depicted Sylvanus Cushman Foss and his older sister, Mary Jane, sitting in the parlor of their family home.[94] The artist loved to present his subjects in interior settings, surrounded by prescribed attributes of nineteenth-century refinement that evoke a cultivated appreciation for the fine arts, literature, and horticulture. Seventeen-year-old Sylvanus holds an open book in one hand, as if momentarily interrupted by Davis's visit. He is about to consult an additional source or return it to the pile of volumes strewn across the elaborately decorated, grain-painted table. The music score on the table at the right indicates that at least one of these siblings was musically proficient. In fact, these subjects may have requested the artist to portray them engaged in conversation about the subject of Sylvanus's book, or perhaps singing together as testimony of their pious lives. Cut yellow, blue, and pink flowers carefully arranged in a melon-shaped gray vase on the table, a potted plant with red berries peculiarly stowed beneath the table, and the delicate pink blooms Mary Jane clasps in her hands, while commonly found in Davis's portraits, are further indications of this household's desire to communicate a fondness for nature's beauty. The romantic landscape hanging on the wall, depicting a fisherman leisurely sitting by a stream, with a basket at his side to hold his catch, also contributes to this culturally prescribed visual vocabulary that Davis dutifully included in his clients' pictures.

The children of William and Sally Foss (née Foss), Sylvanus and Mary Jane were residents of Strafford, New Hampshire, a town located approximately thirty miles from Concord, the state capital. Born on December 24, 1819, Sylvanus married Lydia Drew (née Foss) on June 6, 1839.[95] According to the federal census for 1850, the couple lived with his parents in Strafford, where he worked as a farmer, like his father.[96] At this time, the household also included their three children, Melinda (age nine), William (age three), and Sarah (under one year). While Sylvanus lived to be eighty-three, his wife preceded him in death by some fifteen years; she died on November 11, 1887.[97]

Mary Jane Foss, portrayed in this composition at the age of twenty-one, was born in 1815. By 1840 she had married Demeritt Place, a local farmer with strong paternal ties to the locally influential Freewill Baptist Church, the network through which Davis is believed to have secured many of his commissions.[98] Demeritt's father, the Reverend Enoch Place, served as minister of the Freewill Baptist Church in Strafford Corner

from 1822 to 1853.[99] During his tenure, Reverend Place officiated at the marriage of Mary Jane's brother and his bride, indicating that the Fosses also were members of the church.[100] In addition, both Mary Jane and Demeritt probably were congregants, since they received adult baptism by immersion in December 1833, an event that took place, according to one account, "near Huckins bridge."[101]

—C.E.M.

31a–b. CHARLES EDWIN TILTON and GEORGE BAINBRIDGE TILTON
Joseph H. Davis (act. 1832–1837)
Probably Deerfield, Rockingham County, New Hampshire
1837
Watercolor, pencil, and ink on paper
8¹⁄₁₆ × 6⁵⁄₁₆ in. (sight) and 8⅛ × 6⁷⁄₁₆ in. (sight)
P1.2001.35a, b

INSCRIPTIONS:
Charles: recto, ink: *CHARLES-EDWIN TILTON. / JAN'Y. 10th. / —AGED. 3 YEARS & 2 MONTHS. / —1837—*
George: recto, ink: *GEORGE BAINBRIDGE. TILTON. / —1837— / AGED 7 YEARS & 5 MONTHS. JANY 27th.*

PROVENANCE:
Found in Portsmouth, N.H.; William F. Graham; Edgar William and Bernice Chrysler Garbisch, Cambridge, Md.; Sotheby Parke-Bernet sale 3981, "Garbisch Collection, Part II," 4/77, lots 403, 404.

EXHIBITED:
"The All-American Dog: Man's Best Friend in Folk Art," MAFA, 1977/78 (*George* only).
"Small Folk: A Celebration of Childhood in America," MAFA and N-YHS, 1980/81.
"The Toys of New Hampshire's Children, 1800–1900," New Hampshire Historical Society, Concord, 1985/86.

PUBLISHED:
Bishop, Robert. *The All-American Dog: Man's Best Friend in Folk Art.* New York: Avon Books in association with MAFA, 1978, p. 24 (*George* only).
Brant, Sandra, and Elissa Cullman. *Small Folk: A Celebration of Childhood in America.* New York: E.P. Dutton in association with MAFA, 1980, pp. 28, 29.

94 See also the double portrait of William and Polly Foss and the likenesses of Richard B. Foss, Cotton H. Foss, and Harriet T. Foss, all identified in Kern and Kern, "Joseph H. Davis," p. 53, n. 78.

95 Birth record for Sylvanus Cushman Foss and marriage record for S.C. Foss and Lydia Drew Foss, The Church of Jesus Christ of Latter-Day Saints Family Search Internet Genealogy Service, <www.familysearch.com> (accessed February 2000).

96 1850 federal census for Strafford, N.H. See also entries for Sylvanus C. Foss in 1840 and 1860–1870 censuses and 1870 agricultural census for Strafford, contained in [Delmar W. Goodwin], *Strafford, N.H., U.S. Census & Town Tax Records, People, Land, Livestock, Crops, 1790–1880*, vols. 1, 2 (Hanover, N.H.: privately printed, 1990).

97 Robert Sayward Canney, *Early Marriages of Strafford County, New Hampshire, Supplement, 1630–1870* (Bowie, Md.: Heritage Books, 1997), p. 70.

98 1840 federal census for Strafford. See also entries for Demeritt Place in 1850 and the 1850 and 1870–1880 agricultural censuses for Strafford, contained in [Goodwin], *Strafford, N.H.* In the federal census of 1880, Place is listed as a widower, with an unmarried twenty-nine-year-old daughter at home working as a bookkeeper. D. Place appears to have acted as an administrator for his father's church work, as evidenced by entries he submitted on behalf of his father for marriages he had conducted; see Barrington Town Records, I: 788, 805, 807, microfilm, New Hampshire State Library, Concord.

99 "History of Strafford County, New Hampshire … Strafford," in Hurd, *Rockingham and Strafford Counties*, p. 706.

100 Canney, *Early Marriages* (1991), p. 177.

101 Ann Theopold Chaplin, "The Journal of James Tuttle of Barrington, New Hampshire," *New Hampshire Genealogical Record* 12, no. 3 (July 1995): 130.

As if on the way outdoors to play with their toys and pets, Charles Edwin Tilton and his brother George Bainbridge are depicted in complementary compositions. Charles holds a cap in one hand, tipped back as if he is about to put it on. He brandishes a whip in the other hand, with the lash drawn in a beautifully shaped ripple above his head. A master at capturing mischievous behavior in frisky animals or in children, Joseph H. Davis recorded the moment when little Charles has just cracked his whip, frightening a cat who runs away, knocking over a potted plant that now lies in ruins at the boy's feet. Often seen in male portraits, whips were common toys for young boys, presumably for training them to work with horses, a primary means of transportation in the nineteenth century. One account from 1825 documents that at least one parent was rather indulgent of his son's fondness for this toy. The chronicler reported, "We have seen a boy who literally had twenty new whips in one year, and we were present when his father, to comfort him when he was in pain, went out to buy him a *new* whip, though he had two or three scattered about the room."[102]

Preparing to join his brother outdoors, George is about to trade his book for a remarkable kite adorned with a smiling face, which looks out at the viewer. Known as a "plane-surface" kite, this form was made in a rectangular, or rhomboidal, shape—or, as in this instance, a modified rhomboid with a curved top—and equipped with a tail for stabilization. Believed to have been introduced into Western culture by European sailors traveling from Asia, the plane-surface kite also could have derived from Arabian regions, where it existed at least as early as the ninth century A.D.[103]

Biographical information concerning the identity of these two boys is relatively scarce. Charles, who was born in Deerfield, New Hampshire, about 1834, had at least five children with his wife, Jane Rollins, also a native of Deerfield.[104] According to the 1860 federal census, George, who was born about 1830, is listed in the same dwelling, with his wife, Sarah, and their three children. Although Charles is recorded as a farmer in this census, according to his children's birth records he also worked as a shoemaker, or cordwainer, as did George. In 1860 Deerfield, the largest farming town in Rockingham County, with a population of more than two thousand, boasted two large shoe manufactories, where these boys may have worked as men.[105] By 1874 the town's commercial output in shoes and boots numbered 230,000 pairs, valued at $280,000.[106]

—C.E.M.

32. MARY ANTOINETTE LORANIA PIKE
AND SARAH ADELINE PIKE
Joseph H. Davis (act. 1832–1837)
Probably Maine or New Hampshire
1835
Watercolor, pencil, and ink on paper
8½ × 11 in. (sight)
P1.2001.36

INSCRIPTION:
Recto, ink: *Mary Antoinette, Lorania. Pike. / Aged 6 / years & / 9 months / 1835 / Sarah Adeline, Pike. / Aged / 4-years / & 6 / months / 1835*

PROVENANCE:
Ed and Mildred Bohne, Newmanstown, Pa., 1976.

EXHIBITED:
"Small Folk: A Celebration of Childhood in America," MAFA and N-YHS, 1980/81.

PUBLISHED:
Brant, Sandra, and Elissa Cullman. *Small Folk: A Celebration of Childhood in America.* New York: E.P. Dutton in association with MAFA, 1980, p. 156.

Joseph H. Davis portrayed Mary Antoinette Lorania Pike and her sister Sarah Adeline sporting hairstyles and wearing dresses and accessories that were the height of fashion in the 1830s. Referred to as the "Brutus" or "Titus" style, the Pike sisters' short hair, cropped closely at the neck and above the ears, was in vogue for both boys and girls.[107] The large balloon sleeves narrowing tightly at the wrist, the off-the-shoulder necklines framed with decorative lace, the ribbon necklaces—wrapped twice around, with lockets at the end tucked in at the waist—and the three-quarter-length skirts, exposing pantaloons below, are all features stylistically consistent with clothing from 1835, the year this composition was drawn.[108] Pantaloons were first introduced into women's fashions in this country about 1830 by children visiting from Europe.[109] Sarah Hale, editor of *Godey's Lady's Book*, commented that "the fashion went first to children 'til it got familiar to the eyes, and then ladies, little by little, followed after."[110] As if young girls were wearing trousers under their skirts, these undergarments initially were perceived as masculine clothing. According to historian Karin Calvert, contemporaries believed that a girl who wore pants would likely become coarse and wild "like boys," thus threatening her ability to eventually foster refinement and an appreciation for culture in the American home.[111]

102 Maria Edgeworth, *Works of Maria Edgeworth Complete in Thirteen Volumes* (Boston: Samuel H. Parker, 1825), p. 204, as quoted in Jennifer A. Yunginger, *Is She or Isn't He? Identifying Gender in Folk Portraits of Children* (Sandwich, Mass.: Heritage Plantation, 1995), p. 126.

103 Clive Hart, *Kites: An Historical Survey* (New York: Frederick A. Praeger, 1967), pp. 67–68.

104 Birth records for Charles C. Tilton, Jan. 14, 1862, and George B. Tilton, [?], 1858, Bureau of Vital Records, Concord, N.H.

105 A.J. Coolidge and J.B. Mansfield, *History and Description of New England: New Hampshire* (Boston: Austin J. Coolidge, 1860), p. 465, and Hurd, *Rockingham and Strafford*, pp. 164–67.

106 Fogg, *Statistics and Gazetteer*, p. 125.

107 For information pertaining to the androgynous quality of this hairstyle, see Karin Calvert, *Children in the House: The Material Culture of Early Childhood, 1600–1900* (Boston: Northeastern Univ. Press, 1992), p. 102.

108 Estelle Ansley Worrell, *Children's Costume in America, 1607–1910* (New York: Charles Scribner's Sons, 1980), pp. 75–77.

109 Calvert, *Children in the House*, p. 100.

110 "Fashion," *Godey's Lady's Book* 53 (July 1856): 256, as quoted in ibid., p. 100.

111 Calvert, *Children in the House*, p. 100.

Standing facing each other in this highly symmetrical composition, the girls are flanked by potted plants, flying birds, and two pet cats. One proud cat, sitting at the left, has arrived on the scene with its newly won prize, a dead bird, as if the girls would be pleased to receive homage from this mighty hunter. The cat at the right almost appears to scowl, as it enviously eyes the hunter's prey. The two girls share at their own feet a beautiful, ornate dollhouse, large enough to accommodate at least one doll, who seems to await the occupant of a second chair, for whom she has prepared to serve tea. In pre–Civil War America, dolls and dollhouses were relatively rare acquisitions that were given to young girls as part of their informal training in the domestic arts.[112] In addition to cutting and sewing articles of clothing for these little women of fashion, a young girl pretended to participate in household duties by playing with dolls and their accessories, acquiring skills in preparation for becoming a wife and mother.[113]

<div align="right">—C.E.M.</div>

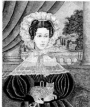

33. MRS. KEYSER
Artist unidentified
Baltimore
c. 1834
Watercolor, gouache, ink, and pencil on paper in original frame covered with embossed paper with traces of gilt
22¾ × 18¼ in. (sight) (34⁷⁄₁₆ × 28⅜ × 1¹³⁄₁₆ in. framed)
P1.2001.37

INSCRIPTION:
Verso, pencil: *Mrs Keyser Dec 7th 1834*[?] *20 N Eu*; printed paper label: *M. BARRETT & BRO.,/ CARVERS & GILDERS,/ NO. 82 Howard Street, Corner Saratoga,/ BALTIMORE,/ MANUFAC-TURERS OF/ LOOKING-GLASS, PORTRAIT AND PICTURE FRAMES, AND/ GILT WORK IN ALL ITS VARIETY,/ ALSO,/ Plain & Fancy Wood Frames,/ AND IMPORTERS OF/ FRENCH & GERMAN LOOKING-GLASS PLATES,/ FINE ENGRAVINGS, & C./ Hedian & O'Brien, Prs., Balto.*

PROVENANCE:
Burton and Kathleen Purmell, New York, 1987.

EXHIBITED:
"Young America: A Folk Art History," MAFA at IBM Gallery of Science and Art, New York, 1986.
"Five-Star Folk Art: One Hundred American Masterpieces," MAFA, 1990.

PUBLISHED:
Bishop, Robert. *Folk Painters of America.* New York: E.P. Dutton, 1979, pl. 53.
Bishop, Robert, and Jacqueline Marx Atkins. *Folk Art in American Life.* New York: Viking Studio Books in association with MAFA, 1995, p. 15.
Johnson, Bruce. *American Cat-alogue: The Cat in American Folk Art.* New York: Avon Books in association with MAFA, 1976, fig. 48.

Lipman, Jean, Elizabeth V. Warren, and Robert Bishop. *Young America: A Folk Art History.* New York: Hudson Hills Press in association with MAFA, 1986, p. 21.
Lipman, Jean, Robert Bishop, Elizabeth V. Warren, and Sharon L. Eisenstat. *Five-Star Folk Art: One Hundred American Masterpieces.* New York: Harry N. Abrams in association with MAFA, 1990, p. 37.

During the early decades of the nineteenth century, the American public was fascinated by a sense of fancy and imagination that came to infuse the decorative arts. This delicate and frothy portrait, executed in opaque and translucent watercolors that create an evanescent beauty, captures the essence of this taste.[114] While the portrait relies upon the conventional composition of column and curtain, with view behind, the multiple transparent layers create an effect of gossamer fragility very different from its stolid oil-on-canvas counterparts. Nevertheless, the watercolor successfully fulfills its function as an identifiable and specific portrait.

Posed against an imaginary riverscape, Mrs. Keyser is composed of a symphony of curvilinear and triangular abstractions. The billowing sleeves play against the curves of her wasp waist. Her refined, oval face is poised on the point of the triangle formed by her shoulders and neck and is framed by the repeating circles of her bonnet. Horizontal elements in her deep bodice—rows of lace on the surface, the dark edge of her neckline beneath—form continuous lines across the picture plane, merging with the windowsill and receding into the viaduct in the distance. A bright tabby cat rests on her lap, held by impossibly small hands, and a ribbon of space appears between her sleeve and waist, reminiscent of the technique employed by Samuel Addison and Ruth Whittier Shute. In fact, *Mrs. Keyser* belongs to the tradition of large-format watercolor portraiture practiced in New England by artists such as the Shutes and Mary B. Tucker (cat. no. 39a–b). The Southern belle in this watercolor, however, appears to be from a wealthier family than many of her New England counterparts, who were frequently young women working in New England textile mills.

The given name of this elegant woman has not been determined, though she is identified as Mrs. Keyser of Eutaw Street in a pencil inscription on the back of the frame. While various members of the Keyser family are listed at addresses on Eutaw Street in Baltimore through 1859, none appears to be a likely candidate as the subject of this watercolor.[115] The framer's label on the back is from M. [Minet or Minnett] Barrett & Bro., carvers and gilders who operated at 82 North Howard Street in Baltimore through 1870.[116]

<div align="right">—S.C.H.</div>

112 Miriam Formanek-Brunell, *Made to Play House: Dolls and the Commercialization of American Girlhood, 1830–1930* (New Haven, Conn.: Yale Univ. Press, 1993), pp. 14–15.
113 My understanding and interpretation of this subject is informed by Formanek-Brunell's study; see, in particular, her chapter entitled "The Politics of Dollhood in Nineteenth-Century America," in ibid., pp. 7–21.
114 The idea of fancy in relation to this portrait is introduced by Sumpter Priddy III, letters to Ralph Esmerian, Feb. 21 and Oct. 12, 1989 (AFAM files).

115 Mary E. Herbert, Maryland Historical Society, Baltimore, e-mail to Tanya Heinrich, MAFA, March 30, 2000 (AFAM files). One candidate for consideration is Mary Ann Manro, who married Charles M. Keyser in 1831; see Rob Schoeberlein, Maryland State Archives, Baltimore, e-mail to the author, May 2, 2000 (AFAM files).
116 Barbara K. Weeks, Maryland Historical Society, letter to Jocelyn Meinhardt, MAFA, March 16, 2000 (AFAM files).

ERASTUS SALISBURY FIELD (1805–1900)

Erastus Salisbury Field was born in Leverett, Massachusetts, in 1805. He and his twin sister, Salome, were named after their parents. Field early demonstrated an artistic talent, and in 1824, at the age of nineteen, he apprenticed in the New York City studio of Samuel F.B. Morse until the sudden death of Morse's young wife in 1825, only three months after Field's arrival. Field returned to Leverett, starting a pattern of patronship among relatives and friends that was to spread throughout western Massachusetts, Connecticut, New York, and Vermont.

In 1831 he married Phebe Gilmur in Ware, Massachusetts—where he later painted Joseph Moore and his family—and a year later their daughter, Henrietta, was born. He continued traveling, as far south as Hartford, New Haven, and New Canaan, Connecticut. Field is considered to have been at the height of his artistic abilities during this period in the 1830s, when his paintings are characterized by quick brushstrokes, a halo effect around the sitter, and modeling achieved through dabs of color. Although he relied on conventions that allowed him to work quickly, the portraits are personal and incisive studies. In 1841 he returned to New York, accompanied by his family. They resided in Greenwich Village, first on Carmine Street and later on Bank Street, and Field is listed in the city directories as a portrait painter until 1843, when he is listed simply as an artist. About the same time, he introduced landscape painting into his repertoire. Field may also have learned the new art of taking daguerreotypes during his second New York sojourn. After his return to New England in 1849, he began using daguerreotypes as the basis for painted portraits, sometimes creating composite compositions from several photographic sources.

Phebe died in 1859, and Field and his daughter moved to Plumtrees, near Leverett. It was here that he built a painting studio and started the series of religious and historical paintings that were to be his major preoccupation for his remaining years. A staunch abolitionist, Field painted biblical scenes of the Hebrews fleeing slavery in Egypt that were undoubtedly intended to convey his objection to slavery in the United States. In 1888 Field completed *The Historical Monument of the American Republic,* a monumental allegorical representation of major chapters and figures in American history, with an emphasis on the Civil War. Shortly before his death in 1900 at the age of ninety-five, Field was remembered as the oldest citizen of Franklin County and an "all-around painter of the old school.... His likenesses of people of past generations are as nearly correct as can well be made in oil."[117]

—S.C.H.

34. PORTRAIT OF A YOUNG MAN (PROBABLY WILLIAM LAURISTON COOK)
Erastus Salisbury Field (1805–1900)
Petersham, Worcester County, Massachusetts
c. 1838–1839
Oil on canvas
29½ × 25¼ in. (sight)
P1.2001.38

PROVENANCE:
Alice M. Kaplan, New York; Dr. William Greenspon, New York; Fred and Kathryn Giampietro, New Haven, Conn.; Sotheby's sale 6392, 1/93, lot 673.

It was not until 1993 that the young man in this portrait was determined to be William Lauriston Cook of Petersham, Massachusetts, whose mother and two aunts were painted by Erastus Salisbury Field between 1838 and 1839.[118] William was the son of Clarissa Gallond Cook and the nephew of Louisa Ellen Gallond Cook and Almira Gallond Moore.[119] Clarissa and Louisa had married two brothers—William and Nathaniel Cook, sons of ship captain Samuel Cook. The portraits of William, Clarissa, and Louisa all share a waterfront view of brick and granite warehouses seen in the distance.[120] William is seated in a rosewood grain-painted chair, with one seemingly disembodied hand draped over the back in a pose that Field relied upon throughout the 1830s. He is dressed in a somber black suit that disappears into the dark background. One shoulder is delineated against a gray column, and his face is thrust into light as it emerges from his white shirtfront, with a deep sweep of red curtain behind.

The harbor view in William's portrait takes a slightly different vantage point than appears in either his mother's or his aunt's paintings. The tree that frames the right side of Clarissa's and Louisa's portraits appears just behind William's head, changing the perspective from a deeper view of warehouses and buildings in the women's portraits to the mostly water view in William's. At the time this portrait was painted, Field was charging $4.00 for a half-length portrait, which he could complete in one day.[121] In her portrait, Clarissa wears a dress and collar that is similar to her sister's, but the collar is clasped with a mourning pin. This may be a reference to Louisa's death in 1838, probably shortly after her own portrait was painted. Field painted the third sister, Almira, around 1839, in a family portrait that includes Louisa's two children flanking their aunt as she sits in her comfortable home with her husband, Joseph Moore, and their own two children, who stand on either side of their father.[122] Mrs. Moore is dressed identically, even in the same jewels, as her sister Louisa was in her portrait.

—S.C.H.

117 Biographical information based primarily on the following three sources: Mary C. Black, *Erastus Salisbury Field, 1805–1900* (Springfield, Mass.: Museum of Fine Arts, 1984), D'Ambrosio and Emans, *Folk Art's Many Faces,* pp. 80–81, and Colleen Cowles Heslip, *Between the Rivers: Itinerant Painters from the Connecticut to the Hudson* (Williamstown, Mass.: Sterling and Francine Clark Art Institute, 1990), pp. 66–75.

118 William was the only male child of the Gallond-Cook unions whose age would have been appropriate for the young man depicted in this portrait. He would have been thirteen or fourteen at the time.

119 The portrait of Louisa is in the collection of Shelburne; see Black, *Erastus Salisbury Field,* p. 78. The portrait of Clarissa was sold at Sotheby's sale 6392 (1/93, lot 672). Because the two portraits are so nearly alike, the identification of the sitter in each continues to be disputed. A large volume of correspondence in Shelburne files documents the process by which its curators

identified the museum's portrait as Louisa. This includes family histories and recollections provided by direct descendants; see Barbara McMurray, Shelburne, letter and curatorial files to the author, June 13, 2000 (AFAM files). When Mary C. Black wrote the definitive monograph on the artist, *Erastus Salisbury Field,* she was still unsure who was depicted in the Shelburne portrait. Further complicating the identification is the portrait pair *Man with a Tune Book: Mr. Cook* (?) and *Woman with Green Book.* They were once identified by Black as Nathaniel Cook and Louisa Gallond Cook; see Black, *Erastus Salisbury Field,* p. 106. In 1992 the portrait was published without an identification but with a note that it could be Clarissa; see Chotner, *American Naive Paintings,* p. 128, n. 5.

120 The harbor view has not been conclusively identified, but it has been conjectured that it is either Hartford or Boston.

121 Rumford, *American Folk Portraits,* p. 95.

122 Collection MFA; see Lipman and Armstrong, *Three Centuries,* p. 76.

Ammi Phillips (1788–1865)

In 1924 a summer fair in Kent, Connecticut, sparked the rediscovery of a major American artist when local residents put several nineteenth-century "ancestor portraits" on display. The strikingly similar canvases depicted graceful women with long slender necks leaning slightly forward within gleaming dark backgrounds and firm men in dark suits, often holding newspapers or books in their hands. The artist, who was then unidentified, was given the appellation "Kent Limner." It was not until 1965 that Barbara and Larry Holdridge, with the support of Mary C. Black, convincingly demonstrated that the Kent Limner portraits were linked to several other disparate bodies of work and that all, in fact, were painted by a single artist—Ammi Phillips—at different points in his career.[123] For more than fifty years, Phillips—whose biblical name fittingly means "my people"—portrayed hundreds, perhaps thousands, of his friends, relatives, and neighbors in New York as far north as Ticonderoga in the Adirondacks, south to Bedford, in Westchester County, and throughout the border areas of Massachusetts, New York, Vermont, and Connecticut.[124]

Phillips was born in Colebrook, Connecticut, in 1788. He was already traveling as an artist by 1809, when he advertised from William Clarke's tavern in Pittsfield, Massachusetts, that he would paint "correct likenesses."[125] Although no portraits are known from this earliest period, the young artist asserted in this and a subsequent ad, placed the following year, that he had extensive experience and would paint his clients with "perfect shadows and elegantly dressed in the prevailing fashions of the day." This promise became a leitmotif of Phillips's work over more than fifty years, from the early romantic portraits of Harriet Leavens and Harriet Campbell—who appear in the guise of fashion plates replete with Chinese silk parasols and reticules—to his last portraits of the 1860s.[126]

When Phillips initially traveled from Connecticut to the Berkshires, he may have been attracted by the presence of a family member, John Ayer, who had purchased land in Egremont, Massachusetts, as early as 1781 and could have introduced the young man to potential customers. Phillips might have been influenced in this formative period by another artist, J. Brown, who, working in Cheshire, Massachusetts, in 1808, painted a portrait of Laura Hall.[127] Clear parallels can be seen between the full-length standing portrait of Laura Hall and Phillips's earliest known efforts, the portraits of Pluma Amelia and Charles Rollin Barstow, painted in 1811.[128]

Phillips married Laura Brockway of Schodack, New York, in 1813 and started a successful pattern of patronage that would continue throughout his life. Unlike many itinerant artists, who traveled a wide radius seeking commissions, Phillips established himself in a community and then painted in the area for a period of years. This permitted a familiarity between artist and client that is evident in portraits that are acute personal studies. The portraits of these years are ethereal in color, large in scale, and minimal in compositional elements. Phillips at this time instituted the compositional convention of males seated with one arm swooping over a chair back.[129] By the 1820s, the portraits were reduced in scale but projected an increased drama through strong color contrasts, a style that was fully realized during the Kent period.

In 1830, shortly after the death of his first wife, Phillips married Jane Ann Caulkins of Northeast, New York, and spent the following years portraying prominent families along both sides of the Hudson River from his home base in Rhinebeck and, later, Amenia, New York. Phillips codified his representations in this period, using conventional motifs and poses for both his own expedience and predictability for his clients. Each portrait, nevertheless, is a fresh and penetrating likeness of a specific individual. Phillips moved back to the Berkshires sometime before 1860 and continued to paint residents of the area until his death. After a career remarkable for its longevity, productivity, and chameleon-like ability to change with the times, Phillips died in 1865, in Curtisville (now Interlaken). Here his obituary in the *Berkshire County Eagle* read simply, "Died at Curtisville, Stockbridge, July 14th, very suddenly, Mr. A. Phillips, aged 78."

—S.C.H.

123 The Holdridges published their premise that Phillips was the Kent Limner and the Border Limner, as well as the artist of additional groups of nineteenth-century portraits, in "Ammi Phillips," *Art in America* 48, no. 2 (summer 1960): 98–103. Here they established that the inscription and artist's signature on the 1840 portrait of George Sunderland was in the style of the Kent Limner, and that the same name was found on early-nineteenth-century portraits in the style of the Border Limner. However, it was not until the exhibition "Ammi Phillips" was presented at the Connecticut Historical Society, in Hartford, November 1965–February 1966, that the artist's development was visually traced. This was expanded in "Ammi Phillips: Portrait Painter, 1788–1865," an exhibition presented by MAFA in 1968.

124 In the checklist of extant works compiled by Howard P. Fertig and published in Stacy C. Hollander and Howard P. Fertig, *Revisiting Ammi Phillips: Fifty Years of American Portraiture* (New York: MAFA, 1994), more than six hundred artworks are cited. Based upon the rate of work indicated by inscriptions and bills of sale, Phillips scholar Mary C. Black estimated the artist probably painted considerably more than this number during his working life.

125 These advertisements in the *Berkshire Reporter* were discovered by Christine Oaklander and published in Eleanor H. Gustafson, "Collectors' Notes," *The Magazine Antiques* 138, no. 4 (October 1990): 662, 698. To date, they are the only known advertisements placed by Phillips.

126 Collections Fogg Art Museum, Harvard University, Cambridge, Mass., and Sterling and Francine Clark Art Institute, Williamstown, Mass., respectively; see Hollander and Fertig, *Revisiting Ammi Phillips*, p. 29.

127 D'Ambrosio and Emans, *Folk Art's Many Faces*, p. 51.

128 Phillips was boarding with Dr. Samuel Barstow in Great Barrington, Mass., when he painted members of the doctor's family. The portrait of Pluma Amelia Barstow is a nascent effort modeled on Brown's portrait of Hall; see Heslip, *Between the Rivers*, p. 55. Phillips continued to develop this format, which reached its culmination in the portraits of Campbell and Leavens. By this time, Phillips had removed any extraneous elements, introduced a subtle floor plane, and developed a masterful command of color and composition.

129 Chotner, *American Naive Paintings*, p. 279, n. 4. In her entry on Phillips, Chotner points out that Brockway's brother Reuben was a furniture maker in Cortland County, N.Y., perhaps heightening the artist's awareness of chair style and decoration from this point forward.

35. GIRL IN RED DRESS WITH CAT AND DOG

Ammi Phillips (1788–1865)
Vicinity of Amenia, Dutchess County, New York
c. 1830–1835
Oil on canvas
30 × 25 in.
P2.1984.1

PROVENANCE:
Charles Wilson Lyons, New York; Leslie and Frances McLaughlin Gill, New York; William Bliss Carnochan, Portola Valley, Calif., 1984.

EXHIBITED:
"The Flowering of American Folk Art, 1776–1876," WMAA, 1974.
"American Folk Painters of Three Centuries," WMAA, 1980.
"Two Centuries of American Folk Painting," Terra Museum of American Art, Chicago, 1985.
"Children in Red by Ammi Phillips," MAFA, 1985/86.
"Young America: A Folk Art History," MAFA at IBM Gallery of Science and Art, New York, 1986.
"Face to Face: M.W. Hopkins and Noah North," Museum of Our National Heritage, Lexington, Mass., 1988/89.
"Expressions of a New Spirit," MAFA, 1989.
"Five-Star Folk Art: One Hundred American Masterpieces," MAFA, 1990.
"Revisiting Ammi Phillips: Fifty Years of American Portraiture," MAFA, 1994.

PUBLISHED:
Bishop, Robert, and Jacqueline Marx Atkins. *Folk Art in American Life.* New York: Viking Studio Books in association with MAFA, 1995, p. 11.
Black, Mary. "Ammi Phillips: The Country Painter's Method." *The Clarion* (winter 1986): 32.
Carnochan, W.B. *Momentary Bliss: An American Memoir.* Palo Alto, Calif.: Stanford Univ. Libraries, 1999, p. 144.
The Clarion (spring/summer 1985): cover.
Hollander, Stacy C. "Revisiting Ammi Phillips." *The Magazine Antiques* 145, no. 2 (February 1994): 273.
Hollander, Stacy C., and Howard P. Fertig. *Revisiting Ammi Phillips: Fifty Years of American Portraiture.* New York: MAFA, 1994, p. 40.
JAMA: The Journal of the American Medical Association (December 15, 1989): cover.
Johnson, Bruce. *American Cat-alogue: The Cat in American Folk Art.* New York: Avon Books in association with MAFA, 1976, fig. 24.
Kogan, Lee, and Barbara Cate. *Treasures of Folk Art: Museum of American Folk Art.* New York: Abbeville Press in association with MAFA, 1994, cover, p. 22.
Lavitt, Wendy. *Animals in American Folk Art.* New York: Alfred A. Knopf, 1990, p. 110.
Lipman, Jean, and Tom Armstrong, eds. *American Folk Painters of Three Centuries.* New York: Hudson Hills Press in association with WMAA, 1980, p. 144.
Lipman, Jean, and Alice Winchester. *The Flowering of American Folk Art, 1776–1876.* New York: Viking Press in association with WMAA, 1974, p. 35.
Lipman, Jean, Elizabeth V. Warren, and Robert Bishop. *Young America: A Folk Art History.* New York: Hudson Hills Press in association with MAFA, 1986, p. 30.
Lipman, Jean, Robert Bishop, Elizabeth V. Warren, and Sharon L. Eisenstat. *Five-Star Folk Art: One Hundred American Masterpieces.* New York: Harry N. Abrams in association with MAFA, 1990, p. 36.

Schaffner, Cynthia V.A. *Discovering American Folk Art.* New York: Harry N. Abrams, 1991, pp. 6–7.
United States 32¢ Postage Stamp, "Four Centuries of American Art," issued 1997/98.
Warren, Elizabeth V., and Stacy C. Hollander. *Expressions of a New Spirit: Highlights from the Permanent Collection of the Museum of American Folk Art.* New York: MAFA, 1989, cover, p. 24.

Ammi Phillips was living and working in Dutchess County, New York, when he painted *Girl in Red Dress with Cat and Dog,* one of four strikingly similar portraits of children he produced. In each painting, the child wears a brilliant red dress over crisply pleated white pantaloons, with red- or black-slippered feet peeping past the sawtooth hem. Their arms cross their bodies in a diagonal parallel arrangement, and they sit with a sweet-faced dog lying by their feet.[130] This, however, is the only portrait in the group that includes a white cat, which the child holds in her arms, rationalizing the otherwise awkward pose.

Three of the portraits depict young girls, each wearing two, three, or four strands of coral beads.[131] Phillips is known to have used similarities of dress and other visual devices to indicate family relationships, but no link has been established among these portraits despite the suggestion that the number of bead strands indicates the child's age.[132] In addition to the cat, which visually centers the composition, the portrait is further set apart from the other three by the exaggerated sweep of the neckline and sleeves that cuts boldly across the canvas in a nearly horizontal plane, counterbalanced by the slope of the skirt edge. The child's delicate neck and bared shoulders, accentuated by the four strands of coral beads, the double row of pleats on the pantaloons, and the lace trim on the sleeves, are indications of the extra care that Phillips lavished on the portrait of this unidentified child.

Girl in Red Dress with Cat and Dog belongs to Phillips's Kent period from about 1829 to 1838, which is defined by the strong contrast of pale faces emerging like jewels from velvety dark backgrounds, heightened bloom in the cheeks, smooth—almost enameled—brushwork, a concentration on the faces of the sitters, and highly geometric treatment of the bodies. The Kent portraits mark a stunning departure from the luminous visions Phillips painted during the romantic years of the teens through the twenties. His mastery as a colorist, honed during those years, is rethought and applied in the new palette of the 1830s. The success of Phillips's essentially mathematical approach to mass, volume, and composition is dependent upon a precise and delicate balance of all the elements. This geometric structure and codified repetitions of format from canvas to canvas combine to create purposeful masterpieces that convey both a sense of individual clarity as well as cultural unity. —S.C.H.

130 Mary Black, "Ammi Phillips: The Country Painter's Method," *The Clarion* (winter 1986): 32–35. There are additional similar portraits, such as *Girl in Pink, James Mairs Salisbury,* and *Mrs. Mayer and Daughter;* see Colleen Cowles Heslip and Charlotte Emans Moore, *A Window into Collecting American Folk Art: The Edward Duff Balken Collection at Princeton* (Princeton, N.J.: Princeton Univ., 1999), p. 59, Hollander and Fertig, *Revisiting Ammi Phillips,* p. 41, and Marshall B. Davidson and Elizabeth Stillinger, *The American Wing at the Metropolitan Museum of Art* (New York: MMA and Alfred A. Knopf, 1985), p. 293, respectively. However, none of these share the exact format of the four under discussion.

131 The fourth portrait was painted in 1834 in Columbia County and depicts Andrew Jackson Ten Broeck at the age of one-and-a-half years; see Black, "Ammi Phillips," p. 34. President Andrew Jackson's young namesake is shown outdoors under a hickory nut tree, with several husks at his feet and one in his hand, a visual play on the president's nickname, "Old Hickory."

He wears a red frock identical to those in the other portraits. When this portrait was painted, young boys wore dresses until about the age of four or five, when they were "breeched." This portrait is signed, indicating the child's gender. However, in unsigned portraits one of the means by which male subjects can be differentiated from females is by hairstyle. Andrew wears his hair combed forward with no part, unlike his female counterparts: each wears her hair parted in the center. In her statistical study of gender in nineteenth-century folk portraits, Jennifer A. Yunginger discovered that boys wore their hair with no part in 45 percent of the 317 portraits analyzed. And when set in exterior views, boys were more likely to be posed in a landscape as opposed to a garden; see Yunginger, *Is She or Isn't He?,* pp. 18, 11–12.

132 Phillips painted four portraits of Sarah Sutherland of Amenia, N.Y., one for each of her four daughters. The portraits are differentiated by the number of circles in the lace on the dress collars.

36a–c. KATHARINE KINTZEL, JOSEPH KINTZEL,
and MARY ANN KINTZEL
The Reading Artist
Berks County, Pennsylvania
c. 1857
Watercolor, pencil, and ink on paper, in original grain-painted pasteboard
frame with modern wood outer frame and glazing
14 1/16 × 11 7/8 in. (*Mrs. Kintzel* and *Mr. Kintzel*) and
14 1/4 × 11 15/16 in. (*Mary Ann*) (framed)
P1.2001.39, 40, 41

INSCRIPTIONS:
Mrs. Kintzel: recto, ink: *Katharine Kintzel*
Mr. Kintzel: recto, bottom margin, ink: *Joseph Kintzel;* on newspaper: *Redinger Adler;* verso of
pasteboard backing, pencil: *Joseph / Kintzel / [?] 54 / 1857.*
Mary Ann: recto, ink: *Mary Ann Kintzel*

PROVENANCE:
Bessie and William Keible, Pennsylvania; Pennypacker sale 5/51, lots 2, 3, 1; Edgar William
and Bernice Chrysler Garbisch, Cambridge, Md.; Sotheby Parke-Bernet sale 4116, "Garbisch
Collection, Part III," 4/78, lots 490, 489, 488.

PUBLISHED:
Spinney, Frank O. "Portrait Gallery of Provincial America." *Art in America* (May 1954): 105
(*Mrs. Kintzel* and *Mr. Kintzel* only).

37. SAHRA REAM
The Reading Artist
Berks County, Pennsylvania
1845
Watercolor, pencil, and ink on paper
9 1/8 × 6 5/8 in.
P1.2001.42

INSCRIPTION (TRANSLATION OF GERMAN):
Recto, ink: *Sahra Ream / 1845 / in the fourth year of life*

PROVENANCE:
Art and Mary Feeman, Jonestown, Pa.; Art Feeman Jr., Jonestown, Pa.; Pennypacker sale 10/81,
lot 632.

More than thirty-five watercolor portraits, primarily executed between 1845 and 1850 in Berks and Lebanon Counties, Pennsylvania, have been attributed to an artist known as the Reading Artist, after the town in Berks County.[133] The subjects, almost all of German heritage, are usually identified in Gothic-style script captions below their portraits, which are outlined with single- or double-ruled ink borders. These inscriptions sometimes give the name of the subject and the year of execution; others actually serve as birth and baptismal certificates and are accompanied by lengthier inscriptions with fuller data. Inscriptions are usually in German and less frequently in English; when in German, the artist's script is based on a broken-letter fraktur style that is often embellished with decorative flourished calligraphy. The subjects themselves are usually depicted full length in interior or exterior views, although a small percentage are shown three-quarter length. When shown seated, the subjects have an awkward relationship with their chairs and appear to slide forward off of them. When depicted standing in a landscape, the subjects have a similarly tenuous relationship with their setting and appear to hover somewhat, particularly when shadows are not indicated at their feet.

Costumes and settings appear somewhat formulaic but are actually quite varied and often apparently representational in detail. Beyond certain repeated stylistic conventions—which include generic diamond-grid patterned walls and floors, drapery swags, window views, columns, cloudy skies, and stippled foliage—there is an attempt to depict a variety of decorated side and rocking chairs, fences, stone walls, and indigenous stone buildings, including houses and churches. In attempting to describe human anatomy, the artist has a proclivity for protruding foreheads, large-pupiled eyes, stiff poses, and clumsily drawn hands. Since two known family groups of portraits by the Reading Artist bear identical grain-painted pasteboard frames, one might expect to find other subjects by this artist framed in the same manner.[134]

The portraits of Joseph and Katharine Kintzel represent, for the most part, the Reading Artist's standard compositional devices; the obvious personalizing prop in Joseph's likeness is the open newspaper, the *Redinger Adler (Reading Eagle).* It has not been determined if this newspaper had particular significance in the subject's life. The portrait of Mary Ann Kintzel represents a somewhat more individualized composition, with stone architecture and a rare prop, a child's squeak toy. The detailed nature of the stone home and the capped stone wall in Sahra Ream's portrait would lead one to believe that it is the artist's effort to capture a real, rather than formulaic, setting. The stippled technique employed to describe foliage is reminiscent of the methods of Jacob Maentel, another artist working in Berks County at the same time (see cat. nos. 8–16a–b).

—D.R.W.

133 An 1845 portrait of David Kistler by this hand (collection Chrysler Museum, Norfolk, Va.,
formerly in the Garbisch Collection), which is inscribed "F. Bischoff pixt I[?]hverish [or
possibly Invenit]," offers only a confusing clue to the actual identity of the artist. There was
a Reading artist named Frederick Christopher Bischoff, but he died in 1834, well before the
portraits in this group were painted. In addition, some other portraits signed by a Bischoff
(collection Historical Society of Berks County, Reading, Pa.) more closely resemble the work
of Jacob Maentel.

134 See the four Hunsicker/Brechbill portraits in D'Ambrosio and Moore, *Folk Art's Many Faces,*
pp. 210–12.

38. COLONEL ISAAC HOTTENSTEIN
The Reading Artist
Vicinity of Kutztown, Berks County, Pennsylvania
c. 1842–1845
Watercolor and ink on paper, mounted on paper
14⅜ × 11 in. (16⅞ × 12⅝ in. with paper backing) (sight)
P1.2001.43

INSCRIPTION:
Recto, ink: *COL: JSAAC s. HOTTENSTEIN / 1st Regiment, 2ons Brigade. 6te Division, Penf. Mil:*

PROVENANCE:
James G. Pennypacker, Reading, Pa.; Pennypacker sale 10/73, lot 187.

EXHIBITED:
"The Pennsylvania Germans: A Celebration of Their Arts, 1683–1850," PMA, 1982/83.

Isaac Hottenstein (1796–1875) was a physician who lived in Shamokin Dam on the west side of the Susquehanna River in Pennsylvania. The son of a physician, he was born at the family homestead in Maxatawny (outside Kutztown) and followed another family tradition by actively participating in the Pennsylvania Militia.[135] In this painting by the Reading Artist, Hottenstein has proudly chosen to be portrayed in his military uniform. Pennsylvania Militia commission books for 1833–1842 list Hottenstein as a lieutenant colonel of the First Regiment, Second Brigade, Sixth Division. The commission books for the years 1842–1845 list him as a colonel.[136] —S.C.H.

39a–b. YOUNG MAN HOLDING A BIBLE and YOUNG WOMAN HOLDING A LETTER AND ROSE
Mary B. Tucker (dates unknown)
Probably Massachusetts
1844
Watercolor, ink, and pencil on paper
21¾ × 16⅝ in. and 22 × 16¾ in.
P1.2001.44a, b

INSCRIPTIONS:
Young Man: recto, bottom right, ink: *Mary B. Tucker. 1844;* on book spine: *Bible;* on open book, left page: *But now commandeth all men every … / to repent Think not to …;* right page: *Blessed are those who hunger and thirst after / []ness for they shall be filled. / [illegible] / For they shall*

PROVENANCE:
Don and Faye Walters, Goshen, Ind., 1985.

A growing number of watercolor portraits can confidently be attributed to Mary B. Tucker, based on a small group of signed and dated examples, of which this portrait of an unidentified man is one.[137] Conjecture about the identity of the artist has placed her in Boston and the Concord-Sudbury area of Massachusetts, but no firm documentation has revealed reliable biographical information.[138] The watercolors fall into two primary groups—profiles and frontal portraits—executed on large-format sheets of paper. This pair exemplifies several conventions typical of the frontal portraits. The figures are placed on a light gray background wash, against which the dark clothes and hair provide a sharp contrast to the lighter elements: white shirt, lace collar and cuffs, letter. In large, glovelike hands, the sitters hold props, which in this case include a Bible, a sprig of flowers, and a letter. Heavy shading along the sides of the noses and below the mouths delineates features, and eyes are clear but empty, seeming to see nothing. The portraits continue a tradition associated with the large-scale, half-length portrait watercolors jointly worked by Samuel Addison and Ruth Whittier Shute, picturing a modest segment of society. —S.C.H.

40. LEARNING THE ABCs
Attributed to Mary B. Tucker (dates unknown)
Probably Massachusetts
c. 1840–1844
Watercolor and pencil on paper
19¼ × 23 in.
P1.2001.45

INSCRIPTION:
Recto, facing pages of book, ink: *Primer / ABCDE / FGHIJ* [backwards] */ KLMNO / [PQ]RST / Y / A BIRD / A NEST*

PROVENANCE:
Skinner sale, 1/75; Mr. and Mrs. Peter H. Tillou, Litchfield, Conn.; Stephen Score, Essex, Mass., 1984.

EXHIBITED:
"Where Liberty Dwells, Nineteenth-Century Art by the American People: Works of Art from the Collection of Mr. and Mrs. Peter Tillou," Albright-Knox Art Gallery, Buffalo, N.Y., 1976.

PUBLISHED:
Tillou, Peter H. *Where Liberty Dwells, Nineteenth-Century Art by the American People: Works of Art from the Collection of Mr. and Mrs. Peter Tillou.* Buffalo, N.Y.: Albright-Knox Art Gallery, 1976, fig. 64.

135 David F. Hottenstein, letter to Ralph Esmerian, 1974 (AFAM files). Isaac's father, Dr. David Hottenstein, served as a brigadier general in the War of 1812 in the Sixth Division of the Pennsylvania Militia; his grandfather was a lieutenant in the Revolutionary War.

136 Biographical information based on Bruce S. Bazelon and Michael J. Winey, Pennsylvania Historical and Museum Commission, Harrisburg, letters to Ralph Esmerian, March 13 and April 3, 1974 (AFAM files), Morton Montgomery, *History of Berks County, Pennsylvania* (Philadelphia: Everts, Peck & Richards, 1886), p. 623, and "A Visit at the Hottensteins'," in *Der Reggeboge (The Rainbow): Quarterly of the Pennsylvania German Society* 8, no. 1 (March 1974): 1–3.

137 In addition to the signed portrait in the Esmerian Collection, five portraits that bear Mary B. Tucker's name are cited in Heslip and Moore, *Window into Collecting,* p. 136, nn. 2, 3.

138 Ibid., p. 136, n. 1. Moore cites speculation by Charles Knowles Bolton of the Boston Athenaeum that Mary Tucker might be the daughter of Nathaniel Tucker and the wife of Rudolph Geyer, of Boston. David A. Schorsch suggests the watercolors were executed in the Concord-Sudbury area of Massachusetts, but without supporting evidence; see Schorsch, *American Folk Art: Selected Examples from the Private Collection of the Late Edith Gregor Halpert* (New York: David A. Schorsch, 1994), p. 27. This information is repeated in Schorsch, *Masterpieces,* p. 56.

Large-scale watercolor portraits attributed to or signed by Mary B. Tucker appealed to some of the most renowned early American folk art collectors, including Edward Duff Balken and Edgar William and Bernice Chrysler Garbisch. In the ensuing decades, sporadic research has yielded little information about the artist, whose personal history remains unknown. A small group of signed and dated watercolors establishes her activity during the 1840s, and there is some evidence that she was working in Massachusetts.[139] This double portrait is among her most decorative efforts, the charm heightened by the inclusion of a straw rattle and illustrated primer held on the children's laps. The composition is more challenging than the artist's typical formats, with the older child's arm reaching behind his sibling's back and the paint-decorated chair that nicely sets off the younger child's white frock. The children's gazes seem more focused and animated than some of their adult counterparts, adding to the appeal of this affectionate portrait. —S.C.H.

short, sharp vertical strokes. One side of the nose is lightly extended from the curve of the brow, with the nostrils indicated by short slashes. The boy holds a bright red book in one hand, and his figure conveys a sense of quiet, his gray skeleton suit contrasting strongly with the plain light background.

Unlike Barney's watercolor portraits, however, which show plain planked floors, the artist who portrayed Master Mitchell placed each of his or her subjects on a densely patterned floor cover. The geometric design in salmon, brown, and green covers the bottom quarter of the watercolor and grounds the boy's vertical figure in the strong horizontal plane. The floor covering is most likely a painted floorcloth or an ingrain carpet, a type of flat-woven reversible carpet that was imported into American cities by the mid-eighteenth century.[143] By the time this watercolor was painted, ingrain carpets were still expensive but available domestically, sharing technology with the woven coverlet industry as it developed.
—S.C.H.

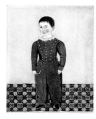

41. JAMES M. MITCHELL
Artist unidentified
Amesbury, Essex County, Massachusetts
c. 1835
Watercolor, gouache, paint, ink, and pencil on paper, mounted on wood backing
8⅞ × 6¹⁵⁄₁₆ in.
P1.2001.46

INSCRIPTION:
Verso, pencil: *James M Mitchell / Amesbury Mass.*

PROVENANCE:
Robert E. Cleaves, Groton, Mass.; Mr. and Mrs. William F. Carr, Chicago; Bert and Gail Savage, Strafford Center, N.H., 1985.

This portrait follows a tradition well established by the 1830s of intimate watercolors that depict standing or sitting figures in settings with colorful, patterned floor coverings.[140] It is one of a small group of watercolors attributed to an unidentified artist, though the work is similar to watercolors by the recently identified Nantucket artist Phebe Fitzgerald Barney (1814–1871).[141] Barney worked on Nantucket during the 1830s, using thin watercolor washes over pencil drawings on off-white paper.[142] Her known watercolors all have wood backboards with secondhand inscriptions, a trait shared by this watercolor of James Mitchell. The child's face is drawn in ink with a fine point and colored overall with a thin layer of white paint; rosy dabs accent his cheeks. The eyebrows are delineated in a distinctive fashion, each in an arc with

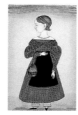

42. YOUNG GIRL IN RED
Justus Dalee (act. 1826–c. 1848)
New York State
c. 1835–1840
Watercolor and pencil on paper
4¾ × 3 in.
P1.2001.47

PROVENANCE:
Frank and Barbara Pollack, Highland Park, Ill.; Barry Cohen, New York; Kate and Joel Kopp, America Hurrah, and David A. Schorsch, New York, 1990.

PUBLISHED:
Schorsch, David A. *The Barry Cohen Collection.* New York: America Hurrah and David A. Schorsch, 1990, p. 65.

Justus Dalee is known for more than eighty-six precise and delicate pencil and watercolor profiles on paper.[144] His movements, primarily throughout New York State, are documented through listings in city directories, signatures on family records and miniature portraits, and his fifty-two-page sketchbook titled *Emblematic Figures, Representations, & to Please the Eye,* in which he calls himself "Professor of Penmanship."[145] Although no biographical information has yet been discovered, these sources indicate that the artist went from Palmyra to Troy by 1830, and by 1832 to Cambridge and West Troy, where he made a family record for Isaac C. Gunnison.[146] In 1835 Dalee executed six miniature portraits of the Gunnison family, each portrayed in profile from the hips up. He expanded this format by the late 1830s, portraying sitters with their

139 The most recent research can be found in the discussion of *Girl in Calico* in Heslip and Moore, *Window into Collecting,* p. 136.

140 Other artists who relied on this formula include J.H. Davis and J. Evans.

141 Other works by this unidentified artist include the portraits of Mary Williams and Master Williams and a portrait of a child in a red dress; see Rumford, *American Folk Portraits,* pp. 261, 262, and Dennis R. Anderson, *Three Hundred Years of American Art in the Chrysler Museum* (Norfolk, Va.: Chrysler Museum, 1975), p. 60, respectively.

142 See the Barney entry by Margaret Moore Booker in Michael A. Jehle, ed., *Picturing Nantucket: An Art History of the Island with Paintings from the Collection of the Nantucket Historical Association* (Nantucket, Mass.: Nantucket Historical Association, 2000), pp. 71–72.

143 Helene Von Rosenstiel, *American Rugs and Carpets from the Seventeenth Century to Modern Times* (New York: William Morrow, 1978), pp. 90–111, 174.

144 Justus Dalee is the subject of ongoing research by Elizabeth V. Warren, consulting curator, AFAM. I would like to express my gratitude for her review of this entry.

145 The sketchbook is in the collection of Walters Art Gallery, Baltimore.

146 Biographical information based on Rumford, *American Folk Portraits,* pp. 77–79, and D'Ambrosio and Emans, *Folk Art's Many Faces,* pp. 56–57. In her entry on *Profile of Man in Black Suit* (N-33.85), Emans cites typewritten notes attached to a portrait miniature of Van Buren Da Lee (collection AARFAM) and two other portraits of members of the "Beauregard family, descendants of the Da Lee and Minten families of New Orleans"; these may suggest that Dalee's origins lie in New Orleans.

heads in profile but their bodies in full frontal view, as in this lovely portrait of a young girl in a colorful red dress.

This portrait is especially appealing because of the daintiness of the child and the clarity of costume and pose, which create a gentle visual rhythm. The black apron with sawtooth border became popular during the latter part of the 1830s, especially worn over a dress in a strongly contrasting color. The zigzag edge is repeated in the small reticule the young girl holds in her hand, as well as in her cuffs, the hem of her pantaloons, and even the shape of one pointed toe. The draped fabric swag on the bodice of her dress is echoed in the gathered beaded necklace and the curve of the bandeau in her hair.

By 1840 Dalee was working in Rochester, which had experienced an economic and population boom after the opening of the Erie Canal in 1825. He is listed the following year in *King's Rochester City Directory and Register* as a "Side Portrait Painter," a fair description of this watercolor. Over the next few years, he is found moving across New York, Massachusetts, Connecticut, and perhaps as far south as New York City, before relocating to Buffalo. There he is listed as a portrait painter for the last time in the 1847–1848 *Commercial Advertiser Directory;* the next volume cites his occupation as "grocer."[147] —S.C.H.

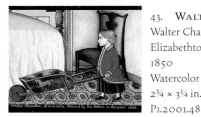

43. WALTER CHANDLER, Æ 21 MONTHS
Walter Chandler (1826–?)
Elizabethtown, Union County, New Jersey
1850
Watercolor and gouache on paper
2¾ × 3¼ in.
P1.2001.48

INSCRIPTIONS:
Recto, paint: *Walter Chandler, Æ 21 months. Painted by his father in the year 1850;* verso, ink: *To / My dear Wife. / This little sketch of our first-born, / a tribute of fondest love and affection, / was painted in Elizabethtown, N. Jersey; / the room being the same, in which / his dear Sister "Maggie" was, soon after, born; / and dear Grandfather subsequently died. / Retouched, Georgetown, D.C., Nov. 1856*

PROVENANCE:
Olenka and Charles Santore, Philadelphia; Sotheby's sale 6075, 10/90, lot 93.

EXHIBITED:
"Small Folk: A Celebration of Childhood in America," MAFA and N-YHS, 1980/81.

PUBLISHED:
Brant, Sandra, and Elissa Cullman. *Small Folk: A Celebration of Childhood in America.* New York: E.P. Dutton in association with MAFA, 1980, p. 134.
Garrett, Elisabeth Donaghy. *At Home: The American Family, 1750–1870.* New York: Harry N. Abrams, 1990, p. 121.
———. "The American Home, Part III: The Bedchamber." *The Magazine Antiques* 123, no. 3 (March 1983): 616.

In his only known work, Walter Chandler sensitively captured the determined expression of his son, also named Walter (1848–1924), as the young child pushes a paint-decorated wooden wheelbarrow across a bedroom floor. The father skillfully accentuates the boy's smallness by surrounding him with what appear to be gigantic pieces of furniture. He is fashionably dressed in a dark blue, pleated skirt and a red jacket. His longish hair appears to be parted in the middle with ringlets at the bottom, a style that was more common in 1860 than when the picture was painted in 1850. The cropped Chippendale chair and Sheraton bedpost were already out of fashion by the time Chandler made this portrait, but the bold and colorfully patterned flat woven rug was popular throughout the century.

The Chandler family resided for many years at 584 Newark Avenue in Elizabethtown, New Jersey, one mile north of the town center. Founded in 1664, Elizabethtown was New Jersey's first permanent community, and it played important roles in the Revolutionary War and the establishment of the new republic. With the introduction of the railroad in 1836, the town experienced tremendous industrial and social changes, which altered its rural character; Elizabethtown became the city of Elizabeth in 1854. The Chandler family was typical of the middle class that settled there, and they enjoyed easy access to schools, churches, the business community, and the railroad system. In the 1850 census, Walter Sr. is identified as a twenty-four-year-old farmer living with his twenty-three-year-old wife, Elizabeth—Walter Jr. is not identified because he was only two years old at the time. The identity of the grandfather referred to on the back of the picture can also be determined from the census; his name was Daniel Chandler, he lived with the family, and he worked as a shoemaker.

As a young man, Walter Jr. lived on Broad Street a few blocks from the railroad station; today, there is a public library on the site. He commuted by train to Manhattan, where he worked as an insurance broker. Eventually, he became manager of Equitable Life Insurance Company, at 120 Broadway, and by 1905 he had moved to New York City. But Walter Jr. maintained strong ties to Elizabeth. In his obituary on the front page of the November 17, 1924, issue of the *Elizabeth Daily Journal,* he was said to have lived in Elizabeth until three years before his death. He was tremendously active in local fraternal organizations, particularly the Masons, for whom he once served as grand master, at the Masonic Grand Lodge of New Jersey. —L.K.

147 D'Ambrosio and Emans, *Folk Art's Many Faces,* p. 57.

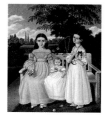

44. THREE CHILDREN IN A LANDSCAPE
Henry Walton (1804–1865)
Finger Lakes region, New York
c. 1838
Oil on canvas
19¼ × 16 in. (sight)
P1.2001.49

INSCRIPTION:
Verso, ink stamp: *PREPARED BY / EDWARD DECHAUX / NEW YORK.*

PROVENANCE:
Frank Ganci, Schooleys Mountain, N.J.; Avis and Rockwell Gardiner, Stamford, Conn., 1985.

EXHIBITED:
"Small Folk: A Celebration of Childhood in America," MAFA and N-YHS, 1980/81.
"Young America: A Folk Art History," MAFA at IBM Gallery of Science and Art, New York, 1986.
"Artist of Ithaca: Henry Walton and His Odyssey," Herbert F. Johnson Museum of Art, Cornell
 University, Ithaca, N.Y., 1988/89.

PUBLISHED:
Brant, Sandra, and Elissa Cullman. *Small Folk: A Celebration of Childhood in America.* New York:
 E.P. Dutton in association with MAFA, 1980, frontispiece, p. 29.
Jones, Leigh Rehner. *Artist of Ithaca: Henry Walton and His Odyssey.* Ithaca, N.Y.: Herbert F.
 Johnson Museum of Art, Cornell Univ., 1988, p. 36.
Lipman, Jean, Elizabeth V. Warren, and Robert Bishop. *Young America: A Folk Art History.* New
 York: Hudson Hills Press in association with MAFA, 1986, p. 20.

Henry Walton captured these three beautiful children in a moment of repose from their play outdoors. Having just picked flowers from the garden, the older sister and her young sibling grasp small posies of delicate blooms while sitting stoically on a white bench. Their sister stands at the right, patiently holding a little kitten in her arms. The ball of yarn unraveled at their feet and a dropped flower convey the immediacy of the scene and the innocent nature of the girls' childish play. Dating from about 1838, this painting portrays the two older girls dressed in gowns with off-the-shoulder necklines, pleated bodices, and sleeves sewn tightly at the tops of their arms, in keeping with costume details of the period. The red coral necklace worn by the young one standing at the right was believed to ward off illness in children.[148]

Nothing is known about these three subjects except that they probably lived in the Finger Lakes region of New York, an area where Henry Walton worked from the late 1830s until about 1850.[149] Born in 1804 in Ballston Spa, New York, Walton descended from New York City's mercantile elite; his grandfather and great-uncle were among the founders of the New York Chamber of Commerce. Once identified by artist John Vanderlyn (1775–1852) as a great "lover of the fine arts," the painter's father, Henry Walton Sr., settled portions of Saratoga County, where he relocated his family, bringing high culture and urban refinement to the unsettled frontier of western New York.[150]

Walton's career as an artist must have resulted, in part, from his father's interest in the fine arts.[151] Beginning in the 1820s, Henry Jr. made etchings and lithographs depicting scenes in Saratoga Springs that were published by printing firms, including Rawdon Clark & Company and Rawdon Wright & Company of Albany and the John and William Pendleton Company of Boston and New York.[152] Land speculation drew Walton in the early 1830s to the Michigan Territory, where he purchased property and resided intermittently throughout his life until his death in 1865 at the age of sixty. During these years, he made trips west to California for gold in the 1850s and east in summers from 1836 until 1851 to execute portraits of local residents and scenes of daily life in northern Pennsylvania, the Finger Lakes region, and the southern tier of New York State.[153]

When in New York, the artist often made Ithaca his center of business, traveling from this venue in search of commissions to towns including Lodi, Dryden, McLean, and Groton. According to one review of his paintings and drawings, published in the *Ithaca Journal* for May 23, 1838, Walton's work, in design and execution, "displayed genius and skill worthy of liberal patronage."[154] Further, his portraits displayed a "beauty of design [that] was only equalled by the neatness and elegance of execution." "In a word," this commentator observed, "his specimens speak for themselves, and they plainly show that he is a master of his profession, and we unhesitatingly say, that Mr. Walton ought to be patronized by every lover and patron of the fine arts."

Besides executing portraits in watercolor on paper or ivory or in oil on canvas, as in this composition, during these years Walton also made a firemen's parade banner depicting Ithaca's Great Fire of 1840, painted town views of Painted Post, New York, and Athens and Troy, Pennsylvania, and continued to work in lithography by generating scenes of Jefferson (now Watkins Glen), Addison, and Elmira, New York, among other subjects.[155]

—C.E.M.

148 Abbey Hansen, "Coral in Children's Portraits: A Charm against the Evil Eye," *The Magazine
 Antiques* 120, no. 6 (December 1981): 1424–31.
149 Unless otherwise noted, biographical information based on Leigh Rehner Jones, *Artist of
 Ithaca: Henry Walton and His Odyssey* (Ithaca, N.Y.: Herbert F. Johnson Museum of Art, Cornell
 Univ., 1988), and Ithaca College Museum of Art, *Henry Walton, Nineteenth-Century American
 Artist* (Ithaca, N.Y.: Ithaca College Museum of Art, 1968).
150 Letters from John Vanderlyn to his nephew John Vanderlyn Jr., dated April 6 and May 21,
 1834, in the Hoes and the Darrow Collections, respectively; transcripts in the archives of the
 Senate House State Historic Site, Kingston, N.Y., as quoted in Jones, *Artist of Ithaca,* p. 6, n. 9.
151 In 1835 and 1836, Henry Sr. installed Vanderlyn's two-thousand-foot canvas entitled *Panorama
 of the Palace and Gardens of Versailles* in a rotunda he built in Saratoga Springs, N.Y., next to his

mineral spring, Flat Rock Spring, a noteworthy tourist attraction; see Jones, *Artist of Ithaca,*
 pp. 7–8, nn. 28, 29.
152 See, for example, *View of the Celebrated Rock Spring at Saratoga,* delineated by Moses Swett
 (c. 1804–1838) and published in Boston by Pendleton, in ibid., p. 16.
153 In all, Walton executed five known works of art while in California, including *William D. Peck,
 Rough and Ready, California; View of Rose's Bar, Yuba County, California, November 1853;* and *View of
 Grass Valley, Nevada Co., Cal., From the N. East Hill, 1857;* see ibid., pp. 75–77.
154 First quoted in Albert W. Force, "H. Walton—Limner, Lithographer, and Map Maker,"
 Antiques 82, no. 3 (March 1962): 284–87.
155 See Jones, *Artist of Ithaca,* p. 39, fig. 34; p. 73, fig. 87; p. 74, figs. 88, 89; p. 67, fig. 77; p. 72, fig. 84;
 and p. 68, fig. 78, respectively.

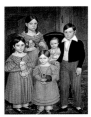

45. THE FARWELL CHILDREN
Attributed to Deacon Robert Peckham (1785–1877)
Fitchburg, Worcester County, Massachusetts
c. 1841
Oil on canvas
52½ × 39½ in.
P1.2001.50

PROVENANCE:
Betty Sterling, Vermont, 1984.

EXHIBITED:
"Small Folk: A Celebration of Childhood in America," MAFA and N-YHS, 1980/81.

PUBLISHED:
Brant, Sandra, and Elissa Cullman. *Small Folk: A Celebration of Childhood in America.* New York:
 E.P. Dutton in association with MAFA, 1980, p. 32.
Garrett, Elisabeth Donaghy. "The American Home, Part I. 'Centre and Circumference': The
 American Domestic Scene in the Age of Enlightenment." *The Magazine Antiques* 123, no. 1
 (January 1983): 214–15.

Victorian America cherished the idea of the nuclear family. Roles were clearly defined, and the sanctum in which the players performed was the home. In this imposing family portrait attributed to Deacon Robert Peckham, the five children of John Thurston and Mersylvia Farwell form a tight group.[156] Each holds a prop appropriate to age and gender—flower, doll, cat—except John Albro, who holds onto the handlebar of the wicker carriage. Baby Mary Jane sits in the carriage at the center of the composition, fingering a locket around her neck, her siblings forming a constellation around her. This may indicate an impetus for the painting commission, as the infant died in 1841, the year this portrait was made.[157] Postmortem portraiture was not uncommon in the nineteenth century, especially as a means to preserve the wholeness of the family unit.

Peckham's long career as an artist spanned from 1809, when he is known to have studied briefly with Ethan Allen Greenwood, through 1850, though his most prolific period was during the 1830s and 1840s, when he painted primarily in Worcester County, Massachusetts.[158] It is not known if Peckham knew the Farwell family, but both he and John Thurston Farwell were deacons of the Congregational Church: Farwell in Fitchburg, where the portrait was painted in his home on Mechanic Street, and Peckham in nearby Westminster, where he served as deacon of the First Congregational Church for fourteen years, beginning in

1828. Peckham's time with Greenwood, the growing influence of photography, and his long years of practice by the time this portrait was painted may account for the competent realism of his depictions, especially of children, and his ability to show spatial relationships.[159]

Peckham was a man concerned with moral and social issues. His home—which he occupied with his first wife, their nine children, and later his second wife—still stands and was a meeting place for the local temperance organization and a station on the Underground Railroad.[160] His outspoken sentiments eventually resulted in his estrangement from his church. He resigned his position in 1842 and was excommunicated by 1850. Peckham and his family moved to Worcester, but in 1862, after Congress passed the Emancipation Proclamation, he returned to Westminster, where he was reinstated in the church. —S.C.H.

156 The children are Elizabeth Mersylvia (1831–?), John Albro (1833–?), Sarah Charlotte Tucker (1835–?), Maria Thurston (1838–?), and Mary Jane (1840–1841). I am grateful to Betsy Hannula, Fitchburg Historical Society and Westminster Historical Society, for sharing information about the Farwell family and Robert Peckham.

157 Elisabeth Donaghy Garrett, "The American Home, Part I. 'Centre and Circumference': The American Domestic Scene in the Age of the Enlightenment," *The Magazine Antiques* 123, no. 1 (January 1983): 214.

158 Biographical information based on Dale T. Johnson, "Deacon Robert Peckham: Delineator of the 'Human Face Divine,'" *The American Art Journal* 11 (January 1979): 27–36.

159 Laura C. Luckey, "The Portraits of Robert Peckham," *The Magazine Antiques* 134, no. 3 (September 1988): 550–57. According to Luckey, signed portraits indicate Peckham had developed a

proficient style at a relatively early date. However, she challenges the attribution of this and related portraits of children in bright interiors, such as *The Hobby Horse* (NGA) and *Rosa Heywood* (AARFAM), to Peckham, whose documented works typically do not include interior details and have plain, somber backgrounds. This group portrait might provide the transition that ties these portraits together, as the interior is in the drab tones associated with Peckham's documented work, while the children are garbed in bright colored clothing, as in the portraits cited.

160 During renovations, the present occupants discovered a small portrait in the house in the style long associated with Peckham's signed paintings.

SHELDON PECK (1797–1868)

The introduction of the daguerreotype about 1840 had dramatic consequences for the art of portrait painting. The majority of Americans, who had relied on local and itinerant artisans, now had the option of a quicker and cheaper method that produced an uncannily accurate likeness. Photography ultimately sounded the death knell for the portraiture that we characterize today as "folk," but in the early years of the daguerreotype, the two methods competed side by side. The impact of photography on the aesthetics of portraiture is clearly seen in the work of Sheldon Peck, who began painting around 1820 in his native Vermont before moving to western New York, in 1828, and then to Illinois, in 1836.[161] Peck's earliest efforts, bust- and waist-length paintings on wood panels, quickly establish his characteristic Spartan approach to portraiture. Sober faces with hard, angular planes, unsoftened by any decorative treatment of dress and furniture, emerge from dark backgrounds in the Vermont portraits. Peck's hallmark use of a rabbit's-paw motif is already established in this first period.

Peck married Harriet Corey (1806–?) in 1824, and by 1828 the couple had moved to Jordan, Onondaga County, where they joined other friends and relatives from Vermont who were relocating to the boom towns along the path of the recently completed Erie Canal. Peck farmed and continued to paint, adding curtains and other details to his generally brighter portraits. In 1836 he suddenly sold his property, and the family left New York for Chicago, where they stayed only briefly, because of the Panic of 1837, before moving to Babcock's Grove (now Lombard), twenty miles west of Chicago.[162] Here Peck reestablished himself as a farmer and painter and also became one of the area's most influential citizens. In 1843 he hired Almeda Jane Powers Dodge to be the community's first schoolmistress, and she operated her "school" from the summer kitchen of the Peck farmhouse. His home was also a station on the Underground Railroad during the Civil War. During these years, Peck may have supported his family primarily through farming, but in 1854 he again set up a studio in Chicago, advertising as an ornamental painter. The 1860 census was the last to include his name, and his occupation is listed as artist. Peck died in 1868, of pneumonia. The house he built in 1839 descended in his family and still stands, the oldest home in Lombard.

—S.C.H.

161 Richard Miller, "Itinerant Artists and Roving Photographers: The Impact of Photography on Folk Portraiture," *Heritage* 3, no. 5 (May/June 1987): n.p. The effects of photography on folk portraiture in general as well as its impact on Peck's work in particular are discussed in this article.

162 This sudden move may have been related to the ad placed in the *Onondaga (N.Y.) Standard,* Nov. 9, 1836: "Be it known to all people, that one Sheldon Peck, and Harriet his wife, not having the fear of God before their eyes, being instigated by the devil, have with malice aforethought most wickedly and maliciously hired, flattered, bribed or persuaded my wife Emeline, to leave me without just cause or provocation. It is supposed that said Peck has carried her to some part of the state of Illinois. This is therefore to forbid all persons harboring or trusting my wife Emeline, for I will pay no debts of her contracting. Hezekiah Gunn." Biographical information based on Marianne E. Balazs, "Sheldon Peck," *The Magazine Antiques* 108, no. 2 (August 1975): 273–84, and Richard Miller, "Six Illinois Portraits Attributed to Sheldon Peck," *The Magazine Antiques* 126, no. 3 (September 1984): 614–17.

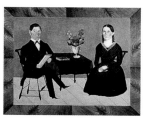

46. **DAVID AND CATHERINE STOLP CRANE**
Sheldon Peck (1797–1868)
Aurora, Kane County, Illinois
c. 1845
Oil on canvas
35¹¹⁄₁₆ × 43⅝ in.
P1.2001.51

INSCRIPTION:
Recto, on newspaper, paint: *COURRIER.*

PROVENANCE:
Mr. and Mrs. William E. Wiltshire III, Richmond, 1979.

EXHIBITED:
"The Flowering of American Folk Art, 1776–1876," WMAA, 1974.
"Sheldon Peck," WMAA, 1975.
"American Folk Painters of Three Centuries," WMAA, 1980.
"Five-Star Folk Art: One Hundred American Masterpieces," MAFA, 1990.

PUBLISHED:
Balazs, Marianne E. "Sheldon Peck." *The Magazine Antiques* 108, no. 2 (August 1975): 279.
Bishop, Robert. *Folk Painters of America.* New York: E.P. Dutton, 1979, p. 186.
Lipman, Jean, and Tom Armstrong, eds. *American Folk Painters of Three Centuries.* New York: Hudson Hills Press in association with WMAA, 1980, p. 138.
Lipman, Jean, Robert Bishop, Elizabeth V. Warren, and Sharon L. Eisenstat. *Five-Star Folk Art: One Hundred American Masterpieces.* New York: Harry N. Abrams in association with MAFA, 1990, p. 43.
Miller, Richard. "Itinerant Artists and Roving Photographers: The Impact of Photography on Folk Portraiture." *Heritage* 3, no. 5 (May/June 1987): n.p.
Woodward, Richard B. *American Folk Painting: Selections from the Collection of Mr. and Mrs. William E. Wiltshire III.* Richmond: Virginia Museum, 1977, pl. 41.

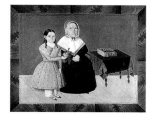

47. **ANNA GOULD CRANE AND GRANDDAUGHTER JANETTE**
Sheldon Peck (1797–1868)
Aurora, Kane County, Illinois
c. 1845
Oil on canvas
35½ × 45½ in.
P1.2001.52

INSCRIPTION:
Recto, on book, paint: *Bible*

PROVENANCE:
Mr. and Mrs. Peter H. Tillou, Litchfield, Conn.; Stephen Score, Essex, Mass., 1985.

EXHIBITED:
"Nineteenth-Century Folk Painting, Our Spirited National Heritage: Works of Art from the Collection of Mr. and Mrs. Peter Tillou," The William Benton Museum of Art, University of Connecticut, Storrs, 1973.
"The Flowering of American Folk Art, 1776–1876," WMAA, 1974.
"Sheldon Peck," WMAA, 1975.
"American Folk Painters of Three Centuries," WMAA, 1980.
"Small Folk: A Celebration of Childhood in America," MAFA and N-YHS, 1980/81.
"Young America: A Folk Art History," MAFA at IBM Gallery of Science and Art, New York, 1986.

PUBLISHED:
Balazs, Marianne E. "Sheldon Peck." *The Magazine Antiques* 108, no. 2 (August 1975): 284.
Brant, Sandra, and Elissa Cullman. *Small Folk: A Celebration of Childhood in America.* New York: E.P. Dutton in association with MAFA, 1980, p. 90.

Lipman, Jean, and Tom Armstrong, eds. *American Folk Painters of Three Centuries.* New York:
 Hudson Hills Press in association with WMAA, 1980, p. 137.

Lipman, Jean, and Helen M. Franc. *Bright Stars: American Painting and Sculpture since 1776.* New York:
 E.P. Dutton, 1976, p. 39.

Lipman, Jean, and Alice Winchester. *The Flowering of American Folk Art, 1776–1876.* New York:
 Viking Press in association with WMAA, 1974, p. 46.

Lipman, Jean, Elizabeth V. Warren, and Robert Bishop. *Young America: A Folk Art History.* New York:
 Hudson Hills Press in association with MAFA, 1986, p. 34.

Tillou, Peter H. *Nineteenth-Century Folk Painting, Our Spirited National Heritage: Works of Art from the
 Collection of Mr. and Mrs. Peter Tillou.* Storrs, Conn.: William Benton Museum of Art, Univ. of
 Connecticut, 1973, fig. 74.

Tobler, Jay, ed. *The American Art Book.* London: Phaidon Press, 1999, p. 338.

The two portraits of members of the Crane family of Aurora illustrate the radical change that affected Sheldon Peck's portraiture in Illinois. Probably to compete against photography and the advantages it offered, Peck introduced a brighter palette and a format of full-length figures set within a stagelike three-dimensional interior. This set quality is deepened by the diagonal floorboards and careful placement of figures, which read almost as silhouettes against a plain backdrop. The interiors have just a few well-chosen props—a baize cloth–covered table, an urn of flowers, a Bible—and in their conventionalized staging are reminiscent of photographers' studios.

David Crane (1806–1849) and his wife, Catherine Stolp Crane (1814–1889), were originally from Pultneyville, New York, which in 1860 had about 450 inhabitants.[163] They were among the many western New York families that migrated to Illinois during the 1830s, attracted by the promise of plentiful and fertile soil. According to a history of Kane County, "Among the early pioneers who arrived in this vicinity in 1835–6–7 the following names are prominent: Isaac Van Fleet, John Peter Scheider . . . Frederick Stolp . . . David Crane"[164]

Frederick Stolp was David Crane's father-in-law. In 1833 he walked from Pultneyville, New York, to Illinois, staked a land claim in an area known as Big Woods, and returned to Pultneyville to retrieve his family. They traveled to Illinois in a wagon in 1834, the year Aurora was first settled, accompanied by his oldest child, Catherine; David Crane, whom she had married in 1832; and their infant son, Frederick.[165]

Janette Wilhelmina (1840–1861) was the Cranes' fourth child, named after her maternal grandmother. She is portrayed with her father's mother, Anna Gould Crane (1774–?), about whom little is known. According to notes in the family Bible, which is prominently displayed on the table, their portrait was painted on a linen sheet provided by the family and paid for with the trade of one cow. The trompe-l'oeil frame on both portraits is a feature that Peck devised in Illinois. There is some evidence that he experimented with faux graining in his earlier periods of production.[166] —S.C.H.

163 J.H. French, *Gazetteer of the State of New York* (Syracuse, N.Y.: R. Pearsall Smith, 1860), p. 694.

164 Dennis Buck, Aurora Historical Society, e-mail to the author, June 21, 2000 (AFAM files).
 This information is contained in R. Waite Joslyn and Frank W. Joslyn, *History of Kane County,
 Illinois,* vol. 1 (Chicago: Pioneer Publishing, 1908).

165 Buck, e-mail to the author.

166 In two small portraits on wood panel that are attributed to Sheldon Peck, the painting on the
 bodies of the subjects continues onto the rabbet of the frame, and there is some grain painting
 on the face of the frames. These paintings are purported to depict members of the Van Vechten
 family of Greene County, N.Y.; see Lee Kogan's entry in Hollander, *American Anthem,* cat. nos.
 44a–b.

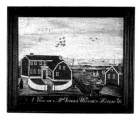

48. A VIEW OF MR. JOSHUA WINSOR'S HOUSE & C.
Rufus Hathaway (1770–1822)
Duxbury, Plymouth County, Massachusetts
1793–1795
Oil on canvas, in original painted wood frame
23¼ × 27½ in. (28 × 32³⁄₁₆ × 2 in. framed)
P1.2001.53

INSCRIPTION:
Recto, bottom, paint: *A View of Mr. JOSHUA WINSOR'S House & c.;* on boat: *RISING SUN*

PROVENANCE:
Descended in family to Mrs. F. Herbert Winsor; New England Historic Genealogical Society, Boston; Stephen Score, Essex, Mass., 1982.

EXHIBITED:
"American Folk Painting in Connection with the Massachusetts Tercentenary Celebration," The Harvard Society for Contemporary Art, Cambridge, Mass., 1930.
"Paintings by New England Provincial Artists, 1775–1800," MFA, 1976.
"American Folk Painters of Three Centuries," WMAA, 1980.
"Young America: A Folk Art History," MAFA at IBM Gallery of Science and Art, New York, 1986.
"Dr. Rufus Hathaway: Artist and Physician, 1770–1822," Art Complex Museum, Duxbury, Mass., 1987.
"Five-Star Folk Art: One Hundred American Masterpieces," MAFA, 1990.

PUBLISHED:
Bishop, Robert. *Folk Painters of America.* New York: E.P. Dutton, 1979, pl. 6.
Bishop, Robert, and Jacqueline Marx Atkins. *Folk Art in American Life.* New York: Viking Studio Books in association with MAFA, 1995, p. 60.
Lipman, Jean, and Tom Armstrong, eds. *American Folk Painters of Three Centuries.* New York: Hudson Hills Press in association with WMAA, 1980, p. 39.
Lipman, Jean, Elizabeth V. Warren, and Robert Bishop. *Young America: A Folk Art History.* New York: Hudson Hills Press in association with MAFA, 1986, p. 18.
Little, Nina Fletcher. *Country Arts in Early American Homes.* New York: E.P. Dutton, 1975, p. 46.
———. "Doctor Rufus Hathaway, Physician and Painter of Duxbury, Massachusetts, 1770–1822." *Art in America* 41, no. 3 (summer 1953): 114.
———. *Paintings by New England Provincial Artists, 1775–1800.* Boston: Leether Press in association with MFA, 1976, pl. 14.
Valentine, Lanci. *Rufus Hathaway: Artist and Physician, 1770–1822.* Duxbury, Mass.: Art Complex Museum, 1987, p. 55.
Valentine, Lanci, and Nina Fletcher Little. "Rufus Hathaway, Artist and Physician." *The Magazine Antiques* 131, no. 3 (March 1987): 640.

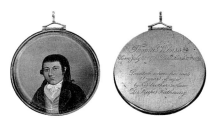

49a–b. THOMAS WINSOR MINIATURE
Rufus Hathaway (1770–1822)
Duxbury, Plymouth County, Massachusetts
1797
Oil on ivory, in gold locket
2⅜ in. diam.
P1.2001.54

INSCRIPTION:
Verso, engraved: *Thomas Winsor / born July 22d 1780. Died March 12th 1832. / Painted when he was / 17 years of age / by his brother-in-law / Dr. Rufus Hathaway*

PROVENANCE:
Bertam K. and Nina Fletcher Little, Brookline, Mass.; Stephen Score, Essex, Mass.; Virginia Cave, New York, 1997.

EXHIBITED:
"American Folk Painters of Three Centuries," WMAA, 1980.
"Dr. Rufus Hathaway: Artist and Physician, 1770–1822," Art Complex Museum, Duxbury, Mass., 1987.

PUBLISHED:
Lipman, Jean, and Tom Armstrong, eds. *American Folk Painters of Three Centuries.* New York: Hudson Hills Press in association with WMAA, 1980, p. 38.
Little, Nina Fletcher. *Little by Little: Six Decades of Collecting American Decorative Arts.* New York: E.P. Dutton, 1984, p. 134.
Valentine, Lanci. *Rufus Hathaway: Artist and Physician, 1770–1822.* Duxbury, Mass.: Art Complex Museum, 1987, p. 69.
Valentine, Lanci, and Nina Fletcher Little. "Rufus Hathaway, Artist and Physician." *The Magazine Antiques* 131, no. 3 (March 1987): 638.

Joshua Winsor was one of the most influential citizens of Duxbury, Massachusetts. With his brother, Nathaniel, Ezra Weston Sr., and Samuel Delano, he was instrumental in establishing the city as a shipbuilding center after the Revolutionary War.[1] By 1787 sixty-four Great Banks fishing vessels were in commission, and Joshua and Nathaniel were successfully engaged in mackerel and cod fishing. The Winsor wharves were the first to be built in Duxbury specifically for business. Rufus Hathaway portrayed Joshua's home, wharves, and warehouses for drying and storing salted fish in 1793 or 1795. These structures represented just part of the extensive properties owned by the Winsor family in the Snug Harbor area.

Hathaway included many anecdotal details in his informative painting of the busy bay: Joshua Winsor himself, holding the keys to his storehouses; a large black dog on the doorstep of his impressive home; a fishing vessel named *Rising Sun;* and an amusing note of a figure felling geese that are flying overhead. The original home, dating to about 1768, was a small wooden gambrel-roofed building, typical of

1 Ann Learnard Bowman, "Joshua Winsor," in Duxbury Rural and Historical Society, *The Duxbury Book, 1637–1987* (Duxbury, Mass.: Duxbury Rural and Historical Society, 1987), n.p.

the houses—eight of which still stand—that sheltered members of the Winsor family.[2] A new main house, built during the prosperous years when the Duxbury fishing industry flourished, featured an impressive pedimented doorway.

Because of its size and central location, visitors to the town sometimes stayed in the Winsor home. One guest may have been Rufus Hathaway, who rode into Duxbury in 1793, when he painted at least ten portraits, six of them for the family of Ezra Weston.[3] He may have portrayed Joshua Winsor and his wife at this time as well. Hathaway was born in Freetown, Massachusetts, and was probably painting professionally by 1790, when he is documented in Taunton by the dated portrait of Molly Wales Fobes.[4] In 1795 the artist returned to Duxbury to portray Winsor's daughters, one of whom, Judith, he married later that year. Soon after his marriage, Hathaway became a physician, possibly at the prompting of his father-in-law. Although his primary occupation became medicine, Hathaway continued to paint occasionally until 1808, making and painting his own frames; the miniature on ivory of his seventeen-year-old brother-in-law, Thomas, was painted in 1797. In 1822 Hathaway was made an honorary fellow of the Massachusetts Medical Society, and it is as a physician that he is remembered on his headstone, in an epitaph that he himself may have composed.[5]

—S.C.H.

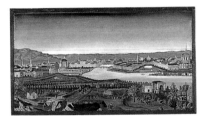

50. SCENIC OVERMANTEL
Winthrop Chandler (1747–1790)
Petersham, Worcester County, Massachusetts
c. 1780
Oil on pine panel with beveled edges
29¼ × 47¼ × 1½ in.
P1.2001.55

PROVENANCE:
Descended in John Chandler family, Petersham, Mass.; Lippett and Bennett families, Petersham, Mass.; Mr. and Mrs. J. Robert Moore, Massachusetts; Skinner sale 1274, 10/89, lot 300.

EXHIBITED:
"The Flowering of American Folk Art, 1776–1876," WMAA, 1974.

PUBLISHED:
Lipman, Jean, and Alice Winchester. *The Flowering of American Folk Art, 1776–1876*. New York: Viking Press in association with WMAA, 1974, p. 195.
Little, Nina Fletcher. "Winthrop Chandler, Limner of Windham County, Connecticut." *Art in America* 35, no. 2 (April 1947): 89, 157–58.

Architectural elements such as overmantels provided some of the earliest formats in America for painted landscapes. Often these painted panels were set directly into the woodwork over a mantel; other times they were painted on a separate panel and then hung on the wall. This overmantel was painted by Winthrop Chandler for his cousin John Chandler (1742–1794), a wealthy merchant in Petersham, Massachusetts, and mounted above the fireplace in the upper northwest parlor of the home, which was built in 1764. The overmantel descended in situ until the mid-nineteenth century, when it was removed and sold.

Winthrop Chandler came from a large family with deep roots in Connecticut and Massachusetts. The Massachusetts branch of the family was made up of notorious Tories, and tradition maintained that this overmantel portrayed London Bridge and the surrounding area before the Great Fire of 1666. However, Nina Fletcher Little later established that it is more likely a romanticized view of Florence, seen from San Miniato.[6] Judging by its architectural inaccuracies, the overmantel may have been painted from a map or plan of the city rather than a published print.

This is one of at least eight overmantels painted by Chandler, who is better known for his imposing portraits of family relations and friends in Connecticut and Massachusetts.[7] Many are fanciful scenes that nevertheless show typical New England architecture and landscapes. Houses are usually painted in bright colors and window frames and corner boards outlined in white, a treatment seen in this example.

There is some evidence that Chandler may have studied painting as an apprentice in Boston before returning to Connecticut after 1770, when he painted Reverend and Mrs. Ebenezer Devotion.[8] He married in 1772 and had seven children. Despite a small inheritance, he experienced financial difficulties throughout his adult life, often working as a house and ornamental painter to supplement his income. He died destitute at Chandler Hill, the family farm in Woodstock, Connecticut. —S.C.H.

2 Alexandra B. Earle, "Shipping Era Houses," in ibid., p. 82; see also Earle, Duxbury Rural and Historical Society, letter to the author, Aug. 26, 1996 (AFAM files).

3 Biographical information about Rufus Hathaway primarily based on Lanci Valentine and Nina Fletcher Little, "Rufus Hathaway, Artist and Physician," *The Magazine Antiques* 131, no. 3 (March 1987): 628–41.

4 Collection MMA. It is Hathaway's earliest known portrait and is also known as *Lady with Pets*; see Jean Lipman and Tom Armstrong, eds., *American Folk Painters of Three Centuries* (New York: Hudson Hills Press in association with WMAA, 1980), p. 37.

5 "Thousands of journeys night and day / I've traveled weary on my way to heal the sick, but now I'm gone / A journey never to return," Mayflower Cemetery, Duxbury, Mass.

6 Nina Fletcher Little, "Winthrop Chandler, Limner of Windham County, Connecticut," *Art in America* 35, no. 2 (April 1947): 75–168.

7 Chandler's best-known portraits include those of his brother and sister-in-law, Captain Samuel and Anna Chandler; see Deborah Chotner, *American Naive Paintings* (Washington, D.C.: NGA, 1992), pp. 66, 67.

8 Collection Brookline Historical Society, Mass.; Nina Fletcher Little, "Winthrop Chandler, 1747–1790," in Lipman and Armstrong, *Three Centuries*, p. 26.

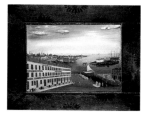

51. FIREBOARD WITH VIEW OF BOSTON HARBOR

Artist unidentified
Massachusetts
c. 1825–1835
Oil on pine panel, in original painted wood frame
27¼ × 32¾ × 1 in. (framed)
P1.2001.56

INSCRIPTIONS:
Recto, on building, paint: *CONCERT HALL / PAINTING; W. BROWN. / [?] GOODS & C. / D. WESTON. / HARD-WARE- / F. GRIMES & CO. / BROKERS. / BANK.;* on pallet: *AUGUST* [?]; lower right: *J.P. J* [?]

PROVENANCE:
Phillip Budrose, Marblehead, Mass.; Scott Bartlett, Greenwich, Conn., 1984.

EXHIBITED:
"American Folk Art," Mead Art Building, Amherst College, Amherst, Mass., 1974.
"Two Centuries of American Folk Painting," Terra Museum of American Art, Chicago, 1985.

PUBLISHED:
Amherst College. *American Folk Art.* Amherst, Mass.: Amherst College, 1974, fig. 26.

Fireboards were placed in front of fireplaces during summer months, when they were not in use. As the fireplace was often the central focus in a room, the fireboard that blocked the hearth occupied a prominent position that warranted decorative treatment. The most common painted depictions were vases of flowers, but occasionally, as in overmantels, a landscape view would adorn the panel. This fireboard remains in its original enframement, which is decorated in a subtle pattern of rayed demilunes.[9]

The fireboard itself features a view of Boston Harbor seen from the vicinity of what was then Fort Point Channel, facing the waterfront. India Wharf is in the foreground, and Long Wharf lies beyond. The buildings on the hill above are the Park Street Church and the Boston State House. The island at the right is probably Governor's Island, with its battery on the shore.[10] The businesses named on the pier have not been positively identified, although the Boston directories for 1825 list a Daniel F. Weston at "Whiting and Weston, oil, glass, and paints."[11]

—S.C.H.

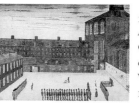

52. CHARLESTOWN PRISON

Artist unidentified
Charlestown (now Boston area)
c. 1851
Watercolor, pencil, and ink on paper
15½ × 20½ in. (sight)
P1.2001.57

PROVENANCE:
Edith Gregor Halpert, New York; Sotheby's sale 5622, 10/87, lot 190.

EXHIBITED:
The Detroit Institute of Arts, 1935.
"Federal Writers," Washington, D.C., 1936.
"Masterpieces in American Folk Art," The Downtown Gallery, New York, 1941.
"Inter-American Folk Art," The Downtown Gallery, New York, 1942.
"The Edith Gregor Halpert Collection," The Corcoran Gallery of Art, Washington, D.C., 1960.
"American Roots," The Downtown Gallery, New York, 1962.
"A Gallery Survey of American Art," The Downtown Gallery, New York, 1965.
"Early American Paintings and Sculpture," Time & Life Exhibition Center, New York, in association with MAFA, 1966.
"The Flowering of American Folk Art, 1776–1876," WMAA, 1974.
"A Place for Us: Vernacular Architecture in American Folk Art," MAFA, 1996/97.

PUBLISHED:
Black, Mary, and Jean Lipman. *American Folk Painting.* New York: Clarkson N. Potter, 1966, p. 113.
Lipman, Jean. *American Primitive Paintings.* New York: Oxford Univ. Press, 1942, fig. 62.
Lipman, Jean, and Alice Winchester. *The Flowering of American Folk Art, 1776–1876.* New York: Viking Press in association with WMAA, 1974, p. 52.
"The Passing Shows." *Art News* 40, no. 2 (March 1–14): 31.

In 1785 Castle Island in Boston Harbor was designated as a site to receive prisoners. It was not until 1804–1805 that a secure state prison was built on five acres in the Lynde's Point section of Charlestown, under the direction of Edward H. Robbins, Charles Bulfinch, and Jonathan Hunnewell. Holding ninety cells, its cruciform plan included a central building surmounted by a cupola with an alarm bell and two four-story wings.[12] Originally hailed as a model plan, within its first few years the Massachusetts State Prison in Charlestown became notorious for its cruel and abusive conditions. For the first sixty years of its operation, inmates wore uniforms that were half blue and half red, with painted caps. A yellow stripe was added for repeat offenders, and convicts were tattooed before being released into the community.[13] The cells were barely large enough to hold a cot and had neither a window nor plumbing. Prisoners received a bucket for waste, which they emptied once each day during their hour of free time. The main activity of the inmate workforce was stonecutting, though there were also shops for a variety of other productions, including cabinetmaking and tinsmithing.

Reforms were instituted in 1829, when the Auburn system, which advocated complete silence and the separation of prisoners at night, was introduced. When this system, too, proved to have unfortunate consequences, modifications were adopted and included some forward-looking

9 Portland, Maine, artist Charles Codman is known to have worked in Boston and to have painted several fireboards with scenic views and decorated enframements. On Oct. 29, 1822, he advertised in the *Portland Eastern Argus* that he would make "fire boards, from historical, military or marine designs." See Tracie Felker, "Charles Codman: Early Nineteenth-Century Artisan and Artist," *The American Art Journal* 22, no. 2 (summer 1990): 61–86.

10 Nina Fletcher Little, letter to Scott Bartlett, Jan. 6, 1965 (AFAM files).

11 Robyn Christensen, The Bostonian Society, e-mail to the author, May 4, 2000 (AFAM files).

12 Gideon Haynes, *An Historical Sketch of the Massachusetts State Prison with Narratives and Incidents, and Suggestions on Discipline* (Boston: Lee and Shepard, 1872), pp. 14–16. Haynes was the prison warden.

13 Information provided by Theresa A. Francisco, Boston Public Library, Charlestown Branch, from the Reverend Wolcott Cutler Collection.

programs such as the establishment of a Sabbath school to teach the Bible and basic reading, writing, and arithmetic and the allotment of separate garden plots for prisoners' use.[14]

The prison was expanded three times; between 1850 and 1851 the latest addition, an octagonal granite structure designed by architect Gridley J. Fox Bryant, increased its capacity to 750 prisoners.[15] The prison was condemned in 1878 but reopened six years later. It finally closed in 1956. It is not known by or for whom this watercolor was painted; it is one of at least three views of the prison made at different times after the addition of the octagonal tower.[16]　　　—S.C.H.

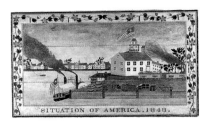

53.　SITUATION OF AMERICA, 1848.
Artist unidentified
New York
1848
Oil on wood panel
34 × 57 × 1⅜ in.
P1.2001.58

INSCRIPTIONS:
Recto, bottom margin, paint: *SITUATION OF AMERICA, 1848.*; on paddlewheel: *SUN.*

PROVENANCE:
John H. Martin, Woodstock, Vt.; Peggy Schorsch, Greenwich, Conn., 1984.

EXHIBITED:
"The Flowering of American Folk Art, 1776–1876," WMAA, 1974.
"Young America: A Folk Art History," MAFA at IBM Gallery of Science and Art, New York, 1986.
"Five-Star Folk Art: One Hundred American Masterpieces," MAFA, 1990.
"A Place for Us: Vernacular Architecture in American Folk Art," MAFA, 1996/97.

PUBLISHED:
Kogan, Lee, and Barbara Cate. *Treasures of Folk Art: Museum of American Folk Art.* New York: Abbeville Press in association with MAFA, 1994, p. 60.
Lipman, Jean, Elizabeth V. Warren, and Robert Bishop. *Young America: A Folk Art History.* New York: Hudson Hills Press in association with MAFA, 1986, pp. 90–91.
Lipman, Jean, and Alice Winchester. *The Flowering of American Folk Art, 1776–1876.* New York: Viking Press in association with WMAA, 1974, p. 192.
Lipman, Jean, Robert Bishop, Elizabeth V. Warren, and Sharon L. Eisenstat. *Five-Star Folk Art: One Hundred American Masterpieces.* New York: Harry N. Abrams in association with MAFA, 1990, p. 67.
Schaffner, Cynthia V.A. *Discovering American Folk Art.* New York: Harry N. Abrams, 1991, pp. 40–41.
Warren, Elizabeth V. "Young America: A Folk Art History." *The Magazine Antiques* 130, no. 3 (September 1986): 467.

Early landscapes and architectural depictions were usually painted on interior architectural elements such as overmantels and fireboards. These forms provided an ornamental focus to the fireplace, one of the most important features of early American homes. Overmantels typically were painted directly on plaster or wood paneling that covered the chimney, but they occasionally appeared on canvas. This late example continues the tradition of architectural depictions on overmantels and draws its inspiration from engraved and published town views that had become popular by this time. It shows the New York City skyline of closely clustered buildings as viewed from Brooklyn, across the East River. Billows of smoke issue from the paddlewheeler *Sun* (built in 1836 with New York as its home port) and the freight train on the wharf, emphasizing the strong ties between economic growth—which had been spurred by shipping on the Erie Canal and overland rail transport—and architectural development. The dome of City Hall appears disproportionately large behind the prominent warehouse situated on the Brooklyn dock. According to an earlier published source, *Situation of America* was removed from the Squire Phillips home in Brookhaven, Long Island, New York, but this home has not been identified and the information has not been documented.[17]　　　—S.C.H.

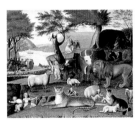

54.　THE PEACEABLE KINGDOM
Edward Hicks (1780–1849)
Newtown, Bucks County, Pennsylvania
1846–1848
Oil on canvas
26 × 29⅜ in.
P1.2001.59

PROVENANCE:
Amos Willets; Robert R. Willets; Mabel Willets Abendroth; William P. Abendroth Jr.; Kennedy Galleries, New York; Raphael Esmerian, 1976.

EXHIBITED:
"Masters of Popular Painting," Museum of Modern Art, New York, 1938.
"In Celebration: Works of Art from the Collections of Princeton Alumni and Friends of the Art Museum," Princeton University Art Museum, Princeton, N.J., 1997.
"Millennial Dreams: Vision and Prophecy in American Folk Art," MAFA, 1999/2000.

PUBLISHED:
Bishop, Robert. *Folk Painters of America.* New York: E.P. Dutton, 1979, pl. 32.
Bishop, Robert, and Jacqueline Marx Atkins. *Folk Art in American Life.* New York: Viking Studio Books in association with MAFA, 1995, p. 40.
Bishop, Robert, and Patricia Coblentz. *American Decorative Arts: 360 Years of Creative Design.* New York: Harry N. Abrams, 1982, p. 216.
Dewhurst, C. Kurt, Betty MacDowell, and Marsha MacDowell. *Religious Folk Art in America: Reflections of Faith.* New York: E.P. Dutton in association with MAFA, 1983, cover.
Kogan, Lee, and Barbara Cate. *Treasures of Folk Art: Museum of American Folk Art.* New York: Abbeville Press in association with MAFA, 1994, p. 101.

14　Orlando F. Lewis, *The Development of American Prisons and Prison Customs, 1776–1845* (Montclair, N.J.: Patterson Smith, 1967), p. 161.
15　Robert B. Mackay, Society for the Preservation of Long Island Antiquities, Cold Spring Harbor, New York, letter to David A. Schorsch, March 1, 1989 (AFAM files).
16　A similar watercolor is illustrated in David A. Schorsch, *Excellence in American Design* (New York: David A. Schorsch, 1991), p. 30. Both were originally ascribed an earlier date of c. 1820, but the inclusion of the octagonal structure determines that the watercolors could not have been painted before 1851. A third version in oil on canvas was painted by C.H. Golder and illustrated

in Monmouth Museum, *Masterpieces of American Folk Art* (Lincroft, N.J.: Monmouth Museum in association with Monmouth County Historical Association, 1975), n.p. This painting is later than the watercolors and shows the prison after it received extensive renovations. In addition to reflecting architectural changes, formal gardens replace the area in the yard where prisoners were marched for inspection. In response to the bird's-eye perspective popular in late-nineteenth-century views, the line of sight has shifted from a low perspective to a high elevation.
17　Jean Lipman and Alice Winchester, *The Flowering of American Folk Art, 1776–1876* (New York: Viking Press in association with WMAA, 1974), p. 192.

Mather, Eleanore Price, and Dorothy Canning Miller. *Edward Hicks: His Peaceable Kingdoms and Other Paintings.* Newark, Del.: Univ. of Delaware Press, 1983, p. 147.

Weekley, Carolyn J. *The Kingdoms of Edward Hicks.* New York: Harry N. Abrams in association with Colonial Williamsburg Foundation, 1999, pp. 147 (detail), 148.

Wertkin, Gerard C. "Millennial Dreams: Vision and Prophecy in American Folk Art." *Folk Art* 24, no. 3 (fall 1999): 45.

Edward Hicks, of Bucks County, Pennsylvania, created this version of *The Peaceable Kingdom* late in his career and near the end of his life.[18] Trained as an ornamental painter in one of the area's many carriage and coach making shops, Hicks began painting easel pictures soon after his apprenticeship was completed in 1801. Two years later he joined the Quaker Middletown Monthly Meeting and married Sarah Worstall, a member of the same meeting.

By 1811 Hicks had purchased a house in Newtown, and near it he opened his ornamental painting business. His primary occupation was decorating coaches, carriages, and other horse-drawn vehicles, although fire buckets, furniture, and a variety of utilitarian wares also were ornamented in his shop. About 1816 to 1818, Hicks began to paint a series of pictures featuring the peaceable kingdom described in the Old Testament book of Isaiah (11:6–9).[19] Sixty-two versions of *The Peaceable Kingdom* by Hicks have been identified to date, although the actual number he completed may have been considerably larger. He probably initiated the pictures in response to criticism he had received from a few Newtown Quakers who felt some of his ornamental work was too fancy and in conflict with the Friends' codes of simplicity and plainness.

The Isaiah prophecy seemed especially suitable for Quaker consumption since it embraced the concept of earthly creatures, having denied self-will for God's will, living in harmony and unity. By the late 1820s, Hicks combined the prophecy message with meanings associated with the four medieval humors represented by the lion, leopard, wolf, and bear.[20] The artist also began to use the *Kingdom* to reflect the disunity and lack of harmony raging among Quakers who, by 1827, divided the Society into two distinct groups: the Hicksites, named after Hicks's elderly cousin Elias Hicks, who maintained allegiance to early Quaker codes and practices, and the Orthodox, who wanted to formalize certain aspects of worship and practice through written materials and other "orthodox" means.

By the 1840s, when this exceptional *Kingdom* picture was painted, Hicks was well aware of the problems facing a divided Society and the strong likelihood that he would not see its members reunited. The overall composition differs significantly from earlier versions in its almost square format and in the dispersal of the animals throughout much of the landscape—they are no longer gathered closely together. Hicks may have been symbolizing the further divisions occurring among both the Orthodox and the Hicksite Friends. Similarly, the facial expressions of

the lion and leopard lack the fierceness and energy seen in Hicks's early versions, especially those created in the 1830s.

The vignette of Penn's Treaty with the Indians is common to many of the *Kingdom* pictures. Hicks and other Quakers viewed this historic event as an important example of living in harmony. The children at the lower left not only have their hands near serpents' holes in the bank but one youngster is handling a serpent. Hicks occasionally brought greater visual clarity to phrases contained in Isaiah's prophecy, in this case the "child shall put his hand on the cockatrice' den." —C.J.W.

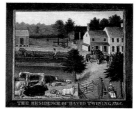

55. THE RESIDENCE OF
DAVID TWINING 1785.
Edward Hicks (1780–1849)
Newtown, Bucks County, Pennsylvania
1846
Oil on canvas, in original wood frame with paint and gold leaf
26⅛ × 29¾ in. (30½ × 35⅞ × 1⅜ in. framed)
P1.2001.60

INSCRIPTION:
Frame, recto, paint and gold leaf: *THE RESIDENCE OF DAVID TWINING 1785.*

PROVENANCE:
Leonardo L. Beans; Sotheby Parke-Bernet sale 4479M, 11/80, lot 22; Andy Williams; Sotheby's sale 7025, 10/97, lot 32.

EXHIBITED:
"Edward Hicks, 1780–1849," AARFAC, 1960.

PUBLISHED:

Mather, Eleanore Price, and Dorothy Canning Miller. *Edward Hicks: His Peaceable Kingdoms and Other Paintings.* Newark, Del.: Univ. of Delaware Press, 1983, p. 193.

Weekley, Carolyn J. *The Kingdoms of Edward Hicks.* New York: Harry N. Abrams in association with Colonial Williamsburg Foundation, 1999, p. 208.

There are four known versions of *The Residence of David Twining* painted by Edward Hicks. All of them were probably painted during the last decade of the artist's life, when he created several other farm scenes, landscapes, and pastorals.[21] Two of the Twining farm pictures were painted for members of the family; the earliest owners of this example and one other are unknown. Soon after the artist's mother died, Isaac Hicks, his father, arranged to board Edward with the Twinings, in 1783. Hicks probably drew the farmhouse and outbuildings from life, while the people and animals and some of the landscape features are shown as he remembered them from childhood.

The Twinings were well-to-do members of the Religious Society of Friends, or Quakers, and lived just outside Newtown. Hicks wrote fondly about his life with this family. In each of the four versions, Hicks

18 Biographical information based on Carolyn J. Weekley, *The Kingdoms of Edward Hicks* (New York: Harry N. Abrams in association with Colonial Williamsburg Foundation, 1999).

19 Isaiah's prophecy reads, "The wolf also shall dwell with the lamb, and the leopard shall lie down with the kid; and the calf and the young lion and the fatling together; and a little child shall lead them. And the cow and the bear shall feed; their young ones shall lie down together; and the lion shall eat straw like the ox. And the sucking child shall play on the hole of the asp, and the weaned child shall put his hand on the cockatrice' den. They shall not hurt nor destroy in all my holy mountain: for the earth shall be full of the knowledge of the LORD, as the waters cover the sea."

20 For more information, see Edward Hicks, *Memoirs of the Life and Religious Labors of Edward Hicks, Late of Newtown, Bucks County, Pennsylvania. Written by Himself* (Philadelphia: Merrihew & Thompson, 1851).

21 Various dates in the mid-to-late 1840s have been assigned to this painting in the past. However, an inscription on the back of the canvas dating it to 1846 was visible in the 1950s: "PAINTED BY EDW. HICKS IN HIS 67 Yr." A photograph of the inscription is contained in the AARFAM archives.

drew himself standing at the knee of Elizabeth Twining, the elderly woman sitting in a chair and reading the Bible. Other persons shown in the painting include David Twining, who stands near the livestock pen, his daughter Mary (on horseback), and her future husband, Jessie Leedom (mounting a horse). The farmhand plowing the field at left has not been identified.

Hicks remained at the farm until he turned thirteen and was apprenticed by his father to William and Henry Tomlinson, coach and carriage makers in Langhorne, Pennsylvania. The Twinings' youngest daughter, Beulah, took over the operation of the farm following her father's death in 1791. She continued to manage the property until her death in 1826. She was a close friend and supporter of Hicks and his family.

Hicks often titled his pictures either on the verso of the canvas or with a more formal title on the lower or upper member of the frame. The 1785 date refers to the year depicted in the scene. One other version carries the same year, while the third example has a 1787 date. No title or date appears on the fourth known version. Each of the four Twining farm scenes is different and has a distinctive arrangement of animals and people. These views probably are accurate renderings of the farm buildings and landscape features, although their orderly environments, including the lineup of pigs in graduated sizes, are features that Hicks intentionally idealized.[22] —C.J.W.

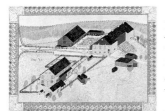

56. FARMSTEAD OF JACOB S. HUNSECKER
Charles H. Wolf (dates unknown)
Southeastern Pennsylvania
c. 1860–1875
Watercolor and ink on paper
23⅞ × 31¾ in.
P1.2001.61

INSCRIPTIONS:
Recto, bottom right, ink: *Drawed by Chas. H. Wolf;* on barn: *Built by / C.G. A. Horst / 1847*

PROVENANCE:
Sotheby Parke-Bernet sale 5215, 6/84, lot 171.

EXHIBITED:
"A Place for Us: Vernacular Architecture in American Folk Art," MAFA, 1996/97.

As folk artists sought to record the landscapes of their experiences, they frequently devised individual solutions to the depiction of realistic linear perspectives and spatial relationships, often with idiosyncratic results. Little is known of the artist Charles Wolf who signed this work, but he achieved spatial perspective in the farmscape by placing buildings in a precise 45° isometric grid.[23] While the effect is oddly distant, suggesting an aerial vantage point that leaves the observer somewhat

disoriented by its stilted positioning, this drawing of a nineteenth-century Pennsylvania farm provides a great deal of information about the layout and character of early farm buildings in the region.

The number and variety of domestic and work structures included in the drawing suggest a successful and prosperous farm operation. As the domestic production of bricks for building increased throughout southeastern Pennsylvania, prices fell, and by the first quarter of the nineteenth century a larger number of prosperous farmers within both the English and the Germanic communities of the state began to prefer the use of brick in farm architecture. Sturdy and handsome, a stylish brick residence or a large brick-end bank barn, such as those depicted in this drawing, became a new symbol of success and stability within many traditional farming communities.

The relatively standard size and shape of red clay brick enabled a number of decorative applications within the bricklaying methods of common or Flemish bond courses. Earlier Swedish and English Quaker domestic architecture in Pennsylvania and New Jersey often utilized decorative glazed headers—or the short side of the brick—interspersed in the exterior end wall to produce ornamental patterns, initials, and dates. During the first half of the nineteenth century, the increased use of brick in barn construction inspired the brick-end bank barn, with decoratively spaced pierced patterns providing ornament as well as ventilation and light. These pierced patterns, produced by the local brick masons, were usually arranged along the diagonal stepped joints of the walls' successive courses and consisted of imaginative configurations of diamonds, pinwheels, triangles, and, in some cases, figures, initials, and dates. —J.L.L.

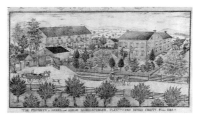

57. THE PROPERTY OF DANIEL AND SARAH LEIBELSPERGER
Ferdinand A. Brader (1833–after 1895)
Fleetwood, Berks County, Pennsylvania
1882
Pencil on paper
30⅝ × 51³⁄₁₆ in. (sight)
P1.2001.62

INSCRIPTION:
Recto, pencil: *THE PROPERTY of DANIEL and SARAH LEIBELSPERGER, FLEETWOOD BERKS COUNTY, PENNA: 1882!*

22 Biographical information based on Weekley, *Kingdoms of Edward Hicks.*

23 A similar, unsigned drawing arranged on such a grid perspective and found near Pottsville, Pa., is in the M. and M. Karolik Collection, MFA; see Lipman and Winchester, *Flowering of American Folk Art,* p. 5.

PROVENANCE:
Mary Lesher, Lancaster, Pa.; Pennypacker sale 6/75, lot 307; Chris A. Machmer, Annville, Pa., 1975.

EXHIBITED:
"A Place for Us: Vernacular Architecture in American Folk Art," MAFA, 1996/97.

This detailed pencil drawing depicting a prosperous, late-nineteenth-century Pennsylvania German farmstead is typical of the work of Swiss immigrant Ferdinand A. Brader, an itinerant artist who traveled throughout Berks, Lebanon, and Lancaster Counties in Pennsylvania and later in eastern Ohio. While best known for his hundreds of carefully rendered farmstead pictures, he is also known to have recorded scenes of local rural industries, such as grist mills, potteries, mines, and quarries. Based upon the inscriptions and dates included in most of the surviving farm landscapes, Brader's most active period in Pennsylvania was from 1880 to 1883, and his travels suggest that late in 1883 he continued westward to Ohio.[24]

Daniel Leibelsperger Jr. was a member of a prominent fifth-generation Berks County family of farmers and orchardmen. He married Sarah Barndt in about 1870, and census records indicate that by 1880 the couple had three children, Liebelsperger's father, and two servants living with them. The senior Liebelsperger, also a farmer, is recorded earlier as living in Fleetwood, and it is possible that the farm depicted in this drawing was originally his property, which he passed on to his eldest surviving son when he became widowed and elderly.[25]

Commissioning a visual record of a successful farm and residence was apparently a popular demonstration of pride. Several are listed in surviving inventories for farms in the Berks County area.[26] Brader's depiction of this farm, its numerous outbuildings, and the surrounding orderly fenced yards, orchards, and distant fields suggests the relative prosperity that established farming families such as the Leibelspergers enjoyed. The architectural details recorded are relatively accurate and include the typical large bank barn with its center ramp, forebay, multiple stables, and numerous traditional painted "hex" signs adorning its upper exterior walls. The main residence dates to the early nineteenth century and appears contemporary in date to the adjacent building to the rear containing a summer kitchen with a bake oven attached to the exterior.

—J.L.L.

58. HOMESTEAD OF JACOB H. LANDIS
Jacob Stauffer (1808–1880)
Lancaster County, Pennsylvania
1879
Watercolor and ink on paper
9⅝ × 13⅜ in.
P1.2001.63

INSCRIPTION:
Recto, ink: *Homestead of Jacob H. Landis, / From a sketch taken by Jacob Stauffer, July 17, 1879, during a visit, in company with Dr. S.S. Rathvon, / and enjoyed the kind hospitality of their host and his family. Presented in commemoration of that / day by the humble delin*[eat]*or, not as a matter of skill or beauty— but as a token of fond memories. / July 22, 1879, aged* [crossed out] *in his 71 year of age, Lancaster, Pa.*

PROVENANCE:
Ed and Mildred Bohne, Newmanstown, Pa., 1970.

PUBLISHED:
Bishop, Robert. *Folk Painters of America.* New York: E.P. Dutton, 1979, pl. 38.

Hand-rendered floral, still-life, and landscape drawings were often created as thank-you gifts or tokens of esteem to mark special events or acknowledge cherished friends, and this practice grew in popularity during the Victorian period. This personalized drawing depicts the artist and his travel companion in conversation with their host on the front porch of the host's main residence. It also records the remarkable late-eighteenth- and early-nineteenth-century residences and farm buildings that still stand along Pennsylvania State Route 999 near the present town limits of Lancaster.

As the turnpike system expanded into the farming communities and agrarian townships of southeastern Pennsylvania, the locations of roads often influenced the layout and configuration of farm buildings, residences, and entire townscapes. Some roads were laid out to accommodate—but preserve—existing residences or farm buildings, while new farms were often located near the roadside to facilitate better marketing and transport of farm goods and supplies. Jacob Stauffer's drawing records the farm of Jacob H. Landis which was situated along such a roadway.

Stauffer was a general storekeeper, artist, printer, pharmacist, lawyer, amateur botanist, and daguerreotypist whose multiple business enterprises placed him in a position of prominence and notoriety in the town of Richland (now Mount Joy), in Lancaster County. He later moved to Lancaster and was appointed librarian of the Lancaster Athenaeum. He married Eliza Ryder in 1833, and the two formed an amazing alliance of equality for the period, keeping diaries and a daily account of their joint activities, which included experimenting in animal husbandry and new methods of orchard keeping, running a grist mill, brick making, house construction, and extensive horseback travels to visit family, friends, and colleagues. This heartfelt drawing probably records one such visit.

—J.L.L.

24 Brader typically inscribed his works with the name of the property's owner, the date, and, in many cases, its number in the chronology of his completed works. The highest number recorded among his surviving Ohio drawings suggests he completed as many as 980 works. One signature, on a drawing of the almshouse in Ravenna, Ohio, records the artist's birthday as Dec. 7, 1833, while another, depicting the property of John and Mary Troxell of Berks County, Pa., documents his origins: it is signed "Ferdinand A. Brader of Switzerland 1882." See Beulah B. Fehr and M. Theodore Mason Jr., "Ferdinand A. Brader: Itinerant Folk Artist," *Historical Review of Berks County* 52, no. 1 (winter 1986/87): 18–39.

25 This pattern of inheritance, with the main farm or valuable real estate passing to the eldest son, was common among Pennsylvania German families. The style of the main farmhouse and several of the outbuilding details also suggest that these buildings existed before the younger Leibelsperger's marriage date and may, therefore, have been part of his parents' farm.

26 Fehr and Mason, "Ferdinand A. Brader," p. 19. This observation is also supported by the number of surviving farm views produced by Brader and other artists in the area during the late nineteenth century.

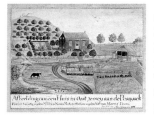

59. NEW JERSEY LANDSCAPE
Peter Oudenaarde (dates unknown)
New Jersey
1786
Watercolor, ink, and pencil on paper
8 × 10¼ in. (sight)
P1.2001.64

INSCRIPTION (TRANSLATION OF DUTCH):
Recto, ink: *A representation of a house in East Jersey on the Passaic River twenty miles northwest of New York and sixteen miles northeast of Morristown. Drawn by Peter Oudenaarde 1786*

PROVENANCE:
Sotheby's sale 6392, 1/93, lot 704.

EXHIBITED:
"A Place for Us: Vernacular Architecture in American Folk Art," MAFA, 1996/97.

The lengthy inscription on this watercolor pinpoints, with fair accuracy, the area of New Jersey where this Dutch farmstead—and those of many other Dutch families—once stood. Today, it would be situated roughly in Wayne, New Jersey, an area known as Preakness in the eighteenth century. This is now part of Passaic County but in 1786 would have been the western edge of Bergen County.[27] The Dutch in New Jersey established farms along rivers and creeks, using the flats for their architecture. Areas of settlement included eastern Passaic County and parts of nearby Morris and Essex Counties.[28]

As seen in this watercolor, small garden plots were planted close to the farmhouses, with the orchard, here precisely drawn with shade and shadows, placed high on the hillside. By the time this watercolor was made, the influence of English architecture had already been felt in these areas, and the most distinctively Dutch characteristic of this farmhouse is the double Dutch door. Utilitarian buildings were less responsive to change. The hay barrack to the right, for example, is a form that remains in common use in the Netherlands today. The peaked roof could be raised and lowered by a jack on poles according to the amount of hay being stored.[29] The wagon, too, is a typical Dutch type visually recorded as early as 1733 in the overmantel depicting the Van Bergen farm.[30] The farm's tidy appearance and fertile crops support observations made during the Revolutionary War by French officers, who noted that the region was "populated by Dutchmen who seem very prosperous. The land is well cultivated and yields abundant harvests."[31] —S.C.H.

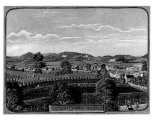

60. WERNERSVILLE, TAKEN FROM THE NORTH-SIDE
Charles C. Hofmann (1821–1882)
Berks County, Pennsylvania
1879
Oil on zinc-plated tin
25½ × 33½ in. (sight)
P1.2001.65

INSCRIPTIONS:
Recto, bottom center, paint: *Wernersville, taken from the north-side, Sept. 4th 1879.*; bottom left: *Chs. Hofman Painter.*

PROVENANCE:
Descended in family to Paul Knorr, Wernersville, Pa.; Earl A. Bare, Wernersville, Pa.; H. William Koch, Turbotville, Pa.; Pook & Pook, Downington, Pa., sale 6/99, lot 276.

What little is known of the itinerant folk painter Charles Hofmann suggests he was consumed by attempts to reconcile his artistic urges and personal hopes with recurrent emotional demons. His bright, carefully executed records of the local architecture and landscape of Berks County belie his life in and out of institutions for the indigent and destitute. Hofmann is best known for his numerous paintings executed between 1865 and 1882 of the Berks County almshouse near Reading, where he periodically committed himself after bouts of heavy alcohol consumption. He was commissioned to paint views for members of the facility's staff and may have used the income to finance his periodic releases, which lasted until the next episode of intemperance necessitated his return. Hofmann's views of the institution's buildings and grounds present a desirable image of a pristine, ordered, and secure environment, free from turmoil and discomfort. In reality, the almshouse was a place of despair, insanity, and desperation.[32]

Hofmann is known to have produced only a few landscape views unrelated to the almshouse pictures. This view of Wernersville, a small, thriving town west of Reading about eight miles from the Berks County almshouse, is one of the largest and most ambitious. It is one of three paintings commissioned from Hofmann in 1879 by John B. Knorr, a prominent Wernersville undertaker and cabinetmaker.[33] Knorr was appointed that year by the institution's governing board to be clerk of the almshouse, and in that post he undoubtedly became acquainted with Hofmann's paintings and skills.

In this painting, the artist's typical idealized order can be seen. Patterned productive fields, green hills, thriving animals and crops, and the pristine maintenance of streets and buildings are set before the Knorr family, who are placed in the foreground dressed in their best finery. Penn Avenue, the main street of the town and the location of the Knorrs' home, runs across the painting, and the steeple of Hains Church, their

27 James L. Kochan, Morristown National Historical Park, letter to Heidi Wilkinson, Sotheby's, Dec. 2, 1992 (AFAM files).

28 Roderic H. Blackburn and Ruth Piwonka, *Remembrance of Patria: Dutch Arts and Culture in Colonial America, 1609–1776* (Albany, N.Y.: Albany Institute of History and Art, 1988), p. 118.

29 Ibid.

30 Collection NYSHA; see ibid., pp. 120–21.

31 Kochan letter.

32 For the most comprehensive and scholarly examination of Hofmann's career and motivations, see Thomas N. Armstrong III, *Pennsylvania Almshouse Painters* (Williamsburg, Va.: Colonial Williamsburg Foundation, 1968).

33 The Knorrs also commissioned Hofmann to paint a picture of their home and Hains Church. See notes by Earl A. Bare, n.d. (AFAM files).

place of worship, can been seen near the center of the composition. On the hillsides above the town, Hofmann included several of the resorts and health sanatoriums of South Mountain, completing an idyllic image he hoped would please his patron. —J.L.L.

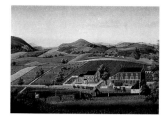

61. BERKS COUNTY FARMSCAPE
John Rasmussen (1828–1895)
Berks County, Pennsylvania
c. 1879–1886
Oil on zinc-plated tin
26⅜ × 35⅜ in.
P1.2001.66

INSCRIPTION:
Recto, bottom left, paint: *J. Rasmussen*

PROVENANCE:
Mr. and Mrs. William E. Wiltshire III, Richmond, 1979.

PUBLISHED:
Bishop, Robert. *Folk Painters of America.* New York: E.P. Dutton, 1979, p. 133.

This crisp view of a prosperous Berks County farmstead, with its pristine, fenced fields, clean, swept yards, and brightly painted buildings, presents an idyllic picture of agrarian life. The controlled environment extends from rolling fields into the distant hills and adjoining farm, with a network of interlacing fields illustrating the cadence and cycle of seasonal crop production, harvest, grazing meadows, and freshly plowed land lying fallow, awaiting planting. The predictable, patterned order, further assured by the promise of continued progress with the arrival of the railroad into the region, depicts a safe and secure world that the painter John Rasmussen could only imagine and one he may have hoped to achieve through his paintings.

Rasmussen was born in Germany in 1828 and arrived in America though the port of New York in 1865. He is listed as a painter and "fresco painter" in the Reading, Pennsylvania, business directories during the years 1867 to 1879. Widowed and suffering from chronic drinking problems and rheumatism, Rasmussen was committed to the Berks County almshouse on June 5, 1879. He arrived roughly three years before the death of painter Charles Hofmann, a fellow inmate. Possibly inspired by the attention Hofmann had received for his painted landscapes and views of the institution, or perhaps as a result of a camaraderie between the two painters, Rasmussen produced almshouse views and other landscapes similar in composition to those of the elder Hofmann during the period of their joint residency. Rasmussen is known to have painted a wider range of subjects than did Hofmann, including portraits, still lifes, various landscapes, baptismal certificates, and, beginning in 1880, at

least six views of the almshouse.[34] In all of these, Rasmussen closely followed Hofmann's 1878 composition of the institution, which hung in one of the administrative buildings of the complex.[35]

While both painters shared common subjects and seemed to prefer using the thin sheet metal available to them through the institution's wagon and machine shops, their techniques differed markedly. In a somewhat more painterly approach, Rasmussen utilized gradual tonal gradations, subtle shading, richer color tonalities, and a higher degree of detail. His former role as a professional painter is particularly evident in his more adept handling of shading and depicting light, which would have been required by the expedient medium of fresco. By contrast, Hofmann tended to repeat stylized figures using few details and to paint in broad areas of color with little shading or attention to the effects of natural light.[36] —J.L.L.

62. THEODOR FRICK, PORKPACKER, RICHMOND, VA.
Carl W. Hambuch (?–1879)
Richmond
1878
Oil on canvas
41 × 42⅛ in.
P1.2001.67

INSCRIPTIONS:
Recto, top, paint: *THEODOR FRICK, PORKPACKER, RICHMOND VA. / BROOK AVENUE AND 6th STREET NRO 307 & 309;* bottom: *ESTABLISHED 1851;* on two wagons: *THEO. FRICK;* bottom left: *Carl W. Hambuch. 1878. July 8.;* on houses: (translation of German): *Carriage House; Stable; Fuel House; Horse Corral; Steam Boiler; Salt and Packing House; Sausage Kitchen; Slaughter House; Boiler; Smokehouse; Dwelling House; Bathhouse; Icehouse; Boardinghouse*

PROVENANCE:
Robert Otto Waldbauer (great-grandson of Theodor Frick); Dr. and Mrs. Henry P. Deyerle, Harrisonburg, Va.; Sotheby's sale 6716, "Deyerle Collection," 5/95, lot 791.

PUBLISHED:
R. Lewis Wright. "Carl Hambuck: Richmond Artist." *The Clarion* (winter 1983/84): 47.

Carl Hambuch immigrated to the United States from Germany sometime around 1873 or 1874.[37] Nothing is known of his history in Germany and little more of his life in America. During the 1870s, he depicted at least three farms and homes of Richmond butchers and meat handlers of German descent, including this one for Theodor Frick; additional paintings are mentioned in Richmond newspapers, but their present locations are unknown.[38]

The large format of this highly detailed and accurate rendering, the bird's-eye perspective, and intricate and beautifully lettered legends suggest an artist conversant with the art of preparing drawings or paintings

34 The two also enjoyed some shared patronage. Rasmussen is known to have been commissioned by one of Hofmann's best patrons, John B. Knorr; see cat. no. 60.

35 For a comparison of the two painters' landscape styles, see Hofmann's *View of Henry Z. Van Reed's Farm* (1872) in Beatrix T. Rumford, ed., *American Folk Paintings: Paintings and Drawings Other Than Portraits from the Abby Aldrich Rockefeller Folk Art Center* (Boston: Little, Brown, in association with Colonial Williamsburg Foundation, 1988), p. 84.

36 For a thorough discussion of Rasmussen and Hofmann, see ibid., pp. 83–91.

37 Biographical information about Hambuch and Frick based on R. Lewis Wright, "Carl Hambuck: Richmond Artist," *The Clarion* (winter 1983/84): 46–48. It is unclear why Wright spells the artist's name with a final *k.* In the Frick painting, the signature is clearly "Hambuch."

38 Ibid., p. 48. These are the paintings of Mr. and Mrs. Phil Lambert's working farm and home and the painting of the C. Holzhauer house. According to the author, a painting of the Richmond Tobacco Association's Planters' Warehouse is cited in *The (Richmond) State,* Aug. 17, 1876, and a family portrait is mentioned in the *Richmond Whig,* Sept. 6, 1876.

to be lithographed. Germany was an important center for early lithographic processes, and published lithographs at this time were colored and stippled by hand. It has also been suggested that Hambuch may have been trained as a coach or sign painter. Interestingly, he has lettered Frick's name on each of the two wagons at the bottom of the canvas. Hambuch's work shares a sensibility with the meticulous Pennsylvania almshouse paintings of the same period.[39] Unfortunately, he apparently shared more than aesthetics with the Pennsylvania almshouse painters. In 1878 he was discovered comatose in West End Park (now Monroe Park) and taken to the city almshouse, where he died soon after. His obituary states, "The chief obstacle to his success was inebriety."[40]

Hambuch's painting of Frick's working farm provides an interesting sense of property use. A handsome residential face is presented to the street, while the working buildings extend deep into the plot. Each "haus" is marked with the nature of its function, from butchering to salting to packing. Frick had emigrated from Germany before the Civil War but fled to his native country during the war years. He returned to Richmond to resume his business after the war was over, but a reminder of the conflict persists in the Confederate flag, now pressed into service as a bedcover and drying on a clothesline. According to family tradition, Mrs. Frick wanted to clear away the laundry but was convinced by the artist to leave the scene unsanitized. Family tradition also maintains that Hambuch created the painting from the roof of a house across the street and was paid $10.00. Frick, his entire family, and a relative from Germany are included in the foreground, as is the artist, who depicted himself near his signature at the lower left. —S.C.H.

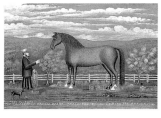

63. **HORSE JACK OF WOODBRIDGE, NJ**
James Bard (1815–1897)
New York
1871
Oil and ink on paperboard
8⁷⁄₁₆ × 11¹³⁄₁₆ in.
PL.2001.68

INSCRIPTIONS:
Recto, ink: *HORSE JACK of WOODBRIDGE. NJ;* paint: —*This Picture / THE PROPERTY of Charles Drake. Presented BY. JAMES BARD the ARTIST. NY. 1871*

PROVENANCE:
Descended in Dunham family, Dunham Corners, N.J.; Sotheby's sale 6957, 1/97, lot 1593.

James Bard is best known for large-format oil portraits of Hudson River steamboats which he painted, initially with his twin brother, John, for a period of more than sixty years, from 1827 to 1890. Bard achieved great success as a ship portraitist in New York but suffered great personal loss with the deaths of five of his six children before 1870. In his declining years, he moved to White Plains with his wife and one remaining daughter. He apparently had trouble making ends meet, and he is buried in the Rural Cemetery in a section allocated for indigents.[41]

In his heyday, Bard was celebrated for the technically precise renderings he made of the steamboats that plied New York's rivers and was acknowledged as "a perfect encyclopedia on the subject of New York harbor and Hudson River steamboats."[42] This small tribute to Charles Drake and his horse, Jack, is singular among Bard's efforts, but many of the treatments associated with the ship portraits can be noted. The figure of Drake is identical to those ordinarily seen on deck in Bard's ship paintings, and the dramatic sky, too, is a familiar element. The tiny fence, rolling green hills behind, and indeed Drake himself are all dwarfed by the handsome Morgan horse, whose coat seems to have been comb-painted for texture.

Morgan horses were renowned for their versatility, from hauling stagecoaches to performing fieldwork. They also saw duty as cavalry mounts and artillery horses, and their genes contributed to the standardbred used in harness racing. This type of portrait descends from an eighteenth-century English tradition of sporting paintings. In the United States, portraits of nationally known horses, as well as local favorites, emerged as a trend in the second half of the nineteenth century as the breeding of horses against competitive standards grew in popularity. —S.C.H.

39 Charles Hofmann, John Rasmussen, and Louis Mader were three German immigrants who painted multiple versions of the almshouses in Berks, Schuylkill, and Montgomery Counties, respectively, often for members of the institutions' administrations. All three were also occasional residents of the almshouses, where they each died.
40 Wright, "Carl Hambuck," p. 48.

41 Anthony J. Peluso, *The Bard Brothers: Painting America under Steam and Sail* (New York: Harry N. Abrams in association with Mariners' Museum, 1997), p. 28.
42 Ibid.

64. DOOR FROM CORNELIUS COUWENHOVEN HOUSE
Daniel Hendrickson (1723–1788)
Pleasant Valley, Holmdel Township, Monmouth County,
New Jersey
Mid-eighteenth century
Paint on yellow pine and white oak, with wrought-iron hinges,
lock, and hardware
78⅝ × 44¼ × 4 in. (with door frame)
P1.2001.69

PROVENANCE:
Descended in family to Mr. and Mrs. P. Hendrick Conover, Monmouth County, N.J.; Robert
and Elisabeth T. Babcock, Woodbury, Long Island, N.Y.; Skinner sale 1100, "Babcock Estate,"
11/85, lot 264.

EXHIBITED:
"Earliest American Landscapes, 1700–1820," MMA, 1952/53.
"Nieuw Amsterdam," MMA, 1953.
"A Place for Us: Vernacular Architecture in American Folk Art," MAFA, 1996/97.

Daniel Hendrickson inherited one of the largest farms in Middletown, New Jersey, from his father, also Daniel, who was the area's first permanent settler.[1] A successful entrepreneur, he expanded the property to more than eight hundred acres, with diversified interests that included a tan yard, sawmill, grist mill, distillery, pantile- and brick-works, earthenware pottery, lumberyard, and stables. He traded extensively, importing consumer goods and exporting bricks and agricultural products to ports that included Jamaica, Curaçao, Virginia, and the Carolinas. Hendrickson was known for his musical and artistic abilities, and he interacted with important colonial artists such as John Watson and Gerardus Duyckinck II. He is credited with painting several portraits of family members, of which only two—a self-portrait and a portrait of his daughter Catharine—are known today. Notes in his surviving journals and account books indicate that he also did ornamental painting on architectural elements, tavern signs, carriages, and chairs.[2]

This is one of two doors that can be confidently attributed to Hendrickson.[3] According to a 1927 newspaper account at the time the door was sold, it was originally situated between a living room and a bedroom in the home built about 1700 for Cornelius Couwenhoven. It is likely that Hendrickson painted the door sometime after his marriage to Couwenhoven's daughter Catharine, in 1743. The significance of the large Netherlands-type home and property pictured in the upper panel is not known. The vase of flowers on the bottom panel is similar to that seen in the portrait of Hendrickson's daughter which was painted about 1770.[4]

—S.C.H.

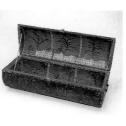

65. TRAVELING TRUNK
Artist unidentified
Possibly New York
c. 1800–1820
Hide-bound wood and paint on paper lining,
with iron hardware and brass tacks
12½ × 31 × 12 in. (closed)
P1.2001.70

PROVENANCE:
Sotheby Parke-Bernet sale 3438, 11/72, lot 396; Robert and Elisabeth T. Babcock, Woodbury,
Long Island, N.Y.; Skinner sale 1100, "Babcock Estate," 11/85, lot 131.

EXHIBITED:
"A Place for Us: Vernacular Architecture in American Folk Art," MAFA, 1996/97.

During the late eighteenth century, Americans became confirmed in a constant pattern of migration that still persists as a part of their national character. Between 1790 and 1840, the system of roads expanded exponentially, and overland travel by stagecoach, wagon, and horseback increased.[5] To transport personal belongings, people needed sturdy compartments that could withstand the rigors of the road. Unlike delicate pasteboard bandboxes, which needed to be handheld to survive rough trips, trunks were made from wood covered with dressed hide and studded on the exterior with brass tacks in decorative patterns, sometimes including the owner's initials. Hide-covered trunks were often cylindrical in shape and were intended primarily for stagecoach travel, during which they were fastened on the outside of the coach. This type of trunk appears in inventories from the seventeenth through nineteenth centuries, with early valuations ranging from one pound to six shillings.[6]

Instead of a maker's label, the interior of this example is lined with paper that is painted with a horizontal frieze of houses punctuated by vertical trees with widespread leafy branches. An additional repeat of circular geometric motifs completes the similarity of the lining to papered, stenciled, block-printed or freehand painted wall coverings of the first quarter of the nineteenth century.

—S.C.H.

1 Biographical information about Daniel Hendrickson and information about the painted door are based upon the following sources: Rosalie Fellows Bailey, *Pre-Revolutionary Dutch Houses and Families in Northern New Jersey and Southern New York* (New York: William Morrow, 1936), pp. 398–418, Roderic H. Blackburn and Ruth Piwonka, *Remembrance of Patria: Dutch Arts and Culture in Colonial America, 1609–1776* (Albany, N.Y.: Albany Institute of History and Art, 1988), pp. 272–73, and Joseph W. Hammond, "Daniel Hendrickson: Farmer, Entrepreneur, & Limner from Middletown, New Jersey," n.d.—I am grateful to Peter and Leslie Warwick, New Jersey, for bringing this essay to my attention.

2 These papers are in Special Collections, Rutgers University Libraries, New Brunswick, N.J.

3 Roderic H. Blackburn cites two doors attributed to Hendrickson: the one under discussion and a second that was removed from the Wyckoff house in Six Mile Run (now Franklin Park),

N.J. It is in the collection of the Jane Voorhees Zimmerli Art Museum, Rutgers University, New Brunswick, N.J.; see Blackburn and Piwonka, *Remembrance of Patria*, pp. 272–73. Joseph W. Hammond cites a third example, formerly in the house built by Garret Schanck in Holmdel, which no longer survives; see Hammond, "Daniel Hendrickson."

4 This is discussed in Deborah Chotner, *American Naive Paintings* (Washington, D.C.: NGA, 1992), pp. 177–80.

5 Jack Larkin, *The Reshaping of Everyday Life, 1790–1840* (New York: Harper & Row, 1988), pp. 206, 211.

6 Nina Fletcher Little, *Neat and Tidy: Boxes and Their Contents Used in Early American Households* (New York: E.P. Dutton, 1980), p. 33.

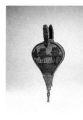

66. **Bellows with Architectural Scene**
Artist unidentified
New England
c. 1830
Paint and ink on wood, with brass tacks and leather
17⅞ × 7¼ × 3 in.
P1.2001.71

PROVENANCE:
Skinner sale 1032, 3/85, lot 132.

EXHIBITED:
"A Place for Us: Vernacular Architecture in American Folk Art," MAFA, 1996/97.

The bellows, already used by ancient cultures to start or stoke a fire, was still an important tool in eighteenth- and nineteenth-century American homes with open fireplaces for heat and cooking. Bellows made for domestic use consisted of two shaped boards with handles, connected by a band of leather all around, with wire or reed ribs to prevent the leather from collapsing. The boards narrowed to a small tip with an open end that was sheathed in brass or some other metal. A larger hole in the center of the back board opened into the bellows and provided a valve for the intake of air, which could be expelled with force from the narrow nozzle at the end.[7]

This is one of a small group of bellows with unusual painted decoration of two-story houses set in landscapes.[8] It features a four-square hip-roofed house with a central chimney and ell, a familiar architectural configuration on the New England horizon as families prospered and moved from small shelters to more impressive homes. The bright yellow houses with cheerful red multipaned windows and chimneys sit in a surrounding verdant landscape of tall trees. The back is ornamented with red floral sprays around the valve. —S.C.H.

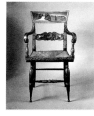

67. **Armchair with View of Ithaca Falls**
Chairmaker unidentified
Decoration probably by R.H. Ranney (dates unknown)
Ithaca, Tompkins County, New York
c. 1817–1825
Paint, bronze powder stenciling, and gold leaf on wood, with rush seat
37¾ × 21 × 16½ in.
P1.2001.72

INSCRIPTION:
Back of crest rail, paint: *R H Ranney / Ithaca*

PROVENANCE:
Stephen Score, Essex, Mass., 1987.

EXHIBITED:
"A Place for Us: Vernacular Architecture in American Folk Art," MAFA, 1996/97.

PUBLISHED:
Bishop, Robert, and Jacqueline Marx Atkins. *Folk Art in American Life.* New York: Viking Studio Books in association with MAFA, 1995, p. 83.
Schaffner, Cynthia V.A., and Susan Klein. *American Painted Furniture, 1790–1880.* New York: Clarkson N. Potter, 1997, p. 153.

Landscape views painted on chairs were advertised in Baltimore as early as 1805, when John and Hugh Finlay offered "real Views, Fancy landscapes, Flowers, Trophies of Music, War, Husbandry, Love, & c."[9] By 1816 an Ohio chairmaker who had previously worked in Baltimore advertised "Broad Tops with landscapes."[10] Both companies were probably referring to chairs similar to this one, which is painted on the broad top rail with a dramatic view of Ithaca Falls and the many mills that it powered. Although the R.H. Ranney who signed the back of this chair has not been identified, he was probably not the chairmaker but the artist who painted the scene. Ithaca could boast several chair factories by the 1820s, including that of A.W. Howland in Fall Creek, the area depicted on this chair, but this example has not been attributed to his shop.

Ithaca Falls had the most dramatic and precipitous drop of the six falls along the stretch of Fall Creek and inspired many artistic interpretations through the nineteenth century, including one possibly by upstate New York artist Henry Walton.[11] The identification of the scene on this chair as Ithaca Falls is confirmed by the presence of the wooden flume, barely visible along the upper right precipice. Between 1830 and 1831, the flume was replaced by a tunnel, which was bored through the rock to funnel the water. The powerful flow of the falls gave rise to a series of mills located one above the other on the southern bank of Fall Creek. By 1817 mills for plaster, carding, grist, oil, and lumber were in operation, and they were soon joined by a woolen mill. The success of these enterprises led to the area's further development as a business center.[12]

Chair making was already a specialized business by the time this fancy armchair was manufactured. Although there were local chair manufactories, parts could also be purchased from wholesalers and assembled and decorated locally. In addition to the painted broad top, this highly embellished example has a scroll seat, ornamental fret, fancy legs, and extravagant bronze stenciled decoration. —S.C.H.

7 Dorothy D. Stone, "Bellows," *The Decorator* 7, no. 2 (summer 1953): 5–6.
8 Carol C. Sanderson and Christopher P. Monkhouse, *Americana from the Daphne Farago Collection* (Providence: Museum of Art, Rhode Island School of Design, 1985), p. 31.
9 Nancy Goyne Evans, "Frog Backs and Turkey Legs: The Nomenclature of Vernacular Seating Furniture, 1740–1850," in Luke Beckerdite, ed., *American Furniture 1996* (Hanover, N.H.: Univ. Press of New England in association with Chipstone Foundation, 1996), p. 39.
10 Ibid.
11 Walton is better known as a portrait painter; see cat. no. 44.
12 Gretchen Sachse, DeWitt Historical Society, Ithaca, N.Y., letter to the author, Aug. 28, 1996 (AFAM files). I am grateful to Ms. Sachse for providing extensive information about Ithaca Falls and the Fall Creek area.

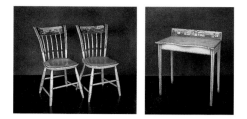

68a–c. PAIR OF SIDE CHAIRS and DRESSING TABLE
Artist unidentified
Worcester, Worcester County, Massachusetts
1820–1835
Paint on maple and pine
Chairs: 33¼ × 15¾ × 18 in. and 33½ × 17 × 18 in., *table:* 37⅜ × 33 × 20 in.
P1.2001.73a, b, 74

PROVENANCE:
I.M. Wiese, Roxbury, Conn.; David A. Schorsch, Greenwich, Conn., 1986.

PUBLISHED:
Schaffner, Cynthia V.A., and Susan Klein. *American Painted Furniture, 1790–1880.* New York: Clarkson N. Potter, 1997, pp. 118–19.

This set of furniture originally comprised six side chairs and the dressing table.[13] Although the set purportedly was made for the Governor Levi Lincoln home in Worcester, Massachusetts, there is not documentation to support this history.[14] The furniture is probably of Worcester manufacture, however; the chairs, in particular, with their wooden plank seats and bamboo-turned legs, are characteristic of the Worcester style.[15] There was a thriving chair industry in eastern Massachusetts and surrounding areas by the time these chairs and table were made; Worcester alone could boast 155 chair and cabinet manufactories.[16] This industry supported many hundreds of workers whose activities shed light on the delegation of aspects of production by the second quarter of the nineteenth century. The final step in furniture production was retailing, but before a chair reached a warehouse, it may have passed through the hands of suppliers of chair stock, framers, and ornamental painters.[17]

Slat-back Windsor side chairs of this type were called by several different names, depending upon regional preference. They were also known as five-rods and ball-backs because they had ball-turned spindles. The slat-style crests are framed between the two posts, leading to the term "mortise-tops."[18] The chairs and table share similar imagery of New England scenes: a church flying a weathervane, a bridge over a running stream, mill buildings, and a public house with a freestanding

signboard. The buildings, staggered in the landscape, are painted a strong yellow with dark pitched roofs. The trees are strongly bisected into light and dark areas, the whole recalling the type of decorative wall painting that was found in homes throughout New England during this period. Although these have been suggested as Worcester views, none of the buildings or landscape settings are specific enough to conclusively identify a locale.

—S.C.H.

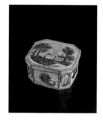

69. TRINKET BOX
Artist unidentified
New England
c. 1820–1830
Watercolor on paper on pasteboard
3½ × 5⁷⁄₁₆ × 4¾ in.
P1.2001.75

PROVENANCE:
Jean W. Fussenich, Litchfield, Conn.; Edgar William and Bernice Chrysler Garbisch, Cambridge, Md.; Sotheby Parke-Bernet sale H-2, "Garbisch Collection," 5/80, lot 893.

Early-nineteenth-century trinket boxes were most often painted and decorated by young women for their own use, and the octagon became a particularly popular shape for the boxes about 1820.[19] The typical decoration featured floral sprays, bucolic pastoral scenes, picturesque ruins, and other romantic landscapes. The delicate watercolor scenes were either first painted on paper and then applied to the box, whether it was wood or a pulpboard of some sort, or painted directly on the box after the paper had been applied. As in other schoolgirl arts, the imagery was usually copied or traced from a print or another source.

This example is painted on paper that has been applied to a homemade box formed by hand-stitching the stiff paper top, bottom, and sides together. Each surface is covered with paint-decorated paper, and the edges are bordered with paper strips painted a contrasting color. The decoration on the top features an oval reserve containing a crenellated tower flanked by two lower structures set in a landscape. While the architectural image appears to have been done with the aid of stencils, the trees on either side are sponge painted. The faceted sides display a cornucopia, doves, shells, urns of flowers, and grape clusters in a combination of stenciled and freehand painting.

—S.C.H.

13 Two additional chairs are promised gifts to AFAM from Tom and Bonnie Strauss; the remaining two are in a private collection.

14 When the furniture was first advertised by I.M. Wiese in *The Magazine Antiques* 117, no. 1 (January 1980): 147, there was no mention of an association with Governor Levi Lincoln of Worcester. In June 1986, however, David A. Schorsch advertised in the *Maine Antique Digest,* pp. 20–21C, that they were from the Governor Levi Lincoln home.

15 Nan Wolverton, Old Sturbridge Village, Sturbridge, Mass., letter to the author, July 18, 2000 (AFAM files). Wolverton writes, "You are correct in asserting that the chairs … are of Worcester County manufacture."

16 Donna Keith Baron, "Furniture Makers and Retailers in Worcester County, Massachusetts, Working to 1850," *The Magazine Antiques* 143, no. 5 (May 1993): 784.

17 Evans, "Frog Backs and Turkey Legs," p. 33.

18 Ibid., pp. 31–32.

19 Little, *Neat and Tidy,* p. 67.

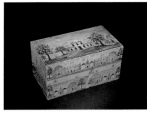

70. GRISAILLE-DECORATED BOX

Artist unidentified
Probably New York
1825–1840
Watercolor, ink, and paint on wood
7⅝ × 14⅜ × 7¹⁵⁄₁₆ in.
P1.2001.76

PROVENANCE:
Found in Cazenovia, N.Y.; Richard A. Bourne Co., Hyannis, Mass.; Daphne Farago, Providence; Sotheby's sale 6133, "Farago Collection," 1/91, lot 1288.

EXHIBITED:
"Four Rhode Island Collectors of American Folk Art: Eliza Greene Metcalf Radeke, Abby Aldrich Rockefeller, Maxim Karolik, and Daphne Farago," Museum of Art, Rhode Island School of Design, Providence, 1985.

PUBLISHED:
Sanderson, Carol C., and Christopher P. Monkhouse. *Americana from the Daphne Farago Collection.* Providence: Museum of Art, Rhode Island School of Design, 1985, p. 32, back cover.

Monochromatic decoration in a variety of mediums has a long history in New York State. The most important group of grisaille-painted furniture are the *kasten*, or cupboards, that were made in the colonial Dutch communities of the state. These were painted in blue-gray shades in imitation of bas-relief carving that might have adorned similar furniture in the Netherlands. The imagery was derived from printed sources and a tradition of architectural ornament that dates back to Roman times.[20]

By the turn of the nineteenth century, the taste for monochromatic ornamentation was strongly tied to the classical vocabulary that infused the decorative arts. A group of needleworks associated primarily with the Albany area of New York interpreted this trend in a technique known as print work.[21] These embroideries, executed exclusively in black silk thread on white silk grounds, were intended to simulate uncolored engravings. The vogue for monochromatic work continued through the nineteenth century in theorem compositions executed in gray washes and, by mid-century, in shimmering charcoal drawings on a marbledust-covered support, known as sandpaper drawings. Throughout this period, architecture was often the inspiration for monochromatic representations.[22]

In this box, architectural imagery is combined with landscapes and seascapes. The box exhibits a combination of freehand and stenciled work in a gray wash over a yellow base coat. The top of the box is ornamented with a large three-part castle surrounded by trees with a seascape and sailing vessel behind. For the decorative panoramic friezes on the front and sides of the box, the artist repeated and recombined several stencils of buildings to create new sequences. —S.C.H.

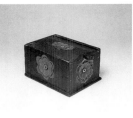

71. CANDLE BOX

Artist unidentified
Guilford, New Haven County, Connecticut
1700–1735
Paint on poplar
5⁷⁄₁₆ × 10½ × 7³⁄₁₆ in.
P1.2001.77

PROVENANCE:
Lillian Blankley Cogan, Farmington, Conn.; Christie's sale 7556, "Cogan Collection," 9/92, lot 123.

EXHIBITED:
"Connecticut Furniture: Seventeenth and Eighteenth Centuries," Wadsworth Atheneum, Hartford, 1967.
"Masterpieces of American Folk Art," Monmouth Museum, Lincroft, N.J., 1975.

PUBLISHED:
Monmouth Museum. *Masterpieces of American Folk Art.* Lincroft, N.J.: Monmouth Museum in association with Monmouth County Historical Association, 1975, n.p.
Wadsworth Atheneum. *Connecticut Furniture: Seventeenth and Eighteenth Centuries.* Hartford: Wadsworth Atheneum, 1967, p. 5.

Of all the basic household equipment used from the seventeenth through the nineteenth century, wooden boxes of one sort or another were the most useful and diverse." So wrote Nina Fletcher Little in *Country Arts in Early American Homes* (1975).[23] The decoration on boxes often reflected broader trends and employed the same motifs and techniques that were applied to more significant furnishings. This small Connecticut utility box was probably made to hold candles and is of simple construction, with a faceted slide top. What distinguishes the box is the remarkable state of preservation of its carved and painted surface.

Early Connecticut furniture was strongly influenced by English taste, and heavily carved furniture forms showed the same tulips, sunflowers, carnations, and roses that were popular in England earlier in the century. By the turn of the eighteenth century, much of the earlier carved decoration was being interpreted in paint, and this box, with its bright salmon-colored flowers, hints at that transition. The boldly carved and painted layered rosettes relate strongly to surface carving on chests from the Connecticut River Valley, most notably the Sunflower group attributed to Peter Blin in Wethersfield, Connecticut, and the Hadley chests of Massachusetts.[24] Similar rosettes are also found on carved gravestones throughout New England.[25] —S.C.H.

20 Blackburn and Piwonka, *Remembrance of Patria*, pp. 261, 265–68.

21 Betty Ring, *American Needlework Treasures: Samplers and Silk Embroideries from the Collection of Betty Ring* (New York: E.P. Dutton in association with MAFA, 1987), pp. 93–95.

22 Shelley R. Langdale, "The Enchantment of the Magic Lake: The Origin and Iconography of a Nineteenth-Century Sandpaper Drawing," *Folk Art* 23, no. 4 (winter 1998/99): 54. Romantic depictions of ruined castles continued to be a favored subject for sandpaper drawings, as they had been in watercolors in earlier decades. Langdale further cites a number of drawings found in the area of Chester, Vt., that depict identifiable buildings in Chester.

23 Nina Fletcher Little, *Country Arts in Early American Homes* (New York: E.P. Dutton, 1975), p. 136.

24 It is thought that the "sunflowers" are actually marigolds, the traditional flower of the Huguenots; see Philip Zea, "Furniture," in Wadsworth Atheneum, *The Great River: Art & Society of the Connecticut Valley, 1635–1820* (Hartford: Wadsworth Atheneum, 1985), p. 187.

25 Francis Y. Duval and Ivan B. Rigby, *Early American Gravestone Art in Photographs* (New York: Dover Publications, 1978).

72. WALL BOX WITH EAGLE AND FLORAL DECORATION

Artist unidentified
Probably vicinity of Wethersfield, Hartford County, Connecticut
c. 1790–1820
Paint on white pine
22 × 13 × 6 in.
P1.2001.78

PROVENANCE:
Fred Giampietro and J.B. Richardson, New Haven, Conn.; Skinner sale 1156, 6/87, lot 201.

The Wethersfield area of Connecticut has been known for its distinctive carving traditions since the late seventeenth and early eighteenth centuries, when Peter Blin is credited with creating the chests known as the Sunflower group. This hanging wall box, made nearly one hundred years later at the turn of the nineteenth century, continues that tradition with its robustly carved surface. Its strong overall embellishment is crowned with a bold carving of a fierce American eagle—proud symbol of the young republic—emerging in relief from a recessed arched reserve carved directly into the wood. The back is made of a single piece of wood, and on the front are two pockets with applied front panels that display exuberant relief carvings of flowering stems, a footed urn of flowers, pinwheels, and the segmented rosettes familiar from other Connecticut River Valley furniture, decorative arts, and gravestones. Tradition maintains that the wall box descended in the Brainard family, which has a long history in Wethersfield and Hartford, Connecticut. A second, closely related example may also have come from a Connecticut family that moved to Mount Vernon, Maine.[26] —S.C.H.

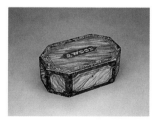

73. OCTAGONAL BOX

Artist unidentified
Probably Vermont
c. 1830
Paint and bronze powder stenciling on pine
4¾ × 12¾ × 8¼ in.
P1.2001.79

INSCRIPTION:
Lid, paint: S, WOOD

PROVENANCE:
Peter Nelson, Woodbury, Conn.; Bertram K. and Nina Fletcher Little, Brookline, Mass.; Sotheby's sale 6526, "Little Collection, Part I," 1/94, lot 105.

PUBLISHED:
Garrett, Wendell D. "Nina Fletcher and Bertram Kimball Little." *The Magazine Antiques* 144, no. 4 (October 1993): 809.
Little, Nina Fletcher. *Little by Little: Six Decades of Collecting American Decorative Arts.* New York: E.P. Dutton, 1984, p. 198.

Historically, boxes have often received the same decorative treatments as case furniture and other more significant forms, whether carved or painted. This octagonal box displays two of the most popular early-nineteenth-century techniques for ornamenting wood. Restrained bronze stenciling is contained in the black borders that define each edge of the box, while shaped reserves on the sides and the top, which echo the octagonal form of the box, blaze with freehand marbleizing in brilliant yellows, greens, and oranges. The exuberance of the patterning and its strong diagonal thrust relate the box to a group of case furniture made in the area of Shaftsbury, Vermont.

Imaginative graining was not intended to be an imitation of wood; rather, it was a creative interpretation of the impression of wood. Over time, regional styles of decorative painting developed. The paint was most commonly applied on a light-colored ground and manipulated with a variety of tools that ranged from brushes and combs to fingers. Vinegar and carbon from candle smoke could be added for special effect. The stenciling was achieved by the application of bronze powder through the hollow-cut portion of a stencil onto a tacky varnished surface.[27]

—S.C.H.

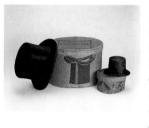

74a. BANDBOX AND BEAVER TOP HAT

Silas Goodrich (bandbox) and
Collins & Fairbanks (top hat)
Boston
c. 1835
Printed wallpaper on pasteboard, with silk-lined beaver skin hat
Bandbox: 9¼ × 14 × 12⁵⁄₁₆ in. oval
Top hat: 5⅝ × 12 × 10 in. oval
P1.2001.80a, b

INSCRIPTIONS:
Lid, silkscreened: *FROM / PETER HIGGINS'S / HAT AND CAP / ESTABLISHMENT, / NO. 1 CITY WHARF, / BOSTON.*; underside of lid, printed paper label: *SILAS GOODRICH, / Manufacturer of / BAND BOXES, / Hat, Store, Muff & Fancy Boxes, / OF EVERY DESCRIPTION, / 25 Court Street, Boston. / Entrance through S.H. Gregory & / Co's Paper Hanging Store.*; inside hat, stamped: *EXTRA QUALITY / TRADE MARK / COLLINS & FAIRBANKS, 383 WASHINGTON St. / OPP. FRANKLIN / BOSTON / REGISTERED*

PROVENANCE:
Bertram K. and Nina Fletcher Little, Brookline, Mass.; Sotheby's sale 6526, "Little Collection, Part I," 1/94, lot 85.

PUBLISHED:
Little, Nina Fletcher. *Neat and Tidy: Boxes and Their Contents Used in Early American Households.* New York: E.P. Dutton, 1980, p. 105.

74b. MINIATURE BANDBOX AND BEAVER TOP HAT

Artist unidentified (bandbox) and George Vail (top hat)
Newark, Essex County, New Jersey
c. 1830
Printed wallpaper on pasteboard, with silk-lined beaver skin hat
Bandbox: 3⅞ × 6⅞ × 5¹³⁄₁₆ in. oval
Top hat: 3½ × 6 × 4⅞ in. oval
P1.2001.81a, b

26 Samuel Pennington, letter to Ralph Esmerian, Feb. 10, 1989 (AFAM files).

27 Cynthia V.A. Schaffner and Susan Klein, *American Painted Furniture, 1790–1880* (New York: Clarkson N. Potter, 1997), pp. 114–15, 125–28.

I nexpensive pasteboard or lightweight wood boxes were in use as early as the seventeenth century to hold gentlemen's neckbands and lace bands. After Dr. Samuel Johnson described such boxes as "a slight box used for bands" in his 1755 dictionary, the term "bandbox" came into general use.[28] Bandboxes were particularly popular in America, especially after the first quarter of the nineteenth century, when wallpaper manufacturers increased their versatility by making large boxes and covering them with decorative block-printed papers.

The larger boxes were suitable for a wide variety of purposes, from travel to storage, and their popularity from the 1820s through the 1840s can be traced through the proliferation of companies, especially in New York and New England, that rose to meet demand. Many of these were primarily wallpaper manufacturers, but businesses devoted exclusively to the production of bandboxes also operated side by side. Papers printed specifically for use as bandbox covers were introduced as early as the late eighteenth century and were available as florals, geometric repeats, scenic views, and commemorative papers. The patterns were designed to the scale and proportion of different sections of the oval or round boxes.

The large bandbox, with a top hat printed on its side, was produced for Peter Higgins, whose name and place of business are printed on the top of the lid. Higgins was a Boston hatmaker who operated at 1 City Wharf during the 1830s and 1840s.[29] Bandboxes came in standard sizes of twelve to fourteen inches high, large enough to store a hat, but were also sold in nests of at least three graduated sizes that were stored or shipped one inside the other.

The miniature bandbox may be one of the smaller boxes of a nest, or it could have been custom ordered to house the miniature beaver top hat within. Although this diminutive hat may have been intended for a child's doll, it is more likely a sample, as the label of the hatmaker, George Vail, is pasted inside the crown. According to the label, Vail's business was in Newark, New Jersey, but the bandbox may have been purchased from one of the many large New York manufactories operating at the time which often advertised that they shipped their products.[30] The rage for bandboxes had quieted by the 1840s and virtually disappeared by the time Elizabeth Leslie dismissed them as "no longer visible among the travelling articles of *ladies*" in *Miss Leslie's New Receipts for Cooking* (1854).[31]

—S.C.H.

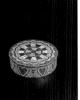

75. ROUND BOX WITH HEART DECORATIONS
George Robert Lawton (1813–1885)
Scituate, Providence County, Rhode Island
c. 1840–1850
Paint on pine and maple
2¼ × 7½ in. diam.
P1.2001.82

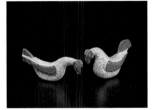

76a–b. TWO ROOSTERS
George Robert Lawton (1813–1885)
Scituate, Providence County, Rhode Island
c. 1840–1850
Paint on pine
2¾ × 3⅛ × 1; 2⅝ × 3¾ × ¾ in.
P1.2001.83a, b

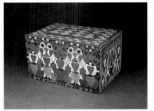

77. BOX WITH HEART DECORATIONS
George Robert Lawton (1813–1885)
Scituate, Providence County, Rhode Island
c. 1842
Paint on pine, with leather hinges, lined with wallpaper and newspaper remnants, printed engraving, and ink drawing
10½ × 17½ × 12¾ in.
P1.2001.84

28 See Catherine Lynn, *Wallpaper in America from the Seventeenth Century to World War I* (New York: W.W. Norton in association with Cooper-Hewitt Museum, 1980), pp. 292–300, for an in-depth discussion on the history of bandboxes, and Little, *Neat and Tidy,* p. 98. Little traces the term "bandbox" back even further, citing a 1636 reference in the estate of Sarah Dillingham of Ipswich, Mass.

29 Little, *Neat and Tidy,* pp. 103, 105. A similar example is illustrated in Lilian Baker Carlisle, *Hat Boxes and Bandboxes at Shelburne Museum* (Shelburne, Vt.: Shelburne, 1960), p. 3.

30 Grace-Ellen McCrann, The New Jersey Historical Society, Newark, e-mail to Lee Kogan, MAFA, Aug. 21, 2000 (AFAM files) and The Church of Jesus Christ of Latter-Day Saints Family Search

Internet Genealogy Service <www.familysearch.com> (accessed Aug. 14, 2000). A George Vail, hat manufacturer, is listed in the Newark city directories of 1861–1862. His listing was changed to "hatter" in the 1865–1866 directory. He is listed in the directory through 1895, with changes of residence throughout that period. Another George Vail, son of Stephen Vail and Bethiah Young, was born July 21, 1809, in Speedwell, Morristown, N.J., and died May 23, 1875. He married Mary Ann Wilson in 1830. Members of the Vail family are buried in the First Presbyterian Church in Morristown.

31 Lynn, *Wallpaper in America,* p. 300.

These exuberantly decorated boxes were once believed to have been made by John Colvin, a Rhode Island woodworker, builder, and carpenter. They have since been established as the work of another Rhode Island craftsman, George Robert Lawton, whose family was related to Colvin's by marriage. Lawton was born in Newport, the son of Robert Lawton and Sarah Anthony.[32] He married Rosinda Searle (1816–1885) in Scituate, Rhode Island, where they raised their five children.[33] At least sixteen pieces that can be attributed to Lawton descended in the family.[34]

Although the flurry of hearts on these boxes might seem to suggest a Pennsylvania German influence, Lawton was of English heritage, with deep roots in Rhode Island. The proliferation of hearts, checkerboards, and other geometric motifs are incised into the wood and painted. The rectangular box is lined with newspapers that bear the date 1842, giving an indication of the period during which Lawton worked. The box itself is of simple construction, with rabbeted and nailed corners and leather hinges. It is, however, outstanding for its complex painted decoration, carefully planned and executed.

The shallow round box is similar in form to bentwood pantry boxes. The incised decoration on the top derives from compass designs and bears a striking resemblance to the radial motifs found on a painted chest from the Hadley area of Massachusetts.[35] But it also relates strongly to the configuration of dartboards. The game of darts has a long history in Europe and America and originally was played on slices of wood cut from the trunk of a tree. The natural rings and radial cracks provided the playing and scoring areas, and ultimately evolved into the board with which we are familiar today, based on a numbering system known as the "clock." The scoring areas are delineated by wire rings called "spiders," which separate the board into three rings and the central bull's-eye.[36] The spots that fill the decorated areas of the round box also resemble the marks left by darts in the surface of the playing board. Unlike the rectangular box, heart decorations on this example are confined to the side, where a painted bird simulates the profile of two carved roosters that also descended with the group. —S.C.H.

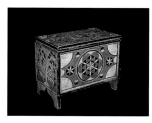

78. CHILD'S BLANKET CHEST
Artist unidentified
Possibly Rhode Island or New York
c. 1830
Paint on pine with iron hardware
16¼ × 20¾ × 11¼ in.
P1.2001.85

PROVENANCE:
Found in Syracuse, N.Y.; Skinner sale 1156, 6/87, lot 148.

The outstanding feature of this child's blanket chest is the painted decoration of bold and singular compass designs, with arcs and circles intersected by arcs in contrasting colors. Like the Lawton boxes (cat. nos. 75, 77), the color scheme is primarily red and white, with an effective use of black to create strong contrasts in the geometric motifs. Both the top and the front corners have quarter-circles painted in white and outlined in black. Additional circular and simple compass motifs, lightly incised, float around a large central compass rose that radiates from a six-pointed center.[37] Surprisingly, the sides feature natural imagery of leafy trees emerging from earthy mounds, one bearing large comma-shaped red fruit, the other a more restrained and traditional tree form in dark paint over shadowy lobes, barely visible. There is precedence, however, for the combination of tree imagery and geometric motifs in earlier eighteenth-century New England furniture.

The unusual construction of the chest suggests it was made by a home craftsman rather than a professional furniture maker. The moldings are applied to the front and sides, and colored black, they literally and visually frame the painted designs. The sides are made from one piece of wood, ending in boot-jack feet, although the applied molding gives the impression the feet are attached separately. —S.C.H.

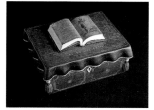

79. LECTERN BOX
Artist unidentified
New England
Second half nineteenth century
Paint on wood with applied printed pages
7½ × 14¼ × 10½ in.
P1.2001.86

INSCRIPTIONS:
Lid, paint: P.F. COIST; printed paper applied to open book: The Rock of Liberty. / OH! the firm old rock, the wave-worn rock, / That braved the blast and the billows shock; / It was born with time on a barren shore. / And it laughed with scorn at the ocean's roar. / 'Twas here that the first Pilgrim band, / Came weary up to the foaming strand; / And the tree they reared in the days gone by, / It lives, it lives, it lives, and ne'er shall die. / Thou stern old rock in the ages past, / Thy brow was bleached by the warning blast; / But thy wint'ry toll with the wave is o'er, / And the billows beat thy base no more. / Yet countless as thy sands, old rock, / Are the hardy sons of the Pilgrim stock; / And the tree they reared in the days gone by, / It lives, it lives, it lives, and ne'er shall die. / Then rest, old rock, on the sea-beat shore, / Our sires are lulled by the breaker's roar; / 'Twas here that first their hymns were heard, / O'er the startled cry of the ocean bird. / 'T was here they lived, 't were here they died, / Their forms repose on the green hill side; / And the tree they reared in the days gone by / It lives, it lives, it lives, and ne'er shall die.

PROVENANCE:
Stewart E. Gregory, Wilton, Conn.; Sotheby Parke-Bernet sale 4209, "Gregory Collection," 1/79, lot 189.

EXHIBITED:
"An Eye on America: Folk Art from the Stewart E. Gregory Collection," MAFA, 1972.
"The Flowering of American Folk Art, 1776–1876," WMAA, 1974.
"The Shape of Things: Folk Sculpture from Two Centuries," MAFA, 1983.
"Neat and Tidy," Philadelphia Antiques Show, 1985.
"Every Picture Tells a Story: Word and Image in American Folk Art," MAFA, 1994/95.

32 Amelia Whitford, letter to Barbara Sarkesian, Jan. 7, 1986 (AFAM files).
33 Matthew Lawton, e-mail to the author, June 18, 2000 (AFAM files).
34 David A. Schorsch, "Discovered: Lawton, Not Colvin," Maine Antique Digest 15, no. 3 (March 1987): 18–19-D.
35 Dean A. Fales Jr., American Painted Furniture, 1660–1880 (New York: E.P. Dutton, 1972), p. 21.

36 <www.geocities.com/Colosseum/Arena /4041> (accessed June 2000).
37 The composition of the decoration on the front is similar to a miniature painted chest from Herkimer County, N.Y.; see Mary Antoine de Julio, German Folk Arts of New York State (Albany, N.Y.: Albany Institute of History and Art, 1985), p. 14.

PUBLISHED:
Fales, Dean A. Jr. *American Painted Furniture, 1660–1880.* New York: E.P. Dutton, 1972, p. 275.

Lipman, Jean. *Provocative Parallels.* New York: E.P. Dutton, 1975, p. 78.

Lipman, Jean, and Alice Winchester. *The Flowering of American Folk Art, 1776–1876.* New York: Viking Press in association with WMAA, 1974, p. 249.

Little, Nina Fletcher. *Neat and Tidy: Boxes and Their Contents Used in Early American Households.* New York: E.P. Dutton, 1980, p. 110.

Museum of American Folk Art. *An Eye on America: Folk Art from the Stewart E. Gregory Collection.* New York: MAFA, 1972, p. 10.

Boxes are often miniature reflections of the prevailing furniture trends of a particular period, and this box is no exception. Although its original purpose can only be guessed at, its form speaks clearly to American Victorian taste. The trompe-l'oeil carving gives the appearance of a black cloth–covered lectern, with heavy tassels at the front corners and a green quilted pad on top. Placed on the "lectern" is a three-dimensional book that is opened to a well-thumbed page containing three stanzas of verse. Completing the illusion, the poem is printed on paper applied to the carved open book.

The facing page has an engraving of an American Indian standing in native garb with his arms crossed over his breast, reminiscent of the seal of the Massachusetts Bay Colony. The poem celebrates the immutability of Plymouth Rock and the stalwart Pilgrim fathers. Using tree-of-life imagery, the repeating refrain is a reference to the tree planted and reared by the Pilgrims that will survive through descendants into eternity.[38]

—S.C.H.

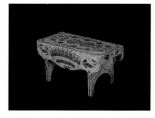

80. MINIATURE FOOTSTOOL
Artist unidentified
Probably New England or Pennsylvania
c. 1830–1840
Paint on wood
4⅞ × 8¹³⁄₁₆ × 4⅜ in.
P1.2001.87

PROVENANCE:
Peggy Schorsch, Greenwich, Conn., 1978.

EXHIBITED:
"Small Folk: A Celebration of Childhood in America," MAFA and N-YHS, 1980/81.
"Flowers in Folk Art," WMAA at Philip Morris, New York, 1984.

PUBLISHED:
Brant, Sandra, and Elissa Cullman. *Small Folk: A Celebration of Childhood in America.* New York: E.P. Dutton in association with MAFA, 1980, p. 78.

This is one of a small group of miniature footstools painted a happy yellow color and closely related by construction, scale, and paint decoration.[39] Their diminutive size clearly marks them as furniture for children, but whether for play or function is not clear. The painted flowers, baskets of strawberries, and slender striping place the stool comfortably within the furniture conventions associated with Windsor chairs, which received similar decorative treatments from the 1820s through the 1840s. This is especially true of the striping that defines the fronts and sides and scalloped apron, recalling similar definition of side posts, plank seats, and arrow-back spindles on Windsor side chairs.

The miniature stools traditionally have been attributed to the Landis Valley area of Pennsylvania. However, neither the construction nor the painted decoration can be tied to that region.[40] Floral designs, including baskets of flowers and fruit, often were painted on the crests of Windsor and fancy chairs of the period, both in Pennsylvania and elsewhere. In addition to furniture, these were common motifs in the decorative arts throughout the mid-Atlantic states, especially in female ornamental arts such as theorem painting, flower painting, flowering on tinware, and needlework.[41] Although yellow was a popular color on Pennsylvania Windsor chairs, it is also seen on country furniture throughout New England.

—S.C.H.

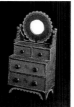

81. MINIATURE DRESSING BUREAU
Attributed to Hanson B. Y[o]ungs (c. 1858–1878)
Conesville, Schoharie County, New York
1872–1878
Paint on cigar-box wood, cigar-box cardboard, and mirror
15⅛ × 7¾ × 4½ in.
P1.2001.88

INSCRIPTIONS:
Pencil, underside of bottom drawer: *HANSON B. YUNGS;* inside top full drawer: *Mr. [?] Hanson B. Youngs;* underside of top full drawer: ink box identification stamp; back: *Mr. Hanson B. Youngs*

PROVENANCE:
Howard and Jean Lipman, Wilton, Conn.; Sotheby Parke-Bernet sale 4730Y, "Lipman Collection," 11/81, lot 162.

EXHIBITED:
"Small Folk: A Celebration of Childhood in America," MAFA and N-YHS, 1980/81.

PUBLISHED:
Brant, Sandra, and Elissa Cullman. *Small Folk: A Celebration of Childhood in America.* New York: E.P. Dutton in association with MAFA, 1980, p. 162.

38 A search of several library databases of American poetry did not yield the author of this work, though several poems about Plymouth Rock and the Pilgrim fathers and mothers were written in the latter part of the nineteenth century.

39 A related example is advertised by David A. Schorsch in *Maine Antique Digest* 15, no. 12 (December 1987): 5-C. The same piece is illustrated in the catalog for Sotheby's sale 6319 (6/92, lot 253); similar pieces are illustrated in the catalogs for Sotheby's sale 6482 (10/93, lot 40) and Christie's sale 7710 (6/93, lot 77).

40 The example advertised by Schorsch is inscribed "E.K.," dated 1840, and described as from the Landis Valley. Another example has "Centre County" (Pa.) inscribed in pencil on the

bottom. After recent visual examination, neither Jack L. Lindsey nor Pastor Frederick S. Weiser, contributors to this volume, feel that the stool is of Pennsylvania origin. According to Vernon Gunnion, former curator of the Landis Valley Farm Museum in Lancaster, it is not typical of Landis Valley or southeastern Pennsylvania (telephone conversation with the author, Aug. 18, 2000).

41 A schoolgirl illustration of a Winchester, Conn., interior in 1826 shows a set of children's furniture in the foreground that features a basket of flowers very similar in treatment to the decoration of this stool; see Schaffner and Klein, *American Painted Furniture,* p. 104.

The Revenue Act of 1865 mandated that cigars be packaged in boxes, which were not recycled.[42] As the popularity of cigar smoking continued to grow through the last quarter of the nineteenth century, box factories proliferated to meet demand. From 1868 to 1960, a box identification was required on all cigar boxes. The identification mark changed in style only about four times during nearly one hundred years. According to the impressed mark found on this piece, it was made from boxes dated between 1872 and 1880.[43] The unforeseen by-product of the discarded boxes was a wealth of wood, freely available to be used for a variety of handcrafts. The best known of these wood projects was tramp art, which is characterized by graduated layers of cigar-box wood whose edges are chip-carved in triangular notches.

This doll-size dresser is fashioned from cigar boxes but is not tramp art because it does not display the characteristic layered and edge-notched construction.[44] In addition to cigar-box wood, the dresser uses cigar-box cardboard to form the backs of the two small upper drawers. Although it is diminutive in size, the dresser features a vanity mirror over two small drawers on top of a two-drawer bureau and clearly draws its inspiration from full-scale furniture of the late Victorian period in which it was made. It combines a variety of decorative paint techniques: plain paint, imaginative painted woodgraining, and stenciling of two prancing horses. The attention to detail is evident in the applied rope trim, S scrolls, and the mirror framed by a happy series of colorful circular cutouts, giving it a flowerlike appearance.

Variants of the name "Hanson B. Youngs" are penciled in three places and probably indicate the maker of this clever miniature dresser. Hanson B. Y[o]ungs was the only son of Parley (1824–1901) and Margaret Richmond Y[o]ungs (dates unknown), of Conesville, Schoharie County, New York. Hanson died at about twenty years of age, and according to genealogical notes he was "a cripple, but extremely ingenius;—made a sewing machine almost wholly of wood, that sewed."[45] His father also worked with his hands, following various occupations as shoemaker, harness maker, and farmer. The Y[o]ungs family was descended from Jurian Jung, who was born in 1727 in Germany and died in 1799, in Kingston, New York.[46]

—S.C.H.

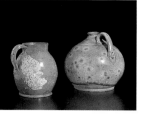

82a. BROWN PITCHER WITH YELLOW AND GREEN SPLASHES
Attributed to Nathaniel Seymour
(1763–1849)
West Hartford, Hartford County, Connecticut
c. 1800–1825
Glazed red earthenware
$6^3/8 \times 5^1/2 \times 4^1/2$ in.
P1.2001.89

PROVENANCE:
Katharine Prentis Murphy, Westbrook, Conn.; O. Rundle Gilbert Auction at Candle Light Farm, Westbrook, Conn., sale 9/67, "Murphy Estate," lot 591.

EXHIBITED:
On loan to N-YHS from Katharine Prentis Murphy, prior to 1967.

82b. OLIVE-GREEN HANDLED JUG WITH RUST AND YELLOW SPOTS
Artist unidentified
Probably vicinity of Gonic, Strafford County, or Plymouth, Grafton County, New Hampshire
c. 1830–1860
Glazed red earthenware
$7^5/8 \times 7^1/2$ in. diam.
P1.2001.90

PROVENANCE:
Mr. and Mrs. John G. Pennypacker, New Canaan, Conn.; Sotheby Parke-Bernet sale 4076, 2/78, lot 76.

83. BURNT ORANGE SLIPWARE PLATE WITH SPIRAL DECORATION
Artist unidentified
Vicinity of Goshen, Litchfield County, or Norwalk, Fairfield County, Connecticut
c. 1820–1850
Glazed red earthenware
$2^1/4 \times 12^3/4$ in. diam.
P1.2001.91

PROVENANCE:
David Pottinger, Topeka, Ind., 1973.

The vast number of folk potters operating in early New England were influenced by wider, less homogeneous styles and cultural forces than were the German and English potters of southeastern Pennsylvania. The earliest New England potters often established their operations during the initial phases of settlement, under harsh subsistence conditions that required simple, affordable utilitarian wares for domestic use,

42 Clifford A. Wallach and Michael Cornish, *Tramp Art: One Notch at a Time* (New York: Wallach-Irons Publishing, 1998), p. 35.

43 Dr. Tony Hyman, National Cigar Museum, Shell Beach, Calif., e-mail to the author, July 14, 2000 (AFAM files). I am indebted to Dr. Hyman for the information regarding the dating of cigar boxes.

44 For a complete discussion of tramp art, see Wallach and Cornish, *Tramp Art*, and Helaine Fendelman and Jonathan Taylor, *Tramp Art: A Folk Art Phenomenon* (New York: Stewart, Tabori & Chang, 1999).

45 J.A. Young, *Jurian Young and His Descendants* (Chilhowee, Mo.: n.p., 1886), cited in <www.rootsweb.com/~nyschoha/jayoung.html> (accessed June 2000).

46 Nancy McNicol, e-mail to the author, July 2, 2000 (AFAM files). Hanson Y[o]ungs was McNicol's first cousin three times removed. The progenitor of the American line is cited variously as Jurian and Jerg Hans Jung or Young.

food preparation, and storage. The strong redware forms and production techniques embraced by these early potters established the region's continued preference in the nineteenth century for sturdy utilitarian forms utilizing simple ornamental techniques. In Pennsylvania, many highly skilled English and Germanic potters arrived in an area already stabilized by more than one hundred years of concentrated, organized settlement. With extensive, supportive economies and consumer markets already in place, these potters found viable markets for more decorative, ornamental wares as well as larger outlets for their standard utilitarian forms.[47]

These three examples of New England earthenware suggest the range of simpler ornamented forms produced by potters within this diverse geographical region. In many smaller agrarian villages, such as Gonic and Plymouth, New Hampshire, common clay sources and the close working and creative relationships among intermarried potting families resulted in distinct forms and decorative glaze types that emerged to characterize the earthenwares of the region. In southern Connecticut, the importation of clays and the migration of trained potters from New Jersey and Pennsylvania, coupled with the migration of German and Dutch settlers into the region, resulted in plain and simple ornamented wares such as the slip-decorated plate, which demonstrates a closer relationship to the styles and forms produced in southeastern Pennsylvania. —J.L.L.

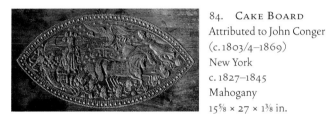

84. CAKE BOARD
Attributed to John Conger
(c. 1803/4–1869)
New York
c. 1827–1845
Mahogany
15⅝ × 27 × 1⅜ in.
P1.2001.92

PROVENANCE:
Sotheby's sale 5500, 10/86, lot 144.

Nineteenth-century baking literature refers to this type of carved board as a cake print, used to impress a design into a New Year's cake.[48] The tradition of baking New Year's cakes was probably introduced by the colonial Dutch, and the cakes were served during open house on New Year's Day. One of the earliest references to such cake boards is dated 1802 and contained in the ledger of Nathaniel Dominy, a furniture and clock maker in East Hampton, Long Island, New York.[49] Patriotic and political themes were well established as subjects to be incised into cake boards by the eighteenth century, but the boards that survive today date largely to the first half of the nineteenth century. The very fine and elaborate gouge carving on this cake print, contained in an

almond-shaped reserve, is sprinkled with stars and clusters of grapes. An American eagle holding the scales of justice is prominently placed at top center. Next to a large cornucopia, an allegorical figure of America as an Indian Princess holds a flagpole topped by a pileus, and two horses, cleverly carved with one body, prance beneath an angel holding the American shield aloft.

Cake prints with such elaborate carving and of this substantial size were used exclusively by professional bakers, restaurants, and hotels. Among the earliest documented New York City bakers to commission these prints were George Wilt and William Farrow, who was active from about 1815 to 1834. The best-known carver was John Conger, whose name has become synonymous with these elaborate carved boards. One John Conger, carver, is listed in the New York City business directories in various locations in lower Manhattan from 1827 until 1832; between 1837 and 1858, he is listed as a print cutter. From 1858 until 1869, Conger is again listed as a carver. During the 1830s, there is also a listing of a John Conger, baker, but his relationship to the carver has not been determined.

Conger's cake prints are sometimes stamped, providing a documented basis for attributing unmarked examples. They are distinguished by their clear and careful carving in short strokes and gouges that would impress cleanly in the baked product. Many elements were recombined from board to board to create new designs, and several feature political images. Conger's boards continued in circulation until about 1900, when the firm of James Y. Watkins bought out the stock and designs. Conger died in 1869 at the age of sixty-five and is buried in Green-Wood Cemetery in Brooklyn; his grave was unmarked until its recent rediscovery by descendants, who subsequently erected a headstone.[50] —S.C.H.

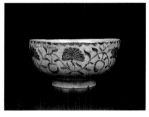

85. PUNCH BOWL
Attributed to John Crolius Jr. (1755–c. 1835)
New York
1811
Salt-glazed gray stoneware
7¾ × 15½ in. diam.
P1.2001.93

INSCRIPTION:
Exterior, incised: *Elisabeth Crane May 22, 1811 C. Crane*

PROVENANCE:
Edward J. Grassman, Elizabeth, N.J.; Sotheby Parke-Bernet sale 4103, 4/78, lot 28; Barry Cohen, New York; Kate and Joel Kopp, America Hurrah, and David A. Schorsch, New York, 1990.

47 For comparative examples and attribution information for the New England earthenware examples discussed here, see Lura Woodside Watkins, *Early New England Potters and Their Wares* (Cambridge, Mass.: Harvard Univ. Press, 1968), figs. 44, 51, 58.
48 Information in this entry based largely on William Woys Weaver, "The New Year's Cake Print: A Distinctively American Art Form," *The Clarion* 14, no. 4 (fall 1989): 58–63, and Louise C. Belden, "Cake Boards," *The Magazine Antiques* 138, no. 6 (December 1990): 1240–50.
49 Belden, "Cake Boards," p. 1242, n. 2. The cake board was made for Isaac Payne.
50 Evelyn Conger Caprio (artist's great-great-granddaughter), telephone conversation with the author, June 25, 2000.

PUBLISHED:

Bishop, Robert, and Jacqueline Marx Atkins. *Folk Art in American Life.* New York: Viking Studio
 Books in association with MAFA, 1995, p. 91.

Cooper, Wendy A. *In Praise of America: American Decorative Arts, 1650–1830.* New York: Alfred A.
 Knopf, 1980, pp. 48–49.

Gray, Kaaren Parker, and Jacqueline Gounet. "The Joy of Collecting American Folk Art: Barry
 Cohen." *House & Garden* (June 1982): 96–97.

Greer, Georgeanna H. *American Stonewares: The Art and Craft of Utilitarian Potters.* Exton, Pa.:
 Schiffer Publishing, 1981, frontispiece.

Pennington, Samuel, Thomas M. Voss, and Lita Solis-Cohen. *Americana at Auction.* New York:
 E.P. Dutton, 1978, p. 192.

Schorsch, David A. *The Barry Cohen Collection.* New York: America Hurrah and David A. Schorsch,
 1990, pp. 90–91.

A masterpiece of American folk ceramics, this large, impressive punch
bowl is one of the rarest and most important pieces of early stone-
ware in existence today. Its basic form follows that of contemporary Chi-
nese export porcelain examples, with a raised straight foot and rounded,
flaring wall, while its incised cobalt sgraffito patterns of undulating vines
and flowers and a lively, full-bodied fish decorating the bottom of its in-
terior show design parallels to Dutch and English tin-glazed bowls from
the seventeenth and eighteenth centuries. Its inscription suggests its
presentation as a marriage or anniversary gift to members of the influ-
ential Crane family, for whom Cranetown (now Montclair), in northern
New Jersey, was named.

The confidently thrown thin walls, even glaze surface, and accom-
plished decorative style of this bowl relate it to a larger group of early
decorated stoneware attributed to the pottery of John Crolius Jr. of New
York City (act. 1790–1812). Crolius was a second-generation potter; his
father, John, and uncle William had both previously established and
operated potteries in the city. His operations were located on the west
side of Chatham Street and probably occupied the site of the earlier
pottery bequeathed to him in 1779 by his uncle. As Crolius served as a
member of the Continental Army during the Revolutionary War, anti-
loyalist sentiments may have prevented his return and full management
of the operation until 1790, when he is listed at the pottery's Chatham
Street address.[51]

The close interrelationships forged by marriages or joint invest-
ment, and the resulting regular exchange of craftsmen and technological
advances between a number of early New York and northern New Jersey
potteries, has led to some confusion in the attribution of unsigned
examples. However, the coggle wheel–decorated, undulating scalloped
design encircling the rim of this punch bowl is found on several examples
signed by Crolius, and a number of examples of his signed work have
surfaced in the area of Montclair, suggesting a prior circle of patronage
enjoyed by the potter from early families like the Cranes. —J.L.L.

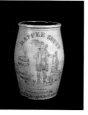

86. STORAGE JAR OR CROCK
Artist unidentified
New England, probably Boston
c. 1850–1870
Glazed gray stoneware
26⅝ × 15¼ in. diam. (at top)
P1.2001.94

INSCRIPTION:
Exterior, incised: *RAPPEE SNUFF / CLARK / BREWER / & SON / 14 / SO. MARKET / ST. /
BOSTON / TOBACCO / 14 SOUTH MARKET ST. / Manufactured by / CLARK BREWER & SON*

PROVENANCE:
Florene Maine, Ridgefield, Conn.; Stewart E. Gregory, Wilton, Conn.; Sotheby Parke-Bernet
sale 4209, "Gregory Collection," 1/79, lot 136.

D urable and inexpensive salt-glazed stoneware decorated with cobalt
oxide blue slip was made in most parts of New England. The pro-
duction of commercial stonewares increased as commerce and the Indus-
trial Revolution brought about the wider processing and distribution of
foodstuffs, spirits, and agricultural goods. Manufacturers up and down
the East Coast placed orders for stoneware jars, bottles, jugs, and larger
open-mouthed crocks, and many potteries offered to customize orders
with the names of enterprises, various decorative advertising and or-
namental patterns, or scenes such as that decorating this large snuff
container.

Research into manufacturing potteries in Boston has revealed no
such pottery operating under this name or at this address during the
nineteenth century. Therefore, it is assumed that the inscribed company
of "Clark Brewer and Son" was a dry-goods merchant or tobacco shop
at the address, and that this crock was a custom-designed advertising
fixture for the retailing of snuff within that establishment. Rappee snuff
was a dark, pungent, finely ground mixed snuff, also known as Cavendish
or Indian weed, and was manufactured in the West Indies, England, and
Holland, as well as America. Functioning much like the fabled "cigar
store Indian," this crock's decorative scene depicts a Native American
chief in full regalia offering tobacco in both its raw and its processed
state. Large in scale, this scene, perhaps of the legendary Seminole chief
Osceola, would have been a curiosity drawing attention to the store and
its contents.

Examples of nineteenth-century American commercial stonewares
with detailed, intricately incised sgraffito decoration on a large scale are
quite rare, and few of this quality are known to survive. Its size, with a
capacity of more than one hundred dry pints, as well as its finely exe-
cuted decoration and glaze, suggest the work of a skilled potter, whose
identity remains unknown. —J.L.L.

51 Crolius may have removed to Somerset County, northern New Jersey, during this time, as
 other members of the family were established there, and left management of the site in New
 York to his cousin, William I. Crolius, also a potter. For a thorough history of the different
 generations of the family's operations in New York and elsewhere, see William C. Ketchum Jr.,
 Potters and Potteries of New York State, 1650–1900 (Syracuse, N.Y.: Syracuse Univ. Press, 1987),
 pp. 45–50.

The successive waves of German-speaking immigrants who relocated to America throughout the eighteenth and early nineteenth centuries left an enduring and far-reaching influence on the cultural and artistic landscape of this country. While forty-eight of fifty states experienced significant Germanic settlement, no other colony and region benefited from and was transformed as significantly by their presence than was Pennsylvania. Among the first to arrive in support of William Penn's "Holy Experiment" in establishing the colony in 1683, Germanic settlers continued a steady migration to Pennsylvania throughout the first half of the nineteenth century. Diverse in background, representing Swiss, Austrian, German Palatinate, Alsacian, Prussian, and numerous other Germanic traditions in Europe, these populations most often partially assimilated into the surrounding, dominant English colonial culture while maintaining important aspects of identity and tradition from their homelands. In this process, the rich, hybridized culture of the Pennsylvania Germans developed, invigorating and transforming the intellectual, political, economic, and creative identity of the region.

While highly skilled, full- and part-time craftsmen were represented within the Pennsylvania German immigrant community throughout its history, their greatest period of artistic achievement seems to have occurred from 1770 to 1840. Roughly coinciding with seven decades of marked agricultural and mercantile development in the southeastern counties surrounding the urban port of Philadelphia, numerous rural, village, and urban craftsmen interpreted the changing needs, aesthetic tastes, and traditional activities of a burgeoning, prosperous, preindustrial community. The craftsmen, many of whom also labored seasonally as farmers, supplied a wide range of high-quality utilitarian and decorative household goods to both Germanic and Anglo-American consumers. The subsequent migration of Pennsylvania German settlers west, north, and south further spread the influence of Germanic traditions into the decorative arts of those regions. Their work inspired close parallels in the production methods, ornament, and aesthetic preferences embraced by craftsmen working in eighteenth- and nineteenth-century Ohio, Kentucky, Tennessee, Maryland, Virginia, North Carolina, South Carolina, Canada, and elsewhere.

Characterized by fine craftsmanship, a love of color and ornament, and the preferred use and maintenance of traditional forms and motifs, the furniture, pottery, metalwork, illuminated fraktur, and other craft products emanating from this rich community of craftsmen and patrons would rarely have been considered art by their makers or owners. These objects were instead valued because of the shared experiences and meaning their form or decoration might have conveyed, or because of the combination of utility, household decoration, communication of status, and daily convenience they may have afforded their owners.

One of the strongest decorative arts traditions maintained within the immigrant Germanic populations that settled in Pennsylvania between 1683 and 1850 was that of ceramics. Both utilitarian and decorative household forms, made from rich local clay deposits, were produced by highly skilled potters working in Philadelphia and the surrounding agrarian communities of Chester, Bucks, Lancaster, Montgomery, and Berks Counties from the earliest period of their settlement. Domestic needs and the developing agricultural market economy of the region created a burgeoning demand for utilitarian earthenwares and stonewares, while the maintenance within these communities of earlier European traditions of decorative ceramics used in ceremonial presentation, gift giving, and foodways ensured the survival of a range of highly ornamented, colorful forms.

Although a long-standing tradition of stoneware production existed in Germany, early examples of domestically produced white or gray stoneware are rare in Pennsylvania, and few traditional Pennsylvania German potters are known to have produced stoneware in the region prior to 1830. Only after 1840 were the finer, denser clays necessary to produce stoneware found in large amounts in the regions of York, Greensboro, Harrisburg, and Williamsport, in the south-central area of Pennsylvania. A number of small potteries and larger factories began to produce both plain utilitarian and decorated stoneware forms in these regions after this date, but their output and variety never equaled those of the earlier earthenware pottery traditions of the state.

The potter most often combined his work with other seasonal activities, placing it into the agricultural calendar whenever the craft's necessary labors could be best accommodated. Local potteries were often operated by a single master potter, who may have been assisted by an apprentice potter, journeymen, or trained family members, depending on the size of the business. Most smaller rural Pennsylvania potteries were able to supply only their immediate vicinity, and few of their products were retailed outside the local markets of nearby towns. Operations were usually passed down from father to son or through intermarriage, preserving not only their marketing position within the community but often the preferred forms, techniques, and decorations.

Pennsylvania German potters employed a relatively limited range of traditional methods in producing their wares. The potter's wheel was the most common forming method, although early immigrant Germanic potters adopted the use of molds through their interaction with the numerous local English-born or -trained potters. Simple thrown, slab-built, or molded wares could be augmented with surface decoration of appliqués, impressed designs, or, more commonly, the addition of incised sgraffito patterns or "trailed" slip decoration. Slip, or liquefied clay, usually yellow or white, could be mixed with metal oxides to produce greens, blacks, browns, and blues. This slip could be brushed or trailed over a form using a small pouring cup fitted with one or more quill spouts, which produced a fine line or lines of slip. The surface of the form could also be coated evenly with slip of one color and, once dried, scratched through to reveal the contrasting colored clay underneath. This sgraffito technique allowed for precisely drawn figural motifs, dates, or other inscriptions; colored metallic oxides applied as dry powders or slips provided further embellishment. The finished decoration usually received a final clear glaze coating composed most often of red lead, flint, and finely ground silica-rich sand.

Most utilitarian and decorated earthenwares such as these received only one firing in a wood-burning kiln, which could require several days of operation to reach its desired temperature. The updraft kilns used in Pennsylvania varied in form and construction, following the potter's individual preferences and accumulated knowledge of proper air flow, temperature, and burning and cooling times. Care and familiarity with the firing process prevented the wares from exploding, warping, or melting during the firing and ensured the desired colors from the slips and glazes. The confidence of these early folk potters and the central purposes their wares served for their communities are perhaps best expressed by an inscription found on a number of surviving sgraffito-decorated plates: "From the earth with sense the potter makes everything."　　—J.L.L.

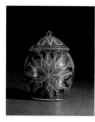

87.　COVERED JAR WITH STAR DECORATION
Solomon Grimm (1787–?)
Rockland Township, Berks County, Pennsylvania
1822
Glazed red earthenware
10 × 5¾ in. diam.
P1.2001.95

INSCRIPTIONS:
Exterior, slip: *1822;* underside, incised: *Grimm*

PROVENANCE:
Howard Feldman, Pennsylvania, 1987.

EXHIBITED:
"Pennsylvania Folk Art," AAM, 1974.

PUBLISHED:
Allentown Art Museum. *Pennsylvania Folk Art.* Allentown, Pa.: AAM, 1974, p. 50.
Schaffner, Cynthia V.A., and Susan Klein. *Folk Hearts: A Celebration of the Heart Motif in American Folk Art.* New York: Alfred A. Knopf, 1984, p. 93.

This colorfully glazed, sgraffito-decorated covered jar is by Solomon Grimm, a potter who was born in Maxatawny Township, Berks County. The son of a prosperous Pennsylvania German farmer and miller, Grimm may have apprenticed with potter John Leisenring, an immigrant from Silesia who was practicing in the township by 1786 and owned land near the Grimms' mill. From 1815 to 1825, Grimm is thought to have apprenticed with a potter by the name of Weiss in Rockland Township, Berks County, where Grimm's name appears regularly in town records. Most of the known dated examples bearing his flowing script signature fall within his years of residence there. His younger brother Daniel may have joined him in the pottery by 1824, as several plates utilizing similar glaze and decoration are known that bear a script *D* on their bottoms.[1]

The form of this jar relates closely to several earlier examples with slip decoration produced within the Moravian and German Reformed communities of southeastern Pennsylvania.[2] The elevated, conical lid

with an interior rim flange, the overturned, pronounced rim of the mouth of the jar, and its lower beaded foot rim are elements found on typical Moravian-influenced examples from Upper Montgomery, Bucks, and Berks Counties. Possibly inspired by his apprenticeship with Leisenring, whose Old World training would have utilized and maintained such early traditional forms, Grimm continued to draw from these late-eighteenth-century forms and patterns of decoration.

Several surviving jars of this form, along with a number of similarly decorated plates bearing Grimm's signature, attest to his preference for dense sgraffito patterns further defined by bright, multicolored slip decoration. Over deep vivid green or bright yellow slip grounds, the potter incised hearts, tulips, diamonds, and oversize compass-drawn pinwheel stars, punctuating the inner fields of these designs with closely spaced, deeply impressed dots and cross-hatching. Some elements were carved through the colored slip grounds, baring the red clay surface of the form. Other elements of the design were repainted with yellow, red, or black slips to further differentiate them from their surrounding surfaces. This multiple layering of slip and sgraffito decorative techniques results in a lavishly glazed and tooled surface and distinguishes Grimm's work from that of most of his contemporaries.　　—J.L.L.

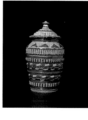

88.　COVERED JAR WITH INCISED VERTICAL AND HORIZONTAL BANDS
Artist unidentified
Southeastern Pennsylvania
c. 1820–1850
Glazed red earthenware
10½ × 5¼ in. diam.
P1.2001.96

INSCRIPTIONS:
Undersides of base and lid, incised: 3

PROVENANCE:
Hostetter Collection, Lancaster, Pa.; Mabel Renner, York, Pa.; Richard Harlow, Pennsylvania; Richard Wood, Baltimore; Evelyn Byrd Deyerle, Charlottesville, Va.; Dr. and Mrs. Henry P. Deyerle, Harrisonburg, Va.; Sotheby's sale 6716, "Deyerle Collection," 5/95, lot 358.

The molded horizontal bands and elaborate tooled cutwork decorating the surface of this covered jar are rarely seen in the work of Pennsylvania's rural potters. This type of turned, molded decoration, elements of which were executed while the completed hand-thrown form remained attached and malleable on the potter's wheel, relates to techniques of "machine tooled," molded, or cut banded decoration found in earlier eighteenth-century English and Continental ceramics traditions. The decoration also relates to a number of late-eighteenth- and early-nineteenth-century earthenware examples from southern Austria; these were carved with a series of wooden ribs and looped wire tools while the form rotated on a wheel. Czechoslovakia and the Austrian

1　One example with similarly executed sgraffito tulips and stars is in the collection of PMA.
2　A jar showing a close relationship in form and decoration, signed by German Reformed potter Christian Klinker of Bucks County and dated 1773, is recorded in the Index of American

Design; see Frances Lichten, *Folk Art of Rural Pennsylvania* (New York: Charles Scribner's Sons, 1946), p. 29.

Tyrol incorporate similar gouge-cut bands and molded, raised surfaces in their decorations.[3] The unusual basic form of this example is drawn more directly from traditional Chinese ceramics than from the Continental and English pottery traditions that more often informed the work of rural folk potters in Pennsylvania.

The potter responsible for this jar had to anticipate the decorative elements to be used during his initial throwing of the form on the wheel. The walls of the vessel, thicker than normal, afforded the later creation of negative-cut bands that, in turn, formed the raised, carved bands of finished decoration. To cut away areas of the vessel's uniform thick wall, the potter pressed a variety of sharp-edged, shaped wooden ribs and handled, looped wire-cutting tools against the vertical surface while the form rotated on the wheel. The individual horizontal and vertical slash cuts on the jar were then either incised one by one by hand or created using a carved wooden or clay rolling coggle wheel, which impressed the ribbed design on the surface of the raised bands of the form. Once the carving was completed, the jar was selectively painted by hand with oxide-colored slips to accentuate the raised and recessed elements of its design.

Only three such examples of this form and decoration are known, all with associated histories in the Lancaster area of Pennsylvania. This jar bears the numeral 3 on the undersides of its base and lid, possibly indicating that it was the third covered jar with such intricate surface decoration produced by this unknown master potter.[4] —J.L.L.

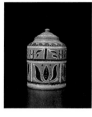

89. COVERED JAR WITH BANDS OF TULIPS
Artist unidentified
Probably Montgomery County, Pennsylvania
c. 1780–1840
Glazed red earthenware
9¾ × 6¼ in. diam.
PI.2001.97

PROVENANCE:
Joe Kindig Jr., York, Pa., 1971.

The Germanic immigrant groups that settled in Pennsylvania were of diverse religious faiths and included Lutherans, German Reformed, and Catholics, as well as various smaller sectarian groups such as the Dunkers, Mennonites, Moravians, and other communal pietist groups. Many brought with them elements from their earlier lives and belief systems which they preserved through the maintenance of traditional ceremonies, religious symbols, domestic lifestyles, and shared aesthetic preferences. The straight, vertical walls, molded foot rim, and raised conical top and banded slip decoration of this jar are characteristic of

a number of similar forms produced by potters working within the Moravian community in Bucks and Montgomery Counties. While many of the jars are thought to have been used for the storage of tobacco or snuff, they most likely served multiple purposes within the household.[5]

Census and tax records document more than forty-five potters operating in the small farming communities and townships scattered over Montgomery County during the first half of the nineteenth century. Working in close proximity and in all likelihood exchanging workmen and production techniques, this concentration of artisans produced a wide range of both utilitarian and decorative ceramic forms. Hand-raised on a potter's wheel, the walls of this jar are thinly thrown. To smooth out and correct any undulations or finger ridges, the potter held a straight-edged wooden rib tool against the walls of the jar while it was still turning on the wheel. The abrupt inward tilt of the jar's shoulder also was formed with this tool.

Slip decoration consisting of horizontal bands with vertical line divisions that create boxes or windows for figural motifs such as tulips, stars, dots, or geometric designs are also often associated with the Moravians.[6] In this example, the potter made yellow clay and black iron oxide, a by-product of iron founding, into slip, applying it to the surface with a slip cup. Once these decorations were complete, the entire surface was coated with a clear lead- and silica-based glaze that, when fired, produced a glossy, hard, and watertight finish. —J.L.L.

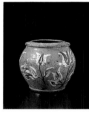

90. JAR WITH TULIP DECORATION
Attributed to Christian Klinker (act. 1773–1798)
Nockamixon Township, Bucks County,
Pennsylvania
c. 1780–1795
Glazed red earthenware (lid missing)
6½ × 6¼ in. diam.
PI.2001.98

PROVENANCE:
Joe Kindig Jr., York, Pa., 1971.

Few surviving hollowware forms of decorated Pennsylvania earthenware can be firmly dated prior to 1800. The tendency within many traditional communities to maintain early utilitarian forms and decorative motifs in the face of changing preference or fashion and the pattern of intergenerational apprenticeships within many potting families resulted in the retention of earlier eighteenth-century styles well into the nineteenth century. Unfortunately little is known of many of the eighteenth-century potters producing in the region; their operations and activities predated most of the periodic census, birth, and tax

3 For related Continental examples, see Frances Lichten Files, American Department, PMA.
4 Of these, a related example with a more ornate lid finial, formerly in the McKearin Collection, is now in the collection of the Henry Ford Museum, Dearborn, Mich. A slightly smaller version, now missing its lid, is in a private collection in Baltimore.
5 For a closely related example, see Beatrice B. Garvan, *The Pennsylvania German Collection* (Philadelphia: PMA, 1982), p. 208; PMA's example was also recorded in 1936 by Frances

Lichten for the Index of American Design, in whose records it is illustrated with a watercolor rendering by WPA artist W.L. Antrim.
6 Pennsylvania Moravians also carried these stylistic traditions in ceramics to North Carolina during the 1770s and 1780s. Similar designs can be seen in the work of several potters in the Moravian communities of Bethabara and Salem.

records that were standardized by the early nineteenth century in most rural Pennsylvania communities.

Several aspects of the fabrication and glaze character of this jar relate it to the earliest traditions of redware production among the Germanic potters working in Pennsylvania and specifically to the work of Christian Klinker, who is listed in surviving real estate documents as an "earthen potter." Several extant pots of similar form, thinly constructed with a raised lid rim flange integral to the base, bear the initials "C.K." on their bases and are decorated with the same light-orange lead glaze, unevenly applied over densely pigmented yellow, green, and black slip decoration.[7] Utilitarian earthenware forms with covers resting on raised base rim flanges are found on Continental Swiss, Austrian, and German hollow-ware examples dating from the late seventeenth century, and it is from these earlier traditions that Klinker and his contemporaries in Pennsylvania probably drew their aesthetic preferences and technical training.

The clays used in this example show little evidence of extensive milling or refining to remove the natural impurities that often characterize nineteenth-century redware. Its dark red color is indicative of a high iron content, which later potters often diluted by adding other clays to their recipes. This high iron content frequently contributed to glaze inconsistencies as chemical changes occurred during the firing process, resulting in color shifts and a lack of proper adherence to the surface of the finished form.　　　　　　　　　　　　　—J.L.L.

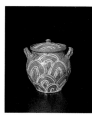

91.　Covered Jar with Handles and Slip Decoration
Artist unidentified
Probably Bucks County, Pennsylvania
1790
Glazed red earthenware
7⅛ × 6¼ × 5⅛ in.
P1.2001.99

INSCRIPTION:
Exterior, slip: *1790*

PROVENANCE:
J. Stogdell Stokes, Philadelphia; Parke-Bernet sale 947, "Stokes Collection," 3/48, lot 38; Arthur J. Sussel, Philadelphia; Parke-Bernet sale 1847, "Sussel Collection, Part I," 10/58, lot 244; Jess Pavey, Detroit; Garth's sale 10/67, "Pavey Collection," lot 589.

While the form of this small covered jar is similar to several others thought to have been made within the early Moravian communities of southeastern Pennsylvania, its abstract decoration of arched, two-color slip is atypical among the known preferred motifs utilized by traditional folk potters in the region. Applied using a two-spouted slip cup, the graduated arched lines of yellow and green covering its sides and lid have been placed by the potter to give the impression of three-dimensional overlapping petals or shells.

Covered jars of this type were most likely used for storing foodstuffs such as sugar, various prepared medicines, or dried herbs. Small containers of this scale and form also held tobacco and snuff, as the unusual petal-like decoration may suggest. Thinly potted and glazed on its interior, the domed lid rests in a raised rim flange. The shallow reservoir at the juncture of lid and flange could be sealed with melted beeswax to keep the contents fresh.[8] While the maker of this jar remains unknown, its overall form and the character of its applied slip decoration show some relationship to the work of Christian Klinker (act. 1773–1798), of Bucks County. An open jar in the collections of the Philadelphia Museum of Art, signed by Klinker and dated 1787, incorporates the raised rim flange, beaded foot rim, and overall form seen in this example, as well as the unusual ruffled or crimped applied handles.[9] The slip decoration on the Klinker example also includes an abstract tulip formed by concentric arched lines laid down similarly to the arched petal or shell designs seen in this piece.　　　　　　　　　—J.L.L.

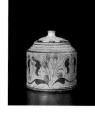

92.　Covered Jar with Sgraffito Tulip Decoration
Possibly Conrad Mumbouer (1761–1845) or John Monday (1809–1862)
Haycock Township, Bucks County, Pennsylvania
c. 1830–1840
Glazed red earthenware
7¼ × 6 in. diam.
P1.2001.100

PROVENANCE:
George Horace Lorimer, Philadelphia; Bernard and S. Dean Levy, New York, 1977.

EXHIBITED:
On loan to TBM from the George Horace Lorimer Collection, c. 1942–1977.

Interrelationships resulting from apprenticeship training, work indentures, and intermarriage were common among Pennsylvania's early potters, and the resulting stylistic ties and parallels in production techniques often make the works of closely related artisans difficult to differentiate. This is clearly illustrated in the work histories and productions of potters Conrad Mumbouer (or Mumbower) and his son-in-law John Monday (or Mondau). This straight-walled jar or canister with sgraffito decoration scratched through an overall yellow slip is typical of the shared forms and decoration produced by both these potters during the second quarter of the nineteenth century. Influencing a wide circle of local potters during the first half of the nineteenth century through various apprenticeships and contractual employment in their shop, Mumbouer and Monday are typical of several local intergenerational pottery family dynasties that developed within the small mercantile and agrarian economies of the region.

7　See Garvan, *Collection*, pp. 177, 207, 361. Also, a low-form handled bowl, descended in the Klinker family and recently acquired by PMA, relates closely to this jar.

8　Two examples of these small lidded containers—one in the collection of the Barnes Foundation,

Merion, Pa., and the other in the collection of PMA—retain traces of these early wax lid seals and the aroma of tobacco in their interiors.

9　Garvan, *Collection*, pp. 177, 361, and Lichten, *Rural Pennsylvania*, pp. 22, 29.

Mumbouer is first recorded as a potter working in Haycock Township with the potters Michael and Henry Stoneback, with whom he probably apprenticed. In 1793, after Henry's death, the operation was transferred to Mumbouer. By 1798 he had improved and expanded it to encompass "1 old log house, 1 log barn and 1 pottery shop, 30 × 15'."[10] The property adjoined the pottery of Joseph and Henry Mills, and he maintained a close tie with these potters as well as with the sons of the Stonebacks, who remained in the area as potters. In 1831 Mumbouer took on as an apprentice John Monday, who, in 1834, married his daughter, Phebe. Father and son-in-law continued to work side by side until the elder potter died in 1845. In his will, he transferred "211 acres and my pottery, together with privilege of taking and converting for his own use all clay in and upon the lot" to Monday.[11] Later apprentices to the operation included German immigrants Mathias Myer and Charles Moritz and Monday's sons Edmund (1835–?) and David (1846–?). Upon Monday's death in 1862, the family pottery, which had operated along Kimbel's Creek at the base of Haycock Mountain since its founding in 1794, was sold to potter Simon Singer for $2,500.[12] —J.L.L.

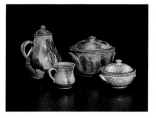

93a. COFFEE OR CHOCOLATE POT
Artist unidentified
Southeastern Pennsylvania
c. 1800–1840
Glazed red earthenware
9 × 5½ in.
P1.2001.101

PROVENANCE:
Elie Nadelman, New York; George Horace Lorimer, Philadelphia; Bernard and S. Dean Levy, New York, 1978.

EXHIBITED:
On loan to TBM from the George Horace Lorimer Collection, c. 1942–1977.

93b. PITCHER
Artist unidentified
Southeastern Pennsylvania
c. 1830–1860
Glazed red earthenware
3⅝ × 4 × 3¼ in.
P1.2001.102

PROVENANCE:
Katharine Prentis Murphy, Westbrook, Conn.; O. Rundle Gilbert Auction at Candle Light Farm, Westbrook, Conn., sale 9/67, "Murphy Estate," lot 601.

EXHIBITED:
On loan to N-YHS from Katharine Prentis Murphy, prior to 1967.

93c. LARGE COVERED BOWL WITH HANDLES
WITH SPONGEWORK AND SEAWEED DECORATION
Artist unidentified
Southeastern Pennsylvania
c. 1820–1850
Glazed red earthenware
6½ × 8¼ × 7¾ in.
P1.2001.103

PROVENANCE:
Sam Yeagley, Annville, Pa., 1972.

93d. SMALL COVERED BOWL WITH HANDLES
WITH SPONGEWORK AND SEAWEED DECORATION
Artist unidentified
Southeastern Pennsylvania
c. 1820–1850
Glazed red earthenware
4 × 5⅞ × 5⅜ in.
P1.2001.104

PROVENANCE:
Ed and Mildred Bohne, Newmanstown, Pa., 1978.

Traditional redware potters in Pennsylvania used a variety of glazing materials and methods and regularly experimented with new techniques that would expand the range of wares they could produce and supply to local markets. Liquefied clays, or slips, were made from naturally occurring white or yellow clays or colored with different mineral oxides. These slips and oxide colorants could be applied by dipping, painting, sponging, or "trailing" the material on the undecorated form with the use of a spouted slip cup (see cat. no. 96b). The most successful potters possessed a knowledge of these mineral-based colorants, their interactions with the clays used in the wares, and the different effects temperature and kiln atmosphere had on their resulting color and glaze character. A number of innovative decorating techniques entered the shops of locally trained potters through the arrival of foreign-trained apprentices familiar with English or Continental production methods; some were developed by local potters through experimentation in an attempt to produce decorative wares to rival popular imported ceramics.

The forms and decoration of this group of locally produced earthenwares were inspired by popular imported English mochawares and agatewares. Beginning in the early 1780s, these refined, decorative tablewares—thinly potted or molded from white earthenware, creamware, and pearlware clay bodies—were imported by a number of Philadelphia merchants. Their naturalistic veined and patterned seaweedlike slip decoration, mottled, colorful glazes, and refined shapes proved to be a popular, affordable alternative to the rarer and more expensive

10 Information based on Garvan, *Collection.*
11 Ibid.

12 For further genealogical information, related examples attributed to the two potters, and similar examples of interconnections among potting families, see ibid., pp. 184–86, 364–65, biographical index.

imported porcelains. Shopkeepers and overland traders from the smaller satellite townships and villages surrounding Philadelphia regularly brought these and other imported ceramics into the Pennsylvania German and Scotch-Irish farming communities, where their affordability, novelty, and decorative appeal found a ready market among middle-class households.

Few local potters succeeded in the production of these technically complex glazes.[13] The iron-rich red clays of Pennsylvania differed from the refined light-yellow and white clays used in England, and impurities affected the final colors of glazes. The lead- and silica-based glazes applied by most Pennsylvania potters were unpredictable and prone to irregular or excessive running when fired. Through experimentation with these local materials, however, some potters developed a thick yellow or white clay slip to which ground feldspar and tin were added. When dried, its surface approximated the lighter, finer quality of the imported wares. A thin "tea" of turpentine, urine, tobacco juice, and metal oxides was applied in heavy splotches near the base of the forms. Copper oxides produced green, while manganese oxide turned an iridescent brown. The forms sat upside down in the kiln during firing, and as the heavy slip and colorant tea mixtures interacted and melted, they flowed downward, producing veined, seaweedlike patterns.[14] Still, this formula and technique were subject to the wide variations of clay and kiln, as the less distinct, blurred patterning of the coffee or chocolate pot in this group suggests.

—J.L.L.

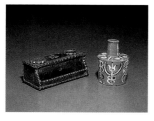

94a. INKSTAND

Attributed to David Haring (1801–1871)
Nockamixon Township, Bucks County, Pennsylvania
1852
Glazed red earthenware
2¾ × 7¼ × 3¼ in.
P1.2001.105

INSCRIPTIONS (TRANSLATION OF GERMAN):
Back, incised: *Black as ink, red as blood. A rash promise or a bad woman's kiss, Heinrich L. Haring, Written in the year 1852 November 13*

PROVENANCE:
George Horace Lorimer, Philadelphia; Bernard and S. Dean Levy, New York, 1977.

EXHIBITED:
On loan to TBM from the George Horace Lorimer Collection, c. 1942–1977.

94b. INK BOTTLE

Artist unidentified
Southeastern Pennsylvania
c. 1835–1860
Glazed red earthenware
5 × 3¼ in. diam.
P1.2001.106

INSCRIPTION:
Underside, slip: *W*

PROVENANCE:
James and Nancy Glazer, Villanova, Pa., 1966.

Literacy and the ability to write were highly regarded among most Pennsylvania Germans. The skills not only allowed the pious to read the Bible and other religious texts but also enabled individuals to keep essential records and calculations required by the farm cycle, business correspondence, and family affairs. Most children received training in penmanship from their schoolmasters, who often were highly skilled in writing and decorative calligraphy. Parochial schools of the German Reformed and Lutheran congregations, as well as seasonal classrooms established by the smaller, minority groups such as the Mennonites, Moravians, Dunkers, and Amish, provided disciplined study during the short school terms scheduled between planting and harvest. The scrivener, usually the traveling schoolmaster and clergyman, supplied decorated certificates of birth and baptism, bookplates for religious texts and songbooks, and the cherished rewards of merit for accomplished students.

This decorated earthenware inkwell and ink bottle provide historical witness to these community traditions. Both were produced by Pennsylvania German craftsmen and follow contemporary forms manufactured in metal and glass. Similar pewter, tin, or brass writing stands, constructed of rolled sheet stock soldered and engraved with decorative ornament or inscriptions, were both imported and produced locally and may have served as a design prototype for the inkstand, whose structure resembles these metal examples.[15] The potter constructed it using traditional slab-building, in which flat sheets of clay were cut and joined together with wet slip clay. The pottery founded by David Haring in 1827 is known to have produced a number of different forms that incorporated slab-built techniques. Some of Haring's tools survive and include the coggle wheels, stamping tools, and rolling pins necessary to have produced and decorated this example.[16]

Blown and molded glass bottles became commonplace receptacles for commercial inks in America by 1830 and may have inspired the high-necked, flat-shouldered form of this clay example that combines slab-built and wheel-thrown techniques. The tulip and circle motifs and the dot patterning in opaque yellow and black slip on this unattributed ink bottle are similar to the slip decoration seen in works by a number of potters working in the Moravian communities of Bucks and Montgomery Counties of Pennsylvania during the period.

—J.L.L.

13 The only signed examples from Pennsylvania of which I am aware were produced by John Bell of Waynesboro, Pa.

14 The formula for the tea glazes followed known English recipes and may have been gained through published sources or from immigrant potters working in the region; see Geoffrey A. Godden, *British Pottery: An Illustrated Guide* (London: Barrie and Jenkins, 1974), for similar lists of glaze components.

15 In addition, several earlier earthenware examples made in the Staffordshire area of England c. 1700–1750 and traditional tin-glazed examples from Holland are known. One English example, with similar hunter and deer motifs, is in the collection of the 1704 Brinton House, Chadds Ford, Pa.

16 Garvan, *Collection*, pp. 76–77.

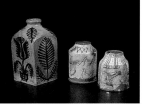

95a. FOUR-SIDED TEA CANISTER
Artist unidentified
Southeastern Pennsylvania
1846
Glazed yellow earthenware
7½ × 3¾ × 3⅝ in.
P1.2001.107

INSCRIPTION:
Underside, incised: *Tea Canister made Sept. 22 1846*

PROVENANCE:
Chris A. Machmer, Annville, Pa., 1994.

95b. TEA CANISTER WITH INITIALS
Artist unidentified
Southeastern Pennsylvania
1793
Glazed red earthenware
5 × 3⁵⁄₁₆ in. diam.
P1.2001.108

INSCRIPTION:
Exterior, incised: *A M 1793 A C*

PROVENANCE:
Harry B. Hartman, Marietta, Pa., 1972.

95c. "DODOE" TEA CANISTER
Artist unidentified
Southeastern Pennsylvania
c. 1790–1820
Glazed red earthenware
4¼ × 3⁵⁄₁₆ in. diam.
P1.2001.109

INSCRIPTION:
Exterior, incised: *Dodoe*

PROVENANCE:
George Horace Lorimer, Philadelphia; Parke-Bernet sale 551, "Lorimer Collection, Part I," 3/44, lot 414; Joe Kindig Jr., York, Pa., 1967.

By the mid-1700s, the exotic custom of drinking tea was firmly established among the upper and middle classes of colonial America. In Pennsylvania, a number of early travelers commented on the widespread popularity of the beverage among both urban and rural English and Germanic households. Swedish minister Israel Acrelius observed during his travels in Pennsylvania in the late 1740s that the custom had reached even the more isolated communities: "Tea is a drink very generally used. No one is so high as to despise it, nor any one so low as not to think himself worthy of it.... It is always drunk by the common people with raw sugar in it. Brandy in tea is called lese."[17] Tea merchants realized the lasting pungency of their products required a dry, relatively airtight storage environment and prescribed such canisters or boxes for their customers.

As new domestic customs in the service of food and beverages emerged, local craftsmen scrambled to create new table forms to accommodate the trends. While matching serving suites for the drinking of tea, coffee, and chocolate remained rare in most Pennsylvania households throughout the eighteenth century, individual teapots, tea "caddies," sugar bowls, cream pots, and cups grew to be regular products of the redware potter. One of the earliest surviving examples of Pennsylvania sgraffito-decorated earthenware is, in fact, a tea canister dated 1767 and made by Bucks County English potter Joseph Smith.[18]

The three tea canisters from the Esmerian Collection suggest the range of techniques employed by Pennsylvania potters to produce the form. The four-sided tea canister, from the mid-nineteenth century, follows the form of contemporary manufactured blown-in-mold glass medicine or "case" beverage bottles of the period. This canister was thrown with rounded walls on a wheel. The walls were then flattened and trimmed on each side while the clay remained wet and plastic; crisp bevels were trimmed on its corner edges prior to application of the trailed slip decoration. Identified by its inscription as a "tea canister," its opening was probably sealed with a simple round cork stopper.

The other two tea canisters are early types, with thin wheel-thrown walls and tapering angular necks. Their form follows that of imported English creamware and pearlware examples. Both are ornamented with opaque yellow slip, through which sgraffito patterns have been applied and green copper manganese splotches added. On one, the sgraffito pattern of a bird and the word "dodoe" has been incised, perhaps documenting the extinct, heavy, flightless bird that held the interest of many amateur naturalists during the period. —J.L.L.

17 Israel Acrelius, *A History of New Sweden; or, The Settlements on the River Delaware,* vol. 2 (Philadelphia: Historical Society of Pennsylvania, 1874).

18 Rawson W. Haddon, "An Early Decorated Canister," in Diana Stradling and J. Garrison Stradling, *The Art of the Potter* (New York: Main Street/Universe Books, 1977), p. 27.

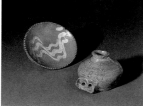

96a. Miniature Slipware Plate
Artist unidentified
Southeastern Pennsylvania
c. 1820–1850
Glazed red earthenware
⅝ × 4¹⁵⁄₁₆ in. diam.
P1.2001.110

PROVENANCE:
John Gordon, New York, 1966.

96b. Slip Trailing Cup
Artist unidentified
Southeastern Pennsylvania
1827
Glazed red earthenware
2¾ × 2⅜ × 3⅛ in.
P1.2001.111

INSCRIPTION:
Exterior, incised: *Jake / 1827*

PROVENANCE:
Dr. and Mrs. Henry P. Deyerle, Harrisonburg, Va.; Sotheby's sale 6716, "Deyerle Collection," 5/95, lot 591.

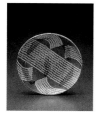

97. Slipware Charger with Combed Decoration
Artist unidentified
Southeastern Pennsylvania
c. 1800–1840
Glazed red earthenware
2⅞ × 15½ in. diam.
P1.2001.112

PROVENANCE:
Walter G. Himmelreich, Ronks, Pa.; Pennypacker sale 5/73, "Himmelreich Collection," lot 205.

EXHIBITED:
"The Pennsylvania German: His Arts and Handicrafts," William Penn Memorial Museum, Harrisburg, Pa., 1968.

Slip decoration, in which liquefied colored clays or mineral oxides are painted, dripped, or "trailed" on the surface of a form prior to firing, was a common traditional method of embellishing utilitarian and ornamental earthenwares. Popular in Europe, the decorating technique was brought by immigrant craftsmen to most centers of pottery production in early America. This potter's slip trailing cup, the miniature plate, or "cup" plate, and the charger illustrate aspects of this popular decorative technique as it was employed by numerous folk potters in Pennsylvania.[19]

While simple in concept, slip decoration required deep knowledge of the different properties of clays and how the various metal oxides and minerals used as colorants reacted with clay and glaze formulas during firing. If the properties of a slip were incompatible with the clay body, or

19 The miniature plate is the first piece of American folk art that Ralph Esmerian purchased.

if the slip did not fuse well with the glaze, it could flake off or excessively melt and flow during the firing, ruining the finished work.

A potter usually made his own slip trailing cups, basing the shape, volume, and number of spout openings on personal preference. It was important that the interior of the cup be glazed so that it could be reused—if left unglazed, its porous interior would absorb and retain traces of the color oxides, contaminating later contents. The holes were fitted with hollow quill or reed spouts, which were sealed in place with wax or wet clay. The spouts helped to promote the even flow of the slip, but rarely were slip cups made with more than four spout openings, as the flow was difficult to manipulate. A potter also had to be mindful of the consistency of the slip in the cup and to apply the designs carefully and quickly before the mixture thickened and clogged the spouts.

The yellow slip design on the miniature plate was produced with a three-spouted cup much like the example illustrated. The potter moved the cup in such a way while pouring the slip to produce the wavering parallel lines of the design. The slip patterns present on the charger required multiple passes of a three- or four-spouted cup, drawn carefully across the form to maintain equal spacing of the trailed lines. Once the lines of slip were applied, a wet quill, stick, or toothed wood comb was pulled through while they were still wet, creating the combed waver of the design. Combing, often found in early English earthenware traditions, could be used with multiple slip colors, producing the swirled "agateware" decoration popular in Pennsylvania and elsewhere.

—J.L.L.

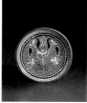

98. Slipware Plate with Black Tulips
Artist unidentified
Southeastern Pennsylvania
1816
Glazed red earthenware
2 × 11⁹⁄₁₆ in. diam.
P1.2001.113

INSCRIPTION:
Surface, slip: *1816*

PROVENANCE:
George Horace Lorimer, Philadelphia; Parke-Bernet sale 551, "Lorimer Collection, Part I," 3/44, lot 443; Pennypacker sale 6/79, lot 118; James and Nancy Glazer, Philadelphia, 1984.

EXHIBITED:
"Swiss Folk Art: Celebrating America's Roots," MAFA, 1991/92.

This plate combines elements of both wheel-thrown and sheet-drape-molded techniques. Its angular outer wall, turned-over edge rim, and trimmed, squared foot are typical of a range of early Continental deep-dish forms made by immigrant earthenware potters in Pennsylvania. The turned-over rim, fashioned on a wheel by first thinning the plate's outer edge and then folding it over and smoothing its surface round, provided a thicker, more durable plate with a rim less susceptible to chipping than those with thin notched coggled edges. Unlike full sheet-drape-molded earthenware plates from the region, this plate has differing inner and outer profile contours because of the combination of techniques used to form it.

The crisp lines distinguishing the multiple colors and dense patterning of this plate make it a masterpiece of slip decoration. The layered applications of colored slips and their careful removal, reapplication, and overlaying required close familiarity with the clays and their interactions and properties when fired in the kiln. Once the plate was partially dry, the potter applied a yellow slip coat to the entire inner face, then placed it back on the wheel and formed the band of yellow by scraping away either side, exposing the red clay underneath. The dark brown band encircling the central floor of the plate was composed of manganese oxide slip, which was applied with a brush over the yellow slip coating while the plate rotated slowly on the wheel. Red and yellow "squiggle" lines were overlaid on these bands with a slip cup. Much like a relief carver, the potter carefully removed the yellow slip coating surrounding the central design of vines and tulips emanating from a heart. The remaining yellow slip elements were further highlighted with brushed copper green and manganese brown slips and the date "1816" applied using a slip cup. Finally, the plate received a coating of clear lead- and silica-based glazes and was fired to meld and unify the different designs ornamenting its surface.

While the maker of this plate remains unknown, the methods and motifs relate closely to the work of several traditional Moravian and German Reformed potters working earlier in southeastern Pennsylvania, such as Abraham and George Hubener (1757–1828), John Leidy I (1764–1846), and John Leidy II (1780–1838) (see cat. nos. 104, 113b).[20]

—J.L.L.

convex plate form—made either of fired clay or of turned wood—on the potter's wheel and trimmed on its edge, thus creating the dished shape of the plate. It could then receive an overall simple lead glaze or a contrasting colored slip and incised sgraffito motifs.

If the plate was to receive slip decoration, the liquid slip was trailed on the flat clay disc with a slip cup. Once this decoration was set enough not to smear or run, the disc was further rolled while flat or turned over on the form and pressed until the applied slip was forced into the surface of the clay. This helped ensure the slip decoration would remain integral with the clay during firing. Once shaped on the plate form and trimmed on the wheel, the edge of the finished form could be decorated using a ridged, rotating coggle wheel, which produced the serrated edge common to most redware plates. While some earthenware plates and shallow pans were raised completely by hand on the potter's wheel, the majority of potters preferred sheet-drape molding, which allowed for more efficiency and speed in the production of multiple plate forms.

This Pennsylvania slip-decorated plate shows a close relationship in glaze, slip color, and clay character to southern Connecticut examples and was likely made in one of the Quaker-owned potteries operating in Montgomery and Bucks Counties. Business ventures and family connections between these Pennsylvania operations and the Quaker-owned potteries in Essex and Bristol Counties of Connecticut brought an exchange of trained potters, local clays, and glaze materials between these two pottery centers, and such ties probably led to the shared stylistic preferences and physical similarities.[22]

—J.L.L.

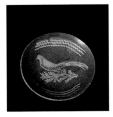

99. SLIPWARE PLATE WITH BIRD ON BRANCH
Artist unidentified
Southeastern Pennsylvania
c. 1800–1840
Glazed red earthenware
2⁵⁄₁₆ × 13¼ in. diam.
P1.2001.114

PROVENANCE:
George Horace Lorimer, Philadelphia; Parke-Bernet sale 551, "Lorimer Collection, Part I," 3/44, lot 449; Mabel Renner, York, Pa.; Pennypacker sale 11/58, "Renner Collection," lot 568; Dr. and Mrs. Henry P. Deyerle, Harrisonburg, Va.; Sotheby's sale 6716, "Deyerle Collection," 5/95, lot 625.

Simple, unadorned plates and more lively slip- or sgraffito-decorated plates, pans, and deep dishes—the staple products of most rural Pennsylvania potteries—were made in great numbers and various sizes. Combining slab-built, molded, and thrown techniques, the potter making such a plate first prepared a mound of refined clay by kneading and wedging it to remove any air pockets. He beat or rolled the clay into a flat sheet, approximately ⅜ to ½ inch thick, and with a disc cutter, a wooden measuring tool similar to a long-armed compass and point, he cut a round disc of the proper diameter.[21] If the form was to be left undecorated, or if it was to be ornamented with sgraffito decoration, the disc, while still malleable, was pressed and shaped over a domed,

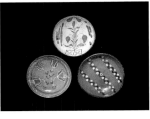

100a. SMALL SGRAFFITO PLATE WITH TULIP DESIGN
Attributed to Philip Mumbouer (c. 1750–1834) and Nicholas Mumbouer (1789–1828)
Haycock Township, Bucks County, Pennsylvania
c. 1810–1825
Glazed red earthenware
1½ × 7 in. diam.
P1.2001.115

PROVENANCE:
Harry B. Hartman, Marietta, Pa., 1972.

100b. SMALL SLIPWARE PLATE OR DEEP DISH WITH FOUR TULIPS
Artist unidentified
Southeastern Pennsylvania
c. 1785–1800
Glazed red earthenware
1½ × 7¼ in. diam.
P1.2001.116

PROVENANCE:
James and Nancy Glazer, Philadelphia, 1975.

20 For related examples by these makers, see Garvan, *Collection*, pp. 175, 180, 182.
21 An example of this tool—and several others discussed in this entry—from the pottery of Pennsylvania potter David Haring are in the collection of PMA.

22 Lura Woodside Watkins, *Early New England Potters and Their Wares* (Cambridge, Mass.: Harvard Univ. Press, 1968), pp. 62–79.

100c. SMALL SLIPWARE PLATE WITH THREE WAVY STRIPES

Willoughby Smith (1839–1905)
Wolmersdorf, Berks County, Pennsylvania
c. 1865–1880
Glazed red earthenware
1⅝ × 7¾ in. diam.
P1.2001.117

INSCRIPTION:
Underside, stamped: *W. SMITH WOMELSDORF*

PROVENANCE:
Philip Cowan, Phoenixville, Pa., 1970.

Smaller earthenware plates, formed on the wheel or by sheet-drape molding, were a common product of most rural Pennsylvania potteries during the first half of the nineteenth century. Simple, undecorated glazed examples, as well as the more ornately decorated versions, were used for serving food at the table and for domestic ornament. Surviving household inventories in southeastern Pennsylvania record multiple "smaller earthen dishes" in the "dresser" or "cupboard" of a kitchen or parlor, and price lists and inventories for potteries operating in the region document the manufacture of plates with diameters measuring between seven and nine inches and ranging in price from 3 to 18 cents.[23] These three examples demonstrate the variety of decorative styles and techniques employed by Pennsylvania German potters in making these smaller domestic forms.

The attribution of the sgraffito-decorated example to Philip and Nicholas Mumbouer (or Mumbower) is based upon similarities in its decoration and execution to a signed example in the collection of the Philadelphia Museum of Art.[24] The Mumbouer family of potters was influential in the stylistic development of earthenware in Bucks County and the surrounding areas of Pennsylvania throughout the nineteenth century, and their operations served as the training ground for a number of the region's best-known potters.

Willoughby Smith apprenticed as a potter during the late 1850s in the Schwenkfelder community near Pennsburg and later entered into partnership, with potter Joseph Freeg, in an early pottery in Wolmersdorf, Berks County, where they operated under the name "Freeg and Smith" until 1879. After purchasing full interest in the business in 1879, Smith carried on the large-scale production of a range of utilitarian forms, specializing in small decorated plates and flowerpots. His slipwork often consists of simple trailed patterns of wavy lines and dots or crisscrossed lines in two or three colors.
—J.L.L.

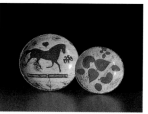

101a. RUNNING HORSE SILHOUETTE RESIST PLATE

Conrad Kolb Ranninger (1809–1869)
Montgomery County, Pennsylvania
1838
Glazed red earthenware
1¾ × 7⅝ in. diam.
P1.2001.118

INSCRIPTIONS:
Surface, incised: *1838 / Con. Ranninger / Conrad K. Ranni*[nger]; underside, incised: *June the 23 1838 / Conrad K. Ranninger / Montgomery County*

PROVENANCE:
Mr. and Mrs. John G. Pennypacker, New Canaan, Conn.; Sotheby Parke-Bernet sale 4076, 2/78, lot 71.

PUBLISHED:
Barber, Edwin Atlee. *Tulip Ware of the Pennsylvania-German Potters: An Historical Sketch of the Art of Slip-Decoration in the United States.* 1903; reprint, New York: Dover Publications, 1970, pp. 72–73 (discussed).
Schaffner, Cynthia V.A. *Discovering American Folk Art.* New York: Harry N. Abrams, 1991, p. 31.

101b. LEAF SILHOUETTE RESIST PLATE

Conrad Kolb Ranninger (1809–1869)
Montgomery County, Pennsylvania
1838
Glazed red earthenware
1⅜ × 7½ in. diam.
P1.2001.119

INSCRIPTIONS:
Surface, incised: *June the 2*[3]*, 1838;* underside, incised: *June the 23 1838 / Conrad K. Ranninger / Montgomery County*

PROVENANCE:
Mrs. N. McLean Seabrease; Jess Pavey, Detroit; Garth's sale 10/67, "Pavey Collection," lot 553.

Few among the early communities of Pennsylvania German potters possessed technical knowledge of resist glaze techniques and the use of stenciled patterns. The unusual method, whose origins can be traced back to Chinese potters of the Northern Song dynasty (A.D. 960–1126), is incorporated in a small group of documented traditional earthenware forms by Montgomery County potter Conrad Ranninger in examples featuring stenciled leaves and cut paper patterns. In a practice derived from traditional textile resist-dyeing and paper printing, potters dipped small, young natural leaves—selected in the summer months when their vascular systems were fully developed—in rendered fat, grease, or wax and pressed them flat into the smooth surface of the clay form prior to applying a slip or glaze layer. In Pennsylvania, leaf resist printing had been popularized in the 1740s by Benjamin Franklin and David Hall in their local issues of printed paper script currencies. The unique patterns of leaf veining incorporated into their designs made counterfeiting difficult, and the degree of clarity of the natural leaf image, as perfected by Franklin and his circle, became the source of widespread curiosity.[25]

23 "Redware Forms," "Inventories for Households," and "Potterie Manuscript Documents and Prices," Frances Lichten Files, American Department, PMA. A drape mold with a diameter of 8¼ in. is in the PMA collection.

24 Garvan, *Collection,* p. 183, figs. 61, 62.

25 For examples, see Philadelphia Museum of Art, *Philadelphia: Three Centuries of American Art* (Philadelphia: PMA, 1976), pp. 38–39.

Ranninger expanded his applications of the leaf resist to include decorative patterns cut from paper. Paper cutting was a popular craft known commonly among many Pennsylvania German communities as *Scherenschnitte.* Silhouetted animal forms, such as the horse and double-headed eagle, as well as more abstract pattern devices such as a lacy "fence," could be accomplished using these applied paper forms. Once the leaves or stencils were secured with wax or grease to the surface of the form, the potter applied an overall layer of yellow clay slip and random splotches of copper oxide to produce the green highlights. Care had to be exercised to avoid smearing or dripping the wax or grease on other areas of the form while the stencil patterns were being applied, for the resist prevented the adherence of the slip or other glaze materials.

Physical evidence on these two plates and in several other examples of Ranninger's surviving works suggests that, unlike most decorated Pennsylvania red earthenwares, this technique required two separate kiln firings. The crisply delineated lines of the pattern edges suggest that the leaves or paper stencils were left on the form for the first firing and burned off during the process, exposing the red clay underneath.[26] Once fired, the plate, with its hardened, contrasting colors of yellow and red, received a clear lead glaze and was fired a second time. The additional labor and extra fuel needed to fire the kiln again would have made these stenciled wares comparatively expensive for the potter to produce. All the known examples of Ranninger's signed stencil-decorated work bear dates during the summer of 1838, possibly suggesting an experimental kiln load that was not repeated.[27] —J.L.L.

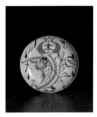

102. SGRAFFITO PLATE WITH SWEEPING TULIP
Attributed to William Mills (c. 1772–1870)
Haycock Township, Bucks County, Pennsylvania
1821
Glazed red earthenware
1⅝ × 10⅛ in. diam.
P1.2001.120

INSCRIPTIONS:
Surface, incised: *1821*; underside, incised: *8*

PROVENANCE:
Jacob Paxson Temple, Tanguy, Pa.; The Anderson Galleries, New York, sale 1626, "Temple Collection," 1/22, lot 1550; David Pottinger, Topeka, Ind., 1973.

The fields and creek beds surrounding Haycock Mountain in Bucks County yielded rich supplies of high-quality clay and supported a number of successful potters throughout the nineteenth century. Henry Mills, a second-generation potter of English descent, was working in the region with his two sons, William and Solomon, by 1795. As was often

the case, the sons of potters served early apprenticeships within the shops of other local potters in hopes of maintaining strategic associations with competitors. William Mills may have been active in the neighboring workshop of German potter Conrad Mumbouer (1761–1845) or Michael Stoneback, from whom Mills rented a log barn, a log stable, and "one potter shop, 24′ × 18′" in 1798.[28] The fine grayish white, yellow, and light-red clays of Mills's known surviving works, such as this plate, are close in character to those produced by a number of potters working and interacting within this close-knit community of German and English immigrant farmers and craftsmen.

A small group of earthenware plates with asymmetrically conceived sgraffito decoration, inscribed dates, and the number *8* marked on their undersides have survived and are attributed to Mills.[29] Also characteristic of Mills's work is his method of applying the slip layer: he poured a small amount of slip into the center of the plate and gently tilted and swirled it to move the excess slip toward the plate's edge. This technique left a sharp line at the edge of the plate where the slip coverage ended and the bare clay of the plate remained visible. Mills also added thinly scratched parallel lines to accentuate the wider carved areas of the tulip petals or other carved areas of a design and seems to have preferred the application of random splotches of green around the edges of his plates, as seen in this example. —J.L.L.

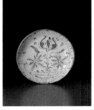

103. SGRAFFITO PLATE FOR JOHAN KETTERER
Attributed to Conrad Mumbouer (1761–1845)
Haycock Township, Bucks County, Pennsylvania
1829
Glazed red earthenware
2¼ × 11⅞ in. diam.
P1.2001.121

INSCRIPTION (TRANSLATION OF GERMAN):
Surface, incised: *Today is the day that I do not want to rest East West mine is the best / JOHAN KETERER / 1829*

PROVENANCE:
George Horace Lorimer, Philadelphia; Bernard and S. Dean Levy, New York, 1978.

EXHIBITED:
On loan to TBM from the George Horace Lorimer Collection, c. 1942–1977.

Based upon its similarities to other known attributed examples, this sheet-drape-molded earthenware plate can be linked to the work of Conrad Mumbouer. Its light-red clay body, refined and dense, as well as the uniform yellowish white slip covering its primary interior surface result from the potter's use of clays indigenous to the region. The lobed petals of the plate's central tulip and the other flower motifs, composed

26 Three other plates utilizing stencil decoration—but predating Ranninger's working dates and exhibiting different styles—are presently unattributed (collection PMA). They, too, suggest that the stencils were left on the forms during the first firing and that a second firing was required to establish the uniform, clear lead-glaze finish.

27 Two other plates signed by Ranninger and bearing 1838 dates are in the collection of Winterthur. An unsigned jar attributed to Ranninger, based upon its paper stencil cutouts and glazing similarities, is in the collection of PMA.

28 Garvan, *Collection,* pp. 364–65.

29 These attributions are based on documentary evidence that survived with one of the plates (collection PMA) and on physical and stylistic similarities of other examples to this documented plate. Another example attributed to Mills is in the collection of the Reading Museum of Art, Reading, Pa.

of carved and outlined petals, feathers, or stamens, are also characteristic of the potter's sgraffito carving style.

Like several other sheet-drape-molded plates attributed to Mumbouer, this example retains faint remnants of broad, flattened marks left by a smoothing rib across its back surface. With this tool, the potter smoothed and pressed a flat sheet of clay over the dome-shaped plate mold. Once formed and refined over the mold, the edges of the plate were trimmed and finished. The tightly spaced, notched coggle wheel used to finish the edge of this plate is also found on a number of examples attributed to the Mumbouer family of potters.

Ornately decorated presentation plates, customized with the names of their owners, dates of presentation or manufacture, or traditional verses or proverbs, were highly cherished, and few show signs of extensive wear or use. The verse on this example, inscribed to Johan Ketterer, a tinsmith, whitesmith, and "chainmaker," proclaims in part, "East West mine is the best," and may have been prescribed by either the maker or the owner as a testament to his skill as a craftsman.[30] —J.L.L.

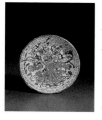

104. SGRAFFITO PLATE OR DEEP DISH
WITH DOUBLE-HEADED EAGLE
Attributed to George Hubener (1757–1828)
Limerick Township, Montgomery County,
Pennsylvania
1792
Glazed red earthenware
2¼ × 12⅝ in. diam.
P1.2001.122

INSCRIPTIONS (TRANSLATION OF GERMAN):
Surface, center, incised: *This is a Double-Headed eagle;* around rim: *1792 out of the Earth with understanding The Potter makes everything. He who can make something is esteemed. The unskilled no one regards.*

PROVENANCE:
George Horace Lorimer, Philadelphia; Bernard and S. Dean Levy, New York, 1977.

EXHIBITED:
On loan to TBM from the George Horace Lorimer Collection, c. 1942–1977.

PUBLISHED:
Kauffman, Henry. *Pennsylvania Dutch American Folk Art.* New York: Dover Publications, 1964, p. 95.

This early earthenware plate, heavily ornamented with traditional symbols and folk inscriptions, is attributed to master potter George Hubener, who was first listed in the tax records for Upper Hanover Township, Bucks County, in 1787 and 1788. Considered one of the most skilled early Pennsylvania German potters for whom an identifiable body of work has survived, Hubener demonstrates influences from his earlier training and ancestry in his use of traditional southern German motifs, such as the double-headed eagle, peacock, heart, and tulip, and in his incorporation of masterfully executed old-style script lettering. His

grandparents Hans and Maria Scholtz Huebner and father, John George Hubener (1720–1792), arrived in Pennsylvania in 1734 from Silesia and settled in the early Schwenkfelder and Moravian community of immigrant craftsmen and farmers.[31] John George had reached a position of prominence within the community by 1771, owning a prosperous 350-acre farm. Perhaps through family connections or his father's influence, George may have been placed as an apprentice with Moravian potter John Ludwig Huebner (1717–1796) or John George Sissholtz (?–1788), another early potter working in the community.[32]

Hubener married Catherine Hartzel in 1785 and established his own pottery by 1787 in Upper Hanover, producing both decorated and utilitarian earthenwares. In 1790 he purchased land in Limerick Township, Montgomery County, and relocated his operation. This pottery, however, was short-lived, as Hubener sold the land, buildings, and equipment in 1792 and moved to Vincent Township, Chester County, where after 1797 he is listed as a mill owner rather than a potter. Most of his surviving wares are inscribed with dates from 1786 to 1793.

Unlike the pieces of many later potters working in Pennsylvania, Hubener's plates follow the earlier, traditional Continental form of a deep dish. They are not form- or sheet-drape molded but are fully wheel thrown, resulting in a deeper angular-walled form with a flat bottom and a thicker, out-turned rolled rim. Evidence of the potter's secondary trimming and shaping of the form's outer wall is seen on most surviving examples. Hubener is also known to have produced sgraffito-decorated hollowware, and several double-handled covered jars with straight walls featuring decorative motifs similar to those found on his plates are known to survive.[33] —J.L.L.

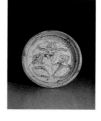

105. SGRAFFITO PLATE OR DEEP DISH
WITH THREE TULIPS
Artist unidentified
Southeastern Pennsylvania
c. 1785–1800
Glazed red earthenware
2¼ × 13 in. diam.
P1.2001.123

PROVENANCE:
Edwin Atlee Barber, Philadelphia; MMA Collection (1913–1952, no. 13.145-4); Joe Kindig Jr., York, Pa., 1967.

PUBLISHED:
Cox, Warren E. *The Book of Pottery and Porcelain,* vol. 2. New York: Crown Publishers, 1966, p. 986.

This early deep dish was collected by Edwin Atlee Barber, a pioneering scholar of American ceramics and the first curator of decorative arts at the Pennsylvania Museum and School of Industrial Art (now the Philadelphia Museum of Art). It relates closely in form, decoration, and glaze type to two other examples by the same unidentified potter that

30 Genealogical information indicates his name was spelled "Ketterer," although the plate is inscribed with one *t*. See Garvan, *Collection,* p. 361.
31 John George Hubener changed the spelling of his surname from "Huebner."

32 I wish to thank Pastor Frederick S. Weiser for his translations on this and other plates in the Esmerian Collection. For a full genealogical sketch of Hubener, see Garvan, *Collection,* p. 360.
33 Examples of these jars are in the collections of PMA and Winterthur.

Barber acquired for the museum.[34] One of the first scholars to truly understand the technical properties of early clays, glazes, and kiln processes, Barber made extensive analytical notes on the group in 1906 and 1907.

Fascinated by the thinness of their slip and glaze and their friable, discolored, deteriorated surfaces, he felt these examples provided important insight into the experimentation and innovation required of early Pennsylvania potters as they sought to master and adapt local materials to produce their wares. He conjectured that the lighter orange clay, much lower in iron content than the average local red clays, may have resulted from the potter's experimentation with different clay sources, mixtures, or recipes. Barber further observed that the potter had misjudged the higher kiln temperature required to vitrify, or fully harden, the richer, finely grained kaolin content of the clay. Left underfired, this clay had caused the thicker, larger-grained yellow slip and the silica-lead glaze to remain porous and relatively unfused to the surface, which, over time, resulted in its discoloration, thinness, and marked wear.

Typical of the earlier deep-dish forms produced by immigrant potters working in Bucks and Montgomery Counties prior to 1800, this dish was fully wheel thrown and shaped with a number of wooden or leather tools called ribs.[35] Care had to be taken while throwing the form to ensure that its floor and outward flaring walls were free of air pockets or bubbles, which could cause the form to collapse or crack when fired. The straight-edged rib, pressed into the clay while it rotated on the wheel, helped maintain the form's uniform density. After the initial throwing, the potter could use different ribs and trimming tools to further refine the outer profile of the dish's wall foot and rim. The absence of visible finger marks in the body of this example indicates this use of ribs.

—J.L.L.

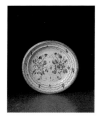

106. SGRAFFITO PLATE OR DEEP DISH WITH FLORAL SPRAYS
Attributed to David Spinner (1758–1811)
Milford Township, Bucks County, Pennsylvania
c. 1785–1805
Glazed red earthenware
1⅞ × 12⅞ in. diam.
P1.2001.124

PROVENANCE:
Edwin Atlee Barber, Philadelphia; Mrs. L. Manievich de Forest, New York; MMA Collection (1934–1952, no. 34.100.127); Joe Kindig Jr., York, Pa.; Joe Kindig III, York, Pa., 1975.

PUBLISHED:
Guilland, Harold F. *Early American Folk Pottery.* Philadelphia: Chilton Book Company, 1971, p. 243 (Index of American Design watercolor illustration, N.Y.C. Cer. 4, cataloged June 18, 1936).

The form of this early deep dish follows that of early-eighteenth-century Swiss examples, retaining a rounded, stepped profile, wide outer flange, and overturned rim. Its maker, thought to be David Spinner, was the youngest son of Ulrich Spinner, who immigrated to Pennsylvania from Basel, Switzerland, in 1739 and settled on purchased land in Bucks County.[36] Around 1776 or 1777, David was placed in apprenticeship by his father with Henry Neis, a cordwainer, and Johannes Neis, a potter, both in Milford Township, where he remained in their employ until inheriting his family's land in 1781. By 1782 Spinner was taxed independently as a successful potter and farmer. He owned more than two hundred acres and numerous livestock and had entered into local leadership and politics as a captain in the First Company Militia, justice of the peace, and tax collector for the township.[37] Like many industrious craftsmen working within the Pennsylvania German community, Spinner enjoyed a relatively comfortable lifestyle as a result of his hard work and talents, and he achieved the prosperous designation of "Esquire" during his later life.

The form and decorative embellishments of Spinner's earthenware productions clearly demonstrate his close association with the Neis family of potters and the conveyance of traditional styles through the established system of apprenticeship. Spinner's plates feature the same even-colored light-yellow slip ground layer and flourishes of copper oxide as seen on the early work of Johannes Neis, and both potters continued to produce the majority of their wares using the wheel rather than molds or forms. Based upon a comparison of a few rare signed examples, it is only in the details of Spinner's sgraffito carving of leafage, flowers, and vines that slight variations from those of the elder Neis can be observed. Spinner's open flowers are portrayed consistently with round centers, while Neis seems to have preferred a scallop-shaped center. Spinner's smaller leaves are simple, inverted comma shapes, a design seldom encountered on examples by Neis. And Spinner's use of curved lines flanked by rows of dots to portray the veining of leaves, or to suggest vines or feathered sprigs of foliage, is also his own interpretation.

—J.L.L.

34 PMA, American Collections; Barber's notes are in the research files for these objects.

35 For examples of these tools, see Garvan, *Collection,* p. 77.

36 This plate was one of several collected by Edwin Atlee Barber, a pioneering scholar and curator at PMA who acquired numerous examples of Spinner's productions directly from the

artist's descendants. An early paper label affixed to the back of this plate documents his ownership.

37 Additional, extensive genealogical information on Spinner and an in-depth analysis of his motifs as compared to those of Neis are in the research archives of the American Department, PMA.

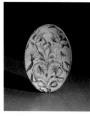

107. OVAL SGRAFFITO DISH WITH
FLOWERS AND HEART
Attributed to Conrad Mumbouer (1761–1845) or
John Monday (1809–1862)
Haycock Township, Bucks County, Pennsylvania
c. 1835–1845
Glazed red earthenware
1½ × 14⅞ in. oval
P1.2001.125

PROVENANCE:
George Horace Lorimer, Philadelphia; Bernard and S. Dean Levy, New York, 1977.

EXHIBITED:
On loan to TBM from the George Horace Lorimer Collection, c. 1942–1977.

PUBLISHED:
Schaffner, Cynthia V.A., and Susan Klein. *Folk Hearts: A Celebration of the Heart Motif in American Folk Art.* New York: Alfred A. Knopf, 1984, p. 93.
Schwartz, Marvin D. *Collectors' Guide to Antique American Ceramics.* Garden City, N.Y.: Doubleday, 1969, p. 24.
Stoudt, John Joseph. *Pennsylvania Folk Art: An Interpretation.* Allentown, Pa.: Schlecter's, 1948, p. 324.

A number of traditional potters working in southeastern Pennsylvania regularly produced different sizes of rectangular earthenware dishes with rounded corners, or "loaf pans," but few geometrically true oval examples such as this rare sgraffito-decorated version have survived. Oval earthenware serving dishes may have been inspired by imported pewter or white earthenware forms, both of which made their way into the farming communities of the region through overland trade with Philadelphia's busy port. Such specialized earthenwares required custom forms over which a sheet of malleable clay was pressed and smoothed. Oval clay forms utilizing wide, continuous curving shapes were more susceptible to warping and distortion during kiln firing. This example, while relatively symmetrical and even in shape, has several small stress fissures on its underside, indicating points of weakness that developed in its wall as a result of pressure from the heat during firing. Subsequently, most potters who experimented with the oval format opted for the more common rounded-corner rectangle versions or a scalloped or lobed oval with more vertical walls, which proved sturdier in the kiln.[38]

The decorative pattern, clay type, and glaze character of this example relate it to the work of Conrad Mumbouer and John Monday, two Bucks County potters whose close working relationship led to shared stylistic preferences and work patterns. The output of both is characterized by forms made from highly refined light-orange clay coated with opaque yellow slip through which sgraffito patterns of tulips, pinwheels, urns, baskets, and hearts were scratched or carved and which often are further embellished with random splotches of copper oxide greens. —J.L.L.

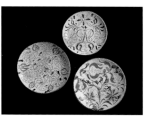

108a. SGRAFFITO PLATE WITH
PINWHEEL FLOWERS AND TULIPS
Attributed to Conrad Mumbouer (1761–1845)
or John Monday (1809–1862)
Haycock Township, Bucks County,
Pennsylvania
c. 1835–1845
Glazed red earthenware
1¾ × 11³⁄₁₆ in. diam.
P1.2001.126

PROVENANCE:
Arthur J. Sussel, Philadelphia; Parke-Bernet sale 1847, "Sussel Collection, Part I," 10/58, lot 252; Hattie K. Brunner, Reinholds, Pa.; John Gordon, New York; Christie's sale 9052, "Gordon Collection," 1/99, lot 234 (mistakenly attributed to Jacob Medinger in sale catalog).

108b. SGRAFFITO PLATE WITH VASE OF FLOWERS
Attributed to Conrad Mumbouer (1761–1845) or John Monday (1809–1862)
Haycock Township, Bucks County, Pennsylvania
c. 1835–1845
Glazed red earthenware
1¼ × 10⅛ in. diam.
P1.2001.127

PROVENANCE:
George Horace Lorimer, Philadelphia; Bernard and S. Dean Levy, New York, 1978.

EXHIBITED:
On loan to TBM from the George Horace Lorimer Collection, c. 1942–1977.

108c. SGRAFFITO PLATE WITH OPEN TULIPS
Attributed to Conrad Mumbouer (1761–1845)
Haycock Township, Bucks County, Pennsylvania
c. 1830–1840
Glazed red earthenware
1⅞ × 11⅞ in. diam.
P1.2001.128

INSCRIPTION:
Underside, incised, post-firing: *Feb. 1, 1779* (of a later date and likely in a hand not that of the maker)

PROVENANCE:
Philip Cowan, Phoenixville, Pa., 1968.

PUBLISHED:
Rebus Inc. *American Country Folk Art.* Alexandria, Va.: Time-Life Books, 1990, p. 89.

38 Another oval example is pictured in Edwin Atlee Barber, *Tulip Ware of the Pennsylvania-German Potters: An Historical Sketch of the Art of Slip-Decoration in the United States* (1903; reprint, New York: Dover Publications, 1970), p. 202. Two scalloped oval versions are in the collections of PMA and Winterthur.

The close-knit Pennsylvania German farming communities of Lower Milford and Haycock Townships in Bucks County supported a number of potters during the first half of the nineteenth century, all of whom were drawn to the region by the abundant clay beds that lay along the creeks running from the base of Haycock Mountain. Joseph and William Mills, Henry and Michael Stoneback, Thomas Strawhen, David and Conrad Mumbouer, and John Monday all established successful potteries in the area prior to 1840, utilizing the abundant finely grained red-, yellow-, and buff-colored clays and other mineral sources available in the immediate area to produce and decorate their wares. These common sources for raw materials, as well as the close network of apprenticeship, shared labor, and intermarriage, resulted in shared techniques, working practices, and a distinctive local style of utilitarian and decorated earthenware. Examples of shared preferences can be seen across the work of Mumbouer and Monday, who were united by community, apprenticeship training, and intermarriage and who shared the same pottery site during much of their years of production.[39]

The surviving plates attributed to Mumbouer and Monday reveal few consistent details in their manufacture or decoration that would distinguish their works. Both potters used a virtually identical range of individual motifs and executed them with the same freehand, fluid carving strokes of sgraffito technique. Only the lobed, two-petaled tulip with pronounced center stamen is seen more consistently on examples attributed to Mumbouer. Both potters surrounded the wider, carved-away components of their designs with thinly incised outlines and decorated the individual petals in their rounded, multipetaled flowers with slashes and dots.

The clays used by both potters were drawn largely from local sources, refined similarly, and exhibit the same finely grained texture and even, light red color. The white slip ground layer through which the decorative sgraffito motifs were carved is also consistently opaque across most known examples, and its content is high in whiting, a calcium-rich ingredient made from burnt and ground seashells and bone.[40] As a result of this added mineral, both the light slips and the copper oxide decorations shared by these three examples appear thicker, more uniform in surface, and more intense in color in comparison to the works of many other earthenware potters operating in the region. —J.L.L.

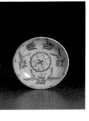

109., SGRAFFITO PLATE WITH
TULIPS AND CENTER MEDALLION
Attributed to Andrew Headman (c. 1756–1830)
Rockhill Township, Bucks County, Pennsylvania
1808
Glazed red earthenware
2⅜ × 9¾ in. diam.
P1.2001.129

INSCRIPTION:
Surface, incised: *1808*

PROVENANCE:
George Horace Lorimer, Philadelphia; Bernard and S. Dean Levy, New York, 1977.

EXHIBITED:
On loan to TBM from the George Horace Lorimer Collection, c. 1942–1977.

Andreas Hettmansperger arrived in Philadelphia on September 17, 1771, from Freidrichsthal, Germany, with his brother, Frans Wilhelm, a master potter. They established a pottery on Eighth Street, just south of Market, where they produced utilitarian redware until 1786. That year, listed as "Andrew Headman" in county records, the potter moved to Rockhill Township in Bucks County, where he founded a pottery on roughly thirty acres he purchased. Headman and his sons, Michael, Andrew Jr., and John, and grandsons Charles and Peter established a prolific and influential pottery business among the Pennsylvania German farming communities of the region.

Several plates incorporating variations of this central, compass-circle pattern with stars or florals radiating around the central motif bear Headman's full signature or initials and the distinctively rendered sgraffito date.[41] Incised in an opaque, light yellow slip containing white lead and feldspar, the designs were further embellished with copper oxide slip. Once the decoration was complete, the potter coated the entire face of the plate with a clear lead glaze and set the form aside to dry in preparation for firing. The density and even coating of this yellow slip prevented the high iron content or other mineral impurities in the plate's red clay from migrating to the surface and causing any discoloration or firing blemishes while in the kiln.

Sgrafitto-decorated plates with geometric and floral patterns composed around a central, compass-drawn circle or petaled star pattern are rarely found outside Bucks or Montgomery County and may be either the result of competition among several potters working in close proximity to one another, trying to produce comparable wares with similar patterns for their customers, or the by-product of close apprenticeships and labor-sharing relationships among these local operations. Contemporary local potters such as Thomas Strawhen (act. 1796–1825) and Henry Troxel (act. 1800–1829) produced similar patterns on plates. —J.L.L.

39 Proper identification is further confused by the work of late-nineteenth- and early-twentieth-century potter Jacob Medinger (1856–1920), who, in a traditional and revivalist mode, copied the work of various local potters, including Mumbouer and Monday. Cat. no. 108a was once thought to be the work of Medinger but has since been proved analytically to be that of the earlier potters.

40 Detailed analytical information on the glaze components and clays used in the works of these two potters is recorded in the conservation and research files maintained by the American Department, PMA.

41 One example with a full signature is illustrated in Harold F. Guilland, *Early American Folk Pottery* (New York: Chilton Book Company, 1971), p. 120.

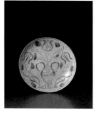

110. **SGRAFFITO PLATE WITH THREE TULIPS IN VASE**
Attributed to John Dry (1785–1870)
Dryville, Rockland Township, Berks County, Pennsylvania
1819
Glazed red earthenware
1½ × 11⅞ in. diam.
P1.2001.130

INSCRIPTION:
Underside, pencil: *Made by John Dry / Dry Pottery / Stony Point Pottery / Dryville / Lydia / David Hess / Frederick / Bought by J.C. Nippon / Nov. 16 1819*

PROVENANCE:
George Horace Lorimer, Philadelphia; Bernard and S. Dean Levy, New York, 1978.

EXHIBITED:
On loan to TBM from the George Horace Lorimer Collection, c. 1942–1977.

PUBLISHED:
Rebus Inc. *American Country Folk Art.* Alexandria, Va.: Time-Life Books, 1990, p. 89.

This slab-molded plate, decorated with a symmetrically placed handled urn of flowing vines and flowers in sgraffito, was made by John Dry (or Drey), the patriarch of an influential and successful Berks County potting family. The pottery, which was active from c. 1806 to 1880, was founded upon the site of an earlier pottery, operated by the Melcher (or Melcheor) family of Berks County, which Dry purchased in 1804. There he and his sons Daniel (1811–1872), Nathaniel (1842–1864), and Lewis (dates unknown) produced a full range of utilitarian and decorative wares, and they were known for their manufactory of pressed, figural pipes, whimsical toys, and decorated household items. The finely grained, even texture of the red earthenware used in this plate suggests that the clay was refined extensively before forming. Such even-textured clay bodies were required of press-molded and slip-cast figural wares and were beneficial in producing the even, unblemished yellow and red decorative colors seen on this plate.

The Drys marketed their earthenwares successfully throughout Berks County, transporting finished loads by wagon to various local markets. Surviving records from the operation indicate the range of goods offered and their prices. A number of simple plates in various sizes, decorated with a single, abstract two- or three-color slip-trailed tulip, survive and are attributed to their manufactory.[42] They are also thought to have produced a range of more ornate plates with customized inscriptions and commemorative dates for specific clients. The date on this plate may refer to a marriage, birth, or other significant date for its owner, or simply the year in which it was made and presented. Its skillfully drawn and carved sgraffito pattern and even glaze surface suggest the skill of the pottery in producing more ornate custom-decorated wares. —J.L.L.

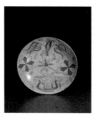

111. **SGRAFFITO PLATE WITH TULIPS AND FLOWERS IN VASE**
Attributed to John Monday (1809–1862)
Haycock Township, Bucks County, Pennsylvania
1830
Glazed red earthenware
2 × 10¾ in. diam.
P1.2001.131

INSCRIPTION:
Surface, incised: *Mar 27 1830*

PROVENANCE:
Philip Cowan, Phoenixville, Pa., 1968.

John Monday, one of a close-knit group of potters working in Haycock Township during the first half of the nineteenth century, is thought to have apprenticed with Conrad Mumbouer (or Mumbower), who had established a pottery in the region by 1793. Monday married Mumbouer's daughter Phebe in 1834 and took over the full operation of Mumbouer's pottery in 1845. Because of this close relationship and the similar techniques and decorative styles shared by the two potters, their surviving works are quite similar and often hard to distinguish. Few documented, signed examples by either artist are currently known.

This plate is attributed to Monday based upon the similarity of several aspects of the pattern design and execution of its sgraffito decoration to one signed example in the collection of the Philadelphia Museum of Art. Each features a thick, opaque white slip ground, which was removed in areas, such as the panels of the pinwheel devices, stylized tulips, and urn, to reveal the red clay body underneath. The carving tool consistently left ⅛-inch wide, flat, shallow blade scars in the clay which are visible through the clear lead glaze. Monday also seems to have used a thinly edged coggle wheel to score in the slightly scalloped, segmented lines forming the stems and outlines of flowers. The stems of these flower designs also incorporate a slight, hollow swell near the flower blossom. The form of tulip seen on this example, with long, thinly carved petals of two different lengths and coggled outlines enclosing a green center with an elongated, feathered stamen, is also characteristic of his sgraffito patterns.

A number of other potters and apprentices worked with Monday in the pottery, including both his sons, Edmund and David, and German immigrant potters Mathias Myer and Charles Moritz. Consequently, we may never truly know the specific primary hands involved in the making of individual examples, even when they bear the signature of the master potter. —J.L.L.

42 Guy F. Reinert, "History of the Pennsylvania German Potters of Berks County," *Historical Review of Berks County* 2 (January 1937): 44.

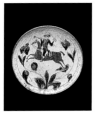

112. SGRAFFITO PLATE WITH
HORSE AND RIDER
John Neis (1785–1867)
Upper Salford Township, Montgomery County,
Pennsylvania
1805
Glazed red earthenware
1¾ × 12⅜ in. diam.
P1.2001.132

INSCRIPTION (TRANSLATION OF GERMAN):
Surface, incised: *I have ridden many hours and days and yet no girl I am able to have 1805*

PROVENANCE:
James and Nancy Glazer, Philadelphia, 1984.

EXHIBITED:
"Expressions of a New Spirit," MAFA, 1989.
"Swiss Folk Art: Celebrating America's Roots," MAFA, 1991/92.

PUBLISHED:
Barber, Edwin Atlee. *Tulip Ware of the Pennsylvania-German Potters: An Historical Sketch of the Art of Slip-Decoration in the United States.* 1903; reprint, New York: Dover Publications, 1970, p. 142 (discussed).
Bishop, Robert, and Jacqueline Marx Atkins. *Folk Art in American Life.* New York: Viking Studio Books in association with MAFA, 1995, p. 91.
Rebus Inc. *American Country Folk Art.* Alexandria, Va.: Time-Life Books, 1990, p. 88.
Warren, Elizabeth V., and Stacy C. Hollander. *Expressions of a New Spirit: Highlights from the Permanent Collection of the Museum of American Folk Art.* New York: MAFA, 1989, p. 100.

A number of fine sgraffito-decorated plates similar to this example depicting a galloping horse and rider and with floral or verse-inscribed borders survive from the pottery of John (or Johannes) Neis. Several potters with similar names, some with close family ties, worked in the area of Rockhill and Salford Townships in Bucks and Montgomery Counties during the late eighteenth and early nineteenth centuries, and the nature of surviving records and fluctuations in the spelling of their names have confused their identities.[43] The John Neis who created this plate was the son of Henry and Maria Elizabeth Neis of Salford Township; his uncles Abraham and Johannes Neis also were potters. John Neis is thought to have apprenticed with his uncles or with David Spinner, a potter of Swiss descent who was also employed by the elder Neises and whose work shows a close stylistic tie to this plate. John's sons Abraham and John followed in their father's and great-uncles' footsteps and became potters in Montgomery County, continuing operations in the area until the end of the nineteenth century.

Decorated earthenware plates with horse-and-rider motifs and banded inscriptions based on folk proverbs or humorous maxims are found in earlier German and Swiss pottery traditions. In Pennsylvania the pattern was maintained by immigrant potters, and rather than portraying a particular military figure, such as Emperor Joseph II or George Washington, the figure had likely become a generic, preferred motif. Civic celebrations and local militia exercises with mounted cavalry riders also could have provided inspiration for such figural portrayals. Many of the sgraffito floral designs executed by Neis have the fluid, confident character of a metal engraving and utilize similar curved, finely scored parallel lines to delineate the petals of flowers, shading, or the turn of a leaf.

—J.L.L.

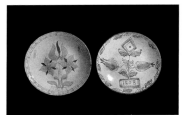

113a. SGRAFFITO PLATE WITH TULIP AND TWO FLOWERS
Attributed to John Neis (1785–1867)
Upper Salford Township, Montgomery County, Pennsylvania
1823
Glazed red earthenware
1¹¹⁄₁₆ × 11³⁄₁₆ in. diam.
P1.2001.133

INSCRIPTION:
Surface, incised: *1823*

PROVENANCE:
Jacob Paxson Temple, Tanguy, Pa.; The Anderson Galleries, New York, sale 1626, "Temple Collection," 1/22, lot 1420; Alfred B. Maclay, New York; Asher J. Odenwelder Jr., Easton, Pa.; Hattie K. Brunner, Reinholds, Pa.; John Gordon, New York; Christie's sale 9052, "Gordon Collection," 1/99, lot 233 (mistakenly attributed to Jacob Medinger in sale catalog).

EXHIBITED:
"250 Years of American Pottery," The Wilton Historical Society, Wilton, Conn., 1970.

PUBLISHED:
Guilland, Harold F. *Early American Folk Pottery.* Philadelphia: Chilton Book Company, 1971, p. 271 (Index of American Design watercolor illustration, N.Y.C. Cer. 97).

113b. SLIPWARE PLATE WITH TWO TULIPS AND
DIAMOND-SHAPED FLOWER
Attributed to John Leidy II (1780–1838)
Franconia Township, Montgomery County, Pennsylvania
1808
Glazed red earthenware
1⅝ × 11 in. diam.
P1.2001.134

INSCRIPTION:
Surface, incised: *1808*

PROVENANCE:
Schuyler Brinckerhoff Jackson, Brownsburg, Pa.; The American Art Association Anderson Galleries, New York, sale 11/33, "Jackson Collection," lot 99; Walter G. Himmelreich, Ronks, Pa.; Pennypacker sale 6/76, lot 286; Ed and Mildred Bohne, Newmanstown, Pa., 1976.

These two earthenware plates were made by Pennsylvania German potters working in close proximity to each other during the first quarter of the nineteenth century. While differing in the decorative glazing used to ornament their surfaces, the layout and placement of the individual decorative elements of their patterns are similar, illustrating one of the traditional, preferred compositions repeatedly produced by not only potters but a number of other craftsmen working in various mediums within the Pennsylvania German community. Such patterns,

43 German and anglicized versions of the name—Johannes, Johannis, Johan, and Neese, Nice, Neez, etc.—have also confused the identities and surviving records of these potters. For the most accurate distinction between Johannes Neis (1754–1826, act. until 1791) and the John (or Johannes) Neis to whom this plate is attributed, see Garvan, *Collection,* p. 365.

which often include a central urn, flower, or geometric shape from which vines, flowers, and sometimes birds emerge in symmetrically balanced compositions, are often referred to as a "tree of life." The versatility of this balanced pattern lent itself easily to the round format of plates, and its basic elements were also frequently utilized by scriveners and fraktur artists, decorative painters, needleworkers, cabinetmakers, carvers, and blacksmiths.

While several potters are known to have made plates bearing the pattern seen in the sgraffito-decorated example dated 1823, it is virtually identical to pieces attributed to John Neis. An undated plate of almost identical pattern in the collection of the Philadelphia Museum of Art was acquired from descendants of the potter.[44] Its glaze, clay character, thickness, and surface crazing are virtually identical, and the atypical, finely spaced, small coggling pattern finishing its edge is present on both examples.

The slip-decorated plate bearing the date 1808 shows marked similarities to the work of John Leidy II of Pennsylvania.[45] Its masterful, thinly drawn slip decoration is unusual in that it is raised and sits atop the yellow slip coating of the plate. Slip decoration of this type was usually rolled or pressed into the surrounding clay body by the potter after it was applied. Leidy's raised slip technique suggests the potter's comfortable familiarity with the properties of his glaze and slip materials and a full understanding of how they would react during firing. Apprenticed to his uncle, potter John Leidy I (1764–1846), the younger Leidy took over the pottery in Franconia Township by 1800, and by 1820 he expanded the operation to include six active kilns, a clay and glaze mill, and two potter's wheels. —J.L.L.

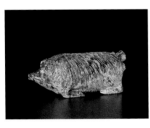

114. PIG BOTTLE OR FLASK
Attributed to Daniel Henne or Joseph Henne
(act. 1830–1876)
Shartlesville, Bern Township, Berks County, Pennsylvania
c. 1830–1860
Glazed red earthenware
4⅝ × 11 × 4⅛ in.
P1.2001.135

PROVENANCE:
George E. Schoellkopf, New York, 1977.

Made by a number of different potters, figural bottles or flasks for the storing of liquor or spirits were popular novelties during the eighteenth and nineteenth centuries and were often caller "rummers." This bottle in the shape of a robust pig is virtually identical to an example in the collection of the Philadelphia Museum of Art. It was acquired for that museum by Titus Geesey, a pioneering collector of Pennsylvania German folk art who noted the bottle came out of the

pottery of "a German named Henney, whose father and grandfather had worked in clay in Bern Township."[46] Daniel Henne and his son Joseph operated a pottery in the area until 1876, when the son retired. Early ceramics historian Edwin Atlee Barber wrote in his fieldwork notes that Henne produced both utilitarian wares and various novelty figures and that his glazes "ran from yellow to pinkish-orange slip glazes with brown spongework to the tin-glazed greens of Bucks County."[47]

Both bottles were formed using a simple two-part mold into which moist clay was pressed by hand, forming the matching halves of the main body of the figure. After removal from the mold, these halves were joined with wet slip and the seam tooled and smoothed to conceal and strengthen the form. The ears, legs, tail, and collared drinking spout attached at the rear were modeled separately and similarly attached. The completed form then received the overall scratched decoration and incised details of its face, legs, and hooves. A thin, yellowish clay slip was then applied, and manganese slip was added randomly over the surface. The entire form was dipped in a clear, silica-rich lead glaze, with care being given that the interior of the bottle was completely coated to ensure its ability to hold liquid. During kiln firing, the manganese slip and clear lead glaze combined to run into the incised lines of the scored decoration, smoothing the outer texture of the bottle but further accentuating its bristly, rough appearance. —J.L.L.

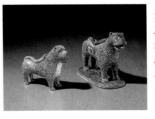

115a. STANDING LION
Artist unidentified
Southeastern Pennsylvania
c. 1830–1860
Glazed red earthenware
5 × 5¾ × 2 in.
P1.2001.136

PROVENANCE:
Arthur J. Sussel, Philadelphia; Parke-Bernet sale 1847, "Sussel Collection, Part I," 10/58, lot 225; Jacqueline D. Hodgson; Sotheby Parke-Bernet sale 3594, "Hodgson Collection," 1/74, lot 198.

115b. STANDING LION ON BASE
Artist unidentified
Southeastern Pennsylvania
c. 1830–1860
Glazed red earthenware
6¼ × 7 × 3⅝ in.
P1.2001.137

INSCRIPTION:
Underside of base, incised: 3 I. e.

PROVENANCE:
Sallie Spears; Pennypacker sale 10/63, "Spears Collection," lot 237; Jack Lamb, Kutztown, Pa., 1972.

44 Ibid., p. 190, fig. 87. Morris and Edwin Atlee Barber acquired the PMA plate from the grandniece of the potter. While several earlier collectors and former owners felt that it had been made by Jacob Medinger (1886–1932) of Montgomery County, Pa.—who was known to have produced intentional copies of earlier plates and other forms—the clay, glaze, style of incised work, and attributes of age do not closely match his other known copies. Hattie Brunner, one of the early owners of the PMA example, owned a number of Medinger plates

among her extensive redware holdings, and this connection may have led to the earlier confusion and misattribution to Medinger.

45 See ibid., p. 178, fig. 48, for a similarly patterned plate attributed to John Leidy I.

46 Ibid., p. 222, and research file collections #55-94-15, American Department, PMA.

47 Barber files, "Berks County Potters compiled 1905," research archives, American Department, PMA.

Traditional folk potters in England, on the Continent, and throughout America produced a wide range of figural toys and household decorations in clay. Comical depictions of a common household pet, a familiar inhabitant of the farmyard or local woodlands, or an exotic animal drawn from print illustrations or the occasional traveling circus—both realistic and fanciful—were produced throughout southeastern Pennsylvania. Germanic and Anglo-American potters carried the traditions of these figures southward along the Great Wagon Road into the Valley of Virginia.

Hand-modeled and hollow in construction, these earthenware figures of lions with half-smiling, half-grimacing expressions relate in scale and surface ornament to examples produced in Pennsylvania. Their finely grained, dark red clay and glassy, mottled lead glazing are typical of the type thought to have been used by traditional potters working in Bucks, Montgomery, and Chester Counties near Philadelphia. The oval base of the lion with an open mouth and protruding, curled tongue is stamp-decorated with floral motifs similar to those produced by leather-embossing tools familiar to saddlers and bookbinders during the period. Like most examples of these figures, the surfaces depicting their fur coats were scratched or punched with a thin, pointed wooden tool or stick and their glazed surfaces selectively colored with metal oxide slips.

Whether these and other depictions of the noble lion were inspired by simple whimsy and made solely for decoration or held deeper significance for their makers and owners is unknown. Prominent in both ancient biblical imagery and heraldic motifs, the lion represented wisdom, courage, and cunning and also figured regularly in common folk proverbs, fables, and humor. Illustrated children's primers printed by Pennsylvania German presses frequently depicted the animal, and the image was also a popular motif in illuminated fraktur, paint-decorated furniture, and engraved metalwork produced in the region. —J.L.L.

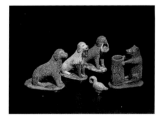

116a. SEATED DOG
Artist unidentified, possibly from the Bell Potteries
Waynesboro, Franklin County, Pennsylvania, or Strasburg,
Shenandoah County, Virginia
c. 1835–1880
Glazed red earthenware
5¼ × 5¼ × 2½ in.
P1.2001.138

PROVENANCE:
Arthur J. Sussel, Philadelphia; Parke-Bernet sale 1847, "Sussel Collection, Part I," 10/58, lot 226; Jess Pavey, Detroit; Garth's sale 10/67, "Pavey Collection," lot 138.

PUBLISHED:
Bishop, Robert. *The All-American Dog: Man's Best Friend in Folk Art.* New York: Avon Books in association with MAFA, 1978, p. 112.

116b. SEATED YELLOW DOG WITH BASKET
Artist unidentified, possibly from the Bell Potteries
Waynesboro, Franklin County, Pennsylvania, or Strasburg,
Shenandoah County, Virginia
c. 1835–1880
Glazed red earthenware
5½ × 4⅞ × 2⅛ in.
P1.2001.139

PROVENANCE:
Helen Janssen Wetzel, Spring Township, Pa.; Sotheby Parke-Bernet sale H-3, "Wetzel Collection," 10/80, lot 1759.

116c. SEATED DOG WITH BASKET OF FRUIT
Artist unidentified
Southeastern Pennsylvania
c. 1835–1880
Glazed red earthenware
5¼ × 5¼ × 2¼ in.
P1.2001.140

PROVENANCE:
Jacqueline D. Hodgson; Sotheby Parke-Bernet sale 3594, "Hodgson Collection," 1/74, lot 199.

EXHIBITED:
"The All-American Dog: Man's Best Friend in Folk Art," MAFA, 1977/78.

PUBLISHED:
Bishop, Robert. *The All-American Dog: Man's Best Friend in Folk Art.* New York: Avon Books in association with MAFA, 1978, p. 105.

116d. SWAN
Artist unidentified
Southeastern Pennsylvania
c. 1850–1880
Glazed red earthenware
2 × 2½ × 1⅛ in.
P1.2001.141

PROVENANCE:
Joe Kindig III, York, Pa., 1982.

116e. BEAR AND TREE STUMP
Artist unidentified
Southeastern Pennsylvania
c. 1835–1880
Glazed red earthenware
5⅝ × 4¾ × 2⅝ in.
P1.2001.142

PROVENANCE:
Joe Kindig Jr., York, Pa., 1967.

The presenting of gifts as tokens of affection—as rewards for honest work and accomplishment and to mark births, baptisms, marriages, birthdays, and seasonal holidays—was an honored tradition among various immigrant German communities throughout North America. These gifts took numerous forms, and in Pennsylvania might be a savory cooked dish or special pie, a colorful, hand-drawn reward of merit, an

ornament for household decoration, or a special, fanciful toy for a lucky child. Small animal figures—molded from clay and colorfully glazed or carved from wood and brightly painted—were produced by traditional Pennsylvania craftsmen during the nineteenth century and survive today in numbers that suggest their widespread popularity among the cherished possessions of households of the region.[48] Many of their forms may have been inspired by imported ceramic figures such as those produced by some Staffordshire-area English potteries or by the molded chalkware figures also popular among the Pennsylvania Germans.

Several Pennsylvania potteries, as well as operations in western Maryland and the Shenandoah Valley of Virginia, are known to have produced a variety of these figures. The similar sculpting and molding techniques, decorative surface modeling, and glazes seen across surviving examples make any firm attribution to a particular pottery difficult.[49] Many have regularly been assigned to the potteries of John Bell in Waynesboro, Pennsylvania (act. 1833–1880), and to several of his sons who continued the pottery there, as well as to his brothers Solomon and Samuel (act. 1839–1882), who operated a successful pottery in Strasburg, Virginia. The three brothers had all earlier apprenticed with their father, Peter, who ran potteries in both Hagerstown, Maryland, and Winchester, Virginia. Any specific attributions to the various Bell productions must remain tentative at best; there remain few signed examples, and there is documentation that this prolific pottery family migrated from shop to shop, exchanged workmen, sent clays, glaze materials, and finished forms back and forth, and influenced and copied one another's productions.[50] Their works most likely also influenced the output of other contemporary potters in each region, such as Simon Singer of Haycock Township, Bucks County, Pennsylvania (act. c. 1850), or Anthony Baecher, who established a pottery near Winchester, Virginia, about 1860.

—J.L.L.

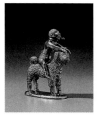

117. PIPE-SMOKING MONKEY
RIDING A DOG
Attributed to Solomon Bell (1817–1882)
Strasburg, Shenandoah County, Virginia
c. 1850–1870
Glazed red earthenware
8⅝ × 6¼ × 2⅛ in.
P1.2001.143

PROVENANCE:
Helen Janssen Wetzel, Spring Township, Pa.; Sotheby Parke-Bernet sale H-3, "Wetzel Collection," 10/80, lot 1757.

EXHIBITED:
"The Shape of Things: Folk Sculpture from Two Centuries," MAFA, 1983.

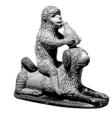

118. MONKEY ASTRIDE A RECLINING DOG
Artist unidentified
Southeastern Pennsylvania
c. 1850–1870
Glazed red earthenware
5¼ × 5½ × 2⅛ in.
P1.2001.144

INSCRIPTION:
Underside of base, incised: 20

PROVENANCE:
Ronald Pook, Downingtown, Pa., 1991.

Redware figural groups such as these depicting monkeys and dogs are rare, and their making required the potter to have a masterful control over his clays and glazes. If the clay was too dense or sculpted too thickly, the figure might crack or explode during firing. Because of their larger volume, the forms were made hollow with vent holes to allow moisture in the clay to escape as it turned to steam and pressure built up. The potter could add ground feldspar or silica sands to the mix to create a more porous, open-bodied clay, but he then ran the risk that the form might slump or warp if the mix was uneven or if the kiln temperature grew too hot.

Modeled separately for greater detail, the individual figures, their accessories, and the bases were conjoined in their plastic state with liquid clay slip, which had to be carefully mixed from the same clays to assure a solid, lasting joint once fired. Glazes also presented specific requirements. If too much silica or lead sands were added, they became too fluid and would pool or run off the figure when fired, spoiling the sculpted detail. Or if the mineral oxides used for color were too concentrated, the glaze would pit and bubble. And imperfections left in the clay could cause unwanted spots and blemishes in the final color or surface. This technical expertise, gained through experiment, observation, and years of experience, enabled the traditional folk potter to create such animated masterpieces.

The images of the monkey and the dog were prominent motifs in traditional folktales and were published in the fables of Aesop and La Fontaine and numerous other sources. The monkey—upright, engaged in human activities, and stylishly costumed—was depicted as an animal trickster in folk sculpture and published cartoons in both northern and southern states. The monkey also frequently embodied prejudicial caricatures within the climate of slavery, abolition, and the conflict of the Civil War, as a minstrel or liveryman, part African slave and part animal.[51] Earthenware figures with bottles or jugs, or engaged in drinking contests, playing music, or traditional games, were also drawn from folk humor and may have been made in response to prohibitionist or evangelical assaults on such celebratory pastimes.

—J.L.L.

48 For similar examples, see Garvan, *Collection,* pp. 219–24. A similar bear and tree stump figure, most likely intended to serve as a vase, is in the PMA collection, as is an unattributed pair of similar dog figures, with the number 8 incised on the undersides of the bases.

49 While some differences in clay types, incising techniques, and decorative stamps used in these figures are present across known surviving examples, few consistent characteristics can be configured given the lack of signed or firmly documented examples. The opaque yellow slip,

mottled glazes, deeply gouged surfaces depicting fur, and the stamped, chainlike decorations on cat. nos. 116a and b are found on several signed examples from the Bell potteries.

50 A.H. Rice and John Baer Stoudt, *The Shenandoah Pottery* (Strasburg, Va.: Shenandoah Publishing House, 1929), pp. 31–40, and William E. Wiltshire III, *Folk Pottery of the Shenandoah Valley* (New York: E.P. Dutton, 1975).

51 For similar examples combining these motifs, see Garvan, *Collection,* p. 224.

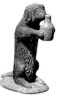

119. UPRIGHT DOG HOLDING A JUG
Attributed to Samuel Bell or Solomon Bell
(act. 1834–1882)
Strasburg, Shenandoah County, Virginia
c. 1850–1880
Glazed red earthenware
6⅛ × 4½ × 2¼ in.
P1.2001.145

PROVENANCE:
George Horace Lorimer, Philadelphia; Bernard and S. Dean Levy, New York, 1977.

EXHIBITED:
On loan to TBM from the George Horace Lorimer Collection, c. 1942–1977.

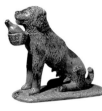

120. SEATED DOG WITH BOTTLE IN BASKET
Attributed to John Bell (1800–1880)
Waynesboro, Franklin County, Pennsylvania
c. 1840–1870
Glazed red earthenware
7½ × 7¾ × 3½ in.
P1.2001.146

PROVENANCE:
Helen Janssen Wetzel, Spring Township, Pa.; Sotheby Parke-Bernet sale H-3, "Wetzel Collection," 10/80, lot 1756.

The Bell family produced four generations of influential and multi-talented potters whose working careers spanned most of the nineteenth century. They established extensive operations and consumer markets in Pennsylvania, Maryland, and the Shenandoah Valley of Virginia. Peter Bell (1775–1847), active in Hagerstown, Maryland, and Winchester, Virginia, after 1800, produced a variety of redware forms and was followed by his sons John and Samuel, who established potteries during the 1830s in Pennsylvania and Virginia; they were followed, in turn, by several of their children later in the century. While sculpted, glazed redware animal figures portrayed in imaginary activities and whimsical stances were likely produced by a number of traditional folk potters working in both regions, a group of these figures exhibit particular characteristics in their fabrication and decoration or have associated histories connecting them to the Bell productions. Within this group, however, few examples bear signatures. Thus, firm attributions differentiating their works remain difficult to establish, given the longevity of the Bells' operations, the consistency in techniques and use of materials known to have been employed by them at their respective potteries, and the existence of competing potteries in both regions that may have patterned products after theirs.

Most of these animal figures are hollow, consisting of a thick-walled, hand-formed tube of clay bent roughly to shape, with clay additions forming the head, legs, and other features. Details depicting facial features, fur, paws, and other surface elements are scratched or drawn in the wet clay. Fur textures seen on those examples attributed to the Bells appear to have been modeled using a thin, pointed stick, leaving narrow, closely spaced, shallow broken "tubes" forming the pelt of the animal. The bases onto which the completed figures were attached were cut or stamped from a sheet of similar clay and decorated with pointed oval or floral stamps.[52] Several of these stamped designs closely echo patterns produced by leather-stamping tools, such as those used by a harness maker or bookbinder. The potter's placement of the stamps indicates that they were applied before the bases were attached to the figures. Once the decoration was complete on both elements, the pieces were joined together in their plastic state with wet slip clay and allowed to dry prior to glazing and firing.

While letters from the Bells document that John sent clay, glaze materials, and finished works from Pennsylvania to Samuel in Virginia during the 1840s, the clay in the figure attributed to Samuel or Solomon is slightly lighter in color and coarser in particulate, similar to other clays found in the Shenandoah Valley. The overall green and yellow slip treatment on this example is also similar in character and color to the slip decoration found on other wares from the Strasburg pottery. —J.L.L.

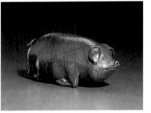

121. SOUVENIR BOTTLE
Attributed to Wallace Kirkpatrick
(1828–1896)
Anna, Union County, Illinois
c. 1880–1885
Salt-glazed gray stoneware
3¼ × 6¾ × 3 in.
P1.2001.147

INSCRIPTION:
Overall surface incised with line map depicting the Mississippi River and the Illinois Central, Cairo, and St. Louis Railroads: *Chicago / the Corn Crib / Tolano / Mattoon / Effingham / Odin / Centralia / Ashley / DuQuoin / Carbondale / Mounds / Cairo / Grand Tower / Miss. River / St. Louis the future Capital in / from / Jno Gaubatz / with a little good old Rye / Cincinnati the / Porkopolis / Ohio Riv*

PROVENANCE:
Gary and Nancy Stass, New Canaan, Conn.; Barry Cohen, New York; Kate and Joel Kopp, America Hurrah, and David A. Schorsch, New York, 1990.

EXHIBITED:
"The Barry Cohen Collection of Early American Stoneware," AARFAC, 1975.

PUBLISHED:
Schorsch, David A. *The Barry Cohen Collection.* New York: America Hurrah and David A. Schorsch, 1990, p. 78.
Walters, Donald R. "The Barry Cohen Collection of American Stoneware." *Antiques and the Arts Weekly* (Oct. 17, 1975): 21.

52 The pointed oval stamp and the repeated, closely spaced round stamp designs seen on both these figures are among the characteristics thought to help distinguish the work of the Bells from that of other potters producing these figures. A stamp-decorated vase signed "S. Bell and Son, Strasburg" (collection Henry Ford Museum, Dearborn, Mich.) bears similar stamped decoration and serves as one of the prime examples toward these attributions.

The sons of an Ohio and Illinois potter, Wallace and Cornwall Kirkpatrick founded one of the most successful potteries in the Midwest, in Anna, Illinois, about fifteen miles from Mound City. The brothers achieved quick success, reported in the (*Jonesboro, Ill.*) *Gazette* of December 3, 1859, as "equal to any we have seen anywhere. It is composed of the best clay, well gotten up by neat and skillful workmen; the patterns are the most improved style, well burned, and showing generally that the workmen by whom it was made thoroughly understand the business." Both brothers were active in civic politics, belonged to several influential fraternal and political organizations, and were members of the United Friends of Temperance. By the 1880s, the pottery employed a large number of workers and produced a full range of utilitarian and novelty pottery, including many of these small pig-shaped flasks, grotesque jugs teeming with demonic serpents and distorted human faces, humorous animal figures, pipes, and whistles.

Much of the wares made at the Anna potteries by the Kirkpatricks used locally available gray stoneware clays decorated with brown "Albany" slips and blue cobalt oxide highlights. While many of the novelty wares conveyed clearly the potter's ideas surrounding the evils of drink, evidence suggests these small drinking flasks, with the spout placed at the pig's rear, were given as political souvenirs and often presented, as this example is inscribed, "with a little good old Rye." —J.L.L.

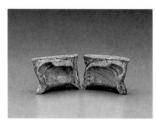

122. RECLINING LAMB SUGAR MOLD
Artist unidentified
Southeastern Pennsylvania
c. 1820–1860
Glazed red earthenware
$1\frac{1}{2} \times 2\frac{1}{8} \times 1\frac{3}{8}$ in. (closed)
P1.2001.148

PROVENANCE:
Joe Kindig III, York, Pa., 1980.

The traditional foodways practiced for both special festivities and daily meals called for molds or special forms that enabled the proud cook to present finished dishes in decorative shapes. Carved from wood, cast or stamped from metal, or formed from clay, molds were popular in both Germanic and English households in Pennsylvania. A number of local potteries produced specialized molds in various forms for presentation cakes, puddings, candies, and other treats. For example, the account book of Josiah Swank, a potter working in Upper Westmoreland County, recorded "pound cake molds" at a cost of 18¾ cents apiece in 1848.[53]

This small two-part mold in the form of a reclining lamb was probably used in the making of molded sugar, chocolate, or other confections. Small molded candies in the form of animals were a popular part of Christmas, Easter, and harvest celebrations, and the making of crystalized sugar candies was a seasonal activity during the fall maple sugaring

cycles. Once gathered, raw maple sap was boiled to concentrate its sweetness and thicken its consistency. As the mixture began to crystallize and harden, it was mixed with a small amount of butter and poured or pressed into such molded clay or carved wooden forms to set. Both professional confectioners and domestic kitchens produced the popular candies.

The glazed interior of this example indicates its use in food production. Glazing, while minimizing the smaller details of the molded design, prevented the absorption of flavors into the mold and promoted the release of the confection once it solidified. Potters, chalkware makers, and other craftsmen employed similar small earthenware molds but usually left the interior surfaces unglazed to facilitate finer detail in the molded features and the absorption of moisture from the liquid clays or plaster to be cast. —J.L.L.

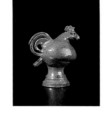

123. ROOSTER WHISTLE
Artist unidentified
Southeastern Pennsylvania
c. 1810–1840
Glazed red earthenware
$6 \times 4 \times 3\frac{1}{4}$ in.
P1.2001.149

PROVENANCE:
Mr. and Mrs. Edwin L. Rothschild, Elkins Park, Pa.; Pennypacker sale 4/63, "Rothschild Collection," lot 657; Jack Lamb, Kutztown, Pa., 1972.

Earthenware figures and whistles in the form of animals were a popular product of numerous Pennsylvania potteries during the first half of the nineteenth century. Pennsylvania Germans sometimes referred to smaller ceramic whistles, often in the form of a bird, as a *Pie Vogelpeif*, or pie whistle. Positioned on the top crust of an unbaked pie, the whistle channeled escaping steam as the pie baked, alerting the cook when the baking was complete. Larger whistles, in the form of fish, squirrels, turtles, or roosters, also survive. Purchased at seasonal or holiday festivals or given as gifts to new home owners or as a part of a dowry, such whimsical novelties were certainly cherished within many rural households. Elizabeth Fussell, a young girl from Montgomery County, recorded in an 1817 letter to her aunt her joy in having received a *Hinkelpeif* (chicken whistle) from her father for her eleventh birthday.[54]

Such figural whistles were produced using a variety of molded, modeled, and wheel-thrown techniques. The hollow, conical base of this example was wheel thrown in one section. The body, neck, and head of the form, also wheel thrown in a symmetrical shape similar to a small jug, was then shaped and manipulated by hand to resemble the rooster's form. The comb, tail, and whistle spout under the tail were all hand-modeled and applied, as were the small round dots forming its eyes and decorating its base. —J.L.L.

53 Scott T. Swank, *Arts of the Pennsylvania Germans* (New York: W.W. Norton in association with Winterthur, 1983), p. 177.

54 This letter is preserved in the Frances Lichten Files, American Department, PMA.

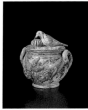

124. COVERED SUGAR BOWL WITH APPLIED BIRDS AND FLOWERS
Attributed to Anthony Wise Baecher (1824–1889)
The Big Hunting Creek Pottery (act. 1881–1883), owned by Joseph E. Simons (1838–1893), Mechanicstown, Frederick County, Maryland
c. 1881–1883
Glazed red earthenware
6¾ × 6 × 5¼ in.
PI.2001.150

INSCRIPTION:
Underside, stamped: *J.E. Simons*

PROVENANCE:
R.T.H. Halsey, New York; Joe Kindig Jr., York, Pa., 1967.

EXHIBITED:
MMA, prior to 1944.

PUBLISHED:
Halsey, R.T.H., and Charles O. Cornelius. *The Metropolitan Museum of Art: A Handbook of the American Wing.* New York: MMA, 1925, p. 221.

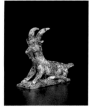

125. SEATED GOAT
Anthony Wise Baecher (1824–1889)
Winchester, Frederick County, Virginia
c. 1870–1889
Glazed red earthenware
6⅞ × 7⅝ × 2³⁄₁₆ in.
PI.2001.151

INSCRIPTIONS:
Base, stamped twice, and underside of base, stamped once: *BAECHER / WINCHESTER*

PROVENANCE:
Headley's Auctions, Long Green, Winchester, Va., sale 10/67; Dr. and Mrs. Henry P. Deyerle, Harrisonburg, Va.; Sotheby's sale 6716, "Deyerle Collection," 5/95, lot 775.

EXHIBITED:
"Folk Pottery of the Shenandoah Valley," AARFAC, 1975.

PUBLISHED:
Comstock, H.E. *The Pottery of the Shenandoah Valley Region.* Winston-Salem, N.C.: Museum of Early Southern Decorative Arts, 1994, p. 169.
Wiltshire, William E. III. *Folk Pottery of the Shenandoah Valley.* New York: E.P. Dutton, 1975, p. 111.

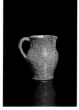

126. PITCHER WITH MOTTLED GREEN GLAZE
Anthony Wise Baecher (1824–1889)
Winchester, Frederick County, Virginia
c. 1870–1889
Glazed red earthenware
5¼ × 4½ in. (with handle)
PI.2001.152

INSCRIPTION:
Underside, stamped: *BAECHER / WINCHESTER*

PROVENANCE:
Sotheby's sale 7253, 1/99, lot 304.

The 1880 federal census records for Frederick County, Maryland, list Joseph E. Simons, from New Jersey, as the owner of a coach shop. In 1881 he and his wife, Mary, purchased a pottery operation along Big Hunting Creek near Mechanicstown that had been run by a potter named Jacob Lynn. Apparently investing on speculation and having no known training as a potter, Simons managed the pottery for approximately two years, using contracted labor supplied by a number of local master potters and apprentices. Among these potters was Anthony Wise Baecher (or Bacher), a potter who first apprenticed with his father in his Bavarian hometown of Falkenberg and, after immigrating, had apprenticeships in Adams County, Pennsylvania. Baecher had formed a partnership with Lynn in the pottery prior to the Simonses' purchase, and Lynn was an investor in an earlier pottery founded by Baecher about 1868–1870 in Winchester, Virginia. Baecher, one of the most skilled Germanic potters in the Shenandoah Valley, retained a regular and active interest in the Maryland pottery with Lynn until about 1880, when he began to focus more attention on his larger operation in Winchester.[55]

While several examples produced at the Big Hunting Creek Pottery bear the stamp of J.E. Simons, the techniques of molded and applied decorations incorporated in many of those examples, such as this sugar bowl with cover, are the same as those developed and perfected by Baecher. A virtually identical sugar bowl whose cover has a hand-molded and applied feeding bird finial and applied leaf decoration, bears the impressed mark "BAECHER, WINCHESTER" on its bottom.[56] Both Germanic and English traditional potters employed these decorative "sprigged" appliqués, hand-sculpted or hand-molded decorations formed separately from the main body of the vessel and secured to the surface with liquid slip while in the wet, unfired state. Most of Baecher's figural works and sculptural appliqués were hand-modeled and show little evidence of the use of molds or casting. His work, which later influenced that of the Bell and the Eberley potting families of the region, demonstrates the popularity and enduring nature of these traditional techniques and the shared influences and talents of these inspired regional potters.

The simple pitcher and the whimsical figure of a seated goat suggest Baecher's range, which stretched from ornamental umbrella stands, birdhouses, animal figures, and other decorative pieces to utilitarian household wares such as crocks, milk pans, and table articles. His colorful, mottled slip and glazed decoration, usually combining opaque yellow, greens, and browns, influenced the whole tradition of ceramics in the valley. Inventive and self-reliant, Baecher improved upon the standard potter's wheel of the period, which usually required the potter to stand before the rotating wheel. Baecher fitted his shop wheel with what was described by his son as a comfortable saddle, similar to that for a horse, which could be raised or lowered for position and comfort.[57]

Some of Baecher's earliest signed works bear a script signature or are marked with a stamp using the original Germanic spelling of his name, "Bacher." These may indicate his tenure of production while in Maryland

55 For a detailed discussion of Baecher and his connection to Lynn and Simons, see Rice and Stoudt, *Shenandoah Pottery*, chap. 9.
56 Collection Henry Ford Museum, Dearborn, Mich.; see Wiltshire, *Shenandoah Valley*, pp. 108–9.
57 Rice and Stoudt, *Shenandoah Pottery*.

or during the initial phase of his activities in Winchester. He retained the script signature on many of his larger custom commissions but seems to have adopted the anglicized spelling "Baecher" in his later mark, as is seen on these examples.

—J.L.L.

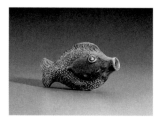

127. FISH FLASK OR BOTTLE
Attributed to Rudolph Christ
(act. c. 1800–1822)
Salem, Forsythe County, North Carolina
c. 1800–1822
Glazed red earthenware
2⅝ × 4½ × 1⅜ in.
P1.2001.153

PROVENANCE:
Dr. and Mrs. Henry P. Deyerle, Harrisonburg, Va.; Sotheby's sale 6716, "Deyerle Collection," 5/95, lot 331.

In 1753 members of several congregations of Moravians in Pennsylvania were granted a lease from agents of Lord Granville on more than 100,000 acres of land, known as the Wachovia Tract, in the Piedmont of North Carolina. They and Moravian immigrants from Middle Germany established three thriving towns—Bethania, Bethabara, and Salem—by 1770. Among their ranks were numerous highly skilled craftsmen, and the prosperity enjoyed by these industrious immigrants to the southern backcountry gained them the reputation as a "people remarkable for their orderly behavior, plain obliging manners, unvaried economy, and steady, unremitting industry."[58] The region was rich in natural clay sources and mineral deposits, and the various potteries established by the Moravians became widely known for the quality of their glazed earthenware stove tiles and their innovative molded forms based on manufactured English and European prototypes, such as this tin-glazed fish bottle.

Rudolph Christ, one of the early master potters in Salem and Bethabara, began about 1800 to produce a range of figural, press-molded bottles and other forms, including fish, squirrels, bears, foxes, turtles, various birds, and other animal figures. Inventories indicate he continued to make wheel-thrown and press-molded wares until his retirement in 1822. Probably inspired by Staffordshire models, press-molded techniques required a more refined clay of finer particulate than that needed for wheel-thrown work.[59] In press molding, clay was pressed by hand directly into plaster molds rather than poured in a liquid state, as in slip casting. Press molding had been perfected earlier in Salem's potteries in the production of molded stove tiles.

In 1793 Christ began experimenting with "faience," or tin-enameled glazes like that on this fish bottle. The brilliant opaque glazes preferred for these molded animal forms were achieved by adding tin oxide to the basic lead glaze recipes containing flint, red lead, and kaolin clay as well as colorants such as copper oxide for green, manganese for brown, black iron oxide for black, lead antimony for yellow, or cobalt for blue.[60] An 1819 inventory for the pottery documents that four sizes of fish flasks were made in Salem and sold for "5d, 9d, 10d, and 12d"; later, in 1829, John Holland, a potter who succeeded Christ, also listed four sizes of the same form.[61] A surviving two-part mold for these fish bottles exists.[62]

—J.L.L.

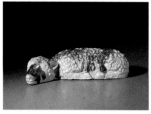

128. SLEEPING LAMB
S. Bell and Sons (Samuel Bell, Charles Bell, and Richard Franklin Bell) (act. 1882–1909)
Strasburg, Shenandoah County, Virginia
c. 1882–1904
Glazed red earthenware
3⅝ × 12 × 5¼ in.
P1.2001.154

PROVENANCE:
Dr. and Mrs. Henry P. Deyerle, Harrisonburg, Va.; Sotheby's sale 6716, "Deyerle Collection," 5/95, lot 563.

EXHIBITED:
"The Shape of Things: Folk Sculpture from Two Centuries," MAFA, 1983.

The figure of a reclining lamb was produced at the Bell family potteries in Strasburg after the death of Solomon Bell in 1882, at which time Samuel, Charles, and Richard Franklin Bell took over the production and marketing aspects of business.[63] Samuel moved to Strasburg in 1833, purchased an existing pottery from a German potter named Beyers, and began full operation the next year. Joined by Solomon, another brother, in 1837, the Bell brothers and their children formed one of the most creative and long-lived ceramic potteries in the South.

The Bells produced a number of different forms using various molding techniques. This lamb, like several of the animal figures made by the family, was formed in a plaster mold into which soft clay was pressed by hand. The clay for larger molded figures such as this solid and surprisingly heavy lamb had to be open-bodied and porous. The bottom of this piece was left unglazed to allow steam to escape from the form's middle during firing, and its granular, open texture retains the maker's fingerprints, left when he pressed the wet clay into the mold. Once fired, the figure in its bisque state received a coating of fine cream-colored clay slip

58 As quoted in John Bivins and Forsyth Alexander, *The Regional Arts of the Early South* (Chapel Hill, N.C.: Univ. of North Carolina Press in association with Museum of Early Southern Decorative Arts, 1991), p. 114.

59 Christ noted to the "Collegium" leadership of Salem in his 1780 request to start manufacturing "fine pottery" that it "cannot be manufactured together with the rough pottery, because the finest grain of sand that comes into the clay will do a great damage." See ibid., p. 77.

60 A rare surviving manuscript in the Moravian Archives in Salem titled "A Collection of Faience-China Glazing Formulas: also, All Sorts of Painter's Colors and How Such Are to be Treated, Salem, 20 October 1793" documents these recipes and Christ's experiments; see ibid., p. 83.

61 Manuscript day books of Christ and of Holland, collection Old Salem, Winston-Salem, N.C.

62 This mold and several other versions of these figural bottles and their related molds are in the collection of Old Salem.

63 Surviving family records indicate that the impressed mark present on this figure was adopted after Solomon's death in 1882. It is thought to have been used until 1904; see Wiltshire, *Shenandoah Valley*.

which was decorated with mineral oxides applied by brush, sponge, or patterned dipping. The Bells preferred slips containing copper oxide to produce the greens and manganese dioxide to create the iridescent browns decorating this example. In areas where the cream slip was left thin, the pinkish color of the clay surfaced during the final firing.

The reclining lamb, a biblical image and one that occurs frequently in folk traditions, popularly connoted peaceful rest and innocence in Victorian America. Stonecutters carved the figure atop gravestones memorializing young children and made small carved white marble lambs in repose as memento mori or keepsakes for bereaved parents and relatives. The Bells often produced their molds from preexisting forms and may have relied upon such a stone carving as a prototype. The pottery also created a reclining lamb figure finished only with a fine white slip, possibly as a cheaper alternative to the marble versions.[64]

—J.L.L.

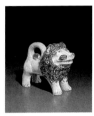

129. LION
Attributed to John Bell (1800–1880)
Waynesboro, Franklin County, Pennsylvania
c. 1850–1860
Glazed red earthenware
8 × 8½ × 4¼ in.
P1.2001.155

PROVENANCE:
Descended in family to Miss Crum, Winchester, Va.; W. Dan Quattelbaum; Harry B. Hartman, Marietta, Pa.; Mr. and Mrs. William B. Wiltshire III, Richmond; Sotheby Parke-Bernet sale 4076, 2/78, lot 1.

EXHIBITED:
"Folk Pottery of the Shenandoah Valley," AARFAC, 1975.

PUBLISHED:
Rubin, Cynthia Elyce, ed. *Southern Folk Art.* Birmingham, Ala.: Oxmoor House, 1985, p. 33.
Wiltshire, William E. III. *Folk Pottery of the Shenandoah Valley.* New York: E.P. Dutton, 1975, p. 26.

This whimsical lion, which may have seen service as a doorstop, is one of four known examples by members of the Bell family of potters. Each was made as a presentation gift to a family member. While similar in overall design and stance, with upturned head, grinning smile, and forward-looped tail, the lions vary slightly in size and detail. Because most redware and stoneware clays, if worked or formed too thickly, were prone to crack or explode during firing as moisture escaped, potters made figural forms thin walled, hollow, and with vent holes to release steam. Different combinations of hand-built, molded, and wheel-thrown techniques contributed to the making of these figures and suggest the experimentation and innovation such individual creations required of even the most talented folk potters.[65]

Once the figure was modeled, the maker incised the lines forming the eyes, nose, teeth, and toes and covered the piece with yellow clay slip. Thin areas of slip on the underside of the tail resemble fingerprint markings and suggest the figure may have been dipped while being held by its tail. The applied, stringlike clay decorating the mane and tail was made by forcing moist clay through a finely perforated metal template or through a piece of coarse fabric, such as burlap, extruding a mass of separate strands of fine clay "fur" which could be attached to the figure using liquefied slip. This decorative technique, often referred to as "coleslaw," was found in the figural productions of numerous potteries in the Staffordshire district of England and was transferred to and utilized by both English and Germanic potters in America. Bell painted manganese dioxide slip in these areas and copper oxide on the eyes of the figure to produce, once fired, the brown and green contrasts.

Bell presented this lion to a niece, a Miss Crum from Winchester, Virginia. She remembered as a child having dropped a pencil, presently trapped inside the figure, through one of the open ear cavities, which doubled as firing vents. W. Dan Quattelbaum, an early collector, acquired the figure from her in 1923 and preserved its oral history in his notes during his negotiations for its purchase.

—J.L.L.

64 This theory was first suggested in ibid., p. 68.
65 A similar lion bearing the stamped signature of John Bell is in the collection of Winterthur and serves as the attribution basis for this example; see Kenneth L. Ames, *Beyond Necessity: Art in the Folk Tradition* (Winterthur, Del.: Winterthur, 1977), p. 44. A third example is in the collection of the Henry Ford Museum, Dearborn, Mich. The fourth example, made by John's brother Solomon (1817–1882), is in the collection of the Museum of Early Southern Decorative Arts, Winston-Salem, N.C., and incorporates a wheel-thrown, tubular body; it was presented to one of John's nieces in Strasburg, Va. The long, rounded, looped tails on the three examples attributed to John may have been formed from wheel-thrown sections joined to the hand-modeled or press-molded bodies.

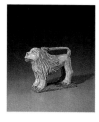

130. LION
Wilhelm Schimmel (1817–1890)
Cumberland County, Pennsylvania
c. 1860–1890
Paint on pine
7⅜ × 7½ × 3 in.
P1.2001.156

PROVENANCE:
Helen Janssen Wetzel, Spring Township, Pa.; Sotheby Parke-Bernet sale H-3, "Wetzel Collection,"
10/80, lot 1764.

EXHIBITED:
"The Shape of Things: Folk Sculpture from Two Centuries," MAFA, 1983.

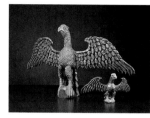

131a. LARGE EAGLE
Wilhelm Schimmel (1817–1890)
Cumberland County, Pennsylvania
c. 1860–1890
Paint on pine
21⅜ × 37¾ × 10 in.
P1.2001.157

PROVENANCE:
Ed and Mildred Bohne, Newmanstown, Pa., 1973.

131b. SMALL EAGLE
Wilhelm Schimmel (1817–1890)
Cumberland County, Pennsylvania
c. 1860–1890
Paint on pine
8 × 14 × 6 in.
P1.2001.158

PROVENANCE:
Helen Janssen Wetzel, Spring Township, Pa.; Sotheby Parke-Bernet sale H-3, "Wetzel Collection,"
10/80, lot 1767.

EXHIBITED:
"The Shape of Things: Folk Sculpture from Two Centuries," MAFA, 1983.

The surviving body of brightly painted carved birds, animals, and other figures attributed to German immigrant carver Wilhelm Schimmel represents one of the best-known groups of American folk carving. By all accounts irascible, unpredictable in temperament, and "a big, raw-boned ugly man," Schimmel arrived around 1860 in Pennsylvania's Cumberland Valley and endeared himself to several families living along the Conodoguinet Creek, about six miles west of the town of Carlisle.[1] John Greider, a miller and farmer, befriended and trusted Schimmel, provided him lodging in the loft of his wash house, and

defended him from those less appreciative of his loud behavior and habitual drunkenness during journeys undertaken to sell his carvings. Despite his behavior, Schimmel was supported within the close-knit community of Pennsylvania German and Scotch-Irish farmers of the valley who, by tradition, felt a mutual responsibility to shelter and care for even the most marginal among them. Schimmel knew on whom he could rely for kindness or shelter along the route of his wanderings, where he would be allowed to scavenge for wood scraps for his carvings, and who might trade food, drink, or lodging for or buy his work. He also gained wood from the local sawmill, from barn raisings, and from a cabinetmaker named Samuel Bloser, who had a workshop in Possum Hill, Cumberland County. Bloser befriended Schimmel, but when the carver took too much wood, he complained, "Don't pick the blocks so close."[2]

Similarly, the carvings Schimmel produced gained a widespread appreciation among the inhabitants around Carlisle as a result of their fascination with the maker, a charitable effort to support him, or a genuine appreciation for the works' bright aesthetic character. His fanciful animals and birds suggested in their irregular carving and direct stances the personality of Schimmel himself. The saloons and taverns the carver frequented displayed numerous examples of his work, which he traded for spirits and food; other residents regularly bought his figures for ten to twenty-five cents—or more, for larger figures such as these eagles, which Schimmel referred to in German as "vogels." Oral histories suggest that several of his larger eagles with full wingspans were displayed on the tops of flagpoles, as exterior architectural ornaments on the crests of gables, or in gardens.[3]

The lion, long a symbol of strength, courage, and royalty in many cultures, may have had particular meaning for Schimmel. In Carlisle he was repeatedly accused of intimidating the children and townspeople by "staggering up the street and roaring like a lion" during episodes of public drunkenness.[4]

This example of the king of beasts, with its erect, frontal stance, roughly carved mane, and looped tail, is similar in form and execution to one of the only other lions attributed to the carver.[5] Both examples survive relatively untouched and document Schimmel's technique of coating the finished carving with a thin layer of gessolike plaster, which served as a priming layer for his colorful painted surfaces and details. As with his other carvings, pigments appear to have been common household oil paints, probably salvaged from discarded cans or leftovers found in his travels or given to the artist by his friends. The base of this lion and those of a number of Schimmel's other carvings retain the character and circular-sawn kerf marks of these milled lumber scraps. Their thickness and dimensions often determined the size and stance

1 Milton Flower, "Schimmel the Woodcarver," *The Magazine Antiques* 44, no. 4 (October 1943): 164–66.
2 Ibid.
3 Ibid.
4 Flower, "Schimmel the Woodcarver," pp. 164–66.
5 M. & M. Karolik Collection, MFA; see Carol Troyen, "Maxim Karolik and Folk Art," *The Magazine Antiques* 159, no. 4 (April 2001): 588.

of the composition and details of the finished carvings. The lion figures differ only slightly in detail and stance from other dog figures and may have had their beginnings in similarly sized scrap stock.

Remarkably, Schimmel's only tool was a common folding pocket knife. He worked directly and confidently and seems to have rarely bothered to smooth or refine the broad facets left from the blade on the surface of his carvings.[6] The eagles demonstrate Schimmel's method of constructing his forms and delineating their surface details. All the known eagles with spread wings have a central body, head, leg, and base section into which the separate wings are shallowly mortised and glued in place. The wing feathers are depicted by deep, angular cuts, gouged out and projecting separately on the frontal, inner face and crosshatched on the rear. The angular cuts of the body, neck, and tail sections of the form complete this bold appearance of irregular, ruffled feathers.

—J.L.L.

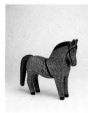

132. HORSE TOY
Artist unidentified
Probably Cumberland County, Pennsylvania
c. 1860–1890
Paint on poplar
11¾ × 12⅜ × 3½ in.
P1.2001.159

PROVENANCE:
Found in Carlisle, Pa.; Edith Gregor Halpert, New York; David A. Schorsch, New York, 1994.

EXHIBITED:
"Centennial Exhibition: American Folk Art," Albright Art Gallery, Buffalo Fine Arts Academy, Buffalo, N.Y., 1932.
"American Ancestors: Masterpieces by Little-Known or Anonymous American Artists, 1720–1870," The Downtown Gallery, New York, 1933.
"Dog, Cat, and Horse Show," The Toledo Museum of Art, Toledo, Ohio, 1933.
"Children in American Folk Art: An Exhibition of Their Portraits and Toys, 1725–1865," The Downtown Gallery, New York, 1937.
"American Folk Art Sculpture, Index of American Design," The Downtown Gallery, New York, 1937.
"Inter-American Folk Art," The Downtown Gallery, New York, 1942.
"American Folk Art: The Edith Gregor Halpert Collection," Eden Hill House, Newtown, Conn., 1952 and 1957.
"American Primitive Art," The Museum of Fine Arts, Houston, Tex., 1956.

PUBLISHED:
Christensen, Erwin O. *The Index of American Design.* Washington, D.C.: Macmillan, 1950, p. 249.
Hornung, Clarence P. *Treasury of American Design: A Pictorial Survey of Popular Folk Arts Based upon Watercolor Renderings in the Index of American Design, at the National Gallery of Art,* vol. 2. New York: Harry N. Abrams, 1972, p. 621.

This lively painted figure of a horse, probably a lucky child's favorite toy, is one of several thought to have been made by an unidentified carver working in the area of Carlisle, Cumberland County, Pennsylvania. This example has a virtual mate; they share like construction, decoration, and overall proportions.[7] Rocking hobbyhorses, or pull-horses on platforms with wheels, were among the most popular of children's toys during the nineteenth century. Inexpensive carved and painted toys imported from the Bavarian regions of Germany and the Austrian Tyrol were popular among the Pennsylvania Germans and may have served as prototypes for locally carved versions.

While the pieced, laminated multipart construction utilized on this horse is similar to that seen on the imported versions, its bold, steady proportions and spirited stance suggest the free, individual interpretation characteristic of a number of folk carvings produced in Pennsylvania during the period. The three elements composing the head and body were first joined together and their shape refined to receive the separate front and back leg elements, which are pinned and glued in place. The extended rounded end at the top of the separate carved tail was then inserted and glued into the rear, and, once assembled, all the joints were further refined with a rasp and knife blade. The painted decoration, consisting of freehand-applied spots over a white ground with a contrasting red tail and black harness, are laid down directly on the bare, unprimed wood.[8]

This horse has long been regarded as one of the icons of American folk art because of its inclusion in a number of landmark exhibitions, its frequent discussion in a number of early significant publications on American folk art, and its early ownership in the collection of pioneering folk art dealer and collector Edith Gregor Halpert. Halpert's involvement with the circle of artists in Ogunquit, Maine, and her Downtown Gallery in New York's Greenwich Village placed her among the first influential figures in American art circles to promote the appreciation and study of traditional American folk aesthetics. Her clientele, some of the most important early collectors in the field, included Abby Aldrich Rockefeller, Electra Havemeyer Webb, Ima Hogg, Henry Ford, Edgar William and Bernice Chrysler Garbisch, and Juliana Force. —J.L.L.

6 On some sections, such as the mid-bodies of his dogs and lions, the surface is much smoother, and Schimmel is thought to have used a piece of broken glass to shave and refine such surfaces.
7 Collection Winterthur; see Kenneth L. Ames, *Beyond Necessity: Art in the Folk Tradition* (Winterthur, Del.: Winterthur, 1977), p. 50.
8 Most imported examples have lighter, thinner elements composing their forms and are roughly shaped. Their forms are further refined with a thick gesso coating, which fills any gaps in the joints and serves as a ground coat for the painted decoration.

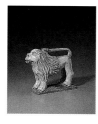

130. LION
Wilhelm Schimmel (1817–1890)
Cumberland County, Pennsylvania
c. 1860–1890
Paint on pine
7⅜ × 7½ × 3 in.
P1.2001.156

PROVENANCE:
Helen Janssen Wetzel, Spring Township, Pa.; Sotheby Parke-Bernet sale H-3, "Wetzel Collection," 10/80, lot 1764.

EXHIBITED:
"The Shape of Things: Folk Sculpture from Two Centuries," MAFA, 1983.

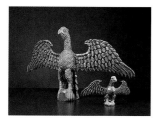

131a. LARGE EAGLE
Wilhelm Schimmel (1817–1890)
Cumberland County, Pennsylvania
c. 1860–1890
Paint on pine
21⅜ × 37¾ × 10 in.
P1.2001.157

PROVENANCE:
Ed and Mildred Bohne, Newmanstown, Pa., 1973.

131b. SMALL EAGLE
Wilhelm Schimmel (1817–1890)
Cumberland County, Pennsylvania
c. 1860–1890
Paint on pine
8 × 14 × 6 in.
P1.2001.158

PROVENANCE:
Helen Janssen Wetzel, Spring Township, Pa.; Sotheby Parke-Bernet sale H-3, "Wetzel Collection," 10/80, lot 1767.

EXHIBITED:
"The Shape of Things: Folk Sculpture from Two Centuries," MAFA, 1983.

The surviving body of brightly painted carved birds, animals, and other figures attributed to German immigrant carver Wilhelm Schimmel represents one of the best-known groups of American folk carving. By all accounts irascible, unpredictable in temperament, and "a big, raw-boned ugly man," Schimmel arrived around 1860 in Pennsylvania's Cumberland Valley and endeared himself to several families living along the Conodoguinet Creek, about six miles west of the town of Carlisle.[1] John Greider, a miller and farmer, befriended and trusted Schimmel, provided him lodging in the loft of his wash house, and

defended him from those less appreciative of his loud behavior and habitual drunkenness during journeys undertaken to sell his carvings. Despite his behavior, Schimmel was supported within the close-knit community of Pennsylvania German and Scotch-Irish farmers of the valley who, by tradition, felt a mutual responsibility to shelter and care for even the most marginal among them. Schimmel knew on whom he could rely for kindness or shelter along the route of his wanderings, where he would be allowed to scavenge for wood scraps for his carvings, and who might trade food, drink, or lodging for or buy his work. He also gained wood from the local sawmill, from barn raisings, and from a cabinetmaker named Samuel Bloser, who had a workshop in Possum Hill, Cumberland County. Bloser befriended Schimmel, but when the carver took too much wood, he complained, "Don't pick the blocks so close."[2]

Similarly, the carvings Schimmel produced gained a widespread appreciation among the inhabitants around Carlisle as a result of their fascination with the maker, a charitable effort to support him, or a genuine appreciation for the works' bright aesthetic character. His fanciful animals and birds suggested in their irregular carving and direct stances the personality of Schimmel himself. The saloons and taverns the carver frequented displayed numerous examples of his work, which he traded for spirits and food; other residents regularly bought his figures for ten to twenty-five cents—or more, for larger figures such as these eagles, which Schimmel referred to in German as "vogels." Oral histories suggest that several of his larger eagles with full wingspans were displayed on the tops of flagpoles, as exterior architectural ornaments on the crests of gables, or in gardens.[3]

The lion, long a symbol of strength, courage, and royalty in many cultures, may have had particular meaning for Schimmel. In Carlisle he was repeatedly accused of intimidating the children and townspeople by "staggering up the street and roaring like a lion" during episodes of public drunkenness.[4]

This example of the king of beasts, with its erect, frontal stance, roughly carved mane, and looped tail, is similar in form and execution to one of the only other lions attributed to the carver.[5] Both examples survive relatively untouched and document Schimmel's technique of coating the finished carving with a thin layer of gessolike plaster, which served as a priming layer for his colorful painted surfaces and details. As with his other carvings, pigments appear to have been common household oil paints, probably salvaged from discarded cans or leftovers found in his travels or given to the artist by his friends. The base of this lion and those of a number of Schimmel's other carvings retain the character and circular-sawn kerf marks of these milled lumber scraps. Their thickness and dimensions often determined the size and stance

1 Milton Flower, "Schimmel the Woodcarver," *The Magazine Antiques* 44, no. 4 (October 1943): 164–66.
2 Ibid.
3 Ibid.

4 Flower, "Schimmel the Woodcarver," pp. 164–66.
5 M. & M. Karolik Collection, MFA; see Carol Troyen, "Maxim Karolik and Folk Art," *The Magazine Antiques* 159, no. 4 (April 2001): 588.

of the composition and details of the finished carvings. The lion figures differ only slightly in detail and stance from other dog figures and may have had their beginnings in similarly sized scrap stock.

Remarkably, Schimmel's only tool was a common folding pocket knife. He worked directly and confidently and seems to have rarely bothered to smooth or refine the broad facets left from the blade on the surface of his carvings.[6] The eagles demonstrate Schimmel's method of constructing his forms and delineating their surface details. All the known eagles with spread wings have a central body, head, leg, and base section into which the separate wings are shallowly mortised and glued in place. The wing feathers are depicted by deep, angular cuts, gouged out and projecting separately on the frontal, inner face and crosshatched on the rear. The angular cuts of the body, neck, and tail sections of the form complete this bold appearance of irregular, ruffled feathers.

—J.L.L.

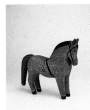

132. **HORSE TOY**
Artist unidentified
Probably Cumberland County, Pennsylvania
c. 1860–1890
Paint on poplar
11¾ × 12⅜ × 3½ in.
P1.2001.159

PROVENANCE:
Found in Carlisle, Pa.; Edith Gregor Halpert, New York; David A. Schorsch, New York, 1994.

EXHIBITED:
"Centennial Exhibition: American Folk Art," Albright Art Gallery, Buffalo Fine Arts Academy, Buffalo, N.Y., 1932.
"American Ancestors: Masterpieces by Little-Known or Anonymous American Artists, 1720–1870," The Downtown Gallery, New York, 1933.
"Dog, Cat, and Horse Show," The Toledo Museum of Art, Toledo, Ohio, 1933.
"Children in American Folk Art: An Exhibition of Their Portraits and Toys, 1725–1865," The Downtown Gallery, New York, 1937.
"American Folk Art Sculpture, Index of American Design," The Downtown Gallery, New York, 1937.
"Inter-American Folk Art," The Downtown Gallery, New York, 1942.
"American Folk Art: The Edith Gregor Halpert Collection," Eden Hill House, Newtown, Conn., 1952 and 1957.
"American Primitive Art," The Museum of Fine Arts, Houston, Tex., 1956.

PUBLISHED:
Christensen, Erwin O. *The Index of American Design.* Washington, D.C.: Macmillan, 1950, p. 249.
Hornung, Clarence P. *Treasury of American Design: A Pictorial Survey of Popular Folk Arts Based upon Watercolor Renderings in the Index of American Design, at the National Gallery of Art,* vol. 2. New York: Harry N. Abrams, 1972, p. 621.

This lively painted figure of a horse, probably a lucky child's favorite toy, is one of several thought to have been made by an unidentified carver working in the area of Carlisle, Cumberland County, Pennsylvania. This example has a virtual mate; they share like construction, decoration, and overall proportions.[7] Rocking hobbyhorses, or pull-horses on platforms with wheels, were among the most popular of children's toys during the nineteenth century. Inexpensive carved and painted toys imported from the Bavarian regions of Germany and the Austrian Tyrol were popular among the Pennsylvania Germans and may have served as prototypes for locally carved versions.

While the pieced, laminated multipart construction utilized on this horse is similar to that seen on the imported versions, its bold, steady proportions and spirited stance suggest the free, individual interpretation characteristic of a number of folk carvings produced in Pennsylvania during the period. The three elements composing the head and body were first joined together and their shape refined to receive the separate front and back leg elements, which are pinned and glued in place. The extended rounded end at the top of the separate carved tail was then inserted and glued into the rear, and, once assembled, all the joints were further refined with a rasp and knife blade. The painted decoration, consisting of freehand-applied spots over a white ground with a contrasting red tail and black harness, are laid down directly on the bare, unprimed wood.[8]

This horse has long been regarded as one of the icons of American folk art because of its inclusion in a number of landmark exhibitions, its frequent discussion in a number of early significant publications on American folk art, and its early ownership in the collection of pioneering folk art dealer and collector Edith Gregor Halpert. Halpert's involvement with the circle of artists in Ogunquit, Maine, and her Downtown Gallery in New York's Greenwich Village placed her among the first influential figures in American art circles to promote the appreciation and study of traditional American folk aesthetics. Her clientele, some of the most important early collectors in the field, included Abby Aldrich Rockefeller, Electra Havemeyer Webb, Ima Hogg, Henry Ford, Edgar William and Bernice Chrysler Garbisch, and Juliana Force.

—J.L.L.

6 On some sections, such as the mid-bodies of his dogs and lions, the surface is much smoother, and Schimmel is thought to have used a piece of broken glass to shave and refine such surfaces.

7 Collection Winterthur; see Kenneth L. Ames, *Beyond Necessity: Art in the Folk Tradition* (Winterthur, Del.: Winterthur, 1977), p. 50.

8 Most imported examples have lighter, thinner elements composing their forms and are roughly shaped. Their forms are further refined with a thick gesso coating, which fills any gaps in the joints and serves as a ground coat for the painted decoration.

133. KANGAROO
Artist unidentified
Probably Pennsylvania
Mid-nineteenth century
Paint on wood
28 × 49½ × 5 in.
P1.2001.160

PROVENANCE:
Found in Lebanon County, Pa.; John Gordon, New York; Christie's sale 9052, "Gordon Collection," 1/99, lot 236.

EXHIBITED:
"The Flowering of American Folk Art, 1776–1876," WMAA, 1974.
"Masterpieces of American Folk Art," Monmouth Museum, Lincroft, N.J., 1975.

PUBLISHED:
Lipman, Jean, and Alice Winchester. *The Flowering of American Folk Art, 1776–1876.* New York: Viking Press in association with WMAA, 1974, p. 176.

Poised alert and ready to pounce, this spotted kangaroo recalls some fantastic animal of another age. While little is known about its history, it has been recognized for many years for its individuality and strong presence. Found in Lebanon County, Pennsylvania, it may have been created as a toy. Regardless of his original intent, its imaginative carver used his sense of humor and knowledge of animal behavior to construct a figure of an exotic beast that he had probably never seen in person. Even if he had, his goal was obviously not to create a likeness, as was often the case with nineteenth-century animal carvings. The image of a kangaroo was the inspiration, not the intention.

The animal presents a rather ferocious appearance with teeth bared and a menacing grin. Its powerful hind legs and short forelegs feature large central claws of threatening proportions, while its long curving neck and undulating tail reinforce the sense of an animal about to strike. In both form and demeanor, it resembles a dragon as much as a kangaroo, like some mythic creature from an ancient bestiary. —R.S.

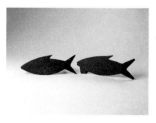

134a. CAST BRACKET OR TOOL HOLDER
Artist unidentified
Southeastern Pennsylvania
c. 1780–1830
Iron
2⅞ × 8 × 3 in.
P1.2001.161

PROVENANCE:
Dr. and Mrs. Henry P. Deyerle, Harrisonburg, Va.; Sotheby's sale 6716, "Deyerle Collection," 5/95, lot 644.

134b. FORGED BRACKET OR TOOL HOLDER
Artist unidentified
Southeastern Pennsylvania
c. 1780–1820
Iron
3¹⁄₁₆ × 8⅜ × 3⁵⁄₁₆ in.
P1.2001.162

PROVENANCE:
Found in vicinity of Lancaster, Pa.; Joe Kindig III, York, Pa., 1971.

Several of these fish-shaped brackets are known to have survived, all with Pennsylvania histories and associations with the early Germanic communities there.[9] The fish is a common image in a number of American folk traditions, perhaps because of its importance as a food source or its prominence in early folktales or biblical references. A number of animal motifs were regularly incorporated into the pattern and design of iron hardware—such as hinges, brackets, and escutcheon plates—made by Pennsylvania's early blacksmiths, and they may have held specific personal or symbolic meanings for their makers or owners.

A close comparison of these two examples reveals that they were not created by the same maker and that no common pattern or template was used as a basis for their shape. Their methods of fabrication also differ significantly. One is forged completely by hand, its beaten sheet iron varying in thickness and surface quality. The quality of the edge suggests it was sawn with a chisel and filed to form its basic shape. The eye, gills, and crescent-shaped scales of the fish were scratched or chisel-stamped into the surface. Its tapered, bracket-form spikes were also forged, then attached with round, riveted iron brads through the body of the fish. The brads and rivets were flattened and beaten on their ends to secure the elements together.

The other example combines cast and wrought techniques. The iron sheet from which the fish-shaped element was formed is of uniform thickness and surface quality, and its rear surface shows clear evidence of sand-cast pitting. Its edge is rounded and even, and it was probably cast in its finished form. The mouth, eye, gills, and scales are also molded, further indicating the use of casting. The bracket spikes attached to its back surface were forged and brazed to the front element.

By oral tradition, these brackets were used to hold an ax and were part of the equipage of the great Conestoga wagons that facilitated westward expansion into the agrarian hinterlands of the state. The positioning of their bracket spikes, one placed slightly higher than the other, would have accommodated a shaped ax head securely once the bracket spikes were hammered into the side rail or architectural wall of a wooden wagon; the long handle of such a tool would fall through and be held firmly behind the fish-shaped plate. —J.L.L.

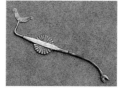

135. PIE CRIMPER
Artist unidentified
Probably southeastern Pennsylvania
c. 1790–1820
Iron
2⅜ × 8 × ¼ in.
P1.2001.163

PROVENANCE:
Chris A. Machmer, Annville, Pa., 1977.

9 In addition to these two examples, a wrought example is in a Pennsylvania private collection, and another is in the collection of the Landis Valley Farm Museum in Lancaster, Pa.; see Vernon S. Gunnion, and Carroll J. Hopf, eds., *The Blacksmith Artisan within the Early Community* (Harrisburg, Pa.: Pennsylvania Historical and Museum Commission, 1976), p. 51. The forged example was found in the Lancaster area.

The baked fruit pie was invented by English and Scotch-Irish settlers, but pastry-crusted baked pies were quickly adopted into the popular food traditions of the Pennsylvania Germans. Baking was routine for most women within traditional Pennsylvania farm households, in which families typically ate four meals a day with fruit, meat, and "sweet" pies a part of the regular fare. The variety of pies produced in many kitchens was noted with amazement by Lewis Evans, an Englishman who traveled through Pennsylvania in 1753. Evans noted that ornately crusted pies were often presented as gifts of hospitality to guests, the infirm, or the elderly, and they were sold at regional fairs and harvest festivals and entered into local baking competitions.[10] In eastern Pennsylvania, sweet raisin pies were reserved as mourning gifts, and certain bakers within the Germanic communities became known for their talents in producing "funeral pies."

Talented household bakers often assembled many different pies during a day and developed patterns of scoring, pinching, or otherwise decorating the crusts to distinguish a dish's hidden contents. Pie crimpers, also known as jagging wheels, were popular decorating tools used by both household and professional pie bakers. Produced from metal, wood, bone, or a combination of different materials, the tool—with a notched, rotating round disc held within a handle—pinched, sealed, and trimmed the edge of the pie's crust, leaving the ruffled edge that grew to characterize the best pies.

At least three virtually identical iron pie crimpers of this form are known, and because of their similarities in manufacture and pattern, they are thought to be by the same maker.[11] Small, finely wrought and finished iron household objects such as this example were often the work of ironsmiths who specialized in "whitework." The thin, light dimensions of this crimper required a strong, dense iron alloy that would stand up to everyday use. In this refined example, the crimping wheel is placed in the middle of the curved pierced shaft. Both the forked and the stylized bird ends of the tool could be used to cut patterns with which to decorate top crusts. —J.L.L.

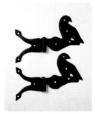

136. PAIR OF DOOR HINGES
Attributed to Hopewell Forge (act. 1744–1780)
Union Township, Berks County, Pennsylvania
c. 1750–1780
Iron
7 × 10¼ × 1 in. each
P1.2001.164a, b

PROVENANCE:
From a house in Oley Valley, Pa.; Joe Kindig III, York, Pa., 1977.

EXHIBITED:
"The Pennsylvania Germans: A Celebration of Their Arts, 1683–1850," PMA, 1982/83.

PUBLISHED:
Garvan, Beatrice B., and Charles F. Hummel. *The Pennsylvania Germans: A Celebration of Their Arts, 1683–1850*. Philadelphia: PMA in association with Winterthur, 1982, pl. 46.
Wilmot, Sandra. "More Than Just Hearts and Flowers," *Americana* 10, no. 4 (September/October 1982): 33.

The Delaware Valley's natural deposits of bog iron, iron ore, and limestone and its ready access to waterpower and abundant timberlands from which to fuel smelting furnaces enabled the development of a widespread iron industry in Pennsylvania by the mid-eighteenth century. Early speculative investment from wealthy English and Germanic entrepreneurs in the colony continued throughout the Revolutionary War period and into the first years of independence, and more than seventy prosperous iron furnaces, forges, and foundries had been established in the state by 1800. These larger operations were joined by innumerable smaller local blacksmith shops and independent ironmongers, each producing a wide variety of utilitarian and decorative iron products for the domestic consumer.

Among the early, influential investors in Pennsylvania's iron industry was English immigrant William Bird (1703–1761), who established Hopewell Forge and the village of Birdsboro along French Creek in the mid-1740s. Upon Bird's death, his son Mark assumed and expanded operation of the forge and furnace. These hinges, decoratively wrought in the shape of birds, are attributed to the Hopewell Forge during the tenure of the Birds, and may have been made for either the father's or the son's own use.[12] During the height of Hopewell's operation, a number of highly trained immigrant and locally trained ironworkers were employed. As is the case with most of these early large iron enterprises, few records survive to document the individual craftsmen. Interestingly, Hopewell Forge was one of the first to employ enslaved and free black craftsmen.[13]

Various types of hardware for both architectural and cabinetmaking applications were supplied to carpenters and furniture makers by local forges and independent blacksmiths. These bird-shaped hinges follow the tradition of incorporating animal motifs or other natural forms into the design of an otherwise utilitarian form, which seems to have been a popular decorative device employed by a number of Pennsylvania blacksmiths. The fabrication of the hinges follows traditional methods of hot and cold hammer forging. The paired main components were formed and cut from rough, hammered sheet iron, which varied in thickness. The edges of the bird-shaped components are hammer-and-file beveled, and their ends have been feathered thin with a hammer, bent, looped, overlaid, and further forged around a cast round pintel post, which is seated and secured into the split-tailed hinge section. Each section was then pierced to accommodate the attaching bolts or nails, with one of these holes positioned to form the eyes of the birds. —J.L.L.

10 Frances Lichten, *Folk Art of Rural Pennsylvania* (New York: Charles Scribner's Sons, 1946), p. 12.
11 One of these (collection MMA) was found near Bethlehem, Pa., among the Moravian communities there, and relates most closely to this example.
12 This premise was first put forth by Donald Fenimore and Vernon Gunnion during their research in conjunction with the exhibition "The Pennsylvania Germans: A Celebration of Their Arts, 1683–1850" (PMA, 1983) and its accompanying catalog.
13 Joseph E. Walker, "The People of Hopewell," *The Historical Review of Berks County* 29 (spring 1964): 53–56.

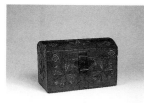

137. BLUE-GREEN DOME-TOP STORAGE BOX
Artist unidentified
Lancaster or Lancaster County, Pennsylvania
c. 1800
Paint on pine and poplar, with sheet-tin
hasp and hardware
7⅜ × 11 × 5⅝ in.
P1.2001.165

INSCRIPTION:
Underside of lid, ink: *Susanna Shrulb 1800*

PROVENANCE:
Jack Lamb, Kutztown, Pa., 1972.

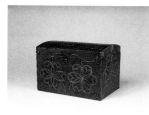

138. RED DOME-TOP STORAGE BOX
Artist unidentified
Lancaster or Lancaster County, Pennsylvania
c. 1800–1840
Paint on pine, with sheet-tin hasp
and hardware
8¾ × 12⅜ × 8¾ in.
P1.2001.166

PROVENANCE:
Sotheby's sale 7253, 1/99, lot 442.

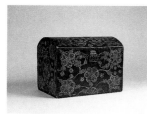

139. BLACK DOME-TOP STORAGE BOX
Artist unidentified
Lancaster or Lancaster County, Pennsylvania
c. 1800–1840
Paint on poplar, with sheet-tin hasp
and hardware
11⅛ × 14⁹⁄₁₆ × 10 in.
P1.2001.167

PROVENANCE:
Sotheby's sale 7253, 1/99, lot 441.

Schmuckkästchen, or small, decorative boxes, were traditional gifts in Germanic Europe and within the Pennsylvania German community and were used to hold small textile accessories, ribbons, trinkets, and personal keepsakes. A number of these boxes have survived, all similarly constructed of thinly milled pine, cedar, or poplar with fine, dovetailed corner joinery, pinned bottom and top boards, and punch-decorated sheet-tin hinges and lock hasps. They include dome-top, flat-top, and sliding-lid versions, as well as the coopered round or oval bandbox or bride's-box form. Several examples are lined with Lancaster County newspapers dating from 1812 to 1838. Others bear pencil or ink inscriptions indicating their initial owners, many of whom lived in the Lancaster area or in the adjacent Lebanon County region of the state. One such inscription, that of Heinrich Bucher of Lancaster County, was originally

thought to identify the maker of these boxes, but it has since been proven that Bucher was an owner of such a box rather than the craftsman responsible for their manufacture or decoration.[14]

The decoration of these boxes is based upon closely related techniques and motifs, suggesting a common maker or group of related makers. The ground colors on known examples are applied directly to the bare wood surface rather than over a priming ground of paint or gesso, as is often found on Continental examples. These red, blue, or blue-green ground colors are then overlaid with patterns of stylized flowers, vines, and pinwheels, laid out with a compass and painted freehand. Several examples reveal stick combing in their patterns, a technique in which a dry point is rubbed through the wet overlaid paint line to expose the surface of a dry undercoat of contrasting paint color. Once complete, the painted decorated surface received a protective layer of overvarnish, which on many examples has darkened over time, muting the original vibrancy of the colors.[15]

The dotted motifs found on many of these boxes suggest a relationship to the patterns of wax resist, indigo-dyed textiles produced within the Pennsylvania German community during this period. In addition, the punch-decorated, sheet-tin hardware utilized on many surviving examples is similar to patterned punchwork employed by numerous traditional tinsmiths working contemporarily within the local community.

—J.L.L.

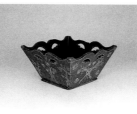

140. OPEN BOX OR TRAY
Artist unidentified
Southeastern Pennsylvania
c. 1820–1850
Paint on pine and poplar
5½ × 10 × 9¾ in.
P1.2001.168

PROVENANCE:
Peggy Schorsch, Greenwich, Conn., 1987.

A number of open boxes, trays, or four-sided bowl forms with square plank bottoms and flared, trapezoidal sides survive with histories relating them to the Pennsylvania German community. The form seems to have been adapted to serve varied purposes: some were used to serve and display food and produce; some were lined with textiles and used as sewing baskets; and others were filled with sawdust or wood shavings and used as cuspidors or spittoons. This example—with full, wedged, dovetailed corner joinery, pierced, sawn cutwork, ogee-shaped top edges, and lively painted decoration—relates to several boxes referred to in early domestic inventories as "egg baskets."[16] Painted with a now oxidized and

14 For more information on Bucher, see Beatrice B. Garvan, *The Pennsylvania German Collection* (Philadelphia: PMA, 1982), p. 355.

15 The original ground colors on these boxes have often oxidized as well: a blue-green ground color darkens to an opaque black.

16 One such egg basket has painted decoration arranged in panel formats and a history of ownership in Berks County, Pa. (collection PMA). Also housed in the PMA archives are the field notes and research archive of Frances Lichten, a pioneering researcher on Pennsylvania German culture whose work formed much of the basis for the Index of American Design under the Federal Art Project during the 1940s. In her studies of Easter traditions and egg decorations among the Pennsylvania Germans, Lichten archived and photographically recorded two similarly decorated wooden egg baskets in local households.

darkened blue-green ground color and decorated with freehand-painted flowers, vines, and leaves in white and red, it relates closely to the similarly decorated dome-top storage boxes and was probably executed by the same hand. Its interior shows no sign of any prior attached textile lining or the residual staining found in wooden cuspidors following this form, further suggesting its use as an egg basket or food bowl.

Within the Pennsylvania German community, domestic customs surrounding the secular celebration of important religious holidays such as Christmas, Easter, and Good Friday inspired various decorations and craft traditions. The Easter rabbit, an image that survived from early Teutonic mythology among German Protestants, was believed to come to lay eggs in assurance of nature's regeneration and in the promise of continued good luck and fertility. On April 23, 1829, a reporter for the *Allentown Republikaner* wrote that on Easter Sunday there was an abundance of "colored eggs that the rabbit had laid! . . . The little ones were pickling eggs; the old folks were scratching tulips on the eggs."[17] Brightly colored, decorated eggs were produced and proudly displayed within many households, and both children and adults were presented with often intricately decorated eggs as tokens of affection and good luck. A decorated tray or "basket," filled with a colorful bounty of fanciful eggs symbolizing the promise of spring, would certainly have served as a source of wonder and pride during such seasonal celebrations. —J.L.L.

mid-case moldings, a repeating S-shaped sawn frieze under the flat pediment, molded vertical inset panels flanking and separating the lower doors, and a shaped, trestle-type foot. The form held its central place and utility in the households of many local families and continued to be popular throughout the eighteenth and into the nineteenth century. Within certain communities, its construction and design changed little over time. Between 1749 and 1839, thirteen daughters from successive generations of the Clemens family of Lower Salford Township, Montgomery County, Pennsylvania, were presented with dressers upon marriage.[18]

The cost of these open cupboards varied, depending upon the woods used and the decorative details included in their design. Walnut and cherry examples were the most expensive, and elaborate moldings, carving, and decorative iron or brass hardware could further increase the charges. Mixed hardwood and softwood versions, painted to preserve, unify, and brighten the surfaces, were less expensive and equally popular. A number of similar dish cupboards constructed in walnut, and others, like this one, with a painted surface, were produced and used in the Lancaster County area. Traditional Germanic woodworking techniques can be seen in the construction and design of this example, such as the wedged dovetailing of its drawers, the double-pinned mortises securing the framed, raised panels of its lower doors, and the pinned construction of its structural case. —J.L.L.

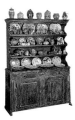

141. OPEN CUPBOARD OR DRESSER
Artist unidentified
Probably Lancaster, Lancaster County, Pennsylvania
c. 1750–1780
Paint on pine and poplar, with iron hardware
85 × 60⅞ × 20¼ in.
P1.2001.169

PROVENANCE:
Israel Sack Inc., Boston and New York; Theodore Clark, Medford, Mass.; Dr. Theodore Clark Jr., Longmeadow, Mass.; George E. Schoellkopf, New York, 1975.

PUBLISHED:
Sack, Albert. *The Fine Points of Early American Furniture.* New York: Crown Publishers, 1950, p. 195.

This large open dresser, often termed a *Schusselschranck*, or dish cupboard, in Pennsylvania German households, was a traditional furniture form frequently presented to a young woman or newly married young couple as an essential component of their home. The upper cupboard contains sturdy shelves mortised into the shaped, scroll-cut side supports and is crowned with a flat, architectural, molded pediment, while the lower portion supplies additional storage with a waist-level bank of drawers and additional shelves concealed behind twin paneled doors. The earliest versions of the form tended to be of single-case construction and incorporated, as seen on this example, pronounced,

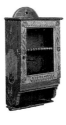

142. HANGING CUPBOARD WITH SPOON SHELF
Attributed to John Drissel (act. 1790–c. 1835)
Milford Township, Bucks County, Pennsylvania
1800
Paint on pine, with glass and iron hardware
19 × 10 × 5⅜ in.
P1.2001.170

INSCRIPTION:
Door front, paint: *Abraham Stauffer / 1800*

PROVENANCE:
M. Austin and Jill R. Fine, Baltimore; Sotheby's sale 5552, "Fine Collection," 1/87, lot 886.

The surname Drissel appears prominently among the early German Mennonite communities of Bucks and Montgomery Counties in Pennsylvania, and the frequency with which the name John Drissel appears in various local town records has caused some confusion in positively identifying the craftsman responsible for this small hanging cupboard and a related group of similarly decorated tape looms, wall boxes, and tabletop boxes with sliding covers.[19] A Johannes Drissel (1762–1846) listed as a carpenter in the records of the East Swamp Mennonite Meeting, Milford Township, Bucks County (1817), is most likely the craftsman who created and signed this important group of decorated domestic objects.

17 As quoted in Beatrice B. Garvan and Charles F. Hummel, *The Pennsylvania Germans: A Celebration of Their Arts, 1683–1850* (Philadelphia: PMA in association with Winterthur, 1982), p. 157.
18 Alan G. Keyser and Raymond E. Hollenbach, *The Account Book of the Clemens Family of Lower Salford Township, 1749–1857* (Breinigsville, Pa.: Pennsylvania German Society, 1975).

19 Known examples from this group include two tape looms (collection PMA); a tape loom, a sliding-lid box, and a hanging salt box (collection Winterthur); and a hanging wall box, which is illustrated in Stacy C. Hollander, *American Anthem: Masterworks from the American Folk Art Museum* (New York: Harry N. Abrams in association with AFAM, 2001), cat. no. 10.

This hanging cupboard, the largest known example inscribed by Drissel, is constructed utilizing shallow blind mortises, lapped and pinned joints in its door framing, and butt joints secured with wooden pins, traditional joinery techniques seemingly preferred by a number of Pennsylvania German cabinetmakers. The arched cutout to the cupboard's interior notched shelf, intended to facilitate the display of prized metal tablespoons, is a design feature found on numerous larger-scale hanging cupboards and shelves produced by local traditional Pennsylvania German craftsmen.

Drissel's decorative paint techniques employed on this cupboard and across the known body of his signed work relate to a larger body of painted decoration produced within the local Germanic community. The thin white or cream ground color and the figural and script decorations of the cupboard are close in design and execution to those popularized by several fraktur artisans practicing contemporarily within the local Mennonite and German Lutheran communities from which Drissel gained many patrons. Several of the names inscribed on surviving examples of Drissel's works were students of Johann Adam Eyer (1755–1837), a schoolteacher, scrivener, and fraktur artist (see nos. 172–75, 177–79) whose surviving watercolor-decorated bookplates and *Taufscheine* (baptismal certificates) show particular stylistic ties to Drissel's lettering and decorative repertoire.

—J.L.L.

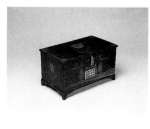

143. **MINIATURE CHEST OR BOX**
Attributed to Jacob Weber (1802–?)
Brecknock Township, Lancaster County, Pennsylvania
1849
Paint on pine, with tin hasp and hinges
6⅛ × 10 × 5¹⁵⁄₁₆ in.
P1.2001.171

INSCRIPTION:
Front, paint: *1849 / Lydia Kinzy*

PROVENANCE:
Howard and Jean Lipman, Wilton, Conn.; Sotheby Parke-Bernet sale 4730Y, "Lipman Collection," 11/81, lot 20.

This small decorated box relates to a known group of similarly decorated and constructed examples, all with Lancaster histories of ownership. Their attribution to the Lancaster Valley craftsman Jacob Weber is based upon early research and genealogical information gathered by Nina

Fletcher Little and is further substantiated by two surviving examples that are signed "J W" in script on the underside of their bottom boards.[20] All these known examples are similarly constructed of thinly sawn or rived white pine, with side panels inset, rabbeted, and pinned into the front and back panels. Edge-molded bottom boards are pinned up into the underedges of the box's sides. Small, solidly carved bracket-form feet or, in some examples, slightly flaring, neoclassically inspired "French feet" are pinned up into these bottom boards at their corners. The tops of all examples are attached to the backboard of the lower case with thin wire cotter-pin hinges. The outer edges of their tops are decorated with a thinly incised, planed, or "quirked" beaded edge. On most examples, an oversize sheet-tin hasp is attached at the center of the front edge of the top, which hinges downward to engage a wire loop set into the front board of the box to accommodate the seating of a separate hanging or "pad"-type locking mechanism.

The painted decoration on this example is typical of the known group associated with Weber. The ground colors are laid down directly on the unprimed wood surface and are thinly applied, ranging from the blue-green of this box to lighter blue, light green, or yellow.[21] Over this ground color is painted the figural decoration. On all known examples, the pattern on the front of the box contains a multiwindowed, Georgian-style, two- or three-story house, complete with side chimneys, story watercourses, and mullioned sashes and transoms. These houses are symmetrically placed and carefully rendered in three dimensions, flanked by a pair of manicured trees in full leaf. This ordered landscape is centered in a gentle, rolling foreground of low hills, painted in thin washes of greens and browns. The side and top panels of this box, like most examples from the group, are decorated with centrally composed, freehand-painted tulips whose leaves and vines are executed in two or three color layers and framed with fans or arches defining the box corners.

It is not known whether the different houses depicted on these boxes were merely Weber's artistic vision or if he painted the particular houses in which his patrons lived. Few examples depict the type of vernacular Georgian architectural detail, such a pent roofs, twin-front facade doors, or arched shed doorways, that was commonly utilized on houses built within the wealthier Lancaster Germanic farming community at midcentury. Interestingly, one pair of boxes, made for sisters Catherine and Hannah Landes and dated 1849, is decorated with identical structures, and may either depict the house in which they lived or simply have been envisioned and painted by Weber to create a closely matched pair of boxes for presentation to the siblings.[22]

—J.L.L.

20 Research by the Lancaster Heritage Center, Lancaster, Pa., suggests the boxes are the work of Jonas Weber (1810–1876) (AFAM files).

21 These ground colors often oxidize to darker colors, appearing black in this case rather than the brighter blue-green original hue that is evident where it has been exposed at points of abrasion and wear.

22 These boxes are recorded in the Decorative Arts Photographic Collections at Winterthur (see Weber file). One is in a private Philadelphia-area collection, and the other is in the PMA collection; see Jacob Weber research file, American Department, PMA.

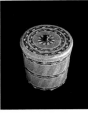

144. SUGAR BUCKET
Joseph Long Lehn (1798–1892)
Elizabeth Township, Lancaster County,
Pennsylvania
1888
Paint on poplar, oak, and iron
8½ × 8¼ in. diam.
P1.2001.172

INSCRIPTION:
Underside, ink on paper label: *Made / by / Joseph Lehn / in his 91 / year. Dec. / 16 1888*

PROVENANCE:
Descended in family; Gary Brooks and Michael Rizutto, York Springs, Pa., 1990.

Joseph Long Lehn, a prolific maker of finely turned and paint-decorated woodenware table objects, coopered buckets, and small cabinetpieces, was born on January 6, 1798, in the farming community of Hammer Creek Valley in Elizabethtown Township, Lancaster County, Pennsylvania. Lehn was a farmer but supplemented his income with woodworking, using his skills as a lathe turner, cooper, and painter to produce a large variety of fancifully decorated domestic objects. A talented turner, Lehn is perhaps best known for his eggcups, covered saffron boxes, and small footed bowls ornamented with lively painted floral motifs on brightly colored blue, pink, or yellow ground colors which follow in their color and form earlier Continental traditions of small, highly decorated, turned-wood table objects.

The tight joinery and confidence of design and craftsmanship demonstrated by Lehn's decorated bucket also attest to his familiarity with the skills of the barrel maker or cooper. A large number of his open buckets and covered sugar buckets survive, all similar to the present example.[23] Of slightly tapering, cylindrical form, Lehn's sugar buckets are consistently constructed using eleven tapering oak staves to form the sides and tulip poplar for the turned lids and plank bottoms. The bottom plank is slightly raised and inset into a wedge-shaped, beveled groove cut into the inside face of each side member. The staves are assembled around this bottom board, and the slight inward bevels of their edges are secured side by side with three thin, sheet-iron riveted straps, each conjoined in slightly increasing diameters and slid over the assembled bucket's tapering exterior. The top is lathe turned, with concentric turned lines echoing the width of the metal side bands. Lehn apparently preferred to purchase the knobs for his covered buckets; the one on this example is mass-produced and typical of those found on other buckets and as drawer pulls on his small multidrawered spice cabinets.

Lehn decorated his covered buckets, once assembled, with a salmon pink ground, onto which he brushed a darker red wash that was combed or figured in vertical diagonal bands. The trailing vines and floral buds decorating the metal joining bands and the bucket lids are also common across most of the known surviving examples attributed to his workshop. —J.L.L.

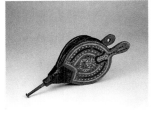

145. BELLOWS
Artist unidentified
Probably Schuylkill or
Northumberland County, Pennsylvania
1847
Paint on pine, with leather and iron
18⅛ × 7⅞ × 4¼ in.
P1.2001.173

INSCRIPTION:
Backboard, paint: *Conrad Kistler / 1847*

PROVENANCE:
H.M. Goodman, Richmond; Robert E. Crawford, Manakin-Sabot, Va.; Dr. and Mrs. Henry P. Deyerle, Harrisonburg, Va.; Sotheby's sale 6716, "Deyerle Collection," 5/95, lot 619.

Facilitating the igniting of a fire by delivering a jet of air, pump-action bellows were a useful addition to the hearth equipment of many eighteenth- and nineteenth-century homes. Brightly painted versions with freehand or stenciled decoration were made by craftsmen and specialized manufacturers up and down the East Coast, and their production and popularity within the Pennsylvania German community is documented by a number of surviving examples. Decorated with stylized tulips, hearts, and patterned lines and dots in vibrant yellow and black on a bright red ground, this bellows relates to a small group of known examples with similar decoration. A small footstool and a shoe-shine box with hinged cover, both in the collection of the Philadelphia Museum of Art, exhibit similar painted decoration and, like the bellows, may have been made by a craftsman working within the Mahantango or Schwaben Creek Valley of central Pennsylvania.[24] Cabinetmakers and decorative painters in this close-knit community produced a distinctive group of forms with brightly painted figural decorations that often included a pattern of closely spaced lines and dots.

Thus far, genealogical research in the regional township records of these counties toward the identification of Conrad Kistler has failed to determine whether this inscription refers to the maker or the owner of the bellows. Names and dates within the painted decoration on other furniture and household utilitarian forms from the region and period have proven more often to be those of the owner rather than the signature of a locally active craftsman or specialized decorator. —J.L.L.

23 Similar buckets attributed to Lehn are in the collections of PMA; Winterthur; The Lancaster Heritage Center, Lancaster, Pa.; and a number of private collections.

24 The shoe-shine box is illustrated in Garvan, *Collection*, p. 14, fig. 17.

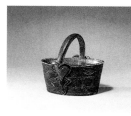

146. **KEY BASKET**
Artist unidentified
Probably Richmond or vicinity
c. 1830–1860
Stained leather
7⅜ × 7¹³/₁₆ × 6⅝ in.
P1.2001.174

INSCRIPTIONS:
Exterior, stamped: *J.R. McK.;* underside: *G F*

PROVENANCE:
Gary Heimbeck, Keedysville, Md.; Robert E. Crawford, Manakin-Sabot, Va.; Dr. and Mrs. Henry P. Deyerle, Harrisonburg, Va.; Sotheby's sale 6716, "Deyerle Collection," 5/95, lot 607.

PUBLISHED:
Harris, W.L. "A Southern Wedding Gift." *Antiques* 5, no. 2 (February 1924): 71.
Morton, Robert. *Southern Antiques and Folk Art.* Birmingham, Ala.: Oxmoor House, 1976, p. 152.
Wright, R. Lewis. "Key Baskets." *Journal of Early Southern Decorative Arts* 8, no. 1 (May 1982): 52.

A number of similarly tooled leather baskets with handles survive with histories of ownership and manufacture in the Richmond area. This basket is constructed of finely tanned cowhide sewn in a tapering oval shape with a flat sheet-form bottom and an attached stationary central handle; it is lined and wrap-finished on its edges with a thin, finer grade of red-stained leather. This red leather is also used in an inset heart design placed where the handle attaches to the sides. The techniques of stitching and construction evident across the known group of these baskets relate closely to the traditional skills of the saddle or harness maker or shoe cobbler. Several examples are signed by their makers.

This basket bears the initials "G F" impressed in block letters on its underside, as do at least three other examples. The 1859–1860 Richmond city directories list a maker of boots and shoes by the name of George Freitag (or Friday) and could indicate the possible maker. Other examples are impressed with the name of the Richmond saddle and harness maker S.S. Cottrell and Company (act. 1858–1887). However, at least two other examples closely related in decoration and form to this key basket have survived with associated provenances suggesting they were made by inmates of the Virginia State Penitentiary in Richmond and possibly by slave craftsmen incarcerated there during the late 1850s. One example, virtually identical in form and decoration to this basket, survives with an unsigned manuscript note relating such a history.[25] It reads, "The convicts were not furnished with work but were allowed to employ their time for their own benefit, making whatever they could that would sell to visitors.... Miss Patterson and I visited the penitentiary, as was a common thing among the residents of Richmond, and brought away some of the work. While there I ordered the basket for her."

These key baskets are highly ornamented with decorative stitching and utilize intricately impressed geometric patterns, stars, and hearts. Based upon surviving information, their original purpose seems, however, to have been largely utilitarian, as receptacles for the numerous household keys essential to running an orderly and effective home. Traditionally thought to have been given as wedding presents to aid the new bride in managing the marriage household, this example bears the embossed initials "J.R. McK.," thought to be those of its original owner.[26] While the identities of their makers may never be firmly established, the leather key basket represents an important, specific regional tradition of folk craft and a distinctive decorative form that developed along locally preferred patterns of gift presentation and household customs. —J.L.L.

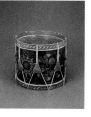

147. **DRUM**
Benjamin Brown (1748–1834)
Bloomfield, Hartford County, Connecticut
1812
Paint on pine and maple, with deerskin, cowhide, brass, and rope
11½ × 13 in. diam.
P1.2001.175

INSCRIPTION:
Interior wall, pencil: *Benj. Brown, Bloomfield, Conn. (Uncle of N.D.) mfg. 1812 for N.D. Phelps Grandpa of H.A. Phelps*

PROVENANCE:
Ed and Mildred Bohne, Newmanstown, Pa., 1974.

D rums, marching music, and regimental displays played a central role during military functions, seasonal festivals, and holiday celebrations within a number of American communities during the eighteenth and nineteenth centuries. Various percussion instruments, including drums, were also called for in religious observances, secular and fraternal ceremonies, and popular and folk musical compositions. Regimental marching, essential to early military exercises and tactical warfare, was regulated by drumbeat, and local militias maintained drum corps or single drummers to provide this important aspect of military discipline. Drums were regularly produced by amateur makers for their own use and also were supplied by professional manufacturers, who advertised their wide range of parade and military drums. Benjamin Brown and several members of his extended family established one of the best-known of these drum manufactories in New England.

This drum follows the basic construction techniques utilized by most drum makers, and its joinery relates closely to that of early coopering and bandbox manufacturing. Its wide wooden side is fashioned from a single, thinly milled sheet of pine, which was bent around a round form while still green and supple. Its ends are overlapped and secured with glue and fine metal brads. The top and bottom edges of the side are reinforced and fitted with bent flat maple rims, similar in form to barrel hoops, which also secure the stretched deerskin heads to the sides. These rims are drilled with regularly spaced holes and laced with rope-securing

25 Private collection; it is illustrated in *Maine Antique Digest* 28, no. 6 (June 2000): 20-A, along with a reproduction of its accompanying note. See also W.L. Harris, "A Southern Wedding Gift," *Antiques* 5, no. 2 (February 1924): 71.

26 One closely related example (collection Lynchburg Museum, Lynchburg, Va.) with similar pattern and construction survives with a documented provenance and a history of having been a marriage gift. The basket bears the initials of its early owner, Lucy Ellen Burrows (1836–1925), who married in 1858; see R. Lewis Wright, "Key Baskets," *Journal of Early Southern Decorative Arts* 8, no. 1 (May 1982): 49–62.

lines, which keep the components of the drum tightly assembled but also adjustable and loose enough to provide the vibrations that augment the drum's resonance when beaten.[27]

The paint decoration on this drum is closely related to the traditions of painted tin. Painted tin decoration enjoyed a concentrated popularity during the early nineteenth century in both Connecticut and Pennsylvania, and the techniques, patterns, and execution are closely related across the regions. The decoration of this example is similar to designs created among the Pennsylvania Germans and incorporates similar motifs of round, stylized roses, comma swags, and brushwork leafage. A small peephole, drilled into the side of the drum's wall and framed by a brass tack and painted surround, reveals the interior inscription, which indicates its Connecticut origins. —J.L.L.

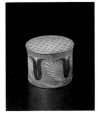

148. STORAGE BOX
Artist unidentified
Pennsylvania
1853
Paint on maple, ash, and tin
$2^{11}/_{16}$ × $3^{15}/_{16}$ in. diam.
P1.2001.176

INSCRIPTION:
Underside, stamped: *PATENT MC*[?] *& CO. Pat. AUG. 31. 1853* [?]

PROVENANCE:
Don and Faye Walters, Goshen, Ind.; Sotheby's sale 5534, "Walters Collection," 10/86, lot 7.

EXHIBITED:
"Neat and Tidy," Philadelphia Antiques Show, 1985.

The love of ornament and bright color among many Pennsylvania Germans led to the decoration of even the most utilitarian forms within certain households. This early manufactured pantry box, or covered measure, was probably sold undecorated as part of a larger, graduated set intended for use in food storage and preparation. Graduated, nested sets of pantry and storage baskets and boxes, sized to gauge or register standard measurements of dry foodstuffs, were a popular addition to an efficient kitchen, and the increased availability brought on by their patented manufacture was undoubtedly a welcome convenience for domestic consumers. This small example's thinly sawn wooden side was formed from one piece of wood that was bent, planed feather thin on its ends, end-lapped, and glued together. The top and bottom edges of this side element were then fitted into rounded, shaped, and soldered sheet-tin foot and top-rim flanges, which, when secured, reinforced the glued side joinery and formed the framework to hold the flat, round wooden panels of the top and bottom of the finished container.

The vibrant red, yellow, and black freehand-painted decoration on this small box may have been applied by its early owner. The technique shows a close tie in execution to the traditions of painted tinware. The bright red ground of this example was first applied over the entire surface of the box. Once it was dry, the confidently executed freehand, black and yellow abstract floral motifs were added using a soft, fine brush. Interestingly, the finely drawn, crosshatched line pattern applied to its top resembles the small-gauged, diagonally woven horsehair screens found on similarly constructed, round, wood-framed dry foodstuff sieves or sifters of the period. —J.L.L.

149. TWO-SHEET WAITER
Artist unidentified
Southeastern Pennsylvania
c. 1820–1825
Paint on tinplate
12 × $17^{1}/_{4}$ × 1 in.
P1.2001.177

INSCRIPTION:
Underside, paint: various names and dates, some legible, including *Sabina Schwartz / Frederick Schwartz 1825 / Anna Schwartz / Mary Balp 1833*

PROVENANCE:
Ed and Mildred Bohne, Newmanstown, Pa., 1975.

Quantities of thinly milled, tin-plated sheet iron began to be imported into America soon after the Revolutionary War.[28] Technological advances in the plating of base metals brought about the material's increased manufacture and lower prices in Great Britain and Middle Germany, making it a raw material ideal for the export market. American craftsmen embraced the material's thinness, malleability, and adaptability to a number of purposes, and the comparative affordability of decorative and utilitarian domestic articles fashioned from tinned iron sheeting in comparison to fine metal, ceramic, and glass articles brought about a dramatic increase in paint-decorated tinware in America during the first half of the nineteenth century.

Because the working of tin required a comparatively small amount of equipment and capital, it was readily adaptable to small, cottage-scale enterprises and traveling itinerant craftsmen. While simple utilitarian vessels such as coffeepots, canisters, covered boxes, trays, hanging candle sconces, and other household items were produced and sold undecorated, the material lent itself to vibrant painted decoration. Many of the most popular painted designs found on American decorated tinware were inspired by imported English and French prototypes, or from common, widely imported ceramics such as the inexpensive Staffordshire-area floral-decorated pearlware and whiteware ceramics, and it is often difficult to differentiate regional differences in American-produced examples.

27 The lacings were probably originally made of thin leather or braided hemp twine.

28 Earliest production of American tinware fashioned from imported tinplate dates to 1750, when Edward Pattison established his shop in Berlin, Conn. The industry ultimately spread throughout the eastern states.

The fluid, flowing style of brushwork seen in the floral painting on most American painted tinwares illustrates the close derivative parallels to these imported ceramic decorative patterns and traditions.[29]

This large rectangular tray, with its rolled, soldered edges and two-part sheet construction, is typical of American examples produced in both Pennsylvania and New England, particularly in areas of western Connecticut and Massachusetts.[30] While the vast majority of surviving decorated tin produced in America utilizes a dark metallic brown or black ground color, red and, more rarely, yellow or cream ground colors were also popular. —J.L.L.

150. YARN REEL
Artist unidentified
Southeastern Pennsylvania
1821
Paint on maple, oak, and poplar, with ink on paper and iron
37½ × 24 × 14 in.
P1.2001.178

INSCRIPTION:
Top of base, paint: *1821 × N 45*

PROVENANCE:
M. Austin and Jill R. Fine, Baltimore; Sotheby's sale 5552, "Fine Collection," 1/87, lot 836.

Specialized craftsmen such as wood turners were often the makers of yarn reels, or wheels, an essential measuring apparatus used in the spinning and weaving of various domestic textiles. Cabinet- and chairmakers who fashioned furniture with turned components, such as Windsor chairs, are also known to have produced yarn reels and spinning wheels for their clients. This finely turned, decorated yarn reel utilizes plank-and-turned elements with mortise-and-tenon joinery and follows the basic mechanical form and construction of most late-eighteenth- and early-nineteenth-century examples produced in Pennsylvania.

The individual spokes of the six-armed, rotating wheel are anchored centrally into a turned hub post and terminate in turned reels.[31] A threaded axle or shaft—wood or iron—is seated in this hub and passes into the box supporting the wheel. This threaded shaft engages a gear positioned inside the box, which, in turn, engages a measuring gear or dial resembling a simple clock mechanism. This mechanism—comprising an inked paper dial and metal hand on this example—can be set to gauge specific lengths of yarn to be wound and measured. A tapered wooden or metal lever, often called a "weasel," is set against the teeth of the measuring gear. As the operator rotates the larger wheel clockwise with the handle

anchored into one of its spokes at its midpoint, the finished wool, linen, or cotton yarn being wound around its circumference is straightened and measured. As the wheel turns, the engaged gears rotate, placing tension on the tapered end of the weasel. When the desired setting is reached, the pressure forces the weasel to slip out of the gear, making a cracking or popping sound. From this signal evolved the expression "pop goes the weasel."

While the maker of this reel remains unidentified, the inscription included in its decoration suggests that by 1821 he had completed forty-five such reels for his clients. Its decorative elements—colored-edge chip carving, painted pinwheels laid out with point and compass, two-color tree-of-life motifs with dot patterning, and brush-applied red, yellow, and black rings on the turnings—are all found across a wide range of painted furniture produced within both Germanic and English communities of Pennsylvania craftsmen. In particular, several turned spinning wheels and yarn reels survive with similar painted rings on their turnings and chip-carved edges, signed by James Fuchs (c. 1785–c. 1862), a Berks County turner and Windsor chairmaker.[32] —J.L.L.

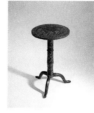

151. CANDLESTAND
Artist unidentified
Probably Berks or Lehigh County, Pennsylvania
c. 1800–1825
Paint on maple and poplar
28½ × 15¼ in. diam.
P1.2001.179

PROVENANCE:
Betty Sterling, Vermont; David A. Schorsch, New York, 1984.

This whimsical candlestand is one of a rare group of three that share similar construction features, painted decoration, and leg terminals with distinctly carved, humanlike feet.[33] Their painted decoration is surprisingly consistent in pattern and execution and originally featured a strongly contrasting palette of red, blue, and white.[34] Each also possesses a finely carved, scrolled collar encircling its central support. Their attribution to the Moravian communities of Berks or Lehigh County is based upon elements of their painted decoration that relate closely to an important group of documented paint-decorated textile chests with figural unicorn motif panels attributed to the same region. In particular, the red and black sawtooth patterning encircling the central support shafts of these stands, just above their carved collars, closely follows the painted borders framing the painted, arc-shaped architectural panels decorating these chests.[35]

29 In particular, the Staffordshire-area wares popularly termed "Gaudy Dutch" and "Gaudy Welsh," and certain types of English "spatterware"—all of which were popular in rural New England and among the rural Germanic communities in Pennsylvania—show the closest decorative relationships to American paint-decorated tin.

30 The inscribed Germanic surnames present on the back of this example, together with a similarly decorated tray with a documented Pennsylvania provenance in the collection of PMA, suggest a Pennsylvania origin for this example.

31 The average circumference of a six-armed wheel approximates two yards.

32 One example is in the collection of the Chester County Historical Society, West Chester, Pa.

33 One of the two other tables is in the collection of the Dietrich American Foundation, on loan to PMA; the other is in a private collection in the Philadelphia area.

34 Oxidation of these original colors—and in two cases darkened overvarnishes—have altered the original hues of the painted schemes, darkening the white to a light brown color and the blue or blue-green to black.

35 For a comparative example, see Garvan, *Collection*, p. 24, pl. 15.

The profuse decorative patterning embellishing these stands is drawn from popular motifs and traditional symbols embraced and maintained by the Pennsylvania German Moravian community. Compass stars, crosses, stylized tulips, and urns, from which sprout vines and flowers, decorate the central support stem, in addition to the motifs already discussed. The tops of the stands also share a common motif of a large bird feeding its young, possibly the craftsman's idiosyncratic version of the Pelican, an allegorical representation of the sacrifice of Christ and a traditional symbolic motif found in widespread usage in early German and German-American folk cultures. This image of the pelican, or another species of bird, sacrificially pricking its own breast to feed its young, was maintained in the folk imagery and printed literature of the Pennsylvania folk community throughout the nineteenth century.　　—J.L.L.

a central panel decorated with a mythical unicorn flanked by other panels containing mounted horses. It is also an image commonly seen in a wide range of Pennsylvania German fraktur, woven textiles, and ceramics. Such popular iconography may have entered the shared consciousness and aesthetic of these communities after the Revolutionary War, with the popular imagery of General Washington on horseback, through earlier European military traditions or through other prominent engraved or printed sources. Similar motifs also appeared in hierarchical iconography such as royal seals, governmental shields, and heraldic crests. The rendering and costume in the horse-and-rider panels found on this small chest relate most closely to motifs on a number of Berks County fraktur. One rider bears a gun, while the other presents a peace pipe, possibly symbolizing the dichotomy of war and peace.

—J.L.L.

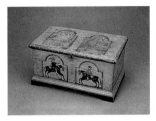

152.　MINIATURE CHEST
Artist unidentified
Probably Berks County, Pennsylvania
c. 1785–1800
Paint on pine and poplar, with iron hardware
11 × 19⅝ × 11³⁄₁₆ in.
P1.2001.180

PROVENANCE:
Nichols Antiques, Breinigsville, Pa., 1994.

Surviving eighteenth- and early-nineteenth-century household inventories indicate that the chest was one of the earliest and most common forms of domestic furniture in the Pennsylvania German interior. The chest was often the only piece of furniture that accompanied immigrant colonists to America, and most decorated chest forms produced within both Germanic and Anglo-American colonial settlements closely follow traditional European or English prototypes.[36]

While a number of scholars have debated the role of the chest within the traditions of marriage and dowry, many details of early Pennsylvania German household chests—the owners' names or initials and the dates of presentation inscribed in paint and surviving genealogical information—confirm that the form was regularly given to a couple to augment the furnishings of a newly formed household or to single men and women as they reached adulthood.[37] Useful for secure storage of valuables and personal property, chests were also adaptable within the limited space of many early households, and their basic forms were regularly called into service for seating and as table surfaces. Their bright decorative treatments were often the work of specialized ornamental painters who rarely signed or otherwise identified their work. This miniature version follows the pattern of construction and decorative composition of full-scale versions roughly three times its size, incorporating the wedged dovetail joinery, pinned moldings, and applied molded, bracketed feet commonly utilized by Pennsylvania German cabinetmakers.

The front boards and lids of a number of Pennsylvania decorated chests are divided into architectonic niches or panels, either by their framed and paneled joinery or, in this instance, by flat, painted panels filled with figural decoration. The horse and rider is a motif found across a group of chests with Berks County histories, many of which incorporate

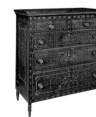

153.　DESK
Artist unidentified
Mahantango or Schwaben Creek Valley,
Northumberland and Schuylkill Counties,
Pennsylvania
c. 1830–1835
Paint on pine, with stamped brass hardware
43¾ × 37⅞ × 20¼ in.
P1.2001.181

PROVENANCE:
Joe Kindig III, York, Pa., 1977.

EXHIBITED:
"American Folk Painters of Three Centuries," WMAA, 1980.
"Decorated Furniture of the Mahantongo Valley," Center Gallery, Bucknell University, Lewisburg, Pa., 1987.

PUBLISHED:
Bishop, Robert. Folk Painters of America. New York: E.P. Dutton, 1979, p. 138.
Reed, Henry M. Decorated Furniture of the Mahantongo Valley. Lewisburg, Pa.: Center Gallery, Bucknell Univ., 1987, p. 43.
———. "Finding the Fabulous Furniture of the Mahantongo Valley." Pennsylvania Heritage 21, no. 4 (fall 1995): 21.
Schaffner, Cynthia V.A., and Susan Klein. American Painted Furniture, 1790–1880. New York: Clarkson N. Potter, 1997, p. 143, fig. 6.17.
Weiser, Frederick S., and Mary Hammond Sullivan. "Decorated Furniture of the Schwaben Creek Valley." In Ebbes fer Alle-Ebber, Ebbes fer Dich (Something for Everyone, Something for You). Breinigsville, Pa.: Pennsylvania German Society, 1980, p. 342.

154.　CHEST OF DRAWERS
Artist unidentified
Mahantango or Schwaben Creek Valley,
Northumberland and Schuylkill Counties,
Pennsylvania
c. 1830–1840
Paint on pine, with stamped brass hardware
47¾ × 42⁹⁄₁₆ × 21¹⁵⁄₁₆ in.
P1.2001.182

36　For more information on traditions surrounding these chests, see Monroe H. Fabian, The Pennsylvania German Decorated Chest (New York: Universe Books, 1978).
37　Philadelphia Museum of Art and Henry Francis du Pont Winterthur Museum, Pennsylvania German Art, 1683–1850 (Chicago: Univ. of Chicago Press, 1984), pp. 137–50.

PROVENANCE:

A.H. Rice, Bethlehem, Pa.; George Horace Lorimer, Philadelphia; Joe Kindig Jr., York, Pa.;
Dr. and Mrs. Henry P. Deyerle, Harrisonburg, Va.; Sotheby's sale 6716, "Deyerle Collection,"
5/95, lot 307.

EXHIBITED:

"Decorated Furniture of the Mahantongo Valley," Center Gallery, Bucknell University,
 Lewisburg, Pa., 1987.

PUBLISHED:

Eberlein, Harold Donaldson, and Courtlandt Van Dyke Hubbard. "Pennsylvania Dutch
 Furniture Combined Color and Vigor." *American Collector* 6, no. 1 (February 1937): n.p.
Nutting, Wallace. *Furniture Treasury.* Framingham, Mass.: Old America, 1928, fig. 296.
Reed, Henry M. *Decorated Furniture of the Mahantongo Valley.* Lewisburg, Pa.: Center Gallery,
 Bucknell Univ., 1987, p. 13.
———. "Finding the Fabulous Furniture of the Mahantongo Valley." *Pennsylvania Heritage* 21,
 no. 4 (fall 1995): 20.
Schaffner, Cynthia V.A., and Susan Klein. *American Painted Furniture, 1790–1880.* New York:
 Clarkson N. Potter, 1997, p. 143.
Stoudt, John Joseph. *Pennsylvania Folk Art: An Interpretation.* Allentown, Pa.: Schlecter's, 1948,
 p. 271.
Weiser, Frederick S., and Mary Hammond Sullivan. "Decorated Furniture of the Mahantongo
 Valley." *The Magazine Antiques* 103, no. 5 (May 1973): 935.
———. "Decorated Furniture of the Schwaben Creek Valley." In *Ebbes fer Alle, Ebber Ebbes fer
 Dich (Something for Everyone, Something for You).* Breinigsville, Pa.: Pennsylvania German
 Society, 1980, p. 347.

The topography of Northumberland and Schuylkill Counties of
southeastern Pennsylvania consists of narrow, interconnecting
creek valleys, which pierce through the Blue Mountains to the north
and empty into the Susquehanna River. The valleys formed in this region
by the Mahantango and Schwaben Creeks fostered a thriving commu-
nity of Pennsylvanians of Germanic descent during the first half of the
nineteenth century. Largely farmers and craftsmen by trade, they estab-
lished relatively isolated communities that preserved and maintained
many of the earlier religious beliefs, farming practices, and folk aesthet-
ics they brought from Europe. Various artisans from the region are
credited with the creation of some of the most exuberant and distinc-
tive paint-decorated furniture and small household objects produced
in early America.

The surviving, known examples of furniture made by this cohesive
group of craftsmen encompass a wide variety of domestic forms, includ-
ing cupboards, blanket chests, clock cases, small hanging cabinets, desks,
and chests with multiple drawers. While differing methods of construc-
tion suggest several cabinetmakers at work, most pieces are more closely
related by similarities in the lively painted motifs embellishing their
surfaces. Few examples bear signatures or marks of their makers or deco-
rators. Several examples, however, are inscribed with the names of their
owners, and in some cases with manufacture or commemorative dates.
Surviving genealogical records from the region, together with the dense
patterns of intermarriage and kinship that existed during the period,
have enabled researchers to suggest the identity of some of these local
artisans.[38]

The chest, with graduated drawers, inset paneled sides, and turned,
vase-form legs, is typical in construction and relates closely to several
similar surviving chests and slant-front writing desks from this group.[39]
This example, however, is distinguished by the quality and pattern of
its painted decoration, consisting of carefully rendered leaping stags,
undulating flowering vines, birds, and stylized central tulips emanating
from urns and compass stars on a salmon pink ground. Many of the
painted decorative devices on the drawers, such as the quarter fans and
painted stringing, may have been influenced by earlier patterns of neo-
classically inspired wooden inlay. The consistent shape and character of
the painted, petal-form, yellow and green rosettes decorating the front
stiles and case rails of the chest suggest that they may have been pro-
duced with a stamp or stencil made and used by this particular decora-
tor, whose identity remains unknown.

The desk is one of only three known examples within the larger
surviving group of painted furniture produced in the Mahantango
Valley region during the second quarter of the nineteenth century.[40]
Its vibrantly colored, figural motifs of carefully rendered angels, birds,
urns, and flowers, together with compass-drawn stars and fans, are
thought to have been inspired by the printed and decorated *Taufscheine*
(baptismal certificates), *Haussegen* (house blessings), and other religious
and secular illuminated texts popular among the Lutheran and German
Reformed groups who established and cultivated the valley.

The painted decoration on the desk is unlike the larger group of
known examples in that it was laid down on the bare wood surface of
the case, rather than applied over a ground layer of surface color. The
fall-front panel concealing its interior writing surface and the graduated
drawer fronts of its lower case are framed by two-color painted line string-
ing and inset corner-fan motifs. The facing female figures decorating
the fall lid, as well as the birds, prancing deer, urns, and compass stars
decorating this element and the lower drawer fronts, are carefully ren-
dered in brightly contrasting opaque pigments. Similar figural motifs
are found in the contemporaneous printed and decorated *Taufscheine*
of printer Heinrich Ebner, of Allentown, Pennsylvania, and J. Baumann,
of Ephrata, Pennsylvania, among others.

Lines of stamp-printed rosettes in alternating yellow and blue visu-
ally frame the various other decorative motifs and serve to further unify
the upper and lower sections of the case. Providing additional ornament
are imported stamped-brass drawer pulls and key escutcheons, which are
also seen on other case pieces made in the valley. Typical in pattern and
design to those produced by English manufacturers in Birmingham,

38 One of the most extensive and thorough studies of this group is Henry M. Reed, *Decorated
 Furniture of the Mahantongo Valley* (Lewisburg, Pa.: Center Gallery, Bucknell Univ., 1987). For an
 extensive study of known examples grouped by similarities in their decorations, see Frederick S.
 Weiser and Mary Hammond Sullivan, "Decorated Furniture of the Schwaben Creek Valley," in
 Ebbes fer Alle-Ebber, Ebbes fer Dich (Something for Everyone, Something for You) (Breinigsville, Pa.:
 Pennsylvania German Society, 1980), pp. 331–94.
39 For comparison, two similar chests, probably decorated by the same hand, are in the collections
 of PMA. A similar chest, formerly in the collection of Liz Whitney Tipett, was sold at auction
 by Weschler's in Washington, D.C., in 1989. The slant-front desk with drawers in the Esmerian

Collection and a similar desk in the collection of Winterthur are also probably from the same
cabinetmaking shop and decorated by the same hand.
40 See Weiser and Sullivan, "Decorated Furniture," pp. 331–94. The feet of this desk have been
moved or replaced, and their present positioning is slightly inward from their original location
at the outermost corners. This original configuration, with the feet being turned from the ex-
tended, lower end of the corner stile of the case, is proven by physical remnants present on the
desk and by this pattern of foot construction on one other surviving desk and on several related
chests of drawers. The present turned feet may be fragments of the originals as their surface is
old and consistent with other areas of the upper case. For an in-depth discussion of the painted
decoration on this group and the different hands of various decorators, see ibid., pp. 342–45.

these brasses were imported, sold, and in use in Philadelphia and other urban centers and were often purchased through dry-goods merchants by the numerous traditional cabinetmakers working in the more rural folk communities throughout southeastern Pennsylvania. —J.L.L.

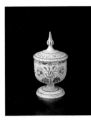

155. SPICE CUP
Attributed to Jared Stiehly (1833–1911) and Elizabeth Mayer Stiehly (1826–1878)
Mahantango or Schwaben Creek Valley, Northumberland and Schuylkill Counties, Pennsylvania
1861
Paint on poplar
7¾ × 4 in. diam.
P1.2001.183

INSCRIPTION:
Lid, paint: *Isaac Stiely May 1861*

PROVENANCE:
Sotheby's private sale, 1997.

The Reverend Isaac Faust Stiehly (1800–1869) was a prominent itinerant minister serving a number of German Reformed churches in the Mahantango Valley region of the adjoining Northumberland and Schuylkill Counties of Pennsylvania. A man of multiple talents, he was also a stonecutter, millwright, and farmer.[41] This ornately turned and decorated covered spice cup is thought to have been made by Isaac's son Jared and decorated by Jared's wife, Elizabeth Mayer Stiehly, as a presentation gift, probably on the occasion of the minister's sixtieth birthday. Jared apprenticed with his father and helped operate a mill the elder Stiehly established along Mahantango Creek, where he specialized as a lathe operator. Elizabeth was the daughter of Johannes Mayer, a local cabinetmaker. Both families were prominent in the religious and artistic lives of their community; such marriages uniting families of similar occupation or social standing were common within many close-knit Pennsylvania German farming communities.

Like the work of the turner Joseph Long Lehn (1798–1892) of Lancaster County, the spice cups produced by the Stiehlys follow earlier Continental prototypes but exhibit a more pronounced stylistic tie to early-nineteenth-century neoclassicism in their urn-shaped turned forms and rims painted with undulating swag-pattern borders. Elizabeth's preference for overlapping fruit and floral compositions and her subtle methods of gradated shading also suggest her possible familiarity with the techniques of brushed and stenciled theorem paintings on velvet

and tin popular during the early Victorian period.[42] The four main floral vignettes she conceived to decorate the sides of this cup depict four different stages of development and maturity in the flowers and fruit of the strawberry, while the primroses separating these compositions are nearly identical, having been laid out with compass and point prior to their being painted. —J.L.L.

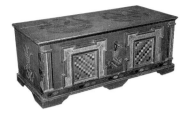

156. DOWER CHEST
Johannes Kniskern (1746–?)
Schoharie County, New York
1778
Paint on pine with iron hasp, key, and hardware
19¾ × 47 × 21 in.
P1.2001.184

INSCRIPTION:
Front, paint: *Jacob 1778 / Kniskern*

PROVENANCE:
Edgar William and Bernice Chrysler Garbisch, Cambridge, Md.; MMA Collection; Joe Kindig Jr., York, Pa.; June Ewing, Westhampton Beach, Long Island, N.Y.; Sotheby's sale 6392, 1/93, lot 557.

PUBLISHED:
De Julio, Mary Antoine. "New York German Painted Chests." *The Magazine Antiques* 127, no. 5 (May 1985): 1156.

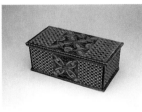

157. MINIATURE CHECKERBOARD CHEST
Artist unidentified
Probably Schoharie County, New York
c. 1790–1810
Paint on pine
8½ × 19⅛ × 10 in.
P1.2001.185

PROVENANCE:
Joe Kindig III, York, Pa., 1975.

Like their contemporary countrymen who were among the first immigrants to the colony of Pennsylvania, the earliest Germanic settlers who populated the Schoharie and Mohawk Valleys of New York during the 1710s and 1720s brought with them the long-established cultural and aesthetic traditions of their former homelands. Palatine Germans, Alsatians, Bavarians, and Swiss-Germans established farms and numerous trading communities in the fertile Hudson River valley, and by 1712 their numbers were expanding into settlements in the northern river valleys. Among them were skilled woodworkers who combined

41 Henry M. Reed, who has conducted extensive studies on the decorated furniture and early craftsmen present in the Mahantango Valley, suggests that Isaac Stiehly may also have been an accomplished scrivener and fraktur artist; see Reed, "Finding the Fabulous Furniture of the Mahantongo Valley," *Pennsylvania Heritage* 21, no. 4 (fall 1995): 24.

42 A closely related covered cup by these artists was sold at Sotheby's sale 7025 (10/97, lot 26). Together the cups help substantiate the later stylistic patterns embraced by the Stiehlys.

the traditions of fine joinery and cabinetmaking with a love of painted ornament and bold color to produce numerous forms of utilitarian and decorative household furniture.

Surviving domestic inventories suggest the decorated chest was among the most common and symbolically important pieces of furniture within these early New York Germanic households. Presented as part of a dowry or commissioned by a new couple for their marriage household, such chests not only held valuable household textiles and other treasured possessions but served as important symbols of wealth, stability, and ancestral identity. The large, decorated textiles chest made by Johannes Kniskern for his brother Jacob, along with two smaller chests he made for his twin daughters, Elisabet and Margreda, make up the most important surviving group of early decorated Germanic chests from the Schoharie Valley.[43] Kniskern's use of applied framed moldings and corner pilasters on the chest's front facade demonstrates his adherence to earlier Germanic cabinetmaking traditions found in Middle Europe dating from the Late Renaissance. Constructed of pine, the chest displays wide corner dovetailing, simple applied base molding, and a heavy, shaped bracket base with a medial third foot member, all typical features of the earliest chests produced in the region.

While the rabbeted, lapped corner-joint construction of the miniature chest suggests a date somewhat later than that of the Kniskern group, its molding profiles, notch-carved top-edge decoration, and painted checkered patterning are found across both examples and relate the smaller chest to earlier Schoharie Valley traditions.[44] On both chests, the decorative patterns were laid out by a series of complicated overlapping lines, deeply scribed with a compass to create a grid and pattern that was selectively filled in with paint. The central circle and star design on the front and top of the miniature chest is similar in pattern and execution to that found on the top of the Kniskern chest, demonstrating the survival of the earlier eighteenth-century decorative tradition well into the nineteenth century within a particular craftsman's shop or within the wider, shared community.

—J.L.L.

JOHANNES SPITLER (1774–1837)

Johannes (or John) Spitler was born on October 2, 1774, the son of Jacob Spitler of Mill Creek, Shenandoah County, Virginia.[45] This specific region of the Valley of Virginia (now in Page County) was known in the eighteenth century as Massanutten, a reference to the fertile river-bottom land between Massanutten Mountain (then called Buffalo Mountain) and the Shenandoah River, near what is now Luray, Virginia. The area had been settled by 1733 by a group of fifty-one German and Swiss pioneers from Lancaster County, Pennsylvania, but, nevertheless, the furniture by Spitler reflects a strong individuality most likely enhanced by the geographic and social isolation of Massanutten itself. As a group, now totaling more than twenty known pieces, the furniture decorated by Spitler forms one of the most concise units of decorated furniture style to be recorded to date.

Although two important tall case clocks by Spitler have been documented, the majority of his work consists of full-size blanket chests (some with a tier below of two side-by-side drawers) and a few smaller-size storage chests. It is not known if Spitler actually built the furniture, which is made primarily of yellow pine and is fairly consistent in construction details, foot profiles, and hardware.[46] Spitler's painted designs range from geometric—checkerboard, diamond, candy stripe, grid patterns, and simple compass work, such as pinwheels—to representational motifs, primarily stylized hearts, flowers, and birds. Growth is an important quality in all of these highly structured schemes. Elements continually build upon themselves, but through symmetry and geometry they maintain a certain purity and balance. In all his pieces, Spitler seems to have been fascinated with additive designs, compartmentalization, positive-negative relationships, bold contrasts, and playful reversals. He was a master of stylization.

Spitler's palette did not vary; the colors he used were black, white, red, and blue.[47] The outlines of motifs were incised into the wood itself, precisely defining shapes, but heavy brushstrokes and fairly thick paint reveal the somewhat haphazard way in which he filled in the designs. Spitler signed and inscribed his pieces in a distinctive manner; of the furniture that is signed, most display an abbreviated contraction of his initials: "j.SP." Additionally, x's are used to flank or separate letters or words. In several, but not all, cases, the n's in inscriptions are written backward. The sequence of a consecutive numbering system, apparently one for clocks and another for chests, has yet to be fully explained. Although it was thought until recently that most of Spitler's furniture had remained in Virginia, close to where it was made, at least two pieces have turned up in Ohio. Spitler, in fact, moved to Fairfield County, Ohio, sometime between 1805 and 1809 but well after most of the dated pieces that have been recorded were painted. He died there on April 18, 1837.

—D.R.W.

43 For a full discussion of these three chests and the locations of the two smaller examples, see Mary Antoine De Julio, "New York German Painted Chests," *The Magazine Antiques* 127, no. 5 (May 1985): 1156–58.

44 The miniature chest was found in north-central Pennsylvania in the early 1970s but has no known relationship to any group of Pennsylvania-produced painted decoration.

45 For a thorough discussion of Spitler, see Donald Walters, "Johannes Spitler, Shenandoah County, Virginia, Furniture Decorator," *The Magazine Antiques* 108, no. 4 (October 1975): 730–35.

46 Ibid., pp. 733, 735.

47 The paint on the three Spitler pieces cataloged here was analyzed using Fourier transform infrared microspectroscopy by Orion Analytical, L.L.C., Williamstown, Mass., August 2000. The pigments tested were identified as lead white, red lead, and Prussian blue.

158. TALL CASE CLOCK
Johannes Spitler (1774–1837)
Shenandoah County, Virginia
1801
Paint on yellow pine, brass and steel works, modern
watercolor and ink on period-paper face, and original
sheet-iron dial
85½ × 14¾ × 8¼ in.
P1.2001.186

INSCRIPTION:
Front, paint: *Jacob Strickler, / 1801, / JOHANNES SPITLER, / NUMBER 3,*

PROVENANCE:
Jacob Strickler, Shenandoah County, Va.; S.H. Modisett family (descendants of Jacob Strickler
and Johannes Spitler), Luray, Va.; Don and Faye Walters, Goshen, Ind.; Sotheby's sale 5534,
"Walters Collection," 10/86, lot 36.

EXHIBITED:
"Swiss Folk Art: Celebrating America's Roots," MAFA, 1991/92.
"It's About Time," Philadelphia Antiques Show, 2000.

PUBLISHED:
Booth, Robert E. Jr., and Edward F. LaFond Jr. "It's About Time." In *Philadelphia Antiques Show
 Catalog.* Philadelphia: Philadelphia Antiques Show, 2000, p. 61.
Reif, Rita. "Mastery, and Mystery, in Old Folk Art." *New York Times,* Sept. 3, 1995, p. 33.
Schaffner, Cynthia V.A., and Susan Klein. *American Painted Furniture, 1790–1880.* New York:
 Clarkson N. Potter, 1997, p. 162.
Walters, Donald. "Johannes Spitler, Shenandoah County, Virginia, Furniture Decorator."
 The Magazine Antiques 108, no. 4 (October 1975): 730, 732.

This tall case clock is the keystone in the research undertaken in the
1970s into the identity of Johannes Spitler. Until the discovery of
this clock, he had been known to researchers only by the initials "j.SP."
Not only does this clock provide Spitler's name spelled in full, but it also
reveals significant connections between his visual vocabulary and that
of his neighbor, fraktur artist Jacob Strickler. Assumptions have always
been made in the study of American Germanic and Swiss furniture,
particularly in regard to Pennsylvania examples, that some designs on
painted furniture were derived from fraktur drawing; rarely does such
compelling evidence exist, however, as it does in the documented visual
communication between Spitler and Strickler.

Indeed, the household in which the case clock descended possessed
an unparalleled wealth of material relating to both men, including ten
fraktur writing and drawing specimens by Strickler, nine of which are
now in the collection of the Abby Aldrich Rockefeller Folk Art Museum
in Williamsburg, Virginia. The tenth specimen (cat. no. 159), found later
in the same household, accompanied this clock when it passed from the
family in 1978. These fraktur, or perhaps a single fraktur like Strickler's
complex 1794 *Zierschrift,* or decorative writing, in the Henry Francis
du Pont Winterthur Museum in Winterthur, Delaware, clearly provided
Spitler with the source for motifs displayed on the clock he personalized

for Strickler. The two distinctive floral blossoms rising from inverted
heart "bulbs" on the sides of the hood segment of the clock, the harlequin
zigzag pattern variation on the waist of the clock, and indeed the precise
style of the fraktur script of the inscription itself on the raised panel on
front are all copied from Strickler fraktur.[48] The crescent-moon faces on
the sides, on the other hand, appear on no other recorded Spitler furni-
ture, or Strickler fraktur, for that matter.

All elements on this clock are painted in Spitler's standard palette.[49]
The only other recorded clock by Spitler with surviving decoration is
inscribed "1800 / j SP No 2"; it has a more conventional, architecturally
inspired form with a broken-arched hood, defined waist, and a base with
bracket feet.[50] The coffinlike Strickler/Spitler clock, however, is rather
unconventional in construction, including a labor-intensive technique
in which the raised panels in the door and the inscription panel above
the door are actually carved in relief rather than inset in framework.

—D.R.W.

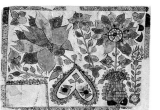

159. FRAKTUR WITH INVERTED HEART
Jacob Strickler (1770–1842)
Shenandoah County, Virginia
1803
Watercolor and ink on paper
6³⁄₁₆ × 8¼ in. (sight)
P1.2001.187

INSCRIPTION:
Verso, ink: *Jacob Strickler, 1803* [plus numerous partial and illegible ink inscriptions]

PROVENANCE:
S.H. Modisett family (descendants of Johannes Strickler and Jacob Spitler), Luray, Va.; Don and
Faye Walters, Goshen, Ind.; Sotheby's sale 5534, "Walters Collection," 10/86, lot 37.

EXHIBITED:
"Swiss Folk Art: Celebrating America's Roots," MAFA, 1991/92.

Jacob Strickler was born November 24, 1770, in what was referred to
at that time as the Massanutten region of Shenandoah County, Vir-
ginia.[51] The first Stricklers to immigrate to this country in the eighteenth
century were Swiss Mennonites; Strickler was a descendant of one of
the fifty-one Swiss and German pioneers from Lancaster County, Penn-
sylvania, who migrated to the Massanutten area by 1733. In his early life,
Strickler lived in close proximity to two Mennonite meeting places,
and, while it is not documented that he belonged to either group, one
can deduce from the papers and books in his preserved library, together
with a rich body of fraktur writings and drawings, that he was probably
by profession a Mennonite preacher or parochial-school leader.

Inscriptions in the books in Strickler's library and in the margins of
his copies of a locally printed German-language weekly provide ample
evidence of his writing styles. The earliest recorded dated fraktur by

48 For a discussion of the imagery on this clock and an illustration of Winterthur's *Zierschrift,* see
 Walters, "Johannes Spitler," p. 731, fig. 3.
49 According to Mr. S.H. Modisett, in whose family this clock descended, the face was overpainted
 by a visiting family friend sometime in the 1940s, presumably when the entire clock was var-
 nished as well; it is illustrated in that altered state in ibid., pp. 730, 732, figs. 1, 2, 2a, and pl. 1.
 The current paper face was created in 1978 under my supervision after Faye Walters and I
 acquired the clock from Mr. Modisett; the design is purely conjectural, but the use of paper was

based on the discovery of a small trace of what may have been the original applied paper face
under the 1940s overpainting of the dial. Since the decoration of this personalized clock was
based on motifs employed by Strickler, it is possible Strickler himself decorated the original
paper face. The twentieth-century glossy varnish was also removed in 1978.
50 Collection AARFAM; see ibid., p. 733, pl. 3.
51 For a thorough discussion of Strickler, see Donald Walters, "Jacob Strickler, Shenandoah
 County, Virginia, Fraktur Artist," *The Magazine Antiques* 108, no. 4 (October 1975): 536–43.

Strickler (1787) was done when he was sixteen years old and demonstrates that he was an accomplished penman by that time and certainly capable of instructing others.[52] We know that he was teaching others penmanship by 1801 through the survival of a *Vorschrift,* or writing sampler, inscribed "For Jacob Strickler Living in Shenandoah County" in English in an unknown hand.[53]

Strickler's known body of fraktur ranges in date from 1787 to after 1815 and includes an elaborate gardenlike 1794 *Zierschrift,* or decorative writing, as well as an important group of nine fraktur writings and drawings that were found stored in a Strickler family Bible.[54] This group comprised every variety of fraktur, from unfinished patterns to decorative birth records and writing exercises to complex allegorical religious subjects. They offer ample evidence of the evolution of Strickler's personal style and distinctive visual vocabulary and hint at his source material, such as printed and drawn fraktur created by more prolific and influential contemporary Pennsylvania fraktur artists.

Certainly the most remarkable and most direct communication with another artist, however, took place right at home, with neighbor Johannes Spitler, the Shenandoah County decorator of painted chests and clocks. The clock that Spitler customized for Strickler is a rare documented example of how folk artists within a tight-knit cultural community can influence one another. Strickler died on June 24, 1842, and is buried in a small family cemetery on a hill behind the house in which he lived and where his clock and most of his known fraktur remained until the late 1970s.

While modest compared with Strickler's elaborate 1794 *Zierschrift,* this small fraktur drawing, with its blank inscription panel, incorporates the signature elements and motifs of the artist's drawing vocabulary.[55] These elements include the distinctive blossom repeated here twice, one characteristically growing from an upside-down heart, and the zigzag diamond borders at the very top and bottom. More important, this small specimen, which descended in Strickler's family together with the 1801 tall case clock decorated for him by Johannes Spitler, is additional evidence of the artistic communication between these two men. In fact, the atypical notion of inverting hearts, which occurs more often than not in Spitler's layouts, appears to originate with Strickler's fraktur. All the elements mentioned above appear with slight variation on one side, at least, of the tall case clock. Since the clock predates this drawing and since it draws even more striking parallels with additional elements (including an elaborate script signature) found in the 1794 example, one must assume that Spitler used that *Zierschrift* or a lost but equally complex fraktur—as the actual source of inspiration for the clock.

—D.R.W.

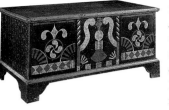

160. CHEST
Attributed to Johannes Spitler
(1774–1837)
Shenandoah County, Virginia
c. 1800
Paint on yellow pine and walnut, with metal and wrought iron hardware
23¼ × 48¼ × 22¼ in.
P1.2001.188

INSCRIPTION:
Underside of lid, pencil: *Bought this at David Rothgeb Sale / in the year 1876.*

PROVENANCE:
David Rothgeb, Page County, Va.; Daniel Hite, Page County, Va.; Hubert Hite, Virginia; Mary Ellen Strickler, Roanoke, Va.; Robert E. Crawford, Manakin-Sabot, Va.; David A. Schorsch, New York, 1984.

EXHIBITED:
"Swiss Folk Art: Celebrating America's Roots," MAFA, 1991/92.

PUBLISHED:
Rubin, Cynthia Elyce. "Swiss Folk Art: Celebrating America's Roots." *The Clarion* 16, no. 3 (fall 1991): 44.
Schaffner, Cynthia V.A., and Susan Klein. *American Painted Furniture, 1790–1880.* New York: Clarkson N. Potter, 1997, p. 165.

This is one of two nearly identical painted chests that, according to oral history, were made for sisters who lived in adjacent homes on the same farm in Virginia.[56] The single most remarkable aspect of these twin chests is the apparent design source for the center panel. In an ingenious two-dimensional interpretation of the three-dimensional form of part of a tall case clock, Johannes Spitler has stylized and re-arranged the elements of a clock hood: broken-arch pediment, spire-and-ball finial, reeded plinth block, shell-shaped plinth support, and fan-patterned rosettes. Indeed, the Spitler-decorated clock in the collection of the Abby Aldrich Rockefeller Folk Art Museum in Williamsburg, Virginia, has all these elements and may in fact have been Spitler's source of inspiration.[57]

In all other ways this chest is a textbook specimen of Spitler chest design vocabulary and construction. Using his standard palette, motifs were created with the aid of a compass and a straight ruler. The ends of the chest are decorated with an overall pattern of tight swirls in blue on a white ground. The profile of the feet, which are dovetailed (as is the case itself), is of a configuration found on the majority of Spitler's chests. Although the paint on the lid is worn and only part of one white six-pointed star remains, one can deduce from the chest's mate that the complete lid design was originally a larger star flanked by two small stars on a blue ground.[58]

—D.R.W.

52 Collection AARFAM; see ibid., p. 538, pl. 1.
53 Collection AARFAM; see ibid., pl. 2.
54 The *Zierschrift* is in the collection of Winterthur; the nine fraktur are in the collection of AARFAM.
55 Paper repairs were made by conservator Elizabeth C. Hollyday in 1978. For the Winterthur example, see Walters, "Jacob Strickler," p. 536, fig. 1.
56 As told separately by Mary Ellen Strickler, Roanoke, Va., and Joseph Gander, Luray, Va.,

respective former owners of these two chests. The other chest is now in the collection of AARFAM; see Walters, "Johannes Spitler," p. 733, pl. 3.
57 Ibid.
58 This chest, including the inside, was overvarnished or shellacked in the mid-twentieth century. The underside of the lid is incised with designs attributed to Spitler which were created with the aid of a compass, forming a spiraled volute and an element of a broken-arch pediment.

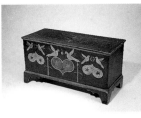

161. SMALL CHEST
Attributed to Johannes Spitler (1774–1837)
Shenandoah County, Virginia
c. 1800
Paint on yellow pine, poplar, and white pine,
with metal and wrought iron hardware
18¼ × 32⅝ × 13¾ in.
P1.2001.189

PROVENANCE:
Neil and Anamae Baxter Gest, Columbus, Ohio; Garth's sale 1/91, "Gest Collection," lot 12;
Stephen Score, Essex, Mass., 1991.

This chest is one of four recorded small chests attributed to Johannes Spitler. These smaller chests differ from one another in size, proportion, and style of foot, whereas most of the full-size Spitler chests exhibit an identical foot profile. This chest is the only one with a splayed foot, in this case applied, mitered, and nailed rather than dovetailed and continuous with the base molding; the case of the chest itself is dovetailed. The palette employs Spitler's standard colors, and the general layout is one more variation on a combination of the motifs most often found on his chests: birds, hearts, pinwheels, tulips, and crescents. This is the only recorded chest with a heart in an upright orientation; Spitler usually positioned them upside down, as shown laterally here and as depicted in the fraktur by Jacob Strickler which were the source for some of Spitler's design motifs.

It is unusual to find two sizes of winged birds or doves in Spitler's work. It appears that Spitler laid out the birds with the aid of templates or stencils before painting; the six birds on this chest have incised lines that define their outlines. The "cornstalk" leaves on the two tulips on the front of this chest relate conceptually to another of the small chests attributed to Spitler on which crescent shapes form the leaves of two stylized plants.[59] The only decoration on the lid of the chest cataloged here is a six-petaled compass star. The wrought-iron hinges with small inverted triangular terminations are typical of Spitler's chests.

—D.R.W.

59 Walters, "Johannes Spitler," p. 733, pl. 3.

No one form of folk art from Germanic Europe was the model for what scholars classify as fraktur. Although the term gained currency in the field of American folk art following its adoption by Henry Mercer in 1897, its use is recorded in Pennsylvania much earlier.[1] Originally a reference to a style of ornate "broken" lettering, fraktur today encompasses a wonderful variety of illuminated texts. Some forms appear to be almost exclusively American: *Vorschriften,* or writing samplers, penmanship example booklets, tunebooks, bookplates, *Liebesbriefe,* or love letters, house blessings, presentation frakturs, and rewards of merit. The most frequently encountered form is the birth record, called a *Daafschein* in Pennsylvania's German dialect. This is true in spite of the fact that the largest number of printed examples are labeled *Geburts- und Taufschein,* or birth and baptismal certificate, and the overwhelming majority of them contain the date and details of a person's birth but not similar information about the baptism.

The *Taufwunsch,* typically a godparent's greeting, however, has clear Continental roots in what is called a *Goettelbrief* in the Palatinate and a *Patenbrief* in standard German. These records are usually addressed to the child by his baptismal sponsors—the persons who spoke on his or her behalf in the sacramental rite—and they frequently give only the child's first name, have a rather limited design vocabulary, and were often wrapped around a coin given by the sponsors to their godchild. In contrast to American examples, *Goettelbrief* and *Patenbrief* sometimes refer to a *Pfarrkirche,* or parish church, a concept not used in Pennsylvania Protestantism. They are also often folded into a small unit, whereas American versions commonly were rolled for safekeeping, which accounts for the appearance of names written on the margins of the backs of the documents. What was a quasi-religious souvenir of the Christian sacrament of initiation in Europe became essentially a record-keeping document in America. It was thus already a secular document, even with scriptural and hymn texts about baptism.

Patently religious designs on American examples are not only highly uncommon, they are replaced by openly secular elements and treated to an immense range of artistic whimsy. The impact of printed *Taufscheine* on others done later by hand, as well as on other types of fraktur, dare not be minimized. As personal authentication of one's existence, they are found pasted inside the lid of the chest each family member owned to house personal possessions. They were submitted as proof of birth with applications for military pensions. And—to the horror of collectors ever since—they were rolled up and placed in the right hands of their owners before burial, as had been done in Alsace if not elsewhere on the Continent.

Taufscheine were mass-produced on printing presses beginning in the 1780s, and printers who dated their editions, such as those in Hanover or Allentown, sometimes needed several reprints in one year and, at the least, a new edition every year because of their popularity. By the end of the 1800s, religious printing houses restored the records with emblems of piety, issued examples in English, German, Scandinavian, and other languages, and sold them to clergy to give as a record of the event. This Pennsylvania German folk custom became a widespread national custom and not only among German groups. Thus it joined these peoples' other contributions to American life, from Groundhog Day and the Easter rabbit to Christmas cookies and trees.　—F.S.W.

162a–b.　**EPHRATA CLOISTER TUNEBOOK**
Artists unidentified
Ephrata Cloister, Ephrata, Lancaster County, Pennsylvania
c. 1745
Watercolor and ink on paper, with cloth and leather binding
8⅜ × 7⅝ × 1⅞ in. (closed)
P1.2001.190

PROVENANCE:
Governor Samuel W. Pennypacker; Samuel T. Freeman & Co., Philadelphia, sale 943, "Pennypacker Collection," 11/08, lot 125; Baldwin's Book Barn, West Chester, Pa.; Richard Machmer, Hamburg, Pa., 1978.

EXHIBITED:
"Millennial Dreams: Vision and Prophecy in American Folk Art," MAFA, 1999/2000.

163a–b.　**EPHRATA CLOISTER TUNEBOOK**
Artists unidentified
Ephrata Cloister, Ephrata, Lancaster County, Pennsylvania
c. 1745
Watercolor and ink on paper, with cloth and leather binding
8¼ × 6¾ × 1³⁄₁₆ in. (closed)
P1.2001.191

INSCRIPTIONS:
Inside front cover, ink: *Jacob Gorgas his Book / in the Year 1783 / Jacob Gorgas / his Book;* flyleaf: *Jacob Gorgas His Book / Wm. R. Gorgas AD 1838*

PROVENANCE:
Sotheby Parke-Bernet sale 4785Y, 1/82, lot 849.

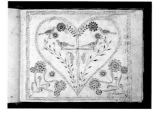

164a–b.　**SNOW HILL CLOISTER TUNEBOOK**
Artist unidentified, possibly Jacob Ritter
Snow Hill Cloister, Snow Hill, Franklin County, Pennsylvania
1852
Watercolor and ink on paper, with leather binding
6¾ × 8¼ × 1¾ in. (closed)
P1.2001.192

1　See a reprint of William M. Fahnestock's "An Historical Sketch of Ephrata; together with a Concise Account of the Seventh Day Baptist Society of Pennsylvania" (1835), in Felix Reichmann and Eugene E. Doll, "Ephrata as Seen by Contemporaries," *The Pennsylvania German Folklore Society* 17 (1952): 164–86.

INSCRIPTION (TRANSLATION OF GERMAN):
Title page, ink: *Book of means / consisting of / all kinds of acceptable melodies / for thanks and praise to our God / and we made for use in the / Christian church at Snow Hill / Brother Jacob Ritter, 1852*

PROVENANCE:
Henry J. Kauffman, Lancaster, Pa.; M. Austin and Jill R. Fine, Baltimore; Sotheby's sale 5552, "Fine Collection," 1/87, lot 1011.

PUBLISHED:
Weiser, Frederick S. *Fraktur: Pennsylvania German Folk Art.* Ephrata, Pa.: Science Press, 1973, pp. 38–39.

Ecclesiastical life in German-speaking Europe in the eighteenth century allowed next to no deviation from a pattern set down two centuries before: the ruler of a territory determined which of three legally tolerated religions his subjects would hold—Roman Catholicism, Evangelical Lutheranism, or Reformed. Anabaptists, persons who delayed baptism until adulthood, and Jews—who did not baptize at all, of course—existed on the margin of society, at times tolerated, at times persecuted. Any other religious expression could expect to be promptly nullified. Thus Pennsylvania, fostered by dissenter William Penn and offering a haven for nearly all forms of religion (or none at all) to its citizens, became a region of religious impulses unwelcome in Europe.

One of the most striking of these was the Ephrata Cloister (1732–1813), a monastery for men and women established on the banks of Cocalico Creek in northern Lancaster County by the German Seventh-Day Baptists, who celebrated the Sabbath on Saturday. It was one of few areas of colonial German life to attract international attention, and it offered constant hospitality to both the curious and religious seekers. In classic monastic tradition, the members gathered for worship many times a day. As Protestants, their worship consisted of hymns rather than chants, and their hymnody poured from the pen of the founder, Georg Conrad Beissel (1691–1768), and other members of the group.[2] The tunes were specific to the order as well. Over and over again, collections of these hymns were published, eventually in the cloister's own print shop, which was founded between 1742 and 1745. One of the chief activities of the monastics became the preparation of *Mittel Bücher,* or tunebooks, for these hymns, each equipped with a printed index. Yet they became obsolete as soon as more hymns were written and a new hymnal published.

Whether drawing on medieval monastic traditions or simply indicative of the ebullience of the cloister members, most of these tunebooks were decorated with graphic elements that filled empty music bars or blank spaces on pages and with decorative capitals in the prose titles of the hymns. Members gifted in calligraphy and decoration participated in a scriptorium, or writing room, at the cloister. Distinctive Ephrata motifs include stylized lilies, carnations, and pomegranates.[3] Various members worked on the decoration, and since none of the work is signed, we shall probably never know their identities. Of the several dozen tunebooks that survive, nearly all are in public collections. While they have attracted scholarly attention and have been the subject of seminars and exhibitions, the painstaking study necessary to arrange the tunebooks chronologically remains to be done. Nor has more than a fragment of the pictorial material been published.

Ephrata's daughter cloister, Snow Hill (1798–1895), across several mountain ranges to the west, in Franklin County, developed in the nineteenth century. Tunebooks and other materials used in the practice of religion there were brought from Ephrata and also produced in the new cloister. Congregations of married persons always worshiped alongside the cloistered celibates, but all used the same hymns so long as the German language prevailed. Most of the work done at Snow Hill was far more modest and far less accomplished than that at Ephrata, but the tunebook that bears the name of Brother Jacob Ritter—which may well have been decorated by one of a number of persons by that name—contains brightly colored fraktur-type images that remain the best examples of what was produced there.　　　—F.S.W.

165.　BOOKPLATE FOR ROSINA HERING
Heinrich Engelhard (dates unknown)
Probably western Berks County, Pennsylvania
1827
Watercolor and ink on paper, in Martin Luther, *Der kleine Catechismus* (Germantown, Pa.: Billmeyer, 1826)
5¾ × 3⁷⁄₁₆ in.
P1.2001.193

INSCRIPTION (TRANSLATION OF GERMAN):
Inside front cover, ink: *Rosina / Hering / in the year / 1827*

PROVENANCE:
Leonard Balish, Englewood, N.J., 1975.

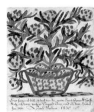

166.　PRESENTATION FRAKTUR
FOR JACOB BORDNER
Heinrich Engelhard (dates unknown)
Probably western Berks County, Pennsylvania
1830
Watercolor and ink on paper
7½ × 6 in.
P1.2001.194

INSCRIPTION (TRANSLATION OF GERMAN):
Recto, ink: *I sing and pray aloud to you, my heart tastes gentle peace / I am adorned with virtues true, Hasten heav'nward when I cease. / Jacob Bordner. 1830.*

PROVENANCE:
Kennedy Galleries, New York, 1972.

2　Beissel's treatise on his unusual music theory and system of composition is included in the cloister's *Turtel-Taube* hymnal (1747), collection Library of Congress, Washington, D.C.

3　For an extended discussion of the decoration in the tunebooks and possible source material, see Cynda L. Benson, *Early American Illuminated Manuscripts from the Ephrata Cloister* (Northampton, Mass.: Smith College Museum of Art, 1995).

As more examples have been found, a relatively large body of fraktur
dated from 1818 to 1831 has recently been attributed to school-
master Heinrich (or Hennrich) Engelhard. The artist seems to have been
the son of Johann Georg Engelhard (1725–1804), who immigrated in
1750 and may have been a schoolmaster himself. After 1800 he and his
children were communicants at Trinity Lutheran Church in New Holland,
where he is buried. Heinrich married Sophia Weil on April 11, 1818, in
the Tulpehocken region, but his earliest pieces of fraktur bear the names
of people who lived in the Schwaben Creek Valley of Northumberland
County; those made between 1827 and 1831 bear names of Berks County
residents. Engelhard prepared bookplates for two volumes owned by
Rosina Hering in 1827. He also made two drawings of baskets of straw-
berries for Jacob Bordner in 1830, as well as a house blessing for Elisa-
beth Bordner that same year.[4] —F.S.W.

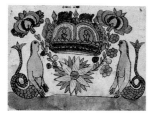

167. PRESENTATION FRAKTUR OF
MERFOLK, FLOWERS, AND CROWN
Johann Henrich Otto (1733–c. 1800)
Probably Lancaster or Lebanon County,
Pennsylvania
c. 1785
Watercolor and ink on block-printed paper
6⅜ × 8 1/16 in.
P1.2001.195

INSCRIPTION:
Recto, ink: *Henrich* [illegible]

PROVENANCE:
Robert Carlen, Philadelphia; Edgar William and Bernice Chrysler Garbisch, Cambridge, Md.;
Sotheby Parke-Bernet sale 3595, "Garbisch Collection," 1/74, lot 125.

Henrich Otto, probably a schoolmaster in Berks, Lancaster, Lebanon,
and Northumberland Counties, arrived from Germany in 1753. He
seems to have been one of the first Pennsylvanians to have made birth
and baptismal records and was one of the first—if not the first—to have
them printed. This example probably postdates the first printed *Taufscheine*
of about 1784; like them it features designs stamped from woodcuts.
A merman (left) and mermaid (right) appear on a sandy beach; a crown
and flowers are at the top of the drawing. Only a few other pieces are
known to have been made by Otto that are not *Taufscheine*. His contribu-
tion to the design vocabulary of Pennsylvania German fraktur is substan-
tial; long after his parrots first appeared in print, for example, they were
being copied by his successors in his craft. At least four sons also made
fraktur: Conrad, Daniel, Jacob, and William. Details of his death have not
survived; like many schoolmasters his estate was insufficient to warrant
a will or probate. He probably concluded his life dwelling in the school-
house of Saint Peter's Lutheran and Reformed Church near Red Cross,
Northumberland County. —F.S.W.

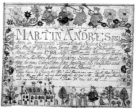

168. BIRTH AND BAPTISMAL RECORD
FOR MARTIN ANDRES
Johannes Ernst Spangenberg (?–1814)
Probably Easton, Northampton County,
Pennsylvania
c. 1788
Watercolor and ink on paper
12¾ × 15⅝ in.
P1.2001.196

INSCRIPTION:
Recto, ink: *MARTIN ANDRES was / born in Greenwich Township in Sussex County and / the state
of West New Jersey the 1st day of February / Anno Domini 1788; His Father named Bernard Andres /
and his Mother Mary Andres. Soon after his birth / day he was Christian like baptized, his Godfather and /
Godmother were his dearly beloved Parents. / Whom have I in Heaven, but thee? and there is none upon
Earth that I desire / besides thee, my flesh and my heart falleth: but God is the Strength of my Heart / and
my Portion for Ever. Psalm 73. Vers 25–26*

PROVENANCE:
Sotheby Parke-Bernet sale 3438, 11/72, lot 658.

EXHIBITED:
"Palette of Pennsylvania Folk Art," Philadelphia Antiques Show, 1976.
"Small Folk: A Celebration of Childhood in America," MAFA and N-YHS, 1980/81.
"Expressions of a New Spirit," MAFA, 1989.
"Always in Tune: Music in American Folk Art," MAFA, 1989.
"Every Picture Tells a Story: Word and Image in American Folk Art," MAFA, 1994/95.

PUBLISHED:
Bishop, Robert, and Jacqueline Marx Atkins. *Folk Art in American Life.* New York: Viking Studio
 Books in association with MAFA, 1995, p. 37.
Brant, Sandra, and Elissa Cullman. *Small Folk: A Celebration of Childhood in America.* New York:
 E.P. Dutton in association with MAFA, 1980, p. 46.
Kogan, Lee, and Barbara Cate. *Treasures of Folk Art: Museum of American Folk Art.* New York:
 Abbeville Press in association with MAFA, 1994, p. 112.
"Loan Exhibit." In *Philadelphia Antiques Show Catalog.* Philadelphia: Philadelphia Antiques Show,
 1976, p. 67.
Schaffner, Cynthia V.A. *Discovering American Folk Art.* New York: Harry N. Abrams, 1991, pp. 52–53.
Warren, Elizabeth V., and Stacy C. Hollander. *Expressions of a New Spirit: Highlights from the Permanent
 Collection of the Museum of American Folk Art.* New York: MAFA, 1989, p. 33.

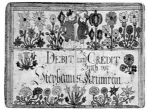

169. ACCOUNT BOOK FOR
STEPHANUS KRUMREIN
Johannes Ernst Spangenberg (?–1814)
Probably Easton,
Northhampton County, Pennsylvania
c. 1790
Watercolor and ink on paper, with leather
binding with watercolor decoration
8 × 6⅞ × 1 in. (closed)
P1.2001.197

INSCRIPTION (TRANSLATION OF GERMAN):
Title page, ink: *Debit and Credit / Book for / Stephanus Krumrein*

PROVENANCE:
Christie's sale 8894, 6/98, lot 90.

4 For the other drawing for Jacob Bordner, see catalog for Garth's sale 10/12/90 (lot 441). The
 house blessing for Elisabeth Bordner is illustrated in Beatrice B. Garvan, *The Pennsylvania German
 Collection* (Philadelphia: PMA, 1982), p. 311, fig. 1.

Music played an extensive role in Pennsylvania German life. An out-growth of the Protestant Reformation, hymns were an imposing part of worship and funeral services. Folk songs were popular in taverns and were sometimes accompanied by what Pennsylvania Germans called a *Zitter*, or dulcimer. Organs were so highly esteemed that any church that owned one was dubbed an "organ church," and for special ecclesiastical occasions musicians with an assortment of instruments would accompany occasional music in worship.

Johannes Ernst Spangenberg, who taught at the church school in Easton, memorialized this custom by depicting violinists, trumpeters, and hornists, as seen in this birth and baptismal certificate for Martin Andres. Other human figures in his work remind us that baptisms were occasions for family gatherings at which wine and cake were served. Spangenberg was bilingual, and he made pieces for children born in the eastern Lehigh Valley and even across the Delaware River in New Jersey, in a region settled by Moravians, who also placed a high value on music.[5] Spangenberg also made bookplates for Bibles and account books. The account book for Stephanus Krumrein contains the text of a church anthem sung at a church dedication in 1790, an assortment of recipes, formulas for veterinary cures, and a variety of business accounts over which a subsequent owner pasted clippings. Spangenberg also decorated the book's cover. —F.S.W.

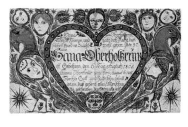

170. BIRTH RECORD
FOR EMANUEL BART
Leacock Township Artist
Probably Leacock Township,
Lancaster County, Pennsylvania
c. 1800
Watercolor and ink on paper
7⅝ × 10 in.
P1.2001.198

INSCRIPTION (TRANSLATION OF GERMAN):
Recto, ink: *Emanuel Bart / is my name / in heaven / is my fatherland / in Leack Township, Lancaster County in state of / Pennsylvania in the year of our / Lord 1793 the 5th May I was born, a student / selected. God give me much happiness and blessing and / lead me on his ways and bring me after / this time to the great glory. / Oh, you upright, do not give up / even if often filled with tears. Lest the help be denied you, Only believe, He will drown your pains at the end of the course / with the song of victory and help you / out of suffering into the eternal bliss.*

PROVENANCE:
James and Nancy Glazer, Philadelphia, 1992.

171. BIRTH RECORD
FOR HANA OBERHOLTZER
David Cordier (dates unknown)
Probably Lancaster County,
Pennsylvania
1816
Watercolor and ink on paper
7¾ × 12¼ in.
P1.2001.199

INSCRIPTION (TRANSLATION OF GERMAN):
Recto, ink: *Hana Oberholtzerin, / Depart from evil and do good; so / shall you abide for ever. Psalm 37[:27] / Hana Oberholtzerin / was born 6 August 1805;* in English: *Hanna Oberholser was born August 6, 1805;* in German: *Fear God and keep his commandments, for that / is the duty of all mankind. / Written 30 May 1816.*

PROVENANCE:
Sotheby's sale 6201, 6/91, lot 258.

Although the term *Taufschein* technically refers to birth and baptismal certificates, in common usage they also comprise records that list only births. Groups that did not baptize infants, such as the Mennonites, naturally still had the need to commission such records. That is surely the case with the Leacock Township Artist's birth record for Emanuel Bart and David Cordier's birth record for Hana Oberholtzer. "Oberholtzer" is a Mennonite surname, enshrined in American life as Old Overholt, a whiskey initially made by a member of this family. And though Emanuel Bart may not have been a Mennonite, his home was in their midst. The walking man on Bart's birth record and the eight faces on Hana's record (two of them in birds' bodies, a mythological reference to apotheosis) emphasize the secularity in which these documents thrived, even with religious poems on them. —F.S.W.

5 The only other work by Spangenberg known to be inscribed in English, aside from wills, is a birth and baptismal certificate for Martin Andres's older sister, Anne, in the collection of NGA; see Monroe H. Fabian, "The Easton Bible Artist Identified," *Pennsylvania Folklife* 22, no. 2 (winter 1972/73): 5. A separate document for Anne inscribed in German is illustrated in John Joseph Stoudt, *Pennsylvania German Folk Art* (Allentown, Pa.: Schlechter's, 1966), p. 223.

Johann Adam Eyer (1755–1837)

One of the longest-producing and most prolific and influential of
Pennsylvania German fraktur artists was a native son, Johann
Adam Eyer, who was born July 27, 1755, probably in Bedminster Town-
ship, Bucks County, Pennsylvania. He was a son of Johann Martin and
Anna Dorothea Beuscher Eyer, the father having come from Alsace in
1749. Except for a remarkable record of his service as a baptismal sponsor
at age thirteen in 1768, we do not encounter Adam Eyer again until the
fall of 1779, when he began service as a schoolmaster—or *Schuldiener,* as
he termed himself in German—in the area of his birth. His roll book of
pupils from 1779 to 1787 survives.[6]

Eyer's teaching career may be followed geographically from Bucks
to Chester to Lancaster County until about 1792, when he seems to have
joined his parents and younger siblings on a farm in Upper Mount Bethel
Township, Northampton County, which was purchased in his name in
1786. There he served the Lutheran congregation as teacher, musician,
and clerk. In 1801 he and his family moved across the mountains to
Hamilton Township in Monroe County, and he began similar service to
the Hamilton Church, the Lutheran congregation of Christ Church, a
position he held until nearly the end of his life. During this time, prob-
ably utilizing his father's money, he laid out the town of Bloomsburg on
land his brother Ludwig owned. Perhaps he was an absentee landlord,
since Ludwig is usually credited as the town's founder. Eyer died at his
home in Hamilton on December 29, 1837, and is buried nearby.

Eyer's career may also be followed through his fraktur. He made *Vor-
schriften,* a handful of *Taufscheine,* bookplates, and title pages and filled in
some family Bibles and the contents for penmanship example booklets
and tune booklets. He also prepared longer religious texts and smaller
presentation pieces, some of them specifying that they were made for
good students. His own family members—some of whose children he
no doubt taught—benefited from his talents. The music collection he
made for his sister Catharina, who was probably retarded, contained in
fact his own collection of music, some of it likely used as anthems in his
churches. When he died, he bequeathed music books to his nephew, and
at his estate sale there was even a likeness of him! Surviving pieces bear
dates from 1779 to the 1820s. He kept the records of the Hamilton
Church into the 1830s.

—F.S.W.

172. **Religious Text with Double Eagle
for Barbara Landes**
Johann Adam Eyer (1755–1837)
Probably Bedminster Township, Bucks County,
Pennsylvania
1788
Watercolor and ink on paper
9⅞ × 8 in.
P1.2001.200

INSCRIPTION (TRANSLATION OF GERMAN):
Recto, ink: *Written the 21 October in the year 1788 / Barbara Landis / Give Jesus your heart / in joy and in pain, In life / and in death this only is gain. / My Jesus, most beautiful treasure / let me be / yours completely and press into my bosom faith. / Let your will constantly bend my own, so that I your bride / may always be. Lighten the candle of love in my heart / [so that] I / may belong / to you my entire life and eternally. I am your member, your child and / your dove. You are the head, the adornment and the cleft in the rocks, / you yourself are the vine, I a grape. I live entirely in you, / in the cave. Away with all complaints on that day, I shall also / be drawn to you in the heavens. Come, dear Jesus, come, let yourself / embrace [me]. My heart is laughing because I see you there, oh kiss / me, most beautiful, on both my cheeks. Let your good Spirit / blow in my heart. I will kiss your feet, Oh Jesus / dearest protection. It is done. My heart is attached only / to your heart. You are the wish of my soul and my desire / you drive all cares away and quiet all pains. To me / nothing else is known because of love. Let me be warmed / in your arms, I lie, oh Jesus! already on your breast. / Ah, your breast is full of many blessings. It soothes / us when death and hell press. You will / also lay me at your side, which gave blood and water / at the time of your passion, through this your suffering let me depart from this vale of tears into blessedness. Jesus, Jesus, is my life. Jesus turns all pain aside / Jesus, Jesus will give me strength of heart and joyfulness. / I sing to Jesus over and over since Jesus dwells in me. JAE SD*

PROVENANCE:
George Horace Lorimer, Philadelphia; Parke-Bernet sale 551, "Lorimer Collection, Part I," 3/44, lot 373; Arthur J. Sussel, Philadelphia; Parke-Bernet sale 1847, "Sussel Collection, Part I," 10/58, lot 302; Edgar William and Bernice Chrysler Garbisch, Cambridge, Md.; Sotheby Parke-Bernet sale 3595, "Garbisch Collection," 1/74, lot 39.

PUBLISHED:
Andrews, Ruth, ed. *How to Know American Folk Art: Eleven Experts Discuss Many Aspects of the Field.*
New York: E.P. Dutton, 1977, pl. 31.
Stoudt, John Joseph. *Pennsylvania Folk Art: An Interpretation.* Allentown, Pa.: Schlechter's, 1948,
p. 204.

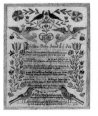

173. **Religious Text with Two Blue Doves
for Barbara Landes**
Johann Adam Eyer (1755–1837)
Probably Bedminster Township, Bucks County,
Pennsylvania
1792
Watercolor and ink on paper
9⅞ × 8 in.
P1.2001.201

INSCRIPTION (TRANSLATION OF GERMAN):
Recto, ink: *This belongs to / Barbara Landesin / the 10th of April / 1792 / Jesus, friend of my soul / let yourself / be greeted lovingly, because you [are] my own / wish and my sign of grace. Refresh me through / comfort and heal my conscience, come to me. Without you / I will always be afraid. Help so that the enemy no longer / robs the soul of your love; You are my place of refuge / can cover me very well, oh spread out your wings to your darling / over me, I ask for nothing else. After need and storms / of misfortune, they go behind your word you are / the true fortress and refuge, says the faith of your dove; Since the cross's burden and heat weigh me down so strengthen / me you yourself and be to me a cleft in the rock in which my weary / spirit may be refreshed again. In caves one finds / always more fresh air. Oh be a little hut of many / green branches to your dove; Those borne by you later the psalm of victory / and in the enemy's blood, as heroes do, / _____ as you sin and death and devil have / conquered, from these a little hut is set up for me. Oh most beautiful treasure, give some from this to your dove; Oh hero in Israel, you have given only yourself / and with you everything that can aid / me because I am here obliged through my / entire life, so heed my conclusion, my dearest saviour / I remain even when I breathe for last time / Your dove.*

6 Collection Goschenhoppen Historians, Green Lane, Pa. For illustration and full transcription,
see Frederick S. Weiser, "IAE SD: The Story of Johann Adam Eyer (1755–1837), Schoolmaster
and Fraktur Artist, with a Translation of His Roster Book, 1779–1787," in *Ebbes fer Alle-Ebber,
Ebbes fer Dich* (*Something for Everyone, Something for You*) (Breinigsville, Pa.: Pennsylvania German
Society, 1980), pp. 440–41, 481–506.

PROVENANCE:
Moss Hart, New York; Mr. and Mrs. Meyer Potamkin, Philadelphia; Sotheby's sale 5810, 1/89, lot 1181.

The two sentimental, religious, and even sensual texts that Adam Eyer prepared for Barbara Landes four years apart raise more questions than they answer. The earlier one is sometimes dubbed "the mystical doves," but while it does mention a dove once, the graphic elements are dominated by a spread eagle, perhaps inspired by the Hapsburg coat of arms.[7] The 1792 fraktur does have two blue doves at the top, and the text is a five-verse hymn in which the singer refers to herself as a dove. Both texts are somewhat mystical (in the religious sense) songs of praise to Jesus reciting what he has done and what he has promised the speaker.

But who was Barbara Landes? Perhaps she was a sister of the Maria Landes for whom Eyer prepared a marriage greeting in 1784, apparently the only piece Eyer completely signed.[8] Or she might have been a sister of Agnes Landes, for whom one of Eyer's spiral texts (see cat. no. 179 for another example) was made in 1783, or of Abraham Landes, who is named in Eyer's roll book and for whom Eyer made a spectacular *Vorschrift* booklet in 1780.[9] The schoolmaster was in his thirties when these pieces were made. Barbara, however, is not listed in his roll book. Were they tokens of the love he had for her? They never married. Did she die? Did her Mennonite faith and his strong Lutheran convictions collide?

—F.S.W.

174. *TAUFSCHEIN* FOR JOHANN MARTIN EYER
Johann Adam Eyer (1755–1837)
Probably Upper Mount Bethel Township,
Northampton County, Pennsylvania
c. 1795
Watercolor and ink on paper
9⅞ × 7⅝ in.
P1.2001.202

INSCRIPTION (TRANSLATION OF GERMAN):
Recto, ink: *Johann Martin Eyer / lawful son of Johannes Eyer and his law / ful wife Margaretha / was born into this world the 15th day / January 1795 and was baptized the / following 15th March / Sponsors were the grand- / parents Johann Martin Eyer and / his lawful house-wife Dorothea. / God, Father, Son, and Spirit grant / that I remain strong in believing in you, / [That I] faithfully remain in my covenant / of baptism's comfort and joy.*

PROVENANCE:
Robert Carlen, Philadelphia; Edgar William and Bernice Chrysler Garbisch, Cambridge, Md.; Sotheby Parke-Bernet sale 3595, "Garbisch Collection," 1/74, lot 37.

EXHIBITED:
"The Pennsylvania Germans: A Celebration of Their Arts, 1683–1850," PMA, 1982/83.

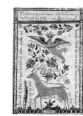

175. PRESENTATION FRAKTUR WITH ANGEL AND DOE
Johann Adam Eyer (1755–1837)
Probably Bedminster Township, Bucks County,
Pennsylvania
1789
Watercolor and ink on paper
7⁷⁄₁₆ × 4¾ in.
P1.2001.203

INSCRIPTION (TRANSLATION OF GERMAN):
Recto, ink: *I knew a worthy city which / has the name of peace, so I name her Jerusalem. God———; I suffer this all for your good. Keep that firmly in your belief. / One will forget my blood and thereto rob my life entirely———; He says / Peace be with you. Haste makes time disappear [Haste makes waste] As a deer longs for flowing streams, so longs my soul for thee, oh God. 1789.*

PROVENANCE:
Fred Wichmann, New York; Sotheby Parke-Bernet sale 5079, "Wichmann Collection," 6/83, lot 140.

EXHIBITED:
"Masterpieces of American Folk Art," Monmouth Museum, Lincroft, N.J., 1975.

PUBLISHED:
Bishop, Robert, and Jacqueline Marx Atkins. *Folk Art in American Life.* New York: Viking Studio Books in association with MAFA, 1995, p. 37.
Kogan, Lee, and Barbara Cate. *Treasures of Folk Art: Museum of American Folk Art.* New York: Abbeville Press in association with MAFA, 1994, p. 116.
Monmouth Museum. *Masterpieces of American Folk Art.* Lincroft, N.J.: Monmouth Museum in association with Monmouth County Historical Society, 1975, n.p.
Weiser, Frederick S. "IAE SD: The Story of Johann Adam Eyer (1755–1837), Schoolmaster and Fraktur Artist, with a Translation of His Roster Book, 1779–1787." In *Ebbes fer Alle-Ebber, Ebbes fer Dich (Something for Everyone, Something for You).* Breinigsville, Pa.: Pennsylvania German Society, 1980, p. 469.

Fraktur artists not infrequently made pieces for their own family members and just as often made them a little fancier than those prepared for others. Adam Eyer's *Taufschein* for his brother's son John Martin displays a typical Eyer bird, a seated figure borrowed from the work of his friend Andreas Kolb, and a very American eagle supporting two persons holding sprigs of flowers. The text, with its reference to the Trinity, is evidence of the family's Lutheran commitment.

Fraktur also was used by schoolmasters in the same way modern educators employ teaching aids. Eyer prepared such pieces for nearly half a century. These included presentation frakturs in the tradition begun by early Pennsylvania schoolmaster Christopher Dock (?–1771), who wrote in 1750 that he gave children who learned their lessons a drawing of a bird or flower.[10] Eyer went a step beyond birds and flowers in this 1789 piece presented to an unknown child: it contains a text about Jerusalem, the city of peace; a crowned angel proclaiming peace; a homespun proverb about the wise use of time; and a deer quoting Psalm 42 about a hart longing for water.

—F.S.W.

7 John Joseph Stoudt, *Pennsylvania Folk Art: An Interpretation* (Allentown, Pa.: Schlechter's, 1948), p. 204. It was also titled *The Mystical Doves* in the catalog for Sotheby Parke-Bernet sale 3595 (1/74, lot 39).
8 Frederick S. Weiser and Howell J. Heaney, comps., *The Pennsylvania German Fraktur of the Free Library of Philadelphia,* vol. 1 (Breinigsville, Pa.: Pennsylvania German Society, 1976), pl. 193.
9 Collections of Schwenkfelder Library, Pennsburg, Pa., and Free Library of Philadelphia, respectively. See Weiser, "IAE SD," p. 459.
10 Christopher Dock, *A Simple and Thoroughly Prepared School Management* (Germantown, Pa.: 1770), quoted in English in Gerald C. Studer, *Christopher Dock: Colonial Schoolmaster* (Scottsdale, Pa.: Herald Press, 1967), p. 276.

176. TUNEBOOK FOR DANIEL ZELLER
Johann Friedrich Eyer (1770–1827)
Tulpehocken, Berks County, Pennsylvania
1804
Watercolor and ink on paper, with
paper binding
3⅞ × 6½ × 3⁄16 in. (closed)
P1.2001.204

INSCRIPTION (TRANSLATION OF GERMAN):
Title page, ink: *This / tunebook belongs to / Daniel Zeller / scholar in the Tulpehocken School / In Berks County / Writ. the 14th May / A.D. 1804*

PROVENANCE:
James and Nancy Glazer, Philadelphia, 1975.

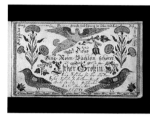

177. TUNEBOOK FOR ESTHER GROSS
Johann Adam Eyer (1755–1837)
Hilltown Township, Bucks County,
Pennsylvania
1789
Watercolor and ink on paper, with
paper binding
4 × 6½ × ⅛ in. (closed)
P1.2001.205

INSCRIPTION (TRANSLATION OF GERMAN):
Title page, ink: *Give Jesus your / heart in joy and in pain / In life and in death, / This only is gain. / This little singing tunebook belongs to / Esther Grossin / singing scholar in the Birken / seh School in Hiltown Townsh[ip] / Bucks County Written / the 4th December / A.D. 1789.*

PROVENANCE:
James and Nancy Glazer, Philadelphia, 1979.

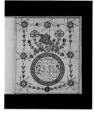

178. PENMANSHIP EXAMPLE BOOKLET
FOR GEORG SCHLOTTER
Johann Adam Eyer (1755–1837)
Hamilton Township, Monroe County, Pennsylvania
1820
Watercolor and ink on paper, with paper binding
8 × 6³⁄16 × ⅜ in. (closed)
P1.2001.206

INSCRIPTION (TRANSLATION OF GERMAN):
Title page, ink: *This / penmanship example book / let belongs to / Georg Schlotter / writing student in the Ha / milton School, written / the 18th March / 1820.*

PROVENANCE:
Sotheby Parke-Bernet sale 3804, 11/75, lot 994.

Both Adam Eyer and his brother Johann Friedrich made tunebooks for their students, although Adam seems to have made far more. Friedrich's work comes from his school terms in Chester and Berks Counties, but to date none has been found from his last appointment at Selinsgrove, Snyder County, where he copublished a printed music book that had a long-lasting impact on Pennsylvania German musicology.

Friedrich's tunebook for Daniel Zeller provides the tunes for 120 hymns. Adam also made such booklets for students in Bucks, Chester,

Northampton, and Monroe Counties across a six-decade period. Although Esther Gross was a student at a Mennonite school, the seventy-four hymns in Adam's tunebook for her are mostly Lutheran chorales. The artistic relationship of the brothers' work is so obvious that it is often confused. Angels and birds were symbolic of singing to praise God.

Adam Eyer also made penmanship example booklets, two sheets of folded paper sewn in paper covers. The original order of this booklet for Georg Schlotter, which has been rebound, was the title page; what Eyer called the "ABC blat [page]," with an acrostic text based on the alphabet and large and small letters and numerals; a page with an entire paragraph that is a hymn based on Revelation 3:20; and a fourth page of handwritten admonitions. As rebound, the booklet also contains sheets set for copying, accounts (either actual or, more likely, examples of how to keep them), and a page with an illustration of a man with a sword and horse. Clearly the Pennsylvania German schoolmaster wanted his students to have one foot secure in the world about them and the other ready to step heavenward in time. —F.S.W.

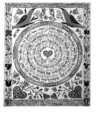

179. SPIRAL RELIGIOUS TEXT
Johann Adam Eyer (1755–1837)
Probably Bedminster Township, Bucks County,
Pennsylvania
c. 1780–1785
Watercolor and ink on paper
8⅝ × 6⅞ in.
P1.2001.207

INSCRIPTION (TRANSLATION OF GERMAN):
Recto, ink: *Let us praise the Lord and increase his fame. Strike up the sweet melodies, those of you who are his possession. May his mercy endure forever. Eternally he will embrace us with sweet protection of love, not remember our guilt. Praise forever his name, you who are the seed of Abraham, Extol his works forever give him praise, glory, and strength. Before one single person was born, he knew us beforehand and chose us in Christ, his protection turned towards us. Even heaven and earth must serve us because we have become his children through his beloved child. Such grace endures forever, which he shares with us in him; eternally we want to strive to love him above all else. This heart of mine shall be given entirely to Jesus. Jesus dwell in my heart when I endure anxiety and pain.*

PROVENANCE:
George Horace Lorimer, Philadelphia; Chris A. Machmer, Annville, Pa., 1990.

PUBLISHED:
Shelley, Donald A. "The Fraktur-Writings or Illuminated Manuscripts of the Pennsylvania Germans." *The Pennsylvania German Folklore Society* 23 (1958/59): fig. 40.

No doubt some favored pupil of Adam Eyer received one of his spiral religious texts at the beginning of the artist's career, for several examples inscribed with the recipients' names and dated in the 1780s are known to exist. Eyer skillfully and carefully lettered the piece while rotating it, and he selected a rhyming text that perfectly fits the space allowed. As usual, his choice of colors and design elements yields an extremely handsome piece. The texts in the hearts at the bottom speak of the heart; the one at the right features a heart motif in place of the word.

—F.S.W.

Johann Christian Strenge (1757–1828)

Johann Christian Strenge, the only son of Johann Henrich Strenge and his wife, Maria Catharina Romer, was born October 24, 1757, in the Hessian village of Altenhasungen. He was baptized there a few days later with Christian Ruhling as his godfather, and he was also confirmed there, in 1772, in the Reformed church. Strenge enlisted in 1776 in the Fifth Company of the Grenadier Regiment led by Colonel Johann Gottlieb von Rall, and the unit landed in New York in August 1776. When Washington crossed the Delaware, Strenge was captured but presently released to the British. Subsequently the unit was in Georgia, but when it returned to Hesse-Cassel in 1783, Strenge was recorded as "on leave."[11] In fact he had deserted, and within a few years he was located in Hempfield Township, Lancaster County, beginning a career as schoolmaster, scrivener, justice, and property owner. He married twice and left a family, for some of whom he made pieces of fraktur, some of which have survived.

Although many of Strenge's students were Mennonites, he was not. He created bookplates, *Vorschriften, Taufscheine, Liebesbriefe,* presentation frakturs, music book title pages, and even a crucifixion scene. He taught at least one school term in Chester County, and he undoubtedly knew and influenced—or was influenced by—Christian Alsdorff, who in turn was artistically related to the Eyers. —F.S.W.

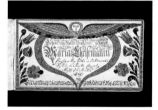

180. Tunebook for Maria Christmann

Christian Strenge (1757–1828)
Vincent Township, Chester County, Pennsylvania
1794
Watercolor and ink on paper, with paper binding
3¹¹⁄₁₆ × 6³⁄₈ × ⅛ in. (closed)
P1.2001.208

INSCRIPTION (TRANSLATION OF GERMAN):
Title page, ink: *This singing tunebook belongs to / Maria Christmännin / Diligent singing scholar in the Vincent / School in Chester County / Written the 6 June / AD / 1794 / Give Jesus your heart in joy and in pain, / In life and in death, this only is gain*

PROVENANCE:
Fred and Katherine Giampietro, New Haven, Conn., 1990.

181. *Liebesbrief*

Christian Strenge (1757–1828)
East Petersburg, Lancaster County, Pennsylvania
c. 1790
Watercolor and ink on cut paper
13¼ in. diam.
P1.2001.209

INSCRIPTIONS (TRANSLATION OF GERMAN):
Recto, ink: *1. My dearest child, I can no longer keep the / feelings of my heart from you. / 2. If it should please you, I have chosen you / For my dear treasure / 3. I will truly promise you my heart, if I find / You willing to do the same. / 4. In my thoughts I have often kissed you, be- / Cause you are such a pretty maiden. / 5. You mean more to me in the world than / all riches, possessions and money. / 6. If from your heart you will be mine, and / always love me and no one else / 7. My heart will be so devoted to you, / That I will love you unto death. / 8. Love, ah, that noble shoot is built on trust / alone. / 9. Love is founded on trust, through mistrust / it soon passes away. / 10. I love you in my heart, you / all-beautiful little treasure. / 11. My heart at all times thinks on you, and / trust alone delights me. / 12. My desire is only to make you happy and / be genuinely bound to you. / 13. I have truly given you my heart / and think about you every hour. / 14. If you remain true to me, no one shall sep- / arate us but death alone. / 15. My dearest treasure, so let it be, I'll be / faithful to you, you faithful to me. / 16. Faithful is beloved's duty, o, dearest one, do not / forget me; at center: Loving without possessing is harder / than digging stone. Loving without being to- / gether is most certainly the greatest pain. This / little letter belongs to the heart of my most be- / loved.*

PROVENANCE:
Sotheby's sale 5429, 1/86, lot 441.

EXHIBITED:
"Christian Strenge's Fraktur," The Leonard and Mildred Rothman Gallery, Franklin & Marshall College, Lancaster, Pa., 1995.

PUBLISHED:
Johnson, David R. *Christian Strenge's Fraktur.* East Petersburg, Pa.: East Petersburg Historical Society, 1995, n.p.

Schoolmasters in the Eyer tradition made tunebooks for their students with melodies that were only named in the hymnals. Christian Strenge did this in Lancaster County and during a term he taught in the German townships of northern Chester County. He bound them in heavy paper covers sewn to the pages. In his tunebook for Maria Christmann, he wrote her nickname, "Polly Christm," on the flyleaf; the book contains melodies for thirty-two hymns.

One of several ways a Pennsylvania German youth might extend a token of his love to a girl he admired was to give her a *Liebesbrief.* Made by "professional" fraktur artists, some of these are dated and bear the name of the donor or even of the recipient. Though they are sometimes called valentines, they were not associated with the fourteenth of February and are probably better called by their generic name. A few of Strenge's love letters have survived, none dated or signed, but all cut in round form with further cutout elements and more than a dozen small hearts with rhyming couplets expressing the donor's feelings for his "dearest treasure." —F.S.W.

11 David R. Johnson, "Christian Strenge, Fraktur Artist," *Der Reggeboge (The Rainbow): Quarterly of the Pennsylvania German Society* 13, no. 3 (July 1979): 18, n. 2.

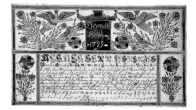

182. *VORSCHRIFT* FOR SAMUEL HOCH
Oley Mermaid Artist
Probably Oley Valley, Berks County, Pennsylvania
1799
Watercolor and ink on paper
7¾ × 12⅝ in.
P1.2001.210

INSCRIPTION (TRANSLATION OF GERMAN):
Recto, ink: *Samuel / Hoch / 1799 / oh, oh, Lord teach me / to ponder constantly that it must end for me, that no security nor this vanity / may turn me away from you; Let me often ponder the last purpose of my life / and much without interruption* [ponder] *that I may be ready when one day my / time comes to sink me into my grave; One must however one day greatly lament what we are given as / gain and much that one still considers the goods of the world desirable / One cannot survive here; Perhaps my purpose will be brought to its end tonight / that I must depart from here. What would my cares help me then since I cannot at any rate avoid the hour of death; My whole life's time is only a foot wide, as* [alphabet in small and large letters and in various letter combinations].

PROVENANCE:
Walter G. Himmelreich, Ronks, Pa.; Pennypacker sale 5/73, "Himmelreich Collection," lot 214.

EXHIBITED:
"The Pennsylvania German: His Arts and Handicrafts," William Penn Memorial Museum, Harrisburg, Pa., 1968.
"Pennsylvania German Fraktur and Color Drawings," Pennsylvania Farm Museum of Landis Valley, Lancaster, Pa., 1969.

PUBLISHED:
Pennsylvania Farm Museum of Landis Valley. *Pennsylvania German Fraktur and Color Drawings.* Lancaster, Pa.: Pennsylvania Farm Museum of Landis Valley, 1969, pl. 52.

The Oley Valley in eastern Berks County, Pennsylvania, is one of the most bucolic and best-preserved areas of early Pennsylvania German settlement. Not only are numerous farmsteads there graced with complete sets of farmhouse, barns, and smaller outbuildings—many of them still roofed with red tiles—the area was the ancestral home of Abraham Lincoln and the residence of Daniel Boone. Indeed, the Pennsylvania German dialect and folkways are alive there to this day. It was early noted as a hotbed of religious dissension, and only after some decades of settlement were Lutheran and Reformed churches and schools established. Thus fraktur, which were largely created by the schoolmasters in these schools, came along later here than in the Goschenhoppen settlement, for instance, a few miles to the east. The Oley Mermaid Artist obviously learned from the work of Johann Adam Eyer. —F.S.W.

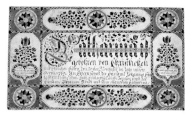

183. *TAUFSCHEIN* FOR CATHARINA EBERHARD
Artist unidentified
Southeastern Pennsylvania
c. 1780
Watercolor and ink on paper
7⅞ × 12¾ in.
P1.2001.211

INSCRIPTION (TRANSLATION OF GERMAN):
Recto, ink: *Catharina / was born to Christian / an honorable parent, the 20th / November in the year of our / Lord 1765. Her parents are the / honorable Johannes Eber- / hard / and his wife Cath. Elisabeth. Sponsors / are the / honorable Abraham Arndt and his housewife Catharina. / In weeping I was born at first / But now I'm chosen to rejoice / Each one shall ponder night and day / How he with blessing find death's way.*

PROVENANCE:
Sotheby Parke-Bernet sale 4590Y, 4/81, lot 557.

The unidentified artist of the *Taufschein* for Catharina Eberhard appears to have drawn it and filled out the baptismal information all in one sitting. Since we have no clue to the location or the clergyman involved (nor to the date of baptism), we may only guess that a local schoolmaster accommodated those who came to him seeking a certificate for their child or godchild. This maker clearly enjoyed utilizing the typical Pennsylvania German motifs of hearts, geometric stars, vines, and tulips.
—F.S.W.

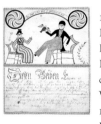

184. *TAUFSCHEIN* FOR JOHANNES DOTTERE
Northhampton County (or Bird-in-the-Hand) Artist
Probably Chestnut Hill Township,
Northhampton County, Pennsylvania
c. 1831
Watercolor and ink on paper
15¹⁄₁₆ × 12 in.
P1.2001.212

INSCRIPTION (TRANSLATION OF GERMAN):
Recto, ink: *A bird in the hand is worth two in the woods / To these two married people namely / Jacob Dottere and his lawful wife Sara nee Serfassin / a son was born into the world in the year of our Lord 1831 the 25 December in Chestnut Hill / Township, Northampton County State of Pennsylvania and received the name through Holy Baptism / Johannes. The sponsors were Philip Dottere and his lawful wife Susanna* [followed by an incomplete text for another baptism].

PROVENANCE:
George E. Schoellkopf, New York, 1975.

EXHIBITED:
"Palette of Pennsylvania Folk Art," Philadelphia Antiques Show, 1976.
"Young America: A Folk Art History," MAFA at IBM Gallery of Science and Art, 1986.

PUBLISHED:

Bishop, Robert. *Folk Painters of America.* New York: E.P. Dutton, 1979, pl. 40.

Bishop, Robert, and Jacqueline Marx Atkins. *Folk Art in American Life.* New York: Viking Studio
 Books in association with MAFA, 1995, p. 39.

Esmerian, Ralph O. "A Fraktur Fable." In *Philadelphia Antiques Show Catalog.* Philadelphia: Philadel-
 phia Antiques Show, 1976, p. 76.

Kogan, Lee, and Barbara Cate. *Treasures of Folk Art: Museum of American Folk Art.* New York: Abbeville
 Press in association with MAFA, 1994, p. 119.

Lipman, Jean, Elizabeth V. Warren, and Robert Bishop. *Young America: A Folk Art History.* New York:
 Hudson Hills Press in association with MAFA, 1986, p. 140.

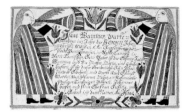

185. *TAUFSCHEIN* FOR ISAAC WUMMER
School of John Conrad Gilbert
Probably Berks County, Pennsylvania
c. 1810
Watercolor and ink on paper
7⅞ × 12³⁄₁₆ in.
P1.2001.213

INSCRIPTION (TRANSLATION OF GERMAN):

Recto, ink: *Isaac Wummer was / born in the year of the Lord Jesus / Christ 1810, the 5th September in the / state of Pennsylvania, in Berks County in / Bern Township. His father is the honorable Jacob / Wummer and the mother Maria, born a / Hufern. The above-mentioned son Isaac / was born in the world to them and was also baptized / by Pastor Meyer, a Reformed / preacher. Sponsors were Johannes / Hufer and his wife Susana and gave him the name, namely Isaac.*

PROVENANCE:
H. William Koch, Turbotville, Pa.; David Wheatcroft, Westborough, Mass., 1998.

PUBLISHED:
Weiser, Frederick S. *Fraktur: Pennsylvania German Folk Art.* Ephrata, Pa.: Science Press, 1973, p. 62.

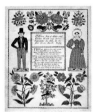

186. BIRTH RECORD FOR WILLIAM KULB
John Zinck (dates unknown)
Probably Lancaster County, Pennsylvania
c. 1832
Watercolor and ink on paper
9⅞ × 7⅞ in.
P1.2001.214

INSCRIPTION:

Recto, ink: *William Son of John and / Esther Kulb was born / September the 30th, In the / year of our Lord, 1832. / 1. THEE we adore, eternal name! / And humbly own to thee, / How feeble is our mortal frame, / What dying worms are we! / 2. [Our wasting lives grow shorter still, / As months and days, increase; / And ev'ry beating pulse we tell, / Leaves but the number less. / 3. The year rolls round, and steals away / The breath that first it gave; / Whate'er we do, where'er we be, / We're trav'lling to the grave.]*

PROVENANCE:
Hattie K. Brunner, Reinholds, Pa.; Edgar William and Bernice Chrysler Garbisch, Cambridge, Md.; Sotheby Parke-Bernet sale 3637, "Garbisch Collection, Part II," 5/74, lot 2.

PUBLISHED:
Shelley, Donald A. "Illuminated Manuscripts." *Art in America* (May 1954): 142.

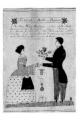

187. CERTIFICATE OF BIRTH AND BAPTISM FOR JOHN WESLEY DASHAM
Henry Young (1792–1861)
Probably Aaronsburg, Centre County, Pennsylvania
c. 1852
Watercolor and ink on paper
11 × 7½ in.
P1.2001.215

INSCRIPTION:

Recto, ink: *Certificate of Birth and Baptism / Mr. John Wesley Dasham, a Son of Mr. Jacob / Dasham and his wife Lydia, born a Royer, was / born December the 16th 1852. This child was born in Potter / Township, Centre County, State of Pennsylvania, and baptized / by the Revd. Rothrauf. His Sponsors were, the Parents.*

PROVENANCE:
Sotheby Parke-Bernet sale 5056, 6/83, lot 370.

The birth certificates grouped here exemplify the manner in which fraktur makers depicted human forms. Human figures naturally increased the appeal of any fraktur. A man and a woman depicted on a baptismal record probably represented the child's sponsors, as the Sussel-Washington Artist indicated by labeling their images (see cat. no. 206). The special relationship between sponsors and godchild extended from a moral responsibility for the child's welfare to the unwritten expectation that the sponsors would raise the child if the parents died, leave a bequest if they had no children of their own, and make gifts at key stages of life.

The couple on the *Taufschein* for Johannes Dottere by the unidentified artist known as the Northhampton County (or Bird-in-the-Hand) Artist are rather relaxed and illustrate the saying "A bird in the hand is worth two in the bush"—or, as here, "in the woods"—a bit of common sense but hardly a religious admonition. The Gilbert-type *Taufschein* for Isaac Wummer presents two clad and shod angels trumpeting, perhaps to announce little Isaac's birth. An assortment of floral decorations completes the drawing. Conrad Gilbert's angels tend to be similarly attired but do not suffer quite the severe trumpeter's lip as these.

John Zinck's stylishly dressed formal folk on the birth record for William Kulb are rather stiff, even as his flowers come closer to realism than did earlier artists' work. Either way, the human figure ties the child to the race of which he is a part.[12] The man and woman in Henry Young's certificate of birth and baptism for John Wesley Dasham are perhaps the sponsors but also in this case the child's parents. The man holds a bouquet of flowers to put into a vase on a stand. The lady wears an apron, once a part of every Pennsylvania German woman's attire but not present on every woman drawn by Young.[13] —F.S.W.

12 John Zinck was identified by Donald A. Shelley; see Shelley, "The Fraktur-Writings or
 Illuminated Manuscripts of the Pennsylvania Germans," *The Pennsylvania German Folklore
 Society* 23 (1958/59): 132–33.

13 Young used several distinct conventionalized formats in his certificates; the development is
 traced in E. Bryding Adams, "The Fraktur Artist Henry Young," *Der Reggeboge (The Rainbow):
 Quarterly of the Pennsylvania German Society* 22, no. 3–4 (fall 1977): 1–25.

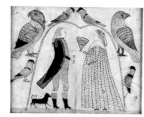

188. COUPLE UNDER AN ARBOR
Artist unidentified
Probably Pennsylvania
c. 1800
Watercolor and ink on paper
11¾ × 14 in.
P1.2001.216

PROVENANCE:
Mr. and Mrs. Peter H. Tillou, Litchfield, Conn.; M. Austin and Jill R. Fine, Baltimore; Sotheby's sale 5552, "Fine Collection," 1/87, lot 1003.

EXHIBITED:
"Where Liberty Dwells, Nineteenth-Century Art by the American People: Works of Art from the Collection of Mr. and Mrs. Peter Tillou," Albright-Knox Art Gallery, Buffalo, N.Y., 1976.

PUBLISHED:
Tillou, Peter H. *Where Liberty Dwells, Nineteenth-Century Art by the American People: Works of Art from the Collection of Mr. and Mrs. Peter Tillou.* Buffalo, N.Y.: Albright-Knox Art Gallery, 1976, fig. 11.

A small number of drawings closely related to Pennsylvania German fraktur and usually made by fraktur artists probably relate to specific events. This is one such example. The picture of a man holding a wineglass and with a dog at his heels and a woman with a fan under a sort of arbor surmounted by three pairs of birds may well be a souvenir of a wedding. Was someone teasing the man that his dog was almost as important as his bride? —F.S.W.

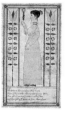

189. RELIGIOUS TEXT
John Van Minian (act. 1791–1835)
Berks or Montgomery County, Pennsylvania, or Baltimore County, Maryland
1820–1835
Watercolor and ink on paper
8⅛ × 4½ in.
P1.2001.217

INSCRIPTION:
Recto, ink: *Supreme eternal uncreated mind / Lord of the world and parent of man kind / thou god of power of wisdom and of love / each perfect gift descends from thee above*

PROVENANCE:
Edgar William and Bernice Chrysler Garbisch, Cambridge, Md.; Sotheby Parke-Bernet sale 3692, "Garbisch Collection, Part III," 11/74, lot 70.

Researchers have failed to learn very much about the elusive artist who created this engaging fraktur. A birth record bearing his signature, in the collection of the Abby Aldrich Rockefeller Folk Art Museum, is the basis for attributing this religious text and other works to him.[14] John Van Minian typically divided his compositions into carefully ruled and differentiated sections in which he placed figures of men (often peering through spyglasses) or women in profile, a handful of highly stylized floral designs and symbolic or patriotic elements, and a text in English or German. He generally wrote in a carefully drawn, ornate Gothic-style calligraphy; his use of cursive script, as in this fraktur, is less usual. Approximately twenty works by the artist are known.

Van Minian created birth and baptismal records, marriage and family records, and decorated religious texts. Although much of his work was undertaken for families in Berks and Montgomery Counties, Pennsylvania, and Baltimore County, Maryland, he also produced a marriage and family record for a couple in Dorset, Vermont, dated 1826.[15] His last dated work records the birth in 1835 of Susannah Guysinger.[16]

Traditional Pennsylvania German folk art often combines sacred and profane elements, a juxtaposition that is especially noteworthy in this small drawing. Here the artist illustrated a spiritual verse with the figure of a standing woman holding a flower; she appears both innocent and worldly, her dress revealing a deep décolletage. The verse itself appears to be from a hymn or poem; the phrase "supreme eternal uncreated mind" refers to Christ, as the Second Person of the Trinity. Isaac Watts (1674–1748), the great English hymn writer, used the same expression in Hymn 170 of Book II of his *Psalms and Hymns* ("Can creatures to perfection find / Th'eternal, uncreated Mind?"). Van Minian's text also contains a New Testament allusion: "Every good gift and every perfect gift is from above, and cometh down from the Father of lights" (James 1:17). —G.C.W.

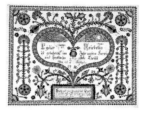

190. BIRTH RECORD FOR LYDIA KRIEBEL
"Gott allein die Ehre" Artist
Montgomery County, Pennsylvania
1806
Watercolor and ink on paper
13⅛ × 15¾ in.
P1.2001.218

INSCRIPTION (TRANSLATION OF GERMAN):
Recto, ink: *Lydia Kriebelin / was born in the / year of our Lord and Saviour Jesus Christ / the 22nd September / 1786 / Elect me to Paradise and let me / ripen in body and soul until / my last journey, thus I will serve / Thee and Thy glory, alone and no / one else, here and there forever. 1806.*

WATERMARK:
JF

PROVENANCE:
Found in Emmaus, Pa.; Robert Burkhardt; Edgar William and Bernice Chrysler Garbisch, Cambridge, Md.; Sotheby Parke-Bernet sale 3637, "Garbisch Collection, Part II," 5/74, lot 202.

EXHIBITED:
"Remember the Ladies: Women in America, 1750–1815," The Pilgrim Society and Plymouth Antiquarian Society, Plymouth, Mass., 1976.
"Small Folk: A Celebration of Childhood in America," MAFA and N-YHS, 1980/81.

PUBLISHED:
Brant, Sandra, and Elissa Cullman. *Small Folk: A Celebration of Childhood in America.* New York: E.P. Dutton in association with MAFA, 1980, p. 52.
De Pauw, Linda Grant, and Conover Hunt. *Remember the Ladies: Women in America, 1750–1815.* New York: Viking Press in association with Pilgrim Society, 1976, p. 131.

14 Beatrix T. Rumford, ed., *American Folk Paintings: Paintings and Drawings Other Than Portraits from the Abby Aldrich Rockefeller Folk Art Center* (Boston: Little, Brown, in association with Colonial Williamsburg Foundation, 1988), p. 316
15 James and Nancy Glazer advertisement in *The Magazine Antiques* 107, no. 5 (May 1975): 817.
16 Catalog for Sotheby Parke-Bernet sale 3692, "Garbisch Collection, Part III," 11/74, lot 154. Several reference works cite Richard I. Barons, comp., *The Folk Tradition: Early Arts and Crafts of the Susquehanna Valley* (Binghamton, N.Y.: Roberson Center, 1982), p. 73, as authority for a later example, dated 1842, but this appears to be a reference to a fraktur by Durs Rudy Jr. rather than Van Minian.

191.　RELIGIOUS TEXT WITH CENTER MEDALLION
David Kriebel (1787–1848)
Probably Gwynned Township,
Montgomery County, Pennsylvania
1804
Watercolor and ink on paper
9⅜ × 7¹⁵⁄₁₆ in.
P1.2001.219

INSCRIPTION (TRANSLATION OF GERMAN):
Recto, ink: *All depends on God's great blessing, / and on the grace we are possessing. / Jesus adorns my heart with love / That to receive your gifts it more. April 2 in the year 1804*

PROVENANCE:
Chris A. Machmer, Annville, Pa., 1990.

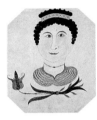

192.　WOMAN WITH CROWN
Sarah Kriebel Drescher (1828–1908)
Worcester Township, Montgomery County,
Pennsylvania
c. 1842–1850
Watercolor and ink on paper
7⅛ × 5⅞ in.
P1.2001.220

PROVENANCE:
Mr. and Mrs. Paul Flack, Holicong, Pa.; Christie's sale 8638, 9/97, lot 198.

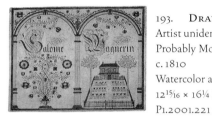

193.　DRAWING FOR SALOME WAGNER
Artist unidentified
Probably Montgomery County, Pennsylvania
c. 1810
Watercolor and ink on paper
12¹⁵⁄₁₆ × 16¼ in.
P1.2001.221

INSCRIPTION:
Recto, ink: *Salome Wagnerin*

PROVENANCE:
Charles Heffner, Reading, Pa.; Fred Wichmann, New York; Gerald Kornblau, New York, 1989.

EXHIBITED:
"The Flowering of American Folk Art, 1776–1876," WMAA, 1974.

PUBLISHED:
Lipman, Jean, and Alice Winchester. *The Flowering of American Folk Art, 1776–1876.* New York: Viking Press in association with WMAA, 1974, p. 108.

The small religious sect of Schwenkfelders immigrated to Pennsylvania from Silesia, a German province now in Poland. Since there were too few of them to warrant printing their devotional writings, they developed a strong tradition of scriveners, who copied them over and over. The proximity of the Schwenkfelders to Mennonites, with their customary fraktur drawings for schoolchildren, had a further impact on the group's artistic impulses. Sometimes generations of a family made such artwork, and the existence of a specialized library in the Schwenkfelder community, whose collection was begun in 1885, helped ensure that family holdings of such material would enter public hands.[17]

A distinctive penmanship, characterized by angular rather than rounded letter formation, developed among the Schwenkfelders through their extensive copying of the theological treatises of their forebears. This script is the key to tying Lydia Kriebel's birth record to a Schwenkfelder source. The artist has been identified as the "Gott allein die Ehre" Artist.[18] At the time of Lydia's birth, Schwenkfelder spirituality rejected any form of baptism, and the record of her birth, made twenty years later, does not mention it. The penmanship on the piece varies from others done by this artist.

David Kriebel apparently was a schoolmaster among his fellow Schwenkfelders prior to his marriage in 1815, but in that short time he was relatively productive.[19] Kriebel's work seems to resemble the heavy patterns of Near Eastern rugs, and he was perhaps influenced by imported prints and textiles. His rich colors were achieved by augmenting pigments with gum arabic, producing a heavy gouache that crackles with age. No owner's name is given on this piece. The text consists of two rhyming couplets with pious sentiments such as those teachers used to set the Schwenkfelder ethos in their students' thinking.

Sarah Kriebel, daughter of the Reverend David Kriebel, departed from the earlier canons of fraktur and drew people, such as the woman with a crown, most likely from prints circulating in her day.[20] After her marriage, her brief career concluded.

The drawing for Salome Wagner relates directly to a similar undated piece that also has text in a Schwenkfelder style by an artist who has been identified as Reverend Melchior Schultz (1756–1826).[21] Two drawings of houses and gardens have also been attributed to Susanna Heebner; they were made, probably for her nephews, in 1818, the year she died.[22] A piece by her hand, or by the maker of the Salome Wagner piece, however, is dated 1771, when Schultz would have been fourteen or fifteen years old, long before there is a record of his being a teacher. Probably another artist altogether made the three pieces, which may safely be said to be by one hand.

　　　　　　　　　　　　　　　　　　　　　—F.S.W.

194.　PRESENTATION FRAKTUR
OF A DOUBLE EAGLE
David Kulp (1777–1834)
Bucks County, Pennsylvania
c. 1815
Watercolor and ink on paper
7⅝ × 6¼ in.
P1.2001.222

PROVENANCE:
Edward and Audrey Kornowski, Royersford, Pa.; Mr. and Mrs. Paul Flack, Holicong, Pa.; Christie's sale 8638, 9/97, lot 304.

17　The Schwenkfelder Library is located in Pennsburg, Pa.
18　He has also been called the Sun and Moon Artist; see Dennis K. Moyer, *Fraktur Writing and Folk Art Drawings of the Schwenkfelder Library Collection* (Kutztown, Pa.: Pennsylvania German Society, 1997), p. 224.
19　Ibid., pp. 114–21.
20　For a discussion of her work, see ibid., pp. 131–37.
21　Museum of Fine Arts, *M. & M. Karolik Collection of American Water Colors & Drawings, 1800–1875,* vol. 2 (Boston: MFA, 1962), p. 284.
22　Moyer, *Schwenkfelder Library Collection,* p. 91.

EXHIBITED:

"The Pennsylvania German: His Arts and Handicrafts," William Penn Memorial Museum, Harrisburg, Pa., 1968.

"Masterpieces of American Folk Art," Monmouth Museum, Lincroft, N.J., 1975.

"The Gift Is Small, the Love Is Great," MAFA, 1995.

PUBLISHED:

Monmouth Museum. *Masterpieces of American Folk Art.* Lincroft, N.J.: Monmouth Museum in association with Monmouth County Historical Association, 1975, n.p.

Weiser, Frederick S. *The Gift Is Small, the Love Is Great: Pennsylvania German Small Presentation Frakturs.* York, Pa.: York Graphic Services, 1994, p. 114.

195. **PRESENTATION FRAKTUR OF AN OWL**
Artist unidentified
Probably Lehigh County, Pennsylvania
c. 1810
Watercolor and ink on paper
5¼ × 3½ in.
P1.2001.223

PROVENANCE:

Mr. and Mrs. Paul Flack, Holicong, Pa.; Christie's sale 8638, 9/97, lot 308.

EXHIBITED:

"The Gift Is Small, the Love Is Great," MAFA, 1995.

PUBLISHED:

Weiser, Frederick S. *The Gift Is Small, the Love Is Great: Pennsylvania German Small Presentation Frakturs.* York, Pa.: York Graphic Services, 1994, p. 113.

Although birds were endlessly fascinating to the Pennsylvania Germans and served as models for worship in song, as some hymn texts attest, the birds on these frakturs reach beyond the normal array of songbirds and parrots they referenced. The presentation fraktur of a double eagle—or *doppelte Adler* in the dialect, and a distant kin bird to those on the Hapsburg imperial arms—is the work of David Kulp, whose frakturs are rarely signed.[23] Kulp was a schoolmaster in the northwestern townships of Bucks County, Pennsylvania, in a Mennonite community that dates to about 1726. In 1782 he enrolled in classes taught by schoolmaster Johann Adam Eyer, from whom he received a decorated Marburg hymnal in 1783. Kulp married Mary Landis and taught at the very schools in which Eyer had taught. There he made large quantities of *Notenbüchlein,* or booklets of musical notation, and bookplates for numerous hymnals. He also served as a scrivener, auction clerk, auditor, appraiser, and assessor.

Almost Siamese in their twinship, the eagles share feet and tail feathers. They were surely as delightful to the child for whom they were made as they are to the eye today. They were a meticulous tour de force for their artist, too, who patiently crosshatched feathers and drew countless leaves on stems bearing tulips and other posies.

The nocturnal owl, whose call was comfort to the insomniac, occupied dead trees that were left to stand in wooded lots just for its housing. The owls' diet of insects and rodents in itself made them esteemed. Not easily drawn, owls rarely occur in Pennsylvania German iconography, and the subject here, on a Franconia-Mennonite type of presentation fraktur by an unidentified artist, is as bright-eyed and startled as owls always seem to be. No clear attribution to an artist may be assigned it. —F.S.W.

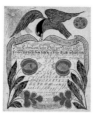

196. *VORSCHRIFT* AND BIRTH RECORD
FOR ELISABETH MEYER
Hereford Township Artist
Hereford Township, Berks County, Pennsylvania
c. 1817
Watercolor and ink on paper
9¾ × 7⅞ in.
P1.2001.224

INSCRIPTION (TRANSLATION OF GERMAN):

Recto, ink: *Elisabeth Meyer was born / 25 June 1817 / in Hereford Township / Berks County, Pennsylvania. / Remember the Lord our God all your days / and refuse to sin or transgress his / commandments. Live uprightly all the days / of your life, and do not walk in the ways / of wrongdoing. Give alms from your possessions to all who / live uprightly. Do not turn your face / away from any poor man, and the face / of God will not be turned away from / you. If you have many possessions, / make your gift from them. Job 4.:10. 6. 7. 8. /* [followed by numbers and alphabet].

PROVENANCE:

Edgar William and Bernice Chrysler Garbisch, Cambridge, Md.; Sotheby Parke-Bernet sale 3637, "Garbisch Collection, Part II," 5/74, lot 9; Ronald Merican, Kingston, N.J.; Sotheby's sale 6800, 1/96, lot 1062.

EXHIBITED:

"Calligraphy: 'Why Not Learn to Write,'" MAFA, 1975.

"Masterpieces of American Folk Art," Monmouth Museum, Lincroft, N.J., 1975.

PUBLISHED:

Johnson, Bruce A. *Calligraphy: "Why Not Learn to Write."* New York: MAFA, 1975, p. 4.

Monmouth Museum. *Masterpieces of American Folk Art.* Lincroft, N.J.: Monmouth Museum in association with Monmouth County Historical Association, 1975, n.p.

"Meyer" is a common name, and there were Mennonite Meyers in Hereford Township, so the *Vorschrift* and birth record may be from this church group as well. Bright American eagles early joined the hearts, flowers, and birds also found on contemporary European peasant art. Eagles were commonly reproduced in printed sources available to the American public. They were by disposition heroic and thus became a natural adoption into the Pennsylvania Germans' design vocabulary.

—F.S.W.

23 In 1995 Mennonite scholars John L. Ruth and Joel D. Alderfer identified a large body of fraktur made by schoolmaster David Kulp after significant writings in his hand were donated to the Mennonite Historians of Eastern Pennsylvania, Harleysville, Pa.

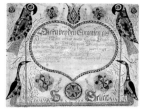

197. *TAUFSCHEIN* FOR
ELISABETH WISSLER
Heinrich Seiler (dates unknown)
Probably Dauphin County, Pennsylvania
c. 1810
Watercolor and ink on paper
12⅛ × 13 in.
P1.2001.225

INSCRIPTION (TRANSLATION OF GERMAN):
Recto, ink: *To these two married people, / namely Johannes Wissler, and his / lawful housewife / Elisabeth a daughter / was born into the world, namely / Elisabeth in the year of our Lord Jesus / 1802, the 25 day of October at / 2 o'clock in the afternoon. Baptismal / sponsors.... This Elisabeth was born / in West Hanover Township, Dauphin / County and state of Pennsylvania.*

PROVENANCE:
Joe Kindig Jr., York, Pa., 1971.

EXHIBITED:
"Palette of Pennsylvania Folk Art," Philadelphia Antiques Show, 1976.

PUBLISHED:
Esmerian, Ralph O. "A Fraktur Fable." In *Philadelphia Antiques Show Catalog.* Philadelphia: Philadelphia Antiques Show, 1976, p. 74.

198. LABYRINTH
Heinrich Seiler (dates unknown)
Probably Lebanon or Dauphin County, Pennsylvania
c. 1820
Watercolor and ink on paper
14¾ × 12⅛ in.
1999.27.3

PROVENANCE:
Helen Janssen Wetzel, Spring Township, Pa.; Sotheby Parke-Bernet sale H-3, "Wetzel Collection," 10/80, lot 1805.

EXHIBITED:
"Swiss Folk Art: Celebrating America's Roots," MAFA, 1991/92.

The work of Heinrich Seiler, of which only a small number are known to exist, has been easily overshadowed by more prominent fraktur artists. Several members of the Seiler family taught throughout the colonial and early national times. A Joh. Christ. Seyler arrived in Philadelphia on the *Two Brothers* in 1752 and likely was a teacher; he wrote many wills in the Tulpehocken area. He left none himself, but his sons may have included Christoph (c. 1750–1822) and Johann Philip (1756–1832), who is specifically called a teacher on his gravestone.[24] Christoph and his wife, Elisabeth, had seven children baptized at the Lutheran church in Schaefferstown, the first of whom was Johann Henrich, born January 21, 1772. There is an incomplete record for Heinrich Seiler's child in 1797 at Schaefferstown and the record of his marriage on October 18, 1796, to Elizabeth Neff. This may have been a second marriage, as a Heinrich and Catharina Seiler had a child baptized at Zion Lutheran Church, in Harrisburg, in 1795. Yet another Seiler—Jacob (1757–1802)—arrived in 1772 and was called a teacher when he died.

Baptismal certificates done by Seiler were made for children born in Heidelberg Township, Dauphin (now Lebanon) County, where Schaefferstown is located; in East Pennsbury Township, Cumberland County; and in West Hanover Township, Dauphin. The *Taufschein* for Elisabeth Wissler's younger sister Catharina is in the collection of Winterthur.[25] The unsigned geometric labyrinth design, surely his work, is the only known piece by his hand that is not a birth or baptismal record.

—F.S.W.

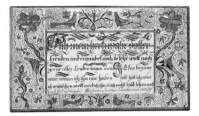

199. RELIGIOUS TEXT WITH BIRDS AND FLOWERS
Jacob Fleischer (1761–1845)
Probably Lancaster County, Pennsylvania
1802
Watercolor and ink on paper
8 × 13⁷⁄₁₆ in.
P1.2001.226

INSCRIPTION (TRANSLATION OF GERMAN):
Recto, ink: *Oh my heart would be full of joy / and would be so refreshed / would gladly endure all suffering / if my Jesus were only with me / If I should only have him / I should have just what I wished / I would not have to see him soon / must entirely go away for suffering. / Written 3 December 1802. J.F.*

PROVENANCE:
Ada Musselman, Ephrata, Pa.; Fred Wichmann, New York; Sotheby Parke-Bernet sale 5079, "Wichmann Collection," 6/83, lot 145.

Decorated religious texts, complete units by themselves, occupy an important place in Pennsylvania German art. They stand closely related to *Vorschriften*, penmanship examples whose texts not infrequently stop in the middle of a sentence. The religious texts were probably presented to students or family members as tokens of esteem or love. Schoolmasters, who made other forms of fraktur, often prepared them.

Jacob Fleischer was born in Reading in 1761 to Johannes and Eva Margaret Fleischer, who arrived in 1753. Johannes was a schoolmaster from 1761 until 1782, and he died on March 18, 1787. No signed fraktur of his is known. Jacob and his brother Andrew were also schoolmasters; Jacob identified himself as a disabled German schoolmaster "afflicted with shaking palsey" on his application in 1818 for a pension based on his service in the Revolutionary War. He had served in the navy and was taken prisoner. He married Hanna Armstrong on August 26, 1783, at Tulpehocken, and subsequent records name eight children born in the area to the couple before 1801. Jacob made *Taufscheine* and the occasional presentation piece, such as the one here, which is dated December 3, 1802, and bears no person's name.

—F.S.W.

24 Freidens Church Cemetery, Bernville, Berks County, Pa.

25 Frederick S. Weiser, "Fraktur," in Scott T. Swank, *Arts of the Pennsylvania Germans* (New York: W.W. Norton in association with Winterthur, 1983), p. 259.

200. BOOKPLATE FOR JACOB RITZMAN
Karl Münch (1769–1833)
Lykens Township, Dauphin County, Pennsylvania
1818
Watercolor and ink on paper (removed from
original book)
7 × 6¼ in.
P1.2001.227

INSCRIPTION (TRANSLATION OF GERMAN):
Recto, ink: *This / hymnal / belongs to / Jacob / Ritzman / Lykens Township / Dauphin County / in the State of / Pennsylvania / 1818.*

PROVENANCE:
Walter G. Himmelreich, Ronks, Pa.; Pennypacker sale 10/71, "Himmelreich Collection," lot 276.

One almost enters another world when studying the drawings, *Taufscheine,* and other fraktur made by Karl Münch. He was born in 1769 in Mattenheim, a town not far from the Rhine in the Palatinate. Early biographical sketches credit him with education at the University of Heidelberg, the ability to speak several languages, and military service against the French, in which he sustained severe wounds. Münch, his wife, and at least one child came to America in 1798 (although he is not on the list of those who arrived at Philadelphia), and he became schoolmaster at the Reformed church in Schaefferstown. Almost at once he made fraktur—chiefly birth certificates but some bookplates as well. He also served at Rehrersburg in Berks County before he moved into the Lykens Valley in northern Dauphin County in 1804, where he remained until his death in 1833, except for a brief period about 1808, when he was at Freeburg, in Snyder County. During most of that time, he seems to have made fraktur.

In the Lykens Valley, Münch taught at Saint Peter's (Hoffman's) Reformed Church and Saint John's Lutheran Church. The bookplate for Jacob Ritzman reveals two aspects of Münch's work. First, his floral style is a post-Enlightenment realistic one, rather than a stylized folk idiom that tends to filter nature through the artist's whimsy; his flowers are realistic, not an artistic interpretation. Second, Münch depicted daily activities and the world around him. The Ritzman bookplate shows a house and barn, the former apparently with a red-tile roof and the latter with a straw roof. The log barn seems to have the forebay typical of bank barns; the house is decidedly federal in style, even though only a fragment shows. Rows of fruit trees are in the background. —F.S.W.

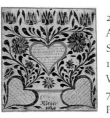

201. RELIGIOUS TEXT FOR ESTHER MEYER
Artist unidentified
Southeastern Pennsylvania
1820
Watercolor and ink on paper
7⁵⁄₁₆ × 6⁷⁄₁₆ in.
P1.2001.228

INSCRIPTION (TRANSLATION OF GERMAN):
Recto, ink: *Oh Jerusalem, Thou beauty / Oh how brightly you gleam / Oh what lovely tones of praise / One hears. There is gentle quiet / Oh the great joy and bliss / which arises on the sun / which goes towards the day / which intends no end; / Oh I have already glimpsed / All this glory! Now I will be / already adorned with the / white heavenly garment / and the golden crown of honor / Behold such joy for yourself / Here I will now dwell forever / Dearest heart to a good night / Your faithfulness will God reward / Which you brought to me perfectly / Farewell together all you kinfolk, / good friends and acquaintances, / to a good night. God… / Esther / Meyer / 1820*

PROVENANCE:
Dr. and Mrs. Henry P. Deyerle, Harrisonburg, Va.; Sotheby's sale 6716, "Deyerle Collection," 5/95, lot 458.

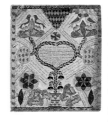

202. RELIGIOUS TEXT WITH BIRDS AND HEARTS
Artist unidentified
Weaverland, Earl Township, Lancaster County,
Pennsylvania
1824
Watercolor and ink on paper
12 × 9⅞ in.
P1.2001.229

INSCRIPTION (TRANSLATION OF GERMAN):
Recto, ink: *Aren't the birds in the / Morning moving their little tongues / To express thanks that daybreak / Wouldn't come so fast. / Do you wish to sing a song in a / quiet surrounding for the Highest? / Not everything comes from the bottom of the heart / The mouth can pronounce beautiful and lovely words. / The man that is born of Woman / Lives a short time only, develops / Like a flower, rises like a shadow / But does not endure. / Pleasure and love for anything reduces / All trouble and labor to almost nothing and / Everything you wish / That people do for you / You should do for them; / That is the law, and the prophets, say / The life span of a human being stretches over / Seventy years and if it is very long then it / May be eighty years, and if it has been beautiful / Then it consisted of Trouble and Work; because / It passes very fast, as if we are flying away. / From the 90th Psalm, Verse 10. / You are told, Man, what is good and / What your Lord and God demands from you, namely, / You young people are to be submissive to the older ones, / Generally, be submissive to each other and stick / To humility, because God is against the vain ones / But He'll grant Grace to the humble ones, therefore / Humbly submit yourselves to the Mighty Hand of God. / a.s.f. / 1824 / Samuel E. Weaver*

PROVENANCE:
George Horace Lorimer, Philadelphia; Parke-Bernet sale 594, "Lorimer Collection, Part II," 10/44, lot 379; Hattie K. Brunner, Reinholds, Pa.; Fred Wichmann, New York; Sotheby Parke-Bernet sale 5079, "Wichmann Collection," 6/83, lot 24.

EXHIBITED:
"Every Picture Tells a Story: Word and Image in American Folk Art," MAFA, 1994/95.

PUBLISHED:
Kogan, Lee, and Barbara Cate. *Treasures of Folk Art: Museum of American Folk Art.* New York: Abbeville Press in association with MAFA, 1994, p. 118.

Only occasionally is there a clear connection between the images on fraktur and their accompanying texts. In the religious text for Esther Meyer, there is no apparent connection. The pictorial elements are hearts and flowers, but the text about one's eternal home in heaven mentions objects such as white garments and golden crowns, which could have found artistic expression but did not. There is no clue as to the artist.

The collection of religious couplets and scriptural texts on the Lancaster County Mennonite fraktur is more literally interpreted. Birds in song are mentioned, and two pairs are depicted; there is a reference to the heart, and a long text is enclosed in one. But as is always true with fraktur, many elements have no patent explanation. If we remember that most fraktur was made by adults for children, we may excuse ourselves from working too hard to explain it all. The texts said what they did; the decoration served them up in an appealing way. The artist of the Lancaster County piece may well have been a schoolmaster at or near the Weaverland Mennonite church in Earl Township, but it is surely not Samuel E. Weaver, who was only a youth in 1824; the piece must have been made for him. A few others by the same hand exist, none signed but nearly all bearing names of Mennonite family members in the Weaverland area. Most of the artist's work consists of bookplates. —F.S.W.

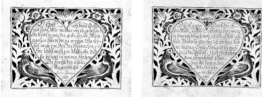
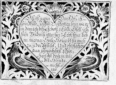

203a–b. RELIGIOUS TEXT PAPERCUTS
William A. Faber (dates unknown)
Probably Lancaster or Berks County, Pennsylvania
1811
Watercolor and ink on cut paper
6⅛ × 7¾ in. each
P1.2001.230a, b

INSCRIPTION (TRANSLATION OF GERMAN):
Recto, ink: [1] *Oh God! Let thy goodness and love / always be before my eyes! They / strengthen the good intention in me to / consecrate my whole life to Thee! They / comfort me in times of pain, they lead / me to good fortune and they put to / rest the fear of my last moment / in my heart. / Anno Domini / 1811;* [2] *This is my thank, this is His will, / I shall be perfect as He is in that I / fulfill His commands and always place His / image here! If His love dwells in / my soul, it drives me to every / duty and even if I fall / from weakness, sin has no dominion / over me. 1811*

PROVENANCE:
Parke E. Edwards; Pennypacker sale 4/69, "Edwards Collection," lot 437.

EXHIBITED:
"Pennsylvania Folk Art," AAM, 1974.

The elusive Wilhelm Antonius Faber made a pair of papercuts with religious text for an unnamed person or persons in 1811. Faber is not the child of the Reformed clergyman John Theobold Faber, but he is probably the William Faber who married Christina Muller on February 1, 1790, at Reading; she asked for a divorce from him in Lancaster on March 17, 1810. His work apparently took him into several southeastern Pennsylvania counties but reveals nothing about his career.

—F.S.W.

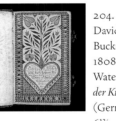

204. BOOKPLATE FOR SARA HOCH
David Kulp (1777–1834)
Bucks County, Pennsylvania
1808
Watercolor and ink on paper, in *Die kleine geistliche Harfe der Kinder zions* (*The Small Holy Harp of the Children of Zion*) (Germantown, Pa.: Michael Billmeyer, 1803)
6¹³⁄₁₆ × 4½ in.
P1.2001.231

INSCRIPTION (TRANSLATION OF GERMAN):
Recto, ink: *This spiritually rich hymnal / belongs to Sara Hochin / written 28 December 1808.*

PROVENANCE:
Mrs. Webster Achey, Spring Valley, Pa.; Harry B. Hartman, Marietta, Pa.; Barry Cohen, New York; Kate and Joel Kopp, America Hurrah, and David A. Schorsch, New York, 1990.

PUBLISHED:
Schorsch, David A. *The Barry Cohen Collection.* New York: America Hurrah and David A. Schorsch, 1990, p. 59.

Nearly every Pennsylvania German had a library, but only in exceptional cases did it contain more than half a dozen books. Most were religious in nature. A Bible or the New Testament and the Book of Psalms bound together was common to all, but right next to it was the hymnal of one's religious affiliation; each person had his or her own to take along to church or meeting. Before American editions appeared (Brethren, 1744; Lutheran, 1786; Reformed, 1797; Franconia Mennonite, 1803; Lancaster Mennonite, 1804), European hymnals, especially those from Marburg, were used—so many, in fact, that leaders in worship had difficulty specifying from which hymnal to sing. Except for the Mennonite-Amish *Ausbund,* which was initially compiled in Reformation days, most hymns were from the Lutheran chorale and Pietist hymn traditions, and there was considerable duplication. Johann Arndt's *True Christianity* (1605–9) and Johann Friederich Starck's *Daily Handbook in Good and Bad Days* (1727) were also popular. Many individuals also owned a catechism, Luther's among his fellow believers and the Heidelberg for the Reformed. And a book of cures for man or beast or both, the only really secular tome, was frequently to be found.

Ownership was often stated by a signature or a fraktur title page, usually drawn on a separate leaf of paper and tipped into the book. Mennonite schoolmasters such as David Kulp prepared many of these, as in this bookplate for Sarah Hoch. Since the books are kept closed except when in use, ex libris frakturs are usually splendid in their original colors, which often transferred to the facing or a subsequent page. Grandparents or baptismal sponsors were usually the donors of these books, a fact that only enhanced their further role as a keepsake.

—F.S.W.

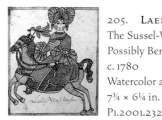

205. Laedy Waschington
The Sussel-Washington Artist
Possibly Berks County, Pennsylvania
c. 1780
Watercolor and ink on paper
7¾ × 6¼ in.
P1.2001.232

INSCRIPTION:
Recto, ink: *Laedy Waschington*

PROVENANCE:
Found in Ohio; Marilyn Idle, Dayton, Ohio; Sotheby's sale 6075, 10/90, lot 116.

EXHIBITED:
"Swiss Folk Art: Celebrating America's Roots," MAFA, 1991/92.

PUBLISHED:
Rubin, Cynthia Elyce. "Swiss Folk Art: Celebrating America's Roots." *The Clarion* 16, no. 3 (fall 1991): 34, 40.

206. *Taufwunsch* for Maria Gertraud
The Sussel-Washington Artist
Probably Berks County, Pennsylvania
c. 1776
Watercolor and ink on paper
6⁷⁄₁₆ × 8¹⁄₁₆ in.
P1.2001.233

INSCRIPTION (TRANSLATION OF GERMAN):
Recto, ink: *Christian Baptismal Wish / You have been baptized, oh dear child, into / Christ's death who has purchased you from / hell with his blood. As a reminder of / this and a constant memorial, I want / to give you this. Grow up to the glory of / God and the joy of your parents, to / the benefit of your neighbor and to your own / blessedness. / Maria Gertraud was born 24 September 1776 / in the sign of aquarius in Becksten* [Paxton] *County* [Township], *Lancaster /* [now in Dauphin] *County in Pennsylvania in / America. May God grant his blessing. / Baptismal sponsor Ludwig Hemperling / Baptismal sponsor Maria Hemperling*

PROVENANCE:
Descended in family to Carrie Railing, Ephrata, Pa.; Historical Society of Cocalico Valley, Ephrata, Pa.; T. Glenn Horst Auctioneers sale at Cocalico Valley Historical Society, Ephrata, Pa., 5/80, lot 337; David and Susan Cunningham, Denver, Pa., 1980.

The unidentified artist known only as "Sussel-Washington" gained his nickname from a drawing inscribed "exselence Georg General Waschingd" and "Ledy Waschingdon," from the collection of Arthur J. Sussel, which brought a large sum at auction in 1958. His production is among the most studied and sought of Pennsylvania German fraktur.[26] The artist's work continued until at least 1788 and was made for children born in what are today Berks, Lebanon, Dauphin, Lancaster, York, and Schuylkill Counties. He made drawings of the Washingtons, the "Queen of Sudbury," children, and animals. He had an impact on the work of Conrad Gilbert, whom he probably knew as a colleague in Berks and Schuylkill Counties; several baptisms for which he made records are recorded at the Altalaha Lutheran Church, one of them in Gilbert's hand. The wording format he followed is European, and as a result, whereas sponsors are named, parents are not. Only sometimes is the officiating clergyman designated, but more often the place is noted. The human figures are clearly intended to represent the sponsors as the placing of their names suggests.

The *Taufwunsch,* or Christian baptismal wish, is for a child named Maria Gertraud, who was born September 24, 1776. Her surname is not disclosed; her sponsors were Ludwig and Maria Hemperling. Efforts to find her in the church records in or near "Becksten County" [Paxton Township] in Dauphin County have been unrewarded. The source for the iconography is unknown; the "bee-bonnet" headwear on the woman may be European. The same head covering, but with more elaborate cuffs, is present in *Laedy Waschington,* which surfaced in Ohio. Essentially the same woman, astride a horse going in the opposite direction, is inscribed "Malley Quen of Sedburg."[27]
—F.S.W.

207. *Taufschein* for Elisabeth Eyster
Artist unidentified
Probably York County, Pennsylvania
c. 1780
Watercolor and ink on paper
8¾ × 6¾ in.
P1.2001.234

INSCRIPTION (TRANSLATION OF GERMAN):
Recto, ink: *Elisabeth was born in / the year of Christ 1776, the 25th February in the sign of / ———. Baptized by Pastor ——— / Sponsors were Peter Spiess and Magdalena Eysterin, single / Elisabeth was born in the province of Pennsylvania / in York County in Manchester Township The father / is named Georg Eyster, the mother Eysterin, born Altlandin. Today, you are pulled, tender soul / from sin's dark hole, brought / by baptism out thereof / Stay henceforth with all the upright so that you will / receive the crown with which God / adorns his own.*

PROVENANCE:
Descended in family to Kleinfelter family, York, Pa.; Joe Kindig Jr., York, Pa., 1970.

EXHIBITED:
"Life in the New World: Selections from the Permanent Collection of the Museum of American Folk Art," Sotheby's, New York, 1987.

PUBLISHED:
Bishop, Robert. *Folk Painters of America.* New York: E.P. Dutton, 1979, pl. 36.
Weiser, Frederick S. "Piety and Protocol in Folk Art: Pennsylvania German Fraktur Birth and Baptismal Certificates." In Ian M.G. Quimby, ed., *Winterthur Portfolio 8.* Charlottesville, Va.: Univ. Press of Virginia in association with Winterthur, 1973, p. 37.

The *Taufschein* for Elisabeth Eyster bears telltale marks indicating that the artist prepared some forms in advance and filled in details in the recipient's home. Spaces for the name of the clergyman and the sign of the zodiac—important because the Pennsylvania Germans used a lunar zodiac system with twenty-four-hour periods—remain blank, and some data is cramped. The image contains a city profile of houses and public buildings apparently built of stone with red-tile roofs. The doggerel amounts to the affirmation that baptism promises salvation and the admonition that one must be conscious of and faithful to its gift.
—F.S.W.

26 Parke-Bernet sale 1847 (10/58, lot 294); the piece is now in the collection of AARFAM.
27 Frederick S. Weiser, *Fraktur: Pennsylvania German Folk Art* (Ephrata, Pa.: Science Press, 1973), p. 97.

208. GENNERAL WASCHINGTON
Artist unidentified
Southeastern Pennsylvania
c. 1810
Watercolor, gouache, ink, and metallic paint on paper
9⅝ × 8 in.
P1.2001.235

INSCRIPTIONS (TRANSLATION OF GERMAN):
Recto, ink: *General Waschington and the city / which was built with his name;* on building:
Con gress House

PROVENANCE:
Michael and Mary Taradash; Ed and Mildred Bohne, Newmanstown, Pa., 1982.

EXHIBITED:
"Young America: A Folk Art History," MAFA at IBM Gallery of Science and Art, 1986.

PUBLISHED:
Kogan, Lee, and Barbara Cate. *Treasures of Folk Art: Museum of American Folk Art.* New York:
 Abbeville Press in association with MAFA, 1994, p. 115.
Lipman, Jean, Elizabeth V. Warren, and Robert Bishop. *Young America: A Folk Art History.*
 New York: Hudson Hills Press in association with MAFA, 1986, p. 116.
Schaffner, Cynthia V.A. *Discovering American Folk Art.* New York: Harry N. Abrams, 1991,
 pp. 62–63.
Warren, Elizabeth V. "Young America: A Folk Art History." *The Magazine Antiques* 130, no. 3
 (September 1986): 471.
Warren, Elizabeth V., and Stacy C. Hollander. *Expressions of a New Spirit: Highlights from the
 Permanent Collection of the Museum of American Folk Art.* New York: MAFA, 1989, p. 32.

Drawings without text or with minimal text are considered in the range of fraktur if their design elements are comparable to those on other pieces of fraktur or if their short texts fit the criteria. The patriotic subject of George Washington in this drawing is less typical, but the inscription bears similarities to fraktur. Possibly a copy of a print, but equally possibly deriving from the artist's imagination, the renderings of Washington and of the Capitol bear not the slightest resemblance to their actual counterparts. Fraktur artists did not seek to be realistic; only on later examples do birds and flowers approach botanical accuracy. —F.S.W.

209. BOOKPLATE FOR ELISABETH HENRICH
Attributed to Samuel Musselman (dates unknown)
Probably Bucks County, Pennsylvania
c. 1815
Watercolor and ink on paper, in *Die kleine geistliche Harfe
der Kinder zions* (*The Small Holy Harp of the Children of Zion*)
(Germantown, Pa.: Michael Billmeyer, 1811)
6¾ × 4⅜ in.
P1.2001.236

INSCRIPTION (TRANSLATION OF GERMAN):
Recto, ink: *This new hymnal belongs to / me Elisabeth Henrichin, written / the 22nd of May in the year /
of our Lord and Saviour Jesus / Christ———. / Should this book e'er misplaced be / Here you can my name
well see*

PROVENANCE:
Robert Carlen, Philadelphia, 1969.

28 Weiser and Heaney, *Free Library*, vol. 1, pl. 166.

210. BOOKPLATE FOR ELISABETH HUTH
Possibly David Kriebel (1787–1848)
Probably Montgomery County, Pennsylvania
1806
Watercolor and ink on paper, in *Catechismus*
(Philadelphia: Henrich Schweizer, 1803)
5½ × 3⅜ in.
P1.2001.237

INSCRIPTION (TRANSLATION OF GERMAN):
Recto, ink: *Elisabeth / Huth / 5 January / in the year 1806*

PROVENANCE:
Joe Kindig III, York, Pa., 1973.

Basic books in the personal libraries of Pennsylvania Germans are adorned with ex libris statements for the world to see. One such example is in a German Reformed catechism owned by Elisabeth Huth. The bookplate is closely related to Schwenkfelder frakturs and may well be the work of David Kriebel (see cat. no. 191). A second, for Elisabeth Henrich, is in a hymnal of the Franconia Mennonites. It has been attributed to Samuel Musselman of New Milford Township, Bucks County, Pennsylvania. Its rhyming couplet offers a reason for putting one's name in a book. —F.S.W.

211. TWO PRIESTS
Artist unidentified
Possibly Berks or Montgomery County,
Pennsylvania
c. 1810
Watercolor and ink on paper
8⅞ × 7¼ in.
P1.2001.238

PROVENANCE:
Edgar William and Bernice Chrysler Garbisch, Cambridge, Md.; Sotheby Parke-Bernet sale
3595, "Garbisch Collection," 1/74, lot 38; Mr. and Mrs. Peter H. Tillou, Litchfield, Conn.;
Ed and Mildred Bohne, Newmanstown, Pa.; M. Austin and Jill R. Fine, Baltimore; Sotheby's
sale 5552, "Fine Collection," 1/87, lot 1027.

EXHIBITED:
"Where Liberty Dwells, Nineteenth-Century Art by the American People: Works of Art from
 the Collection of Mr. and Mrs. Peter Tillou," Albright-Knox Art Gallery, Buffalo, N.Y., 1976.
"Life in the New World: Selections from the Permanent Collection of the Museum of American
 Folk Art," Sotheby's, New York, 1987.

PUBLISHED:
Dewhurst, C. Kurt, Betty MacDowell, and Marsha MacDowell. *Religious Folk Art in America:
 Reflections of Faith.* New York: E.P. Dutton in association with MAFA, 1983, p. 69.
Tillou, Peter H. *Where Liberty Dwells, Nineteenth-Century Art by the American People: Works of Art from
 the Collection of Mr. and Mrs. Peter Tillou.* Buffalo, N.Y.: Albright-Knox Art Gallery, 1976, fig. 9.

The drawing of two priests in chasubles, the normal attire of Roman Catholic clergymen (but also used historically and today by Anglicans and some Lutherans), may well come from the Roman Catholic center around Bally in Berks County near the Montgomery County border. Certainly the tulips, vines, angels, birds, and elaborate swirl at the bottom are to be found on much fraktur. A similar drawing of one clergyman in the collection of the Free Library of Philadelphia suggests that the theme had some appeal.[28]

212. BOOKPLATE FOR JACOB SCHMIDT
Artist unidentified
Franklin County, Pennsylvania
1833
Watercolor and ink on paper, in *Erbauliche Lieder-Gammlung* (*Collection of Edifying Hymns*) (Germantown, Pa.: M. Billmeyer, 1830)
5⅝ × 7¼ in.
P1.2001.239

INSCRIPTION (TRANSLATION OF GERMAN):
Recto, ink: *Jacob Schmidt's / hymnal / in Washington / Township, Franklin / County, Pennsylvania / 5 May / 1833.*

PROVENANCE:
Kate and Joel Kopp, America Hurrah, New York, 1977.

PUBLISHED:
Bishop, Robert. *Folk Painters of America.* New York: E.P. Dutton, 1979, pl. 45.

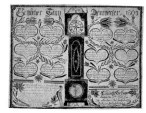

213. RELIGIOUS TEXT WITH SPIRITUAL CHIMES FOR ELISABETH GEISSINGER
Artist unidentified
Probably Bucks County, Pennsylvania
1803
Watercolor and ink on paper
12⅞ × 15⅞ in.
P1.2001.240

INSCRIPTIONS (TRANSLATION OF GERMAN):
Recto, ink: *Spiritual Chimes, 1803 / I. The clock strikes one, O God, Three in One, help me to pay heed to one thing needful. Let me be in union with this one thing until my own Friend takes me out of this present time / II. The clock strikes two, grant that the two sacraments suffice to carry my two parts, body and soul, to a blessed end, and that both idolatry and wealth and poverty be spared me / III. The clock strikes three, I confess forevermore God in three persons, Father, Son, and Spirit, help me to live righteously that I may joyfully appear before the Trinity in heaven without blemish / IV. The clock strikes four, grant that I revere the four hours which Jesus spent for my good, the four powers of the countenance preserve in holiness and the fourfold news, the Holy Gospel, too / V. The clock strikes five, five hours provide me comfort, grant that I employ the five senses in a righteous manner and heed the five parts of the catechism, the five words of His conviction, O God, be merciful to me, a poor sinner, that I never depart from Jesus / VI. The clock strikes six, I work six days. From six-fold danger spare me, my God. Let your six-fold shed blood gently refresh me and with the gift of heaven comfort me always / VII. The clock strikes seven o'clock, the seven-fold petition, the seven last words as Jesus suffered pain. Preserve me from myself and my sin, thy child, from the seven counts that are an abomination to Thee / VIII. The clock strikes eight on the eighth day the Lord freely for your good gave himself to circumcision, eight days of birth, baptismal sacrifice, joys, repentance, cross, bring all to my remembrance / IX. The clock strikes nine, O Jesus! Let Thy dying, as this hour obliges me, bring me to repentance, in the ninth hour you lead me into your vineyard, grant that at nine I not be found thankless / X. The clock strikes ten, this hour points me to the Ten Commandments and the ten thousand pounds I would owe to Thee, O righteous God, at ten make me pure / XI. The clock strikes eleven, oh, oh, how often as with only eleven disciples remaining, have I deserted Thee, But yet be gracious when I go astray and in the eleventh hour lead me to the right way / XII. The clock strikes twelve to the foundation of the twelve prophets and the teaching of the twelve apostles I devote myself heart and mind. Only those in this number is committed hypocrisy banned. Help me cast my lot with that of the twelve. Amen / Whoever is not able to pray these twelve petitions at the given hours, may at any hour which may be the last pray the following devotionally: / I hear the striking hours, O God, be merciful to me / This hour perhaps may be the last / And should it be the last, I am prepared. / O Jesus, bring my soul to the joys of heaven / Where we perfected sing your praise and honor you / With laud and thanksgiving. To that goal let me / succeed that I may there sing the thrice holy. Amen / Dated April 30 / Elisabeth Geissinger / born 22 March in / the year of our Lord and Saviour Jesus / Christ 1754, One thousand, 7 hundred / fifty-four / EMM 1803*

PROVENANCE:
Descended in family to Connie Moyer McMullin, Lancaster, Pa.; David Wheatcroft, Westborough, Mass., 1998.

PUBLISHED:
Weiser, Frederick S. *Fraktur: Pennsylvania German Folk Art.* Ephrata, Pa.: Science Press, 1973, pp. 18–19.

The bookplate for Jacob Schmidt, a resident of Franklin County, appears in the ninth (1830) edition of the American Lutheran hymnal, first issued in 1786. It features a tall case clock and several houseplants on what appears to be a painted floor. Surely the clock is a reminder that "time leads to eternity," as other frakturs state, and that the hymns in the volume are good preparation therefor.

The spectacular drawing of a blue tall case clock with tulips, hearts, a bird, vines, and extensive religious text is the work of an unidentified individual who signed himself "EMM." The presentation piece was apparently made for Elisabeth Geissinger, who was born in 1754, and it remained in the hands of her descendants until 1998. Titled literally "spiritual chimes," or spiritual "hourly awaker," the long text in twelve hearts provides a prayer to be recited at each hour a clock chimed as well as a general devotion to be offered if one could not recite the hourly prayers.

Other frakturs with prayers for the hours exist, and there were printed broadsides with the same theme in Germanic lands. No two texts are alike, but all share the theme that the passage of time leads to one's death. Most Pennsylvania German homes had case clocks, made in walnut or soft woods, sometimes decorated with inlay or paint and geared for daily or weekly winding. They were set so that persons in the kitchen or the stove room could see them. Many men also carried pocket watches, and clockmakers abounded. Time was cherished, as a religious conveyance but also as a marker of productivity; as the expression "Zeit iss Geld" so aptly states: time is money.

—F.S.W.

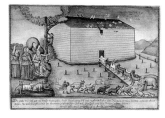

214. NOAH'S ARK
John Landis (1805–?)
Possibly Lancaster County, Pennsylvania
c. 1830
Watercolor and ink on paper
10 × 13⅝ in.
P1.2001.241

INSCRIPTION (TRANSLATION OF GERMAN):
Recto, ink: *God let the first world go under with water, / And Noah went attentively into a large chest / At the last the world will stand in raging fire— / Where will be the refuge of the pious at that time? / I want, Lord Jesus, to prepare an ark for myself / When all will be consumed, out of your wounded side.*

PROVENANCE:
Sotheby's sale 5376, 10/85, lot 6.

EXHIBITED:
"Every Picture Tells a Story: Word and Image in American Folk Art," MAFA, 1994/95.
"Millennial Dreams: Vision and Prophecy in American Folk Art," MAFA, 1999/2000.

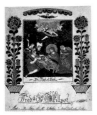

215. THE BIRTH OF CHRIST
John F.W. Stahr (dates unknown)
Probably southeastern Pennsylvania
1835
Watercolor and ink on paper
15¾ × 12⅝ in.
P1.2001.242

INSCRIPTION:
Recto, ink: *The Birth of Christ / Fredck G. Millpot / Made by John F.W. Stahr. March the 15 AD. 1835.*

PROVENANCE:
Found in Morris County, N.J.; Mitchell Work, Nutley, N.J.; Edgar William and Bernice Chrysler Garbisch, Cambridge, Md.; Sotheby Parke-Bernet sale 3595, "Garbisch Collection," 1/74, lot 34.

EXHIBITED:
"Christmas Show," MAFA, 1972.

PUBLISHED:
Bishop, Robert. *Folk Painters of America.* New York: E.P. Dutton, 1979, pl. 35.

Biblical literacy was great in southeastern Pennsylvania and other states among the Germans whose families came to America in the large German emigration between 1683 and 1812. In part this was due to Pietism, a religious movement centered at Halle, in eastern Germany, from which many clergy came to America. It was there, too, that *hand Bibeln*—Bibles in a format that could be held for reading rather than the immense ones that had to be placed on a table—were first printed and widely distributed, as they were in America as well. The natural result was that Bible stories found their way onto frakturs and folk paintings. Inevitably, the beloved story of Noah, his animals, and his ark was one of these. John Landis painted it at least twice. He also drew a scene of the Garden of Eden and the temptation to Adam and Eve, of Joseph and his brothers, and of Jesus in the upper room. The precise relationship of this John Landis to another Johann or Johannes Landes and to John A. Landis, both fraktur artists, has not been clarified. The John Landis who painted *Noah's Ark* is said to have been born in Hummelstown in 1805, to have studied printing and painting, to have journeyed to Europe and Israel, and to have died in the Lancaster County almshouse.

A second popular biblical account, of the birth of Christ, was apparently made for Frederick G. Millpot by John F.W. Stahr in 1835. It is the same picture that is on G.S. Peters's broadside woodcut published some years later. Nothing is known of the artist, but his border decoration of flowers and an angel head relate this work to fraktur. —F.S.W.

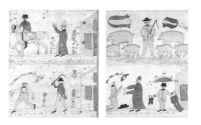

216a–b. THE PRODIGAL SON
Friedrich Krebs (1749–1815)
Probably Dauphin County, Pennsylvania
c. 1805
Watercolor and ink on pieced paper
15 × 12¼ in. and 15¼ × 12 in.
P1.2001.243a, b

INSCRIPTION (TRANSLATION OF GERMAN):
Recto, ink: [1] *The prodigal son departs from his father. Luke 15. / Since he has no more money, he was very _____ embarrassed;* [2] *I will get up and go to my father and say / Father, I have sinned against heaven and you.*

PROVENANCE:
Sotheby's sale 5810, 1/89, lot 1009.

The work of Friedrich Krebs forms a chapter all its own in Pennsylvania German studies. A Prussian soldier who remained after the Revolutionary War, as did many others, Krebs eventually settled near Harrisburg and taught there and nearby in Lutheran parochial schools. He clearly was a seminal figure in stimulating the popularity of *Taufscheine* in his culture—he made hand-drawn examples and filled in printed forms by the hundreds. Both the accounts of his printer in Reading and his estate inventory cite large numbers of them.[29] Yet they were produced with such haste that they are rarely fine works of art. At the same time, he made a series of occasional pieces that constitute a remarkable window on Pennsylvania German life. His subjects include a squabbling man and woman, several Turks, a tale from Grimm's *Märchen*, a slightly naughty scene of a man without pants, small Bible texts and pictures, a large clock, the crucifixion of Christ, and many times, in two or four scenes, the story of the prodigal son (Luke 15:11–32). Travelers encountered broadside engravings of the story in many Pennsylvania German homes and noted that fathers used the tale to set their sons wise to the realities of life. This may explain the enduring popularity of the subject. —F.S.W.

29 Frederick S. Weiser, "Ach wie ist die Welt so Toll! The Mad, Lovable World of Friedrich Krebs," *Der Reggeboge (The Rainbow): Quarterly of the Pennsylvania German Society* 22, no. 2 (1988): 52–55, 60–62.

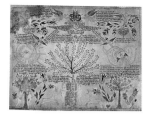

217. RELIGIOUS TEXT
WITH ADAM AND EVE
Artist unidentified
Southeastern Pennsylvania
Early nineteenth century
Watercolor and ink on paper
13 × 15⅞ in.
P1.2001.244

INSCRIPTION (TRANSLATION OF GERMAN):
Recto, ink: *Whoever overcomes I will permit to sit with / me on my throne I have overcome and / am seen with my Father on His Throne / The angels of God await your soul in the / beautiful garden of Paradise. They will lead / you into the throng of heaven's folk. God will / adorn you with a crown. There you will / see all friends, their divine form / and their night in eternity. / And whoever struggles, will however not / be crowned. Do not struggle there. / Whoever conquers will be dressed with / white garments and I will not efface his name / from the book of life and I will confess his name / before my Father and his angels / Whoever conquers I will feed from the tree / of life that is in the Paradise of God. / Be faithful unto death and I will give you the / crown of life, / Whoever conquers shall inherit all things / and I will be his God and he shall be my son. / I am now transferred from the evil world into heaven's tent. / Eve the first woman deceived herself, took poison from a serpent; Adam the first human was laid in the earth in death on account of sin; God the Lord took the man and put him in the garden which he had built and protected and God the Lord commanded the man and said you shall eat from the trees of the garden but from the tree of the knowledge of good and evil you shall not eat for in the day you eat of it you will die. [First] Book of Moses [2], v. 17–18; And the serpent was more subtle than all the animals of the field and spoke to the woman, Is it true that God said you shall not eat from any tree in the garden; Then the woman said, We may eat from any tree except from the tree in the middle of the garden. Then the serpent said, God knows that if you eat of it your eyes will be opened and will be like God. The woman desired it and ate and gave to her husband too; And he ate of it and their eyes were opened and they realized that they were naked; And God the Lord called Adam and said Where are you and Adam said, I hear your voice in the garden and am afraid for I am naked. Who said that you are naked Have you eaten from the fruit which I forbade you to eat? And they heard the voice of God the Lord who went about in the garden for the day was cool and Adam hid himself with his wife from the sight of God the Lord among the trees in the garden and sewed fig leaves together and made themselves aprons; And God the Lord said Behold Adam has become like one of us and knows what is good and evil. Now so that he will not stretch out his hand and break also from the tree of life and live forever God the Lord had him leave the garden which he had just built from which he was taken and drove Adam out and set cherubim and a sword to hinder the way into the garden of life.*

PROVENANCE:
Joe Kindig Jr., York, Pa., 1971.

This undated religious text bearing no person's name or place with a long inscription and related graphic elements is surely an American piece. Its size is that of American rather than Continental paper of the era.[30] The text is a hortatory reminder to remain faithful and to conquer, with paraphrases from the Revelation of Saint John. The promised crown of life is depicted. The angels of God wait for the faithful person's soul, and white garments are shown on a figure caught up in heaven. Heaven is Eden restored—and the Genesis account of Adam and Eve and the snake, the tree, and fruit is paraphrased and depicted. As seems to be the case on most frakturs with heavenly and earthly elements, heaven is at the top of the page and earth at the bottom. The lack of information about the artist, the owner, his home, or the date is overshadowed by the magnificence with which the piece is endowed.　　　—F.S.W.

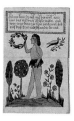

218a–l. METAMORPHOSIS
Durs Rudy Sr. (1766–1843) or Durs Rudy Jr. (1789–1850)
Probably Lehigh County, Pennsylvania
c. 1810
Watercolor and ink on paper
6¹⁄₁₆ × 3¹¹⁄₁₆ in., 6⅛ × 3¾ in., 6³⁄₁₆ × 3¾ in., 6³⁄₁₆ × 3¹¹⁄₁₆ in.
(folded)
P1.2001.245a–d

INSCRIPTIONS (TRANSLATION OF GERMAN):
First book, panel one, ink: *Adam came into the world, as / the first book of Moses announces, and / whoever trusts him, lift / up the page and see his bride;* panel two: *Eve was made from Adam's rib / and at the forbidden fruit did / glance, by the serpent's charm. / Lift the other leaf and you will see / another wonder;* panel three: *Come, follow me, the world's siren pipes up / It sounds so beautiful, but whoever follows / falls into need, indeed to death;* second book, panel one: *You puffed-up child of man / Lift the next leaf and see how sin / your Saviour without grace was / nailed to the cross;* panel two: *O sinner, see how God's lamb / hangs naked and raw on the cross / If you want to see him in the grave as well, / lift the other leaf;* panel three: *The prince of life was also buried in / a cave, as he falls, so may he / instead bring my heart to peace / This grave is given him hereby;* third book, panel one: *A man may be highly placed, wise, rich, or handsome, / but death's hour comes anyway. Lift up the / leaf and you will see; it is the old covenant;* panel two: *If you lift the other leaf, then you can / see how we after this short life / become ashes soon;* panel three: *In Jesus' death can one die well at all times / So I have no fear of the need of death, / It is a step in inheriting life, so my / death is no longer a death;* fourth book, panel one: *When a man quietly in Paradise / may stand, so he comes at once to the mountain / named Zion; lift up the leaf and you will / see how the pure spirits exist there;* panel two: *If one now has climbed the mount of Zion, it is / not far to the beautiful crown which one / receives in the beautiful city, if you / want to see it, lift the leaf;* panel three: *Jerusalem, you pleasant place, joy is in you / Oh, that I were there, how I would to you above all / things sing "Holy Holy Holy."*

PROVENANCE:
George E. Schoellkopf, New York, 1978.

On the making of metamorphosis books, whose pictures and text change as the leaves are turned, the Pennsylvania Germans had no monopoly. They were produced in that community, however, both by fraktur artists and by print shops in a variety of fashions. The form given here, by the Reformed schoolmaster Durs Rudy Jr. or Sr., is less philosophical and more orthodox Christian in its textual and graphic presentation than some forms of the genre. Indeed, both artists belonged to a small number of fraktur artists who often used literal depictions of New Testament events in his work.[31] It is nonetheless part of the large commentary on death present in Pennsylvania German fraktur—its threat, its meaning, and how to cope. Modern connoisseurs may not see beyond the color and whimsy, but the persons for whom the fraktur was originally made surely understood it as admonition and comfort in the face of the certain end of life. As such it matches another large body of Pennsylvania German folk art—tombstone decorations—but stands in strong contrast to the witty sayings on the culture's pottery, which celebrated marital strife with unrestrained glee.　　　—F.S.W.

30 Continental paper was about fifteen by twelve inches. A sheet of Colonial paper was sixteen by thirteen inches and was commonly divided into halves, quarters, and eighths.

31 Another Rudy metamorphosis in four parts is in the collection of Lehigh County Historical Society, Allentown, Pa.; see Gerard C. Wertkin, "The Watercolors of Durs Rudy: New Discoveries in Fraktur," *Folk Art* 18, no. 2 (summer 1993): 39.

219a–d. BOOK OF SAMPLE ACCOUNTS OF JOHN ECKMAN

Artist unidentified, possibly John Eckman (dates unknown)
Lampeter Township, Lancaster County, Pennsylvania
1805
Watercolor and ink on paper, with paper binding
12¼ × 8⅜ × ⅜ in. (closed)
P1.2001.246

INSCRIPTION:
Back endpaper, ink: *JOHN ECK / MAN, IN / LAMPITER TOWNSHIP / LANCASTER / COUNTY / April 8, 1805*

PROVENANCE:
Mr. and Mrs. William E. Wiltshire III, Richmond, 1985.

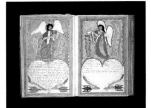

220a–c. BOOK OF ARITHMETIC PROBLEMS OF JOHANNES WHISLER

Artist unidentified, probably
Johannes Whisler (?–1874)
Mifflin Township, Cumberland County,
Pennsylvania
1814–1815
Watercolor and ink on paper, with
leather binding
13 × 8⅛ × 1¹⁵⁄₁₆ in. (closed)
P1.2001.247

PROVENANCE:
Found in Harrisburg, Pa.; T. Glenn Horst Auctioneers sale at Farmersville Fire Hall, Lancaster County, Pa., 5/88; H. William Koch, Turbotville, Pa.; Pook & Pook sale at Long Square Farm, Turbotville, Pa., 6/99, lot 141.

In addition to teaching reading, writing, arithmetic, and the elements of religion, Pennsylvania German schools exposed children to advanced mathematical problems and the intricacies of keeping accurate accounts. Among the most fascinating and instructive documents left by Pennsylvania Germans are the account books of craftsmen, shops, inns, and even churches. Only a few of these have been translated. Many are written in hardly legible German script with repeated misspellings of German words, reflecting the pull of the spoken German dialect on the formal literary language. Almost everything under the sun was documented in these books—genealogical records, recipes for food and cures for man and beast, snippets of autobiographical information, and, in the Esmerian Collection pieces, examples of what has come to be called fraktur. In addition, items such as silverfish corpses, clovers, coins, locks of babies' hair, and even obscene pictures were sometimes found pressed between the pages.

The Eckman book is one of two bearing the same owner's name in the Esmerian Collection; another is in the collection of Winterthur.[32] Two of these have fraktur-type drawings in them. The book of sample business accounts, which is written in English, has a decorated title page, and interspersed throughout are drawings of a man leading a horse and

rider, a woman in a yellow floral dress and black top hat, griffins, birds, and an owl. These renderings are more than doodling but less than the work of a competent schoolmaster, tempting us to believe that at least some of them were by the hand of the book's owner, who placed a decorated statement of ownership inside the back cover.

Johannes Whisler's collection of mathematical problems also became a haven for forms he later used as a county justice and scrivener and for cures, genealogical data, reports to public school directors, and assorted other materials. It is likely the work of its owner, who was probably born in a Mennonite community but married out of it; he filled some pages with rather nervous drawings of the ilk of fraktur. These pages include seven drawings of mounted horsemen, trumpeting angels, tulips, birds, eagles, and various animals. One of the most intriguing entries is an account of Whisler's courtship of and marriage to Esther Scherrer, on December 5, 1815, part of which is entered in a simple code in which nine letters are replaced by numbers. Its deciphering takes time, but the revelations are hardly top secret: with boyish delight, Whisler recorded the day and hour they met! Page after page bears elaborate headings, and a collection of other drawings makes the record a tour de force of a type rarely encountered. —F.S.W.

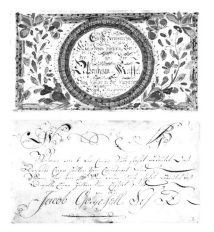

221. TUNEBOOK FOR ABRAHAM KASSEL

Jacob Gottschall (1769–1845)
Skippack, Montgomery County, Pennsylvania
1792
Watercolor and ink on paper, with leather binding
3¾ × 6⅝ × ½ in. (closed)
P1.2001.248

INSCRIPTIONS (TRANSLATION OF GERMAN):
Title page, ink: *A harmonious / Melody booklet Pre- / Pared for / Abraham Kassel / Singing student in the Skippack / School, written / 21 August / 1792;* verso of title page: *If a b stands before a note, it means that the same will be a half tone lower* [flat] */ If a # stands before a note, it means / that the same will be a half tone higher* [sharp] */ Jacob Gottschall, Teacher*

PROVENANCE:
Richard Smith; Harry B. Hartman, Marietta, Pa., 1975.

32 The other account book in the Esmerian Collection does not contain illustrations; for the Winterthur example, see Frank H. Sommer, "German Language Books, Periodicals, and Manuscripts," in Swank, *Arts of the Pennsylvania Germans*, p. 299.

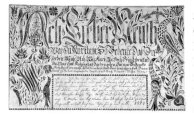

222. *VORSCHRIFT* WITH BIRDS
Gottschall family member
Probably Franconia Township,
Montgomery County, Pennsylvania
1834
Ink, watercolor, and gouache on paper
8 × 12¾ in.
P1.2001.249

INSCRIPTION (TRANSLATION OF GERMAN):
Recto, ink: *Oh dear man / Whatever you do, remember that you / must die. Oh how short life is and / therefore, therefore remember / in certainty / when you go with life and soul, for / death is certain, only the day, the hour can / no one know / therefore remember surely / where you always take your life / keep / God before your eyes and remember / there with that each hour / may be / the last; for even if we were as / wise as Solomon and as handsome / as Absalom, and had all the riches / of Alexander the Great and / the courage of the Roman emperor / and as the Turkish emperor / his kingdom, / we must still all die. Death's arrow has / the power, it strikes the rich, poor, handsome, / young, and old. 1834*

PROVENANCE:
Parke E. Edwards; Pennypacker sale 4/69, "Edwards Collection," lot 439; Jack Lamb, Kutztown, Pa., 1969.

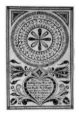

223. RELIGIOUS TEXT WITH
MEDALLION ABOVE HEART
Samuel Gottschall (1808–1898)
Salford Township, Montgomery County,
Pennsylvania
1834
Ink, watercolor, and gouache on paper
12⅛ × 7⅝ in.
P1.2001.250

INSCRIPTIONS (TRANSLATION OF GERMAN):
Recto, around center medallion, ink: *Throughout your life have God before your eyes and in your heart and guard yourself that you do not sin willingly 1834;* in heart: *Oh, finally / finally the end comes / of struggle, of woe / and misery / Then one sinks / eternally into God's arms. / This is the pious person's / last lot / Written in the year 1834*

PROVENANCE:
Ray Egan, Princeton, N.J., 1994.

EXHIBITED:
"Every Picture Tells a Story: Word and Image in American Folk Art," MAFA, 1994/95.

224. RELIGIOUS TEXT WITH
TWO WOMEN IN STRIPED DRESSES
Samuel Gottschall (1808–1898)
Salford Township, Montgomery County, Pennsylvania
c. 1834
Ink, watercolor, and gouache on paper
12¼ × 8 in.
P1.2001.251

INSCRIPTION (TRANSLATION OF GERMAN):
Recto, ink: *When I / meet a beautiful child / which God has blessed with beauty / then thoughts come to me / that God who so many beautiful things / from absolutely nothing / can make / He may well be much greater. / Whoever Jesus / possesses and Jesus / loves, he loves the one who / gives / heaven*

PROVENANCE:
Helen Janssen Wetzel, Spring Township, Pa.; Sotheby Parke-Bernet sale H-3, "Wetzel Collection," 10/80, lot 1854.

EXHIBITED:
"The Pennsylvania Germans: A Celebration of Their Arts, 1683–1850," PMA, 1982/83.

PUBLISHED:
Garvan, Beatrice B., and Charles F. Hummel. *The Pennsylvania Germans: A Celebration of Their Arts, 1683–1850.* Philadelphia: PMA in association with Winterthur, 1982, pl. 32.
Kogan, Lee, and Barbara Cate. *Treasures of Folk Art: Museum of American Folk Art.* New York: Abbeville Press in association with MAFA, 1994, p. 117.
Schaffner, Cynthia V.A., and Susan Klein. *Folk Hearts: A Celebration of the Heart Motif in American Folk Art.* New York: Alfred A. Knopf, 1984, p. 6.
Wilmot, Sandra. "More Than Just Hearts and Flowers." *Americana* 10, no. 4 (September/October 1982): 31.

Jacob Gottschall touched the life of his Mennonite community in many ways. He was born in Bucks County on December 23, 1769, to Johannes and Christina Gottschall, and he was married on September 15, 1795, to Barbara Kindig (1775–1843), with whom he had eleven children. He taught at two of the oldest Mennonite centers in eastern Pennsylvania, in Skippack and in Franconia. Later he had a farm near Harleysville. On December 23, 1804, he was ordained a preacher, and on August 15, 1813, he was made bishop—a post conferred for life. Sometime apparently in the 1830s, he and his sons built and operated schools on their land. Gottschall made fraktur for a short time while he was teaching. Several examples of tunebooks made for his pupils, such as this one, exist, and there are other fraktur examples attributed to him. This tunebook for Abraham Kassel comprises forty-one pages of handwritten melodies, one more indication of the importance placed by teachers on singing.

It is believed that four of Bishop Gottschall's sons taught in the two schools on their land: Martin (1797–1870), William (1801–1876), Samuel (1808–1898), and Herman (1818–1905). They probably all made fraktur but rarely signed their work, making identification difficult. The fact that they ceased making fraktur when they did may be related to the Pennsylvania legislature's decision in 1834 to empower townships to open public schools. Since the action was optional, many Pennsylvania German communities deferred to their existing parochial and neighborhood schools. The coming of public education was one of the key factors in the end of fraktur making and forced a large step away from the use of the German language.

Almost simultaneously, theological trends put more emphasis on confirmation (conversion) than on baptism, and baptismal sponsors ceased to be named. The grim reminders made to children on both baptismal certificates and *Vorschriften* that death was always close at hand may still have been relevant—some fatal childhood diseases would not be eliminated until the twentieth century—but it came less often to expression.

As a young man Samuel Gottschall taught school on his father's property in Salford Township and engaged in weaving. His weaving account book and a weather diary he kept have both survived, enabling comparison of his writing with that on fraktur.[33] An entire series of works dated 1833, 1834, and 1835 with heavy application of gum arabic may safely be said to be Samuel's work. Weaving and teaching were seasonal activities and could easily be undertaken by one individual. Later in life, Samuel and other members of the family operated a mill nearby. —F.S.W.

33 Private collections.

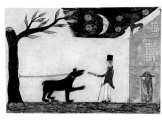

225. MAN FEEDING A BEAR
AN EAR OF CORN
Artist unidentified
Probably Pennsylvania
c. 1840
Watercolor, ink, and pencil on paper
5⅝ × 7½ in.
P1.2001.252

PROVENANCE:
Hattie K. Brunner, Reinholds, Pa.; Fred Wichmann, New York; Sotheby Parke-Bernet sale 5079, "Wichmann Collection," 6/83, lot 9.

EXHIBITED:
"The Flowering of American Folk Art, 1776–1876," WMAA, 1974.
"Young America: A Folk Art History," MAFA at IBM Gallery of Science and Art, New York, 1986.
"Five-Star Folk Art: One Hundred American Masterpieces," MAFA, 1990.

PUBLISHED:
Lipman, Jean, and Alice Winchester. *The Flowering of American Folk Art, 1776–1876.* New York: Viking Press in association with WMAA, 1974, p. 64.
Lipman, Jean, Elizabeth V. Warren, and Robert Bishop. *Young America: A Folk Art History.* New York: Hudson Hills Press in association with MAFA, 1986, p. 27.
Lipman, Jean, Robert Bishop, Elizabeth V. Warren, and Sharon L. Eisenstat. *Five-Star Folk Art: One Hundred American Masterpieces.* New York: Harry N. Abrams in association with MAFA, 1990, p. 27.

Bears and humans have had an ambivalent relationship in North America. The earliest European explorers were not impressed by the American bears they encountered and considered them of little economic value. After the Revolutionary War, however, when there was a compelling need to tame the wilderness and establish communities, the bear took on a frightening aspect as a threat to settlement and a symbol of all that was unknown about the land.[34] There are many possible interpretations of this puzzling but very appealing watercolor. The building, the man, and the chained bear may signify the successful civilization of the frontier. On the other hand, bears have often figured in folktales and other stories because there is something inherently humanlike about them. The man feeding the ear of corn to this bear, who appears small and helpless, may be a twist on an old folktale in which a bear feeds corn to pigs locked in a pen to fatten them up before eating them.[35]

Yet another interpretation of the watercolor may lie in fact rather than fiction. It was not an uncommon practice during the first quarter of the nineteenth century for exotic animals to be put on display to draw customers.[36] While bears could not be considered as exotic as elephants, lions, and camels, they were exhibited in Pennsylvania as attractions outside establishments such as public taverns.[37] In his zoo and museum at Independence Hall in Philadelphia, Charles Willson Peale exhibited two large grizzlies that had been captured by Zebulon Pike.[38] Whatever the actual meaning, the watercolor shares some traits with other Pennsylvania German arts—the tulip and the stars and crescent moon, which may derive from printed almanacs—although they are here expressed idiosyncratically.
—S.C.H.

34 Daniel J. Gelo, "The Bear," in Angus K. Gillespie and Jay Mechling, eds., *American Wildlife in Symbol and Story* (Knoxville, Tenn.: Univ. of Tennessee Press, 1987), p. 133.
35 Ibid., p. 147.
36 Donna-Belle Garvin and James L. Garvin, *On the Road North of Boston: New Hampshire Taverns and Turnpikes, 1700–1900* (Concord, N.H.: New Hampshire Historical Society, 1988), pp. 100, 102.
37 Pastor Frederick Weiser, conversation with the author, May 22, 2000.
38 Gelo, "The Bear," p. 143.

226a–o. METAMORPHOSIS
Artist unidentified
Probably New England
1794
Watercolor and ink on paper
Adam: 6⅛ × 3¹⁄₁₆ in., *Cain:* 6⅛ × 3³⁄₁₆ in., *Lion:* 6¹⁄₁₆ × 3³⁄₁₆ in.,
Child: 6⅛ × 3⅛ in., *Gold and Silver:* 6⅛ × 2¹⁵⁄₁₆ in. (folded)
P1.2001.253a–e

INSCRIPTIONS:
First book, panel one, ink: *Adam comes firſt upon the Stage / And Eve out of his Side / Was given him in Marriage / Turn up and see the Bride;* panel two: *Here Eve in shape you do Behold / One Body sheweth twain / Do but the Lower leaf unfold / And its as Strange again;* panel three: *Eyes look not on the Mermaid face / Nor ears attend her Song / her face hath an allureing grace / More Charming is her Tongue;* second book, panel one: *Here Cain in Suppliant Posture bends / To implore of Heaven its Love / In bleſsing that he moſt Depends / But is not Answer'd from above / For his Heart want right or yet sincere / Turn up his Brothers offering there / CF;* panel two: *Here Abels approv'd in his makers sight / As was not his brother Cain / Turn down you will See in Enmous Fright / How Vilely he was Slain;* panel three: *The Devil tempts one mothers Son / To rage against the other / So wicked Cain was hurried on / Till he had killed his Brother;* third book, panel one: *A Lion roused from his Den / On pirpose for to range / he is Turned into another Beast / Turn up and See how Strange / PP;* panel two: *A Griffen Shape you do Behold / Half fowl half Beast to be / Do but the Lower leaf unfold / And a Stranger Sight you See;* panel three: *Behold within the Eagles Claws / An Infant here doth Lye / which he has gotten as a prey / with wings prepared to fly;* fourth book, panel one: *The Child is Safe to manhood grown / The Eagle far away is Flown / His hearts now set in gathering gold / Turn down the Leaf & it Behold;* panel two: *A Purs of Gold and Silver Store / Has curd my Heart I am sick no more / But my Pleasure fully shall abound / With this Fifty thousand pound;* panel three: *A heart you See oppreſt with care / What Salve can cure the Same / Under this Leaf you ill find it there / Lift up & see how Plain;* fifth book, panel one: *Now I have Gold and Silver store / Bribd from the Rich pawnd of the Poor / No worldly cares can trouble me / Turn Down the Leaf & you Shall See / 17 / 94;* panel two: *Behold o man thou art but dust / thy Gold and Silver is but ruſt / thy Days are past thy Gold is spent / No worldly cares can Death prevent;* panel three: *Sickneſs is come and Death draws nigh / help Gold and Silver or I die / It will not do all is but droſs / Turn up and See a greater croſs*

PROVENANCE:
Joe Kindig Jr., York, Pa., 1968.

EXHIBITED:
"Every Picture Tells a Story: Word and Image in American Folk Art," MAFA, 1994/95.

Mystery plays were episodic religious stories enacted during the European Middle Ages by members of trade and crafts guilds, which each took responsibility for one presentation in a cycle that might include several chapters from the Old and New Testaments. In Elizabethan England, morality plays that were descended from such religious pageants brought home Shakespeare's trenchant observation that all the world is a stage. Capitalizing on the strength of dramatic or comedic performance as a way of disseminating basic truths, vernacular dramas conveyed religious and moral lessons in a popular way that could be understood and appreciated by a broad segment of society. Eighteenth- and nineteenth-century puzzle books functioned in a similar manner, amusing young children while at the same time offering instruction.

The initial verse of this puzzle book calls "Adam ... first upon the stage," harking back to its roots in religious performance. Handmade in both German- and English-speaking communities in America, these books were based upon printed German and English prototypes that featured religious and moral verses in rhyme.[1] Similar to today's flip books, in the early nineteenth century they were called "turn-ups"; they are also known as metamorphosis books because the pictures and verses change as the leaves are turned up or down. This late-eighteenth-century example is closely based on metamorphoses authored by Benjamin Sands and illustrated with cuts by James Poupard. These popular American editions, produced from at least 1787 through 1820, were often copied and hand-colored, sometimes by children or young adults. The verses contained in this version and many of the Sands editions paraphrase the text of *The Beginning and Progress of Man* (London: E. Alsop, 1654).[2] The mythological and biblical references in rhymed verse reinforced the religious precept of life in early America: from original sin to the inevitability of death, the only real reward was not material wealth on earth, but salvation through Christ in death.[3]
—S.C.H.

227a–b. HOBDAY FAMILY RECORD BOOK
Artist unidentified
Frederick County, Virginia
c. 1820–1825
Ink on paper with paperboard binding
10¼ × 8 × ³⁄₁₆ in. (closed)
P1.2001.254

INSCRIPTIONS:
3rd page, ink: *WILLIAM / HOBDAY Was Born / On ye 6th Day of January In the Year of our Lord 1780 / And was Married on ye 20th Day of March A.D. 1803 TO / CHRISTENA / WIDMEYER His Wife, / Who was Born on ye 5th Day of May In the year of our Lord 1775;* 25th page: *ELIZABETH / HOBDAY / Daughter of William Hobday and Christena his Wife / Was Born on the 6th Day of January / In the Year of our Lord 1819*

PROVENANCE:
Descended in family; Morgan Anderson, Frederick, Md., 1987.

EXHIBITED:
"Virginia Fraktur," AARFAC, 1974.

PUBLISHED:
Weekley, Carolyn J. "Decorated Family Record Books from the Valley of Virginia." *Journal of Early Southern Decorative Arts* 7, no. 1 (May 1981): 5–7.
Weiser, Frederick S. *Fraktur: Pennsylvania German Folk Art.* Ephrata, Pa.; Science Press, 1973, pp. 68–69.

1 Beatrice B. Garvan and Charles F. Hummel, *The Pennsylvania Germans: A Celebration of Their Arts, 1683–1850* (Philadelphia: PMA in association with Winterthur, 1982), p. 171.

2 Several of the Sands/Poupard metamorphoses, as examples of handmade copies, are cited in D'Alté A. Welch, *A Bibliography of American Children's Books Printed prior to 1821* (Worcester, Mass.: American Antiquarian Society, 1968), pp. 295–304. I am indebted to Georgia B. Barnhill, American Antiquarian Society, Worcester, Mass., for bringing this volume to my attention.

3 Mythological references to mermaids, or sirens, and griffins suggest a widespread familiarity with classical literature. It is interesting that this metamorphosis makes a transition from a griffin to an eagle to the pursuit of gold. In Greek mythology, the griffin was a creature that guarded deposits of gold. This type of imagery may also be related to Mannerist visual traditions that were filled with such hybrid and mythological creatures; see Robert F. Trent, "The Concept of Mannerism," in Museum of Fine Arts, *New England Begins: The Seventeenth Century*, vol. 3 (Boston: MFA, 1982), pp. 368–79.

This small decorated booklet by an unidentified artist currently contains twenty-six pages, most of which are elaborately illustrated with decorative borders, fancy script and block lettering, flowers, birds, and other devices. On first examination, these little drawings appear to have been created by someone familiar with fraktur drawing and iconography. Closer study of these pages and more than sixteen other surviving books created by the same hand reveals that their cultural context was probably British and perhaps Scotch-Irish or Irish. The Hobdays and many of the other families who commissioned the little books were not of German heritage, and many of them were associated with Presbyterian churches. Most of the clients lived in Frederick County, Virginia, and Berkeley County, Virginia (now West Virginia). The Hobday family was from Frederick County.[4]

The decorative devices used by the artist are easily recognizable and generally consistent in overall shape but shaded and detailed in many different ways. These include several types of flowers, especially large sunflowers and tulips and complex flower groups, trees, peacocks, various birds, butterflies, a highly detailed multistoried building (usually as a frontispiece), and single or double borders that terminate at the page corners in fleurs-de-lis. The latter and the scallop-edge curtains seen on the Hobday Family record book pages and throughout the other books are stylistically similar to the fraktur work of another unidentified Valley of Virginia scrivener known as the Stoney Creek Artist.

The Hobday book is a typical example of this artist's work and includes on its first decorated page an elaborate drawing of the Temple of Solomon with several cupolas and the symbolic Masonic elements in its doorway and central cupola and in the sky. This particular vignette is seen in a number of the books, suggesting that the fathers and heads of the households were Masons. The following pages list first the names and marriage date of the parents and then the births (and when appropriate, deaths) of their children. The page for Sarah Hobday, a deceased child, has a central black coffin that the artist traditionally used for departed loved ones. It is surrounded by the phrase "When this you see, remember me; Least I should forgotten be." The Hobday record book is also fully colored in shades of yellow, red, blue, green, and black inks. As such, it is one of the most colorful examples known by the artist.

—C.J.W.

228. **Birth Certificate for Ann Lippincott**
The New Jersey Artist
Burlington County, New Jersey
1797
Watercolor and ink on paper
8 × 9⅞ in.
P1.2001.255

INSCRIPTION:
Recto, ink: *Ann Lippincott / Daughter of Arney Lippincott & Lydia his wife / Was born September the 28th Anno Domini, 1797 / Great God is this our certain Doom. / And are we yet secure / Still walking downward to the Tomb / And yet prepar'd no more*

PROVENANCE:
Philip Cowan, Phoenixville, Pa.; Walter G. Himmelreich, Ronks, Pa.; Pennypacker sale 10/71, "Himmelreich Collection," lot 266.

EXHIBITED:
"Every Picture Tells a Story: Word and Image in American Folk Art," MAFA, 1994/95.

PUBLISHED:
Kogan, Lee, and Barbara Cate. *Treasures of Folk Art: Museum of American Folk Art.* New York: Abbeville Press in association with MAFA, 1994, p. 113.

Decorated family records occasionally transcended their utilitarian purpose by exhibiting exceptional pictorial decoration and hand-lettered text in well-balanced compositions. Such is the case with the birth certificate for Ann Lippincott, one in an important group of about twelve eighteenth-century decorated birth certificates from the area of Burlington, New Jersey. This set of works is characterized by English lettering in a format of three horizontal tiers, reminiscent of those in needlework samplers, and a pictorial section incorporating figures, flowers, and foliage. Using sepia-toned ink, the creator—identified only as the New Jersey Artist—recorded the relevant vital statistics. Religious concerns about death and ideas prevalent in literature from the 1600s through the 1800s are reflected in the verse. The certificate has a painted border that includes narrow banding within a border that resembles decorative wood beading. A pictorial scene features a central urn, often a symbol for the tree of life. The fashionable couple wears clothing of the republic—the man is in a walking suit, a black frock coat, long pantaloons, and a beaver hat, while the woman wears a loose afternoon dress with short sleeves and her hair in a topknot, fairly short and soft around her face.

Born in Burlington, Ann Lippincott was descended from Richard and Abigail Lippincott, who emigrated from Devonshire, England, around 1639 or 1640. The Lippincotts were associated with early colonists of Massachusetts Bay and were among the wealthiest citizens. Ann's father, Arney Lippincott, a farmer by trade, was born in Hanover or New Hanover Township, Burlington County. Lydia Shinn, his third wife, bore him several children, and in his will he granted the girls—Lydia, Sarah, Lavinia, Ann, and Rebekah—a total of two plantations and 500 pounds each, with the estate to be administered by their brothers William, James, and Arney Jr. On December 14, 1822, Ann married William Wood Stockton, a merchant in Vincentown. She came to the marriage with a handsome dowry from her father. Stockton was highly thought of in his community and was listed as county assessor in 1826.[5] The Lippincotts, the Shinns, and the Stocktons were important in the history of Burlington County and, more broadly, New Jersey.

While previous data puts Ann and her family in Philadelphia, genealogical research firmly places her in Burlington. This discrepancy is not so strange, however, since many upper-middle-class Philadelphia residents maintained country houses and properties in Burlington County. According to the inscription on her tombstone in Vincentown Friends Cemetery, Ann Lippincott died on July 30, 1826, at the age of twenty-nine; her husband died on October 10, 1836, at age forty-four, and is buried in the same cemetery.

—L.K.

4 Information derived from the author's files and Carolyn J. Weekley, "Decorated Family Record Books from the Valley of Virginia," *Journal of Early Southern Decorative Arts* 7, no. 1 (May 1981): 1–19.

5 Major E.M. Woodward, *History of Burlington County of New Jersey with Biographical Sketches* (Philadelphia: Everts and Peck, 1883), p. 184.

Valentines and Love Tokens

The origins of the customs associated with Valentine's Day—February 14—remain obscure. They appear to derive from the pagan Roman festival of Lupercalia, which celebrated the rites of spring, agriculture, and fertility, combined with the tales of two martyred saints, both named Valentine. Valentine's Day customs have traditionally involved textual affirmations of affection, either in the writing of a true love's name on a piece of paper or the sending of a romantic verse. The text frequently follows the outline of cut or drawn motifs, and the recipient must manipulate the token to read the message.

The source for some of the imagery seems to be elements found in artifacts from the British Isles and early Germanic cultures. Interlaced designs such as lovers' knots, labyrinths, and other interwoven images were suggestive of love never ending. In medieval German art, this type of design also held protective connotations that reached back to pagan times, when knotwork was believed to banish demons and avert evil. Vestiges of such interlaced motifs are often seen in Germanic decorative arts, but especially in fraktur and love tokens, where these archaic meanings may have persisted subconsciously for the guarding of lovers and children. —S.C.H.

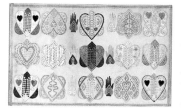

229. HEART AND HAND LOVE TOKENS
Artist unidentified
Probably New England
c. 1820
Watercolor and ink with gilt paper on cut and pinpricked paper, mounted on paper
9¼ × 14⅛ in.
P1.2001.256

PROVENANCE:
Howard and Jean Lipman, Wilton, Conn.; Sotheby Parke-Bernet sale 4730Y, "Lipman Collection," 11/81, lot 88.

PUBLISHED:
Kogan, Lee, and Barbara Cate. *Treasures of Folk Art: Museum of American Folk Art.* New York: Abbeville Press in association with MAFA, 1994, p. 132.
Schaffner, Cynthia V.A., and Susan Klein. *Folk Hearts: A Celebration of the Heart Motif in American Folk Art.* New York: Alfred A. Knopf, 1984, p. 94.

Love tokens, often mistakenly called valentines, were given in affection on days other than February 14. In this exuberant example, fifteen hearts and six heart-and-hand motifs are applied in horizontal rows to a sheet of paper. Most of the twenty-one elements use pin work to create a lacy effect as well as woven strips of paper in an interlacing technique suggestive of love never ending. The heart-and-hand is generally associated with love or friendship and probably originated from Valentine's Day customs. In one tradition, a man gave a woman the gift of a glove, which she then wore in acceptance of his proffered love. In another, a woman gave a man her glove, which he then wore pinned to his sleeve for the duration of the day. The well-known phrase "wearing your heart on your sleeve" derives from this custom. —S.C.H.

230. LOVEBIRD TOKEN
William Johnson (dates unknown)
Probably Pennsylvania
Early nineteenth century
Watercolor and ink on cut paper
16⅛ × 16 in.
P1.2001.257

INSCRIPTIONS:
Recto, ink, outer ring: *The fourteenth day of february It was my chance for to be merry First lots were cast and you I drew Kind fortunes ſaid it must be you As ſure as grapes grow on the vine ſo ſure you are my valentine I choſe you from among the rest the reaſon was I lov'd you best The roſes red the violets blue Carnations ſweet and ſo are you Kind madam it's no my deſign To picture here your heart and mine;* second ring: *But cupid with his fatal dart Has deeply wounded my tender heart And between our hearts has ſet a Croſs which make me too lament my loſs But I'm in hopes when that is gone That both our hearts will join in one I pray take pity on my pain And grant me love for love again;* third ring: *Believe my love my heart is just and true Have pity and don't let me die for you Pray don't think these lines were wrote for fun They're from your lover William Johnson;* innermost ring: *Round is the ring That hath no end ſo is my love to you my friend*

PROVENANCE:
Alma Erb, Hershey, Pa.; Fred Wichmann, New York; Sotheby Parke-Bernet sale 5079, "Wichmann Collection," 6/83, lot 14.

EXHIBITED:
"The Pennsylvania German: His Arts and Handicrafts," William Penn Memorial Museum, Harrisburg, Pa., 1968.
"Pennsylvania Folk Art," AAM, 1974.

Round formats were especially popular in cut-work love tokens and were found in Germanic communities where they were known as *Liebesbriefe,* or love letters. The ownership history of this piece has long associated it with Pennsylvania, but it is unclear whether it is of Germanic origin. Stylistically it shares characteristics with Pennsylvania German decorative arts, in particular the brightly colored kissing birds and cut-work in a round format. However, the Anglican name and the fact that it is written in English suggest strongly that it was not made within a Germanic context.

The association of birds with Valentine's Day had roots in medieval Europe, where it was believed that the mating season for birds began in mid-February. The imagery was first promulgated by Chaucer and his circle of poets in lines such as these from *Parliament of Fowls* (1380): "For this was on seynt Valentynes day, Whan every foul cometh ther to chese his make." In large part, they were responsible for the shift of St. Valentine from Christian martyr to the patron saint of love.[6] The verses in this token refer explicitly to the tradition of drawing lots to pick a valentine for the day. Although the description of this lottery process seems to suggest an ambivalence on the part of William Johnson toward his valentine, it is actually a conventional verse that appears on other examples.[7] These verses were available from sources such as Thomas Sabines's *The Complete Valentine Writer: or, The Young Men and Maidens Best Assistant* (1783), and other chapbooks that contained appropriate sentiments that could simply be copied onto a handmade love token.[8]

—S.C.H.

6 Leigh Eric Schmidt, "The Fashioning of a Modern Holiday: St. Valentine's Day, 1840–1870," *Winterthur Portfolio* 28, no. 4 (winter 1993): 210, 215.
7 Cynthia V.A. Schaffner and Susan Klein, *Folk Hearts: A Celebration of the Heart Motif in American Folk Art* (New York: Alfred A. Knopf, 1984), p. 96.
8 Schmidt, "Fashioning," p. 218.

231. PUZZLE PURSE LOVE TOKEN (recto and verso)
Artist unidentified
Pennsylvania or New England
c. 1790–1810
Watercolor and ink on paper
12½ × 12⁵⁄₁₆ in.
P1.2001.258

INSCRIPTION:
Recto, ink: *As turns the needle to the pole / So my fond heart's inclin'd / To the bright magnet of my soul / And you my Valentine. —/;* verso: *1. A heart my Dear I present to you / A heart that is sincere and true / My Dearest Dear and blest divine / I've pictur'd here your heart & mine; / 2. A heart that ne'er will in*[cline?] *to join / To any other heart but thine / But Cupid with his cruel dart / Has deeply pierc'd my tender heart; / 3. This I my Dear have sent to thee / To show how firm my love should b / And have between us set a cro∫s / Which makes me to lament my lo∫s / 4. Grant me thy love my Dearest Dear / And ease my heart of all its cares / But I'm in hopes when that is gone / That both our hearts will be in one.*

PROVENANCE:
George E. Schoellkopf, New York; Barry Cohen, New York, 1984.

PUBLISHED:
Schaffner, Cynthia V.A., and Susan Klein. *Folk Hearts: A Celebration of the Heart Motif in American Folk Art.* New York: Alfred A. Knopf, 1984, pp. 98–99.

Puzzle purses were double-sided folded love tokens that were decorated on both sides. The "purse" was presented with the corners folded in to form an envelope. As it was opened, verses were revealed and sometimes a special picture as well. The unknown lover who penned this example thoughtfully provided a road map for the intended recipient. The exterior has four numbered pictorial elements. Each is a schematic representation of the content of the corresponding verse that is revealed when the puzzle is opened. In the first, two separate hearts flank a heart from which a branching tree grows. In the second, one of the hearts is pierced by an arrow. A cross grows between the hearts in the third drawing, and in the fourth the two hearts are joined. The last picture to be revealed is the center, which bears a poetic verse and shows a gentleman standing between two trees. In one hand, he holds a bird, and with the other he plucks a heart from a tree. Although the valentine descended with a Pennsylvania history, there is some question whether it is from New England. The metaphor of a compass is perhaps more appropriate for a coastal New England origin. In addition, the association between

love and marital union, with a branching tree springing from a heart, is a motif that is prevalent in family records of coastal Massachusetts, New Hampshire, and Connecticut.[9]
—S.C.H.

232. SKETCHBOOK
Jurgan Frederick Huge (1809–1878)
Bridgeport, Fairfield County, Connecticut
Mid-nineteenth century
Pencil on paper with pasteboard binding and printed paper cover
7⅝ × 10½ × ¼ in. (closed)
P1.2001.259

INSCRIPTION:
Inside front cover, pencil: *JF Huge's sketchbook / it came from Anne Richardson's home / the ship with French flag / is by far the best drawn*

PROVENANCE:
Anne Richardson (artist's granddaughter), Ridgefield, Conn.; Avis and Rockwell Gardiner, Stamford, Conn.; David A. Schorsch, New York, 1990.

PUBLISHED:
Lipman, Jean. "Jurgan Frederick Huge (1809–1878)." In Jean Lipman and Tom Armstrong, eds. *American Folk Painters of Three Centuries.* New York: Hudson Hills Press in association with WMAA, 1980, p. 112.
———. *Rediscovery: Jurgan Frederick Huge (1809–1878).* New York: Archives of American Art, 1973, p. 4.
Schorsch, David A. "The Lost Sketch Book of Jurgan Frederick Huge." *The Clarion* (spring 1992): 46–49.

Jurgan Frederick Huge is best known for his accurate and detailed ship, landscape, and architectural oils and watercolors.[10] It is not known when Huge emigrated from Germany to Bridgeport, Connecticut, but his marriage by 1830 to Mary Shelton, daughter of a prominent Bridgeport family, indicates that he had probably been in the area for some time. This marriage may have prompted the gradual anglicizing of Huge's name from Jurgen Friedrich.[11] Throughout his adult life in Bridgeport, Huge seems to have combined his occupation as a grocer with the artistic activities for which he has earned recognition today. Little is known of his life before he immigrated to Connecticut, save that his brother Peter accompanied him; he brought his mother to live with him at a later date.[12]

Huge's precise rendering of ships and associated maritime features, as seen in *New-York Ballance Drydock* (1877), lends support to the suggestion that he had some prior familiarity with oceangoing activities.[13] His paintings of local architecture—such as *Burroughs* (1876), a building

9 Peter Benes, "Decorated Family Records from Coastal Massachusetts, New Hampshire, and Connecticut," in Peter Benes, ed., *Families and Children: Annual Proceedings of the Dublin Seminar for New England Folklife,* vol. 10 (Boston: Boston Univ., 1987), pp. 91–147.

10 *Bunkerhill* (1838) was the first painting by Huge to come to the attention of Jean Lipman during the 1940s. Over the course of the next forty years, she diligently researched and rediscovered more than fifty paintings by the artist, publishing her findings in several articles and exhibitions. All the biographical information contained herein is based on these sources. The last summary of these findings was published in Jean Lipman, "Jurgan Frederick Huge

(1809–1878)," in Jean Lipman and Tom Armstrong, eds., *American Folk Painters of Three Centuries* (New York: Hudson Hills Press in association with WMAA, 1980), pp. 110–15.

11 Ibid., p. 110.

12 Ibid., pp. 111–12; Lipman cites family tradition that Peter and Jurgan were sea captains who worked their way to America and continued in maritime-related occupations until they found new vocations.

13 Alice M. Kaplan Collection; see ibid., pp. 110, 111.

in Bridgeport—document notable local scenes with great accuracy but with an artistic license that provides the most complete and compelling view.[14] And his paintings of foreign ports, such as *A Fanciful View of the Bay of Naples* (1877–1888), demonstrate his ability to create a composite landscape from a bird's-eye perspective, with a verisimilitude that permits great detail while stretching the limits of what the eye can take in at one time.[15]

This sketchbook is the only one known by Huge, though the competence of the drawings lends credence to the existence of others. It includes twelve sketches of a romantic nature: a shepherdess with sheep, a ruined castle, a steam packet flying a French flag, and a forest chase scene of dogs running after a bird. Although the sketches have a European sensibility, they were probably drawn in Bridgeport rather than Germany and were perhaps based upon published prints, as they have a conventionalized quality.[16] They show an awareness of perspective and foreshortening—in the challenging pose of the shepherdess, for instance, who sits on the ground with one arm leaning on a mound, the other crooked at the elbow and holding a tuft of grass. They also relate to the type of copy patterns provided by drawing instructors, an occupation that Huge himself advertised after 1872. The sketchbook descended with a daguerreotype, c. 1863, that purportedly portrays Huge himself.

—S.C.H.

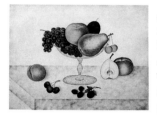

233. FRUIT IN GLASS COMPOTE
Emma Jane Cady (1854–1933)
East Chatham, Columbia County, New York
c. 1895
Watercolor, gouache, pencil, and mica flakes on paper
14¾ × 18¾ in.
P1.2001.260

PROVENANCE:
Robert Herron, Austerlitz, N.Y.; Richard and Betty Ann Rasso, East Chatham, N.Y.; Peggy Schorsch, Greenwich, Conn., 1985.

EXHIBITED:
"The Woman Folk Artist in America," MAFA, 1979.

PUBLISHED:
Dewhurst, C. Kurt, Betty MacDowell, and Marsha MacDowell. *Artists in Aprons: Folk Art by American Women.* New York: E.P. Dutton in association with MAFA, 1979, p. 81.
Piwonka, Ruth, and Roderic H. Blackburn. "New Discoveries about Emma J. Cady." *The Magazine Antiques* 113, no. 2 (February 1978): 420.

This delicate and pristine theorem painting is one of about five pieces identified as the work of Emma Jane Cady of East Chatham, New York.[17] Theorem paintings are created with the aid of cut stencils, and Cady's are remarkable for their technical control, balanced composition, and clarity. By the time Cady made this still life at the end of the nineteenth century, theorem painting had long since passed from favor. But as her work demonstrates, the technique could still be employed to produce an enduring result that defied the fleeting nature of popular trends. By using both watercolors and gouache, Cady achieved an interesting interplay between light and shadow. And by pouncing with a textured cloth rather than a stiff brush, she created a soft gradation of color that recalls the effect of chromolithography. The application of mica flakes to the glass compote enhances the sense of transparency and emphasizes the comparative solidity of the fruit.

When her work was discovered in the 1930s, the artist was known by name but incorrectly identified with New Lebanon, New York. As a result, it was not until 1978, and the serendipitous discovery of an inscribed painting, that she was correctly placed in East Chatham.[18] Subsequently a good deal of information was unearthed about Cady.[19] Her family migrated from Connecticut to Columbia County, New York, in the mid-eighteenth century. Her father, Norman J. Cady, was a farmer, and she herself was remembered by surviving acquaintances to have loved outdoor work, though census records list her occupation as "housework." Cady never married, and after her parents' deaths she moved first to the home of a nephew and then, about 1920, to Grass Lake, Michigan, where she lived with her sister and her sister's family until her death in 1933.

—S.C.H.

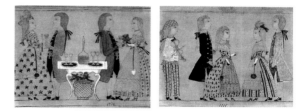

234a–b. THE PRODIGAL SON REVELING WITH HARLOTS
Artist unidentified
Probably Connecticut
1778
Watercolor and ink on paper
7 × 9 in. each
P1.2001.261a, b

14 Collection Bridgeport Public Library, Bridgeport, Conn.; see ibid., p. 115.

15 Jean Lipman, "Jurgan Frederick Huge," *The Magazine Antiques* 132, no. 3 (September 1987): 546–47.

16 David A. Schorsch raises the possibility that the drawings were executed in Germany when Huge was still a very young man; see Schorsch, "The Lost Sketch Book of Jurgan Frederick Huge," *The Clarion* (spring 1992): 48. However, the competence of the draftsmanship and conjecture that Huge was in Connecticut well before 1830 more strongly suggest that the sketches were drawn in Connecticut.

17 These include a remarkably similar composition in the AARFAM collection that has been widely published since its discovery in the 1930s; see Beatrix T. Rumford, ed., *American Folk*

Paintings: Paintings and Drawings Other Than Portraits from the Abby Aldrich Rockefeller Folk Art Center (Boston: Little, Brown, in association with Colonial Williamsburg Foundation, 1988), p. 155.

18 This painting, of two doves, was brought to the attention of Ruth Piwonka and Roderic H. Blackburn while they were organizing the exhibition "Emma Cady and Her Contemporaries," at Columbia County Historical Society, Kinderhook, N.Y., 1978. The painting is inscribed: "Mr. and Mrs. Eben N. Cady / Canaan / Columbia Co. / N.Y. / April 9, 1890 / E.J. Cady / East Chatham / N.Y." See Piwonka and Blackburn, "New Discoveries about Emma J. Cady," *The Magazine Antiques* 113, no. 2 (February 1978): 421.

19 Ibid., pp. 418–21, and Piwonka and Blackburn, "Emma Cady's Theorem Painting," *The (Chatham, N.Y.) Courier*, Jan. 21, 1988, p. A-8.

PROVENANCE:
Found in Goshen, Conn.; Peter H. Tillou, Litchfield, Conn., 1990.

The story of the prodigal son is one of the most powerful redemption narratives in the New Testament. The parable related in Luke 15:11–32 has been a popular theme in American folk art since at least the eighteenth century. The story, with a clear sequence of events, lends itself particularly well to graphic representation and is often portrayed as a series of narrative cells, anticipating both nineteenth-century panoramas and twentieth-century comic strips.[20]

This example, composed on two joined leaves, depicts the prodigal son reveling with harlots. The rigidly staged tableaux are contained within inked borders above and below. The first leaf shows two opposing couples standing on either side of a perfectly silhouetted Queen Anne tea table laden with a bottle of wine and four wineglasses. A large, handled urn of fruit sits underneath the table. In the second, two facing couples dance, both women forward, while a gypsy musician plays the violin. In both scenes, the affectless faces of the participants belie the gay clothes and wanton behavior; instead, they manage to look sedately aristocratic.[21] Interesting details of costume enliven the scene: the men wear bright coats in primary colors, while the women's patterned dresses are striped, dotted, and sprigged. The ladies also wear fancy mittens with triangular flaps turned back, and from each of their waists, a small bag dangles from a ribbon. One lady carries a fan, another carries a bouquet. In the parable, Luke does not describe the prodigal son's licentious behavior, merely referring to "dissolute living." It is the prodigal's brother who provides a more complete picture, decrying his brother for squandering his portion of their inheritance with prostitutes.[22] —S.C.H.

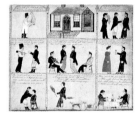

235. THE PRODIGAL SON
Attributed to Ruby Devol Finch (1804–1866)
Probably Westport, Bristol County, Massachusetts
c. 1830–1835
Watercolor, gouache, ink, and pencil on paper
12³⁄₈ × 14 in.
P1.2001.262

INSCRIPTIONS:
Recto, ink, following path from right column to left column to middle: *In spite of the Father's entrea / ties the son became a prodigal & / departed & spent his portion in / riotous living; If money will buy pleasure / There is pleasure yet for me / And freely will I part with it / All for your company; Then said the prodigal / Although I loose the game / I'll still play on for pleasure / With me its all the same; The Father fell upon his neck /*

Embraced and kifsed his son / The rebels heart with sorrow break / For crimes that he had done.; This calf I'll drefs with greatest speed / Because I may the hungry feed.; Lo this many years I have served thee / Yet thou never killed the kid that I might / make merry with my friends; A day of feasting I ordain, let joy and mirth / abound My son was dead yet lives again / Was lost and now is found.; And now my young companions / A warning take by me / Leave off your rambling / And shun bad company

PROVENANCE:
Mrs. Lawrence J. Ullman, Tarrytown, N.Y.; Edgar William and Bernice Chrysler Garbisch, Cambridge, Md.; Sotheby Parke-Bernet sale 3595, "Garbisch Collection," 1/74, lot 99.

EXHIBITED:
"The Woman Folk Artist in America," MAFA, 1979.
"Reflections of Faith: Religious Folk Art in America," MAFA, 1983/84.
"Every Picture Tells a Story: Word and Image in American Folk Art," MAFA, 1994/95.

PUBLISHED:
Dewhurst, C. Kurt, Betty MacDowell, and Marsha MacDowell. *Artists in Aprons: Folk Art by American Women.* New York: E.P. Dutton in association with MAFA, 1979, pl. 14.
———. *Religious Folk Art in America: Reflections of Faith.* New York: E.P. Dutton in association with MAFA, 1983, p. 122.
Rumford, Beatrix T. *American Folk Paintings: Paintings and Drawings Other Than Portraits from the Abby Aldrich Rockefeller Folk Art Center.* Boston: Little, Brown, in association with Colonial Williamsburg Foundation, 1988, p. 237, n. 1.
Walters, Donald R. "Out of Anonymity: Ruby Devol Finch (1804–1866)." *Maine Antique Digest* 6, no. 5 (June 1978): 4-C.

This watercolor was instrumental in Donald R. Walters's identification of Ruby Devol Finch as the artist responsible for an appealing group of paintings that included portraits of friends and neighbors in the community of Westport and Westport Point, Massachusetts, family records, and two versions of the parable of the prodigal son.[23] Ruby Devol married William Finch of New Bedford in 1832. She was active artistically between 1831 and 1843, but it is not known where she received instruction, if any.[24] Watercolor was a medium frequently recommended for arts in female academies, and Finch may have continued to produce artwork in this medium after her own education was completed.

This is almost certainly the later of her two versions of the prodigal son, based upon the greater clarity of the organization.[25] One motif that she established in her earliest known work, the Kirby family record, is still in evidence in this later effort: a leafy vine growing from an urn, which provides vertical divisions in the composition. In *The Prodigal Son,* these form columns that give the appearance of staffs from which canopies fly, bearing the two upper texts. Unlike the earlier version, the verses are not the traditional words of Luke 15:11–32 but possibly Finch's original rhyming scheme. A secular feeling pervades this representation of the prodigal son, which incorporates period details of costume, architecture, and dancing, all depicted in bright primary colors. —S.C.H.

20 The Esmerian gift to AFAM includes two additional versions of the prodigal son, one by Pennsylvania German fraktur artist Friedrich Krebs (cat. no. 216a–b), the other by Massachusetts artist Ruby Devol Finch (cat. no. 235). Each is composed of separate boxes that illustrate the verses of the parable.

21 This peculiarly mirthless delineation is also true of a contemporary example in the AARFAM collection (see Rumford, *American Folk Paintings,* p. 247) and another version sold at Christie's sale 8208 (6/95, lot 91). The striking similarity between the latter and the watercolor under discussion suggests they may be by the same hand.

22 Luke 15:30.

23 Donald R. Walters, letter to Ralph Esmerian, Feb. 26, 1974 (AFAM files). Biographical information based on Walters's research is published in the following two sources: Walters, "Out of

Anonymity: Ruby Devol Finch (1804–1866)," *Maine Antique Digest* 6, no. 5 (June 1978): 4-C, and Rumford, *American Folk Paintings,* pp. 235–37. The second *Prodigal Son* is in the AARFAM collection.

24 Her family record for Silas Kirby is dated 1831; see Rumford, *American Folk Paintings,* p. 339.

25 Rather than nine cells of similar dimensions, the AARFAM version sprawls across the top and center, with smaller individual scenes below. The text reads across the top and center rows and is self-contained in each of the bottom scenes. In the Esmerian example, the text appears at the top of each contained scene, though it follows a somewhat confusing path. It begins in the right column, top to bottom, continues in the left column, bottom to top to middle, and finishes in the center, middle to bottom.

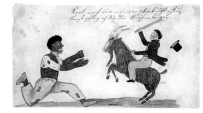

236. TWO MEN AND A GOAT
Artist unidentified
Probably Pennsylvania
c. 1825
Watercolor and ink on paper
4¹³⁄₁₆ × 8¼ in.
P1.2001.263

INSCRIPTION (TRANSLATION OF GERMAN):
Recto, ink: *Buddy, don't scare my goat and make him shy / Lest I'll beat your head in two—or try!*

PROVENANCE:
Joe Kindig III, York, Pa., 1971.

Generally the Pennsylvania Germans had good relationships with the few African Americans in their society, who were often descendants of slaves they had freed and who could speak the German dialect used in southeastern Pennsylvania. Jokes and pranks were common. Consequently, the drawing of a black man on foot and a white man riding a goat, with their mutually threatening gestures, may not be as racially insensitive as it first appears, but more anecdotal. —F.S.W.

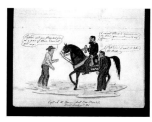

237a–c. SKETCHBOOK:
POINT LOOKOUT PRISON
John Jacob Ommenhausser (1832–1877)
Point Lookout, Dinwiddie County, Maryland
c. 1864–1865
Ink and watercolor on paper with
leather binding
6⁷⁄₁₆ × 4⅛ × ⅛ in. (closed)
P1.2001.264

INSCRIPTIONS:
Cover, ink: *Charles Rambo, Sergt. Co. D 20th U. Ret.;* 1st page, ink: *Sketched by Mr. Obenhauser / a Prisoner of War confined in / Prison at Point Lookout Md.;* 11th page: *Prisoners Cookhouse Point Lookout Md / Is that a cookhouse cup / Oh my soup / Heres your tobacco / for your soup.;* 21st page: *Captain will you please and give / me a pair of shoes. I have not / got any / I cannot attend to buisness on / the street, you must come to my / office. / Captain! I want to take / the Oath. / Capt. J.W. Barnes. Asst. Prov Marshal. / Point Lookout Md.;* 29th page: *Point Lookout Md / Git away from dat dar fence white man, or I'll make / Old Abes gun smoke at you, I can hardly hold de ball back / now. De bottom rails on top now.*

PROVENANCE:
Kennedy Galleries, New York, 1972.

EXHIBITED:
"A Place for Us: Vernacular Architecture in American Folk Art," MAFA, 1996/97.

Point Lookout Prison was established in 1863, after the Battle of Gettysburg, on a sandy stretch of land at the mouth of the Potomac.²⁶ It was built in two enclosures, one of ten acres and the other of thirty. Although the camp was designed to hold ten thousand men, more than twice that number of Confederate soldiers and civilians were housed in tents, often with no blankets and only threadbare clothing. Despite the cold winters, few more-permanent structures were built, and these were of the simplest board-and-batten construction. A rare glimpse into this infamous Civil War prison is provided by the sketches made by John Jacob Ommenhausser during his internment.

Ommenhausser was born in Philadelphia but enlisted as a private with Company A, 46th Virginia Infantry, on April 21, 1861.²⁷ He was captured near Petersburg, Virginia, in 1864 and transferred to Point Lookout, where he was imprisoned for nearly one year. This is one of several sketchbooks and groups of drawings that Ommenhausser apparently made specifically for fellow prisoners, as each has a recipient's name on the title page.²⁸ They were probably exchanged for extra food or tobacco and whatever small luxuries the prison camp afforded. His sketchbooks show the hardships of the conditions in the camp, which recorded more than eight deaths each day by the end of the war, but are also characterized by a strong sense of the absurd. This example has twenty-two drawings, including the title page. In 1866 Ommenhausser married his sweetheart, Annie, who had corresponded with him while he was a prisoner. He supported his wife and two daughters as a candy-maker. He died at the age of forty-six of intestinal cancer and is buried at Shockoe Cemetery in Richmond.²⁹ —S.C.H.

238. MAN WITH A WALKING STICK
Bill Traylor (1852/56–1949)
Montgomery, Alabama
c. 1939–1947
Crayon on paperboard with ink
inspection stamp
10½ × 9¾ in.
P1.2001.265

INSCRIPTION:
Recto, ink, rubber-stamped: *Inspected / B348 / 47*

PROVENANCE:
Charles and Eugenia Shannon, Montgomery, Ala.; Joe and Pat Wilkinson, Evanston, Ill.; Sotheby's sale 7065, "Wilkinson Collection," 12/97, lot 5.

EXHIBITED:
"Bill Traylor Drawings," Chicago Public Library Cultural Center, 1988.

26 Bruce Catton, "Prison Camps of the Civil War," *American Heritage* 10, no. 5 (August 1959): 9.
27 Several sources state John Jacob Omenhausser—with one *m*—was born in Austria in 1831 and was living in Richmond when he enlisted at the age of thirty. A family record, however, has his name spelled with two *m*'s and his place and date of birth as Philadelphia, Oct. 25, 1832 (collection Maryland State Archives, Baltimore).
28 Additional sketchbooks and drawings are in the collections of the University of Maryland, Baltimore; Maryland Historical Society, Baltimore; Maryland State Archives, Baltimore; and Allegheny College Library, Meadville, Pa.
29 Rob Schoeberlein, Maryland State Archives, Baltimore, letter with curatorial files to Judith G. Steinberg, AFAM, Feb. 9, 2000 (AFAM files).

239. ROSS THE UNDERTAKER
Bill Traylor (1852/56–1949)
Montgomery, Alabama
c. 1940
Poster paint and pencil on paperboard
13⅞ × 14⅞ in.
P1.2001.266

INSCRIPTION:
Verso, pencil (in Charles Shannon's hand): *Jan '40 / Ross—The Undertaker / When he comes in he always / looks around…. of down boxes is empty.*

PROVENANCE:
Charles and Eugenia Shannon, Montgomery, Ala.; Sotheby's sale 6392, 1/93, lot 1016.

EXHIBITED:
"Self-Taught Artists of the Twentieth Century: An American Anthology," PMA in association
 with MAFA, 1998.

240. MAN WITH A PLOW
Bill Traylor (1852/56–1949)
Montgomery, Alabama
c. 1939–1942
Poster paint and pencil on paperboard
15 × 25¾ in.
P1.2001.267

INSCRIPTION:
Verso, pencil (in Charles Shannon's hand): *Charles Shannon*

PROVENANCE:
Charles and Eugenia Shannon, Montgomery, Ala.; Joe and Pat Wilkinson, Evanston, Ill.; Sotheby's
sale 7065, "Wilkinson Collection," 12/97, lot 14.

EXHIBITED:
"Bill Traylor Drawings," Chicago Public Library Cultural Center, 1988.

Bill Traylor's life spanned periods of enormous change in the southern United States. He lived through the Civil War, slavery, emancipation, economic depression, and segregation. He was in turn a sharecropper, a factory worker, and a homeless man. During his lifetime, unlike many self-taught artists, he experienced modest artistic recognition. He was a brilliant observer who recorded his memories of farm life in Alabama and his firsthand experience of the contemporary urban scene.

Traylor was born into slavery on a cotton plantation owned by William Hartwell Traylor, in the forested vicinity of Benton, Alabama.[30] Following Emancipation, he continued to work on the plantation, though

as a sharecropper rather than a slave. He married in 1891, and he and his wife, Lorisa, raised twenty children. At the age of eighty-two, he moved to Montgomery, where he became a familiar figure on the downtown streets. It is not known what prompted Traylor to begin drawing, but it is known that he produced approximately 1,500 works on paper over a period of only three years (c. 1939–1942). He worked with a straight-edged stick and a pencil, and later with charcoal, crayon, and poster paint, on irregular scraps of cardboard. He shaped both simple and complex compositions in an abstract, spare style. In 1939, soon after he started to draw, a local artist named Charles Shannon took notice of Traylor's talent and began supplying him with materials.

These three drawings exude energy and demonstrate a whimsical and witty approach to life's everyday routines. Traylor captures all the necessary elements in unerringly well-balanced compositions. Color, when applied, supports the emotional tone of the artworks. Bold, bright, and unshaded reds, yellows, and blues dramatically highlight the graphic elements and act as strong counterpoint to the favored black pencil, crayon, or paint. Traylor's documents of the life around him are stripped of extraneous detail, pared down to their essences, and transformed into universal works of iconic power.

Man with a Plow reveals the artist's ability to imbue his images with a sense of optimism. An electric-blue male figure stands behind common elements of a working farm—the mule and the plow. The man manages the large mule before him with delicately penciled reins. His determined attitude and sprightly gait are underscored by one leg flung forward with grace. The mule works cooperatively and vigorously, judging from the position of his forelegs, which are elevated and in motion. Traylor's innate understanding of this basic farm chore is clearly communicated in this sensitive reading.

A touch of humor can be observed in *Man with a Walking Stick*, a portrayal of a male figure bent over a cane pressing forward along a horizontal path, buttocks thrust out, hand on his hip. The vitality of this old man is incredible, and made only more vivid by the fact that he is constrained by the composition: The top of his hat urgently presses against the top of the page. The crayon strokes enhance his rhythmic movement, as they follow the contour of the outlined shapes. A faint inspection mark on the front suggests the remote possibility that the work was executed in 1947 but is more likely a serial number.

Finally, *Ross the Undertaker* depicts David Callaway Ross, one of the owners of Ross-Clayton Funeral Home, where Traylor sometimes slept in a back room. The subject is identified in an inscription on the back by Charles Shannon, who sometimes recorded Traylor's pithy comments on the reverse of his drawings. (Also on the back of the drawing is an unfinished pencil sketch of a two-chimney house.) Ross is austere in his black suit, with his arms thrust stiffly down and away from his body and clasping a narrow, elongated instrument bag, but this somberness is relieved somewhat by the red and black dots and strokes on his detachable shirtfront.
 —L.K.

30 Biographical information based on original research conducted by Marcia Weber in 1990 and
 from Josef Helfenstein and Roman Kurzmeyer, *Deep Blues: Bill Traylor, 1854–1949* (New Haven,
 Conn.: Yale Univ. Press, 1999), pp. 169–77.

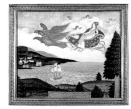

241. AURORA
Artist unidentified
New England
c. 1818–1822
Watercolor on silk with applied gold foil
and paper label, in original gilded
wood frame
21⅜ × 24⅝ in. (24⅞ × 28⅜ × 2¼ in. framed)
P1.2001.268

INSCRIPTIONS:
Recto, printed paper label: *Hail, bright Aurora, fair Goddess of the Morn! / Around thy splendid Car, the smiling Hours submissive wait attendance, ascend—and / reillume the face of Nature with thy refulgent beams, & from the Arch of Heaven banish night;* verso, typeset in ink on paper label attached to original backboard: *STILLMAN LOTHROP / LOOKING-GLASS STORE / NO. 71 MARKET STREET / BOSTON.*

PROVENANCE:
Descended in family; Christie's sale 6842, 6/89, lot 181.

PUBLISHED:
Ring, Betty. *Girlhood Embroidery: American Samplers & Pictorial Needlework, 1650–1850,* vol. 2. New York: Alfred A. Knopf, 1993, p. 549.

This superb painting on silk is one of five renditions of Aurora within a group of ten related paintings attributed to an unknown New England girls' school.[1] Their mutual origin is based on the consistent use of applied gold paper and painting so similar as to suggest the work of one hand. However, close scrutiny reveals that subtle differences exist, but the young artists must have had the careful guidance of a very talented teacher.[2]

The first recorded piece emerged in Quincy, Massachusetts, in 1937, and became the property of Colonial Williamsburg in 1954.[3] Untitled, it was first called *Chariot in the Clouds* and later described as *Venus Drawn*

by Doves. Another untitled piece was found in Salem, Massachusetts, in 1942, and called *A New England Goddess.*[4] It was acquired by the Museum of Art at the Rhode Island School of Design, in Providence, and publication of these two pieces led to responses from owners of three inherited examples.

In 1953 the great-niece of Ruth Downer (1797–1833), of Vermont, wrote to the Rhode Island School of Design and described her similar painting with its printed paper label identifying the goddess as Aurora, and mentioned that she had a companion piece of Diana, also by Downer.[5] Possibly she believed Downer was a teacher responsible for all of the similar paintings or that she was a professional ornamental artist. In any case, thereafter the piece belonging to the Rhode Island School of Design was routinely published as having been painted by Ruth Downer.[6]

In 1957 the Ohio owner of the anonymous *Aurora* illustrated here contacted the Abby Aldrich Rockefeller Folk Art Center after seeing *Venus Drawn by Doves* illustrated in *The Ladies Home Journal.* This painting had come to her from relatives in Barre, Massachusetts, and she provided photographs of its front and back and cheerfully transcribed the contents of its printed label.[7] The fifth *Aurora* to be recorded was painted by Eliza Ann Robeson (1798–1834), of Fitzwilliam, New Hampshire, and had a reserve for a similar label, which is missing. The painting survived with a companion mourning piece of about 1814 and is obviously from the same school.[8] The five *Auroras* were recorded by Beatrix T. Rumford in 1988, along with two related paintings depicting the biblical episode usually known as "Jephthah's Rash Vow."[9] The tenth piece depicts Naiad, a figure from classical mythology, and it bears a typical descriptive label.[10]

—B.R.

1 In federal America, Aurora often appeared on the reverse-painted glass panels of banjo clocks and shelf clocks and was usually standing in a chariot drawn by winged horses; see Lester Dworetsky and Robert Dickstein, *Horology Americana* (Roslyn Heights, N.Y.: Horology Americana, 1972), pp. 52, 67, 148. For a rendition in needlework and paint on silk from Mary Balch's school in Providence, see Betty Ring, "Peter Grinnell and Son: Merchant-Craftsmen of Providence, Rhode Island," *The Magazine Antiques* 17, no. 1 (January 1980): 214, pl. 2. A seated Venus drawn by doves, with Cupid beside her, appears on Marblehead, Mass., and Bristol, R.I., samplers of the 1790s; see Betty Ring, *Girlhood Embroidery: American Samplers & Pictorial Needlework, 1650–1850,* vol. 1 (New York: Alfred A. Knopf, 1993), pp. 135–36, 192.

2 Painting on silk requires considerable skill and delicacy. It is generally recognized that needlework pictures on silk were embroidered by the student and then painted by the teacher, an ornamental artist, or the frame maker.

3 Beatrix T. Rumford, ed., *American Folk Paintings: Paintings and Drawings Other Than Portraits from the Abby Aldrich Rockefeller Folk Art Center* (Boston: Little, Brown, in association with Colonial Williamsburg Foundation, 1988), pp. 225–26. This very beautiful version is smaller than the others in the group, at 14½ × 14¼ in.

4 *The Old Print Shop Portfolio* 1, no. 8 (April 1942): 1, 7.

5 Ruth Downer, the eldest child of John Downer and Hannah Hunt, was born in Sharon, Vt. She married Judge David Pierce of Woodstock, Vt., on Oct. 5, 1819. They had three children, but her paintings descended through the daughter of her sister Hannah Downer Hazen (1798–?); see David R. Downer, *The Downers of America* (Newark, N.J., 1900), p. 90. Downer's *Aurora* and *Diana* remain with family members and have not been published. The inscription on the label on Downer's *Aurora* is identical to the one on this example. Her *Diana* depicts

the goddess holding a bow and arrow and standing beside a stream within a wooded glade accompanied by five young girls. It also has a similar vine-enclosed printed label inscribed "Diana fair and chaste! Celestial Huntress! / Averse to pomp and splendor, seeks, with her lovely votaries, the purer pleasures of the / sylvan shade."

6 C. Kurt Dewhurst, Betty MacDowell, and Marsha MacDowell, *Artists in Aprons: Folk Art by American Women* (New York: E.P. Dutton in association with MAFA, 1979), p. 69, fig. 51.

7 This example appears to be unique in having its original frame, glass, and wooden backboard bearing the frame maker's label. Lothrop was at 71 Market St. in Boston from 1818 to 1822. Also it has a gilt star on Aurora's forehead, as does the anonymous *Aurora* at the Rhode Island School of Design. After seeing a photograph of the Esmerian piece, Mary C. Black, then registrar at AARFAC, closely examined their painting and found evidence that it, too, once had a similar gilt star; see Black, letter to previous owner of this *Aurora,* Oct. 24, 1957 (AFAM files). The Downer and Robeson *Auroras* show no traces of stars on their foreheads.

8 Both were sold at Christie's sale 8076 (1/95, lots 75, 76). The uninscribed mourning piece was surely for Eliza Ann's mother, whose death date is unknown; her father remarried on March 21, 1815.

9 Rumford, *American Folk Paintings,* pp. 226; 239–41, fig. 185; 256–57, fig. 207. See Betsy B. Lathrop's *Jephthah's Return* (1812), suggesting the earliest known date for this school.

10 Sold at Christie's sale 7214 (1/91, lot 177); the label is inscribed "In listening mood, she seem'd to stand,—The Naiad of the fairy strand." My thanks to Barbara R. Luck, AARFAM, and Thomas Michie, Museum of Art, Rhode Island School of Design, Providence, who have kindly contributed essential information concerning these paintings.

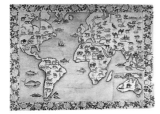

242. MAP OF THE ANIMAL KINGDOM
Artist unidentified
Probably New England
1835
Watercolor, ink, and pencil on paper
26 × 34¾ in.
P1.2001.269

INSCRIPTIONS:
Recto, ink: *1835* [animals labeled with names over entire surface]

PROVENANCE:
Sotheby Parke-Bernet sale 5228, 12/84, lot 156.

In 1806 Nathaniel Dwight propounded the religious and moral virtues of studying geography in his *A Short But Comprehensive System of the Geography of the World:* "Geography opens to our view much of the wisdom and goodness of the creator, in making various and bountiful provision for his creatures, in appointing them their residence in different parts of the globe, and suiting their capacities to their respective circumstances. It teaches us that mankind are one great family, though different in their complexions, situations and habits. It promotes social intercourse and mutual happiness." Dwight might have been describing this map, which shows finely and precisely drawn animals distributed around the globe and the various types of people, dressed in their native garb, who also lived and hunted in those areas. Geography was urged as a course of instruction for females, as "an agreeable study, and as requisite to the reading of the others [history, biography, travels, voyages]."[11] Quaker schools were among the first to include geography and "working maps" as part of the regular curriculum. In 1823 the Litchfield Female Academy in Connecticut charged $5.00 for the academic tuition that included a major study of geography. In addition to memorization and copying passages from texts, students integrated geography into the ornamental arts. Litchfield students drew maps in ink and shaded the boundaries with diffused watercolor in a manner reminiscent of this example.[12]

The early-nineteenth-century maps worked by female students that we are most familiar with today were usually in the form of flat needlework or three-dimensional embroidered globes. This unusual map of the animal kingdom is framed with delicate theorem painting of roses with thorny stems and leaves. The map itself was probably based on a published source—possibly a French or English prototype—and relied on cartographic conventions that included small ink drawings.[13] From 1664 to 1665, for instance, London cartographer John Seller published

A Mapp of New Jarsey, which includes fine renderings of native animals, very similar in treatment to those seen on this map.[14] Another possible prototype might be a publication such as Edward Topsell's *The History of Four-Footed Beasts and Serpents and Insects* (1658), which illustrates all manner of animals, both real and mythical, and describes their natures.
—S.C.H.

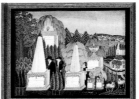

243. OGDEN FAMILY MOURNING PIECE
Ellen Ogden (1795–1870)
Probably Litchfield, Litchfield County, Connecticut
1813
Watercolor and ink on silk, with original reverse-painted eglomisé mat in original gilded wood frame
22⅞ × 29 in. (sight) (29 × 36⅛ × 2 in. framed)
P1.2001.270

INSCRIPTIONS:
Recto, on six grave plinths, left to right, ink: *In Memory of a Brother / Burr Ogden / D[i]ed 1st. Oct. 1796. / Æ 4 Years / Thy growing beauties / wither'd ere t'was noon, / And though must sleep / Ben[eath] the silent Tomb; To the Memo[ry] of a Sister / Nabby Ogden / Obt. 18th July 1810. Æ. 23 Years / Let me not charge / on Providence a crime / Who call'd thee blooming / to a happier clime; In Memory of a Brother / Burr Ogden the 2d. / Who departed this life / 23d. Janr. 1792 / Æ 2 Years / Short was thy paſsage / to the friendly Tomb; To the Memory of a Brother / Serene S. Ogden / Died 20th. April 1810 / Æ 2 Years / No more the rose can bloom / upon thy cheeks, / Nor playful smiles thy parent[s] hearts elate; To the memory / of a Brother / who died in / infancy. / 23th Feba 1798; To the memory / of a Brother / who died in / i[n]fancy. / 26 Feb 1798;* mat, ink and gold leaf: *E. OGDEN. 1813.*

PROVENANCE:
Betsy Cushing Whitney, Manhasset, Long Island, N.Y.; Sotheby's sale 7293, "Whitney Estate," 1/99, lot 1081.

Ellen Ogden's mourning piece belongs to a group of ten similar memorials and is the only one with the date of execution inscribed on the glass mat of its original frame. Eight of these paintings have been published, and seven of the nine schoolgirls who painted them lived in three Connecticut towns. Ellen Ogden, Julia Ann Burr (1800–1819), and Sarah Turney (1801–?), who painted two pieces, were from Fairfield; Ruth Norton Upson (1795–1874) and Betsey Catlin (1799–1893) were from Bristol; and Sally Miller (c. 1783–?) and Delia Coe (1799–1846) were from Middletown. Positive identification is lacking for girls who painted pieces dedicated to McQueen family members of Branford, Connecticut, and to members of an unlocated Gilbert family.[15]

The descendants of Betsey Catlin and Delia Coe left convincing evidence that their memorials were painted while the girls were students at Sarah Pierce's Female Academy in Litchfield, Connecticut.[16]

11 Anita Schorsch, *Images of Childhood: An Illustrated Social History* (Pittstown, N.J.: Main Street Press, 1979), p. 118.

12 Lynne Templeton Brickley, "Sarah Pierce's Litchfield Female Academy," in Catherine Keene Fields and Lisa C. Kightlinger, eds., *To Ornament Their Minds: Sarah Pierce's Litchfield Female Academy, 1792–1833* (Litchfield, Conn.: Litchfield Historical Society, 1993), pp. 34–47, 102–3.

13 Alice Hudson, map division, New York Public Library, e-mail to the author, May 23, 2000 (AFAM files).

14 E. McSherry Fowble, *Two Centuries of Prints in America, 1680–1880* (Charlottesville, Va.: Univ. Press of Virginia in association with Winterthur, 1987), p. 34.

15 See Sarah Turney's two pieces in Martha V. Pike and Janice Gray Armstrong, *A Time to Mourn: Expressions of Grief in Nineteenth-Century America* (Stony Brook, N.Y.: Museums at Stony Brook, 1980), p. 155, fig. 98, and *Antiques and the Arts Weekly* (July 15, 1994): 167; see Betsey Catlin's

work in Anita Schorsch, *Mourning Becomes America: Mourning Art in the New Nation* (Clinton, N.J.: Main Street Press, 1976), fig. 37; see Ruth Norton Upson's in *Connecticut Historical Society Bulletin* 22, no. 2 (April 1957): 61; see Delia Coe's in Emily Noyes Vanderpoel, *More Chronicles of a Pioneer School* (Cambridge, Mass.: Univ. Press, 1927), opp. p. 232; see the McQueen family's in catalog for Christie's sale 6742 (1/89, lot 392); and see the Gilbert family's in Schorsch, *Mourning Becomes America,* p. 128, fig. 36. Julia Ann Burr's unpublished example is in the collection of the Middlesex County Historical Society, Middletown, Conn., and Sally Miller's unpublished work is in the collection of MMA.

16 The Catlin and Coe memorials were given to the Litchfield County and Middlesex County historical societies, respectively, with notes from the donors about their origins at Miss Pierce's academy.

Miss Pierce's renowned school existed from 1792 until 1833 and attracted more than three thousand students from throughout America and even farther afield.[17] Unfortunately, complete enrollment records have not survived, although similar memorials are attributed to her school because of documented examples. Miss Pierce is known to have had various unrecorded assistants who taught ornamental arts. Consequently the woman responsible for these impressive compositions remains unknown, and whether or not similar pieces were created under her instruction elsewhere is undetermined.[18]

On nine of the related memorials, the mourners vary in number from six to twelve, but Ellen Ogden pictured only herself and her parents, for her painting commemorates the deaths of her six siblings—one older sister and five younger brothers. Ellen was the daughter of Sturges Ogden (1762–1835) and Zoa Thorp (1763–1832), of Fairfield. She married Ebenezer Silliman (1789–1864). They are both buried close to Ellen's parents and siblings in Fairfield's Greenfield Hill Cemetery. No evidence that they had children has been found.

—B.R.

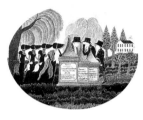

244. HURLBURT FAMILY MOURNING PIECE
Probably Sarah Hurlbut (1787–1866)
Connecticut
c. 1808
Watercolor and ink on paper
17 × 20 in. oval (sight)
P1.2001.271

INSCRIPTIONS:
Recto, on three grave plinths, left to right, ink: *Sacred / to the memory of / Lemuel Hurlburt / Died Aug.t 15th 1808. / Æt. 58. / How can the heart suppress its sighs, / When death dissolves the dearest ties; / Well may the willow spread its gloom; / It shade[s] the kindest father'[s] [t]omb; / Sacred / to the memory of / Th: Hurlbut / Died Apr.l 23rd 1795 / Æt. 3 yr. 8 mo. / No father's faltering voice / Nor mother's dyin[g]—? / E'er wrung th[e]—? the; / Sacred / to the memory of / Hannah H. / Died Sept. 28th 1776 / Æt. 1 yr. 4 mo. / sleep on sweet—? / The orphan's —? / Can ne'er—?*

PROVENANCE:
David Pottinger, Topeka, Ind.; Steve Miller, New York; Hirschl & Adler Folk, New York, 1987.

EXHIBITED:
"Young America: A Folk Art History," MAFA at IBM Gallery of Science and Art, New York, 1986.

PUBLISHED:
Bishop, Robert, and Jacqueline Marx Atkins. *Folk Art in American Life.* New York: Viking Studio Books in association with MAFA, 1995, p. 45.
Kogan, Lee, and Barbara Cate. *Treasures of Folk Art: Museum of American Folk Art.* New York: Abbeville Press in association with MAFA, 1994, p. 137.
Mellow, James R. "Art: Schoolgirl Paintings." *Architectural Digest* 44, no. 12 (December 1987): 144.

A neoclassical vocabulary infused the decorative arts in Europe following the discovery of archaeological sites at Herculaneum and Pompeii during the 1740s. Ancient Greek and Roman funerary forms captured the popular imagination and inspired classical attitudes of mourning on ceramicware, furniture, and memorial paintings. By the end of the eighteenth century, this vocabulary had reached the recently formed American republic and struck a responsive chord, especially after the death of George Washington in 1799. In Europe, classical mourning poses and iconography had been used by artists such as Angelica Kauffmann to memorialize historical and literary heroes. In young America, mourning art—based upon published images after Kauffmann—was democratized to recognize personal loss as well. In its American interpretation, classical elements were combined with Christian symbols, such as cleansing waters, houses that represented the material world left behind, and trees with specific religious meaning, all set in a Christian garden. Mourning pieces embroidered in silk on silk or executed in watercolor became popular as artistic exercises in female academies.

This watercolor memorializes Lemuel Hurlburt (1750–1808) and two of his young children, who died in 1776 and 1795.[19] Hurlburt was a farmer in Newington, Connecticut. In 1773 he married Tabitha Nott (1752–1813), and they moved to West Hartford. The memorial was probably painted by their daughter Sarah, who would have been twenty-one at the time and possibly a student in a Hartford school, though none has yet been identified. The repetition of the slim figures robed in black, their faces obscured by coal-shovel bonnets, creates a wonderful and seemingly unique visual rhythm, as another composition like it is not known.

—S.C.H.

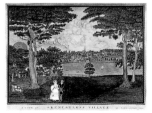

245. A VIEW OF SKENEATLESS VILLAGE
Fanny A. Coney (1814–1838)
Portland, Chautauqua County, or Skaneateles, Onondaga County, New York
1832
Watercolor on paper
14⅛ × 17¾ in. (sight)
P1.2001.272

INSCRIPTION:
Recto, ink: *A VIEW OF SKENEATLESS VILLAGE BY FANNY A. CONEY 1832.*

PROVENANCE:
Christie's sale 7000, 1/90, lot 545.

17 Brickley, "Sarah Pierce's Litchfield Female Academy," p. 69.
18 The monuments with tall obelisks, the decoration on the plinths, the shape of the willow trees, and various other elements strongly suggest that the teacher responsible for these mourning pieces was a former student of Lydia Bull Royse in Hartford, Conn.
19 Betty Ring, letters to the author, June 1 and 11, 2000. Ring identified the Hurlburt family in the Connecticut census of 1790 and in Henry R. Stiles, *The History of Ancient Wethersfield*, vol. 2

(1904; facsimile, Somersworth, Conn.: Wethersfield Historical Society, 1975), pp. 447, 450. Lemuel Hurlburt's death date is published in Stiles as 1815, but the 1808 date on the mourning piece is confirmed in death notices that appeared in the *Hartford Courant* (Aug. 17, 1808), the *(Hartford) American Mercury* (Aug. 18, 1808), and the *Litchfield Gazette* (Aug. 24, 1808). His inscription in the West Hartford Cemetery lists his death as "Aug. 15, 1808 58 years."

By the nineteenth century, published images were a well-established resource for schoolmistresses, who used such images as prototypes for needlework and other exercises for their female students. By the time Fanny A. Coney painted this view of Skaneateles, watercolor had largely replaced expensive and painstaking needlework projects, but exercises were still based on copy patterns.[20] Coney's watercolor is almost identical to an engraving based on a sketch by John J. Thomas, who also contributed a history of Skaneateles that was printed in the Philadelphia publication *Ariel Magazine* in 1830.[21] Such engraved views, often accompanied by town histories, were especially popular after the opening of the Erie Canal and the ensuing expansion in towns and cities along its path. Coney closely follows the major features and the smallest details of the engraving, including the trees on either side and the cloud formations in the sky. Her original touches include a large sun behind the trees on the left and the couple strolling arm in arm in the foreground. This last is an intriguing addition that may have held personal meaning for Coney, as she was married to Joseph Lockwood within a year of executing the watercolor.

The view is from the west side of Skaneateles Lake, the third deepest of the Finger Lakes. The most prominent architectural feature in the engraving and the watercolor is the Presbyterian church in the distance. Reflecting changes in both physical and cultural landscapes, the church was originally the center of community life. But by 1830, when the Thomas view was published, the center of town had shifted to the waterfront, where a recently built Episcopal church is situated.

Coney was the only daughter of John Russell Coney and Sally Sage Keyes. The Coney family, like many New England Yankees, had moved westward into New York State at the end of the eighteenth century. John Coney, the son of a Revolutionary War patriot, was a prominent member of Portland society, operating a tavern, an ashery, and other business concerns. It is not clear whether Coney produced this work in Portland, where she was born in 1814, or in Skaneateles; both locations offered academies for female education. She was eighteen when she made the watercolor, and it is unclear whether she was still a student. Coney died in 1838 and is buried in nearby Brockton.[22] —S.C.H.

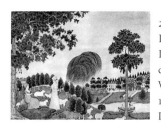

246. RIVER TOWNSCAPE WITH FIGURES
Prudence Perkins (dates unknown)
Possibly Rhode Island
c. 1810
Watercolor on paper
18¼ × 22¼ in.
P1.2001.273

PROVENANCE:
Mr. and Mrs. Peter H. Tillou, Litchfield, Conn.; Peter Socolof, New York, 1990.

EXHIBITED:
"Nineteenth-Century Folk Painting, Our Spirited National Heritage: Works of Art from the Collection of Mr. and Mrs. Peter Tillou," The William Benton Museum of Art, University of Connecticut, Storrs, 1973.
"The Flowering of American Folk Art, 1776–1876," WMAA, 1974.
"The Woman Folk Artist in America," MAFA, 1979.

PUBLISHED:
Bishop, Robert. *Folk Painters of America.* New York: E.P. Dutton, 1979, pl. 11.
De Pauw, Linda Grant, and Conover Hunt. *Remember the Ladies: Women in America, 1750–1815.* New York: Viking Press in association with Pilgrim Society, 1976, p. 108.
Dewhurst, C. Kurt, Betty MacDowell, and Marsha MacDowell. *Artists in Aprons: Folk Art by American Women.* New York: E.P. Dutton in association with MAFA, 1979, p. 70.
Lipman, Jean, and Alice Winchester. *The Flowering of American Folk Art, 1776–1876.* New York: Viking Press in association with WMAA, 1974, p. 52.
Tillou, Peter H. *Nineteenth-Century Folk Painting, Our Spirited National Heritage: Works of Art from the Collection of Mr. and Mrs. Peter Tillou.* Storrs, Conn.: William Benton Museum of Art, Univ. of Connecticut, 1973, fig. 22.

Among the popular ideas that influenced schoolgirl art in the early years of the nineteenth century was the notion of escaping to Arcadia, a pastoral existence far from the complications of the city. This idea was not confined to landscape views but encompassed works such as this river townscape by Prudence Perkins, in which the "shepherdesses" view the material world from a safe distance across a cleansing river.[23] Mourning needleworks and watercolors also drew upon this association between nature and grace and housed the memorial elements in a natural setting, removed from the earthbound aspects of the town. The influence of the needlework aesthetic, as well as the mourning vocabulary, is clearly at play in this watercolor, in both composition and technique. The town seen in the distance, the trees delineated in stitchlike strokes, and the combination of willows, oaks, and evergreens recall the visual iconography and religious symbolism of mourning art.

—S.C.H.

20 The name of the town is misspelled in the inscription.
21 I am grateful to Pat Blackler, Skaneateles Historical Society, for identifying the view and bringing the engraving and E.N. Leslie's *Skaneateles: History of Its Earliest Settlement and Reminiscences of Later Times* (New York: Andrew H. Kellogg, 1902) to my attention.

22 Horace C. Taylor, *Historical Sketches of the Town of Portland, Comprising also the Pioneer History of Chautauqua County, with Biographical Sketches of the Early Settlers* (Fredonia, N.Y.: W. McKinstry & Son, 1873), p. 338.
23 According to earlier publications, the watercolor is signed "Prudence Perkins," but no signature is visible after reframing.

247. **CHARLES STEPHEN MORGAN AND ALCINDA GIBSON MORGAN**
Martha M. Graham (dates unknown)
Virginia
1830
Watercolor on velvet
16 × 22½ in.
P1.2001.274

INSCRIPTIONS:
Recto, front of podium, ink: *Martha M Graham… / Nov the 10th AD 1830;* on red urn: [illegible]; on yellow urn: *AC [G?] M*

PROVENANCE:
Kate and Joel Kopp, America Hurrah, New York, 1995.

PUBLISHED:
Lefko, Linda Carter, and Barbara Knickerbocker. *The Art of Theorem Painting: A History and Complete Instruction Manual.* New York: Viking Studio Books, 1994, frontispiece.

This is one of two similar paintings on velvet that depict Virginian Charles Stephen Morgan (1799–1859) standing at a podium with a pitcher and a glass, probably in the act of addressing a crowd.[24] Morgan achieved fame at a young age as a talented politician and gifted orator. He was born near Morgantown, Virginia (then West Virginia), and represented Monongalia County in the Virginia House of Delegates in 1820, before he was twenty-one. He served as state senator from 1824 until 1832 and distinguished himself at the Virginia Convention of 1829–1830. In 1832, however, Morgan abandoned politics to pursue a cause in which he deeply believed: prison reform. He became superintendent of the Virginia State Penitentiary and devoted himself to improving conditions for prisoners over the next twenty-seven years. He was also an early preservationist and was instrumental in maintaining historic sites such as Jamestown Island, the location of the first permanent English settlement.[25]

This unusual work is a combination of freehand painting and theorem painting with stencils. The unconventional composition shows Morgan standing beside a woman, probably Alcinda Gibson Moss, whom he married in 1833. They wave to an unseen audience, and Morgan holds a book over the side of the podium that bears the date 1830, the year that ended his delegation to the Virginia Convention. The tall, steepled building on the right has not been identified but resembles a church more than the state penitentiary where Morgan devoted so many years. The two urns with flowers at the bottom flank a branching tree and, combined with other images of abundance and fertility, may represent the union of Morgan and Moss, which resulted in the births of seven children.

—S.C.H.

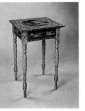

248. **WORKTABLE**
Artist unidentified
New Hampshire, possibly West Nottingham, Rockingham County
c. 1819
Watercolor, pencil, and ink on bird's-eye maple
28⅝ × 18⅝ × 18 in.
P1.2001.275

PROVENANCE:
Ken Miller Auction, Northfield, Mass., sale 9/72; Richard S. Joslin, Chicago; George E. Schoellkopf, New York, 1979.

EXHIBITED:
"Expressions of a New Spirit," MAFA, 1989.
"The Art of Embellishment: Painted and Stenciled Masterworks from the Museum of American Folk Art," Philadelphia Antiques Show and MAFA, 1992.
"A Place for Us: Vernacular Architecture in American Folk Art," MAFA, 1996/97.

PUBLISHED:
Bishop, Robert, and Jacqueline Marx Atkins. *Folk Art in American Life.* New York: Viking Studio Books in association with MAFA, 1995, p. 77.
Kogan, Lee, and Barbara Cate. *Treasures of Folk Art: Museum of American Folk Art.* New York: Abbeville Press in association with MAFA, 1994, p. 195.
Schaffner, Cynthia V.A., and Susan Klein. *American Painted Furniture, 1790–1880.* New York: Clarkson N. Potter, 1997, p. 29.
Sessions, Ralph. "The Art of Embellishment: The Ornamental Painter and His Techniques." In *Philadelphia Antiques Show Catalogue.* Philadelphia: Philadelphia Antiques Show, 1992, p. 33.
Warren, Elizabeth V., and Stacy C. Hollander. *Expressions of a New Spirit: Highlights from the Permanent Collection of the Museum of American Folk Art.* New York: MAFA, 1989, pp. 49–50.

Portrayals of government seats were statements of support for the ideals of the new American republic. State houses, capitol buildings, city halls, courthouses: all were designed with an eye to the larger symbolic role they played in the public consciousness. This worktable belongs to a tradition of depicting such important public architecture in samplers, watercolors, and other arts taught at early-nineteenth-century female academies. The Rhode Island State House provided the focus for a spectacular group of samplers stitched under the tutelage of Mary Balch at her school in Providence.[26] Related, though less common, is the delicate watercolor on the top of this worktable, which depicts the State House in Concord, New Hampshire, after its completion in 1819.[27]

Instructions specifically for painting on wood were offered to female students, although the school where this example was made is not identified. The unfinished table would have been procured from a cabinetmaker and the drawings completed by the student, after which the table was professionally varnished. As in other schoolgirl work, images typically were traced or copied onto paper from a published source or a pattern, probably provided by a teacher, and transferred to the wooden

24 See Rumford, *American Folk Paintings,* pp. 126–27, for the similar version. AARFAM dates their example c. 1838, and the painting shares a similar composition with Graham's example. It is divided into two parts by the central liberty pole, and each side is flanked by a tree. The scene at the left shows Morgan addressing the convention, while the right includes two figures much like those in the composition under discussion. Both feature odd little animals, birds, and butterflies. Because of the similarities, both may have been painted by Graham or were based on similar print sources.

25 E. Lee Shepard, Virginia Historical Society, Richmond, letter to the author, June 6, 2000 (AFAM files), and Virginius Cornick Hall Jr., *Portraits in the Collection of the Virginia Historical Society* (Charlottesville, Va.: Univ. Press of Virginia, 1981), pp. 174–75.

26 *Rebecca Carter Sampler* (cat. no. 259). For an in-depth discussion of these needleworks, see Betty Ring, *Let Virtue Be a Guide to Thee: Needlework in the Education of Rhode Island Women, 1730–1830* (Providence: Rhode Island Historical Society, 1983).

27 Leon W. Anderson, *The State House Sesquicentennial, 1819–1969* (Concord, N.H.: Evans Printing, 1969). The State House was designed by Stuart J. Park and built between 1816 and 1819; it was occupied in 1819.

surfaces, usually the top and four sides.[28] The outline was retraced in ink, and the image filled in with watercolor, one color at a time. Instructions for this type of painting were also available from sources such as Rufus Porter's *A Select Collection of Valuable and Curious Arts and Interesting Experiments* (1825). —S.C.H.

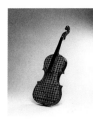

249. VIOLIN
Artist unidentified
Probably New England
c. 1830
Watercolor, pencil, and ink on wood
23½ × 8⅛ × 2¾ in.
P1.2001.276

INSCRIPTION:
Interior, ink on paper label: *Ez Bucaissi* [or Bucaiossi]

PROVENANCE:
Peggy Schorsch, Greenwich, Conn., 1986.

Musical motifs were not uncommon in schoolgirl arts by the second decade of the nineteenth century. Sometimes they were essential elements in scenes based upon literary sources such as poems, myths, and folklore. Other times they were simply representations of specific instruments with classical overtones.[29] Lyres, harps, flutes, and violins embellished forms as diverse as quilts, furniture, paintings, and needlework, and they were executed in silk embroidery, bronze stenciling, and watercolor.

This violin with painted decoration may be the handiwork of a student at a nineteenth-century female academy. Painting on wood was an instruction that many schools offered, though today we are most familiar with finely painted pieces of small furniture, such as sewing tables, that typically were covered on the top and four sides with elaborate scenic views or floral arrangements. This unusual violin with simple diamond patterning may have been a preliminary exercise for a more challenging project, such as a table. The forms that provided the "canvas" for young women were usually professionally made and left unfinished, and this violin is no exception. It is an inexpensive commercial instrument that has been enhanced by its colorful overall diamond pattern. Although there is a label inside the violin, neither the maker nor the artist has been identified.[30] —S.C.H.

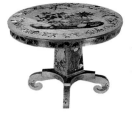

250. SARAH D. KELLOGG CENTER TABLE
Sarah D. Kellogg (1822–1854)
Amherst, Hampshire County, Massachusetts
c. 1841
Watercolor, ink, and pencil on maple
27½ × 35¼ in. diam.
P1.2001.277

INSCRIPTION:
Pedestal, ink: *Amherst, July 9, 1841 Sarah D. Kellogg*

PROVENANCE:
Descended in Kellogg-Knight family, Hartsdale, N.Y.; David A. Schorsch, Greenwich, Conn., 1985.

EXHIBITED:
"America's Painted and Gilded Legacy: Nineteenth-Century Painted Furniture," Philadelphia Antiques Show, 1998.

PUBLISHED:
Schaffner, Cynthia V.A., and Susan Klein. *American Painted Furniture, 1790–1880.* New York: Clarkson N. Potter, 1997, p. 28.
———. "America's Painted and Gilded Legacy: Nineteenth-Century Painted Furniture." In *Philadelphia Antiques Show Catalog.* Philadelphia: Philadelphia Antiques Show, 1998, p. 58.

This center table painted with musical motifs, baskets of fruit and shells, wreaths of flowers and leaves, and pastoral landscapes is an unusually extravagant example of schoolgirl painting on wood. This type of exercise is more frequently associated with small pieces of occasional furniture, such as sewing tables, and dates more commonly to the early years of the nineteenth century. The large Empire-style pillar-and-scroll center table must have represented a great challenge to the patience and skills of the young artist, and, in fact, Sarah D. Kellogg never finished her work. Around the perimeter of the decorative top, pencil outlines indicate where Kellogg intended to fill in the border with more flowers and leaves. As such, it provides a rare insight into the process of amateur decorative painting on wood.[31]

Sarah was the daughter of James (1792–1868) and Phidelia Kellogg (1796–1866). They were married in 1817 in Amherst, where James was listed two years later as a harness and saddlemaker.[32] In 1835 he purchased a wooden faucet business, producing a variety of wooden planes in large quantities. As business expanded, the operation moved to the area that became known as Kelloggsville. His new success may explain his daughter's choice of the large center table for her project. After Sarah's death in 1854, the table remained in her parents' care and was carefully preserved in the family until 1985. —S.C.H.

28 The process is explained in Cynthia V.A. Schaffner and Susan Klein, *American Painted Furniture, 1790–1880* (New York: Clarkson N. Potter, 1997), pp. 29–31.

29 Glee Krueger, "Paper and Silk: The Ornamental Arts of the Litchfield Female Academy, 1792–1833," in Fields and Kightlinger, *To Ornament Their Minds,* pp. 87, 96. See, for instance, the representations of Malvina, based upon Scottish myths, and the watercolor that includes all the accoutrements of early music instruction: violin and bow, flute, harp, horns, and pages of music, with a friendship verse below.

30 I am grateful to Joe Peknik, MMA, for examining the violin and sharing his expertise.

31 This process is explained in Schaffner and Klein, *American Painted Furniture,* pp. 29–31, with reference to primary nineteenth-century sources, such as Rufus Porter's *A Select Collection of Valuable and Curious Arts and Interesting Experiments* (Concord, N.H.: Rufus Porter, 1825).

32 Kenneth W. Knight, "Information on Sarah D. Kellogg Obtained from Records at the Town Hall and the Jones Library in Amherst, Massachusetts" (March 22, 1985). This journal contains handwritten notes detailing the research that Mr. Knight, a descendant, conducted on Kellogg, her family, and the provenance of the table (AFAM files).

Samplers, Pictorial Needlework, and Painting on Silk: Boarding School Lessons in Early America

In the ancient world and throughout the Middle Ages, sewing was a universal and essential domestic skill, and ornamental needlework was a woman's most accessible and acceptable means of artistic expression. Sewing skills were passed down through successive generations of women, but when more formal education became available to European children of the rising middle classes during the fourteenth and fifteenth centuries, needlework was the primary subject of girls' instruction, and a teacher's success depended largely on the quality of her students' work. The custom of working the embroideries we now know as samplers, as well as the word to describe them, probably emerged as early as the sixteenth century, and an Anglo-French dictionary of 1530 defines a sampler as "an exemplar for a woman to work by."[33] From the Renaissance until the Industrial Revolution, samplers remained a standard part of a girl's education, and the period between 1640 and 1840 saw this practice produce the largest body of historical needlework now extant. In 1806, when sampler making was at its peak, it was defined as "a piece of girls' needlework; a pattern."[34] But the custom was fading from memory by 1879, when *McGuffey's Fifth Eclectic Reader* explained to American schoolchildren that a sampler was "a needlework pattern; a species of fancy-work formerly much in vogue."[35]

By the time those fifth graders reached adulthood, this "species of fancywork" had become of interest to collectors, and in England and America the best-known early collectors were men. Prominent in Britain was Marcus Bourne Huish (1845–1921), the author of *Samplers and Tapestry Embroideries,* which was the first book devoted solely to these subjects.[36] In America, New York art director Alexander W. Drake (1843–1916) formed an impressive collection that was widely exhibited before 1910, and well before 1920 a number of prominent women also were collecting.

By comparison, collecting was somewhat dormant at midcentury, but interest was dramatically revived about 1966 when Theodore H. Kapnek, a dynamic Philadelphia businessman, aggressively proceeded to assemble a superior collection; it was exhibited at the Museum of American Folk Art in 1978. Since then, collecting samplers has continually escalated, partly because of their inherently satisfying qualities: the pieces were normally worked by children and usually signed and dated, they were never created to be sold, and, until very recent years, they were invariably authentic.

Surprisingly, despite their appeal and the many informative publications devoted to them, samplers and needlework pictures have not been widely understood. Only recently have collectors gradually begun to relinquish the belief that these objects reflect the artistic impulses of the children who worked them, when in reality, the designs were the teacher's choice, and she may have given the same pattern to every child in the class! The wonderfully appealing pictorial samplers so eagerly sought today should, indeed, be credited to the often anonymous schoolmistresses who have been the most neglected folk artists of early America. Samplers and needlework pictures may, in fact, become our key to the rediscovery of many exceptionally talented women. —B.R.

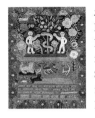

251. Adam and Eve in Paradice
Lydia Hart (dates unknown)
Boston
1744
Silk on fine linen
11½ × 9 in.
P1.2001.278

INSCRIPTION:
Recto, silk thread: *Adam and Eve In Paradice That Was The / ir Pedigree They Had A Grant Never To / Die Would They Obedient Be. 1744*

PROVENANCE:
Skinner sale 927, 10/83, lot 208.

PUBLISHED:
Bishop, Robert, and Jacqueline Marx Atkins. *Folk Art in American Life.* New York: Viking Studio Books in association with MAFA, 1995, p. 100.
Ring, Betty. *Girlhood Embroidery: American Samplers & Pictorial Needlework, 1650–1850,* vol. 1. New York: Alfred A. Knopf, 1993, p. 43.

Lydia Hart worked the most visually appealing example within Boston's earliest known group of samplers which presently dates from 1724 to 1754. Nine pieces portray nearly identical figures of Adam and Eve above similar beasts, birds, and bugs. They also include elegant renditions of the Scottish thistle and Tudor rose, signifying the 1603 union of Scotland and England upon the ascension of James I (1566–1625).

Lydia's work is the first to have what became a characteristic border for these and later eighteenth-century pastoral samplers, but its solidly worked background is unique. Earlier pieces by Mehetabel Done (1724), Martha Butler (1729), and Abigail Pool (1737) depict Adam and Eve beneath borderless alphabets and band patterns. In 1734 Ann Peartree and Elizabeth Langdon worked nearly identical borderless pictorial samplers with similar motifs on brown linen. More closely related to Lydia's work are samplers by Rebekah Owen (1745), Sarah Lord (1753), and Mary Lord (1754), with the same borders and gardens.[37] Rebekah and Mary worked the same inscription as Lydia.

Lydia's identity remains uncertain. The Lydia born in Boston to Elias and Lydia Hart on September 12, 1719, is unlikely to have worked this at

33 John Palsgrave, *Lesclarcissement de la langue francoyse,* n.p.
34 Noah Webster, *A Compendious Dictionary of the English Language* (Hartford, Conn.: n.p., 1806), p. 265.
35 New York: American Book Company, 1879, p. 167.

36 London: Longmans, Green, 1913.
37 For five of the nine samplers mentioned here, another closely related example, and the best-known English prototype, see Ring, *Girlhood Embroidery,* vol. 1, pp. 37–41, figs. 33–37, 39, and the catalog for Sotheby's sale 7010 (6/97, lots 330, 331, 332).

the age of twenty-four.[38] Among the nine pieces described, the known ages of six makers range from nine to thirteen years. A Lydia of appropriate age was born in Northington, Connecticut, to Joseph and Mary Bird Hart on August 8, 1728. Her father was a shoemaker, deacon of the church, and a town magistrate.[39] Quite possibly his daughters were educated in Boston. This Lydia married Noah Gillet (1718–1790) on December 15, 1748, and their ten children were born in Farmington, Connecticut.[40]

No woman is known to have kept a Boston girls' school from 1724 through 1754, but circumstantial evidence suggests that these samplers may have been worked under the instruction of Susanna Hiller Condy (1686–1747) and her sister-in-law Abigail Stevens Hiller (?–1775), who advertised her school from February 1748 until May 1756.[41] Four samplers dated 1765 to c. 1772 have Lydia's border and similarly worked flowers, including one by Mary Welsh, whose sister Hannah married Abigail's son Joseph (1721–1758).[42] —B.R.

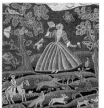

252. HANNAH CARTER CANVASWORK PICTURE
Hannah Carter (dates unknown)
Boston
c. 1748
Silk and wool on fine linen
21 1/16 × 18 7/8 in.
P1.2001.279

INSCRIPTION:
Recto, silk thread: *HANNAH CARTER*

PROVENANCE:
Skinner sale 732, 2/81, lot 331; Stephen Score, Essex, Mass., 1981.

EXHIBITED:
"Expressions of a New Spirit," MAFA, 1989.

PUBLISHED:
Kogan, Lee, and Barbara Cate. *Treasures of Folk Art: Museum of American Folk Art.* New York: Abbeville Press in association with MAFA, 1994, p. 294.
Rebus Inc. *American Country: The Needle Arts.* Alexandria, Va.: Time-Life Books, 1990, p. 25.
Warren, Elizabeth V., and Stacy C. Hollander. *Expressions of a New Spirit: Highlights from the Permanent Collection of the Museum of American Folk Art.* New York: MAFA, 1989, p. 137.

Hannah Carter's elegant lady in a pastoral setting belongs to colonial Boston's most famous form of needlework, featuring the so-called fishing lady motif. It first captured the attention of collectors and scholars when seven canvaswork pictures featuring an identical lady

holding a fishing pole were published in 1923.[43] It was 1941, however, before convincing evidence was offered that these and related pastoral embroideries were worked by young girls who were attending Boston boarding schools.[44] Twelve fishing ladies were recorded within a group of fifty-eight related pieces, and eventually they all became known as "fishing lady" pictures, with or without the pole or the lady. Today, seventeen pieces that depict the fishing lady are known, but only six makers have been identified, and the schools they attended have defied discovery. The close similarity of motifs in Hannah's embroidery, especially the flowering tree at left, leaves little doubt that she was taught by the fishing lady instructress.[45]

The artist's identity may never be proven, but the most likely Hannah Carter was born in Boston on August 31, 1732. She was the eldest child of shipwright Ralph Carter (1700–?) and Sarah Bomer Thompson (1705–?), who were married by Dr. Joseph Sewall at the Old South Church on November 21, 1731.[46] She may also have been the Hannah Carter who married rope maker Thomas Ayres (1728–?) on July 12, 1753.
 —B.R.

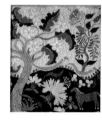

253. CREWELWORK PICTURE
Artist unidentified
New England, probably Massachusetts
c. 1750–1760
Wool on linen
9 × 7 3/8 in.
P1.2001.280

PROVENANCE:
Bertram K. and Nina Fletcher Little, Brookline, Mass.; Sotheby's sale 6526, "Little Collection, Part I," 1/94, lot 298.

This delightful crewelwork picture bears no clue to its maker's identity. Its small size suggests that she was very young, and after it was finished and framed, she must have smiled whenever she saw the result. Below the tangled branches of its flowering tree, a white-maned red horse seems undaunted by the giant carnation, and above them a mammoth butterfly is attracted to a cascade of coral-colored berries, while scattered fruit on the ground is about to be eaten by slithering wormlike creatures with white collars. On the left, a spotted bird carries a berry in its mouth.[47]

Another, more complicated, picture was probably worked under the same instruction. It has eight people in a garden with plants in equally

38 This was probably the Lydia Hart who worked a borderless band sampler inscribed "Boston" and dated "February The 4 Day 1731" (collection New Hampshire Historical Society, Concord).

39 Alfred Andrews, *Genealogical History of Deacon Stephen Hart and His Descendants, 1632–1875* (Hartford, Conn.: Case, Lockwood, and Brainard, 1875), pp. 169, 181.

40 Wilma Gillet Thomas, *The Joseph Gillet/Gillett/Gillette Family of Connecticut, Ohio, and Kansas* (Chicago, Ill.: Adams Press, 1970), p. 32.

41 *Boston Evening-Post* (Feb. 1, 1748, April 22, 1751, and April 9, 1753), and *Boston Gazette* (June 11, 1754, May 26, 1755, and May 24, 1756).

42 Stephen Huber and Carol Huber, *The Sampler Engagement Calendar 1992* (Old Saybrook, Conn.: 1991), fig. 45, *Calendar 1993*, fig. 38, Elisabeth Donaghy Garrett, "American Samplers and Needlework Pictures in the DAR Museum, Part I: 1739–1806," *The Magazine Antiques* 105, no. 2 (February 1974): 358, and Ring, *Girlhood Embroidery*, vol. 1, p. 53, fig. 51.

43 Helen Bowen, "The Fishing Lady and Boston Common," *Antiques* 4, no. 2 (August 1923): 70–73.

44 Nancy Graves Cabot, "The Fishing Lady and Boston Common," *The Magazine Antiques* 40, no. 1 (July 1941): 28–31, and Cabot, "Engravings and Embroideries," *The Magazine Antiques* 40, no. 6 (December 1941): 367–69.

45 Five fishing ladies seated in front of a similar tree can be found in Bowen, "Fishing Lady," figs. 1, 3, 5, 6, 8. Hannah Carter was about the same age as fishing lady embroiderers Desire Dillingham (1729–1807), Sarah Warren (1730–1797), Eunice Bourn (1732–?), and Mary Avery (1735–?). Sarah and Mary both worked their names and the date "1748" on their pictures, and an anonymous chimney piece is also dated 1748; see Susan Burrows Swan, *A Winterthur Guide to American Needlework* (New York: Crown Publishers, 1976), fig. 24, pl. 4.

46 Hannah's mother was the daughter of shipwright Thomas Bomer and the widow of Benjamin Thompson of Roxbury when she married Carter. The occupations of Hannah's father and grandfather are revealed in *Massachusetts Deeds* 70:17, 18, executed April 11, 1745.

47 These are worked with French knots, outline stitches, and Roumanian couching.

disproportionate array and a tree with similar garlands of coral-colored fruit being plucked by a large spotted bird; above the door of a yellow mansion it is dated "1758." Its maker is also unknown, but it descended in the Chandler family of Worcester, Massachusetts.[48]

Canvaswork pictures were stitched by English girls in the seventeenth century, but Boston's earliest-known canvaswork picture is signed and dated "Ann Peartree 1739."[49] The earliest to advertise such work appears to have been Susanna Condy. In the *Boston News-Letter* (April 27/May 4, 1738), she offered "All sorts of beautiful figures on Canvas for Tent Stick" as well as "Cruels of all sorts." Many other women soon advertised a variety of needlework instruction, but there is no way to specifically distinguish the form shown here and now often described as a crewelwork picture, for the word "crewel," with varied spelling, applied to slackly twisted two-ply worsted yarn, and pictures worked in tent stitch used the same yarn.[50]

The majority of colonial canvaswork is in tent stitch, and only one definitely related group of crewelwork pictures is known. These pictures are often more crudely worked than the Esmerian piece and feature a seated shepherdess usually accompanied by a shepherd in a large black hat. Their school of origin is unknown.[51] —B.R.

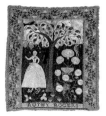

254. RUTHY ROGERS SAMPLER
Ruthy Rogers (1778–1812)
Marblehead, Essex County, Massachusetts
c. 1789
Silk on linen
10½ × 9 in.
P1.2001.281

INSCRIPTIONS:
Recto, silk thread: *RUTHY ROGERS*; verso, ink on paper label: *For Jacquelyn This sampler was made by your great-great-grandmother in the 1700s somewhere, presumably 1730. She was my great-grandmother. Grandfather Andrews first wife. Dec. 25, 1923.*

PROVENANCE:
Descended in family; Skinner sale 1156, 6/87, lot 182.

PUBLISHED:
Kogan, Lee, and Barbara Cate. *Treasures of Folk Art: Museum of American Folk Art.* New York: Abbeville Press in association with MAFA, 1994, p. 297.
Ring, Betty. *Girlhood Embroidery: American Samplers & Pictorial Needlework, 1650–1850,* vol. 1. New York: Alfred A. Knopf, 1993, p. 130.

Ruthy Rogers's bewitching composition features a piquant wasp-waisted, floral-crowned figure amid giant blossoms and curious birds. Unfettered by instructive alphabets or pious maxims, it tends to suggest a happy schoolroom of little girls guided by a cheerful and imaginative schoolmistress. This sampler represents one of four fascinating forms that emerged in Marblehead, Massachusetts, in the late eighteenth and early nineteenth centuries but which eluded the recognition of collectors and scholars throughout most of the twentieth century, until an appealing piece by Betsy Gail appeared at auction in 1980. It featured a winsome figure in profile, much like another in a then-unpublished 1789 sampler by Hannah Stacy.[52] Both the Gail and Stacy families have been traced to Marblehead, and the recognition of Marblehead's exceptional samplers grew quickly.[53]

Perhaps the most spectacular of the group are the many-peopled pieces with silk-worked black backgrounds. The 1784 work of Mary Russell appeared in color in the 1921 edition of *American Samplers,* by Ethel Stanwood Bolton and Eva Johnston Coe (pl. 111), and in 1941 it was classified by Boston scholar Nancy Graves Cabot as a "fishing lady" picture (see also cat. no. 252).[54] Thereafter it and its counterparts became confused with Bristol, Rhode Island, samplers.[55] Bolton and Coe also published Mary Traill's 1791 sampler in 1921 (pl. 46) and correctly assigned it to Marblehead, but the obvious relationship went unrecognized.

The Marblehead samplers are now attributed to schoolmistress Martha Tarr Barber (1734/35–1812), although few specific facts about her teaching have been found. She evidently commenced keeping school after becoming a widow for the second time, in 1780. Eventually the Barber school spanned the entire federal period, for Martha's youngest daughter, Miriam, born in 1775, became her mother's assistant and continued teaching until her death, in 1830.

Ruthy Rogers was the daughter of Marblehead tailor William Rogers (1747–1835) and Ruth Vickery (1751–?). She married shipmaster Benjamin Andrews Jr. (1775–1821) on June 28, 1799, and died of consumption on May 4, 1812, at age thirty-four. She was survived by three of their five children. Her husband married Mary L. Smith of Salem on November 25, 1812, and one of their three sons lived to adulthood. Captain Andrews drowned off Sumatra "by Overseting the Boat."[56] —B.R.

48 Ring, *Girlhood Embroidery,* vol. 1., p. 51. For two other possibly related pieces of this quality, see the shepherdess with piper in the catalog for Skinner sale 1000 (10/84, lot 208), and Mary Taylor Landon and Susan Burrows Swan, *American Crewelwork* (New York: Macmillan, 1970), p. 42.

49 In addition to the canvaswork picture (collection MFA), Ann Peartree worked a sampler in 1734 (collection Cooper-Hewitt National Design Museum, Smithsonian Institution, New York). See Ring, *Girlhood Embroidery,* vol. 1, p. 46, fig. 42, and p. 39, fig. 36, respectively.

50 For a variety of needlework described by teachers, see George Francis Dow, *The Arts & Crafts in New England, 1704–1775* (Topsfield, Mass.: Wayside Press, 1927), pp. 273–76, and Robert Francis Seybolt, *The Private Schools of Colonial Boston* (Cambridge, Mass.: Harvard Univ. Press, 1935), pp. 88–89.

51 At least nine pieces have been recorded; see Ring, *Girlhood Embroidery,* vol. 1, p. 50, fig. 48—the work of Polly Burns is the most elaborate of this group but the color is poorly reproduced here. See also Landon and Swan, *American Crewelwork,* p. 41, and Nancy Jo Fox, *Liberties with*

Liberty: The Fascinating History of America's Proudest Symbol (New York: E.P. Dutton in association with MAFA, 1986), p. 34.

52 Skinner sale 674 (4/80, lot 208).

53 Louise Woodhead, the knowledgeable textile specialist at Skinner, traced the families; for the Stacy sampler and other Marblehead forms, see Ring, *Girlhood Embroidery,* vol. 1, pp. 131–43.

54 Cabot, "Fishing Lady," p. 46. Mary Russell's 1784 sampler entered the collection of Emma Blanxious Hodge (1862–1928), of Chicago, between 1914 and 1921 and was illustrated on the cover of the *Bulletin of the Minneapolis Institute of Arts* for April 1921, when the collection was shown there. After Mrs. Hodge's death, its whereabouts were not known until it was found in damaged condition in a Florida shop by Kay Barrett. It was sold in Christie's sale 8704 (6/97, lot 285).

55 For the 1983 confusion of Marblehead and Bristol samplers, see Ring, *Let Virtue Be a Guide to Thee,* pp. 206–27; for the solution, see Ring, *Girlhood Embroidery,* vol. 1, pp. 190–93.

56 *Vital Records of Marblehead, Massachusetts,* vol. 2 (Salem, Mass.: Essex Institute, 1904), pp. 476, 477.

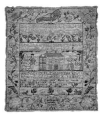

255. ELIZABETH SHEFFIELD SAMPLER

Elizabeth Sheffield (1771–?)
Newport, Rhode Island
1784
Silk on linen
13 × 11 in.
P1.2001.282

INSCRIPTION:
Recto, silk thread: [alphabet] / *ELIZABETH SHEFFIELD / BORN JULY 20 177*[?] / [alphabet]
*ELIZABETH SHEFFI / Now in thy youth take hold on truth / Let Jesus be thy Guide / Be allway mindfull
of the Lord / Prepare to be his Bride / Elizabeth / Sheffield / October / 11 / 1784*

PROVENANCE:
Skinner sale 870, 1/83, lot 182; Stephen Score, Essex, Mass.; Marjorie Schorsch, Greenwich,
Conn., 1983.

EXHIBITED:
"Rhode Island Needlework, 1730–1830," MMA, 1984.

PUBLISHED:
Ring, Betty. *Let Virtue Be a Guide to Thee: Needlework in the Education of Rhode Island Women, 1730–1830.*
 Providence: Rhode Island Historical Society, 1983, p. 74.

Rhode Island samplers were among the first American schoolgirl embroideries to be recognized by serious collectors and textile scholars as a distinctive group with extraordinary visual appeal. This interest was no doubt stimulated by an unprecedented exhibition of 334 New England samplers that was sponsored by the Rhode Island Historical Society in Providence in 1920 and consisted largely of Rhode Island pieces. The following year, Ethel Stanwood Bolton and Eva Johnston Coe completed their incomparable landmark study called *American Samplers,* and they drew particular attention to the similarities of the samplers of Providence and Warren, Rhode Island.[57] Surprisingly they failed to mention that the forms seen in these samplers originally emanated from Newport, the birthplace of Providence and Warren schoolmistresses Mary Balch (1762–1831) and Martha Pease Davis (1743–1806), despite the fact that Hannah Burrill's superb 1770 Newport sampler had been exhibited in 1920. Burrill's sampler represented Newport's many-peopled form of the 1770s with figures in its upper border as well as in its deep central band.[58] Perhaps the authors were aware of the dominant Newport style of the 1780s with birds in the upper border, for in *American Samplers* they described Elizabeth Sheffield's 1784 sampler and revealed that it had been for sale at Koopman's, a Boston shop, in February 1919.[59]

The Sheffield sampler is delicately worked with an unusually pleasing combination of colors in its strawberry band pattern and a unique

spread-winged bird in its upper left corner. Although Elizabeth provided her birthdate, in the typical Newport sampler manner, her identity is uncertain. She may have been the daughter of Amos and Mary Burrington Sheffield who married James Tallman in Newport on October 18, 1787.

Since 1921, awareness of Newport and Providence samplers, as well as those from Warren and Bristol, has increased dramatically, and a great many previously unknown pieces have emerged, including the 1773 Newport samplers of schoolmistress Mary Balch and the 1746 work of her mother, Sarah Rogers Balch (1735–1811).[60] Despite late-twentieth-century efforts, however, the Newport schoolmistress responsible for introducing the sampler styles that would spread throughout Rhode Island is still unknown.

—B.R.

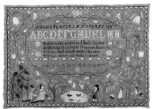

256. MARY COFFIN SAMPLER

Mary Coffin (1790–1864)
Newburyport, Essex County, Massachusetts
1801
Silk on linen
15 × 20½ in.
P1.2001.283

INSCRIPTION:
Recto, silk thread: [alphabets] / *Here in this green and shady bower / Delicious fruits and fragrant
flowers / Virtue shall dwell within this seat / Virtue alone can make it sweet / Mary Coffin AE. 10. 1801.*

PROVENANCE:
Eldred's, East Dennis, Mass., sale 11/88; Stephen Score, Essex, Mass., 1989.

EXHIBITED:
"Every Picture Tells a Story: Word and Image in American Folk Art," MAFA, 1994/95.

PUBLISHED:
Ring, Betty. *Girlhood Embroidery: American Samplers & Pictorial Needlework, 1650–1850,* vol. 1.
 New York: Alfred A. Knopf, 1993, p. 119.

The schools of Newbury and Newburyport, Massachusetts, produced several groups of extraordinarily handsome samplers and silk embroideries during the federal period. Ten-year-old Mary Coffin's sampler is one of the most colorful and appealing examples within a group of eleven pieces worked in Newburyport between 1799 and 1803. Nine of Mary's classmates ranged in age from eleven to seventeen, and, like Mary, all but one worked the same verse. The earliest within this group portrays an exotic tropical scene with thirteen people, and none like it has yet appeared.[61] Nine others share Mary's basic pattern, with minor variations.[62]

57 Ethel Stanwood Bolton and Eva Johnston Coe, *American Samplers* (Boston: Massachusetts
 Society of the Colonial Dames of America, 1921), pp. 367–69.

58 Betty Ring, *Let Virtue Be a Guide to Thee: Needlework in the Education of Rhode Island Women,
 1730–1830* (Providence: Rhode Island Historical Society, 1983), p. 69, fig. 9.

59 Bolton and Coe, *American Samplers,* p. 74.

60 Betty Ring, "Mary Balch's Newport Sampler," *The Magazine Antiques* 124, no. 3 (September
 1983): 501–2.

61 It was worked by twelve-year-old Sally Johnson in 1799 and is illustrated in color in Bolton
 and Coe, *American Samplers,* pl. 104. Sally centered her "shady bower" poem but worked the
 ends of each of its four lines above rather than below the line where it begins.

62 See Sarah Bartlett's (1800), in Ring, *Girlhood Embroidery,* vol. 1, p. 118; Mary Little's (1800),
 described in Bolton and Coe, *American Samplers,* p. 189; Sally Frost Blunt's (c. 1800), in cata-
 log for Sotheby's sale 6942 (1/97, lot 2029); Abigail Prince's (1801), in Betty Ring, *American*

Needlework Treasures (New York: E.P. Dutton in association with MAFA, 1987), p. 12, fig. 18;
Mary Caswell Cook's (1801), in John Hardy Wright, *Vernacular Visions: Folk Art of Old Newbury*
(Newbury, Mass.: Historical Society of Old Newbury, 1994), p. 34, fig. 20; Elizabeth Thurston's
(1802), in the catalog for Skinner sale 1222 (10/88, lot 207); that of Mary Todd (1803), who
worked a frequently found four-line verse that begins "How blest the maid whom circling years
improve," in Elisabeth Donaghy Garrett, "The Theodore H. Kapnek Collection of American
Samplers," *The Magazine Antiques* 114, no. 3 (September 1978): 545; and that of Dolly Pearson
Johnson (1806), who surely attended the same school and worked a simpler form with the
"shady bower" verse and one peacock but lacking people or animals, in Peter Benes, *Old-Town
and the Waterside* (Newburyport, Mass.: Historical Society of Old Newbury, 1986), p. 174. Mary
Ann Perkins's (1802), collection Stevens-Coolidge Place, North Andover, Mass., is unpublished,
as is a well-preserved but unsigned and undated piece in the collection of the Society for the
Preservation of New England Antiquities, Boston.

These samplers have been attributed to the Newburyport school kept by Miss Mary Emerson (1753–1815) with her sisters Elizabeth (1760–1853) and Martha (1764–1827).[63] They were the spinster daughters of Bulkeley Emerson (1732–1801) and Mary Moody (1730–before 1777). Their father, a bookbinder and stationer, served as Newburyport's first postmaster, from May 13, 1775, until his death; their youngest brother, Joseph, was also appointed postmaster.[64]

Mary Coffin was born in Newburyport. She was third among the twelve children of military officer, shipmaster, and shopkeeper Major David Coffin (1763–1838) and his first wife, Elizabeth Stone (1767–1811). When she was fifteen, Mary attended Bradford Academy in Bradford, Massachusetts.[65] On November 12, 1815, she was married to Newburyport merchant Nathaniel Noyes Jr. (1791–1864), and they had seven children.[66]

—B.R.

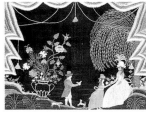

257. SALLIE HATHAWAY NEEDLEWORK PICTURE
Sallie Hathaway (1782–1851)
Probably Massachusetts or New York
c. 1794
Silk on silk
17 × 20¼ in.
P1.2001.284

INSCRIPTION:
Verso, ink on paper label: *Work done by / Mrs Sallie Hathaway Jenkins / in the year / 1787*

PROVENANCE:
Descended in family to Alice and Robert P. Stone, Dayton, Ohio; Sotheby's sale 5905, 10/89, lot 92.

Sallie Hathaway's elegant embroidery on black silk must have brought delight to her parents, for she was their eighth child but the first to survive infancy.[67] Nevertheless, this was an adventurous family. Sallie's father, John Hathaway (1753–1818), was a mariner of Freetown, Massachusetts, who married Sarah Conkling of Long Island in 1774, but they were in the western Massachusetts town of Great Barrington before Sallie was two years old.[68] In 1784 they were among the second group of settlers to arrive in the newly established town of Hudson, New York, where John Hathaway soon became the successful owner of a fleet of ships.

No records reveal where Sallie was educated during the formative years of this port city on the Hudson River. Quite possibly she attended a boarding school in New York City or studied at the recently opened school kept by Miss Betsy Bostwick (1771–1840) in Great Barrington.

Bostwick was the eldest daughter of the highly esteemed minister Gideon Bostwick (1742–1793) and Gesie Burghart (1749–1789). Gideon, a Yale graduate of 1762, first settled in Great Barrington as the director of a classical school. In later years he was ordained and served as minister of the Saint James parish as well as pastor of nearby congregations in New York. The duration of Miss Bostwick's school is unknown, but she may have been responsible for the exceptional schoolgirl art produced in Great Barrington between 1807 and 1811.[69]

At present, the best-known pictorial embroideries on black silk were worked at unknown schools of Salem, Massachusetts, from the 1740s through the 1770s, and in Boston during the 1750s and 1760s.[70] Black silk was also the most popular ground material for Boston coats of arms during the second half of the eighteenth century. As yet, however, nothing even slightly akin to Sallie's silk embroidery has been found, and its place of origin remains a mystery.

Sallie Hathaway married Seth Jenkins Jr. (1776–1831), whose father was among the original proprietors of the town of Hudson and its first mayor, and whose family members continued to be leading citizens for a century thereafter. The couple had nine children, and Sallie's needlework descended in the family of their youngest son, Louis Henry Jenkins (1827–1883).

—B.R.

258. LUCY LOW SAMPLER
Lucy Low (1764–1842)
Danvers, Essex County, Massachusetts
1776
Silk on linen
14½ × 11⅜ in.
P1.2001.285

INSCRIPTION:
Recto, silk thread: [alphabets and numbers] / *O May I Always Ready Stand / With My Lamp Burning In My Hand / May I In Sight Of Heaven Rejoice / & Joy To Hear The Bridegrooms Voice / Lucy Low Her Sampler Aged 12 1776.*

PROVENANCE:
Theodore H. Kapnek; Sotheby Parke-Bernet sale 4531Y, "Kapnek Collection," 1/81, lot 127.

EXHIBITED:
"A Gallery of American Samplers: The Theodore H. Kapnek Collection," MAFA, 1978/79.
"Samplers: Skills and Sentiments," Philadelphia Antiques Show, 1979.
"Expressions of a New Spirit," MAFA, 1989.
"Every Picture Tells a Story: Word and Image in American Folk Art," MAFA, 1994/95.

63 Wright, *Vernacular Visions*, p. 34.
64 Benjamin Kendall Emerson, *The Ipswich Emersons, A.D. 1636–1900* (Boston: David Clapp and Son, 1900), pp. 124, 174–75.
65 *Semi-Centennial Catalogue of the Officers and Students of Bradford Academy, 1803–1853* (Cambridge, Mass.: Metcalf, 1853), p. 41.
66 In 1850 their four sons and three daughters, then aged fifteen to thirty-four years, were still living in their household. See *1850 Census of Newburyport, Massachusetts*, p. 401.
67 They later had five sons and four daughters, but only the daughters lived to adulthood.
68 John and Sarah Hathaway signed a deed (19/562) in Great Barrington on March 25, 1784,

quitclaiming property in Adams, Mass., to John's father, Isaac; see Elizabeth Starr Versailles, *Hathaways of America* (Northampton, Mass.: Gazette Printing, 1970), pp. 261–62.
69 In 1808 nine-year-old Nancy Sibley signed and dated an exceptional sampler named *Grt Barrington*. This sampler has alphabets and numerals above a pastoral scene that was worked with silk and chenille, partly painted on appliquéd cotton, and surrounded by an appliquéd black silk border filled with silk-worked floral patterns and banners with inscriptions in silver metallic threads; the sampler also contained a silk-worked basket with applied painted paper fruit. The school of its origin is unknown. See Ring, *Girlhood Embroidery*, vol. 1, p. 17.
70 For Boston and Salem embroideries on black silk, see ibid., pp. 54–59, 64, 69–75, 100–104.

PUBLISHED:

Kogan, Lee, and Barbara Cate. *Treasures of Folk Art: Museum of American Folk Art.*
 New York: Abbeville Press in association with MAFA, 1994, p. 296.
Krueger, Glee F. *A Gallery of American Samplers: The Theodore H. Kapnek Collection.* New York:
 E.P. Dutton in association with MAFA, 1978, p. 26.
Ring, Betty. *Girlhood Embroidery: American Samplers & Pictorial Needlework, 1650–1850,* vol. 1.
 New York: Alfred A. Knopf, 1993, p. 110.
Schaffner, Cynthia V.A. *Discovering American Folk Art.* New York: Harry N. Abrams, 1991, p. 22.
Warren, Elizabeth V., and Stacy C. Hollander. *Expressions of a New Spirit: Highlights from the
 Permanent Collection of the Museum of American Folk Art.* New York: MAFA, 1989, p. 136.

Below her alphabets and above a colorful scene, Lucy Low worked a slight variation of the sixth verse of *A Midnight Hymn* by English theologian Thomas Ken (1637–1711).[71] These lines do not apply to earthly marriage but to the acceptance of death and the joy of heaven with Christ as the bridegroom of the church. They also appear on the 1757 Boston samplers of Mary Simpkins and Prudence Clark and in Mary Gale's work of 1787.[72]

In 1776 Lucy was the youngest of three first cousins who worked similar scenes below different pious inscriptions.[73] Obviously they were attending the same school in Danvers, or perhaps in Salem; the part of Salem known as Salem Village became the town of Danvers in 1752. These may be the earliest samplers within a group that features a rose tree flanked by stubby trees, and later pieces often have pineapple-like flowers in the corners of a surrounding floral vine border.[74] Many talented women were teaching in Salem and adjacent towns during the last quarter of the eighteenth century. Although the schoolmistress who introduced this form remains unknown, her typical motifs were favored until at least 1801.

Lucy was the daughter of Major Caleb Low (1739–1810) and Sarah Shillaber (1739–1815), of Danvers, and it was a seafaring family. Lucy married Captain John Frost (1758–1829) in 1781. In 1784 her father owned the 152-ton brigantine *Lucy,* which was perhaps named for her. It was commanded by her husband, who later became its owner. The Frosts had seven children, each of whom married and had issue except Stephen (1794–1808), who died in Havana. Three of their six sons became sea captains and four resided for most of their lives in Virginia. Their fourth child and their only daughter, Sarah Frost Winchester (1789–1875), outlived all her brothers.[75]

—B.R.

259. REBECCA CARTER SAMPLER
Rebecca Carter (1778–1837)
Providence
1788
Silk, metallic thread, and human hair on linen
19¼ × 13½ in.
P1.2001.286

INSCRIPTIONS:

Recto, silk thread: [alphabets and numbers] / *Honor and renown. fhall the ingenious / crown / State House / Rebecca / Carters / work made / AD 1788 / R C;* verso, ink on paper label: *This sampler was begun by my eldest sister the late / Mrs Ann Brown wife to the Honourable Nicholas Brown, / while she was at school in Newport at Mrs. Wilkinson, (I think.) / She was then about 9 years old. Finish'd by me at Miss Balches / School when I was about 16 years; I design it for my beloved / Son Amos Throop Jenckes and wish him to preserve it in / remembrance of his Aunt, and of his affectionate Mother / Rebecca C. Jenckes…. When this was finished my late honoured Father, John Carter Esq. / employed Mr. John Carlile to frame it.— immediately he was much / pleased with it…. 1825. June 8th….*

PROVENANCE:

Descended in family to the Honorable Mrs. Pepys; Sotheby's sale 5736, 6/88, lot 279.

EXHIBITED:

"The John Brown House Loan Exhibition of Rhode Island Furniture," The Rhode Island
 Historical Society, Providence, 1965.
"Let Virtue Be a Guide to Thee: Needlework in the Education of Rhode Island Women,
 1730–1830," The Rhode Island Historical Society, Providence, 1983/84.
"Rhode Island Needlework, 1730–1830," MMA, 1984.
"A Place for Us: Vernacular Architecture in American Folk Art," MAFA, 1996/97.

PUBLISHED:

[Ott, Joseph K.] *The John Brown House Loan Exhibition of Rhode Island Furniture.* Providence: Rhode
 Island Historical Society, 1965, p. 143.
———. "The John Brown House Loan Exhibition of Rhode Island Furniture." *Antiques* 87, no. 5
 (May 1965): 571.
Ring, Betty. *Girlhood Embroidery: American Samplers & Pictorial Needlework, 1650–1850,* vol. 1.
 New York: Alfred A. Knopf, 1993, p. 182.
———. *Let Virtue Be a Guide to Thee: Needlework in the Education of Rhode Island Women, 1730–1830.*
 Providence: Rhode Island Historical Society, 1983, p. 123.
———. "Mary Balch's Newport Sampler." *The Magazine Antiques* 124, no. 3 (September 1983): 505.

Rebecca Carter's sampler provides everything any collector could seek in an eighteenth-century American sampler. Its flawless silk stitchery is exquisitely lustrous, it portrays the historically important 1762 State House in Providence, and it contains the commendable maxim "Honor and renown shall the ingenious crown."[76] Its six elegant and lively figures have golden blond human hair, and its maker signed it with her name and initials and dated it 1788. The back proves to be equally exceptional. There Rebecca's adult notations reveal that it was begun by her sister Ann at the long-forgotten school of Abigail Wilkinson in

71 The fourth line of verse six reads "When e'er I hear the Bridegroom's Voice!"; see *Morning,
 Evening, Midnight: 3 Hymns by Thomas Ken* (New York: Peter & Katharine Oliver, Publishers, 1937),
 pp. 25–28.
72 See verse 496 in Bolton and Coe, *American Samplers,* pp. 47, 75, 317.
73 For the samplers of Elizabeth and Mary Shillaber, aged thirteen and fourteen, see catalog for
 Skinner sale 1332 (6/90, lot 81), and Ring, *Girlhood Embroidery,* vol. 1, p. 111.
74 See the 1788 sampler of Abigail Purintun, who was born in Danvers on March 3, 1778, in Susan
 Burrows Swan, *Winterthur Guide to American Needlework* (New York: Crown Publishers, 1976),
 p. 14; Lydia Burrill's (1789) in the catalog for Sotheby's sale 6942 (1/97, lot 2037); and Sally
 Oliver's (1801) in the catalog for Skinner sale 756 (6/81, lot 244).

75 John Eldridge Frost, *The Nicholas Frost Family* (Milford, N.H.: Cabinet Press, 1943), pp. 21, 28,
 42–43.
76 This building still exists. Newport was the first state capital, but between the 1750s and 1854
 there were two, Newport and Providence. When built in 1762, the five-bay State House was
 about sixty-five-feet wide and thirty-six-feet deep. The east and west facades were alike but
 with a parade on the west side that was fenced in 1767. Rebecca's sampler depicts a narrowed
 version of the west facade on Benefit Street. In the same year, Eliza Waterman worked a simi-
 lar sampler with a five-bay State House. See Ring, "Mary Balch's Newport Sampler," p. 504.

Newport and completed by Rebecca at Miss Mary Balch's school in Providence—leading to the rediscovery of Mrs. Wilkinson's career—and that its ideally appropriate frame was provided by Providence cabinetmaker John Carlile, thus making it the only eighteenth-century Rhode Island sampler frame of known provenance.

This sampler also testifies to the superb talents of Mary Balch (1762–1831), an irreproachable schoolmistress whose forty-five years of teaching produced what is probably the largest quantity of recognizable needlework known to survive from an early New England school. The epitaph on her gravestone in North Burial Ground in Providence aptly described her as "The first who established a FEMALE ACADEMY in this Town, which by her industry and amiable qualifications attained a high reputation. She was a sincere and tender Friend and her love to God and goodwill to men were conspicuous traits of her character."

Rebecca Carter was born on August 22, 1778, the sixth among twelve children. Her father, John Carter (1745–1814), was born in Philadelphia, and in 1767, after an apprenticeship with Benjamin Franklin, he moved to Providence, where he married Amy Crawford (1744–1806) in 1769. He soon became a prominent bookseller, town postmaster, and publisher of the *Providence Gazette*.[77] Rebecca married Amos Throop Jenckes (1778–1809) in 1801. Their fifth child was an infant when he died in Havana, and only two of their children reached adulthood.[78] Rebecca died on June 20, 1837.

—B.R.

260. NEWBURYPORT NEEDLEWORK PICTURE
Artist unidentified
Newburyport, Essex County, Massachusetts
c. 1805–1810
Silk on linen
16¼ × 17½ in.
P1.2001.287

INSCRIPTION:
Verso, ink on paper label: *Sampler formerly owned by Nancy Todd Morrison, born in 1836 of Newburyport, Massachusetts. Sampler embroidered by a nine-year old Newburyport girl.*

PROVENANCE:
Descended in family of Nancy Todd Morrison; Sotheby's sale 5429, 1/86, lot 439.

EXHIBITED:
"A Place for Us: Vernacular Architecture in American Folk Art," MAFA, 1996/97.

Neoclassicism finally flowered throughout America during the first decade of the nineteenth century, and its most conspicuous evidence in schoolgirl art was a wealth of lustrous urns, willows, and weepers derived from prints commemorating George Washington's death on December 14, 1799. Far more uncommon is this solidly worked silk embroidery featuring an elegant three-story federal mansion within a serene setting. Its delicate flowering garden is carefully protected by a white fence from peacefully grazing sheep and cows and a sprightly horse gamboling beside a sparkling pond, where placid ducks swim. People clad in natty, slim garments appear to pause for conversation as they amble along the gently curving pathway from town, while a young girl observes them from beneath a tree by the lakeside.

Unfortunately, the girl who worked this piece neither signed nor dated it.[79] There is no evidence of how Nancy Todd Morrison (1836–1935) acquired this piece, nor of her presence in Newburyport. She was born in Ripley, Maine, and was third among the four children of Ira Morrison (1798–1870) and Sophia Colby (1801–after 1880). She was educated at the Sanbornton Bridge Conference Seminary and Female College (Sanbornton Bridge, New Hampshire) and at Atkinson Academy (Atkinson, New Hampshire). In 1880 she was described as a teacher and artist in Rowley, Massachusetts.[80] Furthermore, the *Diary of Deacon Joshua Jewett* of Rowley reveals that Morrison taught school there in 1859 and for many years resided with the family of the Reverend John Pike.[81] Like her parents and her siblings, she died in Braintree, Massachusetts, and the embroidery became the property of her niece.

At present this embroidery's closest counterpart was worked by Phebe Carlton of North Andover, Massachusetts. It has a two-story mansion with a fenced front garden, a similar horse near a duck pond in the right foreground, and two little ladies in dresses of about 1796. Its major difference is a silk ground material and a painted sky.[82]

—B.R.

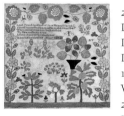

261. LEAH YOUNG SAMPLER
Leah Young (c. 1831–?)
Peters Township, Washington County, Pennsylvania
1847
Wool and linen on linen
25½ × 24½ in.
P1.2001.288

INSCRIPTION:
Recto, wool thread: *Leah Young daughter of Joseph and Mariah C / Young wrought this sampler in the year 1847 / When we devote our youth to God / Tis Pleasing in his eyes / A flour that is offered in the bud / Is no vain sacrafice. Mary Tidball / RV*

PROVENANCE:
W.B. Mollard, Westfield, N.Y.; Edgar William and Bernice Chrysler Garbisch, Cambridge, Md.; Sotheby Parke-Bernet sale 3637, "Garbisch Collection, Part II," 5/74, lot 52.

EXHIBITED:
"The Pennsylvania German: His Arts and Handicrafts," William Penn Memorial Museum, Harrisburg, Pa., 1968.
"Pennsylvania Folk Art," AAM, 1974.

77 John Carter Brown Woods, "John Carter of Providence, Rhode Island, and His Descendants," *Rhode Island Historical Society Collections* (October 1918).

78 For more about Rebecca Carter, see Ring, *Let Virtue Be a Guide to Thee*, pp. 51, 122, 123, endpapers.

79 Titi Halle, a costume authority in New York, derived the most likely approximate date, c. 1805–1810, from the garments.

80 Leonard A. Morrison, *The History of the Morison or Morrison Family* (Boston: A. Williams, 1880), pp. 89, 99–100, 120.

81 "Mr. Ezechi Rogers Plantation, 1639–1850," in Amos Everett Jewett and Emily Adams Jewett, *Rowley, Massachusetts* (Salem, Mass.: Newcomb & Gauss, 1946), p. 295.

82 Stephen Huber and Carol Huber, *The Sampler Engagement Calendar 1994* (Old Saybrook, Conn.: 1993), fig. 31. Phebe was named on the back of this piece. She may have been the Phebe born to Daniel and Mary Kimball Carlton of Andover on March 3, 1786.

PUBLISHED:
Allentown Art Museum, *Pennsylvania Folk Art*. Allentown, Pa.: AAM, 1974, p. 70.
Ring, Betty. *Girlhood Embroidery: American Samplers & Pictorial Needlework, 1650–1850*, vol. 2.
 New York: Alfred A. Knopf, 1993, p. 464.
"Stitch and Learn Samplers." *Good Housekeeping* (March 1990): 150.

Leah Young's bold and exuberant sampler represents a remarkable group that appears to have been unpublished and unknown to sampler collectors until this piece was illustrated as lot 52 in the catalog of the second part of the 1974 sale of folk art from the Edgar William and Bernice Chrysler Garbisch Collection.[83] These three sales consisted of an almost incomprehensible treasure trove of schoolgirl art and many other appealing forms that were then unrecognized and their origins unexplored. Reviewing the catalogs is a reminder of how much was discovered about these objects during the last quarter of the twentieth century.[84] Certainly Leah's sampler was the catalyst leading to the recognition of the latest major group of traditional American samplers, for at least ten samplers are now known to bear the name or initials of schoolmistress Mary Tidball.[85]

 During the 1830s, the sampler-making era was definitely ending as educational reformers sought more academic education for women, and relatively few important groups of embroideries arose in that decade. However, it has been previously recognized that Pennsylvania schools appear to have produced the latest meritorious groups of samplers.[86] What inspired Tidball remains unknown, but from 1836 until 1852 she provided her students with robust dynamic designs and yarns of brilliant colors, and the results are infinitely more appealing than the monotonous Berlin work then in vogue. As with most ingenious women of earlier years, the unanswerable question arises—who taught Mary Tidball?[87]

 —B.R.

262. RICHARD INKSONS DOUBLE POCKETBOOK
Artist unidentified
Possibly Pennsylvania
1776
Wool on linen with silk lining and wool twill tape binding
10½ × 8¼ in. (open)
P1.2001.289

INSCRIPTION:
Interior panel, wool thread: *Richard Inksons 1776*

PROVENANCE:
Ed and Mildred Bohne, Newmanstown, Pa., 1981.

In 1763 an advertisement in the (*Philadelphia*) *Pennsylvania Gazette* for a lost pocketbook listed the contents of one man's "pocket": "Pieces of silver, some small Bills of Paper Money, sundry Invoices of Goods, a Ticket of Leacock Lottery, endorsed Camalt, and a Receipt for Fifty Shillings, in Part of Land, with sundry Endorsements on it."[88] Based upon a survey of similar advertisements in early American newspapers and examples in museum collections, it seems that such worked pocketbooks were most popular from about 1740 until 1790.[89] As opposed to leather pocketbooks, those made in needlework on linen canvas were almost always the product of female hands and were often made as gifts. Both women and men carried them to hold small valuables, but while men's held money and important papers, women's usually contained jewelry, sewing implements, and the like. Pocketbooks were most commonly sewn in the Irish stitch—which was worked quickly and provided a sturdy cover—and were fashioned in two shapes that resemble today's letter-size envelope: a single form closed by a flap and a double pocket that folded over in the center.[90] Those with double pockets often had the owner's name stitched along an edge, inside the fold. The pocketbooks were lined in silk and the edges were usually bound with a wool twill tape or a silk ribbon.

 —S.C.H.

263. POCKET
Artist unidentified
Pennsylvania
c. 1740–1770
Crewel on linen with cotton and linen binding
10¼ × 8¼ in.
P1.2001.290

INSCRIPTION:
Each side of opening, near top, thread: *S1/M F*

PROVENANCE:
Sotheby's sale 5500, 10/86, lot 147.

During the eighteenth century, the term "pocket" referred to a flat pouch, with a slit in the front for access, that was tied around a woman's waist. Pockets were worn either over a dress or under an overskirt, where they could be easily reached. Usually one pocket was sufficient, though they could be worn in pairs. Because eighteenth-century fashion dictated an exaggeratedly wide profile at the hips, the extra bulk added by the pocket was incidental.[91] Although pockets continued to be worn well into the nineteenth century in some areas, as

83 Sotheby Parke-Bernet dispersed the collection in three segments: sale 3595 (1/74); sale 3637 (5/74); and sale 3692 (11/74). The three sales consisted of 583 lots.

84 At that time, needlework from Abby Wright's school in South Hadley, Mass., had not been identified, nor were mourning embroideries and print-work memorials from Mary Balch's school in Providence, work on silk from patterns drawn by Samuel or Godfrey Folwell, typical samplers from Fitzwilliam, N.H., or a typical silk embroidery from the Moravian Seminary in Bethlehem, Pa.

85 In recent years, Lawrence L. Lacquement and his wife, Lee, have diligently pursued the history of Mary Tidball and her school, and their in-depth study of this schoolmistress and the sampler makers will soon be published.

86 Ring, *Girlhood Embroidery*, vol. 2, pp. 450–65.

87 In 1993 discovery of a related sampler of 1838 naming "Mary McCosh" led to speculation that Mary McCosh may have become Mrs. Mary Tidball. This was soon disproven by the

appearance of pieces dated 1836 with Mary Tidball's name. Evidently McCosh, a former Tidball student, had commenced teaching. For the McCosh sampler and another Tidball example, see Huber and Huber, *Sampler Engagement Calendar 1992*, fig. 38, and *Calendar 1993*, fig. 40, respectively.

88 Susan B. Swan, "Worked Pocketbooks," in Betty Ring, ed., *Needlework: An Historical Survey* (New York: Main Street/Universe Books, 1975), p. 53.

89 Ibid.

90 Today this stitch is also known as flame, bargello, and Florentine, but eighteenth-century usage almost always referred to it as the Irish stitch.

91 My gratitude to Linda Baumgarten, Colonial Williamsburg Foundation, for her comments regarding the date of this pocket.

fashions slimmed with the vogue for everything classical, small bags known as reticules became more popular.

Eighteenth-century women used pockets much as purses are used today, to house the items they found necessary to hold close during the day, such as keys, papers, pins, scissors, and other odds and ends. Pockets often received fine needlework embellishment, such as the crewel embroidery evident on this example. American crewelwork, in general, favored fewer stitches than its English counterparts, and this pocket is worked in cross, chain, and outline stitches.[92] —S.C.H.

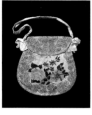

264. RETICULE WITH STILL LIFE
Possibly Ruth Brown (dates unknown)
Brattleboro, Windham County, Vermont
c. 1825
Watercolor and ink on velvet with silk lining
and woven ribbon tie
9 × 8½ in.
P1.2001.291

INSCRIPTION:
Back, ink: *Ruth Brown*

PROVENANCE:
Paul McInnis Inc., Hampton Falls, N.H., Americana sale 1/85, lot 110.

The art of theorem painting, accomplished with the use of stencils, was widely taught at female academies and seminaries during the early decades of the nineteenth century. Still-life compositions of fruit and flowers were the typical compositions, often based upon patterns that were either published or provided by a teacher. Surviving templates show that some compositions required several stencils to create a single arrangement. The taste for still-life and flower painting was nurtured by the proliferation of botanical prints by the end of the eighteenth century. Combined with the increasing availability of watercolors, theorem-painting exercises gained in popularity as an alternative to expensive and time-consuming needlework projects.

Because the theorems were completed with the aid of stencils, each element has a sharply defined edge. The color was pounced against the hollow edge of the stencil and worked toward the center, resulting in the distinctive shading associated with this form. This technique is evident on both sides of the bag, the front decorated with an arrangement of two large flowers and a smaller spray between, the back with a still life of fruit. Both sides are united by a border of spiky pine needles that also adorns the top flap. Ruth Brown has not been identified, and it is not known if she embellished this bag herself or received it as a token of friendship. —S.C.H.

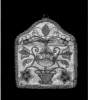

265. POCKETBOOK WITH BASKET OF FLOWERS
Artist unidentified
Pennsylvania, possibly Chester County
c. 1720–1750
Silk and metallic thread on silk over linen with spangles
4½ × 5½ in. (closed)
P1.2001.292

PROVENANCE:
Edgar William and Bernice Chrysler Garbisch, Cambridge, Md.; Sotheby Parke-Bernet sale H-2, "Garbisch Collection," 5/80, lot 861.

In 1597 John Gerard (1545–1612) published *The Herball or Generall Historie of Plantes*, whose illustrations became a primary source for needlework patterns. The basket of flowers stitched on this tiny pocketbook appears to take its cue from one such illustration; the diamond patterning on Gerard's basket and the cross-hatching of a pinecone-like flower are loosely interpreted in needlework stitches.[93] English embroidery traditions greatly influenced American needlework, especially in urban areas, where professional needleworkers advertised their services. Levy Simons, probably once a member of the English Embroiderer's Guild in London, advertised himself in the *New York Mercury* of October 9, 1758, as an "Embroiderer from LONDON," and stated that he "worked in Gold or Silver, shading in Silk or Worsted."[94]

The flowers worked in crewel on this small pocketbook are shaded in silk. The technique, as described in Simons's advertisement, was used to spectacular effect in large-scale projects such as bed furnishings but is less common in this small format. Metallic threads and spangles continued to be used in pictorial needlework of the late eighteenth and early nineteenth centuries, when popular taste dictated neoclassical forms and shimmery silk-on-silk embroideries, with the effect heightened by the use of reflective materials like spangles and mica flakes.[95]

—S.C.H.

266. BED RUG
Artist unidentified
Connecticut River Valley
c. 1790–1810
Wool on woven wool
100 × 96 in.
1995.32.2

PROVENANCE:
Found in Providence; Skinner sale 927, 10/83, lot 200.

EXHIBITED:
"Life in the New World," Selections from the Permanent Collection of the Museum of American Folk Art, Sotheby's, New York, 1987.
"Expressions of a New Spirit," MAFA, 1989.

PUBLISHED:
Bishop, Robert, and Jacqueline Marx Atkins. *Folk Art in American Life.* New York: Viking Studio Books in association with MAFA, 1995, p. 107.

92 Information based on Yolanda van de Krol, "Ladies' Pockets," *The Magazine Antiques* 149, no. 3 (March 1996): 438–45.
93 Virginia Churchill Bath, *Needlework in America: History, Designs, and Techniques* (New York: Viking Press, 1979), frontispiece, p. 81.
94 Susan B. Swan, *Plain & Fancy: American Women and Their Needlework, 1700–1850* (New York: Holt, Rinehart and Winston, 1977), pp. 109–10.
95 My gratitude to Linda Baumgarten, Colonial Williamsburg Foundation, for her comments regarding the date of this pocketbook.

Kogan, Lee, and Barbara Cate. *Treasures of Folk Art: Museum of American Folk Art.* New York: Abbeville Press in association with MAFA, 1994, p. 300.
Warren, Elizabeth V., and Stacy C. Hollander. *Expressions of a New Spirit: Highlights from the Permanent Collection of the Museum of American Folk Art.* New York: MAFA, 1989, p. 141.

In colonial America, the term "rug"—or "rugg," as it was commonly spelled—held different meanings than it does today. "Rug" might connote an expensive table cover, sometimes made in imitation of knotted "Turkey work," or a heavy, handworked pile bedcover. Such bed rugs were once confused by contemporary observers with hooked rugs.[96] Bed rugs, however, are embroidered with a needle and wool thread in a running stitch on a woven wool (or occasionally linen) foundation. The loops are left intact on the surface or are clipped to give a shaggy pile. Hooking, on the other hand, is a later technique that is executed with a special tool to draw individual threads through holes in a heavy canvas or burlap foundation.

Bed rugs represented a massive undertaking on the part of the maker, as all the materials were home manufactured, from shearing the sheep to dyeing, spinning, and weaving the wool, all before plying a needle.[97] Because they were home woven, the foundations are often pieced in two or three lengths. This example is made of three panels that are twenty-four, thirty-seven, and thirty-six and one-half inches wide. Several extant examples of these rare bedcovers originated in Connecticut, and originally they were thought to be particular to that state. In the late 1970s, however, it was established that bed rugs were produced throughout New England, with a concentration in the Connecticut River Valley, from the early eighteenth century to just past the first quarter of the nineteenth.

The designs on bed rugs derived from Jacobean embroidery and imported Indian block-printed bedspreads with flowering tree-of-life patterns known as palampores, and they relate to seventeenth- and early-eighteenth-century American colonial furniture, whose painted decoration was based on English aesthetic concepts. At least one prominent motif can be traced specifically to Richard Shorleyker's *A Schole Howse for the Needle,* published in London in 1632.[98] This is the carnation within a roundel that is repeated to form a border, which appears in the Esmerian example. A small group of similar bed rugs made between 1796 and 1802 all feature this border as well as a color scheme of apricots and light reds on an ivory background.[99]

The Esmerian piece is most like the bed rug made by Eunice Williams Metcalf (1775–?), of Lebanon, Connecticut. In both, the central floral motif is a large carnation with spreading branches and other flowers. Spiky leaves emerge at intervals, and the stem twists to form two stacked elliptical enclosures. A palmette placed at the top center hangs over the carnation. Unlike the other examples in this group, the twisting central vine does not emerge from an urn, and the border of carnations and rondeaux is arranged so that one motif falls in each rounded bottom edge, and an additional pointy flower is encapsulated in each upper corner.

—S.C.H.

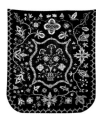

267. CREWEL BEDCOVER
Artist unidentified
New England or New York
1815–1825
Wool with wool embroidery
100 × 84 in.
1995.32.1

PROVENANCE:
Betty Sterling, Vermont; Stephen Score, Essex, Mass., 1983.

EXHIBITED:
"Expressions of Trust: Recent Gifts to the Museum of American Folk Art," MAFA, 1996.

PUBLISHED:
Bank, Mirra. *Anonymous Was a Woman.* New York: St. Martin's Press, 1979, p. 96.
Bishop, Robert, and Jacqueline Marx Atkins. *Folk Art in American Life.* New York: Viking Studio Books in association with MAFA, 1995, p. 110.
Nelson, Cyril, and Carter Houck. *The Quilt Engagement Calendar Treasury.* New York: E.P. Dutton, 1979, p. 43.

This bedcover belongs to a small group of richly embellished early textiles ascribed to the period from about 1760 to 1830.[100] Most are worked on a black, or occasionally brown, twill-woven woolen foundation, and they share a similar composition of a basket of flowers against a field of vines and flowers.[101] Unlike most of the bedcovers in this group, however, this example retains a central medallion format containing the basket of flowers. It is densely embroidered overall, in a combination of large and small floral motifs that gives an impression of symmetry, though no sections are exactly alike. The surface embroidery is in crewel, a worsted yarn of loosely twisted two-ply colored threads with a long history of usage in English embroidery. Pattern books were already disseminating designs suitable for such embroidery by the seventeenth century, the best-known being Richard Shorleyker's *A Schole Howse for the Needle,* published in 1632, which may have served as a source for some of the motifs in this crewel bedcover: "Here followeth certaine patterns of cut workes: newly invented and never published before. Also sundry spots as flowers, birds, fishes, and will fitly serve to be wrought in gold, some in silke, and some with crewell in colors; or otherwise at your pleasure."[102]

96 William L. Warren, *Bed Ruggs, 1722–1833* (Hartford, Conn.: Wadsworth Atheneum, 1972). In 1972 Warren organized the first exhibition to seriously examine American bed rugs. The exhibition discussed the derivation of the terminology, the techniques used in the rugs' manufacture, and their primary decorative schemes. The catalog for the exhibition still stands as the principal source of information about these rare and important early bedcovers.
97 Ibid., p. 16.
98 I thank my colleague Lee Kogan for bringing this to my attention. The motif appears with and without the feathered arc in Shorleyker's important needlework source. It is published without the feathers in Cyril G.E. Bunt, "An Embroidery Pattern-Book," in Ring, *Needlework,* p. 15.

99 This group includes the bed rugs made by Philena McCall of Lebanon, Conn. (1802), Hannah Johnson of New London County, Conn. (1796), Eunice Williams Metcalf of Lebanon, Conn. (c. 1790–1800), and an unidentified maker of Colchester, Conn. (1796). All are illustrated in Warren, *Bed Ruggs.*
100 Related examples are in the collections of AARFAM, the Art Institute of Chicago, the Henry Ford Museum, Dearborn, Mich., and the Wadsworth Atheneum, Hartford, Conn., among others.
101 The basket and flowers on this example are most closely related to the Harriet Dunbar bedcover in the collection of the Wadsworth Atheneum.
102 Bunt, "An Embroidery Pattern-Book," p. 15.

The earliest American embroidery is a direct descendant of needle-work produced in seventeenth-century England by professional, semi-professional, and domestic needleworkers. In America, a naturalism and grace reinterpreted conventionalized English motifs. The designs were freer and less dense and used fewer varieties of stitches: mainly self-couching Roumanian, flat, outline, and stem—though chain, button-hole, herringbone, and loop stitches were also used. Among the forms we associate with American crewelwork are bed furnishings that were usually worked on white linen in fine colored crewels and often took years to complete. This type of bed covering declined after the Revolu-tionary War, but other forms took its place, including woolen bed-covers with surface embroidery in large-scale designs worked in heavier crewels, such as this example. Regional preferences developed in the embroidery patterns, especially in more isolated areas. The group of crewel-embroidered bedcovers to which this example belongs was made primarily in Massachusetts and then in New York State, as migration from New England increased by the end of the nineteenth century.

—S.C.H.

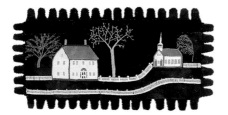

268. PICTORIAL TABLE RUG
Artist unidentified
Possibly Otisfield, Oxford County, Maine
c. 1840
Wool appliqué, gauze, and embroidery on wool
29 × 53 in.
P1.2001.293

PROVENANCE:
Found in Bridgton, Maine; Morrills Auctions, Inc., Gray, Maine, sale 6/78; Stephen Score, Essex, Mass., 1986.

EXHIBITED:
"A Place for Us: Vernacular Architecture in American Folk Art," MAFA, 1996/97.

PUBLISHED:
Pennington, Samuel, Thomas M. Voss, and Lita Solis-Cohen. *Americana at Auction.* New York: E.P. Dutton, 1979, fig. 609.
Rebus Inc. *American Country: The Needle Arts.* Alexandria, Va.: Time-Life Books, 1990, p. 101.
Woodard, Thomas K., and Blanche Greenstein. *Crib Quilts and Other Small Wonders.* New York: E.P. Dutton, 1981, p. 73.

In America, the term "rug" has variously referred to a table cover, an early type of warm bedcover, and a woven or knotted floor cover. By the early nineteenth century, a new type of rug was in vogue; referred to as a "table rug," it was probably intended for placement in front of the hearth to protect floors or expensive carpets from soot and flying cinders. As with fireboards and overmantels—two other forms ranged around a fireplace—architectural themes were sometimes used to embellish early table or hearth rugs. The imagery on this rug succinctly and powerfully illustrates the strong link between church and home. The two centers of community life are connected and defined by the white picket fence. A willow tree—an essential symbolic element in mourning embroideries—is appropriately placed beside the church, while the oak by the house evokes strength and fertility.

In 1985, when this rug was acquired, it was purported to have de-scended in the Otisfield house in which it was made, and which was said to still stand. If, in fact, the rug depicts an Otisfield home, the likeliest candidate is the Johnson Knight house, which was located just north of the Bell Hill Meetinghouse situated at the top of Bell Hill Road. Most early Otisfield homes had center chimneys, but the Knight house had two gable-end chimneys, as depicted on this rug. It was also renowned for its elaborate front door—a prominent feature of the rug—which was made by Timothy Fernald.[103]

—S.C.H.

103 David Hankins, Otisfield Historical Society, provided information on Fernald and the Knight house from William S. Spurr, *A History of Otisfield, Cumberland County, Maine* (Oxford, Maine: n.p., 1953), pp. 387, 453. See letter to the author, May 26, 2000. I am grateful to Mr. Hankins for discussing the imagery on the rug with forty members of the historical society. None, how-ever, could positively identify the house or church depicted on the rug. The suggestion of the Knight house does not accord with the tradition, which descended with the rug, that the house shown was still standing in 1985, as the Knight house burned down in 1905.

269. APPLIQUÉD CARPET
Artist unidentified
Northeastern United States, possibly Maine
c. 1860
Wool appliqué and embroidery on wool
112 × 158 in.
P1.2001.294

PROVENANCE:
James and Judith Milne and Jolie Kelter and Michael Malcé, New York; Susan Parrish, New York; Kate and Joel Kopp, America Hurrah, and David A. Schorsch, New York, 1992.

PUBLISHED:
Bishop, Robert, and Jacqueline Marx Atkins. *Folk Art in American Life.* New York: Viking Studio Books in association with MAFA, 1995, pp. vi, 146–47.
Sherrill, Sarah B. *Carpets and Rugs of Europe and America.* New York: Abbeville Press, 1996, p. 255.

It is thought that this extraordinary room-size appliquéd and embroidered textile is a floor cover, but its pristine condition belies its use in this function. Because of its complex design and masterful execution, it has been likened to the embroidered carpet made by Zeruah Higley Guernsey in Castleton, Vermont.[104] But it is also related to a small number of appliquéd floor and bed coverings made in Maine from about 1845 until about 1870.[105] These textiles are characterized by whimsical pictorial elements in a block set surrounded by a border. This example is further elaborated by a central medallion with a tapestry-inspired scene of two trees, with birds in the branches, tall grasses, and a blue rabbit. Two opposing inside corners are further distinguished by dense branching appliqués, and a wreathlike motif is centered on four sides. Rather than the rigid square or rectangular block seen in the other examples, the repeated flower motifs are separated by arch-shaped leafy branches, lending a dynamism to the conventionalized overall pattern.

Appliqué gained favor as a technique for small table and hearth rugs about 1840. As in quiltmaking, the appliqué technique involves cutting elements from one fabric and stitching them onto a different fabric foundation. Early designs often feature an urn with sprawling flowers, but the pieces from Maine show a particular sense of freedom in their compositions. Because the shapes are cut out rather than pieced, there is great pictorial flexibility, evident in this monumental textile. —S.C.H.

104 This famous embroidered carpet, also known as the Caswell Carpet, is in the collection of MMA; see Jean Lipman, Robert Bishop, Elizabeth V. Warren, and Sharon L. Eisenstat, *Five-Star Folk Art: One Hundred American Masterpieces* (New York: Harry N. Abrams in association with MAFA, 1990), p. 147.

105 Jane Gove of Wiscasset, Maine, made her rug in 1845 at the age of eleven. It is in the Western History Collection of the Natural History Museum of Los Angeles County; see Joel Kopp and Kate Kopp, *American Hooked and Sewn Rugs: Folk Art Underfoot* (New York: E.P. Dutton, 1985), p. 127. A third related example is a bedcover made in 1870 by Hannah Riddle of Woolwich, Maine, which won first prize at the Woolwich Fair in 1870; see Cynthia V.A. Schaffner and Susan Klein, *Folk Hearts: A Celebration of the Heart Motif in American Folk Art* (New York: Alfred A. Knopf, 1984), pp. 34–35.

The first Shakers coalesced as a religious group in mid-eighteenth-century Lancashire. Rejecting the formal liturgical traditions of the Church of England, they sought a freer, more personal expression of Christian faith. This took the form of ecstatic, emotional gatherings for worship, during which the participants became "exercised with singing, shouting and leaping for joy."[1] It was from these unrestrained practices that the members of the small group received their popular name—"Shakers."

The early Shakers did not articulate a fixed creed or doctrine. In the spirit of English religious dissent that drew its adherents from the country's petty tradesmen, artisans, and laborers, they were deeply affected by a sense of God's immanence in a lost and sinful world. As a consequence, they were drawn to millenarian prophecy and speculation about the Second Coming of Christ. Attracting few converts in England, the Shakers might well have been lost to history were it not for the reception into their numbers in 1758 of Ann Lees (the name was shortened to "Lee" in Shaker usage), the daughter of a Manchester blacksmith.

Ann Lee (1736–1784), whose own religious background was Anglican, not only became leader of the group but was so influential in the development of its belief system that she is recognized as the founder of the Shaker faith. Because of the noisy exuberance of their worship, the Shakers attracted the hostility of their neighbors and the civil authorities; several Shakers, including Ann Lee herself, were fined or imprisoned in the early 1770s. In 1774 Mother Ann—as her followers now called her—led a small group of Shakers to America, following a "special revelation" that the faith would flourish there.

On August 6, 1774, Ann Lee and eight followers disembarked in New York, after a lengthy sea voyage from Liverpool. During the next ten years, Mother Ann and her companions undertook preaching journeys in upstate New York and New England. By the time of her death in 1784, the groundwork had been laid for the organization of Shaker communities throughout the region and beyond. Under her American-born successors, Father Joseph Meacham (1741–1796) and Mother Lucy Wright (1760–1821), Shakerism was established in New York, Connecticut, Massachusetts, New Hampshire, Maine, Ohio, Kentucky, and Indiana.

In their self-contained villages, the members of the United Society of Believers in Christ's Second Appearing, as the Shakers became formally known, practiced celibacy, separation from the world, communal ownership of property, pacifism, and confession of sin, all of which they based on the New Testament accounts of the life and teachings of Jesus. Women enjoyed equality with men in the various departments of community life, a practical application of the Shaker concept of God as Father and Mother. An emphasis on simplicity, harmony, and perfection within the communities prompted the development of a distinctive tradition in the arts and crafts, notable for its paring down of vernacular forms. Shaker furniture is simple but elegant, without decorative turnings, carvings, or painting, but exacting in craftsmanship and purity of line.

At its height in the first half of the nineteenth century, the United Society comprised nineteen principal communities, with approximately five thousand members. At first reviled by their suspicious neighbors, the Shakers in time were admired for their neat, efficient farms, the excellence of their products, and the innovative technology and genius for invention that marked their history. By the mid-nineteenth century, however, a slow but unremitting disintegration, the result in large part of a failure in leadership, began to affect the Shaker villages until, one by one, they closed. Only three villages survived into the second half of the twentieth century—Hancock, Massachusetts; Canterbury, New Hampshire; and Sabbathday Lake, Maine. Today only Sabbathday Lake remains as an active center of the Shaker faith.　　—G.C.W.

270. KNITTED RUG
Attributed to Elvira Curtis Hulett (c. 1805–1895)
Probably Hancock, Berkshire County, Massachusetts
c. 1890–1895
Wool
50 in. diam.
P1.2001.295

PROVENANCE:
Richard and Betty Ann Rasso, East Chatham, N.Y.; George W. Sieber, Ashley Falls, Mass.; Suzanne Courcier and Robert W. Wilkins, Austerlitz, N.Y., and Thomas C. Queen, Columbus, Ohio; James and Bonnie Udell, New York, 1990.

EXHIBITED:
"Shaker Design," WMAA, 1986.

PUBLISHED:
Rebus Inc. *American Country: The Needle Arts.* Alexandria, Va.: Time-Life Books, 1990, p. 140.
Sherrill, Sarah B. *Carpets and Rugs of Europe and America.* New York: Abbeville Press, 1996, p. 260.
Sprigg, June. *Shaker Design.* New York: WMAA in association with W.W. Norton, 1986, pp. 186–87.

Rugs of various kinds were woven, braided, hooked, and knitted in Shaker communities, both for household use and for sale to visitors. The earliest Shaker rugs were probably produced in the 1830s, at about the same time that floor rugs became widely used by the general American population.[2] Late-nineteenth- and early-twentieth-century photographs of the salesrooms at the neighboring Shaker villages of New Lebanon, New York, and Hancock, Massachusetts, show decoratively patterned rugs displayed for sale. By then, earlier strictures against ornamentation had been relaxed by the leadership of the Shaker society.

This striking knitted rug is attributed to Elvira Curtis Hulett, a Hancock Shaker, on the basis of a note on the backing of an example almost identical in design and technique. The note identifies the rug as the work of "Sister Elvira in 1892 in her eighty-eighth year."[3] Hulett entered the Hancock community as a child in 1812. She apparently was

1　Calvin Green and Seth Youngs Wells, *A Summary View of the Millennial Church, or United Society of Believers* (Albany, N.Y.: Packard & Van Benthuysen, 1823), p. 5.
2　Beverly Gordon, *Shaker Textile Arts* (Hanover, N.H.: Univ. Press of New England, 1980), pp. 95–96.
3　June Sprigg, *Shaker Design* (New York: WMAA in association with W.W. Norton, 1986), p. 188.

engaged in textile production during the course of her long life as a Believer; her name appears on an early-nineteenth-century pattern draft for huckaback, a type of weave.[4]

The rug is a technical tour de force. It is distinguished by a brilliant use of contrasting colors and the varied patterns—crosses, diamonds, checkerboards, and chevrons—that decorate each of its concentric rings.[5] These patterns are suggestive of Hulett's early experience as a weaver. She knitted the rug in strips of two or more colors worked together. The strips were sewn together, and then the rug was edged with a braid of woven fabric. The center clockwise spiral tapers to a point, forming a circle, which is surrounded by five knitted rings, each with a different pattern.[6]

It is not certain whether this rug was intended for sale or for use within the community. The late nineteenth century was a time of new directions within the United Society—in part an effort to resist the tides of communal disintegration. At Hancock, for example, the trustees' office, the building in which business with the non-Shaker world was transacted, was remodeled in 1895 "to conform to the prevailing Victorian architectural fashion."[7] Interior decoration—colorful wallpapers, ornamental moldings, and linoleum floor coverings—were now countenanced, and Sister Elvira's exuberant rug would not have been out of place in this new Shaker environment. —G.C.W.

271. VIEW OF THE CHURCH FAMILY, ALFRED, MAINE
Joshua Bussell (1816–1900)
Alfred, York County, Maine
c. 1880
Pencil, ink, and watercolor on paper
17½ × 27¾ in.
P1.2001.296

INSCRIPTIONS:
Recto, pencil: *1 Stable 2 Wood House / 3 Office 5 Hired Men's House / 4 Wood & Lumber & Carriage House / 6 Meeting House 7 Ministry's Shop / 8 Sisters Shop / 9 Dwelling House / 10 Brethrens Shop 11 Black Smith Shop / 12 Lumber &c. 13 Shop 14 Shop & Wood House / 15 Infirmary 16 Wood House 17 Laundry 18 W.H. / 19 Cow Barn 20 Ox Barn;* verso, in another hand, pencil: *Poland Hill, Maine* [sic].

PROVENANCE:
Sister Olive Hayden; A.Hayward Benning, Albany, N.Y.; Richard and Betty Ann Rasso, East Chatham, N.Y., 1984.

EXHIBITED:
"The Gift of Inspiration: Art of the Shakers, 1830–1880," Hirschl & Adler Galleries, New York, 1979.
"Shaker Design," WMAA, 1986.
"A Place for Us: Vernacular Architecture in American Folk Art," MAFA, 1996/97.
"Millennial Dreams: Vision and Prophecy in American Folk Art," MAFA, 1999/2000.

PUBLISHED:
Bishop, Robert, and Jacqueline Marx Atkins. *Folk Art in American Life.* New York: Viking Studio Books in association with MAFA, 1995, pp. 86–87.

Emlen, Robert P. *Shaker Village Views Illustrated Maps and Landscape Drawings by Shaker Artists of the Nineteenth Century.* Hanover, N.H.: Univ. Press of New England, 1987, p. 155.
Hirschl & Adler Galleries. *The Gift of Inspiration: Art of the Shakers, 1830–1880.* New York: Hirschl & Adler Galleries, 1979, p. 51.
Kogan, Lee, and Barbara Cate. *Treasures of Folk Art: Museum of American Folk Art.* New York: Abbeville Press in association with MAFA, 1994, p. 65.
Lipman, Jean, Elizabeth V. Warren, and Robert Bishop. *Young America: A Folk Art History.* New York: Hudson Hills Press in association with MAFA, 1986, p. 77.
Sprigg, June. *Shaker Design.* New York: WMAA in association with W.W. Norton, 1986, p. 201.
Wertkin, Gerard C. *Millennial Dreams: Vision and Prophecy in American Folk Art.* New York: MAFA, 1999, pp. 12–13.

Maine's two Shaker communities consolidated in 1931 in response to dwindling resources and numbers. That year the twenty-one Shakers remaining at Alfred joined their fellow Believers at Sabbathday Lake (or New Gloucester). With the closing of Alfred Shaker Village and the sale of its properties to the Brothers of Christian Instruction, a Roman Catholic teaching order, the continuous Shaker presence in the town, which could be traced back almost 150 years, came to an end.

Today few of the Shaker buildings at Alfred survive, and those that remain have been substantially altered. Joshua Bussell's detailed drawings of Alfred Shaker Village provide the only complete visual record of this place, which the Shakers called "Holy Land." Bussell also created drawings of the Shaker community at New Gloucester, its subsidiary Poland Hill family, and Canterbury Shaker Village in New Hampshire. The artist, who came to the Shakers in 1829, was a cobbler by trade.

In keeping with the principles of community organization in the United Society of Believers, Shaker villages were composed of "families," consisting of a mere handful to well over one hundred members, each having its own leadership, economic interests, and property in common. Bussell served as elder of Alfred's Second Family; his painting, despite the misleading inscription on the reverse, depicts the Alfred Church Family as it appeared about 1880. The Church Family was the location of the meetinghouse; it is the gambrel-roofed structure marked "6" in the drawing. Earlier in Shaker history, only the meetinghouse would have been painted white. By 1880 that practice had come to an end.

During the 1830s and 1840s, the Shaker central leadership at New Lebanon, New York, encouraged the drafting of illustrated maps or site plans of the Shaker communities in order to record the location of dwellings, shops, barns, pastures, orchards, and other features of the natural and built environments. Initially, gifted Shaker draftsmen created documentary records with meticulous detail but little artistic expression. Bussell, whose first drawing is dated 1845, carried the tradition later into the nineteenth century than any other Shaker artist. By the 1880s his early diagrammatic renderings had evolved into fully developed paintings.[8] —G.C.W.

4 Gordon, *Shaker Textile Arts,* p. 56.
5 Sprigg, *Shaker Design,* p. 188.
6 For her technical analysis of Hulett's rug, I am indebted to my colleague Joan Walsh.
7 Deborah E. Burns, *Shaker Cities of Peace, Love, and Union* (Hanover, N.H.: Univ. Press of New England, 1993), p. 170.

8 For a full discussion of the drawings of Joshua Bussell and other Shaker mapmakers, see Robert P. Emlen, *Shaker Village Views: Illustrated Maps and Landscape Drawings by Shaker Artists of the Nineteenth Century* (Hanover, N.H.: Univ. Press of New England, 1987).

272. SHAKER RED OVAL BOX
Artist unidentified
New York or New England
Early-to-mid-nineteenth century
Paint on maple and pine with nails
1⅝ × 4¾ × 3⅛ in.
P1.2001.297

PROVENANCE:
David A. Schorsch, New York, 1990.

Although nineteenth-century Shakers proscribed the use of decorative or ornamental painting, the rich painted colors of their oval boxes demonstrate that color had an important place in Shaker life. Written rules and regulations, which helped order life in the communities during part of the nineteenth century, even specified the colors to be applied to various classes of buildings, inside and out, as well as to certain kinds of household furniture and other utilitarian objects. Reds and yellows are among the more frequently used colors on boxes, a reflection, perhaps, of the Millennial Laws or Gospel Statutes and Ordinances of 1845; according to Part III, Section IX, of this compilation, "[o]val or nice boxes may be stained reddish or yellow, but not varnished."[9]

The creation of an oval box requires great skill. The body of the box, often a thin strip of maple, must be shaped around an oval mold following steaming or soaking in water to obtain the necessary degree of suppleness. The characteristic swallowtail joints, or "fingers," give the box its distinctive appearance. Tiny tacks are used to affix the joints and attach the bottom, generally a thin pine board. The top, which must be crafted to exacting measurements to fit properly, is constructed in similar fashion.

Shaker craftsmen created oval boxes in many sizes, sometimes in graduated nests. While made for a variety of needful purposes, small boxes like the exquisite red box in this collection were often intended as keepsakes or gifts.
—G.C.W.

273. SHAKER RED ROUND BOX
Attributed to Joseph Johnson (1781–1852)
Canterbury, Merrimack County, or Enfield, Grafton County, New Hampshire
c. 1851
Paint on maple and pine with copper nails
1¾ × 3 in. diam.
P1.2001.298

INSCRIPTION:
Underside of box, pencil: *To Pug, Eld Ida C.*

PROVENANCE:
Eldress Ida F. Crook, Canterbury, N.H.; Olive Hayden Austin, Clinton, Conn.; A. Hayward Benning, Albany, N.Y.; Willis Henry Auctions, Marshfield, Mass., sale 8/89, lot 158.

Although the oval box is more frequently encountered, Shaker craftsmen also created round boxes. This box is attributed to Joseph Johnson because of its closeness to two similar red-stained examples, both of which have contemporaneous presentation inscriptions and dates (1851 and 1852) relating them to this Shaker elder. June Sprigg has noted that the straight joints of these small round boxes are closer to the construction of wooden dippers—also staples of Shaker woodenware—than to the swallowtail joints of oval boxes.[10]

Johnson was a member of a family of gifted Believers; his father was the well-known Shaker master builder Moses Johnson, who was responsible for framing each of the gambrel-roofed meetinghouses in the northeastern Shaker communities in the late eighteenth century. Johnson himself was a Shaker leader, serving as senior elder in the New Hampshire ministry. The group of round boxes appears to have been made during the last year of his service as a member of the ministry, after which he retired to the Canterbury community. The box in this collection contains a presentation inscription from Eldress Ida F. Crook (1886–1965), a Canterbury Shaker who served in the ministry from 1960 until her death.
—G.C.W.

274. SHAKER OVAL BOX WITH PINCUSHION
Artist unidentified
Enfield, Grafton County, New Hampshire
c. 1846
Paint on maple and pine with copper tacks and worsted top
2³⁄₁₆ × 3¹¹⁄₁₆ × 2½ in. oval (including cushion)
P1.2001.299

INSCRIPTION:
Underside of lid, ink: *This Box / was given to / Anna E Hovey. / by the Shakers / in / Enfield N.H. / 1846. / While on a Visit with / My Mother.*

PROVENANCE:
Willis Henry Auctions sale at Mount Lebanon Shaker Museum, Old Chatham, N.Y., 8/86, lot 158.

Creating a variation of the familiar oval box, a Shaker artisan affixed a pincushion to the lid. The diminutive sewing box anticipates by at least a quarter-century the large-scale production in Shaker communities of sewing boxes, pincushions, and related items, which were intended for sale to the public. The inscription demonstrates the practice among the Believers of using small, meticulous examples of Shaker woodenware as gifts.
—G.C.W.

9 The Millennial Laws of 1845 represent the most elaborate statement of Shaker rules of conduct and were amended and simplified in 1860. For a full transcription, see Edward Deming Andrews, *The People Called Shakers: A Search for the Perfect Society* (New York: Oxford Univ. Press, 1953), pp. 249–89.

10 Sprigg, *Shaker Design,* p. 111.

275. SHAKER YELLOW OVAL BOX
Artist unidentified
Enfield, Grafton County, New Hampshire
1836
Paint on maple and pine with copper nails
1 × 2¹⁵⁄₁₆ × 1⅞ in.
P1.2001.300

INSCRIPTION:
Underside of lid, pencil: *From C. A. Enfield, N.H. 1836.*

PROVENANCE:
Willis Henry Auctions, Marshfield, Mass., sale 6/83, lot 239; Gregory and Barbara Reynolds, Barnet, Vt.; Skinner sale 1274, 10/89, lot 388.

Utilitarian woodenware of various kinds was a staple of Shaker villages throughout the nineteenth century and—in several of the more vigorous communities—into the twentieth century as well.[11] Perhaps the most characteristic of these were oval boxes, which the Shakers produced in many sizes, both for household use and for sale to the public. Although the form was not a Shaker innovation, it was so fully developed and refined by the Believers that it has become symbolic of their craftsmanship. Among the Shakers at New Lebanon, New York, oval boxes were made as early as 1798.[12]

The Shaker village at Enfield, New Hampshire, was founded in 1793 and remained active until 1923, when its remaining members moved to New Hampshire's other Shaker community, at Canterbury. The production of woodenware was an important industry at Enfield; the North Family there produced wooden pails and tubs for sale in large quantities. Enfield is also one of the communities for which the large-scale production of oval boxes is documented.[13]

Although private ownership of personal property technically does not exist within Shaker society, small items often were passed from Believer to Believer as keepsakes. In particular, gifts of oval boxes or other woodenware served as a means of expressing affection and esteem. This exceptionally fine and diminutive box carries a presentation inscription, indicating that the practice began early in Shaker history. "C.A." may be H. Chase Allard or Cynthia Annis, members of two large natural families that became Shakers at Enfield. —G.C.W.

11 Brother Delmer C. Wilson (1873–1961) of Sabbathday Lake, Maine, the nation's sole remaining Shaker community, was still producing Shaker boxes and carriers in the 1950s. In the late 1990s, members of the community revived the practice.

12 Edward D. Andrews, *Community Industries of the Shakers* (Albany, N.Y.: Univ. of the State of New York, 1933), p. 160.

13 June Sprigg and Jim Johnson, *Shaker Woodenware: A Field Guide* (Great Barrington, Mass.: Berkshire House, 1991), p. 26.

276. GIFT DRAWING FOR URSULA BISHOP
(double-sided)
Polly Ann (Jane) Reed (1818–1881)
New Lebanon, Columbia County, New York
Probably 1844
Ink on cut paper
4 × 4 in.
P1.2001.301a

INSCRIPTIONS:
Recto, ink: *The Word of the Holy Heavenly Father / To a Daughter of his Love. / Come unto me, O thou little innocent lamb of my / love, pleasure and delight. For lo! thy Father in / Heaven doth behold thee with pleasure, and with / smiles of joy doth he greet thee, O thou well-belov- / ed Saint of his glory. For thou hast faithfully / laboured in his holy vinyard, hast honored thy / Mother, and borne the † of thy blessed Saviour; / hast traveled in sorrow, and mourned in / grief. Yet thou hast ever praised & / honored thy God, for his condesen- / sion and goodness to thy soul. / So cheer up thy spirit and / be strong, for the ar- / mies of Heaven / will help thee / along, / to;* verso, ink: *a mansion of rest of quietness / and peace, Where all mortal sorrows will e- / ternally cease. Where with holy Angels and / Seraphs thou shalt join, In my arbor of love, Eter- / nal and sublime. Beyond the vain terrestrial, yea / the fading things of time, Where eternal joys / shall ever-more be thine. So come & receive a crown of / my holy love, and on thy bugle shout, the song of sweet mirth / Ursula Bishop. / A holy Princess / of righteousness, / Crowned with / Eternal / glory.*

PROVENANCE:
Charles "Bud" Thompson, Canterbury, N.H.; Milton Sherman, Armonk, N.Y., 1990.

EXHIBITED:
"Every Picture Tells a Story: Word and Image in American Folk Art," MAFA, 1994/95.
"Millennial Dreams: Vision and Prophecy in American Folk Art," MAFA, 1999/2000.

A receptiveness to visions and prophecy has shaped the beliefs of the Shakers from early in their history. The roots of the small religious community lie in eighteenth-century Lancashire, England, and the visionary experiences of Mother Ann Lee (1736–1784), who founded the faith and brought it to America in 1774. For Ann Lee and her followers, revelation was not confined to the pages of the Bible but represented a continuing process.

Over a period of twenty or more years that began in 1837, an intense religious revival swept through the Shaker villages. During this period—known in Shaker history as the Era of Manifestations or Mother's Work—Believers accepted trances, prophetic utterances, speaking in tongues, spirit communications, and other visionary experiences as a part of daily life. These phenomena were recognized as "gifts" by the Shaker leadership, following the language of the New Testament: "Every good gift and every perfect gift is from above, and cometh down from the Father of light" (James 1:17).

Among other manifestations, thousands of gift messages and songs were "received by inspiration" and recorded during this period. The Believers who received and transmitted these gifts were recognized as "instruments." Some talented Shakers were inspired to create drawings as well. Although they are far less common than other Shaker visionary expressions, gift drawings should be understood in the context of the oral and written gifts; all these forms share equivalent symbolic language and imagery. They generally offer messages of encouragement, consolation, or exhortation from deceased Shaker leaders or figures from sacred history, and they may bestow spiritual presents such as crowns or baskets of fruit on their recipients. Just over two hundred gift drawings survive, all but a few of them the work of women.

Polly Reed was one of the most accomplished Shaker artists. Among other works, a series of exquisite two-sided heart-shaped drawings is attributed to her, each inscribed to an individual Believer. At least twenty-seven of Reed's heart-shaped gifts survive, including the three illustrated in this catalog. Those that are dated invariably bear the year 1844, very early in the eleven-year period in which she is known to have created gift drawings.[14] At this time, Reed's work was principally textual in nature, although some of the emblematic figures that typify her later, more elaborate compositions may appear. This drawing is inscribed to Ursula Bishop, a member of the First Order of the Church, New Lebanon, New York, where the artist also resided. —G.C.W.

277. GIFT DRAWING FOR ELEANOR POTTER
(double-sided)
Polly Ann (Jane) Reed (1818–1881)
New Lebanon, Columbia County, New York
1844
Ink on cut paper
4 × 4 in.
P1.2001.301b

INSCRIPTIONS:
Recto, ink: *The Word of the Holy Heavenly Father, / To a Child of his pleasure. / Arise and be joyful, O thou little child of my love; / Sail no longer upon the waters of sorrow, neither re- / main any longer upon the waters of sorrow, neither re- / main any longer upon the mountains of dispair, nor / drink at the fountains of grief. For I am that God / of love who hath sustained thee thro' many dark and trying / hours, who did mark thee for my own, when in thy infancy, / and who has ever held thee in my arms of love; yea I / am thy Father and thy friend, and will thy feeble / bark defend; Thro' every sorrow that may roll, or ad / verse winds that ever blow. For thou art truly / my delight, By day I view thee, and by night. / Yea I blefs the doings of thy hand. So come / rejoice & be joyful, my child, for thou / art not forsaken, but owned as a / faithful laborer in my vin- / yard, whose delight it is / to praise my name, / and blefs the doings / of my All- / righteous / hand;* verso, ink: *Thy Mother thou hast hon- / ored, and her gospel thou hast obeyed. The nar- / row path thou hast traveled, and forsaken all for / thy Lord. Therefore thou shalt in no wise lose thy / reward. But thou shalt sit in pleasant places, in the / beautiful City of Jerusalem, and join thy praises / with the Angels in Heaven, and play upon thy instru- / ments, the song of eternal joy. / June 2nd 1844. / Eleanor Potter;* in cartouche: *A / child / of my glory / and heir of my / Kingdom. The / Fathers delight, / and Mothers / pleasure.*

PROVENANCE:
Charles "Bud" Thompson, Canterbury, N.H.; Milton Sherman, Armonk, N.Y., 1990.

EXHIBITED:
"Every Picture Tells a Story: Word and Image in American Folk Art," MAFA, 1994/95.
"Millennial Dreams: Vision and Prophecy in American Folk Art," MAFA, 1999/2000.

Polly Reed's heart-shaped drawings were intended as gifts for the members of the First Order of the Church at New Lebanon, New York, the Shaker family in which the artist lived. Daniel W. Patterson has suggested that Reed may well have created 148 of these meticulous drawings, equaling the number of Shakers, including children, residing in the First Order in 1844.[15] Almost half of the extant heart cutouts are dated, and they all bear various dates in April 1844, but this example, perhaps uniquely, has the date of June 2—possibly a final effort by the artist before the hearts were distributed to the members of the family later the same day.

A manuscript journal records that on Sunday morning, June 2, 1844, the members of the First Order gathered in the family meeting room for a solemn ceremony. A table had been placed in the front of the room, spread with a white cloth on which "Hearts of Blessing" from "our Merciful, Holy & Heavenly Father" had been placed. "[T]he writing was now accomplished—& the presents ready to be given out. The brethren and sisters then came forward, kneeling down & receiving the papers, in the form of a heart; beautifully written over with words of blessing in the name of the *Father*."[16]

This drawing is inscribed by Polly Reed to Eleanor Potter (1812–1895), a member of the First Order. Potter was also an "instrument," and several gift drawings are attributed to her. In this drawing, Reed has included a number of symbolic figures that are common to the Shaker gift tradition: doves, trees, roses, and a lyre. While various meanings may be assigned to these images, they are all emblematic of the celestial sphere. For Shakers of the period of Mother's Work, gift drawings provided a glimpse into heaven itself. —G.C.W.

278. GIFT DRAWING FOR JANE SMITH
(double-sided)
Polly Ann (Jane) Reed (1818–1881)
New Lebanon, Columbia County, New York
Probably 1844
Ink on cut paper
4 × 4 in.
P1.2001.301c

INSCRIPTIONS:
Recto, ink: *The Word of the Holy Heavenly Father, / To a Child of his Love. / Why is thy countenance mournful, and why doth / grief creep upon thy brow, O thou Saint of my love, and / child of my pleasure. Come ye up before / me, and with a crown on thy head, and / with a timbrel in thy hands, play a mer- / ry tune before the Lord, for lo! he is / well pleased with thee. As an anchor / thou hast been to support the weak / and with and outstretched arm and hand of love, / hast gathered the Lambs of my flock. And even as / thy spirit hath breathed forth blefsing upon them / so doth thy God delight to smile upon thee, / and breathe forth an everlasting blefs- / ing upon thee, which shall remain / thro' time, for thou are lovely / and beautiful in his sight / And as sweet smell- / ing incense do / thy praises / ascend;* verso, ink: *unto my Throne; For thou has / walked the path of virtue, and drank the cup / of sorrow, yet never hast thou murmured against / thy God, nor raised thy hand against the straitnefs / of the road. And now thou shalt in my kingdom shine / with a garment unspotted, and a robe that is pure, / for thou hast stood steadfast, unshaken and sure. So / come and receive a bright seal of my love, by which / thou shalt be known by my Angels above, To be a pure / child of my eternal glory bright, who has walked / the path of the just and upright. / Jane Smith.* In circle, below: *A Holy Saint / Of the most High, / Crowned with his / everlasting Love, / and enrobed with / his richest / blefsing.*

PROVENANCE:
Charles "Bud" Thompson, Canterbury, N.H.; Milton Sherman, Armonk, N.Y., 1990.

EXHIBITED:
"Every Picture Tells a Story: Word and Image in American Folk Art," MAFA, 1994/95.
"Millennial Dreams: Vision and Prophecy in American Folk Art," MAFA, 1999/2000.

14 Daniel W. Patterson, *Gift Drawing and Gift Song: A Study of Two Forms of Shaker Inspiration* (Sabbathday Lake, Maine: United Society of Shakers, 1983), pp. 80–82.
15 Ibid., p. 9.

16 "Records Kept by Order of the Church," entry for June 2, 1844 (Shaker Manuscripts Collection, Rare Books and Manuscripts Division, New York Public Library). Quoted in ibid. and in Sally M. Promey, *Spiritual Spectacles: Vision and Image in Mid-Nineteenth-Century Shakerism* (Bloomington, Ind.: Indiana Univ. Press), p. 18.

It is difficult to assess the phenomena associated with the Era of Manifestations so long after their occurrence. Too many gifted and devout Shakers are known to have participated in the visionary experiences of the period to dismiss them simply as pious fraud or delusion. Whatever the motivation of the "instruments," the historical record seems to support the sincerity of their own belief in the veracity of their gifts. To the leadership of the United Society, the meaning of the phenomena was clear: they were signs of the divine, a heavenly call for the Believers to return to their founding principles after a period of encroaching worldliness and spiritual stagnation.

On New Year's Day in 1840, a Shaker diarist recorded that "now, in these days . . . [t]here is seldom a meeting without some communication, or message, from the spirits."[17] Many of these were believed to emanate from God, who could be referred to in either male or female terms in accordance with Shaker belief. The "inspiration" in each of Polly Reed's heart cutouts is from the Heavenly Father; each heart incorporates a message of encouragement believed to be of divine origin. Jane Smith, to whom this gift was inscribed by Reed, is commended for her steadfastness. Despite having tasted "the cup of sorrow," she has stood "unshaken and sure."

Reed was accomplished in needlework; one of her principal occupations was as a "tailoress." It is not surprising that elements of the artist's drawings seem to mimic or replicate stitching—as may be seen around the periphery of this heart.

—G.C.W.

In its style and use of symbolic elements, this drawing is similar to others created in the First Order of the Church, New Lebanon. Several accomplished artists resided in this Shaker family, including Polly Reed, and they were clearly influenced by one another's work. This gift drawing contains a number of telltale signs associated with Sarah Bates: the head of the hovering dove has a distinctive bulb shape, one of the wings of the dove in flight is thrust out "like the arm of a swimmer," and the surfaces of the tree trunks and tables are covered with cross-hatching.[18] Daniel W. Patterson's attribution of this drawing and others with similar stylistic details to Bates, a Shaker "tailoress" and schoolteacher, is convincing but circumstantial—based primarily on his analysis of the membership of the First Order of the Church.[19] The calligraphy and drawing are as precise and elegant as Reed's.

This small drawing contains many of the iconographic elements that are associated with the larger, more complex works produced in the First Order of the Church. The meaning of these symbols is not always clear, although their ultimate source may be in the language of the Bible. A Shaker diarist at New Lebanon, commenting in 1840 upon the phenomena of Mother's Work, reflected this uncertainty: "[t]here is . . . an endless variety of gifts, and spiritual presents, bro't & given to us collectively & individually, much of which we do not fully understand & some of which we do understand as being signs and representations of divine things—such as lamps—doves—branches, balls of love, crosses &c &c."[20]

Among the emblems introduced by the artist in this drawing are two feathers, one from the wings of the "Heavenly Father" and the other from the wings of "Mother Wisdom." These references to God are expressed here in paternal and maternal terms in accordance with the Shaker conception of deity. Perhaps the most engaging symbols in this drawing are the fanciful lamp and musical instrument. Imaginary machines of various kinds, often with wheels and pulleys, are not uncommon in the gift drawing tradition at New Lebanon, a reflection, perhaps, of the inventive spirit that animated life in the Shaker communities. The drawing is inscribed to Sally Lomise, a member of the ministry of the Shaker villages at Harvard and Shirley, Massachusetts.

—G.C.W.

279. GIFT DRAWING FROM HOLY MOTHER WISDOM TO SALLY LOMISE
Attributed to Sarah Bates (1792–1881)
New Lebanon, Columbia County, New York
1847
Ink on cut paper
6¾ in. diam.
P1.2001.301d

INSCRIPTION:
Recto, ink: *From Holy Mother's heavenly / tree I've pick'd a branch of peace / for thee. O will you all receive this / love, For I am Holy Wisdom's Dove. / A Feather from / Holy Mother Wisdom's Wings. / A feather from the / Heavenly Father's Wings. / A heavenly Trumpet. / A Musical Instrument / A heavenly Lamp. / Words of Holy Mother. / Go faithful child / And sound my trumpet / of victory, till every / captive is set free, / And when thou . . . / hast faithfully done / thy work, a crown / of life I will give to thee / to wear thro' all e- / ternity. Brought / by Holy Wisdom's / message bearing Angel. / From / Holy Mother / Wisdom, To Sally / Lomise /; May 20th / 1847*

PROVENANCE:
Faith and Edward Deming Andrews, Pittsfield, Mass.; Mr. and Mrs. Jerome Count, New Lebanon, N.Y.; Willis Henry Auctions sale at Mount Lebanon Shaker Museum, Old Chatham, N.Y., 8/90, lot 88a.

EXHIBITED:
"The Gift of Inspiration: Art of the Shakers, 1830–1880," Hirschl & Adler Galleries, New York, 1979.
"Every Picture Tells a Story: Word and Image in American Folk Art," MAFA, 1994/95.
"Millennial Dreams: Vision and Prophecy in American Folk Art," MAFA, 1999/2000.

17 [Seth Youngs Wells], "Records Kept by Order of the Church," entry for Jan. 1, 1840 (Shaker Manuscripts Collection, Rare Books and Manuscripts Division, New York Public Library).
18 Patterson, *Gift Drawing and Gift Song*, pp. 16–18.
19 Ibid., pp. 61–62.
20 [Wells], "Records Kept by Order of the Church," entry for Jan. 1, 1840.

280. GIFT DRAWING: A REWARD OF TRUE FAITHFULNESS FROM MOTHER LUCY TO ELEANOR POTTER

Polly Ann (Jane) Reed (1818–1881)
New Lebanon, Columbia County, New York
1848
Watercolor and ink on paper
11⅜ × 10½ in. (sight)
P1.2001.302

INSCRIPTIONS:

Recto top left, ink: *Dove of the Morning.*; top right: *Dove of the Evening.*; top center: *Hear me my child says Mother, while / I speak words of truth unto you. I have / marked you with the star and crofs, and / fed and nourished you, that you might be a / thrifty plant in my vinyard, bringing forth / fruits of righteousnefs and every godly virtue.*; center left: *But what I am a- / bout to say to you, is, / that your path thro' time / will be interset with / hedges, and formed of an / uneven level. But you / must patiently bear what- / ever trials or afflictions / may come upon you: for / truly you have the gospel / to cheer your dreary way, / and my blefsing to light / you thro' the dark wilder / nefs of time.*; center right: *And for this you ought / never to retire to rest at / night withithout giving / special thanks to God. For in his loving kindnefs, he / hath separated you from a / world of wickednefs, to par- / take of the joys of Eternal / Life. So be encouraged / to keep my way, and in / my love farewell. / From your Loving / Mother Ann.*; bottom center: *A Reward / of True Faith- fulnefs / From Mother Lucy / To Eleanor Potter. / July 22nd / 1.8.4.8.*; bottom left: *Flowers plucked from Mother*; bottom right: *Lucy's Tree of Increase*

PROVENANCE:

Phelps Clausen, Buffalo, N.Y.; Mr. and Mrs. Peter H. Tillou, Litchfield, Conn.; Katherine and James Neil Goodman, New York, 1991.

EXHIBITED:

"Nineteenth-Century Folk Painting, Our Spirited National Heritage: Works of Art from the Collection of Mr. and Mrs. Peter Tillou," William Benton Museum of Art, University of Connecticut, Storrs, 1973.
"The Gift of Inspiration: Art of the Shakers, 1830–1880," Hirschl & Adler Galleries, New York, 1979.
"Shaker Design," WMAA, 1986.
"Every Picture Tells a Story: Word and Image in American Folk Art," MAFA, 1994/95.
"Millennial Dreams: Vision and Prophecy in American Folk Art," MAFA, 1999/2000.

PUBLISHED:

Hirschl & Adler Galleries. *The Gift of Inspiration: Art of the Shakers, 1830–1880.* New York: Hirschl & Adler Galleries, 1979, p. 26.
Sprigg, June. *Shaker Design.* New York: WMAA in association with W.W. Norton, 1986, p. 202.
Tillou, Peter H. *Nineteenth-Century Folk Painting, Our Spirited National Heritage: Works of Art from the Collection of Mr. and Mrs. Peter Tillou.* Storrs, Conn.: William Benton Museum of Art, Univ. of Connecticut, 1973, fig. 103.
Wertkin, Gerard C. *Millennial Dreams: Vision and Prophecy in American Folk Art.* New York: MAFA, 1999, p. 23.

In addition to heart cutouts, Polly Reed is credited with creating other small but meticulous gifts, including a series of double-sided leaf-shaped drawings, a spiritual map, and seven larger, more fully developed works in watercolor.[21] Possessing an elegant, sure hand, she had the capacity to combine disparate elements into complex but remarkably balanced and pleasing compositions, which seem to bear the influence of needlework samplers created by young women outside the Shaker communities.

A Reward of True Faithfulness, unlike Reed's other major watercolor paintings, contains few individual emblems and is striking in its directness. The artist has placed four almost identical flowers ("plucked from Mother Lucy's Tree of Increase") around a strong, central image of an eight-pointed star. The figures of the doves (identified here as "Dove of the Morning" and "Dove of the Evening") are drawn from Reed's familiar repertoire of images.

"Mother Lucy" was Lucy Wright (1760–1821), a principal leader of the United Society of Believers during its formative years. The composition also contains a message attributed by the "instrument" to Mother Ann Lee (1736–1784), the founder of the Society. Reed inscribed this gift drawing to Eleanor Potter (1812–1895), then a thirty-six-year-old member of the First Order of the Church, New Lebanon, New York.[22] The First Order of the Church was arguably the most important of New Lebanon's eight or more families, and the home of many Shaker leaders.[23] Later in her life, the artist, who was also skilled in needlework, served as an eldress in the Central or Parent Ministry, the highest authority in the United Society. —G.C.W.

281. GIFT DRAWING: 1ST MY CHILDREN DEAR, WHOM I DO LOVE

Polly Collins (1801–1884)
Hancock, Berkshire County, Massachusetts
1854
Ink, pencil, and watercolor on paper
19 × 12 in.
P2.1997.2

INSCRIPTIONS:

Recto, ink: *1st My children dear, whom I do love / And nourish with my care; Yea daily feed you from above / And hear your fervent prayer. 2nd Tis I once more your Mother dear / who does you now addrefs; / And daily guides you with that fear / which you should ever pofsefs. 3rd To those who ask I give my love, / Kind Elder's now believe; / That when you look to Heaven above / you'll certainly receive. 4th For those like you who faithful are / Shall ever be blest by me / I know full well you have much care / And troubles oft you see. 5th When upon Earth my care was great / Afflictions oft I felt / The wicked scoffed yea did berate / And harshly with me dealt. 6th But to my God I then did look / His mercy to implore / When many times my frame was shook / By an Almighty power. 7th This gave me strength for to perform / My duty while below / Though dragon like in man made form / Some raged to and fro. 8th But now dear children you can sing / In peace within your doors / Praises unto your Heavenly King / and dance upon your floors. 9th For this unto the Lord give thanks / That you have liberty / To dance and sing in Zion's ranks / And praise your Maker free. / This drawing was given by Mother Ann as an emblem of her love, for the Elder Sisters at the Church; City of Union, / Brought by Sara Dana to an inspired Sister at the City of Peace / and drafted by the same June 1854*

PROVENANCE:

Sotheby's sale 6957, 1/97, lot 1561.

PUBLISHED:

Andrews, Jeanmarie. "A Rare Find." *Early American Homes* (April 1997): 80.
Kramer, Fran, and Lita Solis-Cohen. "Shaker Gift Drawings Surface." *Maine Antique Digest* 24, no. 11 (November 1996): 42-A.
Reif, Rita. "A Shaker Rarity Causes a Stir." *New York Times,* Jan. 12, 1997, p. 44 (detail).
Solis-Cohen, Lita. "It All Depends on Who You Know." *Maine Antique Digest* (December 1996): 10-A.
Wertkin, Gerard C. "Director's Letter." *Folk Art* 22, no. 1 (spring 1997): 11.

21 Patterson, *Gift Drawing and Gift Song,* pp. 80–85.
22 Potter was also the recipient of one of Polly Reed's heart-shaped gifts; see cat. no. 277.
23 For a brief discussion of "families" in a Shaker context, see the entry for *View of the Church Family, Alfred, Maine,* cat. no. 271.

When this work was discovered in 1996, it joined fifteen gift draw-
ings attributed to Polly Collins and bearing dates from 1841 to
1859.[24] Her compositions are not as bold and direct as those of another
Hancock Shaker, Hannah Cohoon, but they often incorporate similar
arboreal motifs. Collins was very active as an instrument, or medium,
at Hancock during the revival period. In addition to the drawings, she
recorded many visionary experiences and gift messages.

For this and several other drawings, Collins constructed a distinctive
grid of squares or rectangles, each of which contains stylized figures of
trees, colorful flowering plants, and, occasionally, arbors or other objects.
The overall compositions of these works and their individual elements
suggest the design of album quilts. Despite their insularity, the Shakers
were not immune to influences from outside their villages. Not only were
memories of the visual culture of the region retained, but new directions
in design found their way into Shaker communities through recent con-
verts, publications, and the reports of those Shakers who were charged
with doing business with the outside world. Decorative bedcovers were
not made or used in nineteenth-century Shaker villages, and album quilts
had not become a popular form at the time Collins entered Hancock in
1820. By 1854, however, when she created this drawing, album quilts were
widely known, and their influence on this drawing cannot be dismissed.

According to the inscription on this drawing, it was inspired by
Mother Ann Lee (1736–1784), the founder of the Shaker faith, and in-
tended as a gift to the Church family eldresses (or "Elder Sisters") at the
City of Union. During the Era of Manifestations, each Shaker village
received a spiritual designation. The community at Enfield, Connecticut,
for example, was known as the "City of Union," while Hancock was the
"City of Peace." Collins inscribed a similar drawing from Ann Lee to
the elders of the North family, probably at Hancock. —G.C.W.

282. GIFT DRAWING: THE TREE OF
LIGHT OR BLAZING TREE
Hannah Cohoon (1788–1864)
Hancock, Berkshire County, Massachusetts
1845
Ink, pencil, and gouache on paper
16 × 20⅞ in.
P2.1997.1

INSCRIPTION:
Recto, ink: *The Tree of Light or Blazing Tree / The bright silver couleured light streaming from the edges
of each green leaf resembles so / many torches. NB I saw the whole tree as the angel held it before me as dis-
tinctly as I ever / saw a natural tree, I felt very cautious about taking hold of the tree lest the blaze should /
touch my hand. Seen and received by Hannah Cohoon in the City of Peace Sab Oct 9th / 10th h. A.M. 1845
drawn and painted by the same hand;* verso, ink: *NB Be cautious and not lay warm hands / on the paint as
it is easy to cleave to the / hand and take off little pieces of paint; / Sister / Be so kind as to accept of this little
/ token of my love and remembrance / Hannah Cohoon / 60*

PROVENANCE:
Sotheby's sale 6957, 1/97, lot 1560.

PUBLISHED:
Andrews, Jeanmarie. "A Rare Find." *Early American Homes* (April 1997): 80.
Kramer, Fran, and Lita Solis-Cohen. "Shaker Gift Drawings Surface." *Maine Antique Digest* 24,
 no. 11 (November 1996): 42-A.
Reif, Rita. "A Shaker Rarity Causes a Stir." *New York Times*, Jan. 12, 1997, p. 44.
Wertkin, Gerard C. "Director's Letter." *Folk Art* 22, no. 1 (spring 1997): p. 11.

With a handful of exceptions, all extant Shaker gift drawings
were created in the two neighboring communities of New Leba-
non, New York, and Hancock, Massachusetts. Many of the Hancock
examples—in contrast to those from New Lebanon—are dominated
by floral or arboreal imagery, as in this watercolor painting by Hannah
Cohoon. Until this work was discovered in 1996, it had long been
thought that only four drawings by Cohoon had survived.[25] All but
one of these depict trees.

This drawing is nearly identical to another work by Cohoon.[26] Both
depict a blazing tree that the artist described having seen in a vision,
held before her by an angel "as distinctly as [she] ever saw a natural
tree." According to the inscription at the bottom of the work, this vision
occurred on October 9, 1845. Sometime thereafter, Cohoon prepared
the two drawings.

Unlike the automatic writing or spirit drawing of nineteenth-
century Spiritualism, Shaker instruments rarely claimed to create while
"possessed" or in a trance state, although some examples of spontane-
ous "spirit writing" do exist in the context of the Shaker revival period.
The more usual order of events was for the drawing—or the message
or song, for that matter—to follow the vision. Gift drawings, which were
believed to be records of visionary experiences, were the conscious acts
of their creators. Cohoon carefully planned her *Tree of Light* in pencil
before she added thick, opaque watercolors.

Hannah Cohoon entered the Hancock Shaker community in 1817
when she was twenty-nine years of age, accompanied by two small
children. Her drawings reflect the visual culture outside the Shaker
communities—popular prints, quilt motifs, needlework samplers. An
inscription on the back of the drawing indicates that it was intended
by Cohoon as a gift for an unidentified Shaker sister. —G.C.W.

24 Patterson, *Gift Drawing and Gift Song*, pp. 51–54.
25 When Sister Alice Smith of Hancock introduced Shaker drawings to pioneer collectors
 Edward Deming Andrews and Faith Andrews in the 1930s, she told them that as a child she
 saw an eldress "putting under the fuel log in the bake oven a roll of papers with many colored
 and pen-and-ink designs.... She begged the eldress to let her have them, and when the re-
 quest was granted she took the bundle to her own room" and saved them. It is assumed that
 many gift drawings were destroyed after the period of Mother's Work ended, especially as
 the villages were being closed. See Edward Deming Andrews and Faith Andrews, *Fruits of the
 Shaker Tree of Life: Memoirs of Fifty Years of Collecting and Research* (Stockbridge, Mass.: Berkshire
 Traveler Press, 1975), p. 96.
26 See entry on Hannah Cohoon in Sharon Duane Koomler, *Seen and Received: The Shakers' Private
 Art* (Pittsfield, Mass.: Hancock Shaker Village, 2000), n.p.

"Scrimshaw," a word of unknown origin, denotes the making of knick-knacks, novelties, keepsakes, and tools from bone or ivory derived from whales and other marine mammals; it is largely the product of the New England whaling industry and dates from about 1830 through the early twentieth century.[1] Most scrimshanders were young men—forecastle hands were usually in their teens or twenties, and officers were just a little older—seeking to relieve the tedium peculiar to whaling voyages. Their work is not emblematic of an exciting or enviable profession. Voyages often lasted years, with long stretches of relative idleness between whale encounters, and contact with the outside world was infrequent.[2] Because a whale ship required multiple boat crews to capture and slaughter a whale, far more seamen were carried aboard than were needed to sail and maintain the primary vessel. Consequently, filling endless hours and occupying idle hands became a serious, even urgent, challenge. Accordingly, creative hobbies flourished aboard whale ships more than on other maritime vessels.

Aspiring scrimshanders invariably began with a simple project, moving on to more ambitious work as their skill and confidence increased. The most intricate scrimshaw was probably made by veteran whalers who had grown proficient over several voyages. A whaling captain, for example, would have ascended through the ranks, refining his scrimshawing technique along the way. Other finely crafted pieces are undoubtedly the work of ship carpenters and coopers who had the expertise and the tools to produce sophisticated work. Some whaling journals describe scrimshawing as an assembly-line process. Extracting and preparing the raw materials—bone, teeth (from sperm whales), and baleen (a dark, resilient substance taken in massive strips from the upper jaws of right and bowhead whales)—was a labor-intensive group effort. Carving, lathe turning, and decorating fell to those with the requisite tools and skills.[3] For pictorial subjects, whalers commonly copied or traced illustrations from books or periodicals.

Although scrimshaw is generally regarded as a quintessentially American art form, some care must be taken with attribution. The United States dominated the whaling industry for most of the nineteenth century, but superb scrimshaw was produced aboard ships of other nations as well, notably Britain and Australia.[4] Moreover, as the nineteenth century progressed, crews on American vessels became increasingly cosmopolitan. Thus, scrimshanders on Yankee vessels might well have been Azorean, Polynesian, European, or Inuit.[5]

Shipboard life was rough—so much so that desertion was endemic and few recruits who finished a voyage reenlisted.[6] Scrimshaw therefore reflects the preoccupations of young men struggling with overwhelming boredom, shipboard grudges, persistent hunger, and nagging homesickness. Small wonder, then, that some of the most inspired examples are kitchen gadgets and love tokens for sweethearts, wives, and children. Truly tender objects could, and did, emerge from truly tough conditions.

—K.R.M.

283a. CLENCHED FIST JAGGING WHEEL
AND PIE TESTER
Artist unidentified
New England
c. 1850
Walrus ivory with metal
3½ × 9⅛ × 1⅛ in.
P1.2001.303

PROVENANCE:
Found in Edgartown, Mass.; Kristina Barbara Johnson, Princeton, N.J.; Sotheby Parke-Bernet sale 4758Y, "Johnson Whaling Collection, Part I," 12/81, lot 487.

283b. OPEN HEART JAGGING WHEEL
Artist unidentified
Probably eastern United States
c. 1850
Whale ivory with metal
1¹¹⁄₁₆ × 5⅞ × ½ in.
P1.2001.304

PROVENANCE:
Kristina Barbara Johnson, Princeton, N.J.; Sotheby Parke-Bernet sale 4758Y, "Johnson Whaling Collection, Part I," 12/81, lot 342.

283c. HAND AND CUFF JAGGING WHEEL
Artist unidentified
Probably eastern United States
c. 1850
Probably walrus ivory with nails
1¾ × 6 × 1¼ in.
P1.2001.305

PROVENANCE:
Kristina Barbara Johnson, Princeton, N.J.; Sotheby Parke-Bernet sale 5130, "Johnson Whaling Collection, Part IV," 12/83, lot 477.

EXHIBITED:
"The Art of the Whaleman," Snug Harbor Cultural Center, Staten Island, N.Y., 1983.

PUBLISHED:
Bishop, Robert, Judith Reiter Weissman, Michael McManus, and Henry Neimann. *The Knopf Collectors' Guides to American Antiques: Folk Art.* New York: Alfred A. Knopf, 1983, pl. 311.

1 For a discussion of the term's origin, see E. Norman Flayderman, *Scrimshaw and Scrimshanders, Whales and Whalemen* (New Milford, Conn.: N. Flayderman, 1972), pp. 3–4, and Stuart M. Frank, *Dictionary of Scrimshaw Artists* (Mystic, Conn.: Mystic Seaport Museum, 1991), p. xix.

2 Richard C. Malley, *Graven by the Fishermen Themselves: Scrimshaw in Mystic Seaport Museum* (Mystic, Conn.: Mystic Seaport Museum, 1983), p. 19.

3 Kenneth R. Martin, *"Some Very Handsome Work": Scrimshaw at the Cape Cod National Seashore* (Eastham, Mass.: Eastern National Park & Monument Association, 1991), pp. 8–9.

4 For international examples, see Janet West and Arthur G. Credland, *Scrimshaw: The Art of the Whaler* (Hull, England: Hutton Press in association with Hull City Museums & Art Galleries, 1995).

5 Malley, *Graven by the Fishermen*, p. 19.

6 Briton C. Busch, *"Whaling Will Never Do for Me": The American Whaleman in the Nineteenth Century* (Lexington, Ky.: Univ. of Kentucky Press, 1994), pp. 8–17.

284. SEA HORSE JAGGING WHEEL
Artist unidentified
New England
c. 1870
Whale ivory and ebony with silver pins
2¾ × 6 × 1½ in.
P1.2001.306

PROVENANCE:
Sotheby's sale 5429, 1/86, lot 494.

EXHIBITED:
"Five-Star Folk Art: One Hundred American Masterpieces," MAFA, 1990.

PUBLISHED:
Bishop, Robert, and Jacqueline Marx Atkins. *Folk Art in American Life.* New York: Viking Studio
 Books in association with MAFA, 1995, p. 172.
Lipman, Jean, Robert Bishop, Elizabeth V. Warren, and Sharon L. Eisenstat. *Five-Star Folk Art:
 One Hundred American Masterpieces.* New York: Harry N. Abrams in association with MAFA,
 1990, p. 143.

Many whalers preferred the jagging wheel—or pie crimper—as a showcase for their originality. A common kitchen device with a crenellated wheel to trim and perforate pie crusts, it may have been made by scrimshanders in response to a longing for home and decent food.[7] The clenched fist jagging wheel, with a two-pronged fork for testing pie crust, is almost weaponlike. Fists were sometimes carved with the thumb aligned with the fingers, a position said to connote friendship. This scrimshander, however, used the traditional defiant clenched fist. The dainty handle of the open heart jagging wheel was cleverly carved from a single sperm whale tooth, and its heart-shaped terminus strongly suggests that it was intended as a gift for a loved one. A master carver fashioned the handle of the hand and cuff jagging wheel from a single piece of walrus ivory; the cuff buttons are made with nail heads. The strongly masculine quality of the piece belies the delicate task for which the utensil was designed. And the glorious sea horse jagging wheel transcends its utilitarian purpose and exemplifies the art of scrimshaw at its most elegant and refined. The sea horse, a common motif in nautical arts, is unusual in scrimshaw. —K.R.M.

285. DOLL CRADLE FOR SARAH TURNERLY
Jacob Turnerly (dates unknown)
Possibly vicinity of Clinton,
Middlesex County, Connecticut
1853
Cherry, ebony, and whale skeletal bone
with paint and ink
13⅞ × 22⅝ × 12¾ in.
P1.2001.307

INSCRIPTIONS:
Front of bonnet, ink: *Sarah Turnerly;* front end, paint: *1853*

PROVENANCE:
Kate and Joel Kopp, America Hurrah, New York; Sotheby's sale 5810, 1/89, lot 1075.

EXHIBITED:
"Small Folk: A Celebration of Childhood in America," MAFA and N-YHS, 1980/81.

PUBLISHED:
Bishop, Robert, and Patricia Coblentz. *American Decorative Arts: 360 Years of Creative Design.*
 New York: Harry N. Abrams, 1982, p. 229.
Brant, Sandra, and Elissa Cullman. *Small Folk: A Celebration of Childhood in America.* New York:
 E.P. Dutton in association with MAFA, 1980, p. 157.

This graceful doll cradle, dated 1853 and lovingly crafted of cherry with inlays of ebony and whale skeletal bone, may have been made by a whale ship's carpenter. It is obviously the work of a seasoned scrimshander and a prime example of scrimshaw's endearing qualities. The inscribed bone plaque on the visor is apparently a later addition. Although a few whaling captains sailed with their wives and even children aboard, this item was probably made for a child ashore. —K.R.M.

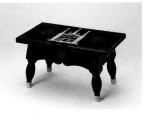

286. FOOTSTOOL WITH SCRIMSHAW DECORATION
Artist unidentified
Probably eastern United States
c. 1850
Mahogany, exotic wood, whale ivory,
and whale skeletal bone
7⅝ × 12½ × 7⅛ in.
P1.2001.308

PROVENANCE:
Garrit Honig; Kristina Barbara Johnson, Princeton, N.J.; Sotheby Parke-Bernet sale 4758Y,
"Johnson Whaling Collection, Part I," 12/81, lot 437.

PUBLISHED:
Flayderman, E. Norman. *Scrimshaw and Scrimshanders, Whales and Whalemen.* New Milford,
 Conn.: N. Flayderman, 1972, p. 210.
Meyer, Charles R. *Whaling and the Art of Scrimshaw.* New York: David McKay, 1976, p. 197.

7 Clifford Ashley, *The Yankee Whaler* (1926; reprint, Garden City, N.Y.: Halcyon House, 1942),
 p. 115.

This footstool is a flashy demonstration of a scrimshander's skill and originality. The form, inlays, and carved swirls conform to no furniture fashion of the day, but the elements work together perfectly. Even the spired building, inlaid with skeletal bone (so called to avoid confusion with baleen, which is commonly but incorrectly called "whalebone"), appears to be a figment of the maker's imagination. The inlaid stars on the seat suggest compass roses, popular motifs in nautical folk art. The feet are of ivory and, like the legs, were turned on a small lathe.

—K.R.M.

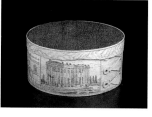

287. DITTY BOX
Artist unidentified
Probably New England
c. 1845
Whale skeletal bone, mahogany, and rosewood with nails
3⅓ × 6¼ in. diam.
P1.2001.309

PROVENANCE:
Kristina Barbara Johnson, Princeton, N.J.; Sotheby Parke-Bernet sale 5075, "Johnson Whaling Collection, Part III," 4/83, lot 87.

EXHIBITED:
"Cross Currents: Faces, Figureheads, and Scrimshaw Fancies," MAFA, 1984.
"A Place for Us: Vernacular Architecture in American Folk Art," MAFA, 1996/97.

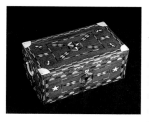

288. SEWING BOX
Artist unidentified
Probably eastern United States
c. 1850
Mahogany, exotic woods, whale ivory, and baleen with metal hardware
6⅛ × 13½ × 7⅜ in.
P1.2001.310

PROVENANCE:
Kristina Barbara Johnson, Princeton, N.J.; Sotheby Parke-Bernet sale 5075, "Johnson Whaling Collection, Part III," 4/83, lot 467.

EXHIBITED:
"Hunt for the Whale," MAFA, 1968.
"The Flowering of American Folk Art, 1776–1876," WMAA, 1974.
"Scrimshaw: The Sailor's Art," Smithsonian Institution, Washington, D.C., 1977.
"The Barbara Johnson Whaling Collection and Scrim Sculpture by Tom Johnston," Mystic Seaport Museum, Mystic, Conn., 1978.

PUBLISHED:
Lipman, Jean. *Provocative Parallels.* New York: E.P. Dutton, 1975, p. 77.
Lipman, Jean, and Alice Winchester. *The Flowering of American Folk Art, 1776–1876.* New York: Viking Press in association with WMAA, 1974, p. 251.
Meyer, Charles R. *Whaling and the Art of Scrimshaw.* New York: David McKay, 1976, p. 63.

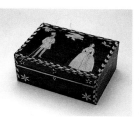

289. BOX WITH TWO FIGURES
Artist unidentified
Massachusetts
c. 1830–1860
Wood, baleen, whale skeletal bone, rosewood, mother-of-pearl, and sealing wax with metal hardware
4¹³⁄₁₆ × 11⅛ × 7¹³⁄₁₆ in.
P1.2001.311

PROVENANCE:
James R. Bakker, Littleton, Mass.; Wayne Pratt, Marlboro, Mass.; Paul J. De Coste, Newburyport, Mass., 1992.

Box making was a challenge for an advanced scrimshander. Indeed, many wooden trinket or sewing boxes are so refined that, were it not for the use of whale products, they would be indistinguishable from professional work.[8] These spectacularly inlaid wooden boxes with components of whale ivory and baleen are cases in point; the pulls for the compartment lids inside the sewing box are a startling group of nine upthrust, clenched fists. The sides and lid rim of the oval ditty box are made of thin strips of skeletal bone—probably "pan bone," removed from a sperm whale's jaw—bent to shape and pinned in the manner of commercial pantry boxes. The precisely incised images of the White House and the United States Capitol were taken from printed sources. The box's superb condition and refinement of construction suggest that it, like its wooden companions, was intended for home use.

—K.R.M.

290. BUSK WITH SHIP AND ANGEL
Attributed to A.V. Booth (dates unknown)
Probably eastern United States
c. 1840
Ink on whale skeletal bone
12⅝ × 1¹¹⁄₁₆ × ¹⁄₁₆ in.
P1.2001.312

INSCRIPTION:
Recto, ink: *Remember Me / When Far Away / UNITY / LOVE*

PROVENANCE:
Kristina Barbara Johnson, Princeton, N.J.; Sotheby Parke-Bernet sale 4758Y, "Johnson Whaling Collection, Part I," 12/81, lot 445.

EXHIBITED:
"Hunt for the Whale," MAFA, 1968.
"Seascape in the American Imagination," WMAA, 1975.
"Cross Currents: Faces, Figureheads, and Scrimshaw Fancies," MAFA, 1984.

PUBLISHED:
Whipple, A.B.C., et al. *The Whalers.* Alexandria, Va.: Time-Life Books, 1979, p. 129.

8 Flayderman, *Scrimshaw and Scrimshanders,* p. 154.

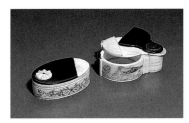

291. BUSK WITH HARBOR VIEW
Artist unidentified
Possibly New Bedford Harbor, Bristol County,
Massachusetts
c. 1845
Ink on whale skeletal bone
13¹⁄₁₆ × 1¹⁄₄ × ¹⁄₁₆ in.
P1.2001.313

PROVENANCE:
Kristina Barbara Johnson, Princeton, N.J.; Sotheby Parke-Bernet sale 5130, "Johnson Whaling Collection, Part IV," 12/83, lot 610.

EXHIBITED:
"Hunt for the Whale," MAFA, 1968.
Old Barracks Association, Trenton, N.J., 1971.
"Scrimshaw: The Sailor's Art," Smithsonian Institution, Washington, D.C., 1977.
"Cross Currents: Faces, Figureheads, and Scrimshaw Fancies," MAFA, 1984.

Bodice busks, or stays, made of whale skeletal bone or baleen were favored keepsakes for wives or ladyloves ashore. Scrimshaw busks probably evolved from the eighteenth-century maritime practice of chip-carving wooden busks, and their popularity endured in spite of changes in women's fashions.[9] The simple form was more suitable for a draftsman than a carver, and busks were often personalized with intimate sentiments or symbols of love.

The busk with ship and angel combines the patriotic with the romantic. Tender inscriptions, indicating the maker was on a voyage far from his sweetheart, appear alongside the classic American motifs of an eagle and draped flags in addition to what appears to be a warship. Most of the polychromed images were likely copied from published sources. The busk with harbor view displays a detailed, fanciful scene with Old Glory flying conspicuously and ships anchored in the harbor of a bustling port. The scrimshander's linear approach is appropriate to the form and adds appeal to the scene. —K.R.M.

292. PUZZLE BOX
Attributed to Captain Edward
Penniman (1831–1913)
Probably Cape Cod, Massachusetts
c. 1870
Ink on whale ivory with tortoiseshell
and metal
1 × 2³⁄₄ × 1¹¹⁄₁₆ in.
P1.2001.314

PROVENANCE:
Kristina Barbara Johnson, Princeton, N.J.; Sotheby Parke-Bernet sale 5130, "Johnson Whaling Collection, Part IV," 12/83, lot 412.

EXHIBITED:
"Hunt for the Whale," MAFA, 1968.
"Barbara Johnson Scrimshaw Collection," Nantucket Whaling Museum, Nantucket, Mass., 1977.

293. PUZZLE BOX FOR BESSIE PENNIMAN
Attributed to Captain Edward Penniman (1831–1913)
Cape Cod, Massachusetts
c. 1885
Ink on whale ivory with tortoiseshell, copper, and silver
1¹⁄₈ × 3 × 1⁷⁄₈ in.
P1.2001.315

INSCRIPTION:
Side, ink: *B.A. Penniman*

PROVENANCE:
Kristina Barbara Johnson, Princeton, N.J.; Sotheby Parke-Bernet sale 5075, "Johnson Whaling Collection, Part III," 4/83, lot 71.

These sophisticated puzzle boxes—there is a trick to making the lids slide open—are attributed to Captain Edward Penniman (1831–1913) of Eastham, Massachusetts. Penniman commanded his first ship, the New Bedford, Massachusetts, bark *Minerva,* in 1860 and again in 1864, followed by tours on the *Cicero* (1874), the *Europa* (1876), and the *Jacob A. Howland* (1881). A dedicated scrimshander, he is believed to have made the boxes while at sea.[10] In 1968 Donald Penniman, a distant cousin, recalled an "ivory and tortoiseshell box" as among the many scrimshaw articles that the celebrated captain fashioned; in some written materials it is referred to as "Bessie's puzzle box."[11] The "B.A. Penniman" inscribed on the side of one puzzle box is either Captain Penniman's wife, Elizabeth (Betsey) Augusta Knowles Penniman (1839–1921), or their daughter Bessie (1868–1957). The box is ingeniously carved from a sperm whale's tooth, and the inscription is embellished with a vignette of a robin perched upon a rosebush branch.

Mrs. Penniman was a frequent companion on her husband's voyages, and she kept a journal aboard the *Minerva* from 1864 to 1868.[12] Captain Penniman's own shipboard Bible, account book, journals, souvenirs, and equipment are just some of the wealth of items from the Penniman family that survive. In 1867 Penniman began construction on his Fort Hill home—which is now part of the Cape Cod National Seashore—but did not retire for many more years. —K.R.M.

9 Ibid., pp. 172–73.
10 Barbara Johnson, "E. Penniman," in catalog for Sotheby Parke-Bernet sale 5075, "Johnson Whaling Collection, Part III," 4/83, n.p.
11 Hope Morrill, United States Department of the Interior, National Park Service, Cape Cod National Seashore, South Wellfleet, Mass., letter to Stacy C. Hollander, March 20, 2001 (AFAM files).
12 Augusta Penniman, *Journal of a Whaling Voyage, 1864–1868* (Eastham, Mass.: Eastern National Park & Monument Association, 1988).

294. CANE WITH THREE TWISTED SNAKES
Artist unidentified
Probably eastern United States
c. 1860
Whale skeletal bone
34⅛ × 1¼ in. diam.
P1.2001.316

PROVENANCE:
Kristina Barbara Johnson, Princeton, N.J.; Sotheby Parke-Bernet sale 5075, "Johnson Whaling Collection, Part III," 4/83, lot 434.

EXHIBITED:
"Voice of the Whaleman," Boston University, 1975.
"Barbara Johnson Scrimshaw Collection," Nantucket Whaling Museum, Nantucket, Mass., 1977.
"The Barbara Johnson Whaling Collection and Scrim Sculpture by Tom Johnston," Mystic Seaport Museum, Mystic, Conn., 1978.
"Cross Currents: Faces, Figureheads, and Scrimshaw Fancies," MAFA, 1984.

295. CANE WITH ELEPHANTS, LIONS, WHALES, AND SHIPS
Artist unidentified
Nantucket, Massachusetts
c. 1845
Whale ivory with ebony, tortoiseshell, abalone shell, mother-of-pearl, amber, and silver
32¼ × 1¾ in. diam.
P1.2001.317

PROVENANCE:
Karl Wede; Kristina Barbara Johnson, Princeton, N.J.; Sotheby Parke-Bernet sale 5130, "Johnson Whaling Collection, Part IV," 12/83, lot 618.

EXHIBITED:
"Cross Currents: Faces, Figureheads, and Scrimshaw Fancies," MAFA, 1984.

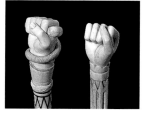

296a. CANE WITH FIST HOLDING SNAKE HANDLE
Artist unidentified
Nantucket, Massachusetts
c. 1840
Whale ivory and whale skeletal bone with ebony, tortoiseshell, abalone shell, mother-of-pearl, and silver
35⅛ × 2 in. diam.
P1.2001.318

PROVENANCE:
Kristina Barbara Johnson, Princeton, N.J.; Rafael Osona Auctions, Nantucket, Mass., sale 8/94, lot 147.

PUBLISHED:
Bishop, Robert. *American Folk Sculpture.* New York: E.P. Dutton, 1974, p. 346.
Whipple, A.B.C., et al. *The Whalers.* Alexandria, Va.: Time-Life Books, 1979, p. 130.

296b. CANE WITH FIST HANDLE
Artist unidentified
Probably New England
c. 1850
Whale ivory and whale skeletal bone with ebony, tortoiseshell, abalone shell, brads, and brass
34⅞ × 1½ in. diam.
P1.2001.319

PROVENANCE:
Kristina Barbara Johnson, Princeton, N.J.; Sotheby Parke-Bernet sale 5130, "Johnson Whaling Collection, Part IV," 12/83, lot 297.

EXHIBITED:
"The Art of the Whaleman," Snug Harbor Cultural Center, Staten Island, N.Y., 1983.

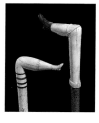

297a. CANE WITH FEMALE LEG HANDLE
Artist unidentified
Probably eastern United States
c. 1860
Whale ivory and whale skeletal bone with horn, ink, and nail
29¾ × 3½ in.
P1.2001.320

PROVENANCE:
Kristina Barbara Johnson, Princeton, N.J.; Sotheby Parke-Bernet sale 4758Y, "Johnson Whaling Collection, Part I," 12/81, lot 439.

EXHIBITED:
"Hunt for the Whale," MAFA, 1968.

PUBLISHED:
Phelan, Joseph. *The Whale Hunters in Pictures.* New York: Time-Life Books, 1969, p. 26.
Whipple, A.B.C., et al. *The Whalers.* Alexandria, Va.: Time-Life Books, 1979, p. 130.

297b. CANE WITH FEMALE LEG AND DARK BOOT HANDLE
Artist unidentified
Probably eastern United States
c. 1860
Whale skeletal bone, mahogany, and ivory with paint
34 × 3¾ in.
P1.2001.321

INSCRIPTION:
Handle, paint: *Ladies Walking stick / made from whales tooth and mahogany / baleen shoe Unusual 3255-nan [?] / 1845 period*

PROVENANCE:
Kristina Barbara Johnson, Princeton, N.J.; Sotheby Parke-Bernet sale 4758Y, "Johnson Whaling Collection, Part I," 12/81, lot 439.

EXHIBITED:
"Hunt for the Whale," MAFA, 1968.

PUBLISHED:
Phelan, Joseph. *The Whale Hunters in Pictures.* New York: Time-Life Books, 1969, p. 26.
Whipple, A.B.C., et al. *The Whalers.* Alexandria, Va.: Time-Life Books, 1979, p. 130.

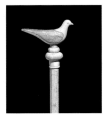

298. CANE WITH BIRD HANDLE
Artist unidentified
Probably eastern United States
c. 1860
Whale ivory and whale skeletal bone with ink
39¾ × 4¾ in.
P1.2001.322

INSCRIPTION:
On ring below bird, ink: 200 W[E]T

PROVENANCE:
Kristina Barbara Johnson, Princeton, N.J.; Sotheby Parke-Bernet sale 4758Y, "Johnson Whaling Collection, Part I," 12/81, lot 332.

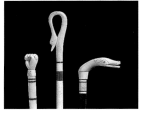

299a. LADY'S WALKING STICK
WITH FIST HANDLE
Artist unidentified
Probably eastern United States
c. 1850
Whale ivory, whale skeletal bone, and
baleen with ink and metal
28 × ⅞ in. diam.
P1.2001.323

PROVENANCE:
Kristina Barbara Johnson, Princeton, N.J.; Sotheby Parke-Bernet sale 5130, "Johnson Whaling Collection, Part IV," 12/83, lot 550.

299b. POINTER WITH SWAN HANDLE
Artist unidentified
Probably eastern United States
Nineteenth century
Whale skeletal bone, whale ivory, and wood
34½ × 1³⁄16 in.
P1.2001.324

PROVENANCE:
Kristina Barbara Johnson, Princeton, N.J.; Sotheby Parke-Bernet sale 4758Y, "Johnson Whaling Collection, Part I," 12/81, lot 483.

299c. RIDING CROP WITH SERPENT HEAD HANDLE
Artist unidentified
Probably eastern United States
c. 1870
Ironwood and ivory with nails
26¾ × 2¾ in.
P1.2001.325

PROVENANCE:
Kristina Barbara Johnson, Princeton, N.J.; Sotheby Parke-Bernet sale 4758Y, "Johnson Whaling Collection, Part I," 12/81, lot 274.

Canes, in their simplest form, as well as pointers and riding crops, were often a whaler's first scrimshaw project, which may explain their profusion. In 1844, after a spate of scrimshawing activity aboard the Delaware whaleboat *Lucy Ann,* a whaler noted that there were enough canes aboard the vessel "to supply all the old men in Wilmington."[12] It is also likely that many fancy canes were made not for practical use but to show off a scrimshander's skill. These illustrated specimens are the work of practiced hands.

Folk painters characteristically found hands difficult to paint, but scrimshanders frequently carved them with competence. The pervasiveness of the closed fist in scrimshaw has led to the suggestion that it represents the carvers' repressed hostility.[13] The cane with the fist handle is noteworthy for its fluted and inlaid shaft of whale skeletal bone. Serpent-head motifs were often used for cane handles; the cane with three twisted snakes is quite an extraordinary example. The shaft and three full-length intertwined snakes were carved from a single piece of whale skeletal bone. Some scholars maintain that the snake motif is sexually symbolic.[14] Regardless, the form was a natural for ambitious cane makers. The carver of the cane with elephants, lions, whales, and ships clearly took pride in his nautical calling—the tapering shaft is of whale skeletal bone inlaid with tortoiseshell whales, dolphins, and steamers. And as seen in the two examples of canes with female leg handles, a slightly risqué lady's leg, shod, gartered, and very tactile, was a popular way to test the threshold of Victorian taste. —K.R.M.

12 John F. Martin, quoted in Frank, *Dictionary of Scrimshaw Artists,* p. 91.
13 Richard C. Malley, *In Their Hours of Ocean Leisure: Scrimshaw in the Cold Spring Harbor Whaling Museum* (Cold Spring Harbor, N.Y.: Whaling Museum Society, 1993), p. 39.
14 Malley, *Graven by the Fishermen Themselves,* pp. 92–93.

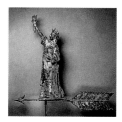

300. STATUE OF LIBERTY WEATHERVANE
Probably J.L. Mott Iron Works
New York
After 1886
Copper, zinc, and iron with gold leaf
53¼ × 55¼ × 5 in.
P1.2001.326

PROVENANCE:
Yonder Hill Dwellers, Palisades, N.Y., sale 11/72; Gerald Kornblau, New York; Thomas Rizzo, New York; Sotheby Parke-Bernet sale 4911M, "Rizzo Collection," 4/82, lot 8.

EXHIBITED:
"American Folk Art," Mead Art Building, Amherst College, Amherst, Mass., 1974.
"New York: The State of the Art," New York State Museum, Albany, 1977.
"The Art of the Weathervane," MAFA, 1979/80.
"The Shape of Things: Folk Sculpture from Two Centuries," MAFA, 1983.
"Images of Liberty: Models and Reductions of the Statue of Liberty, 1867–1917," Christie's, New York, 1986.
"Liberties with Liberty: The Changing of an American Symbol," MAFA, 1986.

PUBLISHED:
Amherst College. *American Folk Art.* Amherst, Mass.: Amherst College, 1974, fig. 105.
Bishop, Robert. *American Folk Sculpture.* New York: E.P. Dutton, 1974, p. 73.
Bishop, Robert, and Jacqueline Marx Atkins. *Folk Art in American Life.* New York: Viking Studio Books in association with MAFA, 1995, p. 163.
Bishop, Robert, and Patricia Coblentz. *A Gallery of Weathervanes and Whirligigs.* New York: E.P. Dutton, 1981, p. 47.
Blanchet, Christian, and Bertrand Dard. *Statue de la Liberté: Le Livre du centenaire.* Paris: Edition Comet's, 1984, p. 134.
Fox, Nancy Jo. *Liberties with Liberty: The Fascinating History of America's Proudest Symbol.* New York: E.P. Dutton in association with MAFA, 1986, cover, p. 40.
Klamkin, Charles. *Weather Vanes: The History, Design, and Manufacture of an American Folk Art.* New York: Hawthorn Books, 1973, p. 93.

Frederic Auguste Bartholdi's colossal sculpture *Liberty Enlightening the World,* better known today as the Statue of Liberty, was well on its way to becoming a national icon even before it was erected in New York Harbor in 1886. A joint effort of France and the United States, it was conceived as a commemoration of the centennial of the Declaration of Independence and intended for completion in 1876. Fund-raising went slowly on both sides of the Atlantic, while in Paris, Bartholdi had to enlist Gustave Eiffel, of Eiffel Tower fame, to design the iron framework for the massive sculpture. In the United States, benefit art exhibitions, theatrical events, auctions, prize fights, and a public fund-raising campaign brought national attention to the monumental statue. The torch was displayed at the Philadelphia Centennial Exposition in 1876, sparking widespread public interest. With thousands of spectators in attendance, the statue was finally dedicated by President Grover Cleveland ten years later.

In addition to being a finely modeled weathervane with an old gilded surface, this outstanding rendition of the Statue of Liberty appears to be unique. If other similar examples were made, they have not survived.[1] The piece surfaced at an auction at Yonder Hill Dwellers in Palisades, New York, in 1972.[2] This would tend to give it a local provenance, as the proprietors of that antique shop and auction house specialized in objects and estates from the Lower Hudson Valley and Bergen County area.

An illustration of a *Liberty Enlightening the World* that is nearly identical in design appeared in the 1892 catalog of the J.L. Mott Iron Works, which accounts for the probable attribution of this weathervane. A caption reads, "Modeled after the great Bartholdi Statue of Liberty, erected on Bedloe's Island, New York Harbor."[3] To complicate matters, though, a similar illustration of a weathervane with the same title, but shown from a different perspective, was offered in the 1893 catalog of J.W. Fiske of New York.[4]

—R.S.

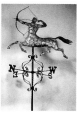

301. CENTAUR WEATHERVANE
Probably A.L. Jewell & Company
Waltham, Middlesex County, Massachusetts
1852–1867
Copper with gold leaf, with iron directionals
50½ × 43 × 29 in. (with directionals)
P1.2001.327

PROVENANCE:
Abel Colburn farm, Hollis, N.H.; Skinner sale 1156, 6/87, lot 140.

This magnificent centaur is from the barn of the Abel Colburn farm in Hollis, New Hampshire, which was built in 1854.[5] In addition to its fine condition, it is particularly notable for the geometric pattern on its gilded surface, created by the weathering of squares of gold leaf. Several other centaur weathervanes have survived, suggesting that the subject was fairly popular in the second half of the nineteenth century. An example by the same maker is in the collection of the Shelburne Museum in Shelburne, Vermont.[6]

Half man and half horse, the mythological centaur personifies man's dual nature. Embodying the conflict between instinct and intellect, he epitomizes masculine strength and aggression while at the same time he possesses divine wisdom and knowledge. In ancient Greece, the most celebrated centaur was Chiron, a great and wise teacher who had himself been instructed by Apollo and Artemis. As a constellation and the ninth sign of the zodiac, he is Sagittarius.

This centaur was probably made by A.L. Jewell & Company. An innovator in the development and marketing of three-dimensional copper weathervanes, Alvin L. Jewell founded his company in Waltham,

1 A Statue of Liberty weathervane of a different design and by a different maker is in the AARFAM collection.
2 "Statue of Liberty Sets Auction Record," *Antiques and the Arts Weekly* (May 7, 1982): 23.
3 J.L. Mott Iron Works, "Illustrated Catalogue 'Q' and Price List" (1892), p. 54.
4 J.W. Fiske, *Illustrated Catalog* (1893; reprint, Princeton, N.J.: Pyne Press, 1971), p. 59.
5 Lucy B. Wright, letter to Douglas Marshall, owner of the property, c. mid-1950s (AFAM files).

6 Charles Klamkin, *Weather Vanes: The History, Design, and Manufacture of an American Folk Art* (New York: Hawthorn Books, 1973), p. 164. For other examples of this design, see Tom Geismar and Harvey Kahn, *Spiritually Moving: A Collection of American Folk Art Sculpture* (New York: Harry N. Abrams, 1998), fig. 69, and Steve Miller, *The Art of the Weathervane* (Exton, Pa.: Schiffer Publishing, 1984), p. 66.

Massachusetts, in 1852. In addition to creating many distinctive designs, he seems to have been the first to issue illustrated price lists for mail orders.[7] Although he died prematurely, in June 1867, his business practices provided a model for many of the weathervane makers who followed him. The attribution of this weathervane and similar examples is complicated by the fact that Jewell was succeeded by Cushing & White in 1867, which became L.W. Cushing & Sons in 1872. The Cushing company continued to produce weathervanes from Jewell's patterns while also creating new types.[8] —R.S.

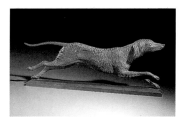

303. FOXHOUND WEATHERVANE PATTERN
Attributed to Henry Leach (1809–1885)
Boston
1869–1870
Pine
10½ × 26⅝ × 2¾ in.
P1.2001.329

PROVENANCE:
Henry Francis du Pont, Southampton, Long Island, N.Y.; Sotheby's sale 5968, 1/90, lot 1327.

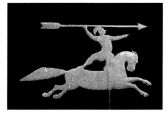

302. HORSE AND RIDER WEATHERVANE
Artist unidentified
New England
c. 1870
Cast iron with traces of paint
22⅛ × 42½ × 1 in.
P1.2001.328

PROVENANCE:
Donald A. Pettee, Francistown, N.H.; Wayne Pratt, Marlboro, Mass.; Peggy Schorsch, Greenwich, Conn., 1983.

This rare cast-iron weathervane, which surmounted a barn in Francistown, New Hampshire, for a hundred years or so, highlights the diversity of weathervanes made in the nineteenth century. Perched on a galloping horse, an acrobatic Indian figure holds an oversize arrow as if it were a spear he is about to hurl. The top of the figure's head and left hand are flared to accept two screws that fix the arrow to them, indicating that this is the weathervane's original configuration. A photograph of the weathervane while it was still installed on the barn shows the arrow in this position, not in the more customary location below the horse.

The profile of the horse is reminiscent of some copper weathervanes attributed to A.L. Jewell of Waltham, Massachusetts. This is not to suggest that it was made by Jewell but to underscore the influence of his designs on other makers. Cast iron may seem to be an unlikely material for weathervanes, given their need to turn freely in the wind. Then again, their symbolic and decorative functions have always been just as important, and, by the second half of the nineteenth century, other methods of indicating wind direction were available. Two other types of cast-iron weathervanes are known. An unidentified workshop that probably operated in New Hampshire or Maine around midcentury produced a distinctive style of horse, also known today as a "formal horse," and a rooster, both of which have cast-iron bodies and sheet-iron tails.[9] —R.S.

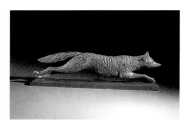

304. FOX WEATHERVANE PATTERN
Attributed to Henry Leach (1809–1885)
Boston
1869–1870
Pine
6¾ × 22½ × 2⅝ in.
P1.2001.330

PROVENANCE:
Henry Francis du Pont, Southampton, Long Island, N.Y.; Sotheby's sale 5968, 1/90, lot 1328.

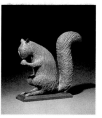

305. SQUIRREL EATING NUT WEATHERVANE PATTERN
Attributed to Henry Leach (1809–1885)
Boston
1869–1870
Pine
16¼ × 16¾ × 17½ in.
P1.2001.331

PROVENANCE:
Henry Francis du Pont, Southampton, Long Island, N.Y.; Sotheby's sale 5968, 1/90, lot 1330.

7 J. Howard & Company of West Bridgewater, Mass., issued a price list between about 1855 and 1860, but it was not illustrated; see Myrna Kaye, "The Many Directions of J. Howard, Weathervane Maker," *Maine Antique Digest* 10, no. 8 (August 1982): 13-A, and Miller, *Art of the Weathervane*, p. 13.

8 Many of the illustrations in a Jewell price list dated January 1866 were repeated in a Cushing & White flyer of about 1872. For a reproduction of the Cushing list, see Klamkin, *Weather Vanes*, p. 30. Another style of centaur that can be firmly attributed to A.L. Jewell is shown on his 1866 price list. Confirming the difficulties of the attribution of copper weathervanes,

however, an example of this type is illustrated in 1928 in a newspaper article about Charles W. Cushing; see W.A. Macdonald, "The Man Who Tells the World Which Way the Wind Blows," *Boston Evening Transcript*, July 7, 1928, sec. 5, p. 1. For other similar examples, see Robert Bishop and Patricia Coblentz, *A Gallery of Weathervanes and Whirligigs* (New York: E.P. Dutton, 1981), p. 84, fig. 142, and Miller, *Art of the Weathervane*, p. 65.

9 For examples of these weathervanes, see Bishop and Coblentz, *Gallery*, p. 72, fig. 118, and p. 34, fig. 45.

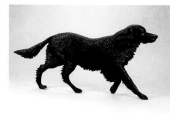

306. ENGLISH SETTER
WEATHERVANE PATTERN
Attributed to Henry Leach (1809–1885)
Boston
c. 1871
Paint on wood
17 × 35½ × 4 in.
P1.2001.332

PROVENANCE:
Herbert Waide Hemphill Jr., New York; Sotheby's sale 5551, 1/87, lot 1099.

EXHIBITED:
"The Herbert Waide Hemphill Collection of Eighteenth-, Nineteenth-, and Twentieth-
 Century American Folk Art," Heritage Plantation, Sandwich, Mass., 1974.
"Bicentennial Cultural Exhibition," United States Information Agency and Japanese
 Government, Tokyo, 1976.
"The All-American Dog: Man's Best Friend in Folk Art," MAFA, 1977/78.
"Vision: USA," Museum of International Folk Art, Santa Fe, N.M., 1978.
"The Art of the Weathervane," MAFA, 1979/80.

PUBLISHED:
Bicentennial Cultural Exhibition. Tokyo: United States Information Agency and Japanese
 Government, 1976, fig. 77.
Bishop, Robert. *The All-American Dog: Man's Best Friend in Folk Art.* New York: Avon Books
 in association with MAFA, 1978, p. 10.
Bishop, Robert, and Patricia Coblentz. *A Gallery of Weathervanes and Whirligigs.* New York:
 E.P. Dutton, 1981, p. 19.
Heritage Plantation. *The Herbert Waide Hemphill Collection of Eighteenth-, Nineteenth-, and
 Twentieth-Century American Folk Art.* Sandwich, Mass.: Heritage Plantation, 1974, p. 32.
Kaye, Myrna. *Yankee Weathervanes.* New York: E.P. Dutton, 1975, p. 144 (rendering).

Between 1867 and 1871, Henry Leach carved a number of wooden
weathervane patterns for Cushing & White of Waltham, Massa-
chusetts. These four are attributed to him on the basis of entries in
Leonard Cushing's journals and by comparison with illustrations in
the 1883 catalog of L.W. Cushing & Sons, as the firm was known after
1872.[10] Leach probably carved the foxhound, fox, and squirrel weather-
vane patterns in 1869 and 1870. The English setter pattern is not listed
in the journal but is attributed to him because of its stylistic similarity
with the other patterns and the illustration of it that appeared in the
Cushing catalog. Examples of weathervanes made from each of these
patterns have survived.[11]

 Henry (or Harry) Leach was born in New Milford, Pennsylvania, and
was working at various occupations in Boston by 1847. Between 1865
and 1872, he listed himself in the Boston directories as an "ornamental
carver" at 2 Indiana Street. In 1872 or 1873, he moved with his family to
Woburn, a suburb ten miles northwest of Boston, where he was listed in
directories as a "carver" and "woodcarver" from 1874 to 1884. He then
returned to his hometown in Pennsylvania, where he died in 1885.[12]

Leach was obviously a talented woodcarver, but the nature of his
training is unknown. Recent research has uncovered a number of pieces
stamped "H. Leach," as well as a series of business cards and *cartes de
visite* with photographs of his carvings. On the backs of many of them,
Leach characterized himself as a "Sculptor in Wood." The work includes
animal figures that appear to be weathervane patterns, elaborate picture
frames, carved animal heads mounted like trophies, and a number of
allegorical and "fancy" pieces, as they were known at the time.[13] In addi-
tion, Leach created at least two distinctive chairs that have three carved
owls as backs and two dogs on their front stretchers.[14]

 Wooden patterns like these were the first step in the production
of most hollow-bodied copper weathervanes in the second half of the
nineteenth century. Cast-iron molds were made from the patterns, into
which sheets of copper were hand-hammered. Alternatively, the larger
workshops added another step to the process. Molten lead was poured
into the mold, forming a positive and a negative impression. A copper
sheet was placed between the iron mold and the lead and hammered into
shape. Details were then sharpened by hand before the weathervane was
soldered and gilded. —R.S.

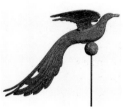

307. PHEASANT HEN WEATHERVANE
Artist unidentified
Probably Connecticut
c. 1875
Pine with traces of paint
22 × 31 × 10 in.
P1.2001.333

PROVENANCE:
Found on Albert Shriber property, Georgetown, Conn.; Edith Gregor Halpert, New York;
David A. Schorsch, New York, 1994.

EXHIBITED:
"Masterpieces in American Folk Art," The Downtown Gallery, New York, 1941.
"Amateur Art of 100 Years Ago," The Downtown Gallery, New York, 1952.
"The Edith Gregor Halpert Collection," The Corcoran Gallery of Art, Washington, D.C., 1960.

PUBLISHED:
Schorsch, David A. *American Folk Art: Selected Examples from the Private Collection of the Late Edith
 Gregor Halpert.* New York: David A. Schorsch, 1994, pp. 12–13.
Williams, Hermann Warner. *The Edith Gregor Halpert Collection.* Washington, D.C.: Corcoran
 Gallery of Art, 1960, n.p.

The graceful sweep of this pheasant hen weathervane, from its deli-
cate beak to its long, flowing tail, makes it a prime example of
nineteenth-century woodcarving. The entire surface is intricately
worked with the bold strokes of a master carver who favored strong
outline and stylized design. It is also well constructed, as seen in the

10 The journals are in the collection of the Waltham Historical Society. Leach is also listed in
 Cushing's journal as the carver of a Dexter, Ethan Allen, leaping deer, cow, roosters, and
 eagles; see Myrna Kaye, "Cushing and White's Copper Weathervanes," *The Magazine Antiques*
 109, no. 6 (June 1976): 1121, 1123, 1126, and Kaye, *Yankee Weathervanes* (New York: E.P. Dutton,
 1975), pp. 144–45. The four weathervanes are shown in L.W. Cushing & Sons, "Illustrated
 Catalogue of Copper Weathervanes" (1883), pp. 17, 19.
11 For an illustration of the squirrel with a Cushing & White seal, the English setter, and the
 foxhound, see Bishop and Coblentz, *Gallery*, p. 56, fig. 87; p. 19, fig. 19; and p. 66, fig. 106,

respectively. The foxhound and fox could also be ordered together on one weathervane;
 see Miller, *Art of the Weathervane*, p. 57.
12 Boston and Woburn Directories; unpublished research by William F. Brooks Jr., Vermont
 State Craft Centers, Burlington, Middlebury, and Manchester.
13 I would like to thank Mr. Brooks for generously sharing the results of his research.
14 One of the chairs is illustrated in Miller, *Art of the Weathervane*, pp. 16–17.

tightly fitted tongue-and-groove joint with which the tail is attached to the body. The wings are done in a manner that is similar to those of many eagles, in both their shape and the way in which they are attached to the pheasant's back. At the time, carved wooden eagles were in great demand as architectural ornaments, figureheads, and weathervane patterns, as well as for any number of civic and ceremonial purposes. Shipcarvers, in particular, specialized in creating them for local markets throughout the Northeast. In this case, the skillful simplification of form and the overall handling of the feathers suggest that this weathervane was made by a shipcarver who was familiar with the genre.

Found on an outbuilding of a property in Georgetown, Connecticut, the piece was once in the collection of Edith Gregor Halpert, the influential dealer who was a leading figure in the revival of interest in American folk art. In 1931 she established the American Folk Art Gallery, the first such venture in this country. The gallery was on West 13th Street in Manhattan, on the second floor of her Downtown Gallery, which was frequented by the modernist artists she represented as well as, at one time or another, many progressive critics and collectors. In 1940 she moved the gallery to East 51st Street, where this weathervane was exhibited in the early 1950s.[15]

—R.S.

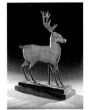

308. Miniature Deer Weathervane
Attributed to J. Howard & Company
West Bridgewater, Plymouth County, Massachusetts
c. 1852–1867
Paint on zinc and copper
12¾ × 9 × 5 in.
P1.2001.334

PROVENANCE:
Frank Gaglio, Wurtsboro, N.Y.; Kate and Joel Kopp, America Hurrah, New York; David A. Schorsch, New York, 1992.

This stately little deer was probably made by J. Howard & Company of West Bridgewater, Massachusetts, a relatively short-lived workshop that created some of the most distinctive weathervanes ever produced in this country. The attribution is based on stylistic comparisons with larger deer weathervanes from Jonathan Howard's shop, as well as with his celebrated horses, which share some similar features.[16] A price list issued by the company between 1856 and 1867 included two sizes of deer weathervanes, although this piece would seem to be too small to have ever been mounted on a building. In addition, its body is cast entirely in zinc, which is unusual for Howard weathervanes. Larger examples combine zinc castings for the front part of the animal's body with hollow copper mid and rear sections and sheet-copper tails. This deer may have been used as a model of some sort.

Howard's small workshop was making weathervanes in West Bridgewater by about 1852.[17] In 1855, when the company was known as J. & C. Howard, it employed three workers and had a stock of weathervanes valued at $4,000.[18] The following year, the name of the firm changed to J. Howard & Company. The shop continued to operate for another decade, until it became H.L. Washburn & Company, in 1867. Apparently Horatio Washburn was not any more successful than Howard had been, for he was no longer listing himself as a weathervane maker by 1869; instead, he was manufacturing eyelet machines. His partners were Jonathan and Horatio Howard, the latter probably being one of Jonathan's cousins. As with many small-town entrepreneurs of his day, Jonathan was also a farmer. Later in life, he operated a vinegar and pickle business.[19] So while he is justly famous today for his elegant weathervane designs, his varied occupations present a more typical nineteenth-century scenario of a talented craftsman and farmer who by circumstance was concerned primarily with earning a living and supporting his family.

—R.S.

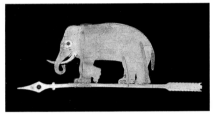

309. Elephant Weathervane
Artist unidentified
Probably Bridgeport, Fairfield County, Connecticut
Late nineteenth century
Paint on pine with iron
19½ × 48¼ × 1 in.
P1.2001.335

PROVENANCE:
Found in Bridgeport, Conn.; David L. Davies, San Francisco, 1995.

PUBLISHED:
Bishop, Robert, and Jacqueline Marx Atkins. *Folk Art in American Life.* New York: Viking Studio Books in association with MAFA, 1995, p. 162.
Bishop, Robert, and Patricia Coblentz. *A Gallery of Weathervanes and Whirligigs.* New York: E.P. Dutton, 1981, p. 53.

With a uniquely stylized silhouette, this elephant weathervane presents a bold outline that is easily read from a distance. Flat board cutouts such as this were one of the most popular types of weathervanes in the nineteenth century. Usually one of a kind, they were highly individualized efforts limited only by their creators' skill and artistic imagination. In this case, the animal's body, head, trunk, and tusks are well

15 The Halpert papers are at the Archives of American Art, Smithsonian Institution, Washington, D.C. See Diane Tepfer, "Edith Gregor Halpert and the Downtown Gallery Downtown, 1926–1940: A Study in American Art Patronage" (Ph.D. diss., Univ. of Michigan, 1989), for a detailed discussion of Halpert's life, including her interest in folk art.

16 For examples of the larger deer, see Bishop and Coblentz, *Gallery,* p. 55, fig. 86, and Miller, *Art of the Weathervane,* p. 135.

17 "Weathervanes," n.d., Old Bridgewater Historical Society files, West Bridgewater, Mass.
18 Kaye, "J. Howard," p. 10-A.
19 "Weathervanes," and ibid., pp. 10–12-A.

proportioned, and if the legs are slightly short and bulky, they are all the more successful in transmitting the idea of a massive and powerful animal. Concentric circles of black and white serve as the elephant's eye and are echoed by the black circle in the point of the arrow, creating a subtle sense of forward momentum. The old weathered surface and iron straps that reinforce the piece attest to many years of use.

The weathervane was found on a barn in Bridgeport, Connecticut, an appropriate locale because the town was the home of circus impresario P.T. Barnum. Both J.W. Fiske and J.L. Mott Iron Works of New York City offered full-bodied copper elephant weathervanes in two sizes, suggesting that the image had achieved a certain level of popularity in the late nineteenth century.[20]

—R.S.

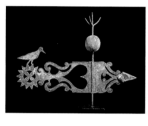

310. BANNERET AND BIRD
WEATHERVANE
Artist unidentified
Possibly New England
c. 1880
Iron and zinc with gold leaf and wood
34 × 48 × 6½ in.
P1.2001.336

PROVENANCE:
Eden Galleries, Salem, N.Y., 1972.

PUBLISHED:
Schaffner, Cynthia V.A., and Susan Klein. *Folk Hearts: A Celebration of the Heart Motif in American Folk Art.* New York: Alfred A. Knopf, 1984, p. 80.

By linking several traditional motifs, this distinctive weathervane synthesizes two popular nineteenth-century types, the banneret and the scroll. Bannerets were characterized by their rectangular shape reminiscent of flags and pennants, as seen in the central section of this example. Scrolls were composed of any number of different openwork elements arranged along a horizontal axis. Here a bracketed arrowhead is followed by a large heart, a pair of neoclassical S curves, and a sun wheel variation.

The shorebird is an unusual feature and was probably not an original design element. Bannerets and scrolls were generally quite formal and nonrepresentational, and while new types could certainly be ordered by customers, in this case the banneret and bird are made of different metals. A more typical configuration would consist of an eagle or other bird perched on a ball above a scroll, as shown in the catalogs of some weathervane companies.[21] Patterns of weathering indicate that this bird has been in place for many years, though, suggesting that it was attached at an early date in the piece's history. By adding it, the owner personalized his weathervane, creating an unusual and imaginative interpretation of an old theme.[22]

With origins lost in heraldic tradition, nineteenth-century bannerets were direct descendants of one of the oldest types of weathervanes. Along with weathercocks, they were prevalent in Europe by late medieval times. The Old English word *fane* signified a banner or lance pennant used by knights and nobility to display their coats of arms. When affixed to the top of a building, it proclaimed rank and ownership. The word later merged with the Dutch word *vaan* to become "vane."

—R.S.

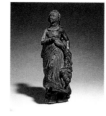

311. FIGUREHEAD MODEL
Artist unidentified
Probably New England
c. 1810
Wood with traces of paint
18 × 5¾ × 6 in.
P1.2001.337

PROVENANCE:
Marvin Sadik, Maine, 1990.

While her small size indicates that she was not intended to be fitted on a ship, this early-nineteenth-century figure otherwise precisely replicates a full-scale figurehead. Carved in the latest style, with a flowing Empire gown and windswept hair and drapery, she holds a cornucopia of fruit and flowers that adds allegorical overtones to her fashionable appearance. As she strides forward, the outline of her left leg is visible under her gown, and although she has sustained some loss, it is evident that her left foot would have been poised on the scroll base.

This type of full-length, freestanding figurehead became popular in the United States in the last decade of the eighteenth century. Originally French, the style was widely admired for its naturalistic presence and sense of movement emphasized by a forward lean with one foot raised and supported on a scroll. Philadelphia sculptor and shipcarver William Rush is traditionally credited with introducing the type into this country.[23] This example shares certain stylistic affinities with figureheads carved in the Boston and Salem, Massachussetts, area in the early nineteenth century, though, particularly in the handling of the face. Its vertical orientation further confirms its date, as ships of the period typically had straight-stemmed bows. Another notable detail is that it was carved with a lacing piece, a postlike timber on the back of a figurehead that was used to attach it to a vessel.

As an accurate, small-scale version, this figurehead might have been used as a model or a sign for a shipcarving workshop. A related example that is attributed to Salem carver Samuel McIntire is in the collection of the Peabody Essex Museum in Salem. Stylistically different and slightly larger, it is thought to have been created for a similar purpose and never mounted on a ship.[24]

—R.S.

20 J.W. Fiske, *Illustrated Catalog*, p. 29, and J.L. Mott Iron Works, "Illustrated Catalogue," p. 23.
21 See J.W. Fiske, *Illustrated Catalog*, pp. 43–46.
22 The large wooden ball and pronged wrought-iron finial are also very atypical and probably not original. Their history is impossible to determine at this point.

23 John F. Watson, *Annals of Philadelphia* (Philadelphia: E.L. Cary & A. Hart, 1830), p. 551, and Marion V. Brewington, *Shipcarvers of North America* (Barre, Mass.: Barre Publishing, 1962), p. 33.
24 Nina Fletcher Little, "Carved Figures by Samuel McIntire and His Contemporaries," in Essex Institute, *Samuel McIntire: A Bicentennial Symposium* (Salem, Mass.: Essex Institute, 1957), p. 193.

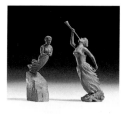

312a–b. MINIATURE FIGUREHEADS:
MERMAID AND WOMAN WITH TRUMPET
Artist unidentified
Probably Salem, Essex County, Massachusetts
Second half nineteenth century
Cherry
4⅛ × 1³⁄₁₆ × 1⅞ in. and 5½ × 1¼ × 1⅝ in.
P1.2001.338, 339

PROVENANCE:
Found in Salem, Mass.; Bertram K. and Nina Fletcher Little, Brookline, Mass.; Sotheby's sale 6526, "Little Collection, Part I," 1/94, lot 210.

EXHIBITED:
"New England on Land and Sea: An Exhibition of the Collection of Bertram K. and Nina Fletcher Little," Peabody Museum, Salem, Mass., 1970.

PUBLISHED:
Bishop, Robert. *American Folk Sculpture.* New York: E.P. Dutton, 1974, pp. 100–101.
Little, Nina Fletcher. *Country Arts in Early American Homes.* New York: E.P. Dutton, 1975, p. 124.
———. *Little by Little: Six Decades of Collecting American Decorative Arts.* New York: E.P. Dutton, 1984, p. 62.
Peabody Museum. *New England on Land and Sea: An Exhibition of the Collection of Bertram K. and Nina Fletcher Little.* Salem, Mass.: Peabody Museum, 1970, pp. 22.

Found in an old house in Salem, Massachusetts, these miniature figureheads are finely detailed representations of the type of carvings that graced the prows of oceangoing vessels during the last great era of the wooden sailing ship. Given their small size, they were probably done by a skilled carver for personal enjoyment or perhaps as a gift to a friend or relative. The woman with a trumpet strikes a dramatic pose as she leans forward with head raised, grasping the horn, long arms extending forward and back, and a windswept skirt that terminates in a well-carved scroll base. Even without wings, she closely resembles a Gabriel figure, which was a popular type on land and at sea. The mermaid, too, is delicately carved, with hands clasped to her chest in typical figurehead fashion and a stylized tail that suggests a flutter of movement through the waves.

Figureheads with the sharp forward lean seen in these two miniatures were first developed in the late 1840s for ocean clippers, fast and sleek vessels that dominated the China trade for a generation. Because of a change in bow design, figureheads were attached higher than before, at an inclined angle that gave them a more horizontal orientation. Shipcarvers responded by creating a new style of figure that appeared to extend farther out, ahead of the ship, leading it onward in a rush of motion. The type remained popular until the demise of the figurehead tradition at the end of the century.[25] —R.S.

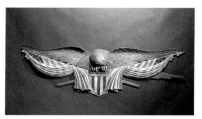

313. EAGLE
John Haley Bellamy (1836–1914)
Kittery Point, York County, Maine
c. 1890
Paint on pine with traces of gold leaf
30 × 99 × 10 in.
P1.2001.340

PROVENANCE:
Pauline S. Woolworth; Sotheby's sale 6613, 10/94, lot 258.

PUBLISHED:
Smith, Yvonne Brault. *John Haley Bellamy, Carver of Eagles.* Hampton, N.H.: Portsmouth Marine Society, 1982, p. 74.

One of the masters of the last generation of traditional shipcarvers was John Haley Bellamy of Kittery Point, Maine. The son of a contractor and boatbuilder, he studied art in Boston and New York as a young man and then apprenticed with Laban Beecher, a talented Boston shipcarver. Upon completing his training, he worked for a few years at the Charlestown Navy Yard and, returning to his birthplace, at the Portsmouth Navy Yard. He kept a workshop in Portsmouth for a time but, for most of his life, operated out of a shop on the second floor of the building in Kittery Point in which his father and brother built boats.[26] His trade card from Portsmouth indicates the diversity of work that he created over his long and productive career. It reads, in part, "John H. Bellamy, Figure and ornamental CARVER, particular attention paid to House, Ship, Furniture, Sign & Frame Carving, GARDEN FIGURES."[27]

Bellamy has become justly famous for his distinctive eagles, which were something of a specialty—many of the smaller plaques were gifts for friends. His most impressive work is an eagle figurehead carved for the USS *Lancaster* in 1880 that is now at the Mariners' Museum in Newport News, Virginia. Made of blocks of wood that were bolted and screwed together, it has a wingspan of more than eighteen feet and weighs more than 3,200 pounds.

In terms of sheer artistry, this piece ranks among Bellamy's finest. It has all the characteristics of his larger eagle carvings, including a bulbous neck with a graceful sweep of the head, fully delineated talons, and deep, concave wings. The crossed flags and large central shield are particularly well designed, while its old surface and wingspan of more than eight feet are exceptional. It may originally have been done for a public building, which, according to Bellamy's nephew, was the most frequent destination for his large eagles with American flags.[28] —R.S.

25 For a discussion of the development of American figureheads, see especially Brewington, *Shipcarvers.*
26 For accounts of Bellamy's life and work, see Victor Safford, "John Haley Bellamy, the Woodcarver of Kittery Point," *The Magazine Antiques* 27, no. 3 (March 1935): 102–7, and Brewington, *Shipcarvers,* pp. 88–89. The most recent and most complete treatment is Yvonne Brault Smith,

John Haley Bellamy, Carver of Eagles (Hampton, N.H.: Portsmouth Marine Society, 1982). Bellamy's original papers and some of his tools are in the collection of AFAM.
27 Safford, "John Haley Bellamy," p. 104.
28 Ibid., p. 103.

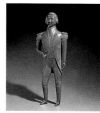

314. GEORGE WASHINGTON
Artist unidentified
Probably Pennsylvania
Mid-nineteenth century
Walnut
24½ × 8 × 3⅛ in.
P1.2001.341

PROVENANCE:
Mr. and Mrs. Benjamin Ginsberg, Tarrytown, N.Y.; Leigh Keno, New York, 1990.

EXHIBITED:
"The Flowering of American Folk Art, 1776–1876," WMAA, 1974.

PUBLISHED:
Bishop, Robert. *American Folk Sculpture.* New York: E.P. Dutton, 1974, p. 117.
Lipman, Jean, and Alice Winchester. *The Flowering of American Folk Art, 1776–1876.* New York:
 Viking Press in association with WMAA, 1974, p. 125.

As every American knows, the image of George Washington has been carved, cast, and painted for just about every conceivable purpose since the late eighteenth century. A transcendent figure in the national imagination, he leads the pantheon of American heroes. Among the best characterizations of his exalted position is a well-known observation by Paul Svinin, a Russian diplomat who toured the United States between 1811 and 1813. In his travel journals, he wrote, "It is noteworthy that every American considers it his sacred duty to have a likeness of Washington in his home, just as we have images of God's saints.... Washington's portrait is the finest and sometimes the sole decoration of American homes."[29] The same can be said of public buildings, fraternal organizations, and countless businesses, large and small.

One of the most distinctive images of Washington is this uniquely stylized wooden figure, which is believed to have been created for the Washington Masonic Lodge in Adams, Pennsylvania. Carved in the half-round, it has a flattened back that indicates it was intended to be mounted on a wall. The carver has captured the essence of the popular conception of Washington with a minimum of extraneous detail. Particular attention has been paid to the head and broad shoulders emphasized by epaulets, from which the body tapers to relatively short legs terminating in the suggestion of military boots. —R.S.

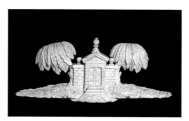

315. MEMORIAL: GATE OF HEAVEN
Artist unidentified
Possibly Maine
Mid-nineteenth century
Paint on wood
12⅝ × 29½ × 3⅜ in.
P1.2001.342

PROVENANCE:
Found in Maine; Marguerite Riordan, Stonington, Conn., 1973.

This rare wooden memorial vignette utilizes motifs that are much more frequently encountered in two-dimensional mediums, particularly schoolgirl needlework and watercolors. As records of accomplishment of female students, embroidered and painted memorial artworks that commemorated departed family members decorated the walls of countless American homes in the nineteenth century. In this carving, a stone mausoleum with heavy double doors and three ball spires is set in a rising landscape and flanked by two stylized willow trees. The symmetry of the composition is in keeping with neoclassical ideals of harmony and noble tranquility, while its imagery was part of a shared design vocabulary known to artists in all walks of life.

The carving can also be seen to reference the rural cemetery movement, which had wide-ranging influence in mid-nineteenth-century America. By integrating romantic landscape design with symbolic architecture and memorial sculpture, these parklike sites offered the public a serene setting in which to visit the graves of loved ones, stroll the grounds, and otherwise contemplate immortality. They were also popular spots for picnics and other family outings. Established in 1831, Mount Auburn Cemetery in Cambridge, Massachusetts, was the first such cemetery in the United States, followed by Laurel Hill Cemetery in Philadelphia in 1836 and Green-Wood Cemetery in Brooklyn in 1838.[30] By midcentury these sites had inspired similar, if more modestly scaled, cemeteries in cities and towns across the country. Found in Maine, this carving presents an idealized image of one such bucolic setting. —R.S.

29 Pavel Petrovich Svin'in, *A Picturesque Voyage in North America* (St. Petersburg: n.p., 1815), p. 150, quoted in Avrahm Yarmolinsky, *Picturesque United States of America: Being a Memoir on Paul Svinin* (New York: William Edwin Ridge, 1930), p. 34.
30 For a contemporary source on Mount Auburn and Green-Wood that includes a number of fine engravings, see Nehemiah Cleaveland and Cornelia W. Walter, *The Rural Cemeteries of America* (New York: R. Martin, 1847). Recent scholarship includes Blanche Linden-Ward,

Landscape of Memory and Boston's Mount Auburn Cemetery (Columbus: Ohio State Univ. Press, 1989), David Charles Sloane, *The Last Great Necessity: Cemeteries in American History* (Baltimore: Johns Hopkins Univ. Press, 1991), and Jonathan L. Fairbanks and Rebecca Ann Gay Reynolds, "The Art of Forest Hills Cemetery," *The Magazine Antiques* 154, no. 11 (November 1998): 696–703.

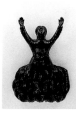

316. FLAMES OF JUDGMENT
Artist unidentified
Northeastern United States
Mid-nineteenth century
Paint on wood
11⅛ × 7¼ × 2¼ in.
P1.2001.343

PROVENANCE:
Robert Carlen, Philadelphia, 1975.

EXHIBITED:
"The Shape of Things: Folk Sculpture from Two Centuries," MAFA, 1983.

The powerful symbolism of this expressive carving belies its relatively small size. As an image of transcendence, a figure emerges from the flames, arms raised in a gesture to heaven. The flames are boldly rendered in teardrop shapes, while the delicately carved figure is clothed in what appears to be a robe or gown, reinforcing the idea of one of the faithful rising from the dead at the time of the Last Judgment. An alternative interpretation, which depends in large part on the viewer's perceptions and personal outlook, sees the figure engulfed in the flames of hell, a soul pleading for mercy in the face of eternal damnation.

These two equally dramatic readings result from a certain level of ambiguity in the carving's imagery. When placed in the larger social and religious context of the time, they are not at all as contradictory as they might first appear. They are, in fact, the complementary poles of a central concern of most nineteenth-century Christians. Salvation or damnation, the fate of every individual, was not certain until the end, and even those who believed in predetermination could not be assured of the mysterious workings of the Divine. In this way, the carving embodies a fundamental millennial notion that inspired a number of utopian sects and expresses a motivating force in the lives of many members of the general populace.

While its original purpose is not clear, the piece has obvious funereal associations. An identical example in a private collection even shares the fairly recent black enamel finish over an old paint surface. The fact that they are a pair lends credence to the idea that they were used as decorations on a funeral wagon or hearse, though they might also have been applied as interior architectural ornaments of some sort. —R.S.

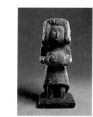

317. LADY WITH MUFF
William Edmondson (1874–1951)
Nashville
c. 1940
Limestone
15½ × 6½ × 6¾ in.
P1.2001.344

PROVENANCE:
Edmund L. Fuller, Woodstock, N.Y.; Martin Cohen, New York, 1992.

EXHIBITED:
"Self-Taught Artists of the Twentieth Century: An American Anthology," PMA in association with MAFA, 1998.
"The Art of William Edmondson," MAFA, 2000.

PUBLISHED:
Lindsey, Jack L. "William Edmondson." *Folk Art* 20, no. 1 (spring 1995): 43.

William Edmondson was the first African American artist to be recognized by the Museum of Modern Art with a solo exhibition. "Sculpture by William Edmondson" was presented at the museum in 1937. One review said that "the figures are not decorative enough to be attractive to many, nor have they really enough emotional or intellectual content to be of lasting interest, and it is likely that after the show closes … they and Mr. Edmondson will soon be forgotten."[31] The reviewer's evaluation and predictions couldn't have been further off; Edmondson has certainly not been forgotten.[32]

Edmondson was born on a plantation outside Nashville to former slaves Orange and Jane Brown Edmondson. As an adult, he worked for the Nashville, Chattanooga, and St. Louis Railroad and as a hospital janitor, a porter, and a stonemason's helper. After his retirement, he spent most of his time tending the vegetable garden and fruit trees behind his house near Vanderbilt University, until, as he tells the story, God told him he should carve stone.

Edmondson focused primarily on making gravestones to sell but later turned to garden ornaments and religious and secular figures. He used an old hammer and a railroad spike to chisel discarded limestone blocks that he gathered from demolished buildings and curbstones, and he spent many hours arranging the finished sculptures in his yard for display. Edmondson died in 1951 and is buried in Mt. Ararat Cemetery, Nashville's oldest African American graveyard.

Lady with Muff is one of several similar female forms he carved, each with a distinct personality. The figure is fashionably attired in a scoopneck gown that goes from mid-length in the front to floor-length in the back, and she clasps what appears to be a muff. The contours of her bobbed hair echo the curve of her hemline. The interplay of the deeply incised hair and patterned gown with the smoothness of the face, arms,

31 *The New Yorker* (Nov. 6, 1937): 51–52.
32 "The Art of William Edmondson," a traveling exhibition organized by the Cheekwood Museum of Art, Nashville, and presented at MAFA in 2000, received enthusiastic reviews in the *New York Times* (May 14 and June 9, 2000).

and legs demonstrates skillfully crafted contrasts. With the large head, the fullness of the hair, and the chunky hands in relation to the smallness of the body, facial features, and shoes, the artist displays his characteristic liberty with scale. In this sculpture, Edmondson captures the essence of femininity with wit and style and transforms a limestone block into a minimally carved and sensitively nuanced form of power and grace.

—L.K.

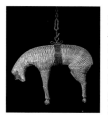

318. Hanging Sheep Shop Sign
Artist unidentified
Northeastern United States, Canada, or England
Mid-nineteenth century
Paint and traces of gold leaf on wood with metal
33 × 38 × 9 in.
P1.2001.345

PROVENANCE
Adele Earnest and Cordelia Hamilton, Stony Point Folk Art Gallery, Stony Point, N.Y.; Stewart E. Gregory, Wilton, Conn.; Sotheby Parke-Bernet sale 4209, "Gregory Collection," 1/79, lot 14.

PUBLISHED
Earnest, Adele. *American Folk Art: A Personal View.* Exton, Pa.: Schiffer Publishing, 1984, p. 72.

Representational images such as this finely carved hanging sheep are among the oldest types of shop signs, along with painted signboards. While its origin is lost in time, the practice can be traced to at least the late Middle Ages, when the resurgence of commerce and growth of trade sparked economic development throughout Europe. In Britain hanging sheep traditionally referred to the Golden Fleece, the object of Jason's ancient quest with the Argonauts. Appropriately sheep were most commonly used as signs for woolen drapers, or dealers in woolen cloth, and, to a lesser extent, by all trades related to cloth and clothing.[33]

Throughout the nineteenth century, three-dimensional images remained a popular way for merchants to identify and advertise their places of business in America as well as in England. The signs retained their symbolic function and many familiar associations long after the general rise of literacy had rendered their original purpose obsolete. Recalling the 1870s and 1880s, Louis Jobin, a well-known French-Canadian carver, once remarked that in addition to creating religious figures and altars, "above all I made signs.... I created a hanging sheep, to represent a tailor."[34] This example is particularly well executed. The sloping body and delicately carved forelegs and hooves that hang straight down create a strongly naturalistic presence that convincingly transmits the impression of an actual animal suspended by a metal band around its middle.[35]

—R.S.

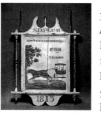

319. S.D. Plum Tavern Sign (double-sided)
Artist unidentified
Probably Meriden, New Haven County, Connecticut
1813
Paint on pine with iron
51 × 34 × 3 in.
P1.2001.346

INSCRIPTIONS:
Recto and verso, paint: *S, D, PLUM, / ENTERTAINMENT / FOR / TEAMS. / 1813*

PROVENANCE:
Bernard M. Barenholtz, Marlborough, N.H.; Sotheby's sale 5969, "Barenholtz Collection," 1/90, lot 1502.

EXHIBITED:
"Every Picture Tells a Story: Word and Image in American Folk Art," MAFA, 1994/95.

Sometime around 1803, Seth D. Plum bought a house on Broad Street in Meriden, Connecticut. Conveniently located along the route of the new Meriden turnpike, which opened in 1799, it served as a tavern for many years. Meriden was a busy stopover, long known as the halfway point on the road between Hartford and New Haven. As for Seth Plum, he appears to have been an enterprising man who achieved a certain level of prosperity, for he also operated a tin shop in Meriden from about 1808 to 1835.[36]

The signboard for Plum's tavern is a fine example of the most popular type of American tavern sign from around the middle of the eighteenth century until the mid-1820s or so. A scrolled and framed painted pine plank set in a vertical orientation between two turned posts, it incorporates design elements that were also typical of the architecture and furniture of the period.[37] The coach and horses are particularly engaging, especially the way in which the horses are arranged one slightly in front of the other, with multiple pairs of legs giving the impression of rapid movement.

Signboards have a long history in both North America and Europe. In 1644 the General Court of Connecticut ordered all towns in the colony to provide a place where travelers and strangers could obtain food and lodging.[38] Following English tradition, inns and taverns were prominently marked with painted signs, often suspended between two high posts as close as possible to the road. At the same time, hanging signs had become subject to regulation in several European cities because of their ever-expanding numbers. A few years after London's Great Fire of 1666, for example, an ordinance was enacted that required signboards to be affixed to the walls of buildings instead of projecting out into the streets.[39] Apparently, the efforts of merchants and tradesmen to continually outdo

33 Cecil A. Meadows, *Trade Signs and Their Origins* (London: Routledge and Kegan Paul, 1957), pp. 47, 57.

34 Charles Marius Barbeau, "Le Dernier de nos grands artisans, Louis Jobin," *The Royal Society of Canada, Mémoires* 27, sec. 1 (1933): 45.

35 An undated photograph from the 1950s or 1960s shows the figure without a right ear, indicating that it could have been replaced.

36 C. Bancroft Gillespie and George Munson Curtis, *A Century of Meriden* (Meriden, Conn.: Journal Publishing, 1906), pp. 152, 340, 353. I would like to thank Donna-Belle Garvin, New Hampshire Historical Society, Concord, for this reference.

37 For detailed and extended discussions of Connecticut signboard history, construction, imagery, and conservation, see Susan P. Schoelwer, ed., *Lions & Eagles & Bulls: Early American*

Tavern & Inn Signs from the Connecticut Historical Society (Princeton, N.J.: Princeton Univ. Press in association with Connecticut Historical Society, 2000). An earlier source that considers the same collection is Connecticut Historical Society, *Morgan B. Brainard's Tavern Signs* (Hartford: Connecticut Historical Society, 1958). Both books include several illustrations of signboards that are similar in design to this example.

38 Margaret C. Vincent, "'Some suitable Signe ... for the direction of Strangers': Signboards and the Enterprise of Innkeeping in Connecticut," in Schoelwer, *Lions & Eagles & Bulls*, p. 36, and Connecticut Historical Society, *Tavern Signs*, p. 4.

39 Meadows, *Trade Signs*, p. 7.

one another in order to attract business had resulted in a dense, overhead canopy that clogged narrow urban streets and threatened pedestrians.

Connecticut supported a large number of taverns and inns in the eighteenth and nineteenth centuries because of its extensive network of roads and the heavy traffic generated by its proximity to several urban areas in New England and New York. In 1800 more than 650 licensed innkeepers were operating there. Consequently the state was something of a center for signboard production and ornamental painting. It has been estimated that more than 5,000 signs were used by taverns, inns, and hotels in Connecticut between 1750 and 1850. Of these, only about one hundred survive today.[40]　　　　　　　　　　　　　　　—R.S.

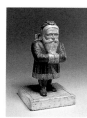

320.　SANTA CLAUS
Artist unidentified
Northeastern United States
Late nineteenth century
Paint on wood
22½ × 11⅞ × 11¾ in.
P1.2001.347

PROVENANCE:
Sotheby's sale 5376, 10/85, lot 14.

This stocky little Santa Claus presents a late-nineteenth-century image of the venerable character that can be compared with Samuel Robb's version of about 1923 (cat. no. 321). In the early nineteenth century, Santa Claus—or Saint Nicholas, as he was better known in New York at the time—was usually portrayed as a small, gnomelike figure rather than the rotund, jovial fellow of the present day. The modern conception of Santa Claus began to emerge in 1862, when Thomas Nast created the first of his famous Santa illustrations for *Harper's Weekly*. By the time he completed the series in 1886, his characterizations had captured the imagination of Americans to the extent that they more or less defined Santa's features for future generations.[41]

In this case, Santa Claus is represented with both old and new features. His full face and long, flowing white beard fit Nast's model, while the proportions of his body in relation to the relatively large head recall earlier images. The fur-trimmed jacket and hat are traditional garments that persisted throughout the nineteenth century and are still familiar today, although the preferred cap style has changed somewhat over the years. The backpack, which is filled with candy canes and doll-like stick figures, is also an old element, more recently replaced by the well-known sack of gifts that he usually carries over his shoulder. His expressionless face, on the other hand, has never been typical. Instead of displaying Santa's legendary jolly demeanor, this figure has the solemn air of a religious icon.　　　　　　　　　　　　　　　—R.S.

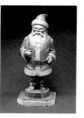

321.　SANTA CLAUS
Samuel Anderson Robb (1851–1928)
New York
1923
Paint on wood with mica flakes
38¾ × 16 × 15⅞ in.
P1.2001.348

INSCRIPTION:
Underside of base, ink: *THIS IS THE / LAST FIGURE / MADE BY SAMUEL A. ROBB / ABOUT 1923 / Elizabeth W. Robb / MAY 16, 1966.*

PROVENANCE:
Elizabeth Wilson Robb; Frederick and Mary Fried; Sotheby Parke-Bernet sale 5094, 10/83, lot 11.

EXHIBITED:
"The Image Business: Shop and Cigar Store Figures in America," MAFA, 1997/98.

PUBLISHED:
Fried, Frederick. *Artists in Wood: American Carvers of Cigar-Store Indians, Show Figures, and Circus Wagons.* New York: Clarkson N. Potter, 1970, p. 237.

Samuel Robb created this lively characterization of Santa Claus as a Christmas present for his daughter, Elizabeth, in 1923. According to her, it was the last figure that he carved.[42] The smiling face and finely carved beard are especially engaging features, demonstrating that Robb still had the master's touch at age seventy-two. He died five years later after an extended illness.

Robb was the most prominent member of the last generation of traditional shipcarvers who created shop and cigar store figures. He was born in New York, the son of a Scottish shipwright who had recently immigrated to the United States. His mother was related to Jacob Anderson, one of the most talented New York shipcarvers at midcentury. Robb was probably apprenticed to Thomas V. Brooks, another successful shipcarver, in 1864.[43] After serving his term in Brooks's shop, Robb went to work carving figures for William Demuth, a tobacco products distributor who carried a full line of shop figures.

Robb closed his workshop at 114 Centre Street in 1903, not long after completing a series of elaborate carvings for circus wagons for Barnum & Bailey. For the next few years, he kept small shops in various locations in Manhattan and, from 1908 to 1910, shared space in Brooklyn with another carver, Charles Brown. After that, he worked out of his home, first on 156th Street and then on Seaman Avenue in upper Manhattan, where this figure was made.[44]　　　　　　　　　　—R.S.

40 Susan P. Schoelwer, "Introduction: Rediscovering the Public Art of Early American Inn Signs," in Schoelwer, *Lions & Eagles & Bulls*, p. 7, and Vincent, "'Some suitable Signe,'" pp. 36, 41.

41 Thomas Nast chronicled his work in his book *Christmas Drawings for the Human Race* (New York: Harper & Brothers, 1890). Since then, a number of books have been written about Santa Claus, although many are long on imagination and short on facts. Two good sources are William Walsh Shepard, *The Story of Santa Klaus* (1909; reprint, Detroit: Gale Research, 1970), and Teresa Chris, *The Story of Santa Claus* (London: Apple Press, 1992).

42 Handwritten note by Elizabeth W. Robb, Sept. 3, 1966 (AFAM files).

43 Frank Weitenkampf, "Lo, the Wooden Indian, the Art of Making Cigar-shop Signs," *New York Times*, Aug. 3, 1890, p. 13. Weitenkampf reported that "S.A. Robb, who has been at it for twenty-six years, is full of reminiscences concerning the history of the art."

44 See Frederick Fried, *Artists in Wood: American Carvers of Cigar-Store Indians, Show Figures, and Circus Wagons* (New York: Clarkson N. Potter, 1970), pp. 193–238, for an extended discussion of Robb's life and career.

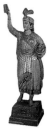

322. Sultana
Attributed to the workshop of Samuel Anderson Robb
(act. 1876–1903)
New York
c. 1880
Paint on wood with iron
86 × 26½ × 28 in.
P1.2001.349

INSCRIPTIONS:
Cigar band in upraised hand, paint: [?] *E. CIGARS*; in basket, on box: *FINE / TOBACCO*; on cigar band: *M. ROSE*; on second box: *TOBACCO*; left side of base: *PIPES*; front of base: *TOBACCO & CIGARS / AT WHOLESALE*; right side of base: *CIGARETTES.*; top of base: *HANDS OFF*

PROVENANCE:
Bruce & Crandall Galleries, Ellenville, N.Y., sale 9/73, lot 416; Gerald Kornblau, New York; Eileen and Richard Dubrow, Bayside, N.Y., 1984.

EXHIBITED:
"American Folk Art," Mead Art Building, Amherst College, Amherst, Mass., 1974.

PUBLISHED:
Amherst College. *American Folk Art.* Amherst, Mass.: Amherst College, 1974, fig. 100.
Bishop, Robert. *American Folk Sculpture.* New York: E.P. Dutton, 1974, p. 254.

This monumental Sultana has survived intact with an original paint surface that shows almost no evidence of retouching, a very rare condition among nineteenth-century tobacconist figures, which spent much of their working lives outdoors exposed to the elements. Her many details, including a jeweled and feathered turban, fringed sash around her waist, and basket of cigars and tobacco boxes cradled in her left arm, make her one of the finest known examples of a New York show figure, as this type came to be called in the second half of the nineteenth century.

It is also interesting to note that the Sultana holds the bunch of cigars aloft in her right hand in a manner that is strikingly similar to the way in which the Statue of Liberty holds her torch. While Liberty was not erected on Bedloe's Island until 1886, her configuration was well known in the United States in the 1870s. Her torch was, in fact, displayed at the Philadelphia Centennial Exposition in 1876. Other cigar store figures share the Sultana's pose, so it is possible that one or more carvers were inspired by Bartholdi's famous statue.

The New York show figure style was developed by three generations of shipcarvers, a small group of men who were bound by master-apprentice relationships and a number of short-lived business partnerships. Among the five master carvers most responsible for the style were Samuel A. Robb (1851–1928) and Thomas White (1825–1902). Robb operated the most successful workshop during the last quarter of the century, first at 195 Canal Street from 1876 to 1888 and then at 114 Centre Street from 1888 to 1903. White joined him when he opened his Canal Street shop, forming a productive relationship that lasted more than twenty years. In an article that appeared in the *New York Times* in 1890, a reporter discussed a number of notable figures that could be seen in the New York

area.[45] He then added that "nearly all of these figures came from Robb's shop, and many of them are Thomas White's handiwork."

After about 1870, William Demuth, a New York tobacco products distributor, offered a full line of show figures through catalog sales. Both Robb and White carved for him, and other shipcarvers probably did as well. Together, they established New York City as the leading center for production and distribution, spreading the New York show figure style throughout the country. Found in upstate New York, this figure may have been ordered in this way.

—R.S.

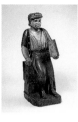

323. Newsboy
Artist unidentified
Eastern or midwestern United States
c. 1880
Paint on pine
35½ × 11½ × 13¼ in.
P1.2001.350

INSCRIPTIONS:
Front of base, incised: *Ossendorf Brand 90*; newspaper front, paint: *Tobacco / and cigars*; newspaper back: *Tobacco and cigars*; sides of boxes, paint: *50 1841, 1500 1870, 200 1869.*

PROVENANCE:
Gerald Kornblau, New York, 1993.

During the second half of the nineteenth century, sentimentalized images of urban youth and working-class types were popular in a number of different mediums. Genre painters like John George Brown achieved great success with anecdotal scenes of streetwise children engaged in such pursuits as hawking newspapers and shining shoes to playing rough-and-tumble games.[46] Prints and illustrations of similar subjects frequently appeared in magazines and newspapers, capitalizing on their widespread appeal. Picturesque narratives of modern urban life, they were often imbued with strong moral overtones through allusions to important social issues of the day, such as exploitative child labor practices, neglected children from poor immigrant families, and the plight of homeless orphans.

This engaging figure of a newsboy leaning against a stack of boxes falls squarely within this tradition. His ragged outfit and worldly demeanor capture the image of a tough street kid of humble origins forced to survive by his own wits. Thought to have been used in New Philadelphia, Ohio, the figure was evidently created by an experienced carver who was well versed in his art, probably in an urban workshop setting.

An important distinction between this piece and other newsboy figures is that it was a sign for a tobacco shop, as indicated by the cigar in the boy's mouth and the words "Tobacco and cigars" painted on the newspapers under his left arm. Outside of genre scenes, most representations of newsboys were used by their employers, the newspapers themselves. They adorned mastheads and stationery of newspaper companies,

45 Weitenkampf, "Lo, the Wooden Indian," p. 13.
46 For more on John George Brown and contemporary interest in images of street children, see Patricia Hills, "The Painters' America: Rural and Urban Life," *The Magazine Antiques* 106, no. 4

(October 1974): 646–47, and Martha Hoppin, "The Little White Slaves of New York: Paintings of Child Street Musicians by J.G. Brown," *American Art Journal* 26 (1994): 4–43.

as well as the facades of office buildings as relief sculpture in terra-cotta and stone. A particularly well-known example of a striding wooden newsboy selling the *Pawtucket (Rhode Island) Record* is in the Hall Collection at the Milwaukee Art Museum.[47] —R.S.

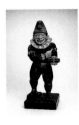

324. PUNCH
Charles Henkel (1842–1915)
Brattleboro, Windham County, Vermont
1870
Paint on wood
25⅜ × 9⅛ × 9⅛ in.
P1.2001.351

INSCRIPTION:
Back of base, incised: *CH H[E]NKEL / MAKER / BRATTLEBORO, VT / 1870*

PROVENANCE:
Doyle sale 11/82; Edmund L. Fuller, Woodstock, N.Y.; Christie's sale 5978, 10/85, lot 58.

As a cigar store figure, Punch was particularly popular in the 1870s and 1880s.[48] The character was well known from Punch and Judy puppet shows that delighted nineteenth-century audiences throughout the United States and England. There was also a brand of cigars of the same name. Punch himself is actually much older than either of these two sources, however. In his traditional English guise of Punchinello, he can be traced through France to Renaissance Italy, where Pulcinella was a comic figure in the commedia dell'arte.[49] His ultimate progenitor is Maccus, a humpbacked, hooked-nosed character from the Atellanæ, an ancient form of Roman satirical drama.

The usual depiction of Punch in this country, as created by Anglo-American shipcarvers, was a somewhat rotund character with a pronounced humpback, hooked nose, and mischievous leer. This example is more typical of Germanic tradition, a leaner figure with the same sort of vaguely malevolent grin but less emphasis on other features. Appropriately enough, its carver, Charles Henkel, was born in a small town near Neustadt, Germany. At the age of eight, he came to New York with his parents. As a young man, he attended an art school run by Ernst Plassmann, a German-born sculptor and woodcarver who was well known in his day. After completing his studies, Henkel moved to Springfield, Massachusetts, and then settled in Brattleboro, Vermont. There he had a woodcarving shop, but he mainly worked for forty-eight years as designer and head carver for the Estey Organ Company, creating the elaborate organ cases that were then in fashion.[50]

Henkel and Plassmann are just two of a number of talented German sculptors and carvers who immigrated to the United States in the second half of the nineteenth century. In particular, many came after the Revolution of 1848. Because of cultural and language differences, they generally worked on the margins of the artworld, and many remain unidentified or obscure today. The best-known is probably Julius Melchers, who settled in Detroit in 1855 and operated a workshop for more than forty years that produced architectural sculpture, shop and cigar store figures, and ornamental carvings of all types. —R.S.

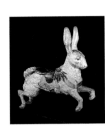

325. CAROUSEL RABBIT
Dentzel Company
Philadelphia
c. 1915
Paint on wood with glass
57¼ × 49 × 12½ in.
P1.2001.352

PROVENANCE
Eden Galleries, Salem, N.Y., 1973.

The Dentzel Company, besides being the first carousel maker in this country, was also one of the largest and most successful workshops, operating for more than sixty years. Gustav Dentzel immigrated to Philadelphia from Germany in 1860. After a profitable tour with his first carousel seven years later, he changed the name of his cabinet shop to "G.A. Dentzel, Steam and Horsepower Caroussell Builder." By the mid-1880s, the Dentzel workshop was creating a variety of different animals noted for their realism and elegant design. As the popularity of carousels increased, business expanded, and by 1903 the company was building five or six carousels a year.[51]

When Dentzel died in 1909, his son, William, assumed control of the family business. This was the era of the grand carousel, elaborate steam-driven machines that featured a menagerie of animals, three and four abreast. In addition to horses, which were always favorites, lions, tigers, giraffes, ostriches, pigs, cats, swans, and other animals were included in larger carousels at seaside resorts and amusement parks across the country. This rabbit was a jumper, designed for an inside row. It is thought to have been used in Far Rockaway, New York. A Dentzel carousel did, in fact, operate at Rockaway Beach for a number of years, but an undated photograph of it shows only horses. This remains inconclusive, though, because a menagerie carousel could have been in use at some other time.[52]

Over the years, many talented carvers worked for the Dentzels. Among the most prominent was Salvatore Cernigliaro, an Italian-trained furniture carver who joined the company in 1903. Cernigliaro has been

47 Milwaukee Art Museum, *Common Ground/Uncommon Vision: The Michael and Julie Hall Collection of American Folk Art* (Milwaukee: Milwaukee Art Museum, 1993), pp. 130–31, and Jean Lipman, Robert Bishop, Elizabeth V. Warren, and Sharon L. Eisenstat, *Five-Star Folk Art: One Hundred American Masterpieces* (New York: Harry N. Abrams in association with MAFA, 1990), pp. 114–15.

48 "The Punch Factory under New Management," *Tobacco* 9 (Oct. 31, 1890): 1, and "Wooden Indians," *Tobacco* 24 (Jan. 28, 1898): 3.

49 For a history of Pulcinella and other characters of the commedia dell'arte, see Maurice Sand, *The History of the Harlequinade*, 2 vols. (1915; reprint, New York: Benjamin Blom, 1968).

50 "Designed Organs for Many Years, Charles Henkel, Formerly with the Estey Organ Co. 48 Years, Died in His Home Yesterday Morning," (*Brattleboro*) *Vermont Phoenix*, Nov. 5, 1915, p. 1.

51 Tobin Fraley, *The Carousel Animal* (Berkeley, Calif.: Zephyr Press, 1983), p. 11.

52 Frederick Fried, *A Pictorial History of the Carousel* (Cranbury, N.J.: A.S. Barnes, 1964), p. 61. I would like to thank Tobin Fraley for bringing this to my attention.

credited with developing this type of rabbit around 1907.[53] The popularity of carousels peaked at about 1920. William Dentzel died in 1928, and what remained of the company was sold to the Philadelphia Toboggan Company, which stopped making carousels in 1934. None of the old workshops survived the Depression. —R.S.

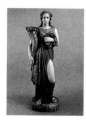

326. ALLEGORICAL FIGURE: FLORA
Artist unidentified
Probably New York
1840–1880
Paint on wood
53½ × 14¾ × 17½ in.
P1.2001.353

PROVENANCE:
Found on Staten Island, N.Y.; Dennis Insalaco, New York; Christie's sale 9054, 1/99, lot 214.

EXHIBITED:
"The Image Business: Shop and Cigar Store Figures in America," MAFA, 1997/98.

PUBLISHED:
Folk Art 22, no. 3 (fall 1997): cover, p. 5.
Sessions, Ralph. *The Image Business: Shop and Cigar Store Figures in America.* New York: MAFA, 1997.

A captivating image of ideal beauty, this allegorical figure is a prime example of nineteenth-century American figure carving. Found on Staten Island, she was probably used as a garden or architectural figure, though her present condition suggests that she was protected from the elements for most of her existence. The delicate handling of her face, her flowing hair adorned with roses, her pose, and the treatment of her drapery in a late neoclassical style indicate that she was made by a master carver who was familiar with current trends in the fine arts.

The figure was created by either an American shipcarver or, more likely, a European-trained carver who immigrated to the United States around midcentury. A number of German figure carvers came to the United States after the Revolution of 1848. Many of them had trained with master sculptors who were proficient in both wood and stone. In these workshops, apprentices studied ancient and modern sculpture and learned principles of drawing and composition as well as carving techniques.

The figure holds a cornucopia and a wreath and is adorned with many roses. She may represent Flora, the Roman goddess of flowers, who was usually portrayed with a cornucopia of blossoms that she scattered over the earth. The ancient image of Flora became quite popular in the early nineteenth century due to the revival of interest in flower symbolism, otherwise known as the "language of flowers." Starting in Napoleonic France, a seemingly endless number of gift books, dictionaries, and emblem books gained a huge audience on both sides of the Atlantic. Books like Charlotte de Latour's *La Langage des fleurs* (1819) and Elizabeth Wirt's

Flora's Dictionary (1829) became international best-sellers, inspiring all sorts of related visual imagery, from prints to ceramic figures. In the United States, language of flowers books reached a high point of popularity in the 1840s and 1850s, though they maintained their appeal until the end of the century.[54] —R.S.

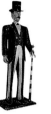

327. DAPPER DAN
Artist unidentified
Probably Washington, D.C., or Philadelphia
c. 1880
Paint on wood with metal
68¼ × 22⅛ × 17¾ in.
P1.2001.354

INSCRIPTION:
Front of hat, paint: *DAN*

PROVENANCE:
Found in Washington, D.C.; John Bihler and Henry Coger, Ashley Falls, Mass.; Gerald Kornblau, New York; Mr. and Mrs. Francis Andrews, Lincoln, Mass.; Sotheby Parke-Bernet sale 4369, 5/80, lot 610; Don and Faye Walters, Goshen, Ind.; Sotheby's sale 5534, "Walters Collection," 10/86, lot 29.

PUBLISHED:
Bishop, Robert. *American Folk Sculpture.* New York: E.P. Dutton, 1974, p. 126.

This nattily dressed figure was evidently used as a sign for a barbershop, as indicated by the red-and-white-striped pole that he steadies with his left hand. Although most commonly identified with tobacco shops, carved wooden figures served to advertise a wide variety of goods and services in the second half of the nineteenth century. In 1871 one New York firm advertised that it had a "Large and Varied Assortment of Wooden Show Figures which we are constantly manufacturing for all classes of business, such as Segar Stores, Wine & Liquors, Druggists, Yankee Notions, Umbrella, Clothing, Tea Stores, Theatres, Gardens, Banks, Insurance Companies, &c."[55]

Found in Washington, D.C., this Dapper Dan is almost certainly a unique carving, probably commissioned by a shop owner from a local woodcarver. Tall and thin with broad shoulders, he creates a striking presence that is heightened by an old paint surface and a significant amount of original detail. Several features suggest the work of an experienced self-taught carver, most notably the overall handling of form, which is less articulated than contemporary examples from the urban shipcarving workshops that created the majority of shop and cigar store figures.

A caricature of a contemporary urban type, Dapper Dan is closely related to representations of the Dude, a slightly disreputable character who was popular in many parts of the country. As a New York carver explained in 1886, "Dudes had quite a go for a while. I have got fully

53 Ibid., p. 123, and William Manns and Peggy Shank, *Painted Ponies: American Carousel Art* (Millwood, N.Y.: Zon International Publishing, 1986), p. 44.
54 For an extended discussion, see Beverly Seaton, *The Language of Flowers: A History* (Charlottesville, Va.: Univ. of Virginia Press, 1995).

55 Single-sheet advertisement, William Demuth & Company, New York, 1871. A copy is in the archives of the National Museum of American History, Smithsonian Institution, Washington, D.C.

twenty-five dudes planted around in Brooklyn and New York now, though dudes are on the wane."[56] The perfect image of the city slicker, he was also known as a Sporting Dude or Race Track Tout.[57] —R.S.

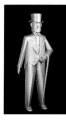

328. TIN MAN
David Goldsmith (1901–1980)
Long Island City, Queens, New York
c. 1930
Paint on galvanized sheet metal
72 × 25 × 11 in.
P1.2001.355

PROVENANCE:
West End Sheet Metal and Roofing Works, Long Island City, N.Y.; Gerald Kornblau, New York;
Mr. and Mrs. Eugene S. and Elaine Terner Cooper, New York, 1986.

EXHIBITED:
"American Folk Art," Mead Art Building, Amherst College, Amherst, Mass., 1974.
"Two Hundred Years of American Sculpture," WMAA, 1976.
"Young America: A Folk Art History," MAFA at IBM Gallery of Science and Art, New York, 1986.
"Five-Star Folk Art: One Hundred American Masterpieces," MAFA, 1990.

PUBLISHED:
Amherst College. *American Folk Art.* Amherst, Mass.: Amherst College, 1974, fig. 120.
Armstrong, Tom. "The Innocent Eye: American Folk Sculpture." In Whitney Museum of
 American Art. *Two Hundred Years of American Sculpture.* New York: WMAA, 1976, p. 106.
Bishop, Robert. *American Folk Sculpture.* New York: E.P. Dutton, 1974, p. 39.
Lipman, Jean. *Provocative Parallels.* New York: E.P. Dutton, 1975, p. 40.
Lipman, Jean, and Helen M. Franc. *Bright Stars: American Painting and Sculpture since 1776.*
 New York: E.P. Dutton, 1976, p. 83.
Lipman, Jean, Elizabeth V. Warren, and Robert Bishop. *Young America: A Folk Art History.*
 New York: Hudson Hills Press in association with MAFA, 1986, p. 148.
Lipman, Jean, Robert Bishop, Elizabeth V. Warren, and Sharon L. Eisenstat. *Five-Star Folk Art:*
 One Hundred American Masterpieces. New York: Harry N. Abrams in association with MAFA
 1990, p. 122.

David Goldsmith conceived his tin man as an image of Uncle Sam in top hat and tails, according to family members. He based much of the costume on articles of clothing that he had in his shop, and he modeled the figure's hands after his own.[58] In a stylized fashion, the piece combines rounded and angular forms dictated by its sheet metal construction with finely crafted details of costuming, including bow tie, tailored lapels, shirt buttons, and dress shoes complete with laces. At six feet tall, this imposing figure demonstrates Goldsmith's design skills and the attention to detail that he learned as a tinsmith and silversmith, while its jaunty air reveals his innate sense of humor. As far as is known, it is the only figure Goldsmith created.[59]

Appropriately enough, David Goldsmith was the son of an Austrian goldsmith. At age fifteen, he traveled to Kraków to learn the trade of

tinsmithing, and in 1920 he immigrated to the United States. He worked as a tinsmith and a silversmith for several years, finally founding the West End Sheet Metal and Roofing Works in Long Island City in 1929. Goldsmith placed the tin man in the window of his shop, where it stood as a local landmark for many years. As such, it assumed the role of a shop sign of sorts, following in the tradition of shop and cigar store figures of previous centuries. When Goldsmith retired and sold his business in 1964, the tin man remained behind.[60] In 1976 it was included in the landmark exhibition "Two Hundred Years of American Sculpture" at the Whitney Museum of American Art in New York, as a testament to Goldsmith's artistic imagination and the creative use of the materials of his trade. —R.S.

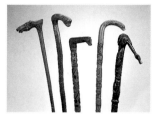

329a. CANE WITH HORSE HEAD
AND BRIDLE HANDLE
Artist unidentified
Possibly Pennsylvania
Late nineteenth/early twentieth century
Dogwood with brass ferrule
36¼ × 5³⁄₁₆ in.
P1.2001.356

PROVENANCE:
Oliver Christman, Pottstown, Pa.; Richard Machmer, Hamburg, Pa., 1978.

329b. CANE WITH DOG HEAD HANDLE
Attributed to "Schtockschnitzler" Simmons (act. 1885–1910)
Berks County, Pennsylvania
c. 1900
Dogwood root with paint with brass ferrule
37³⁄₈ × 4⅝ in.
P1.2001.357

PROVENANCE:
Harry B. Hartman, Marietta, Pa., 1972.

329c. ANIMALS AND VINE CANE WITH
HORSE HEAD HANDLE
Artist unidentified
Eastern United States
Late nineteenth/early twentieth century
Paint on wood
30 × 4½ in.
P1.2001.358

PROVENANCE:
Chris A. Machmer, Annville, Pa., 1977.

56 "Designed by Whittling Yankees, a Studio Where Many Statues of Native Americans Are
 Made," *Tobacco* 1 (May 14, 1886): 7.
57 "Dapper Dan" is usually used to describe a nattily dressed gentleman. Although the exact gene-
 sis of the name is unclear, one source traces it to Handsome Dan, a bulldog that became the Yale
 football mascot in 1892. Its roots may indeed be earlier, as this type of figure has a long associa-
 tion with barber shops; William T. Stolz, Western Historical Manuscript Collection, Ellis Library,
 University of Missouri, Columbus, e-mail to Stacy C. Hollander, Feb. 7, 2001 (AFAM files).

58 Rochelle Spielvogel (artist's granddaughter), letter to Elaine Cooper (former owner),
 March 14, 1989 (AFAM files).
59 Many different types of tin men continue to serve as signs for metalworking shops,
 while others are in museum and private collections. For two examples from the 1970s
 and 1980s, see Milwaukee Art Museum, *Common Ground*, pp. 133–35.
60 A photocopy of biographical notes compiled by Spielvogel, c. 1985, is in the AFAM files.

329d. ANIMALS CANE WITH DOG HEAD HANDLE
Probably the Bally Carver
Berks County, Pennsylvania
c. 1900
Wood with metal ferrule and rubber tip
32¾ × 4¾ in.
P1.2001.359

PROVENANCE:
Chris A. Machmer, Annville, Pa., 1978.

329e. DOG AND ROOSTER CANE
Artist unidentified
Eastern United States
c. 1896
Wood with ink and varnish
34¼ × 5 in.
P1.2001.360

INSCRIPTIONS:
Top of shaft, ink: *JULY 1896*; underside of handle: *SBM*

PROVENANCE:
Ken Mundis, York, Pa., 1974.

Canes with animal-head handles were particularly popular among nineteenth- and early-twentieth-century carvers. If they were made from saplings, handles frequently followed the shape of root patterns. Alternatively, handles could be carved separately and attached to the shaft. These differing techniques resulted in a wide range of interpretations, as seen in these five examples.

One cane, with a handle in the shape of a rounded, snub-nosed dog head with leaf ears, is identified with the work of "Schtockschnitzler" Simmons. By tradition he is thought to have been a German immigrant who wandered parts of Berks County, Pennsylvania, with a pack of finished and unfinished canes on his back with which he bartered for food, drink, and a night's stay. He had two nicknames, "der Alt" (the old one) and "der Schtockschnitzler" (the cane carver), but his given name is unrecorded. While he is best known for his bird canes and bird trees, his dog and horse canes are equally distinctive.[61]

The other two canes with dog handles are just as stylized and have well-carved shafts with animal and plant motifs. As with most makers, these cane carvers' approaches are highly individualized. The cane that is probably by the Bally Carver features animals of a fairly consistent depth that wrap around the shaft, while the carver of the dog and rooster cane chose to combine relatively high relief on the upper shaft with incised floral patterns on the lower part.[62]

The two horse head canes are similarly varied. On one, the carver focused all his attention on an imaginative and finely detailed horse-and-bridle motif, leaving the shaft undecorated. On the other, the maker was concerned primarily with the shaft. Highlighted in polychrome, animals, birds, and a horse and rider are interspersed among a leafy vine that wraps around its entire length.

—R.S.

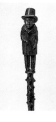

330. SHIP CAPTAIN CANE
Artist unidentified
Probably New England
Mid-nineteenth century
Hickory with brass ferrule
33 × 2¼ in. diam.
P1.2001.361

PROVENANCE:
Kristina Barbara Johnson, Princeton, N.J.; Sotheby Parke-Bernet sale 5075, "Johnson Collection, Part III," 4/83, lot 484.

EXHIBITED:
"Hunt for the Whale," MAFA, 1968.

PUBLISHED:
Bishop, Robert. *American Folk Sculpture.* New York: E.P. Dutton, 1974, p. 347.

The freestanding figure that serves as the handle for this unique cane is a rare feature among nineteenth-century walking sticks. Carved in the round, a stern gentleman is rendered with several fine details, including a dour facial expression, small arms that are partially engaged in the body, creased trousers, and a delicate cane that rests on his right shoe. While its sculptural qualities are exceptional, the figure does not make a particularly functional handle, suggesting that the cane was made as a presentation piece or a gift and was not intended for daily use.

As with much scrimshaw and other mariners' arts, it may have been carved by a sailor during idle hours at sea. By tradition it is believed to have been made on a whaling voyage.[63] Wearing a frock coat and top hat, the figure does, in fact, bear a strong resemblance to a mid-nineteenth-century Nantucket or southern New England ship captain or ship owner.

—R.S.

61 For biographical information, see Richard S. Machmer and Rosemarie Machmer, "The Birds of 'Schtockschnitzler' Simmons," *Historical Review of Berks County* 39 (spring 1974): 58–59, 79, and Richard Machmer, *Just for Nice* (Reading, Pa.: Historical Society of Berks County, 1991), p. 76. For related examples, see Machmer, *Just for Nice*, p. 20, fig. 19, and George H. Meyer, *American Folk Art Canes: Personal Sculpture* (Bloomfield Hills, Mich.: Sandringham Press, 1992), p. 47, fig. 60.

62 Little is actually known about the Bally Carver other than that he worked in the Berks County area around the turn of the twentieth century. For a related example, see Meyer, *American Folk Art Canes*, p. 47, fig. 58.

63 Robert Bishop, *American Folk Sculpture* (New York: E.P. Dutton, 1974), p. 349.

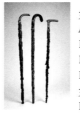

331. SNAKE CANE
Artist unidentified
Eastern United States
Late nineteenth/early twentieth century
Paint on poplar and wisteria with glass and cat's teeth
33½ × 2 in. diam.
P1.2001.362

PROVENANCE:
Chris A. Machmer, Annville, Pa., 1972.

332. SNAKE CANE WITH NESTING BIRDS HANDLE
Artist unidentified
Probably Duanesburg, Schenectady County, New York
Late nineteenth/early twentieth century
Paint on wood with brads and metal thimble ferrule
38¼ × 2¼ in. diam.
P1.2001.363

PROVENANCE:
Kate and Joel Kopp, America Hurrah, New York, 1976.

333. SNAKE CANE WITH FIST HANDLE
Artist unidentified
Eastern United States
Late nineteenth century
Paint on olive wood with ivory, brads, and brass
34½ × 2 in. diam.
P1.2001.364

INSCRIPTION:
Cufflink and ring, incised: *R*

PROVENANCE:
Kristina Barbara Johnson, Princeton, N.J.; Sotheby Parke-Bernet sale 4758Y, "Johnson Whaling Collection, Part I," 12/81, lot 268.

More than any other single motif, the snake is a defining characteristic of the handmade cane. From a design perspective, a twisted snake that winds its way up the shaft is ideally suited for the circular surface of a walking stick. As a visual image, it can serve as a metaphor for the natural world, a creature bound to the earth, familiar and yet mysterious, alluring and sometimes threatening.

On a deeper level, the snake's hold on the human imagination is firmly rooted in our collective psyche. As an inhabitant of the shadowy realm between earth and underworld, its symbolism is ancient and universal. In many cultures, the snake signifies rebirth and regeneration and is often linked with power and authority, while in Judeo-Christian tradition, it assumes its decidedly more contradictory associations with knowledge and temptation. For all these reasons, the snake is a potent image, one that has appealed to cane carvers for generations.

Three variations are presented here. In the first, a stylized and decorated snake, made of wisteria, is wrapped around a painted poplar sapling. Glass eyes add definition to its head, and a pair of fangs fashioned from what appear to be cat's teeth bite into the shaft. The next cane, with a snake and nesting birds handle, features a deeply incised and painted snake that seems to be approaching three small nesting birds on a ring below a large knobbed handle, suggesting an age-old narrative of hunter and prey. In the last example, a finely carved clenched fist holds a snake's head in a clever integration of handle and shaft. Inlaid fingernails and a ring and cufflink incised with the letter *R* provide a counterpoint to the darkly painted and textured snakeskin and natural stick. —R.S.

334. PORTRAITS AND ANIMALS CANE
Artist unidentified
Possibly Pennsylvania
Late nineteenth century
Paint on wood with copper and rubber ferrule
37 × 5¼ in.
P1.2001.365

INSCRIPTION:
Rubber tip, stamped: *Daisy*

PROVENANCE:
Kate and Joel Kopp, America Hurrah, New York, 1975.

335. EAGLES, SNAKES, AND LIZARD CANE
Artist unidentified
Eastern United States
Late nineteenth/early twentieth century
Paint on wood
37 × 6⅛ in.
P1.2001.366

INSCRIPTION:
Shaft, incised: *WLL*

PROVENANCE:
Chris A. Machmer, Annville, Pa., 1977.

336. ANIMALS CANE
Artist unidentified
Eastern United States
Late nineteenth/early twentieth century
Paint on wood with brass handle and ferrule
34⅞ × 4⅝ in.
P1.2001.367

INSCRIPTION:
Bottom of shaft, paint: *Maid By J.F.W. To F. Wright*

PROVENANCE:
Nichols Antiques, Breinigsville, Pa., 1994.

337. THE TIMES CANE

Artist unidentified
Northeastern United States
Late nineteenth century
Wood
39 × 1 in. diam.
P1.2001.368

INSCRIPTION:
Shaft, incised: *THE TIMES*

PROVENANCE:
Eileen and Richard Dubrow, Whitestone, N.Y., 1978.

One of the major differences between formal canes made commercially and walking sticks handmade by self-taught artists is the extent to which the shaft was used as a carving surface. On formal canes, cast and carved handles were the main focus of decoration, and shafts were, for the most part, smooth or only slightly ornamented. Shafts of handmade canes, on the other hand, were frequently worked for their entire length with a density of visual motifs. Designs could be organized in fairly regular bands or registers, often with images that wrapped around the shaft or with more random patterns that juxtaposed discrete elements in a riotous composition. In either case, the carver's central concern was demonstrating his skill, ingenuity, and sense of humor in manipulating a challenging, small-diameter medium.

The *Times* cane is named after a central vignette of a woman standing in her kitchen reading a newspaper that is incised with that title. Above and below her are a series of contemporary scenes that cover the shaft, from a bar interior to a hunt to a circus setting. As such, the newspaper title gains a second meaning that unifies the composition as a depiction of modern life.

The other three canes feature a wide range of animal and human motifs in high and low relief on elaborate polychromed surfaces. Portrait heads, patriotic symbols, and exotic and domestic animals dominate to varying degrees. One is particularly notable for its unusual combination of a formal embossed and engraved brass handle with a carved shaft that is packed with animals and animal heads of various depths, including several that are modeled in three dimensions. —R.S.

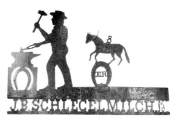

338. J.B. SCHLEGELMILCH BLACKSMITH SHOP SIGN AND WEATHERVANE

Artist unidentified
Southeastern Pennsylvania
Mid-nineteenth century
Iron with traces of paint
28⅜ × 42 × ¼ in.
P1.2001.369

INSCRIPTION:
[Blacksmith] & [Horseshoe] *ER / J.B. SCHLEGELMILCH. M / JO*

PROVENANCE:
Found in Mount Joy, Pa.; Bernard Plomp, Michigan; Bernard M. Barenholtz, Marlborough, N.H.; Sotheby's sale 5969, "Barenholtz Collection," 1/90, lot 1600.

EXHIBITED:
"Every Picture Tells a Story: Word and Image in American Folk Art," MAFA, 1994/95.

Found in Mount Joy, Pennsylvania, this ingenious conception appears to have served more than one purpose. It was, first and foremost, a blacksmith shop sign for J.B. Schlegelmilch, whose name appears at the bottom. The dominant motif of a craftsman at his anvil with a raised hammer in one hand and a pair of tongs in the other sends a clear message, which is cleverly reinforced by the small horse with an ampersand on its back, poised on a horseshoe, within which are the letters "ER." Visually it reads "and horseshoe-er." The composition is further strengthened and balanced by the cutout horseshoe in the block below the anvil.

In addition to its primary function, the sign was designed and weighted as a weathervane. The large blacksmith and anvil shift the balance point forward to a vertical axis that extends up through the figure. Two forged metal rings are attached to his back to receive a pole, while the horizontal band at bottom extends back to catch the wind. Weathervanes were often chosen to represent the purpose of the structure upon which they were mounted, and several are known to have been used as signs of one type or another. From the roof of Schlegelmilch's shop, this finely crafted piece would have been an effective eye-catching image.

A closely related example that is probably by the same maker is in the collection of the Landis Valley Museum in Lancaster, Pennsylvania.[64] Collected by the Landis brothers sometime between the 1890s and about 1940, it is presumed to be from southeastern Pennsylvania. Schlegelmilch is still a local name in the area.[65] —R.S.

64 Vernon S. Gunnion and Carroll J. Hopf, eds., *The Blacksmith Artisan within the Early Community* (Harrisburg, Pa.: Pennsylvania Historical and Museum Commission, 1976), cover, p. 63.

65 Susan Messimer, Landis Valley Museum, and Vernon Gunnion, telephone conversations with the author, June 19 and 26, 2000, respectively.

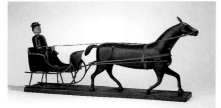

339. HORSE-DRAWN SLEIGH AND DRIVER
Artist unidentified
Probably New England
Late nineteenth century
Paint and varnish on wood with leather
12⅝ × 26 × 5 in.
P1.2001.370

PROVENANCE:
Rosalind Rossier; Sotheby Parke-Bernet sale 2314, 12/64, lot 634; Harvey and Isobel Kahn, Millburn, N.J., 1993.

EXHIBITED:
"Young America: A Folk Art History," MAFA at IBM Gallery of Science and Art, New York, 1986.

PUBLISHED:
Bishop, Robert. *American Folk Sculpture.* New York: E.P. Dutton, 1974, p. 328.
Lipman, Jean, Elizabeth V. Warren, and Robert Bishop. *Young America: A Folk Art History.* New York: Hudson Hills Press in association with MAFA, 1986, p. 89.

A mong the most personalized forms of nineteenth-century wood-carving are small-scale vignettes of everyday life, many of which feature horse-drawn conveyances of one type or another. Usually created in household settings, they are all the more engaging for their intimate associations with childhood and family. Depending upon the carver's skill and sense of humor, the results varied from the realistic to the highly inventive. In this case, a self-taught artist has created an elongated horse of improbable dimensions pulling a sleigh. The horse is stylized further with a mane that is incised into its neck, a cropped tail, and short legs with well-formed hooves. The carver paid particular attention to the sleigh, an accurate construction with delicate runners and stays, while he rendered its stocky driver in a more suggestive fashion.

The piece was most likely made as a toy but could have served some other purpose. It may once have been part of a larger grouping, as some carvers frequently created individualized works that expressed their personal worldviews. One of the best-known examples of this is a group of about forty figures and vignettes by a different carver which is believed to have been displayed in a Vermont store around 1910 as a panorama of American life.[66] —R.S.

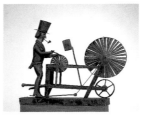

340. KNIFE GRINDER
Artist unidentified
Probably New England
c. 1875
Paint on tin
13½ × 16¼ × 3½ in.
P1.2001.371

PROVENANCE:
Found in Marblehead, Mass.; Edmund L. Fuller, Woodstock, N.Y.; Kate and Joel Kopp, America Hurrah, New York; Marvin and Jill Baten, White Plains, N.Y., 1986.

EXHIBITED:
"Young America: A Folk Art History," MAFA at IBM Gallery of Science and Art, New York, 1986.
"Five-Star Folk Art: One Hundred American Masterpieces," MAFA, 1990.

PUBLISHED:
Bishop, Robert, and Patricia Coblentz. *A Gallery of American Weathervanes and Whirligigs.* New York: E.P. Dutton, 1981, p. 114.
Lipman, Jean, Elizabeth V. Warren, and Robert Bishop. *Young America: A Folk Art History.* New York: Hudson Hills Press in association with MAFA, 1986, p. 146.
Lipman, Jean, Robert Bishop, Elizabeth V. Warren, and Sharon L. Eisenstat. *Five-Star Folk Art: One Hundred American Masterpieces.* New York: Harry N. Abrams in association with MAFA, 1990, p. 116.

K nife grinders such as the gentleman depicted here were a common sight in urban areas and larger towns in the nineteenth century, at a time when tradesmen and vendors plied the streets in search of business. By mounting a grinding stone on a handmade cart, knife grinders could offer a convenient service to customers, particularly in residential neighborhoods where the periodic sharpening of blades used in the home and garden was best accomplished on a large wheel.

While the inspiration for this delightful construction was a familiar activity, the piece itself has a unique history of survival. At some point in the early twentieth century, it was enclosed behind the lathing of a plaster wall in a house in Marblehead, Massachusetts, only to be redis-covered during a later renovation. The large slatted wheel in front was undoubtedly designed to catch the wind. When it rotates, two long pins move the figure's right leg. Another pin in the left shaft of the cart handle suggests that the smaller grinding wheel once turned as well, but the original configuration of the mechanism cannot be determined at this point.

The grinder's costume, particularly the hat and stand-up collar, is typical of the 1830s, and the details of his pipe and long hair provide additional period touches. However, the tin can suspended on a stick over the grinding wheel—the vessel that would have dripped water on the knife grinder's revolving wheel to cool it—indicates that the piece is of a later date. Spurred by the Civil War, the American canning industry developed rapidly after 1860. Before that time, tin cans were very scarce.[67] As a retrospective presentation, then, the knife grinder can be seen as a romanticized reflection of the trade's earlier era. —R.S.

66 These figures are now in several museum and private collections, including AARFAM and the Margaret Woodbury Strong Museum, Rochester, N.Y. For a representative illustration, see Herbert Waide Hemphill, ed., *Folk Sculpture USA* (Brooklyn: TBM, 1976), p. 50.

67 Frank G. White, Old Sturbridge Village, Sturbridge, Mass., letter to Stacy C. Hollander, Feb. 10, 2000 (AFAM files).

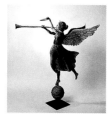

341. FAME WEATHERVANE
Attributed to E.G. Washburne & Company
New York
c. 1890
Copper and zinc with gold leaf
39 × 35¾ × 23½ in.
P1.2001.372

PROVENANCE:
Charles Kessler, New York; Century Boat Company, New York; Christie's sale 7492, 6/92, lot 84.

EXHIBITED:
"Millennial Dreams: Vision and Prophecy in American Folk Art," MAFA, 1999/2000.
Takashimaya department stores, Japan, 2000.

The ancient Greek goddess and allegorical figure of Fame experienced a revival with the rise of neoclassicism in the late eighteenth and early nineteenth centuries. This weathervane is particularly notable for its well-preserved detail and fine old surface. It is thought to have been the last of its type created toward the end of the nineteenth century by E.G. Washburne & Company of New York City. From about 1908 to 1963, the weathervane hung from the Washburne workshop at 207 Fulton Street. In 1964 Charles C. Kessler, a long-time employee and eventual owner of the company, described the scene in years past: "Once upon a time we had vanes hanging all over the front of the building—eagles and arrows and banners and horses, and even a big golden cow—and when the sun shone, how they did gleam!"[68]

Isaiah Washburne founded the business in 1853 in a second-floor workshop at 708 Broadway. In 1907 the company moved to 207 Fulton Street. Sometime in the 1920s, Kessler acquired the firm and its name and continued to produce weathervanes from the old molds.[69] In 1956 he sold out, and production moved to Danvers, Massachusetts. Kessler kept an office at 207 Fulton, though, until 1963, when he moved across the street to 206.[70] He sold this weathervane in January 1963, probably because he was leaving the old workshop.

Two closely related versions are in private collections. It has been suggested that they were made by the J.L. Mott Iron Works, based on their similarity to an illustration in that company's 1892 catalog.[71] This highlights the difficulty of determining the source of many copper weathervanes, as well as the relationships between the different companies. The situation in New York City is particularly complex, given the many firms that advertised and sold them. Larger companies like E.G. Washburne, J.L. Mott, and J.W. Fiske made their own weathervanes, to be sure, but they frequently borrowed designs from one another, as evidenced by the illustrations in their catalogs. Smaller operations were known to buy parts from the larger shops and then assemble and sell them as their own. Still other metalwork companies were primarily agents and retailers for other workshops. —R.S.

68 "Vanes," *The New Yorker* (Sept. 12, 1964): 39.
69 Klamkin, *Weather Vanes,* p. 24.
70 "Vanes," pp. 39–40.
71 J.L. Mott Iron Works, "Illustrated Catalogue," p. 63.

CONTRIBUTORS

STACY C. HOLLANDER is the senior curator and director of exhibitions of the American Folk Art Museum. She received her B.A. from Barnard College, Columbia University, and her M.A. in American folk art studies from New York University. She was the cocurator of "Revisiting Ammi Phillips: Fifty Years of American Portraiture" (1994, with H. Fertig, with catalog) and "American Anthem: Masterworks from the American Folk Art Museum" (2001, with B.D. Anderson, with catalog), and curator of "Harry Lieberman: A Journey of Remembrance" (1991, with catalog), "Every Picture Tells a Story: Word and Image in American Folk Art" (1994/95), "A Place for Us: Vernacular Architecture in American Folk Art" (1996/97), and "Mary Ann Willson: Artist Maid" (1998). Hollander lectures and publishes widely and is a frequent contributor to *Folk Art*.

HELEN KELLOGG AND STEVEN KELLOGG have been collecting American folk art, paintings, and painted furniture since they moved into their eighteenth-century Connecticut farmhouse thirty-five years ago. During the 1970s, intrigued by several watercolor portraits in their own collection, Helen Kellogg compiled information that identified the husband-and-wife team of Dr. Samuel Addison Shute and Ruth Whittier Shute as the artists of a large group of watercolor portraits; she remains the leading authority on their work. Her research and findings were published first in *Antiques World* (December 1978) and then in *American Folk Painters of Three Centuries* (1980). With Colleen Cowles Heslip, she also identified the elusive painter long known as the Beardsley Limner as eastern Connecticut pastelist Sarah Perkins. This research was published in *The Magazine Antiques* (September 1984).

LEE KOGAN is the director of the Folk Art Institute at the American Folk Art Museum and coordinator of special projects for the Museum's Contemporary Center. She is also an adjunct professor of art and art education at New York University. Kogan was curator of "Ninety-Nine and a Half Won't Do: The Art of Nellie Mae Rowe" (1998, with catalog) and project coordinator for "Self-Taught Artists of the Twentieth Century: An American Anthology" (1998, with catalog). She publishes and lectures frequently on folk art subjects. Kogan received her B.A. from Queens College, an M.A. from Teachers' College, Columbia University, and an M.A. in American folk art studies from New York University.

JACK L. LINDSEY is the curator of American decorative art at the Philadelphia Museum of Art. He received his B.A. in American history and studio ceramics from Guilford College, Greensboro, N.C., and his M.A. in American civilization and museum studies and his Ph.D. in folklore and folklife from the University of Pennsylvania. Lindsey has published and lectured extensively on American furniture and silver, Pennsylvania German decorative arts, African American material culture, and American folk and self-taught artists. Recently he was the curator of "Worldly Goods: The Arts of Early Pennsylvania, 1680–1758" (1999/2000, with catalog). He is currently documenting pre-1755 cabinetmakers in Philadelphia and producing a series of collection catalogs on the Philadelphia Museum's extensive holdings of American furniture from the eighteenth and nineteenth centuries.

KENNETH R. MARTIN is a writer and historian specializing in maritime history and folk art. He received his B.A. from Dickinson College and his M.A. and Ph.D. from the University of Pennsylvania. Martin is the author and coauthor of more than a dozen books, including *Whalemen's Paintings and Drawings: Selections from the Kendall Whaling Museum Collection* (1983), *"Some Very Handsome Work": Scrimshaw at the Cape Cod National Seashore* (1991), and *"Heavy Weather and Hard Luck": Portsmouth Goes Whaling* (1998). Recently, he served as guest curator for folk art exhibitions at the Maine Maritime Museum and the Art Gallery of Nova Scotia. A former director of the Kendall Whaling Museum, Martin lives in Woolwich, Maine, where he collects country furniture, decorative militaria, and nautical folk art.

CHARLOTTE EMANS MOORE is an independent scholar with a concentration on American painting. She received her B.A. from the College of William and Mary and her M.A. from New York University; she presently is completing her Ph.D. in the American and New England studies program at Boston University. Moore is coauthor of *Folk Art's Many Faces: Portraits in the New York State Historical Association* (1987, with P. D'Ambrosio), *American Paintings in the Museum of Fine Arts, Boston: An Illustrated Summary Catalogue* (1997, with C. Troyen and P.K. Diamond), and *A Window into Collecting American Folk Art: The Edward Duff Balken Collection at Princeton* (1999, with C.C. Heslip). She was a major contributor to *Addison Gallery of American Art: 65 Years, a Selective Catalogue* (1996), *Facing the New World: Jewish Portraits in Colonial and Federal America* (1997), and *Picturing Nantucket: An Art History of the Island with Paintings from the Collection of the Nantucket Historical Association* (2000), among other publications.

BETTY RING is a needlework collector and scholar with a concentration on the regional characteristics of schoolgirl embroideries and their importance as sources for expanding the knowledge of women's early education in America. On this subject, she has lectured widely and has been a frequent contributor to *The Magazine Antiques*. Ring has served as guest curator for needlework exhibitions sponsored by the Rhode Island Historical Society, Providence, and the American Folk Art Museum. Her principal publications include *Let Virtue Be a Guide to Thee: Needlework in the Education of Rhode Island Women, 1730–1830* (1983) and *Girlhood Embroidery: American Samplers & Pictorial Needlework, 1650–1850* (1993).

RALPH SESSIONS is an independent curator and art historian who specializes in nineteenth- and early-twentieth-century American art, with a particular interest in folk sculpture. He received his B.A. from the University of Pennsylvania, his M.A. from the University of North Carolina at Chapel Hill, and his Ph.D. in art history from the City University of New York. He was guest curator of the traveling exhibition "The Image Business: Shop and Cigar Store Figures in America," organized by the American Folk Art Museum (1997/98). At present, he is writing a book on figure carving and ship carving in America. Sessions has served as chief curator of the American Folk Art Museum, director of the Abigail Adams Smith Museum, New York, and director of the Historical Society of Rockland County, N.Y.

DONALD R. WALTERS is an antiques dealer specializing in American folk art with his wife, Mary Benisek, in Northampton, Mass. He received his B.S. in design and his M.A. in museum practice at the University of Michigan. From 1972 to 1979, he served as curator at the Abby Aldrich Rockefeller Folk Art Museum in Williamsburg, Va., where he organized the exhibitions "Virginia Painted Furniture" and "Virginia Fraktur" and authored articles on those subjects in *The Magazine Antiques.* His original research on several nineteenth-century American folk portraitists and miniature watercolor portraitists was published as a series in the *Maine Antique Digest* (1977/78). Walters was a major contributor to *American Folk Portraits: Paintings and Drawings from the Abby Aldrich Rockefeller Folk Art Center* (1981).

CAROLYN J. WEEKLEY is the director of museums at the Colonial Williamsburg Foundation, encompassing four institutions: Abby Aldrich Rockefeller Folk Art Museum, Bassett Hall, Carter's Grove, and DeWitt Wallace Gallery. She received her B.A. in art history from Mary Baldwin College, Staunton, Va., and her M.A. in early American decorative arts and cultural history from the University of Delaware's Winterthur Program. She previously held positions at the Museum of Early Southern Decorative Arts, Winston-Salem, N.C., and the Virginia Museum of Art, Richmond. She was a major contributor to *Joshua Johnson: Freeman and Early American Portrait Painter* (1987), and she has written numerous articles for *The Magazine Antiques* and *The Journal of Early Southern Decorative Arts.* Most recently, she was the curator of the traveling exhibition "The Kingdoms of Edward Hicks" (1999, with catalog).

FREDERICK S. WEISER is a retired parish pastor in central Pennsylvania. He is a graduate of Gettysburg College and received his B.D. and S.T.M. from the Lutheran Theological Seminaries in Gettysburg and Philadelphia, respectively. He has taught at Gettysburg College and has served as archivist of Lutheran Theological Seminary in Gettysburg.

From 1966 to 1992, he was editor of the publications series of the Pennsylvania German Society. Weiser has identified several important fraktur artists, and he coauthored the seminal publication on Pennsylvania German fraktur, *The Pennsylvania German Fraktur of the Free Library of Philadelphia* (1976, with H.J. Heaney). Weiser has lectured widely on fraktur and other Pennsylvania German decorative arts and has translated Pennsylvania German materials for Winterthur; Colonial Williamsburg Foundation, Williamsburg, Va.; Old Salem, Inc., Winston-Salem, N.C.; Dietrich Foundation, Philadelphia; Museum of Fine Arts, Boston; Free Library of Philadelphia; Philadelphia Museum of Art; and many regional historical societies. He was guest curator of "The Gift Is Small, the Love Is Great" (1994, with catalog) organized by the American Folk Art Museum. He resides at Parrehof near New Oxford in Adams County, Pa.

GERARD C. WERTKIN is the director of the American Folk Art Museum. He is also an adjunct associate professor of art and art education at New York University. He was cocurator of "The Jewish Heritage in American Folk Art," jointly organized by MAFA and the Jewish Museum, New York (1984/85, with N. Kleeblatt), and curator of "City Folk: Ethnic Traditions in the Metropolitan Area" (1988). Long interested in the spiritual dimension in American vernacular culture, he has organized exhibitions exploring this theme, such as the recent "Millennial Dreams: Vision and Prophecy in American Folk Art" (1999/2001, with catalog). Recognized as an expert on the art and culture of the Shakers, Wertkin is the author of *The Four Seasons of Shaker Life: An Intimate Portrait of the Community at Sabbathday Lake* (1986) and other publications. In 1997–1998 he was visiting professor of Jewish art at the Jewish Theological Seminary of America. Wertkin holds an A.B. from Syracuse University and J.D. and LL.M. degrees from New York University.

ABBREVIATIONS

INSTITUTIONS AND AUCTION HOUSES

AAM Allentown Art Museum, Allentown, Pa.

AARFAM/AARFAC Abby Aldrich Rockefeller Folk Art Museum, Colonial Williamsburg Foundation, Williamsburg, Va. (formerly Abby Aldrich Rockefeller Folk Art Center)

AFAM/MAFA American Folk Art Museum, New York (formerly Museum of American Folk Art)

CHRISTIE'S Christie, Manson & Woods, International, New York

DOYLE William Doyle Galleries, New York

ELDRED'S Robert C. Eldred Co., East Dennis, Mass.

EMAS Evansville Museum of Art and Science, Evansville, Ind.

GARTH'S Garth's Auctions, Delaware, Ohio

MMA The Metropolitan Museum of Art, New York

NGA National Gallery of Art, Washington, D.C.

N-YHS New-York Historical Society, New York

NYSHA New York State Historical Association, Cooperstown, N.Y.

PARKE-BERNET Parke-Bernet Galleries, New York

PENNYPACKER Pennypacker Auction Centre, Reading, Pa.

PMA Philadelphia Museum of Art

SHELBURNE Shelburne Museum, Shelburne, Vt.

SKINNER Robert W. Skinner, Bolton, Mass.

SOTHEBY PARKE-BERNET Sotheby Parke-Bernet, New York

SOTHEBY'S Sotheby's, New York

TBM The Brooklyn Museum, Brooklyn, N.Y.

WINTERTHUR Henry Francis du Pont Winterthur Museum, Winterthur, Del.

WMAA Whitney Museum of American Art, New York

INDEX